Also by Peter Watson

LANDSCAPE OF LIES

WISDOM AND STRENGTH

THE NAZI'S WIFE

THE CARAVAGGIO CONSPIRACY

TWINS

FROM MANET
TO MANHATTAN

FROM MANET TO MANHATTAN

THE RISE OF THE MODERN ART MARKET

PETER WATSON

RANDOM HOUSE NEW YORK

Grateful acknowledgment is made to the following for
permission to reprint previously published material:
BLACKWELL PUBLISHERS: One chart from *Muses and*
Markets by Bruno Frey and Werner Pommerehne.
Reprinted by permission of the authors and the
publisher.
ÉDITIONS CALMANN-LÉVY: Excerpts from *Diary of an*
Art Dealer by René Gimpel. Copyright © 1964 by
Éditions Calmann-Lévy. Reprinted by permission.
THE NEW YORK REVIEW OF BOOKS: Ten lines from "The
SoHoiad" by Robert Hughes, originally published in
The New York Review of Books. Reprinted by
permission of *The New York Review of Books.*

Library of Congress Cataloging-in-Publication Data
Watson, Peter.
From Manet to Manhattan : the rise of the modern
art market / by Peter Watson.
p. cm.
Includes bibliographical references and index.
ISBN 0-679-40472-4
1. Art, Modern—19th century—Marketing. 2. Art,
Modern—20th century—Marketing. 3. Art auctions.
4. Art as an investment.
I. Title.
N6447.W3 1992 709'.04—dc20 92-5138

Manufactured in the United States of America
Designed by J. K. Lambert
98765432
First Edition

For Kathrine

There is no historical precedent for the price structure of art in the late twentieth century.

Robert Hughes, *Nothing If Not Critical*

CONTENTS

Author's Note *xv*

Preface: Beauty as a Commercial Concept *xxiii*

1. Selling *Dr. Gachet* 3

I | 1882–1929
THE POST–PRE–RAPHAELITE BROTHERHOOD

2. "This Painful Subject . . . the Ruinous Tendency of Auctioneering" *31*

3. Outroping, Sales by Candle and Mr. Colnaghi's Levee: The Early Years of the Art Market *45*

4. Paris in the Golden Age: Manet and the Birth of Modernism *75*

5. The Street of Pictures: Rue Laffitte and the First Dealers in Impressionism *81*

6. The Barbizon Boom: Taste and Prices a Hundred Years Ago *101*

7. Siegfried Bing, Murray Marks and Their Oriental Friends *107*

8. The Widows *118*

9. Du Vesne, Duvane, Duveen *131*

10. Quaritch, Hoe and Belle of the Books *145*

11. Vollard's Paris, Cassirer's Germany *151*

12. Sotheby's First Old Master *164*

13. "291" and the Armory Show *174*

14. The £10,000 Barrier: Taste and Prices on the Eve of World War I *185*

15. War and the Major *189*

16. The Kahnweiler Affair *203*

17. The Paris Dynasties *219*

18. The Cult of the Portrait: Taste and Prices on the Eve of the Great Crash *227*

II | 1930–1956
THE UN-GENTLE ART OF MAKING ENEMIES

19. The Great Crash *235*

20. Bad Blood *245*

21. The Mathematician and the Murderer *252*

22. The Great Drought: Taste and Prices on the Eve of World War II *261*

23. War and the Marshal *265*

24. Peter Wilson Looks West *280*

25. Shanghai to Suez, via Hong Kong *291*

III | 1957–
IMPRESSIONISM, SUNRISE

26. The Picasso Business and the Epiphanies of Leo Castelli *301*

27. Sotheby's versus Christie's *318*

28. The £2 Million Barrier *329*

29. Manhattan's New Street of Pictures *338*

30. Porcelain and Pensions *350*

31. The Apotheosis of Peter Wilson *359*

32. The Fall of Sotheby's and the Rise of Alfred Taubman *369*

33. The New Sotheby's and the New Collectors *379*

34. The Japanese Passion for *Medama* *388*

35. Van Gogh, Inc., and *Kaneamari Gensho* *396*

36. Picasso, Inc., and the Galleries of the Ginza *405*

37. False Start? The Market in Contemporary Art *416*

38. The Price of Pleasure: Art as Investment *423*

39. Manhattan to the Marais: The Revival of Europe *433*

40. Climax: The Billion-Dollar Binge *447*

41. Anticlimax: The Art of *Zaiteku* *456*

 Epilogue: The Post-*Gachet* World *467*

 Appendix A:
 World Record Prices Paid for Works of Art (with Their
 Present-Day Equivalents) *483*
 Graph Showing World Record Prices Paid for Paintings *486*

 Appendix B:
 The Real Value of Paintings in History: An Index to
 Convert Prices in the Past to Present-Day Values, by
 Dr. B. R. Mitchell *489*

 Notes *495*

 Bibliography *525*

 Index *539*

AUTHOR'S NOTE

Inanimate objects, said Russell Baker, may be divided into three kinds: those that don't work, those that break down and those that get lost. The inanimate objects that are the subject of this book, works of art, may also be divided into three: those that cost a lot of money, those that cost enormous amounts of money and those that cost so much money that the publishers and I went into a huddle to see if there was any way some of these enormous sums could be redirected our way. If you paid retail for this book, our conspiracy worked.

The art market has become—war apart—the great spectator sport of our day. Picasso, Renoir and van Gogh slug it out in the salesrooms, the prices of their canvases going through more acrobatics than the *Saltimbanques* they so often painted. In the Eighties and Nineties, Sotheby's and Christie's have come to dominate the art market, and their names are household words, at least in smart households. Yet their British provenance is misleading because the rise of the modern art market is a story set first in the United States, second in France and only third in Britain. This is because the dominance of the salesrooms is relatively recent. The modern art market is the result of three more or less contemporaneous developments: the commercial and industrial changes in the United States that followed the Civil War; the rise of the Impressionists in France—not because their fuzzy images were so important or so beautiful or so badly received, but because the painters revolted against the official *salon* and spawned an alternative system for selling their works; and the passage of the Settled Lands Acts in Britain in 1882 and 1884, which brought treasures to the market for a quarter of a century, boosting Christie's and helping to transform Sotheby's from a specialized book auction house to what it is today.

No one can really understand the art market in its entirety, and for this book I have confined myself to three areas: First, I have considered painting, which is still the senior branch of the fine arts. This is so not simply because van Goghs and Picassos have recently changed hands for sums that make even bankers dizzy, but because painting still evokes a greater popular response

than do other art objects. People do not travel by the hundreds of thousands to see silver exhibitions or furniture displays, the way they traveled to the van Gogh centenary exhibition in Holland in 1990. When the royal treasures of Sweden were exhibited at the Royal Academy in London in 1983, a mere 44,000 visitors turned out. When the Monet "series" paintings were shown at the same venue in 1990, the number of visitors over the same period was more than half a million. There is a heavier body of scholarship attached to painting than to anything else in the art world, and far more column-inches in the press are devoted to exhibitions of paintings than to any other form of art. It remains the most important branch of the visual arts.

Second, I have concentrated on books, book collecting and book collectors. Collecting books is almost as old an activity as collecting paintings: of the early-eighteenth-century auction houses in London, for instance, rather more sold books than sold pictures. Coincidentally, in both Britain and the United States at the turn of the century, one of the two main auction houses dealt in books to start with, then began to poach on its rival's territory. Later still, sales of books kept auction houses alive and afloat when categories more susceptible to fashion collapsed. A final reason for considering books is that they throw picture collecting into relief. They do not display well. Books are a quieter pleasure; they call for more effort from the viewer to give up their charms, more coaxing to release their appeal. Indeed, that *is* their appeal. As a result, the history of book collecting has run at a different speed and involved some very different people.

Third, I have looked at the market in Oriental art, which differs from the other two areas not only in its rhythms but in its basic assumptions. For example, in traditional Chinese painting the "master" is esteemed for the ease with which he performs his task. One effect of this, however, is that he can produce an accepted masterpiece in minutes. From this it follows that a true master produces thousands of masterpieces in a normal lifetime. This confounds the Western notion of the link between rarity and quality; it is a problem of aesthetics, but it also has important implications for the market. Another, more pragmatic reason for considering the Oriental market is that in recent years the Far Eastern economies have been the most successful in the world, and Hong Kong now rivals Switzerland as the third great center for art sales, after New York and London. Regular sales in Tokyo are scheduled to begin in the early 1990s, so this is an area where the best is yet to come.

—

The organization of the book may surprise some readers. In the art world, unlike other areas of human activity, the two world wars did not in them-

selves act as catalysts for long-term change. During World War I, trade in Paris was disrupted, as indeed was art itself, since several painters (like Braque) went off to fight and were wounded. London, too, was quiet for a while, but in New York several new galleries opened in 1914 and 1915. In World War II, Paris was again badly hit, but in London's darkest days the Eumorfopoulos collection was sold, and by 1945 Sotheby's, for perverse but nonetheless real reasons directly related to the war, was in a better financial state than it had been in 1939. In New York, European exiles and native Americans were getting together to found the Abstract Expressionist movement and the commercial structure that surrounded it.

After the modern art market began in the early 1880s, the first real change of direction came in the wake of the Wall Street crash in 1929. There were great sales, and great deals, in the Thirties, Forties and early Fifties, but compared with the earlier years, and with the thirty years leading up to 1990, the period 1929–57 was lackluster. Great dealers—Joseph Duveen, Ambroise Vollard, René Gimpel, Félix Fénéon—died, the auction houses in America declined and the wake of World War II seemed almost as grim as the war itself. Life did not properly return to normal, or to the pre-1929 glory and glamour, until 1957, when a quartet of important sales began the boom in Impressionism as our generation has known it. Peter Wilson took over at Sotheby's, Victor Waddington moved from Ireland to Cork Street in London and Leo Castelli at long last opened his own gallery in Manhattan. The contemporary art market took on the form that is now so familiar. Hence this book is also divided into three.

—

My first and greatest debt is to Christopher Burge, president of Christie's in New York. To the alarm of several of his colleagues and the general bewilderment of his rivals at Sotheby's, he agreed to give me unprecedented access "backstage" for a major auction in order to provide the first chapter of this book. The sale we chose was that held in New York on May 15, 1990, the auction of Impressionist and modern works which included van Gogh's *Portrait of Dr. Gachet*. In view of the outcome of this sale, a world record price, it would be nice to pretend great foresight on his or my part. In fact, it was luck.

My second debt is to the authors of several books, each of which I have pillaged, précised and paraphrased shamelessly. In general, the American side of art market history has been better told than any other. Aline Saarinen's account of the main American collectors, *The Proud Possessors* (New York: Random House, 1958), is rich in stories without being overly anecdotal. Wesley Towner's account of the American Art Association, the Ander-

son Galleries and Parke-Bernet, *The Elegant Auctioneers* (New York: Hill & Wang, 1970), is extremely funny and well written. He gives no sources and I have heard some aspersions as to his accuracy, but it is still the best account by far. (This book was completed by Stephen Varble after Mr. Towner's death.) On the British side, Frank Herrmann's *Sotheby's: Portrait of an Auction House* (London: Chatto & Windus, 1980) is meticulous and enviably comprehensive, and Nicholas Faith's *Sold: The Revolution in the Art Market* (London: Hamish Hamilton, 1985) is excellent on the same firm's more recent history. This is a book, rich in detail, which deserves to be much better known, especially in the United States. Curiously, the history of Christie's is much less well documented. All the pre–World War II accounts are dull and incomplete. John Herbert's *Inside Christie's* (London: Hodder & Stoughton, 1990) is much the best but covers only his years with the firm, 1958–85. Pierre Assouline's *An Artful Life: A Biography of D. H. Kahnweiler,* published originally in France as *L'Homme de l'Art* (Paris: Éditions Balland, 1988), is the best book on a single art dealer, though René Gimpel's *Diary of an Art Dealer* (New York: Farrar, Straus & Giroux, 1966) comes close and is funnier. William Grampp's *Pricing the Priceless* (New York: Basic Books, 1989) is another book that deserves to be much better known, especially in Europe. Anne Distel's *Impressionism: The First Collectors* (New York: Harry N. Abrams, 1990) is as invaluable on early dealers as on collectors.

Lastly, no one treads on this territory without the basic map provided by Gerald Reitlinger's three-volume *The Economics of Taste* (London: Barrie and Rockliff, 1960–70) and F. Lugt, *Répertoire des catalogues des ventes publiques interessant l'art au la curiosité,* three volumes (The Hague, 1938).

■

To research this book I followed the rhythms of the international art market for more than a year. From my home in London this took me to New York, Los Angeles, Melbourne, Sydney, Hong Kong, Tokyo (twice), Taipei, St. Moritz, Monte Carlo, Paris—and very nearly to the bankruptcy court back in London. In each of those places I interviewed dealers, collectors and salesroom people, almost all of whom are mentioned at appropriate points in the text. Several of them, however, went beyond the call of duty. First I would like to thank Julian Thompson, deputy managing director of Sotheby's with responsibility for the Far East. He pointed me in the right direction and helped to arrange interviews. His firm's representative in Tokyo, Kazuko Shiomi, was extremely helpful, put her office at my disposal for several days, and helped with translation, transportation and my induction into sushi.

In New York, I should like to thank Mimi Russell, Barbara Jacobson, Leo Castelli, Eugene Thaw (who directed me to several important source materials), Mary Boone, André Emmerich, Gabriel Austin, Allan Stone, Jeffrey Deitch, Larry Gagosian, Jeannie Curtis, Ivan Karp and virtually the entire staff of Christie's. From Sotheby's: Diana Phillips, Matthew Weigman, Diana D. Brooks, John Marion, Michael Ainslie, Alfred Taubman, David Nash. My thanks also to Werner Kramarsky, Robert Miller, Fred Hughes, Paula Cooper, Richard Brown Brooks, Estelle Schwartz, Andrea Farrington, Lawrence Rubin, Inge Heckel, Fred Hill. Special thanks to my editor at Random House.

For help in planning my research in Australia, I would like to thank Phyllida Fellowes, Charles and Caroline Benson, and Grant and Di Jagelman. Also Susan and Robert Sangster, Rex Irwin, Sandra McGrath, Anne Purves, Lauraine Diggins, Tony Wenzel, Georges Mora, Joseph Brown, Ann Lewis, Warren Anderson, Robert Bleakley, Penelope Seidler, Tony Oxley. In Hong Kong Kai-Yin Lo, Giuseppe Eskenazi, Chung Lee-Ron, T. T. Tsui, Gerald Godfrey, Warren King, Hugh Moss, Joseph Chan, Kingsley Liu, Andrew Lai, Robert Chang, Au Bak Ling. In Tokyo Kazuo Fujii, Etsuya Sasazu, Iwao Setsu, Tokushichi Hasegawa, Kojiro Ishiguro, Hideto Kobayashi, Mutsumi Odan, Sakiko Tada, Ayako Akaogi, Murray and Jenny Sayle, Susumu Yamamoto, Masanori Hirano, Noritsugui Shimose, Yoshiko Fujii, Hiroshi Ishikawa, Junichi Yano, Mark Tippetts, Yasuhiro Kobayashi, Yukiko Kodama and Norio Suzuku. In Switzerland François Curiel, Inez Franck, Thomas Ammann, Nicholas Rayner, David Bennett, Georges Marci, Walter Feilchenfeldt. In Paris Guy Loudmer, Marzina Marzetti, Eric Turquin, Marianne Nahon, Alan De Fay, Mari Lanxade, Brigitte Mamani, Thierry Picard, Vivienne Roberts.

In Britain I am especially grateful to Elisabeth and Anthony Stanbury and to the following members of the British trade who were helpful: Leslie Waddington, Peter Nahum, Charles Allsopp, Fiona Ford, Martin Summers, Desmond Corchoran, Rodney Merrington, Derek Johns, David Posnett, Johnny van Haeften, Raphael Vals, Roger Keverne, Noel Annesley, Roy Davids, Arthur Freeman, Giuseppe Eskenazi, Julian Stock, Franco Zangrilli, D'Esté Bond, Peter Mitchell, Gordon Watson, Thomas Gibson, Billy Keating, Angela Neville, Giles Milton, Arabella Murdoch, and Julia Jay. Two colleagues on the London *Observer,* Melvyn Marckus and Loranna Sullivan, were very kind. And special thanks to my editors in London: Richard Cohen and Paul Sidney. For help with picture research, the staff of the Visual Arts Library, especially Celestine Dars and Susan Green.

None of the above is in any way responsible for such errors as remain. I

used the National Art Library, at the Victoria and Albert Museum, whose staff I wish to thank, and the London Library, which continues to be an old-fashioned gem.

I am also grateful to Dr. Brian Mitchell, of Trinity College, Cambridge. Dr. Mitchell is an authority on historical statistics and has kindly prepared a special table, set out in Appendix B, which enables prices in the past to be converted into present-day values. He outlines the rationale underlying the table in the appendix.

When I started researching this book, the pound was worth about $1.70. While I was writing, the rate sometimes touched £1 = $1.97 and varied by as much as a cent every few hours. Thus in converting prices from the past into present-day values in pounds sterling, I have used the conversion rate of £1 = $1.85, a round figure more or less halfway between. These conversions are approximate, in any case, adjusted up or down to the nearest round number, and are designed for the convenience of readers who want to know roughly what something was worth in the past, rather than precise calculations, as professional economists might wish.

—

Finally, I am especially grateful to a number of scholars and dealers, and the authors of some of the books referred to earlier, for reading all or parts of the manuscript, for correcting errors and suggesting improvements: Frank Herrmann, who is now the foremost authority on the history of the British art market, helped me greatly, as he has helped other authors in the past; Calvin Tomkins; Theodore Reff; Anne Distel; Alfred Taubman; Robin Duthy; Colin Simpson; Nicholas Faith. None of them is responsible for such errors as remain.

—

My aim has been to produce what is, perhaps surprisingly, the first integrated account of the development of the modern art market. In attempting this I have tried to emulate the style of the American authors mentioned above, to write a book rich in good stories but one that is not merely anecdotal. Although the salesrooms claim the attention of the press and television in our own day, the most interesting and influential people, intellectually or in terms of taste, have almost invariably been dealers or collectors. Art dealers are perhaps the most paradoxical figures of all. They have been flamboyant salesmen, fastidious scholars, fascinating crooks, and there are enough stories in this book about all of these. The one that seems to me to sum up the eternal tension of the art market, to capture the balance between the pathos of the artist and the tightrope act that is art dealing, the characteristic that

makes the trade so magnetic, is Osbert Sitwell's story about Walter Sickert. Sickert had gone swimming. He was well offshore when he encountered someone else, who was apparently out of his depth and beginning to get worried. Sickert saw this other person first and recognized him immediately as an art dealer who, some months before, had promised to buy some pictures but reneged on the deal. The artist took a deep breath, ducked under the surface and swam submerged until he was close to the man. Choosing his moment, he kicked himself clear of the water just as a wave broke over the dealer, worrying him still further. Like a serpent from the deep, Sickert rose up in front of him and roared like an angry monster, "*Now* will you buy my pictures?"

PREFACE: BEAUTY AS A COMMERCIAL CONCEPT

There are some people for whom the mere mention of art and money in the same book, let alone the same breath, is high treason, a hanging offense. To them it is as if money were a form of fiscal defoliant; set it among the fragile flowers of the art world and in next to no time you will have a wasteland. Perhaps we ought not to be too surprised by this. As almost anyone who can operate a word processor has pointed out in print, museums have become the new cathedrals of modern city life. All religions have their fundamentalists, and to them a splashy evening auction must seem like a Black Mass with all the trimmings. They have no shortage of examples to cite. Marcel Duchamp's barbs are best known—especially his reference to art dealers as "lice on the backs of the artists." Necessary lice, he added, but lice all the same. William Blake was another critic. "Where any view of money exists," he complained, "art cannot be carried on." This notion was clearly a popular idea among the English Romantics, for it was shared by Wordsworth. "High Heaven rejects the lore/Of nicely-calculated less and more." Even Émile Zola, novelist, champion of Dreyfus and art critic, had his suspicions of dealers. In *L'Oeuvre,* his oeuvre about his friend Manet and the world of the Impressionists, he puts down the dealer, Père Malgras, a fictional character who resembled the real-life Père Tanguy: "As a superb liar," the narrator of the novel is made to say, "he had no equal."

This attitude took root very early on. A seventeenth-century print shows an auctioneer selling a picture of a windmill. Such is the fastidious connoisseurship of those present—auctioneer, dealers and collectors alike—that no one has noticed that the windmill is upside down. In fact, in those days connoisseurs did not enjoy the respect they are given today. Another print, from the 1770s, shows a bevy of collectors examining with all due seriousness a chamber pot, while nearby a dog urinates on a pile of books—symbol of learning—which the others ignore (see figure 24). Then as now, the message appears to be the same: the art market is venal.

There will be no such nonsense in this book. Art has always been traded, at least since ancient Rome, where the Saepta Julia was the Bond Street or Madison Avenue of the day, and where Damasippus was as prominent in his world as Leo Castelli is in his, before he went bankrupt trying to sell Greek

old masters to the *novae fortunatae* of Rome. For every William Blake or Marcel Duchamp there is an equally great artist who took the opposite line. Renoir was one. "Get this into your head," he told an admirer; "there's only one indicator for telling the value of paintings, and that is the saleroom." Rembrandt, we know, loved "his freedom, art and money" and perhaps money most of all. He would bid up his prints at auction to maintain their value, and his pupils used to paint coins on the studio floor to see if he would bend to pick them up. In his *Lives of the Artists,* Giorgio Vasari was an early realist. "Sodoma said that his brush danced according to the tune of money," and Perugino "would have gone to any lengths for money." Joshua Reynolds allied his art and his income closely: he charged four times as much for a portrait he painted all by himself as for one where he did the head only.

The link between art and money is intimate and long-standing. Art dealing is not the oldest profession but it is pretty ancient nonetheless. It is not only a question of age or longevity, however. As this history of the art market will show, dealing, economics, politics and the law have all played a significant part in the development of taste—at least as important as the part played by collectors, who are themselves, after all, subject to economic and political events. Dealers, as Richard Herner (then at Colnaghi's) has pointed out, are in the best position to acquire those "tactile values" so beloved of Bernard Berenson. And: "Not for nothing have nearly all the greatest art historians of the past been intimately connected with the commercial art world. It gave a practical as well as an economic vitality to their work." Yet there have been many more histories of collecting than of the trade as a whole, histories in effect with a major element left out. This book is an attempt to rectify that, at least in part. The *price* of artworks is not the most important thing about them, still less the most important aspect in their history, but it is not negligible, either.

However, it is one thing to face the art-and-money question head on; it is quite another to accept the art market—dealers, collectors, the salesrooms—at their own valuation. The art world is nothing if not snobbish; indeed, in intellectual snobbery it is second to none.

Let us begin, then, as we mean to go on. A "gallery," as in "art gallery," is not a retreat for learning, where man's nobler aspirations are aired. A gallery is a shop. In Paris, perhaps, or in the St. James's area of London, it may be lined with brocade, or if it is in SoHo in Manhattan or Cork Street in London, it may be lined with whitewash, its pristine, snowy walls resembling nothing so much as Peter Sanredam's spartan church interiors of the seventeenth century. But whatever their persuasion, these chapels are nonetheless seraglios of commerce.

The clients of the galleries are in fact customers. "Collector" is an even

more loaded word than "client." Throughout history the collector has been regarded as a fine fellow, estimable, civilized, a leader of taste, a person of substance. But it is important not to overstate the case. Many art customers of the past and present have indeed been civilized, and sometimes even leaders of taste, but nowadays the word "collector" has been debased beyond a joke. Acquiring cookie jars because they have been owned by men who wear wigs is not collecting; amassing rock 'n' roll memorabilia with all the seriousness of an archaeologist is not collecting; hoarding Swatch watches because the auction houses tell you to is not collecting. These activities are simply a form of shopping. Nor can a collection be formed only by spending a great deal of money. If you are filling your apartment in Manhattan, Melbourne or Milan with Renoirs, Pissarros, Vlamincks and Utrillos just because everyone else you share a bottle of bubbly with is doing the same thing, this does not make you a collector; it makes you a sheep. The difference between the collector and the shopper—and there is one—is a crucial distinction, which will emerge as this book proceeds.

But by far and away the two most treacherous words in the art market canon, far more abused than "gallery" or "collector," are "beauty" and "unique." It is important to realize that in the art market these are both *commercial* concepts, not philosophical or aesthetic ones. This came home to me early one evening some years ago in a small gallery in the St. James's area of London. I was standing next to a dealer and we were looking at an oil painting of the Bolognese school. The canvas showed a number of naked women, and the main figure had fingers the shape of bananas, buttocks that would not have disgraced a buffalo and a bright red nose. The dealer turned to me and in awed tones whispered, "Isn't that beautiful?" To my shame, I muttered something neutral and escaped. That red-nosed, banana-fingered minx was no more beautiful than a road accident. She did, however, set me thinking. What a commercially elastic concept beauty is. The modern scientific revolutions from Freud onward have done their best to instill in us the notion that there is no such thing as objectivity; that facts are matters of interpretation, the understanding of which depends on the observer's personal history; and that beauty is in the eye of the beholder. The recent history of art appears to support such a view. The very names Impressionism, Fauvism and Cubism were first used derisively, as terms of abuse. But history turned on the deriders. What one generation finds ugly or nonsensical, the next finds beautiful. This recent history is important and is misused by the trade. The general customer is often invited to believe that what he thinks is downright ugly is in fact a subtle form of loveliness that for the moment escapes him. He is led to understand that, given time, he and everyone else will see the beauty locked up in the ugly object that is being offered for sale.

Of course, knowledge and aesthetics *are* related, and intimately so, as anyone who has learned to love opera by understanding more about it will testify. But that is a long way from saying, as dealers often do, that what is ugly today will invariably not be tomorrow. Of course dealers are trying to make a market, to create a demand for objects of which they have a supply. In this game, the more that beauty can be written off as unquantifiable and unobjectifiable, the better.

In fact, there is a great deal of agreement on the subject of beauty, more than many people acknowledge. Equally important for the subject of this book, there is a good correlation between what is considered great art and what is expensive art. Anyone who is skeptical of this should read Sir Alan Bowness's Walter Neurath lectures, *The Conditions of Success: How the Modern Artist Rises to Fame,* published in 1989. Bowness, a former director of the Tate Gallery in London, surveyed the rise to fame of four schools of art: the Pre-Raphaelite Brotherhood, the Impressionists and Post-Impressionists, the Abstract Expressionists and the painters of the London School grouped around David Hockney. In each case Bowness distinguishes an identical four-stage process on the way to success. The first is peer recognition. Other artists come to regard a particular colleague as significant. The second stage is recognition by the serious critics. The third stage is recognition by collectors and dealers, and the last is recognition by the general public.

Bowness's lectures describe a general theoretical process, but they have clear implications for the argument in these pages: that aesthetics—beauty— and price go more or less hand in hand. The artists who are respected and thought important, whose work is most esteemed for its innovation and beauty, become the most expensive. More important, although this doesn't happen instantly, in most cases it doesn't take long—Bowness calculated about twenty-five years. Agreement is reached quite quickly, and thereafter the link between price and quality is fairly settled. Price and quality are not the same thing; but they *are* strongly related.

A further refinement of Bowness's argument is that "most truly original art is the result of group activity": he cites Turner and Girtin, Delacroix and Géricault, the Pre-Raphaelites, the Barbizon School painters, the Impressionists, the Fauves, the Cubists, Die Brücke and Blaue Reiter. Pollock, Rothko and de Kooning were close, as were Jasper Johns and Robert Rauschenberg, who had studios in the same building. The group nature of great art has important aesthetic and historical implications and at least two commercial ramifications. On the one hand, it means that what the artists in any particular group think of each other is important. The Impressionists are perhaps the best example of all; among themselves the painters recognized

that Manet, Degas, Cézanne and Monet were greater artists than Renoir, Sisley and Pissarro, and by and large their prices reflect this. The second ramification, as Bowness points out, is this: "To imagine that there are unrecognised geniuses working away in isolation somewhere, waiting to be discovered, is simply not credible. Great art doesn't happen like that." In other words, the idea that dealers can discover great new talent in a vacuum, before other artists and critics know about it, is simply untenable.

A different kind of evidence comes from Germany. There, in the 1970s in Cologne, Willi Bongard conducted an unusual, irritating but nonetheless fascinating exercise in research. His motive was frankly financial; he was interested in finding bargains in the art market. But Bongard's original slant was his definition of "bargain": work by painters whose prices did not match their intellectual standing. This definition led Bongard to a specific—and to many people crass—mathematical approach. He attached numerical values to certain notable events in an artist's career. For instance, an artist was awarded three hundred points for each work of his or hers in a major museum. If the artist was mentioned in a variety of reference works, he received further points—fifty for this book, fifty for that and so on. In this way, Bongard ranked a hundred contemporary artists. Finally, he correlated this ranking with the prices of the artists' paintings.

Professor William Grampp, professor of social sciences at the University of Chicago, now enters the story. He is an economist and a connoisseur, very knowledgeable about art and a witty writer. He made a statistical analysis of the rankings of points and prices "to see if the price of a painter's work was consistent with the points assigned to him." This analysis, published in 1989, concluded that the two rankings were indeed related. For example, one of his findings was that as the number of points an artist amassed increased by 10 percent, the price of his work increased 8 percent. The link between quality and price was far from perfect, of course, but it was surprisingly strong.

As a final piece of evidence, talk to dealers; they will confirm the argument by throwing it into relief. There is a strong consensus in the art trade on ugliness. You can't sell still lifes of dead fish or game; the French don't like snow scenes; pictures of King Charles spaniels may walk out of the galleries but large dogs don't move; in the field of marine pictures storms don't sell—people want calm seas. In the 1920s, the *Burlington Magazine,* the academic journal in which art historians announce their discoveries of "lost" Old Masters, ran an article entitled "A Portrait of the Ugliest Princess in History." This was Duchess Margaret of Tyrol, "better known as Pocket-mouthed Meg," though not even this does justice to her sensational ugliness (see figure 1). She was a nymphomaniac, a bigamist and a poisoner, and a

great deal of her nature shows in her hideous portrait. Whatever the art dealers of St. James's say, this woman will *never* be regarded as beautiful.

The doublespeak about beauty is matched only by that which surrounds another cherished art market commodity: the idea that art is "unique." We are encouraged to believe that true beauty is so hard to achieve that it is virtually impossible to repeat it, and what great artist would want to do so anyway? He is so concerned with innovation that repetition is simply not an option. How often do we hear auctioneers hedging when they give estimates on the price of artworks due to be sold because, of course, all artworks are unique? It is true that uniqueness is part of the attraction of art; unlike anything mass-produced, unlike even yachts, private jets or diamonds, pictures are one of a kind and irreplaceable; and naturally this makes them more expensive. But surely this is an overworked concept. Yes, pictures are unique, but so are numbers, fingerprints and freckles. But in each case the *significance* of the uniqueness varies: it may matter and it may not. Yes, all Renoirs are unique, but in some of his journeyman portraits of young girls, the only difference seems to be that some have been punched in the mouth by a left hook and the others by a straight right. Think of all the Dutch church interiors by Peter Sanredam, mentioned earlier: they differ only in the hymn number shown above the pulpit. Think of all the other expensive painters whose pictures are little more than repetitions: Canaletto, Bellotto, Guardi, Marieschi. Think of all those still lifes of lobsters, dusty bread, oyster shells and glasses of wine, which differ only by a grape or a lemon rind, or all those flower studies, which differ no more than real vases of flowers. Think of Brueghel and his skaters—some pictures have twenty-three, others have twenty-seven; think of seascapes or hunting pictures; think of all those Cuyp cows sitting or standing, standing or sitting. Think of Andy Warhol.

The fact is, the "unique" card has been vastly overplayed in the art market. The worst part about it is that it enables dealers and auctioneers to have it both ways. They can play it when it suits them in order to add to the appeal of a painting, or it can be downplayed if it gets in the way. Strictly speaking, if something is genuinely unique it should, in theory, be "priceless" because there is nothing like it. But of course many Renoirs are not really unique, not in any sensible use of that word, and the same applies to Brueghels, Canalettos and Sanredams. In turn this gives them the character of a commodity, when the tactic suits dealers, and enables a market to form.

There is no answer to this doublespeak other than to be aware of it, and to make sure that anyone who tries to take advantage of it knows that you know. The history of art and commerce, the relationship of beauty to money, is endlessly fascinating, but it is quite fascinating enough without the cunning manipulation of concepts that we thought were familiar to us.

FROM MANET
TO MANHATTAN

I | SELLING *DR. GACHET*

It is a warm May evening in Manhattan. A close, sunny day is turning cloudy. In a paneled fourth-floor office overlooking the corner of Fifty-ninth Street and Park Avenue two men are seated at a table. In front of each is a sales catalogue for the auction that will begin downstairs in just under half an hour, at 7:00 P.M. The taller of the two men, Christopher Burge, president and chief executive officer of Christie's in the United States, will be the auctioneer at the sale, and as usual he allows himself a solitary scotch to settle his nerves. The other man, Michael Findlay, is a pleasant-faced pixie, his fine fair hair beginning to thin out. He is the head of Christie's Impressionist department and he is too worried to drink.

The two men have good reason to be nervous. Within the next thirty minutes Burge will open the bidding on Daumier's *Un étalage,* the first lot in the firm's most important sale of the season. The star item in the sale is Vincent van Gogh's remarkable *Portrait of Dr. Gachet* (see figure 2). This work was executed almost exactly one hundred years ago, between June 3 and 5, 1890, barely six weeks before van Gogh committed suicide. Many people regard the painting as one of the most important works of art ever to come to auction, and the estimate placed on the picture, $40–50 million, reflects this. But it could well break the world record for a work of art sold at auction, which stands at $53.9 million (including commission), paid for the same artist's *Irises* in November 1987, at Sotheby's, Christie's fierce rival.

The worry that both Burge and Findlay feel, however, is not whether the record will be broken but whether the picture will sell *at all.* When the sale was announced, four months previously on January 25, 1990, the art market had just completed an extraordinary decade, during which prices for Impressionist paintings had risen by 940 percent. In the last two years alone, the increase has been 153.4 percent. The boom, combined with tax changes in the United States that made it less profitable for millionaires to donate their paintings to museums, meant that masterpieces of ever-greater importance had been coming onto the market, culminating this week with *Dr. Gachet* and at Sotheby's, in two days' time, with Pierre-Auguste Renoir's *Au Moulin de la Galette,* which also carries a presale estimate of $40–50 million.

Between the announcement of the sale and the event itself, however, the world economic picture had begun to change, decidedly for the worse. In the week beginning February 19 the Tokyo stock market fell 2,569 points, 6.9 percent down and its steepest fall since the worldwide crash in October 1987. The fall in Taiwan was just as dramatic. In April several sales in London had proved catastrophic, notably one of contemporary Russian art at Sotheby's, at which 76 percent of the paintings failed to sell because they did not reach their "reserve," the minimum price their owners wanted. Only the night before, at the sale of Impressionist and modern pictures held by the Geneva-based firm of Habsburg-Feldman, an even higher proportion of pictures—85 percent—had not reached their reserve price and been "bought in."

Hence Burge and Findlay are moments away from a sale that could be their biggest triumph or their costliest and most visible flop. For the past several days, the Christie's building on Park Avenue, part of the old Delmonico's Hotel complex and right next to Regine's Night Club, has been thronged with people: sellers, spectators, security guards, the trade from Europe, America and Japan, the press from Europe, America and Japan—and perhaps even some buyers. About an hour ago, however, an eerie silence settled over the building. Everything that can be done to make the evening a success has been done. The sound system has been checked and rechecked, the seating plan has been checked and rechecked, the currency converter, which blew up this morning, has been repaired by an emergency team flown down from Toronto. In a dress rehearsal for the main attraction, *Dr. Gachet* has been placed on the turntable to make sure it fits and that the spotlight is correctly placed. At 6:00 P.M. the shutters come down. It is too late now to make any more last-minute adjustments. It is more important that people snatch a quiet breathing space, relax and clear their heads. While the rest of the building lapses into silence the only activity is in the rest rooms, where the staff are changing, men into black tie, women into cocktail dresses.

In his office Burge, who has just changed, has about a finger of whisky left.

He has to time it just right. If he drinks it too soon, the effect will have worn off; too late and his nerves will still be with him on the rostrum. Outside, in the street, there is a cacophony of horns. Yellow taxis and black limousines are backed up as far as Bloomingdale's to the east, as far as the Pierre Hotel to the west. Twelve hundred well-heeled people create a lot of traffic.

Burge takes a last look at the *Portrait of Dr. Gachet* in the catalogue. The old man looks melancholy. As van Gogh himself put it, he has "the heart-broken expression of our times." The whisky obviously isn't working yet. Burge finishes his Dewar's and inspects his watch: 7:50. He straightens his tie, grasps the auctioneer's book and leaves his office. This sale has been six months in the making. The last act is about to begin.

—

As far as *Dr. Gachet* was concerned, the sale had actually been four years in the making. Siegfried Kramarsky, who bought the picture just before World War II from the Städtische Galerie in Frankurt, died in 1961. A Jewish banker, Kramarsky was born in Altona, near Hamburg. He left school at eleven and thereafter was completely self-educated. Like other Jewish bankers who were also collectors (Georges Lurcy, William Weinberg, Jakob Goldschmidt), he had been forced to leave Europe in the Thirties because of his religion. In Kramarsky's case, he had at first decamped to Holland. He stayed there until the outbreak of the war, when the Nazis and anti-Semitism caught up with him again. Then he emigrated to Canada, arriving there in 1940, but moved south to the United States two years later. He was already a rich man; he dealt in currencies and securities, but according to his son Werner, known to everyone as Wynne, arbitrage was closest to his heart, and he prospered more than ever in the United States.

Always attractive to women, Kramarsky met his wife, a schoolteacher, during the period of hyperinflation in Germany and won her devotion when he advised her to convert her salary checks into foreign currency. His wife outlived him, but in 1983 and 1984 she suffered three cerebral hemorrhages, and it was her medical condition that precipitated the sale. There are three Kramarsky children, two brothers and a sister. By tradition they had always loaned *Dr. Gachet* to the Metropolitan Museum of Art in New York for a few weeks every year for the summer show, but for the last six years it had been there on permanent loan. In 1986, however, with Mrs. Kramarsky still very ill and with the art market roaring ahead, the Kramarskys thought again. The picture was held in trust, a trust that was now increasing in value but producing no income. For their mother's sake, the three children decided to sell.

To begin with, the Metropolitan Museum was not told of the decision but

Christie's was. Business-getting is the most important and most fiercely contested part of the auction world, and since there are so few real differences between the two main auction houses, apparently trivial differences come to matter very much. (In Britain years ago, Lord Scarbrough once refused to have anything to do with Sotheby's because they had spelled his name like the seaside town Scarborough.)

In most cases, every piece of business is fought over ferociously by the two big auction houses. When a rich collector dies, the auction-house staffs go through agonies deciding how soon they may approach the heirs or trustees of an estate. If it is too soon it looks ghoulish and you risk offending people; too late and it could be . . . too late. One reason why auction-house people dress so somberly is that they go to a lot of funerals. With *Dr. Gachet,* however, there was never any question of Sotheby's getting the business. Christie's had always done Kramarsky's appraisals and valuations, and in two cases their contacts with the family had blossomed into genuine friendships. Jo Floyd, Christie's chairman from 1974 to 1988, was one such family friend, and Stephen Lash, executive vice president in New York and a former investment banker with Warburg's, was even closer; Wynne Kramarsky and his children and Lash and his would regularly have kitchen suppers together on Sundays after they had all returned from the country.

Although on this occasion Christie's did not have to contend with Sotheby's, the sale was not plain sailing, for a major legal problem loomed in the form of Kramarsky's widow, Lola, whom the sale was designed to benefit. Under the terms of her husband's will she was a trustee of the trust that owned the picture, but because of her strokes, she was mentally incapable of giving her consent to the sale. Thus the other trustees, her three children, were forced to go to court to have their mother disqualified. Given her condition and the purpose of the sale, the court's judgment was more or less a formality; nonetheless, it had to be done and it took a year and a half. It was a nerve-racking time for the Kramarskys; they knew their picture was a record breaker and the art market was fizzing as it had never fizzed before. *Sunflowers,* also by van Gogh, sold for $39.9 million in London in March 1987. Then came the stock market crash of 1987 and the Kramarskys thought they had missed the tide. But no—two days after "Black Monday" Christie's held its most successful jewelry sale ever, and only weeks later yet another van Gogh, *Irises,* outdid even *Sunflowers,* selling for an extraordinary $53.9 million.

By the early summer of 1989, *Dr. Gachet* was finally clear of all legal restrictions, and the art market was still booming. That May Picasso's self-portrait *Yo Picasso* had sold at Sotheby's in New York for $47,850,000, Pontormo's *Portrait of Duke Cosimo I de' Medici* had fetched $35,200,000

at Christie's and Gauguin's *Mata Mua (In Olden Times)* had brought $24,200,000, also at Sotheby's. *Dr. Gachet* was arguably more significant than any of these.

Now began the lengthy discussions with Christie's regarding the contract. The first problem arose over the proposed date of the sale, May 10. It was an emotional date for the Kramarskys and the entire family objected. Wynne and his brother had been born in Holland, and they had all fled to the New World as a result of the Nazi invasion of the Netherlands, which had taken place exactly fifty years earlier, on May 10, 1940. This was unarguable, and the sale was shifted to May 15. Another bone of contention was insurance. Who should bear the risk, and for how long, while the picture was at Christie's? Wynne specified what forms of physical contact were to be allowed and stipulated that the painting could not travel. He knew it was in good condition, and air travel might cause damage.

He also knew that the picture had an extraordinary iconographical status. Like van Gogh, Gachet was an eccentric. A rabid republican, he was also a Darwinist, a free thinker and a socialist. He had known Corot and Courbet, Daumier and Victor Hugo. He believed in homeopathy, free love and cremation and was "bent on enlisting all his acquaintances in a Society for Mutual Autopsy." In his house at Auvers there were pictures by his many Impressionist friends, particularly Pissarro, Guillaumin, Renoir, Sisley and Cézanne. According to van Gogh in one of his letters, Gachet's house was "full of black antiques, black, black, black."

Two further details about Gachet were even more important. First, he was fanatical about van Gogh's portraits. Vincent wrote his brother, Theo, "He understands them exactly, exactly." Dr. Gachet had told the artist that he could help him overcome his melancholia, but his appreciation and instinctive understanding of van Gogh's works was to prove more important to his patient. Second, Gachet and Vincent were remarkably similar in appearance. Both had "glittering woebegone blue eyes, a pensive furrowed brow, an acquiline nose, a narrow downward-tending mouth and protruding chin," in addition to what van Gogh described as "the face of an overheated brick, scorched by the sun, with reddish hair." Vincent, Theo and Gachet himself all shared a good laugh about this, but it was not merely a superficial matter. As Oscar Wilde said, to some extent all portraits are self-portraits; *Dr. Gachet* comes much closer than most to fulfilling this notion.

There was also a mystery about the picture. In a letter that he never sent to Paul Gauguin, van Gogh likened his portrait of Gachet to Gauguin's *Christ in the Garden of Gethsemane: Self-Portrait* and lamented that the painting was "destined to be misunderstood." This does not make much sense unless the picture is both a straightforward image and a cipher for

something else. A clue to this, according to Matthew Armstrong of Christie's, lies in the following letter of van Gogh's:

> I painted a portrait of Dr Gachet with an expression of melancholy, which would seem like a grimace to many who saw the canvas. And yet it is necessary to paint of the extent to which, in comparison with the calmness of the old portraits, there is an expression in our modern heads, and a passion—like a waiting for things as well as a growth. . . . At times this might make a certain impression on people. There are modern heads which people will go on looking at for a long time to come, and which perhaps they will mourn over after a hundred years.

These ideas led van Gogh to a new philosophy of portraiture, which he outlined in another letter, this one to his sister:

> What impassions me most—much, much more than all the rest of my metier—is the portrait, the modern portrait. . . . *I should like* to paint portraits which would appear after a century to the people living then as apparitions. By which I mean that I do not endeavour to achieve this by a photographic resemblance, but by means of our impassioned expressions.

The uniqueness of Gachet's portrait is underlined by the fact that it was both the first and the last portrait to exemplify this new approach, for no sooner had it been completed than van Gogh shot himself. Wynne Kramarsky and the rest of the family felt that anyone seriously interested in the painting would undoubtedly know all about its background and have been moved by it, and would travel anywhere to see it.

Another clause in the contract concerned the commission to be paid. Here again *Dr. Gachet* was unusual. Some years earlier, Christie's had followed Sotheby's lead and, in the case of the very top pictures, eliminated the commission they charged to the seller, simply to get the business. *Dr. Gachet* clearly fell into this category, but here the close friendship between Stephen Lash and Wynne Kramarsky paid off again. Although Christie's was planning to charge the Kramarskys no commission, Wynne insisted that the house take 3 percent. This may not have been such a selfless gesture as it sounds, however, for it made his next contractual point more difficult to resist. The art market may have survived the crash of October 1987 but that event had nonetheless entered the race memory, and the world's stock markets were now receiving more than their usual share of scrutiny. Accordingly, Kramarsky specified a complicated formula whereby if a combined index of two of the world's top three stock markets, New York, Tokyo and London, fell more than 25 percent in a few days, the picture would be withdrawn from sale.

When the main elements of the contract were settled, the Metropolitan Museum was informed that it would be losing the picture ("They were chagrined," says Wynne, "but they understood") and the sale was announced. One doubt remained in the minds of the Kramarskys and Christie's at this stage: though they both felt that *Dr. Gachet* was more important than *Irises,* they also realized that *Gachet* might appeal to art historians or museum curators but that the kind of person likely to be able to pay a record price for it might prefer pretty flowers to a somber portrait. Therefore Christie's concluded that it would be better to have a slightly shy estimate beaten rather than to have an aggressive estimate fail. For these reasons the estimate put on the picture was $40–50 million, less than the sum *Irises* had fetched but still the highest estimate ever placed on a work of art. Now they all had to sit back and wait, hoping that the favorable economic wind that had been blowing throughout the Eighties would hold for a few more months.

—

It was to prove an anxious time. In the first place, and by a piece of extraordinary commercial and artistic symmetry, Sotheby's announced the upcoming auction of their own $40–50 million picture, Pierre-Auguste Renoir's *Au Moulin de la Galette.* On the face of it, *Galette* was a considerable challenge. The picture, owned by Mr. and Mrs. John Hay Whitney, came from the same stable as *Irises,* owned by Mrs. Joan Whitney Payson. Furthermore, the fact that it carried the same estimate as *Dr. Gachet* did was not the only parallel between the paintings. Whereas Gachet had been portrayed by van Gogh, Cézanne, Norbert Goeneutte and Charles Léandre (see figures 3–6), the Galette had been depicted by Renoir, Picasso, Henri Rivière, Alexandre Steinlen and Adolphe Gérardet. Each picture existed in two versions, and the version not being sold was in the Musée d'Orsay in Paris. Further, whereas *Gachet* had belonged to Ambroise Vollard and Paul Cassirer, two of the great early Impressionist dealers, *Galette* had been in the possession of Victor Chocquet, a great early patron of the Impressionists, and Bernheim-Jeune, yet another of the great nineteenth- and early-twentieth-century Parisian dealers. It was almost as if the rivalry had been stage-managed.

In fairness to Sotheby's, it had to be acknowledged that *Galette* was possibly the finest Renoir in private hands, and like van Gogh, Renoir is a favorite of the Japanese, who were expected to be strong contenders at the two May auctions. Would the undeniable attractions of *Au Moulin de la Galette* lure some potential bidders away from *Dr. Gachet*? Wynne Kramarsky later told me he was never worried by the Renoir. "That gave me less pause for thought than either the Manet or the other van Gogh—the self-

portrait—in the Christie's sale. I wasn't sure whether having three major pictures in one sale was an advantage or a disadvantage."

Kramarsky was referring to Edouard Manet's *Le Banc (Le Jardin de Versailles)*, which had been sent to Christie's for sale by Mrs. John Barry Ryan, with an estimate of $20–25 million, and van Gogh's 1888 *Self-Portrait,* which was one of five pictures consigned by the heirs of Robert Lehman, a banker and former chairman of the Metropolitan Museum. The Manet was a very distinguished picture, the finest painting he produced in the summer of 1881, when he was confined to the garden of a villa in Versailles, already suffering from the locomotor ataxia that would kill him. It had long been regarded as one of the masterpieces of Impressionist painting and was illustrated in color in John Rewald's magisterial *History of Impressionism.* The van Gogh *Self-Portrait* carried an estimate of $20–30 million; it too had once been owned by Galerie Bernheim-Jeune in Paris, and was exhibited by Paul Cassirer in Berlin in 1904. Despite all this competition, Wynne did not ask Burge to withdraw any of the other paintings.

Over the next weeks, there were to be other nerve-racking moments. The fall of the Tokyo stock market and the collapse in Taiwan have already been noted. Closer to home was the news, released in March, that *Irises* had been sold to the Getty Museum for an undisclosed sum. Alan Bond, who had "bought" the painting in 1987 for that record price, was now said to be $5 billion in debt. Most worrying was the fact that the price the Getty paid was secret. Bond was brash, the kind of man who would be anxious to prove he had done well on this deal; likewise, Sotheby's would want *Irises* to be seen as a good investment. If the Getty *had* paid more than Bond did for the picture, the figure would surely have been released. The secrecy, therefore, did not bode well and was hardly a good advertisement for art as an investment.

April saw a spate of poor sales in London and many people thought that the break in the market had finally arrived. But even then Wynne was not concerned. "I did not think that London was poor in terms of *performance*; I thought that the pictures were not up to it." He was more concerned at that point by the continuing weakness of the Tokyo stock market. However, his mood was bolstered by the number of people who were calling him for tickets to the sale. There was little he could do to help them, but the calls showed that interest in the auction was building, and that New Yorkers sensed, as they tend to, that this would be a piece of theater not to be missed. Thus April turned into May on a more optimistic note than might have been the case.

In the prelude to a major sale, the pecking order in a top auction house changes in important ways. It is like an army confronted at last by war, when strategic issues take a back seat and instead the focus is on the impending skirmishes of battle. As a result Stephen Lash, who played such a vital background role in bringing *Dr. Gachet* to market, becomes less involved and gives way to two very different people.

For about two weeks before a major Christie's sale in New York Barbara Strongin is arguably the single most powerful person in the art market. Strongin is in charge of seating. She heads a department that is ten strong, and their combined aim is simple: if they do their job properly, there should be virtually no bids on an auction night from any of the side rooms. These rooms are connected to the main salesroom by closed-circuit television, but that is not the point: all the big players should be accommodated in the main room. She has the Christie's computer to help her. This tells Barbara who has spent what at similar auctions in recent years. Yet there are always surprises—new bidders—and so she also needs to rely on her instincts. She knows many of the main players by sight, and she has a fax or phone relationship with countless others. Strongin says that as a rough guide, $300,000 is the cut-off point. If you haven't spent that much money with Christie's in the past two or three years you won't get a seat at this auction. She also has her preferred list, fifty to seventy people who have spent at least $2 million with Christie's in the immediate past. The existence and dimensions of this list have never before been admitted.

But that is only one of Strongin's problems. There is also the headache of keeping dealers and "privates" apart. In the logic of the salesrooms, "privates" are treated like generals, for they are the private collectors who prefer to attend the auctions and bid for themselves. Their presence is gold dust; they are living proof of how healthy the market is. Some of them go to a number of dealers before a big sale to see who can get them the best seats, which is a cunning way of seeing who in the trade has the most clout. However, many of them do not wish to sit anywhere near the dealers. Some of the older dealers like to sit in the front row, where their confidential bidding techniques are more easily seen. For others in the trade, rows five and six are more popular; there they can see *and* be seen. Some dealers like to sit together if they are bidding together, and Strongin needs to know this. One dealer likes to sit in the main room but leaves his seat for another in the side room, from which he bids where the trade can't see him.

Five days before the sale, Barbara Strongin's seating plan is already full and there are one hundred names on the waiting list for the main room. These include Agnew, the venerable London dealers, who unaccountably left it late

in applying for tickets. On the other hand, perhaps they were not intending to come until a client gave them a commission. About now the flowers, champagne and chocolates start to arrive, as often as not from dealers who were given seats for the last sale but did not turn up and now want to reingratiate themselves. None of it will work. Strongin has heard the "most amazing" lies and doesn't fall for any of it. Her powers are absolute, and this goes for Christie's staff just as much as for outsiders. Of course she will listen to Christopher Burge and to Michael Findlay, but other than those two, the person she is most likely to listen to is Susan Rolfe, head of Special Clients. ("Special clients": these two dry words in fact stand for four far more evocative ones: "very, very rich collectors.")

Rolfe and her troop inhabit a small cubbyhole with no windows and only pictures of African big game on the wall. It does not smell like the jungle, though; Chanel competes with Dior, which in turn is swamped by Saint-Laurent. Rolfe's eccentricity is to wear different-colored spectacles every day and fingernails as long as her pedigree. She heads a department of three. The others are Heidi Trucker, with boyish blond hair and a talent for languages, and Kim Solow, whose necklines get lower and miniskirts get higher as the sale approaches (if the sale had been delayed by just a day or two, she might have been wearing nothing at all). These women have to be on first-name terms with all two hundred of Christie's "special clients." They cosset them, run errands for them and send them gifts throughout the year. They are the first-class stewardesses of the art world.

Today, Susan's glasses are a vivid green. Weber plays quietly in the background. "People like to spend money," she says. "Our job is to make it fun for them. But that's not necessarily as easy as it sounds. For instance, we will get up at five in the morning to bid at a sale in Monaco for a client. I'm coming in this Saturday to help someone look at a nineteenth-century picture. He'll be between planes and it's the only time he can do it."

Susan's main problem at this point is that four of her clients are interested in the same picture, and she doesn't know what she will do if two or more ask her to bid for them. She will take the first one to suggest it, of course, but this may annoy others, who may be—well, more special. She, Heidi and Kim have sent out transparencies and paperwork on *Dr. Gachet* to everyone they think might be interested, "plus a 'love note.'"

How many people is that?

"About twenty."

And?

As yet, no interest.

"There's a lot of interest in the ———— painting." This is a phrase you often hear bandied about the auction scene. What exactly does it mean? With a few days to go, I ask Christopher Burge, who has agreed to see me at the end of each day to review progress and discuss any issues that crop up. "People ask for a condition report, or they ask what terms are available. A frequent request is for 'thirty, sixty, ninety'—that is, a third of the price to be paid within thirty days, another third at sixty days and the balance at ninety. Granting these terms can be very important and repay our effort, sometimes invisibly. For instance, it may be that the underbidder was given credit and therefore pushed up the actual buyer, who perhaps didn't need it." I ask how many people in the world have both the funds and the appetite to go for *Gachet.* Burge hesitates. "Five to ten people in Japan. Two or three in Switzerland. Three in London, but none of them English. Five here in the United States. One in Germany. None in France, though Wildenstein keep their cards very close to their chest."

This morning there has been a breakfast. Among the guests were Gerald Piltzer, head of 20th Century Fox, Ian Woodner, one of the world's greatest collectors of Old Master drawings, and Barbara Walters, the television personality. Some of the people at the breakfast have left bids.

Today has been useful, says Burge, for he has accomplished one important but far from obvious task. He has, as he puts it, "covered the Daumier": that is, he thinks he now has a buyer for the opening lot. This is clearly important, not least psychologically, for it means that the sale will open with a success. However, it does point up an odd feature of salesroom protocol: the lots are sold broadly according to the dates of the artists' lives. Therefore many Impressionist and modern sales begin with works by Honoré Daumier (1808–79), a notoriously unpopular painter in recent years. In sticking to this tradition the auction houses have made it difficult for themselves; on this occasion, however, it looks as though the Daumier is safe. Burge, who has also been worried about the Manet, now reports that interest in it is "picking up," and that the low end of the estimate, which they had reduced from $20 million to $13 million, is now edging back up, nearer $15 million. There is also interest in the Modigliani portrait, *Jeanne Hébuterne con grande capello,* and "a tickle" on the Monet *Nymphéas* (estimate: $6–8 million). On the other hand, a Japanese dealer has canceled the six seats that he had asked for.

Now Burge confides that at this stage of the equivalent sale last year, he had somewhere between fifty and a hundred bids in the book.

I ask the obvious question: How many bids are there in the book this time?

Burge has a habit of pushing his spectacles back up his nose. He does this now before answering, "One; exactly one." He looks at me and sips his

whisky. He seems calm but what he actually says is "Something is wrong. Very wrong."

—

Over the weekend Christie's looks busy, as indeed it is at the front of house. Upstairs, behind the scenes, the offices are deserted, but downstairs thousands of people throng through the public rooms. Some of the London staff have by now arrived. James Roundell, all six feet five of him, is one. He has excellent contacts in Japan and was largely responsible for introducing Yasuda Fire and Marine Insurance to *Sunflowers,* which they bought in 1987 for $39.9 million, then a world record price. Charles Allsopp, Christie's chairman in London, is also here, and this sets tongues wagging among the privileged few. The best-kept secret of this sale so far is that although Wynne Kramarsky stipulated that *Dr. Gachet* must not travel, a request had come from Switzerland, where, he was told, a certain European businessman wanted to see the picture. As Kramarsky put it to me, "I asked Burge if this businessman had suffered an injury lately that made it difficult for him to travel." Burge said he was bound by confidentiality, but there were no flies on Kramarsky—he knew that Stavros Niarchos, the Greek shipowner, who has a fabulous collection of paintings and has a house in Switzerland, had suffered an eye injury recently. Had Allsopp come to bid for Niarchos? No one had the faintest idea, but it was an extra tidbit for the in-house gossips.

The Sunday before the sale, May 13, was the day of the main cocktail party, to which perhaps three hundred sellers, dealers, collectors and general hangers-on had been invited. One notable absentee was Barbara Strongin, not because she hates parties or had something better to do, but because she would have been mobbed by people who wanted main-room tickets but as yet had not got them. She stayed home. Burge was in and out of the public rooms all weekend, being pleasant to the trade, the "privates" and the press in turn. As far as he can tell, attention is focusing more and more on *Dr. Gachet* and is drifting away from the Manet. He is more worried by this than he lets on.

On Monday morning, however, the mood is very different. Roundell is on the phone constantly and so is everyone else, worrying about problems while there is still time to make a difference. Roundell is obviously more nervous for *Dr. Gachet* than he is for the other pictures, on several of which he expects to be bidding for European clients. "There is something wrong if *Gachet* doesn't make a great price, but it *is* a museum picture. It is almost too great a picture for a private collector; it might make some people uncomfortable." Then he adds, "The Manet may suffer from being in the same sale. If it were the front-line picture tomorrow, people would fall all over themselves."

Michael Findlay comes in. It is his birthday, and a diamond-shaped cake has been baked for him, iced in red, yellow and white, with black lines, a replica of the Mondrian in the sale. He is carrying several cartons of coffee with which to wash down the cake, as well as a photograph that shows Marilyn Monroe inspecting a Degas sculpture that is in a later sale. He is almost ashamed to voice his thought, which we all share: Would this persuade anyone to buy the sculpture? There is a nervous joke about the blonde leading the blind. At least Findlay's problems with the catalogue are behind him. Catalogue planning can be tricky. Although pictures are sold chronologically, the aim is to have peaks every so often. There are other rules of thumb: never put two Renoirs together (it confuses the less knowledgeable buyers); watch the colors on Miró, which can be tricky; and for some reason, Foujita and Buffet don't sell well at evening auctions.

Downstairs Barbara Strongin reports that the waiting list, far from contracting, has actually expanded, and that faxes begging for seats are still coming in. Agnew are still on the list: they are likely to get into the main room now, she thinks, but she has to wait for the right seat to become available; she can't put them among "privates." Susan Rolfe, whose eyeglasses are bright blue today, says that there were two people at last night's party who spend "ten to fifteen to twenty million" a season. There were others who spend five million. She adds that she thinks the Matisse is coming up after two other good paintings, which I take to mean that she thinks the Fauve picture may suffer because the "five-million people," though interested in the painting, are also attracted by the earlier pictures and can't afford both.

In the afternoon Barbara Strongin holds the Bid Department meeting. The primary responsibility of this department is to accept bids from people who can't or don't want to attend the sale. This afternoon's meeting is about something else. There are twelve "bid spotters" at the meeting, and each is given a section of the room to watch over. Their job is to stand around the edges of the room and to make sure that Christopher Burge misses no bids. They are also to be on the alert for underbidders. In an auction at this level, *anyone* bidding is noted; if the spotters do not recognize someone, they are told to write down the chair number so that his or her identity can be checked later. This is especially true, says Strongin, of bidders in the side rooms. They are more likely to be new clients, who can then be stroked and nourished for the future.

Stephen Lash is relaxed. He's not very busy but that's the point, and it is part of Christie's style. If any customer has a last-minute doubt or panic, there's a senior figure on hand to listen. His relaxed demeanor makes it look as though the staff are more in control than they actually are. In his words, "It's important to be available."

Patricia Hambrecht, the firm's attorney, is also relaxed for once. There appear to be no major legal problems this time, unlike last year, when there was a row after a big dealer contested the title to some of the pictures a Hollywood figure was selling. That had involved last-minute dashes to and from court. "There's always something last minute. Often it's wives or husbands who are splitting up. One partner will notice a painting in a catalogue, a picture he or she thought he or she part-owned. They arrive with all their blue lights flashing." The only nerves I can detect in Hambrecht, and this applies to all the senior staff, are those about the guaranteed lots. (Christie's has guaranteed the heirs of Robert Lehman a minimum sum for their five paintings, which the auction house will have to pay whether or not the pictures sell.) Hambrecht and the others comfort themselves with the knowledge that while Christie's has guaranteed $50 million in pictures, the equivalent figure in the Sotheby's sale is $135 million.

As usual, at the end of the day I visit Burge. Tonight we go through the catalogue and Christopher predicts what will and will not sell. He says the Pissarro will be a disaster. "It has been bought and sold six times in the last six years. Michael [Findlay] is convinced that we've sold the important Chagall. Henry Kravis's man was in today, but it wasn't clear whether he liked anything. Wildenstein came in with their list, the top four, so perhaps the French market will bail us out. They were also interested in the Cassatt, but as far as the Pissarro, *Effet de neige à l'hermitage,* is concerned, they have been very Gallic: 'You can't sell snow in France.' " Burge concludes, "We are going to get hit in the Renoirs, and there could be thirty-three to thirty-five lots unsold out of eighty-one."

The situation is still amazingly fluid. Who knows which dealers are cooking up what deals in the hotel bars of the Upper East Side? Burge and I share a cab uptown. In the cab he confesses he hasn't been sleeping well for the past few nights.

Sale day starts at 7:30 A.M., at least it does for Barbara Strongin and her aides. She has bought three coffees on the way to the office but they are all unopened; her direct line hasn't stopped ringing. Now she finishes her conversation, opens one coffee and hits the phone again. She is calling Switzerland, London, Taipei and Osaka. Any dealer who is still at home obviously can't get to the sale tonight and she is going to give his seats away. It is an effective technique; by 9:45 A.M. the waiting list is down to thirty-five. Agnew, surprisingly, are still on it, at number one, but this is only because Barbara is waiting to give them good seats.

The TV crews are starting to arrive, their equipment spreading over the

salesroom floor like the debris of a traffic accident. Roberta Maneker, head of the press office, is on the phone pleading with a reporter *not* to come tonight. Anyone applying so late in the day obviously isn't very professional, and who needs that kind of coverage? Many of the women on the staff who had some way to come in to the office are already in their cocktail dresses.

At 10:30 A.M. a print sale gets under way in the main salesroom. It seems as if normal life is continuing. In fact, this is a terrifying balancing act. Brian Cole, the auctioneer, must appear relaxed, yet complete the auction by 4:00 P.M. at the latest so that the room can be rearranged in time for tonight's main bout. Despite all the activity, however, there is no hiding the fact that there is a lot of gloom this morning, brought on by the news of last night's sale of Impressionist and modern paintings held across town by the Geneva-based house of Habsburg-Feldman. At one time Archduke Geza von Habsburg worked for Christie's in Geneva, before leaving to start up for himself. In the past he has been successful in what is, after all, a very competitive business. But last night . . . last night, fully 85 percent of the pictures at Habsburg-Feldman failed to sell and the archduke passed into legend immediately when he joked from the rostrum that bidding *was* allowed. This morning, at a rival house, it doesn't seem such a good joke.

Susan Rolfe is wearing red spectacles today: a red spec day. She has not lost her style despite the pressure. As usual she is on the phone. One of her special clients wants still better seats than he has already been allocated and she is trying to reassure him. "Call me five-ish, after you land, okay? Now, I think you should go and have a drink, relax, count your money or whatever." The hemlines in her office are definitely shorter today, and so are the tempers. "Takeshima already *has* six tickets and he wants two more. Jee*sus!*" But he has told her he is definitely going to be bidding "somewhere between lots one and nineteen." She calls Barbara Strongin's office and is told she is busy. "So am I!"

Upstairs, in and around Christopher Burge's office, there is an air of quiet desperation. John Lumley, another arrival from London, is on the phone to France, speaking in fluent French about Renoir, so perhaps Burge was right and the French *will* rescue the evening. Something is brewing with Hans Thulin, a Swedish millionaire, from whom a fax has been received. The Banque de Scandinavie is involved. Michael Findlay rushes into Burge's office, followed swiftly by Patty Hambrecht. They all look serious and I hear mutterings about Habsburg-Feldman. Sheryn Goldenhersh, Christopher's personal assistant, looks at me and says, "Laughing is not allowed today." Yet when Burge comes out of the meeting about Thulin he looks relaxed. He says there have been "noises" about the Lautrec but that the owner will not relent on the reserve price—$3.5 million—so it is still touch and go. There

have been a host of last-minute calls, mainly from people asking for extra time to pay. A new call comes in, and after listening for a while, Burge says, "Well, I'll look for you tonight on the magic lot." He smiles and hangs up. He says that he met with the Kramarskys this morning and that they have "fixed the magic number," meaning the reserve price. I learned later from Wynne Kramarsky himself that this was $35 million, almost identical to that on *Irises,* which confirms that neither Christie's nor the Kramarskys were being greedy but also that interest in the picture seemed not to be very strong. "There is talk out there," and Burge waves to Park Avenue, "of some Americans going hell-for-leather—Kravis, Annenberg and so on. But does that mean at Christie's or at Sotheby's?"

At this I wonder whether Lumley was talking about the *Sotheby's* Renoir? Are they all more worried by this than they have let on? Burge pushes his spectacles back up his nose. "Well, the interest in *Gachet* does seem to be crystallizing, but we can't dismiss what happened at Habsburg-Feldman last night. You can't totally ignore the fact that the sale was a complete disaster." He says that he now thinks the Manet *will* sell, but it will be a struggle, and that the Salvador Dalí, despite its ornate title, *Assumpta corpuscularia lapis-lazulina,* won't. "People gasp in surprise when they see it—it really is lovely—but they think it's worth somewhat less than the estimate, four to six million. There are a lot of nibbles too on the van Gogh *Self-Portrait,* notably from the Gallery Urban and Wildenstein. Martin Summers, of London's Lefèvre Gallery, is going to be on the phone from his home in London." Also a European businessman on his boat is going to be on *two* phones. This explains the presence of Allsopp; the businessman will bid as he usually does through Maria Reinshagen, of Christie's Zurich office, who will be on one phone, but because he is on a boat and communications could be problematic, two phones have been set up and Allsopp will be on the reserve. Someone else—Burge won't say who—will be sitting in the main room but bidding through an agent in the side room; "Now there's a situation that could produce a complete cock-up." At this stage, Christopher predicts that *Gachet* will sell and that it will come very close to the record price, but just miss it.

Patty Hambrecht is back, this time to discuss the five Lehman pictures, the paintings on which Christie's has, for the first time, provided guarantees. This will be her particular responsibility tonight. Christie's has guaranteed a huge sum for all five pictures; in return for this, they fix the reserve prices on them. However, since Sotheby's is the only other company to have done this, and since all the guaranteed sales so far have been successful, there is no precedent regarding the proper fiduciary duty of a public company in a case like this. The first duty of the directors of Christie's is to their shareholders,

but how is that duty to be discharged in a weakening market—if we *are* in a weakening market? Should the pictures be sold at any price or held over for later, when they might—but only might—be sold for more? What would happen to Christie's stock price in such a contingency? Presumably the firm has decided on a formula, but Christopher confesses that he is uncomfortable with guarantees and wishes they weren't forced to use them.

Plenty of people have asked for terms, almost all of them European dealers. In each case except one the paperwork has to be prepared. The exception is the European businessman on the boat, whose word, says Burge, is his bond. "But the wild cards are the Japanese, since they rarely ask for terms."

George Walker is in charge of credit control. As with many jobs in auctioneering, style is important. "My problem is that people *do* overbid at auction. They may negotiate, say, a two-hundred-thousand-dollar credit with me but then, in the heat of the moment, spend four hundred thousand. What do we do then? Not recognize their bid in the salesroom? That would be very damaging, even if the auctioneer could remember everyone's credit limit, which of course he can't. So people often take longer to pay than they intended—and we have to make allowance for that. Then there are times when people bid as agents and the principal backs out. It happens. In that case we usually go to the underbidder and ask him if he still wants what he just failed to buy. We usually offer special terms, of course, for helping us out. We reject about five percent of requests for credit, but we reduce the amount in almost half the cases, and this applies to requests for ten thousand dollars or ten million. For this sale we have had a lot of requests for special terms. We charge no interest for thirty days but after that it's one and a half percent a month. That's steep, and it is in fact cheaper for clients to borrow from the banks and pay us off, which is of course what we prefer.

"In general, at these levels it is not hard to check credit. Many clients will have their own special banking officer at their bank. We get his name and the name of the bank but, to be on the safe side, we get the phone number ourselves from Information. We identify ourselves and ask whether So-and-So is good for, say, two hundred to three hundred thousand dollars. We may get a yes, or 'I can't speak for that amount,' or 'I'm sorry, I don't know So-and-So that well.' When we do get a negative reference, we usually alert Sotheby's as well, and they do the same for us, for obvious reasons. The real problem is that this is all done at the last moment—it's the nature of the business—so occasionally we get negative banking references *after* people have registered for the sale. Here the numbered paddles that we now insist everyone use come in handy because we can tell Christopher not to recognize certain numbers, and he simply ignores their bids. I am at the registration table for all the main sales, and one of my jobs is to tactfully refuse paddles

to the very few undesirables. In fact, it happens less at a big sale like this one than at smaller sales, but I have to tell you that bad banking references are equally common among trade and privates, at least here in New York. After the sale, I consult with Christopher about the release of merchandise. Our best payers are Wildenstein and Niarchos. Normally payment is due within three days, and I send out the first collection letter after ten days, though some of our special clients never receive collection letters. After seventeen days we call clients. We are still very polite but say we would like to know when we can expect payment. The drawn-out cases are usually due to disputes over authenticity or bidding problems, but since all auctions are tape-recorded, this is not the kind of problem it could be. You can usually tell after two phone calls whether someone is lying. All order bids for this sale, for instance, have to be in Christopher's book by four o'clock this afternoon. Only very special clients can get in after that. Also, for any sale a late bid for a significant amount—say one hundred thousand dollars—is refused if there isn't time to make a credit check. As for tonight, I think it's going to go better than people are saying. We have two or three new clients whose credit I've checked—in the mid-sevens [i.e., $3–7 million]."

Lunchtime in the press office: two French television crews have shown up but space has been allotted for only one. "Get me the Paris office," yells Roberta Maneker. "They can choose who we let in." It is already 6:00 P.M. in Paris; will the office be manned? "It had better be."

There is a request for press accreditation from "Yani Zoar."

"Is that a person or a country?" someone asks.

"Who cares?" groans Roberta. "Blow them away."

There may be no time for laughter today, and there's none for lunch either. By 2:45 the print sale has reached lot 295, which fetches $560,000 against an estimate of $150,000–200,000. The computer shows that so far the sale is 85.4 percent sold. Better than Habsburg-Feldman. A good deal better.

At 3:10 P.M. Barbara Strongin's waiting list has shrunk magically to six, but she has stopped accepting any more calls and tells her assistants that if anyone is really going to bid, they can have a telephone. Christopher and Michael are making a last tour of the pictures before they come down off the walls, discussing the final reserve prices. Susan is depressed. One or two of her Americans have pulled out and she is still waiting to hear from a client in California who was interested in five pictures; he too is worried about the state of the stock market. She gazes at the African wildlife on her walls. "That's where I'd like to be right now," she says. Heidi, on the other hand, still has a lot going on. One of her most important clients, who didn't like any of the transparencies she sent him and refused her offer of tickets, has now turned up. He much prefers the originals to the transparencies and now *does*

want tickets. He likes to buy anonymously, so she tries to get him into a small viewing room where he can watch the sale by closed-circuit television.

At 3:45 the prints-and-drawings sale is showing a rate of 87 percent sold. The sale has reached lot 452 out of 472, and Brian Cole is moving fast. A few moments later, lot 463, estimated at $14,000–18,000, goes for $48,000. The sale finishes at precisely four o'clock, exactly on schedule, with 87.12 percent of the pictures sold. It is a quiet triumph for Brian Cole, and as the porters move in to reset the chairs in the main room, morale shifts up a gear.

The bid book is now closed, the pictures are off the walls and the front desk is quiet. Now that the prints-and-drawings sale is over, there is a short dress rehearsal in the main room. Christopher stands at the rostrum to test the sound, the turntable and the currency converter. *Dr. Gachet* is put on the turntable, and as it revolves I pass through at the back of the room. Christopher is speaking: "Fifty million," he is saying, "fifty-one million . . ." Is this an accident? Is he trying the words on for size, or does he know something he hasn't hinted at in our conversations? The currency converter is working at last; it shows £26,315,790, SF64,455,265, DM76,634,212, ¥6.75 billion, $51 million.

Five o'clock. Susan Rolfe has already changed. She is wearing a black-and-white dress, but her mood is all black. Almost every one of her clients has backed out, and for the first time in a long while she probably will not be bidding at all in a big sale. Her only hope is one more client, coming in shortly to look at something. The press meeting in Christopher Burge's office decides what to say in advance in the event of certain outcomes, both good and bad. There will be a press conference whatever happens, but Roberta emphasizes that for most of the television crews, who deal in headlines, the sale will be a major story only if *Dr. Gachet* breaks the world record. If this happens, there will be no problem with the press, so most of the discussion is over what to say if *Dr. Gachet* fails, and if the Lehman pictures don't do well.

At six a strange silence settles over the building. The front desk is deserted. Gill, the doorman, who has almost as many uniforms as Susan has spectacles, has changed into the dark blue one, his favorite, but the front door is quiet. Major sales are social events, and people want to make their entrance fashionably late. In all, seventeen hundred people will arrive between six-thirty and seven. The lavatories are packed, as people all over the building start to get changed. Christopher has already done so and meets with Michael Findlay in his office to go over the sale one final time and to discuss estimates again. Then Christopher looks at Barbara Strongin's seating plan. He looked at it yesterday too, but now he notes in his marked catalogue, or "book," who is sitting where. As he reaches each lot he will know where the people interested in that particular painting are seated, which means that he is less

likely to miss bids. Even experienced dealers give it away when they are about to bid, he says. "You can sense it from the rostrum. It is not so much *when* they bid as a few bids before. They sit up, shift in their seat and look at you more intently. I have to be careful not to return their stare in kind; it can frighten them off." He also has to work out where to start the bidding so that he hits the bids in the book "on the right foot."

What this means is complicated. Let us say that the reserve on a painting is $15 million, and that Christopher has been left a bid of exactly that sum. To do his duty by both the seller and the bidder he must reach $15 million "in the book," not in the room. This means that he must start the bidding an even number of bids beforehand so that he gets to $15 million when he wants to. This takes some calculating. He would normally start the bidding at about 50 percent of the low estimate—in this case $7.5 million. Until $10 million, bids are in $500,000 jumps, but they go up a million dollars each time after that. This means that Burge can start the bidding at $7.5 million or at $8.5 million, but not at an even $8 million. And this calculation has to be done on all lots with order bids—that is, bids in the book.

Finally Christopher practices the first three or four lots. He actually goes through the bidding out loud, in Michael's presence.

Downstairs, Sheryn Goldenhersh has welcomed two of the consignors. Her job tonight is to look after them in a private room, just as Stephen Lash and Jo Floyd, who has flown over specially, will look after the Kramarskys. Lash is calm, or appears so, as he has all the way through. "If a big picture fails," he says, "it is important to *be* there with the client." Barbara Strongin is installed just inside the main door with a batch of tickets for people she knows by sight. She is accompanied by a big security guard; one night some years ago an art-world groupie assaulted her when she refused him tickets. There are no assaults tonight, but there are an extraordinary number of pleas. The most popular story is that So-and-So (a senior member of Christie's staff, presumably picked out of a hat) said that he/she would leave a ticket at the door. A director of Sotheby's tries this, as does a minor pop star. Promptly at 7:00 P.M. Barbara and everyone else leave the front door and take the back stairs to the salesroom. Because people are always late, Christopher has stipulated that seven o'clock sales actually begin at 7:12. This sounds silly, but not only does it allow the most illustrious latecomers to find their seats, it also helps people on the telephones to reassure anxious clients that they have not missed the picture they were interested in.

For this sale, and because of this book, I am allowed on the stage with Christopher and Barbara. Having arrived by the back way, I know that behind the stage, as in any other theater, a posse of stagehands is at work— putting pictures on the back of the turntable and taking them off again once

they have been shown. They are presided over by a uniformed, armed security guard. This evening, art worth at least $246 million—in theory—will pass through their hands.

We watch the room fill. I note that the Agnew people got good seats after all. There are a lot of Japanese. Charlie Allsopp is already on the phone; so is Susan Rolfe, so perhaps the Californian did come through. Heidi is next to Susan. Kim Solow passes down the aisle in a tight black crêpe dress, her hemline shorter than ever. Roberta Maneker rolls her eyes and whispers, "That dress . . . is illegal." As Christopher steps onto the rostrum I ask him to forecast what *Dr. Gachet* will fetch. He looks extremely relaxed, pushes the spectacles back up his nose, and says, "I think that number you overheard when we were trying out the microphone won't be far wrong." I am puzzled; has he been holding something back? But it is too late to ask because he has tapped the rostrum with his gavel and wished everyone "Good evening," and we are at last, at long last, off.

———

The Daumier, estimated at $1–1.5 million, fetches $1 million. Lot 2, the first Renoir, sells, but below its estimate of $1.2–1.6 million. Lot 4, the second Renoir, also sells, but also below its estimate. Nothing is jumping above expectations, and the first failure comes with the Pissarro snow scene. It is bought in at $750,000, well below its estimate of $1.2–1.6 million ("Bought in" is simply salesroom jargon for "unsold."). Wildenstein was right; it's not just Eskimos and Frenchmen that you can't sell snow to. Lot 8 is the first of the guaranteed lots, still another Renoir, with an estimate of $6–8 million. The bidding stops at $5.5 million, but the picture is sold and Patty Hambrecht can breathe a little easier. Lot 13 is the Manet. Bidding starts at $8 million and reaches $15 million with apparent ease, then stops dead. Christopher was right; the trade liked the picture but thought the estimate too high. Still, the picture sells.

Several people now reach for the phones. Salesroom practice is for the phone staff to call clients some seven to eight lots ahead of the one they are interested in. This would take us to lot 21—*Dr. Gachet.* Among those on the phone now is Maria Reinshagen, a Christie's staffer from Zurich.

Two Renoirs fail, the first Toulouse-Lautrec sells within its estimate for $11.8 million, to Heidi on the telephone. Other pictures sell for just below expectations. Lot 20, the one before *Dr. Gachet,* is a Sisley called *Soleil du matin à Saint-Mammès.* It goes for $1.5 million against an estimate of $1.4–1.8 million. Nothing is soaring upward.

And so, lot 21, Vincent van Gogh's *Portrait of Dr. Gachet,* has arrived among us. The room hushes and the television lights go on. From my

privileged position, I notice that a couple of the Christie's staff have crossed their fingers. Where will Christopher start the bidding? There had been gasps at Sotheby's back in 1987 when John Marion started *Irises* off at $15 million.

"I'll start this at twenty million," says Christopher coolly. "Twenty million, twenty-*one* million . . ." Strangely, in the overheated atmosphere of those months, Christopher's opening is less surprising than Marion's was.

The bidding now rose steadily. For some reason I made a note that at $35 million Christopher again pushed back his specs. I didn't know then that $35 million was the reserve price, and that this gesture was a relaxation on his part, knowing that the star of the show had been sold, whatever else happened.

So far, Christopher had been looking across at Maria Reinshagen on the telephone to his right. She was the only bidder I could see. At $40 million, however, the bidding faltered; someone had dropped out. One could almost taste the disappointment in the room as the silence lengthened. Forty million was forty million, but it was a long way from the record many people had come to watch broken.

Then from the back of the room, in a seat on the right aisle, someone raised his arm. This was Hideto Kobayashi, a forty-four-year-old dealer with his own gallery off Dentsu Street in Tokyo's Ginza district. Kobayashi had arrived the previous Saturday and checked into the Plaza Athenée hotel on Sixty-fourth Street, where he had been given room 1111. Kobayashi thought this a good omen; he says that he is not superstitious but that he likes "round numbers," numbers with a ring to them. Kobayashi's presence shows just how hit-or-miss the art market can be. He had a client who was very interested in *Dr. Gachet* but who never once came to see the picture at Christie's. The client, a Japanese businessman, had a passion for portraits and had admired *Gachet* when it was displayed in the Metropolitan Museum. He had never imagined it would be sold. Kobayashi himself saw the picture at Christie's on the day he arrived in New York, and again on the Monday, but he never once had a conversation with any of the senior staff at Christie's. He had asked Sachiko Hibiya, the firm's representative in Japan, if there was any other Japanese interest in *Gachet* but was assured there was not. That was all. He had registered normally. There was no question about his not having a good seat since his gallery is well known. (When I later visited it, the main attraction was a wonderful Monet *Waterlilies.*) He had been trained by another distinguished dealer in the Ginza, Kazuo Fujii, so Christie's knew very well who Kobayashi was but never had an inkling that he was interested in *Gachet.* Even the people sitting next to Kobayashi, who had accompanied him from Tokyo, were surprised when he put up his arm. With his penchant

for round numbers, Kobayashi was pleased when the bidding stopped at $40 million. Things were going his way.

Maria Reinshagen was raising her arm more slowly now; even so the bidding crept up inexorably to $49 million, when Kobayashi equaled the record bid for *Irises*. There was a barely perceptible delay; then Maria Reinshagen signaled that her client would go to $50 million. This produced applause and whistles and people started to stand, looking back to see who it was in the back of the room who was still bidding. For amid all the applause the contest went to $55 million very quickly, and it was suddenly clear that with *Irises* well beaten, there was no telling how high *Dr. Gachet* might go. Sixty million was reached, to the sound of appreciative low whistles. At $65 million the silence was very respectful indeed.

Unknown to anyone else at the time, Kobayashi's limit was $70 million, another round sum. But since he had entered the bidding at $41 million, it was his bid that took the price to $69 million. As Maria Reinshagen capped it with $70 million, Kobayashi decided on the spur of the moment to go to the next round figure, $75 million. He knew his client and felt free to do so. He raised his arm for $71 million. Maria was bidding more slowly now, but not much more, and she signaled $72 million. Kobayashi came back with $73 million. Maria was talking into the phone, the slight smile that she had worn the whole time still playing across her face. She whispered into the phone at length. Christopher wasn't going to rush anybody, and certainly no one else minded. At last she nodded: $74 million. Kobayashi didn't hesitate. It was, he had decided, his last bid, but he didn't want anyone to guess as much. He bid as though he were willing to go on all night. All eyes turned back to Maria. She was still smiling, but listening now rather than talking. Perhaps her man thought in round numbers too, and $75 million was round enough. It would be $82.5 million with the 10 percent buyer's premium added on. She nodded her head at the phone and said a few words. Perhaps they were "Good-bye," for now she looked up at Christopher and decisively shook her head.

The sound of Burge's gavel sealing the sale was drowned in applause and the entire room stood to look at Kobayashi. Christopher turned to me and smiled. "Congratulations," I said. He shook his head slightly, as if to ask whether all this was real. Then he pushed back his specs and turned to conduct the rest of the sale.

There were several remarkable sequels to that night. Later in the evening van Gogh's *Self-Portrait* went for $26.4 million, to become the ninth-most-ex-

pensive painting ever sold at auction, and the fourth-most-expensive van Gogh. The Chagall fetched $9 million, and the Mondrian that looked like Michael Findlay's birthday cake went for $8 million. Matisse's *Boléro violet* sold for $2.3 million—to Susan Rolfe on the telephone, so she was happy; special clients had proved special after all. The Dalí *did* sell but twenty-four pictures out of eighty-one didn't—30 percent, which was definitely on the high side. As to Christopher's presale predictions, his pessimism about the Renoirs proved correct, and he was right about the Léger, the Redon and Monet's *Nymphéas*; all were fine. He was also right about the Bonnard being a "dead duck" but he was wrong about the Miró and the Klee, which he thought would sell and didn't. The five guaranteed pictures sold for a total that was $9.1 million above the low estimate—a relief all around, especially for James Roundell, who at the party afterward at the Bar du Théâtre danced like a dervish.

Two nights later Kobayashi did it again, bidding $71 million at Sotheby's for Renoir's *Au Moulin de la Galette* (which, with the buyer's premium, cost him $78.1 million). He was so nervous, he said, that he lost six pounds in a week. Both pictures, it was revealed, were bought on behalf of Ryoei Saito, owner and honorary chairman of the Daishowa Paper Manufacturing Company (see figure 86). Saito said it was "no big deal" to have paid $160.6 million for the two works and added that he had borrowed against his company's landholdings to finance the purchases. What was not revealed was that Saito and Kobayashi were ready to go even higher for the Renoir than for the van Gogh, but they never needed to do so.

The sequel I liked most concerned the payment for *Dr. Gachet*. Given the rumpus over Alan Bond's failure to complete his purchase of *Irises,* both the Kramarskys and Christie's were more than a little concerned that the same thing not happen with their van Gogh. In fact, Saito and Kobayashi settled with Christie's before the end of May, and the pictures arrived together in Japan, shipped by Sotheby's, on June 13, less than a month after they had been sold. The Kramarskys should have been paid by Christie's within thirty days of the sale. In fact, they were paid on Friday, June 15, twenty-four hours after the deadline. "But they were very proper," says Kramarsky. "The check they sent showed one day's interest on the money." One day's interest at 3 percent above prime on $72,750,000, which is what the Kramarskys were entitled to after the 3 percent commission they insisted Christie's take, is $10,700.

I | 1882-1929
THE POST-
PRE-RAPHAELITE
BROTHERHOOD

2 | "THIS PAINFUL SUBJECT ... THE RUINOUS TENDENCY OF AUCTIONEERING"

Toward the end of 1882 Mr. Thomas Kirby announced that he was giving up auctioneering "forever." He was weary, he complained, and had recently returned from Europe, where he had been advised to visit several spas for his health. To those stalwarts who knew him from his regular appearances on the rostrum of his own firm at 845 Broadway, in New York City, this was a surprise. His coloring was still ruddy, his bark as strong as ever, and although he wore a clipped pointed beard (known as an Imperial) and was never in public without a wing collar, cutaway morning suit and striped trousers, which gave him the air of an already wizened bank clerk, he was only thirty-seven.

Kirby was being less than frank. The fact was that he had a better offer. At that time auctioneers in America ranked a fair way below the salt. This was thanks in part to "Colonel" J. P. Gutelius, one of the greatest nineteenth-century auctioneers, who relished his reputation as "one of the wickedest men who ever lived in Oklahoma." This reputation had lasted until, he boasted, he had been "happily converted" to the ways of the Lord one rainy night after he had "glimpsed a comet through a black umbrella." After his conversion Gutelius, in the spirit of the times, combined auctioneering (of almost anything you care to name) with soul-saving and a Wild West show. When he arrived in town, according to Wesley Towner, he would open proceedings with a prayer and then introduce an "outlaw stallion" known to

have killed several men. Perched on the back end of a covered wagon, wearing a cowboy hat and brandishing a bell instead of a hammer, he would deliver his forthright spiel: ". . . makita five, makita five . . . O let's take the glory road, Folks! I got the five, makita six . . . Six! Thank you, Lord, for the blessings of the day. The six . . . the seven . . . and the lady makes it eight! Thank you, Mother. I'll ask him to give you a double portion of grace . . ."

The auctioneers' prayers were not always answered. They might pretend to be preachers but they were in the dock more often than they were in the pulpit. In New York throughout the last half of the nineteenth century a self-appointed anti-auction committee issued a series of propaganda sheets "on this painful subject," namely, "the ruinous tendency of auctioneering," which was said to lead to "death, dissipation and bankruptcy." These guardians of virtue pulled no punches: "Speculation, deprived of its accustomed opportunities for adventure, now shows itself in sales at auction, which are fashionable machines of polite and licensed swindling. . . . Already the respectable classes congregate by the hundreds before the knights of the hammer. . . . Bad passions ascend. . . . There is little doubt that auctioneering will, unless returned to the hell which commissioned it, root out in the end every seed of intellectual polish from the mind and change us back to rank Barbarians."

But the colonel and his kind owed their notoriety only in part to their own alleged shortcomings. Two other factors played a role. One was that for many people the dominant activity of auctioneers, at least in the nineteenth century and in the South, was the selling not of art but of slaves. The second was the "auction war," which was, in effect, an inheritance of the Napoleonic wars. Under Napoleon, as Brian Learmount has pointed out, French trade was so badly disrupted by hostilities that the nation lagged in exploring and exploiting the technological advances that inevitably go with war, and at which the British were adept. While the British developed mass-produced, cheap goods, the French continued to manufacture well-crafted and expensive luxury items. The United States, not wanting to become involved in the European imbroglio, discouraged its ships from entering European ports. Though understandable, this policy amounted to a blockade in reverse and produced in America a strong demand for European goods, especially the wide range of cheap things that the British had to offer. Aware of this, the British stockpiled such goods in their possessions nearest to America—Bermuda or Halifax—and awaited the cessation of hostilities. At the same time, war itself had stimulated the auction habit; when prizes were taken at sea during the conflict, the seized cargoes were sold by auction for speedy dis-

posal, as often as not in U.S. seaports. When the 1812–14 war ended, the British invaded America with large quantities of cheap goods, which were also sold in the seaports where the seized cargoes had been auctioned. This approach was a huge success—so much so that an official New York City investigation concluded that the British-operated auctions could sell three times the amount of goods that regular U.S. importers could handle. Naturally this provoked resentment on a massive scale. Anti-auction committees, pamphlet campaigns and trade associations cropped up everywhere. Eventually Congress was prevailed upon to investigate the situation but found that many auctioneers were honorable men and that there were many arguments in favor of auctions. Legislation to ban auctions was introduced but thrown out. However, the pattern was set. As the nineteenth century progressed, auctioneering was seen by many in the United States as in some way "un-American."

On grounds of social prestige alone, therefore, Thomas Kirby might well have wished to give up auctioneering. But there were other considerations. One was the American Art Gallery, just around the corner from 845 Broadway, at 6 East Twenty-third Street, on the south side of Madison Square. This gallery was then owned by two men, James F. Sutton, son-in-law of Rowland Macy, proprietor of the fledgling department store on Fourteenth Street, and Rufus Moore, an art dealer. Their partnership had started in 1880 and was designed to sell the Oriental objects being collected in the Far East by Sutton's great friend Austin Robertson, and to promote American art. However, the partnership between Sutton and Moore never really prospered, and in the autumn of 1882 Kirby was called in to help liquidate the "Ming porcelains, hundreds of years old," that the gallery had acquired. Yet Sutton still held the lease on Madison Square, and though the business had failed, he enjoyed being involved with art objects and was convinced there was money to be made from the right kind of art dealing. Having been impressed by Kirby's flair on the rostrum, Sutton asked him if he would take over the running of the firm.

The American Art Gallery had several assets in its favor. Towner reminds us that, as Macy's son-in-law, Sutton was obviously not short of money, and the gallery's location was ideal. In those days, Madison Square was the social center of Manhattan. Neither the Flatiron Building nor Madison Square Garden had yet been built. The square was at the intersection of Broadway and Fifth Avenue. On Broadway, to the south of the square, were the many fashionable stores that made up what was then known as the Ladies' Mile. To the north, mainly on Fifth Avenue, were the houses, mansions and palaces of the Astors, Stewarts and Vanderbilts. In these exalted surround-

ings Thomas Kirby flourished as he never had on Broadway or in Philadel-
phia, where he had started "crying" auctions, as the phrase then was, for a
crusty old Quaker, Moses Thomas.

Kirby was also lucky with his timing, for by the time he had found his feet
and Sutton had been persuaded to have the gallery lavishly redecorated, the
new year had arrived. And in New York 1883 was an extraordinary year. In
May the Great East River Bridge, soon known to the world as the Brooklyn
Bridge, was inaugurated with fireworks and the finest gathering of ships seen
anywhere outside wartime. In the same year, the Metropolitan Opera House
opened on Broadway between Thirty-ninth and Fortieth streets with a per-
formance of Gounod's *Faust.* The year 1883 was also when American design
and craftsmanship received what even a confirmed republican might concede
was the ultimate accolade: Tiffany & Company was appointed imperial and
royal jeweler to Queen Victoria, the emperor of Russia and the sultan of
Turkey. Further, 1883 was the year of Mrs. William K. Vanderbilt's legend-
ary Corinthian costume ball, held to celebrate the completion of her new $3
million palace on Fifth Avenue. (Three million dollars in 1883 would be
roughly $62.33 million today.*)

The Vanderbilt ball quickly passed into legend (its preparations provided
employment for 140 dressmakers) and set the seal on a fabulous year. The
American century had begun.

Kirby sensed this instinctively, and his clever response was to put some
new wine into the old bottle on Madison Square. This gloss had two clever
ingredients: after the redecoration, the walls were hung with paintings by
unknown—and therefore "unappreciated"—American artists, and the firm
was reintroduced to society, but not simply as any old art gallery. What was
born in 1883 was the American Art Association, the AAA (see figure 21). In
what had once been a place of common trade, there now existed an associa-
tion "for the Encouragement and Promotion of American art." In the cul-
tural climate then blossoming in New York, this was a brilliant slant, and the
AAA became an immediate succès d'estime. Only a few months before, a
journal, *The Art Amateur,* had written disparagingly about Moore and Sut-
ton; now it called the American Art Association's first exhibition the "most
notable" event of the season.

Kirby had hit his stride. One imaginative scheme followed another. Still
keen to maintain the spirit of 1883 and the promotion of American art, he
instituted prizes and inveigled rich men not only to provide the money, but
also to do the judging. Towner tells us that Andrew Carnegie, Benjamin
Altman, Jay Gould and Collis P. Huntington all played this game. As a

*See Appendix B for conversions of prices to present-day values.

result, the AAA was talked about, and within months it formed a kind of salon, which the "respectable classes" actually visited. Clubs held meetings there; art-appreciation classes were given there "over tea"; connoisseurs or would-be connoisseurs took to dropping in on their way to and from Wall Street to look over the paintings and "talk art."

It was a notable achievement of Kirby's. Still, the AAA would not have been one of the fathers of the modern art market without the actions—the mistakes—of another individual, George Ingraham Seney. He was the president of the Metropolitan Bank and ostensibly a "conservative and respectable" man. In fact, Seney had for years been secretly using the bank's resources for rash railroad speculation. In the course of only two or three years he had amassed a personal fortune of $9 million ($198.5 million at today's values), but the railroads he had gambled on were bankrupt, and when a stock-market slump occurred in 1885, the Metropolitan failed. Investigation soon showed Seney's culpability, and to escape prosecution he agreed to turn over to the receivers all his personal possessions. These included a large house in Brooklyn and his art collection.

Seney's paintings—there were 285 of them—included many pictures by the immensely fashionable Barbizon School: pictures of hardworking peasants, agricultural landscapes and farmyard scenes. Despite this, Kirby's partners, Sutton and Moore, were uneasy about selling the collection, for it meant turning the AAA back into an auction house. Kirby didn't agree. Although the association's attempt to "push" American art had been a succès d'estime, it had not made much money. To help persuade his partners to undertake the auction, therefore, Kirby poached an idea from Samuel P. Avery.

At that time New York had perhaps three art dealers of note: Michael Knoedler, who had been on the scene since the 1840s; Jean-Baptiste Goupil, from whom Knoedler had broken away; and Avery, a lordly man who considered himself an arbiter of taste as much as a dealer and liked to present himself as the social equal of the collectors. He knew little about art but was a superb salesman, and over the years more than fifteen hundred pictures of his were sold at auction. Avery's pet project was the establishment of a museum for New York, to be called the Metropolitan Museum. The committee that pushed this through met in Avery's Art Rooms, and he was appointed a trustee when the museum was established in 1870. This was an honor for him but less propitious for the museum. A cartoon published at the time showed him on the prow of a ship, brandishing a banner with the names of the painters he was bringing from Europe: Boughton, Cabanel, Detaille, Escosura, Madrazo, Schreyer, Vibert—"a lamentable cargo," as John Walker, a former director of the National Gallery in Washington, D.C., put it. Avery managed to acquire class but he never had any taste.

However, he had found a clever way to avoid the disreputable aura associated with auctioneering. When sales were necessary for clients or friends of his, he would commission an auctioneer but *manage* the sale himself, a procedure foreign to British auctioneers but quite similar to the one at the Hôtel Drouot in Paris. A sale "under the direction of Samuel P. Avery" relegated the auctioneer to a supporting role and made the whole enterprise seem less shady. This was the system Kirby proposed for the Seney collection: the AAA would manage the auction. It was a distinction without a difference but it satisfied Sutton and Moore.

If all had gone according to plan, the world might have heard little more of Thomas Kirby, but the Seney sale had one extra ingredient that Avery would have hated but that Kirby relished: scandal.

The actual sale of Seney's pictures was scheduled to take place over three nights in 1885 at the Chickering Hall in Manhattan, but first the collection went on display in the AAA's Madison Square gallery. Kirby saw to it that when the collection was hung the right tone of reverence and grandeur was adopted. Guards employed to keep watch over the pictures were issued silk gloves, as if these wonderful objects were somehow untouchable. A one-dollar admission charge was posted to keep out the "riffraff." However, it didn't work, at least in the sense that the press was admitted. This was an age when New York had more newspapers than skyscrapers (there were twenty-three dailies). The *Tribune* and the *Times* were civil enough, but the *Evening Post* "went so far as" to label ten of the Seney pictures, including a Decamps, a Gérôme and a Turner, as fakes. Then as now, many people were more interested in forged, smuggled, or stolen art than in art for its own sake, and after the *Evening Post*'s allegations were published, crowds started to form at 6 East Twenty-third Street to snigger at Seney's pictures.

Outraged, Kirby stormed into the *Post*'s offices and demanded a retraction. The editors of the *Post,* Towner tells us, refused. Now Kirby showed his guile. Ten days before the sale, he brought suit against the paper, claiming $25,000 in damages for malicious libel. Of course he was well aware that courtroom proceedings would not begin before the sale, but his ploy was news, and it was reported in all the other New York newspapers, rivals of the *Post*. Moreover, many of the other rags took Kirby's line that the *Post* was wrong and the pictures genuine. This fresh crop of publicity brought crowds of new visitors to the AAA, so it appeared that the *Post*'s assault had backfired. No one could be sure, however, until the sale itself.

It was an evening auction. On the first night crowds thronged the streets outside Chickering Hall, and Kirby was forced to seek police help to let the "wealthy patrons of the arts" through the masses. Inside, eighteen hundred seats were filled with the rich and famous. The porters, now dressed in

Second Empire livery, placed each picture in turn on an easel draped with crimson velvet. (Auctions had come a long way since the days when Gutelius operated from the back end of a covered wagon.) Kirby showed that during his years in the salon atmosphere of Madison Square, the "crier" of auctions had lost none of his old flamboyance. He was magnificent that night, coaxing and bullying, badgering and seductive. "Why, you could smell the breath of the cattle on this one, taste the breeze on another," one journalist reported. *The Smoker* by Jean-Louis-Ernest Meissonier appeared on the easel but the bidding was lackluster. What? "Had no one heard that Meissonier was the modern Leonardo? Had all these people dwelt in darkness?"

The highlight came on the last evening, when Jules Breton's *Evening in the Hamlet* was offered. Breton was the star of Barbizon, perhaps the first superstar of the modern art market, whom even van Gogh thought was "unsurpassable." Bidding was brisk and the picture, then only three years old, was knocked down for $18,200 ($401,473 today), the highest price a picture had brought at auction in the United States. In total, the sale raised $405,821 ($8.9 million today), an extraordinary sum, well ahead of any previous auction total in the New World. As for the so-called fakes, Kirby "auctioned them off as nonchalantly as the rest"; then, since they fetched more or less what they would have had they not been attacked, he dropped his suit. As Towner wrote, it would have been hard for him to prove damages; in any case, "Privately he remarked that, but for the necessity to save face, he would have given away those ten pictures in return for the publicity that had helped swell the crowd at Chickering Hall."

But though Kirby had wrested triumph from near-disaster, though the AAA had made money from the sale, and though the publicity was phenomenal, James Sutton was still unconvinced that he wanted to follow the auction road. It still reeked of the Wild West and the wickedest man in Oklahoma. While Kirby had been immersing himself in his fight with the *Post,* Sutton had been paying attention to developments in France. In Paris people were talking about a new group of painters who were known, derisively in some quarters, as the Impressionists. He had heard that these new painters were "lunatics," but that the great Parisian dealer Paul Durand-Ruel had put money behind them. Sutton determined to look them over on his next trip abroad.

—

The modern art market, as we now know it, dates from the early to mid-1880s, when a number of events took place more or less simultaneously in several different countries. Some of them, like the birth of Picasso in Spain in 1881, or the arrival of Vincent van Gogh in Paris in 1886, or that of Henry

Duveen in New York in the same year, would not bear fruit for some time. But Thomas Kirby's arrival in Madison Square in 1882 was accompanied by two other events in that same year which helped to give the art market the international outline it has retained ever since. One of these events, the passing of the Settled Lands Act, took place in Britain; the other, a government honor to Manet, occurred in Paris.

In Britain in February 1882 Messrs. Christie, Manson and Woods announced a sale billed as "the most important sale ever," and for once this wasn't auction-house hype. What single private collection nowadays could offer six Mantegnas, a Velázquez, several Van Dycks and Rubenses, a Botticelli and a Leonardo da Vinci, not to mention Gobelin tapestries, Reisener furniture and thousands of rare books? Despite the enormous prices fetched for objects in the late twentieth century, Christie's sale of the contents of Hamilton Palace may still be a world record, in terms of the quality of objects that were sold.

Nowadays there is little to distinguish Christie's from Sotheby's; but it was very different then. Sotheby's had started first, in 1744, but had set itself up mainly as book auctioneers, whereas Christie's, which followed in 1766, concentrated on pictures and furniture. The original James Christie was a colorful man who, some said, numbered Flora Macdonald among his ancestors. He was a brilliant auctioneer, "able to descant on anything," according to *The Times,* but he also had the ability to make fashionable and influential friends. Dr. Johnson, Sir Joshua Reynolds and David Garrick were all close, as was Tattersall, the horse auctioneer, who at one stage shared with Christie ownership of the *Morning Chronicle.* For all these reasons, Christie's rooms, which for most of his lifetime were in Pall Mall, acquired a fashionable *ton* that Sotheby's never did. They became a place where "the upper ten thousand," as British Society was then called, could gather, the place acquiring something of the aura of fashionable coffeehouses in Continental cities. For big auctions, Christie would hire the chief doorman from Covent Garden; he was better than any ticket system, for he knew everyone who counted, and if he didn't know you, you didn't get in.

Even by Christie's standards, however, the Hamilton Palace sale was exceptional. Not only were the dukes of Hamilton the premier dukes of Scotland, but Alexander, the twelfth duke and the man who in 1882 was selling his family's fabled treasures, had married Susan Euphemia Beckford, the younger daughter of William Beckford. Beckford is a legendary figure in the history of collecting and was a notable eccentric. Frank Herrmann, in his history of the English as collecters, tells us that Beckford, the son of a man who was twice lord mayor of London and who owned extensive plantations in the West Indies (there were fifteen hundred slaves), was brought up amid

great splendor. However, his life took a singular course. His wife died when he was only twenty-six and afterward he became involved with a boy, William Courtenay. The resulting scandal meant almost permanent ostracism, and Beckford responded by building Fonthill Abbey near Salisbury in Wiltshire, once described as "the wildest piece of gothic extravanga ever erected." There he lived a life of seclusion but added busily to his remarkable collection of pictures and other works of art and his superb library. He bought everything on a lavish scale: enamels, jade, a van Eyck, a Rembrandt, a Dürer. The dispersal of his collection in 1823 took forty-one days. However, Beckford's family portraits and library were not sold; they passed to his daughter and, on her marriage, to Hamilton Palace, where the library was given a wing to itself. The duke already had his own very respectable library, so now the palace had two, separated by a vast dining room.

Hamilton Palace was massive and not at all beautiful. It did, however, contain objects no less remarkable than those at Fonthill Abbey. Even in those days, *The Times* of London had its own salesroom correspondent, George Redford, who was a well-known character, and his preview of the sale, published on February 6, 1882, has been republished by Herrmann:

> Hamilton Palace dates back to times as early as the old kings of Scotland. . . . The present mansion, however, retains nothing of the ancient palace . . . presenting a front by no means imposing but rather heavy and gloomy. . . . Having a *souterrain* of vast mineral wealth it has suffered like many other great residences in the North from the encroaching spread of coal and iron works . . . rendering it every year more and more unsuitable as a residence for a great nobleman. . . . The state dining salon which is between the Hamilton and Beckford libraries . . . contains some extremely fine full-length portraits, among which is that of Philip IV [of Spain] by Velasquez. . . . There are cabinets of odd Florentine mosaic and pietra-dura work, one of which is said to have been designed by Michel Angelo. . . . By Andrea Mantegna, there are six examples. . . . By Botticelli there is an "Adoration of the Magi." . . . By the rare master Antonella da Messina . . . there is a portrait dated 1474 . . . ; by Leonardo, the "Boy with a horn-book." . . . In these respects the sale will certainly surpass in interest the celebrated sales of Stowe, Strawberry Hill . . . and other great continental collections dispersed in recent times.

It did. The sale, which took place in June and July, consisted of more than two thousand lots and lasted for seventeen days, living up to expectations and fetching a record total of £397,562 ($41.1 million at present values). Buyers came from all over; in fact, the sale was so celebrated that, besides the catalogue that Christie's produced, another was issued afterward, with a

series of engravings of the objects sold, the prices fetched and the names of the purchasers.

However, there was another aspect to the sale that is quite alien to us in the 1990s, when the world's top two auction houses are locked in fierce rivalry. Whereas the furnishings and pictures from Hamilton Palace were sent to Christie's to be sold, the books went to Sotheby's. This practice was normal at the time and in fact continued until World War II. By the 1880s Sotheby's, then located in Wellington Street, near the Aldwych, was the dominant book auctioneer in London, chiefly known for the quality of its cataloguing. The Hamilton Palace books were sold in two separate parts: the books that Beckford had assembled, and the duke's own library. The sale of the Beckford library opened on June 30, 1882, four days before Christie's finished auctioning off the furniture and pictures, an overlap that would be unthinkable now. Beckford's books were remarkable for the splendor of their bindings, the quality of their illustrations and their superb condition. Another attraction, says Herrmann, was that Beckford himself had penciled "quaint and often sarcastic notes on the fly-leaves of almost the greater portion of his books."

Edward Hodge was the auctioneer in the Sotheby's part of the sale. Just as today Christie's full title is Christie, Manson and Woods, so Sotheby's, until 1924, was known as Sotheby, Wilkinson and Hodge. The firm had been started by Samuel Baker, and he was followed by George Leigh and three Sothebys, John, Samuel and Samuel Leigh. John Wilkinson, a Yorkshireman and a friend of Edmund Kean, the great Shakespearean actor, joined the firm in the 1820s. Edward Grose Hodge, a Cornishman, followed in 1847, becoming a partner in 1864. If the first James Christie had been a delight on the rostrum, Edward Hodge was almost as impressive. During the Hamilton Palace library sale, Hodge followed his usual practice, which was to make little speeches before he started accepting bids for the important lots. The sale of the Hamilton Palace libraries was as successful as that of the furniture and pictures, and totaled £86,444 ($8.9 million today). This made a grand total in 1992 values of exactly $50 million.

The Hamilton Palace sale is of interest today not only because it was an excellent example of a collaboration between Britain's two venerable auction houses but also because it was the first auction to take place after the first Settled Lands Act was passed in 1882. The ups and downs of the art market have been affected by many laws in the last century, but it was this act more than any other that determined the shape of the art market as we know it today.

The Settled Lands Act was a response to a crisis that had economic causes and very social consequences. It arose from developments in the United

States, where, throughout the 1860s and the 1870s, the rapidly expanding railroad system brought about an extraordinary opening-up of midwestern prairie lands. In 1873, the production of grain was further facilitated by the invention of a self-binder that could be attached to every reaping machine. The growth of the steel industry also meant that steam was at last rapidly replacing sail, especially in busy transatlantic transport. These factors reduced drastically the cost of sending grain from the United States to Europe. To give an example, quoted by Frank Herrmann, the cost of transporting grain from Chicago to Liverpool fell from £3 7s. a ton in 1873 to £1 4s. in 1884. Unlike most other European countries, Britain refused to put a tariff on imported wheat; such tariffs had bitterly divided British politics in the 1840s and no one wanted a return of the issue. But the consequences were catastrophic. The price of a bushel of wheat in Britain fell by nearly 50 percent in the nine years following 1877, and the amount of imported grain, which had been 2 percent in 1840, rose to 45 percent in 1880.

Furthermore, all this took place against a background in which growing industrialization was drawing agricultural workers away from the land and into the cities. Therefore the great estates of Britain lost revenues on two fronts: what wheat they could produce could not compete in price with American prairie wheat; and their rental income was decimated as agricultural workers left for the towns. To give an idea of the size of the slump, an estate of seven thousand acres could produce an annual rental income, in 1992 terms, of $1–1.2 million. Faced with such losses, many vast holdings in Britain failed.

The auction rooms of London were one of the places where these changes were soon felt. In most great families the assets—the land, house and treasures inside it—were all held in trust, so that one generation could not squander the heritage of later generations. But the 1882 Settled Lands Act, recognizing that circumstances in Britain in the late nineteenth century were exceptional, enabled families to petition the Court of Chancery to break the "entail," the terms of a trust. With the court's permission, heirlooms could now be sold to provide cash to help the estate, providing the land and house remained in trust.

Britain's aristocratic families had been among the world's great collectors from the time of Charles I to the end of the Napoleonic wars, and their treasures now started to appear on the market. This gave the British houses of Christie's and Sotheby's a shot in the arm and is one reason why they became so preeminent in the field. Between 1882 and the end of the century, many aristocratic collections came onto the market, including those of the Duke of Marlborough, from Blenheim (Sebastiano del Piombo); the Marquis of Exeter (Petrus Christus); the Marquis of Lothian (Rubens); Lord Ash-

burnham (Rembrandt, Rogier van der Weyden); the Duke of Buccleuch; the Duke of Somerset (Gainsborough, Hoppner, Romney); Lord Egremont of Petworth (Gainsborough, Reynolds); the Earl of Dudley (Raphael, Rembrandt, Giorgione, Fra Angelico, Andrea del Sarto, Canaletto); the Duchess of Montrose; Lord Methuen (Van Dyck); the Earl of Hopetoun and several others.

Because of the Settled Lands Act more great works of art were put up for sale in the years between 1882 and the start of World War I than at any time since the Napoleonic era. This coincided exactly with the great cultural awakening in America, when a number of very rich collectors began to appear. By themselves, these developments would have been more than enough to create a major change in the art market. But there is one other event of 1882 that must be considered. Without it, the art market would not be the creature it is today.

In the late spring of 1882, the French painter Édouard Manet was staying at Rueil, a small town on the Seine a few miles west of Paris. Though he was only fifty, Manet was already very ill, suffering from the debilitating and embarrassing spasms of locomotor ataxia that would kill him within a year. A few weeks before, he had exhibited at the Paris salon a large canvas, *Un Bar aux Folies-Bergère*. Though no one knew it at the time, it was to be his last full-scale, fully finished work; by the summer, as John Rewald has pointed out, he was capable only of less ambitious pastels and watercolors. Despite his illness, however, *Un Bar aux Folies-Bergère* revealed that the master had lost none of his power. The subtlety of his observation, the virtuosity of his brushwork, his appetite for new subjects, were all present in every part of this composition. Of course it was bitterly received at the salon, for the subject scandalized a public blind to Manet's magnificent technique and sense of color.

By now Manet was familiar with ridicule and vilification. As one of the initiators of the new style in painting in the 1860s, he had often found himself the subject of bitingly sarcastic articles in the Parisian press, where "Impressionism" was a term of abuse. Indeed, since the Impressionists had been dubbed "Manet's gang," he was seen as their leader, only one of the critics' many misconceptions. "A laughable collection of absurdities" had been one reaction to the Impressionists' first group exhibition in 1874, when Claude Monet was said to have "declared war on beauty" and Paul Cézanne was described as "a kind of madman painting in the midst of delirium tremens." Writing in the periodical *Charivari,* Louis Leroy had produced one of the

longest and most sarcastic attacks; he was particularly incensed by what he considered to be the unfinished state of Impressionist canvases. "Why, wallpaper in its embryonic stages is more finished. . . ."

Manet had never exhibited at any of the seven group shows that had been held by the "independents," but this didn't prevent his being linked with the other Impressionists in the public's mind; nor did it stop the criticism. His paintings were seen as "intruders" at the salons (when they were accepted) and were dismissed as ridiculous. Rewald quotes one critic who described *The Railroad,* shown at the salon of 1874, as a "fearful daub" in which the figures, a young girl and a child, had been "cut out of sheet-tin, apparently." Like most of the other Impressionists, Manet never got used to the sarcasm, or came to terms with the abuse and bitterness that his work provoked.

But by 1882 the world was changing. There *were* collectors of Impressionism, as the new way of painting became more widely understood, and the painters themselves were beginning to have a few friends in high places. Antonin Proust, Manet's friend since schooldays, had been appointed minister for fine arts in the new government at the end of 1881, and he had long recognized Manet's genius. Proust's promotion was to pay off. No sooner had he been appointed than he set about ensuring that Manet at last received the recognition he craved and that many others, including Renoir, thought he deserved. In the New Year's honors list for 1882, Manet became a Chevalier de la Légion d'honneur.

Manet's honor was not the only recognition Impressionism received that year. It was the first year Cézanne was admitted to the salon, as well as the year when the composer Richard Wagner granted Renoir thirty-five minutes to draw his likeness in Palermo on the day after he had finished *Parsifal.* Also, as Edmond de Goncourt confided to his diary, that year the salon itself was infected with the bright colors that were one of the hallmarks of Impressionism.

The other important event that year in Paris was the Impressionists' seventh group show, which opened on March 1 at 251 rue St.-Honoré. These group shows had begun in 1874, following the refusal of the jury of the French Academy to admit any Impressionist paintings to the official salon. The actual composition of the group kept changing, and this made the 1882 show important for two reasons. In the first place, as John Rewald, the historian of Impressionism, has written: "Never had the Impressionists organized an exhibition so lacking in alien elements, never had they been so much to themselves. After eight years of common struggle they managed at last (but with what difficulties!) to stage an exhibition which truly represented their art." The exhibition included works by Monet, Renoir, Sisley, Pissarro,

Caillebotte, Berthe Morisot, Guillaumin, Vignon and Gauguin, and it was doubly remarkable in that for the first time a series of favorable notices appeared in the press. The battle was far from won—one critic said they had the right ideas but the wrong colors—but 1882 was a turning point, critically if not yet commercially.

3 | OUTROPING, SALES BY CANDLE AND MR. COLNAGHI'S LEVEE: THE EARLY YEARS OF THE ART MARKET

Being conservative, Victorian life in Britain prided itself on nothing so much as its eccentricity, and William Wethered was as eccentric as any. Astonishingly, he managed to combine the trade of picture dealing with that of being a tailor. His London shop was at 2 Conduit Street—still a home for both trades—and his elaborate letterhead declared that he was the "Sole inventor of the Grecian Waistcoat." He was also the sole inventor of some of the most entertaining invoices the art trade has ever produced. Wethered once sent the following bill to Joseph Gillott, a notable collector:

	£	s.	d.
Black super frock coat lined throughout with silk	5	10	0
Pair of black cas. trousers, lined throughout	1	18	0
Two Etty pictures	210	0	0

By the 1880s art dealing and auctioneering were well established, but although dealing had the more flamboyant and less reputable characters, auctioneering had a longer documented history. Herodotus is a notably unreliable historian, the sole inventor of half of Grecian and Roman history, if you believe later scholars, but there seems no reason to doubt his account, the earliest known, of auctioneering in Babylon about 500 B.C.:

In every village once a year all the girls of marriageable age used to be collected together in one place, while the men stood around them in a circle; an auctioneer then called each one in turn to stand up and offered her for sale, beginning with the best-looking and going on to the second best as soon as the first had been sold for a good price. Marriage was the object of the transaction. The rich men who wanted wives bid against each other for the prettiest girls while the humbler folk, who had no use for good looks in a wife, were actually paid to take the ugly ones, for when the auctioneer had got through all the pretty girls he would call upon the plainest, or even perhaps a crippled one, to stand up, and then ask who was willing to take the least money to marry her—and she was knocked down to whoever accepted the smallest sum. The money came from the sale of the beauties, who in this way provided dowries for their ugly or misshapen sisters.

This practice ought to be better known. There is surely a case for adopting the same procedure at picture auctions: bidders should be paid to take away the misshapen rubbish, no less common among art objects than among Babylonian wives.

The Romans made a fuss about auctions. The word "auction" comes from the Latin *auctio,* which means "increase." There was a recognized type of businessman, known as an *argentarius,* who organized the sales, and there was the *praeco,* who was both the promoter of the sale and the auctioneer. Premises where auctions took place, the *atrium auctionarium,* existed in many towns, though house sales were by no means unknown. Brian Learmount notes that both Caligula and Marcus Aurelius auctioned off their furniture at different times to meet debts. The first famous auctioneer we know anything about was Lucius Cecilius Jucundus, in Pompeii in the reign of Nero. His invoices were uncovered in the 1845 excavations and are on public view in the Naples Museum. They are not as varied as William Wethered's, but they do show that, unlike auctioneers in later years, he took only a 1 percent commission. Like his later colleagues, on the other hand, he frequently made loans to people who intended to sell at some point in the future. (Those who accuse Alfred Taubman at Sotheby's of introducing new and barbaric practices into the salesrooms are simply showing their lack of a classical education.) Auctioneers also followed the course of the Roman army, for its many victories provided enormous amounts of plundered booty and slaves. These were known as *sub hasta,* or "under the spear," sales.

Damasippus, already encountered in Chapter 1, is generally regarded as the first art dealer known to history. Cicero was a customer of his and bought a group of Bacchantes. After Roman times, little is known about auctioneering until the sixteenth century, save for a report that in seventh-century China the personal belongings of deceased monks were auctioned off, and a

French account of a sale in A.D. 1328 of goods belonging to Queen Clemence of Hungary. Among the objects sold was a shrine said to contain the crown of thorns worn by Christ.

The earliest dealers in Italy appeared at the end of the fourteenth century, selling small religious pictures to decorate chapels in private houses or to accompany travelers on their journeys. Benedetto di Banco degli Albizzi, a Florentine wool trader, also dealt in these objects, using as his foreign agent Francesco di Marco Danti, who operated as far afield as Avignon. But most dealers did not have their own stock; they were really commission agents.

In Antwerp in the fifteenth century, an art market known as the Pand took place in the cloisters of the cathedral, by permission of the archbishop and cardinal. It was open twice a year, for six weeks at a time, at Easter and again at the Feast of the Assumption in mid-August, and consisted of some seventy to ninety stalls for picture sellers, framemakers and color grinders. Both Holbein and Dürer bought colors at the Pand. The records have survived and show that altarpieces were traded there (the Bishop of Bruges bought one), and that there were several "art booms," one in the 1460s, for example, and another in the early sixteenth century.

In Holland at the end of the fifteenth century and the beginning of the sixteenth there was a boom in pictures in which standardized patterns were used to simulate such subjects as brocade or urban backgrounds. This technique cut down the cost and made it worthwhile to produce the works on speculation, for sale on the open market. More individual works, on the other hand, were reserved for commissions.

Jacopo da Strada, born in Mantua in 1507, was an educated man—he trained as a goldsmith—and well connected; unlike Albizzi, da Strada traveled widely, not only buying on commission but also acquiring anything he thought would appeal to his wide range of rich and royal clients, including the Fugger banking family of Augsberg, Duke Albrecht V of Bavaria and Emperor Rudolf II of Prague.

Meanwhile, in France, auctioneering was becoming organized. In 1556 the French government passed an act that created a group known as *huissiers-priseurs* (bailiff-auctioneers), who had "exclusive rights to deal with and appraise and sell property left by death or taken in execution." These early French auctions were impromptu affairs, without the benefit of catalogues or prior viewing, and were held on the premises of the deceased. Everything was sold at once, from kitchen utensils to paintings. The *huissiers-priseurs* were not allowed to sell new objects and were strictly governed by the king, who forbade them to enter any other business; in return they became judicial auxiliaries, with state protection. The idea was that they should be independent, disinterested experts who would guarantee fair play to both seller and

buyer. (This is still the essential difference between French auctioneers and their Anglo-Saxon counterparts.) As trade grew, permanent locations were used. The earliest sales were held in the open air, at the pont St.-Michel or the quai de la Ferraille, and began at two or three in the afternoon. Later they were moved to the Couvent des Grands Augustins, which, Brian Learmount tells us, had "the largest room in Paris." This allowed better presentation of the goods and was more convenient for customers; trade was stimulated, and in the later part of the seventeenth century, Paris began to attract sales from other countries.

Bookselling, as opposed to auctioneering, was recorded in Britain as early as 1628, when the "Warden of the Stationers' Company compiled a list of thirty-eight booksellers who also dealt with 'old libraries,' i.e., secondhand books," some of which would have been imports from the great Continental book fairs at Frankfurt, Leipzig, Leiden and Kraków. According to Frank Herrmann, the idea of auctioning books seems to have been imported from Holland, where it had been in use for nearly a century.

The "English method" of auctioneering, in use in the seventeenth century and perhaps before, was sale by candle: an inch of candle was lit, and the successful bid was the last one shouted out before the flame disappeared. Samuel Pepys attended several of these auctions, at which, for example, ships discarded by the Royal Navy were sold. "After dinner we met and sold the Weymouth, Successe and Fellowship hulkes, were pleasant to see how backward men are at first to bid; and yet, when the candle is going out, how they bawl, and dispute afterwards who bid the most first. And here I observed one man cunninger than the rest, that was sure to bid the last man, and carry it: and inquiring the reason, he told me that just as the flame goes out, the smoke descends, which is a thing I never observed before, and by that he do know the instant when to bid last." Most of these sales were held in one of the fashionable coffeehouses in or around Covent Garden Piazza, where the principal auctioneers, according to Ralph James, were a Mr. Gilleflower and Edward Millington. James also reports that a system of auctioneering known as "mineing" was imported from Holland. This was the Dutch auction with a variation: the auctioneer would start high and call out descending amounts until someone shouted "Mine!," at which point others in the room were free to call out increases.

All of this suggests that by the end of the seventeenth century there were several, and perhaps many, auction houses in London. John Spink, a goldsmith, had started his firm, which would evolve into a famous coin dealer and auction house, also specializing in Oriental objects, in 1666. One book auctioneer we know quite a bit about was William Cooper, also a bookseller. His catalogue shows that he allowed imperfect books to be returned and offered

one month's credit to his clients. To begin with he held his sales on the premises of the deceased. By the end of the century there were perhaps thirty sales a year, each one lasting for several days. Advertisements for auctions of "Paintings and Limnings" (watercolors) also indicate that specialist picture sales took place. In fact, around 1680 a great change was occurring in Britain. Until then (and excepting King Charles I, the Duke of Buckingham and the Earl of Arundel), the British were ignorant of and uninterested in painting. (A similar lack of interest could be found elsewhere. When Marguerite de Lannoy died, her pictures went to her servants, whereas her relatives got the jewels and the manuscripts.) After 1680, however, there was a proliferation of both auction houses and art dealers. This happened partly because after the Restoration more people were free to embark on the Grand Tour, but also because the Cromwellian law that had totally banned the import of paintings was repealed in the 1680s, with the result that London was now glutted with artworks trying to find a buoyant market away from war-torn Europe. According to one account, more than fifty thousand paintings flooded into Britain at this time.

One place they came from was the Low Countries. John Michael Montias's studies of the sixteenth- and seventeenth-century art trade in the Netherlands have shown that there was intense competition in Holland at this time "because, in addition to the professional dealers, almost every seventeenth-century painter bought and sold the works of other artists from time to time." Lacking land, wrote one traveler, everyone in the Netherlands "invested" (his word) in pictures. Salesrooms were much less common than dealers. Nonetheless, Rembrandt seems to have contracted "auction-house fever" and frequently overbid for pictures. Two art dealers, Lodewyck van Ludik and Adrian de Wees, testified that he had paid at least double, and perhaps quadruple, what his collection was really worth, and this contributed to his bankruptcy. It was no accident that this occurred in Holland at a time when its economy was booming and financial speculation was rife. The parallels between seventeenth-century Holland and late-twentieth-century Manhattan or Tokyo are uncanny: "Seventeenth-century observers were astonished at the ease with which payment could be assigned by bank credit. . . . 'The seller, so to speak, sells nothing but wind and the buyer receives only wind.' " Against this background, Rembrandt conceived the idea of buying back his own prints at auction to keep up the price. Moreover, there was "a small but lively market in Rembrandt's promissory notes," since some clients believed that the only way to ensure delivery of a painting by the master was to place him in their debt.

Montias's pioneering research has also hinted that economic considerations affected aesthetic developments, in that artists in seventeenth-century

Holland developed stylized techniques so that they could produce pictures more quickly. He quotes a competition between François Knibbergen, Jan Porcelli and Jan van Goyen as to who could paint the best picture in a day.

According to Montias, in both Delft and Amsterdam professional dealers first emerged in the 1630s and 1640s and became increasingly specialized; some dealt in battle scenes, others in "fish and lizards." Further there was an increasing mention of "attributed" paintings in notarized inventories (i.e., those drawn up after someone's death), which Montias believes indicates an increasing concern with authenticity. New artists would be employed by dealers, perhaps for a year at a time. In 1706, for example, Josef von Brandel signed a contract with the art-and-wine dealer Jacob de Witte which guaranteed him, in the first year of work, six guilders a copy, in the second, eight guilders, and in the third year, ten guilders a copy. (He was expected to copy the works of Jan Brueghel, Philips Wouwerman and other popular masters.)

The Low Countries had elaborate laws to preserve local interests. Only guild members could sell paintings, and usually only local people could be in the guilds. Auctions and lotteries were forbidden, especially if they contained works by out-of-town artists. In Amsterdam a city ordinance of 1617 barred from sale all paintings made outside the seven provinces of the Dutch Republic. In The Hague "amateurs"—that is, art lovers who were not dealers—were allowed to buy foreign works and hang them at home but were not allowed to sell them without the consent of the burgomasters.

By the seventeenth century in Italy, in places such as Venice, picture collecting was strong. Marco Boschini mentions 75 picture owners there in 1660, and Carlo Ridolfi says there were 160 in 1648, 15 in Verona, 19 in Brescia and 6 in Vicenza. Some collections, such as that of Daniele Dolfin, were of contemporary works; others, like Ottavio di Canossa's, were of Old Masters—that is, painters dead more than fifty years. Old Masters were more expensive, and even in those days Boschini endeavored "to demonstrate the superiority of painting over gold," citing on one occasion two pictures by Tintoretto in the Madonna dell'Orto church, "for each of which 50 ducats were paid immediately after completion but which would surely fetch 50,000 ducats if only they were put up for sale." Pictures were traded. Some 10 to 30 percent of the pictures in Venetian collections were by "foreigners," half of these from the north. Foreign dealers existed: Daniel Nys, an Englishman, the Reynst brothers, Dutch merchants, and a Frenchman, Monsieur Alvarez, who bought the Muselli collection for 22,000 ducats and sold it to the Duke of Orléans. Some of these foreign dealers were criticized, by Boschini among others, for introducing genre subjects—still lifes, fruits and flowers. The traditional Venetian taste was for historical subjects—paintings of historical episodes allegedly illustrating some great "truth"; and the Muselli collection,

for example, contained not a single still life or landscape. At first, as inventories of Venetian collections show, the few genre pictures that were bought did not occupy the prestigious rooms of a house—the galleria, studio or portico—but Krzysztof Pomian's analysis of seven Venetian inventories between 1646 and 1709 demonstrates that as time went by, genre painting was more highly regarded and represented a larger proportion of collections.

This may be one reason why traditional Italian pictures appeared on the British market in greater numbers toward the end of the seventeenth century—historical pictures had been displaced by genre works. A more potent reason, however, was the decline of the Papal States after the Thirty Years' War. Many of the grand families were impoverished and sold off their pictures and other valuables, as often as not to the British.

Reliable figures on the importation of paintings into Britain were not kept until 1722; by then, importations varied from 165 a year in 1745, to 1,384 in 1771, rather less than in the 1680s. It is clear that Italian pictures predominated, not simply by reason of British taste but also because the Italian states were in decline and because France and Holland had strong local markets. In addition, after the Restoration, society in Britain was opening up, London was growing in size (it was now home to 10 percent of the population) and the new money in the capital did not have the grand houses or vast estates that the aristocracy did. It is a familiar story: painting and art became one of the ways that men could show that they had taste. Throughout the period 1680–1770 "taste"—its definition and the civilizing effects it was believed to have—was a constant preoccupation of such learned men as John Locke, David Hume, Alexander Pope, John Dryden and many others.

This concern with taste helped to initiate some of Britain's great collections, but it also spurred three new factors in the art world: the virtuoso, the auctioneer and the art dealer.

The concept of the virtuoso grew out of the movement in the arts known as Mannerism, which was often larded with mysticism. Together these implied that the arts contained hidden truths available only to the initiated, and that intimate acquaintance with the arts was a civilizing and therefore a virtuous preoccupation. The significance of the virtuosi was twofold: they helped create a demand for fine art; and many of them traveled in Europe, where they bought art, either for themselves or as agents for others. On their return to Britain, at least some of their acquisitions were pushed onto the market.

The great influx of paintings into Britain therefore started in the 1680s and helped to establish London as one of the centers of the art trade. Aristocrats on the Grand Tour were one source of paintings and sculpture. Diplomats were another source: Lord Fauconberg and Consul Smith in Venice, Sir Luke

Schaub in Spain, Thomas Wentworth in Germany. A third source was the professional agent working on commission; William Petty did this for the Earl of Arundel and Prosper Henry Lankrink did it for Charles Fox, the postmaster general. However, the demand for pictures in England became so strong in the 1680s and 1690s that agents soon saw that more could be made if they operated on their own account, as dealers.

Among the first to do this was Thomas Manby, a landscape painter who studied in Italy. While there he acquired 168 pictures, which he sold by auction on his return to London in 1686. Between 1711 and 1713 James Graham held three sales and advertised them in *The Spectator,* claiming, "[I have] travelled Europe to furnish out a show for you, and have brought with me what has been admired in every country through which I have passed." As the eighteenth century progressed, British dealers coalesced into two types: the shop dealer and the international dealer. International dealers did not invariably supply shop dealers directly; as often as not they sold their pictures at auction. Analysis of buyers at these auctions by Iain Pears in his *The Discovery of Painting,* from which these remarks are taken, suggests that at this point there was a kernel of about half a dozen good shop dealers in London: Isaac Colivoe, Captain George Smart, Gerard van der Gucht, Parry Walton, John Howard and a Mr. Matthysen.

The international dealers, by virtue of their manner of operation, were more interesting. Andrew Hay may well have been the first full-time profes-sional art dealer in Britain. A Scotsman and originally a portrait painter, he set off to study in Italy. Seeing the kind of competition he had to face on arriving in Rome, and "possessing only a middling degree of talent, he soon abandoned [portrait painting] and, as he had passed several years in Italy, he had acquired a knowledge in the works of the great masters and of course became a dealer." Hay had several adventures, in part because in the early eighteenth century, following the religious wars of the seventeenth century, art dealing was a common cover for espionage. In his book *Connoisseurs and Secret Agents in Eighteenth-Century Rome,* Lesley Lewis records the activities of Cardinal Alessandro Albini, "a kind of Duveen of the eighteenth century," who sold antiquities to the English Jacobites in Rome, not all of whom were what they purported to be (Anthony Blunt was nothing new).

Also in Italy was another British dealer of note, Gavin Hamilton. He himself excavated at Hadrian's Villa, and he also traveled across Italy, ac-companied by an artist who copied the altarpieces Hamilton hoped to ac-quire and sell, mainly in England; the idea was that the copy would replace the original. It was Hamilton who bought Raphael's Ansidei Madonna and Leonardo's *Virgin of the Rocks,* both of which went to Britain. He also sent to Britain several Veroneses and Titians and two alleged Giorgiones. Apart

from his auction sales, Hamilton sold to some of the most distinguished men of the day: Lord Burlington, the Duke of Devonshire, Robert Walpole, Lord Cavendish. Hamilton often profited from these transactions more than the buyers did. For example, he sold Lord Harley a number of works: of the thirty-seven that can be identified, the total cost to Harley was £688 14s; yet these, when sold at auction after Harley's death, fetched only £318 2s 6d. They were therefore scarcely a good investment and reflect the fact that, even then, "buying by private treaty was generally recognised as a more expensive way of acquisition," i.e., compared with buying at auction.

Samuel Paris, like Andrew Hay, was a painter who decided to abandon the brush for a more lucrative side of the business. Unlike Hay, however, Paris conceived the idea of trading British goods, such as Birmingham-made knickknacks, for paintings, a scheme that did not succeed, forcing him into bankruptcy. He was chased around the Continent by creditors, was jailed in France, extricated himself and by the late 1730s was holding sales in London. Like Hay, he concentrated on the middle of the market, pictures costing from £2 to £10. Anything over £40 was then regarded as expensive, which throws into perspective Paris's one great coup: the pair of pictures he sold to Peter Delmé. These were both Poussins, the *Triumph of Bacchus,* which cost £230, and the *Triumph of Pan,* slightly more, at £252.

Along with other dealers such as Kent, Winde, Lloyd, Rongent and Black-wood, Samuel Paris figured in an interesting exercise in 1758, in which a number of dealers bought back the works they were selling at auction. This meant that a portion of the trade in the art market was artificially generated, as Iain Pears says, "with the result that, in part at least, art dealing became not only a market in the normal sense of the word, but even began to show distinct signs of a commodity market, where the article traded has its external value as a painting complemented by an abstracted value as a speculative asset." And this was 220 years ago. But the chief significance of Hay and Paris is that, like other dealers active between 1745 and 1760, neither seems to have been a collector in his own right or to have expressed much interest in becoming a connoisseur. The art dealer, the full-time merchant, had arrived.

This separation of the artistic and the commercial exacted its toll because it was another reason for people to dislike and satirize the art trade. Such feelings mushroomed in the eighteenth century and found expression in various ways, from cartoons (see figure 10) to the theater, where David Garrick (who was to become Christie's good friend) played Peter Puff the Auctioneer in Samuel Foote's 1748 play. With his sidekicks, Brush and Varnish, whose job it is to bid up prices, Puff exploits the ignorant aristocracy and tricks them out of their money.

According to the calculations of Iain Pears, in the first half of the eighteenth century there were between fifteen and twenty-five auctions a year, involving several thousand pictures (though other accounts suggest there were more, as discussed below). Dealers accounted for 35 to 40 percent of this trade (a proportion not very different from the percentage now). From 1740 on, prices in Britain started to inflate, and there were some notable coups. Delmé's pair of Poussins, for example, bought in 1741–42 from Samuel Paris for £482 (say, $2,500 now), were sold in 1790 to Lord Ashburnham for 1,630 guineas (roughly $14,000). Even so, pictures were not regarded as a great investment. In the eighteenth century, England was not short of places for the rich to put their money where it would earn interest; the standard was the average offered by government bonds, which fluctuated between 3.5 and 4.5 percent. Iain Pears has compared this performance with the figures for the Roger Harenc collection, where enough details are available for the comparison to mean something. Harenc had only a moderate fortune but was an enthusiastic attender of auctions, buying pictures at thirty-two sales between 1734 and 1760. He died in 1762, and his collection of 239 paintings was sold by his son in 1764 for a total of £3,799 14s 6d. Of the seventy-seven pictures known to have been bought at auction, thirty-five have been identified by Pears in the 1764 sale. All but two improved in price, but when figured as a compound percentage increase per annum, the paintings provided a rate of return of 4.18 percent—no better and no worse than government bonds. The collection of John Barnard proved somewhat bleaker. Purchased at auctions between 1738 and 1759, only eleven works could be identified at the Thomas Hankey sale in 1799 (Hankey had inherited the collection). The eleven pictures cost £295 10s and fetched £463 5s, an increase of 55.4 percent, or a compound rate of 0.9 percent per annum. Fine art may have been a passion in the eighteenth century, but it was not much of an investment.

But while British art dealers and auctioneers were profiting from the great influx in Old Masters at the turn of the seventeenth century, many native painters—notably and most vociferously Hogarth—complained long and hard that the dealers' activities were robbing living artists of their livelihoods. This protest culminated in the creation of the Royal Academy in 1768 to train and promote British artists, but it also helped bring about a change in attitudes. The Reformation was receding and Protestant England had fewer worries about the veneration of images. Drawing and painting in watercolors became fashionable under the Georges (even the queen took up the brush), and it became popular to patronize living artists. Portrait painting now became a booming business, *business* being the operative word. According to Marcia Pointon, who studied this matter at the University of Sussex, artists of this genre were so successful that they had "probably one of the greatest

opportunities for social mobility of the period." Between 1781 and 1784 the proportion of portraits exhibited at the Royal Academy rose from 34 percent to 50 percent. Sir Joshua Reynolds had once taken the view that "all London could not support eight artists," but eight hundred were now in evidence. In fact Pointon brings to light a quite different aspect of the art market as it then existed: the portrait painter was surrounded by a host of services related to himself—copyists, miniaturists, framers, shippers, wax modelers, color merchants, engravers—all with shops or workshops near Cavendish Square, where many artists lived. She likens the portrait painter's studio to a modern hairdressing salon, where clients could leaf through a portfolio of prints and choose a "style."

From 1755 to 1790, Reynolds's appointments were kept in a copy of *The Gentleman's and Tradesman's Daily Pocket Journal.* This has survived and shows that appointments were made for 8:00 A.M., 10:00 A.M. and noon, or 10:00 A.M., noon and 2:00 P.M. (three a day being enough). Prices charged by portrait painters were high, ranging from £52 (Joseph Wright in Derby), to 60 guineas (Gainsborough in Bath), to £150 (Reynolds in London). Yet the Bedford family spent more in a month with upholsterers and furniture makers than they paid Gainsborough.

A different kind of eighteenth-century dealer, and the next stage in the development of the trade, was epitomized by Arthur Pond. Born in 1701, Pond was the son of a surgeon, and, like others, he trained as a painter before he turned dealer. His significance lay in his interest in attribution. Until the middle of the century and Pond's arrival, dealers had overattributed everything, for obvious reasons: a work that was a Titian was worth far more than one that was not. Pond, however, took to writing on the back of a drawing his opinion as to whether it really was what it was purported to be. By this practice he injected into his dealing a credibility that many of his colleagues lacked. This significantly helped the trade in Old Master drawings.

Pond made an equal contribution in the realm of prints. Compared with other Europeans, the British were late entering the print market, just as they had been late with painting. After the revocation of the Edict of Nantes and the War of the Spanish Succession, a wave of Dutch and French refugee artists had arrived in England to fill a gap in the London art world that the English were just beginning to discover: print-making and book illustration. By the middle of the century print-making was, with auctioneering, the biggest growth area of the art market, and Pond was one of those who started a print-publishing business. Print-making was part art and part science. This was the age of the Enlightenment, and civilized men of the time were interested not only in the engravers' reproductions of great art but also in prints portraying natural history in great detail—rare birds, exotic plants, strange

shells, the different "races" around the earth.* Prints were popular among artists, who bought them to copy from, and so a new kind of lower-order connoisseur emerged, those who couldn't afford paintings. Thus was the art market expanded.

Pond was a first-class example of a stage in the development of art dealing: the man who, because of his knowledge, his travels and his eye, can lead taste. An important refinement of this notion was being developed in France by another dealer, Jean-Baptiste-Pierre Lebrun. Born in 1748, Lebrun also started life as an artist, and in 1776 he married Élisabeth Vigée, who was to become probably the most famous portrait painter of her day in France. Lebrun did not remain a painter for long and soon entered into the French tradition of "dealer-connoisseur" when he was given the care of the fabled Orléans collection (which would be dispersed after the Revolution). However, he is important in the history of the art market less for his role as a curator than because he was one of the first dealer-connoisseurs to dream up the idea of the rediscovery of once-forgotten artists. In doing so, he not only changed the nature of taste in France but, along with people like Pond, changed the very function of the art dealer.†

Lebrun was the first to realize the commercial significance of the fact that there were many artists who were unknown but were just as good as more recognized painters. As a result of his insight, the art dealer became more than simply an entrepreneur. Instead, he became something much more worthwhile, someone whose eye was important, an insider who could obtain a good painting cheaply by recognizing an artist who had merit but who was not appreciated at the time. Lebrun traveled in Spain and elsewhere and helped to rehabilitate Holbein, Ribera and Louis Le Nain, among others, artists we now take for granted as first-rate.

Auctions had developed alongside dealing. In Britain a popular alternative to sale by candle or by "mineing" was known as "outroping." It had been in use at least since 1585 and was defined as to "sell by the voyce, for who gives most"—in other words, auctioneering as we know it. Outroping was an official activity, like that of the *huissiers-priseurs* in France, and the profits

*There was even an auction house in London, opened by Benjamin Pitt in 1749 or 1750, that was devoted entirely to shells. Shells were present in 21 percent of French collections in the same period.

†That there was great interest in picture prices in eighteenth-century France is shown by the publication in 1783 of C. F. Joullain *fils's Répertoire de tableaux, dessins et estampes, ouvrage utile aux amateurs.* This was the first time anyone had thought it worthwhile to publish a more or less systematic document listing pictures that had recently become available, their provenance and their price, and it had some influence on Lebrun.

from the sale of public goods were intended to benefit orphans. The first picture auction proper in Britain for which there are records was held in 1682, and a massive boom followed in the later 1680s, when there were more than four hundred auctions in the space of five years. At this point auctions other than outroping were, strictly speaking, illegal, but a huge blind eye was turned by the authorities, for it was apparent that with the vast influx of Continental art and the new prosperity, auctioneering was now a lucrative occupation.

At first the quality of paintings was not important. Anything might be labeled "Titian" or "Rubens," but few people were taken in. The British wanted pictures, but not necessarily good ones. One auctioneer, Edward Millington, admitted that many of the paintings he sold were slight or damaged. Millington also held book auctions in Cambridge, Oxford, Norwich and High Wycombe. Later some auctioneers, among them Edward Davis and John Smith, began to specialize in better paintings. By far the most important of these was Parry Walton, mender of the king's pictures and a pupil of the painter Peter Lely. He auctioned the Duke of Norfolk's paintings, and Lely's own. By the middle of the eighteenth century there was a small group of socially acceptable auctioneers, men who knew painting and also knew how to sell. Then there were the rest, many of whom had their origins in the Upholders Company, the liveried company of upholsterers who had the age-old right to sell secondhand household goods. Traditionally, they had fixed-price sales; but according to Iain Pears, as the picture market flourished, and auctioneering with it, the upholsterers began to sell paintings by auction. By 1730, furniture was sold at estate sales at a fixed price but the paintings were auctioned. At the time, these poorer paintings were known as "furniture pictures."

Among the more distinguished auctioneers of the eighteenth century were Lambe, Langford, Prestage, and Thomas Ballard. Ballard specialized in books and, according to Frank Herrmann, worked almost exclusively from St. Paul's Coffee House. His catalogues were often titled in Latin, and he sold the library—200,000 volumes—of Thomas Rawlinson, FRS, the largest library then sold at auction. Rawlinson's brother, Richard, was also a book collector famous "because his four rooms in Gray's Inn [he was a lawyer] were so stuffed with books that he was forced to sleep in the corridor outside." But the most famous eighteenth-century auctioneer until Christie was Christopher Cock. He sold books but achieved more fame as an art auctioneer. Surviving contracts show that Cock's was a large company, and that the commission charged at the time was 5 percent on objects up to £40 or £50, and less thereafter. Catalogues were produced.

Until 1777 the government exercised hardly any control over auction

houses, with the result that they sank in reputation and prestige, were held to be populated by "scoundrels" and to be "places of fraud." They were a popular target for satirists (Hogarth especially, though he made use of auctions to sell his own works) and for heavier critics as well. For example, in 1731 *Taste of the Town* had this to say: "I am sensible that many People . . . will immediately object to the Progress these Auctions have made, and call loudly for a stop to be put to so growing an Evil. They'll assert, that in Time, their irregular Motions will cause a stagnation in Trade, hinder Money to circulate justly, and ruin even those of large Fortunes, by buying so many good Bargains." Laws passed in 1777 and 1779 sought to license auctioneers, and although this cut down outright fraud, auctions retained their racy image.

—

These developments in Britain were more or less paralleled in Paris. The traditional auction locations referred to earlier were superseded by the "Grands Cordeliers" in the rue du Battoir and the hall of the Hôtel d'Espagne in the rue Dauphine. The most notable auctioneers, who in the early days tended to come from the Auvergne, had rooms of their own. They included Pierre Remy in the rue Poupée, Sieur Lebrun in the rue de Cléry at the Hôtel Lubert, and Paillet, also a picture dealer, with rooms at the Hôtel d'Aligre. Louis XIV had tried to tidy up the profession in 1691 by increasing the number of auctioneers in Paris to a hundred and twenty, but people had hardly rushed to fill these posts. Despite the fact that they were official positions, Parisians were skeptical about the profitability of the trade. In 1715 Louis changed the title of the auctioneers to the one they have today: *commissaires-priseurs.* The French system encouraged the development of the expert, a feature almost unknown in Britain or America but one that still exists in Paris and the French provinces. Experts were, and are, employed by auctioneers to catalogue sales within their competence, and to guarantee the authenticity of the works being sold. Famous experts in the eighteenth century included Mariette, Balon and Gersaint, who was as fashionable in France as Christie was in England: François Boucher designed his letterhead and Watteau painted his ensign.

Mariette and Gersaint were responsible for a marked improvement in cataloguing during this period. Before 1756, when the catalogue for the sale of the Duc de Tallard's pictures appeared, descriptions of paintings being sold were vague; often they were identified only by school, and little distinction was made between originals and copies. After this date catalogues gave the artists' names more prominence, indicating a growing interest in authenticity, and the descriptions of the works included aesthetic appreciations,

then regarded as the most important aspect. Sometimes these were several pages long, and the dealer might even give several connoisseurs' conflicting opinions, seeing no need to take sides.

Pierre-Jean Mariette and P. Remy were the first dealer-experts to shoulder responsibility for firm attributions in their catalogues, making use of the provenances of pictures, when known, and other factors—for example, how the organization of a picture justified its attribution. Again, this discussion could take up quite a lot of space in a catalogue. In France, where the auctions had a judicial status, these developments posed a problem, for sellers naturally wanted a picture to be given the highest possible aesthetic value, and this did not necessarily accord with the dealers' newfound status, so that by the end of the eighteenth century a new situation had arisen. There were now far more collectors in France (up from 150 between 1700 and 1720 to 500 between 1750 and 1790), but whereas these "amateurs" were familiar with the terms of aesthetic discussion, it was the professional dealers who were now the authorities on attribution. This was a major shift in the balance within the trade; it helped Lebrun advance the role of the dealer, as discussed earlier, and was also one of the factors that led to a fresh round of speculation in painting. The Choiseul sale in 1772 produced amazing results, and in the same year M. Grimm, discussing two pictures by Van Loo (Carle or Jean-Baptiste—it isn't clear which he meant) that had been bought for twelve thousand livres and sold to Catherine the Great for thirty thousand, remarked, "Clearly, buying paintings in order to sell them constitutes an excellent form of investment." The extent of this attitude may be gauged from the fact that F.-C. Joullain, himself a dealer, felt constrained to criticize "the most reprehensible class of amateurs . . . I refer to that class . . . which, possessing no precise taste for anything in particular, pursue everything with an eye to speculation, [and] buy in order to sell."

Public auctions rose in Paris from five a year in the 1750s to more than thirty a year in the 1780s. And it was in this eighteenth-century world that both Samuel Baker, the founder of Sotheby's, and James Christie began their businesses.

Baker was a well-known bookseller who was in the trade as early as 1733 or 1734. He had been an apprentice of Richard Mallard, a bookseller, in 1704, for an annual wage of £5 (which would be $860 now). After he started up for himself, his first auction catalogue was dated March 11, 1744. Books were sold by size—octavo first, then quarto, finally folio. Titles were listed in random order, but "important and potentially expensive titles were set in italic." He was a part-time auctioneer for many years—being also a stationer

and a publisher—and in those days book auctions were rather gentlemanly affairs and somewhat leisurely. They were held in the early evening, when the learned classes could get to them, and only a few books were sold at a time, so that sales might last forty or fifty days.

Christie, who started up for himself in Pall Mall in 1766 after an apprenticeship in Covent Garden, made an impact straightaway because of his elegance and wit, which the satirists immediately seized on (see figures 8 and 11): "Will your ladyship do me the honour to say £50,000—a mere trifle—a brilliant of the first water, an unheard-of price for such a lot, surely?" (fifty thousand pounds in the late eighteenth century would be around $6.2 million now). One of the first objects Christie sold was a coffin "having been made originally for a man who had recovered from a malady deemed usually by the medical confraternity to be fatal." His first picture sale was held in March 1766, and the objects sold must have been pretty dubious, for a "Holbein" fetched £4 18s, a "Titian" realized £2 2s and a "Teniers" made all of fourteen shillings.

In the same year, 1766, Baker went into partnership with one George Leigh, a much younger man, and on Baker's death in 1778 his nephew John Sotheby joined the firm (see figure 9). The firm of Baker and Leigh now became Leigh and Sotheby. Three generations of Sothebys ran the firm, until the line died out in 1861. Leigh was a popular man and helped change taste in Britain: collectors became less obsessed by the Greek and Roman classics and turned instead to early English and Elizabethan literature and manuscripts. This was a time when prices rose markedly. Until the third quarter of the eighteenth century, books rarely went above two guineas (£2 2s), and the only ones that did were heavily illustrated works of reference in many volumes. But, according to Frank Herrmann, "After 1780 a price of £20 was not that exceptional" (£20 in 1780 would be $2,800 now).

By 1776 Christie, who had moved down Pall Mall to bigger rooms, had become friendly with Thomas Gainsborough, who was his next-door neighbor. Gainsborough agreed to paint Christie's portrait free of charge on condition that it be hung prominently in the auction rooms as an advertisement for his studio. (Eventually the picture was acquired by Paul Getty; see figure 7.)

Both Sotheby's and Christie's were well established by the end of the eighteenth century, but they had rivals, one of which was Stewart, Wheatley and Adlard (Benjamin Wheatley had been chief clerk at Sotheby's). This firm held regular auctions at 191 Piccadilly from 1794 to 1837, when it became Fletcher & Wheatley. In 1841 its premises and goodwill were acquired by Thomas Puttick and William Simpson. Puttick & Simpson was a strong rival of Sotheby's in the nineteenth century but faded thereafter and was taken

over in 1954 by Phillips. If Puttick & Simpson may be seen as an offshoot of Sotheby's, Phillips occupied the same position in relation to Christie's. Harry Phillips was thirty when he resigned as James Christie's head clerk and started out on his own in April 1796. Although he had premises at 73 New Bond Street, and was therefore a neighbor of Lord Nelson's, he was best known in his early days for "outside" sales, auctioning on their own premises the effects of a series of notables, from George "Beau" Brummell to William Beckford. Phillips's timing in leaving Christie was canny; he too benefited from the Napoleonic upheavals, handling the sale of, among others, Prince Talleyrand's collection.

The tumult of revolution in France and the subsequent wars had an enormous impact on the art market. In Paris the *commissaires-priseurs* disappeared during the Revolution. Stolen goods started to be included in sales, and public confidence in auctions collapsed. The famous "Hôtel Bullion" in the rue des Plâtrières was opened in 1780 in the vast building erected by Claude de Bullion, and by 1817 the principal Paris auctioneers were located there. A contemporary engraving shows that in those days the object being offered for sale was passed around the room during the bidding. Sébastien Mercier, a contemporary commentator, was scathing about the practices he saw: "An auctioneer is often dealer and salesman in one, either on his own account or 'hand and glove' with the other dealers . . . knocking down the article when it suits him according to his private plans and those of his secret associates in the 'deal.' " Even in those days, Mercier tells us, there was a "ring," known variously as La Graffinade or the Bande Noire.

In London, the political traumas across the Channel at first played havoc with the supply of Old Masters reaching England. Naturally Christie's was affected more than Sotheby's, and was forced to switch to jewelry, a merchandise more transportable and easier to conceal than paintings. (Apparently the change was only partially successful, for around this time Christie's moved premises again, to Dean Street in Soho, nowhere near as smart as St. James's.) Over the next years, however, the art market began to experience some positive consequences of the Revolution and the Napoleonic wars, since many members of the ancien régime, both French and Dutch, ended up in London with art, their one transportable asset. In addition, several of the more adventurous British dealers—men such as William Buchanan—were able to acquire cheaply in Italy large numbers of paintings from aristocrats terrified that their pictures would be confiscated by the French. Thus, in one way or another, enormous numbers of aristocratic collections from Europe were sold at auction in London. From France there came the collections of Calonne, the Prince de Conti, Laffitte, Sereville, Talleyrand and the controversial sale of the Comtesse du Barry's jewelry, which fetched £13,412 9s 6d

and gave Christie a commission of £559 7s 6d (4.17 percent). From Holland came the effects of van Zwieten, van Hasselaer, van Leyden, Schlingelandt and Braamcamp.*

The most notable sale by far was the Orléans collection. Assembled by the Regent of France in the early eighteenth century, it was sold by his great-grandson, Philippe-Égalité, to pay off gambling debts and finance his political ambitions in the Revolution. The collection included fabulous paintings by Raphael, Titian, Veronese, Bellini, Velázquez, da Vinci, the Carracci (very expensive) and Watteau. At the end of the eighteenth century, British taste had been for contemporary art—and contemporary British art at that. The Orléans pictures, however, were of such a quality that taste now veered back again to Old Masters. G. F. Waagen, a German connoisseur who toured Britain looking at the great pictures in private houses, and published his experiences, both benefited from and promoted this trend.

The best-known of the dealers to benefit from the vogue in Old Masters, and someone who enjoyed more adventures than most, was William Buchanan. Son of a Glasgow hat maker, he was a rough Regency diamond with "a vile tongue." However, he did have a crude commercial instinct that told him there were pictures to be bought in Italy and sold in Britain. In this task, he was aided, says Hugh Brigstocke, editor of Buchanan's letters, by two particular personal qualities: "An almost total ignorance about works of art, which enabled him to turn a deaf ear and a blind eye to any criticism of his wares, and an utter contempt for his clients and indeed for picture lovers of every kind, institutional, aristocratic, nouveau-riche." (This may do him some injustice. As Frank Herrmann has pointed out, Buchanan worked hard for the establishment of a National Gallery in London.)

Buchanan operated through agents, James Irvine in Italy and George Wallis in Spain, both of whom were painters of some talent (Wallis was known as "the English Poussin"). Buchanan raised money in Britain (he had £30,000 in the venture in 1803, which would be roughly $2.65 million now), his agents did the buying, and then he tried to place the pictures. Often the Scotsman would match a picture to a specific client at the outset, or sometimes he would send out an "open letter" to several clients. If these efforts failed he would go to Christie's, where he or his London agents would attend auctions and note who paid how much for what (not unlike Barbara Strongin's bid department today). Buchanan's letters show how little some things change: "Vanity principally prompts the English to buy—and that vanity leads purchasers to please the prevailing taste of fashion of their friends."

*The three-volume *Répertoire des catalogues des ventes publiques* by F. Lugt (The Hague, 1938) is the standard reference work for anyone who wishes to look up a famous sale.

There were times when it was a glamorous trade. Buchanan was responsible, for example, for bringing to Britain such works as Velázquez's *Pope Innocent X,* the same artist's Rokeby Venus, Raphael's Alba Madonna, Rubens's *Rainbow Landscape,* Titian's *Venus and Adonis* and Van Dyck's *Charles I.* At the time of Buchanan's death in 1864, nearly a quarter of the paintings in London's National Gallery had passed through his hands. At other times, trade foundered and Buchanan and his associates were reduced to staging lotteries to sell pictures, or bribing members of the Royal Academy to put in a good word for their wares. In fact, neither Buchanan nor anyone else made the fortune he hoped for. The Bank of Scotland repossessed paintings, another creditor took the deeds to Buchanan's house, and Irvine died in Italy, unable to return home for fear of his creditors.

Among Buchanan's rivals was John Smith, of 137 New Bond Street, who specialized in Dutch and Flemish pictures and published an immense nine-volume catalogue raisonné on the subject. He bought for Sir Robert Peel at auction and expended much energy warning him and others against the dangers of bad restoration. Another was C. J. Nieuwenhuys, of Flemish origin, who sold paintings his father sent him from Holland. He, too, wrote books and sold pictures to Peel. (Peel's main rival as a collector was Edward Solly, whose family ran a timber-importing business. Solly spent a lot of his time in Stockholm and Berlin and helped stimulate the collecting of, and dealing in, Old Masters in Germany. Through Professor Friedhof in Berlin and Girolamo Zanetti in Venice, among others, he amassed three thousand pictures at his house on the Wilhelmstrasse in Berlin. As Frank Herrmann points out, it was through Solly that von Bode and other Germans learned so much about the British methods of dealing in art.)

But in Britain Buchanan's main rival was Michael Bryan. Like William Wethered, Bryan had one foot in the art business and the other in the rag trade, for his brother was a clothier in Yorkshire and Michael acted as his London agent. He lived in Throgmorton Street in the City but his gallery was in Savile Row. On one of his buying expeditions abroad, he was in Rotterdam when an order arrived from Napoleon, whose forces were occupying Holland, to intern all English visitors. For Bryan this was a cloud with a spectacular silver lining, for during his internment he met Comte Laborde de Méréville, a rich French landowner and deputy in the French Chamber, who owned the French and Italian pictures that had once belonged to the Duc d'Orléans. Bryan introduced Méréville to the Duke of Bridgewater, who bought the Orléans French and Italian pictures and sold off those he didn't want in Bryan's own rooms.

An interesting aspect of this sale, which took place in 1798, was that the auctioneers were Peter Coxe, Burrel and Forster. Evidently Christie's did not

at the time have the hegemony they now share with Sotheby's. Nonetheless, when Christie died in 1803, he left his firm relatively healthy, thanks to the works flooding in from abroad. By now Sotheby's was equally strong, its prosperity due in part to the fact that it was also a publishing house. This was a clever arrangement; it guaranteed a steady supply of sales of libraries, since when Sotheby's authors died, their heirs naturally sold the estates through the firm. Leigh now took over from Christie as the doyen of auctioneers, and was famed for his use of snuff. Frank Herrmann, in his history of Sotheby's, quotes the antiquarian Richard Gough: "When a high price book is balancing between £15 and £20, it is a fearful sign of its reaching an additional sum if Mr Leigh should lay down his hammer and delve into [his] crumple-horn-shaped snuffbox."

In Paris the *commissaires-priseurs* had reorganized—or been reorganized—in 1801. An elected fifteen-member governing body was reinstituted and assumed stronger powers than it had possessed before, and the profession now took on a sociopolitical character quite alien to auctioneering anywhere else. For example, when the price of bread rose, the *commissaires-priseurs* donated part of their profits to the working classes; in 1813 they gave more than 12,000 francs for rearmament against Russia, and in the revolutions of 1830 and 1848 they helped the injured. In an attempt to reimpose formality and respectability on the auctions after the chaos and dishonesty during the revolution, rules were passed requiring that black coats and French hats be worn at auction. This didn't always work; in 1807 certain dealers objected to the public's being allowed into auctions and spilled powder on the salesroom floors, which inflamed throats so much that people coughed up blood. For a while the chamber considered banning the "bourgeois"—that is, the public—from the sales to appease the traders. But it didn't happen (see figure 12).

The arrangement between clerks and "criers" also became established formally in the early nineteenth century. At first the criers merely repeated the bids, but gradually they became more creative, and in many cases a well-known auctioneer and crier would become a team, a sort of patter act, joking, cajoling, building suspense. The most famous duo of this kind was Maître Bellier and Monsieur Vial (see figure 16). In the 1850s, the *commissaires-priseurs* acted together to build their own rooms on the site of an old opera house; they never moved again.

The *commissaires-priseurs* remained prosperous throughout the nineteenth century, though they ran into trouble with the government of the Third Republic, which was worried by their behavior during the Paris Commune; in the crisis of 1871 there was an auction of foodstuffs allegedly not belonging

to the person selling them. Drouot had dealt in stolen goods in the revolution; was it doing so again?

As the nineteenth century progressed in Britain, both Sotheby's and Christie's flourished. They were helped by the creation of the British Institution, where fashionable people could show off their recent acquisitions to the public—a nice touch that lasted well into the Victorian age. Sotheby's, however, met strong competition in the early nineteenth century from Robert Harding Evans, a man respected enough to have sold the Duke of Roxburghe's books (the duke was a noted bibliophile, who gave his name to the great booksellers' club). In fact, in one account of London's auction houses, published in 1848, Sotheby's is listed as second to Harding Evans, who was described as the more scholarly of the two houses. (Sotheby's was felt to be more "aristocratic.") However, the scholarly book sales attracted much less publicity than the sales of paintings and furniture at Christie's. There, the large crowds contained many spectators, as is true today. Percy Colson quotes a contemporary observation: "They cannot or do not buy, but they like looking on and watching things sold. . . . In the realm of material things there is no such liberal education to be found anywhere else, unless it be in the less invigorating atmosphere of a museum, where everything is dead and laid to rest. In the sale-room things are alive and merely changing hands; sometimes, in the case of great sales, with an intensity of suspense and subdued excitement which is quite sensational."

This excitement sometimes approached zealotry. The Victorians were in fact the first to draw attention to the parallel between art and religion, when the Evangelicals of the 1830s "proclaimed it a teacher, a guide, and a healer." Of course the hypocritical Victorians were adept at seeing the works of God amid those of Mammon, especially as by now even contemporary works were a good investment. Ruskin's *Modern Painters* had something to do with this trend, which culminated in 1863 with the sale of Elhanen Bicknell's collection of "fairly nondescript" British landscapes. Bought for around £25,000 thirty years earlier, they had trebled in value. People were astonished. In 1839, in an attempt to establish a climate of patronage, Samuel Carter Hall, editor of one of many art journals, had urged his readers to "consider the investment possibilities of British art."

But against this optimism and religious zeal, beginning with the Stowe sale in 1848 (caused by the sensational bankruptcy of Richard Plantagenet Temple Nugent Brydges Chandos Grenville, second Duke of Buckingham and Chandos, who had more names than money), the great estates of Britain were embarked on the great decline that was to culminate in the Settled Lands Act of 1882.

Lebrun and Pond, Gavin Hamilton and William Buchanan had spent a lot of time looking back to the Old Masters and to antiquity. In Britain, however, as the nineteenth century began, and despite the enormous impact of the Orléans sale, there was also a vogue for contemporary art. The fashionable concern for the arts under the Georges had paid off, and as the eighteenth century came to a close, Britain entered what has been called the "golden age of the.living painter." As Francis Haskell has pointed out, the nation had no other golden age to look back upon, no Italian Renaissance, no seventeenth-century equivalent of Rembrandt or Vermeer, no Rubens, Poussin or Claude Lorrain, no Watteau. But one only has to list the British painters alive or recently dead at that time to see what talent there was: Gainsborough, Reynolds, Turner, West, Raeburn, Gilpin, Hoppner, Zoffany and Sandby. Sir Thomas Lawrence was only thirty-one but already in the Royal Academy and painter to the king since Reynolds's death. George Stubbs was seventy-six, Blake was forty-three.

All these developments—new attitudes, a new self-consciousness among dealers, and an unprecedented burgeoning of artistic talent—combined to nurture the first of the world's great dealers in contemporary art. That person was Ernst Gambart. Gambart was born in Courtrai, Belgium, in October 1814, of a family of printers, booksellers and bookbinders.* He moved to Paris in 1833, after the Belgian revolution (when the Dutch were driven out). For the nineteen-year-old Belgian, Paris was the city of Daumier—narrow, stinking streets, crime-ridden and poverty-stricken. But in the turbulent wake of revolution and war, the system of state patronage in France was on the wane, and artists had to rely more and more on dealers. Those from whom Gambart learned included Alphonse Giroux, Susse, Marie-Fernande Ruel, Jean-Marie-Fortune Durand and Jean-Baptiste Goupil. However, the most famous of them was a man with an English name, John Arrowsmith. He had made his reputation and fortune after listening carefully to Géricault, on the latter's return from a Royal Academy banquet in London where he had been a guest. Géricault sang the praises of an underrated English painter, John Constable. Some months later, Arrowsmith arrived at Constable's studio unannounced, and so began a very profitable relationship for both of them: the English artist sold twenty landscapes in France, more than he sold in England during his lifetime.

In Paris at the time dealers in modern pictures often dealt as well in artists'

*Most of what we know about Gambart is based on the research of Jeremy Maas, British dealer, author and specialist in the Victorian art world.

colors or luxury goods; small pictures, like leather goods, made excellent gifts. (Several of the early Impressionist dealers also sold artists' colors.) Gambart started out in this way himself and might well have stayed in Paris but for the fact that his father was caught in a fraud and was jailed. The shame caused the son to move to England. At the time Gambart arrived in London printsellers were in their heyday, helped by the invention of the durable steel plate, introduced in 1820. The most renowned printsellers included Rudolph Ackermann, Colnaghi and Puckle, P. & D. Colnaghi, Arthur Fores; and the greatest of them all, Sir Francis Moon, who had his gallery at 20 Threadneedle Street. In Britain printsellers were now the commercial kings of the art world; a single painting might satisfy its purchaser, but prints of it ran to enormous numbers and provided huge royalties to the artist and the dealer, who became famous and rich in the process. When Moon died in 1872, he left just under £660,000, a fortune that today would be worth $63.6 million.

In Gambart's day, the print trade was hierarchical. According to Jeremy Maas's research, at the bottom were the street sellers of cheap engravings, who would roam London's more fashionable areas, especially in fine weather, with their engravings pinned to the insides of umbrellas which were opened and laid on their sides on the pavements. Gambart was not an umbrella man, though to start with he was not at the top of his trade. He formed a partnership with a Mr. Junin and specialized in prints of royalty and engravings of simpering young women, both of which were immensely fashionable. In 1843 Gambart and Junin had a shop in Denmark Street. Nowadays known as Tin Pan Alley, Denmark Street in the nineteenth century was already the home of music publishers, but it was not a bad location for an art dealer. Artists and shops selling artists' colors or canvases were to the north, around Berners Street and Charlotte Street, and Wardour Street was to the west. Berners Street was the best location, Wardour Street the worst. Now the home of film companies, it was then notorious for its junk shops and dubious galleries bulging with spurious Old Masters. It was the fashion for the shady art dealers at the bottom end of the trade to wear gaudy, if not Grecian, waistcoats.

Within a year Gambart and Junin had premises in Berners Street, and it was from there that Gambart launched himself on the more serious side of the Victorian art world. The 1840s were a period of change in British taste. The memory of the Orléans sale was fading, and many of the Old Masters now imported from the Continent were inferior rubbish. The Old Masters trade was not helped by a juicy scandal that involved the discovery of a "Canaletti manufactory" where at least eighty "Canaletti" had been "baked." Gambart had the good sense to steer clear of this quagmire, but his

ultimate success was due to yet another contagion of the period. This was "exhibition mania," which unfolded with a vengeance as the 1840s gave way to the 1850s. The Great Exhibition of 1851 was one reason, but not the only one. The mania reflected a widespread interest in art, and furious arguments were now aired in the press about whether people should buy art directly from artists, from dealers, from salesrooms or from the exhibitions, many of which were managed by the artists themselves. The *Art-Union,* a journal that had been fastidious in the preceding years in exposing the corruption of the Old Master market, now came out with a new message: its readers were exhorted to "avoid the Auction-rooms and the Dealers, and visit the Exhibitions."

Gambart would have none of this. As he saw it, exhibitions were simply camouflage; underneath lay the popularity of living painters, and he saw this trend for what it was. *He* started buying heavily at auction. This brought him into contact with several artists, because once he had acquired their works, Gambart was eager to negotiate the rights to have the paintings turned into prints, and it is probably this tactic for which he will be chiefly remembered. These artists, "his" artists, were: Holman Hunt, Rosa Bonheur (see figure 27), W. P. Frith, John Everett Millais, Alma-Tadema and Dante Gabriel Rossetti. Whether it was Bonheur's *The Horse Fair* or Hunt's *The Finding of the Saviour in the Temple* or Rossetti's *The Blue Bower,* Gambart attracted attention to himself by paying record prices for the canvases. The massive publicity continued as he took these works on tour, and of course an entry fee was charged at these exhibitions. Finally, when this avenue had been exhausted, he published prints of the now-famous paintings. He was brilliantly successful. By 1856, he had two galleries in London, in Berners Street and Pall Mall, and another in the rue de Bruxelles in Paris.

Besides his expansion in Paris, Gambart was one of three European dealers—the others were Goupil and Cadart—who now sought to exploit the United States. Goupil, Vibert and Co. had sent Michael Knoedler to New York in 1846, at first to specialize in the sale of French, English and German engravings. In May 1848 Goupil initiated the International Art-Union, featuring "Original Productions of the Most Celebrated Artists of the Modern French School." The exhibition, at which all the works were for sale, was shown in Boston, Philadelphia, Baltimore and New York. According to Lois Marie Fink, in her history of French art in nineteenth-century America, it was attacked as "lascivious," and people were urged not to buy "because there is not enough money in this country to support art, without having to pay profits to individuals to procure foreign paintings." People who joined the Art-Union were entitled to engravings of the pictures and stood a chance to win one of the paintings by lottery. The other firm, Cadart and Luquet of

Paris, sent the most important French art to cross the Atlantic up to that point—Corot, Monet and Jongkind—and the trade stimulated in this way led such American dealers as Leeds, Schauss, Snedecor, the Pilgeram Gallery, and Samuel P. Avery to follow suit.

In mid-century America there was a speculative atmosphere in the art market, fueled by the fact that during the economic depression of 1857 works by living artists continued to bring good prices at auction. In 1876, J. T. Johnston sold for $8,000 a Gérôme that he had bought a short while earlier for $1,275.

Gambart spent the last twenty-five years of his life in splendid retirement. He bought two mansions, one in Spa in Germany, and the other in Nice. By 1870, when the Franco-Prussian War broke out, he was abroad permanently and therefore missed the influx of French painters—Monet, Pissarro, Daubigny—who had fled to London. He also missed the exhibition of Impressionist art mounted at the German Gallery in Bond Street by Durand-Ruel. It was probably just as well, for though Gambart had been a modern, he hated Impressionism.

Yet thanks to the techniques he employed, and to the prosperity in Britain due to the Industrial Revolution, the best living painters of the nineteenth century could expect £5,000 or even £10,000 for a commission. (Today the equivalent figure would be roughly $1 million.) Contemporary painters would not have the same financial success again until our own day. But taste, techniques and world events were still changing; photography was killing off the demand for reproductive prints, and a growth in scholarship was helping to bring back Old Masters even as Impressionism was born. Hence, in the last years of the nineteenth century Gambart's mantle in London was taken over by two other dealers, dealers who over the years had been rivals and, on occasion, partners in print-publishing ventures but who were now better suited to the changing times. These dealers were Colnaghi and Agnew.

—

Colnaghi is the older of the two firms. It was founded in the middle of the eighteenth century by Giovanni Battista Torres, an Italian pyrotechnist, who opened a shop in Paris known as the Cabinet de Physique Experimentale, selling scientific equipment and books. In 1767 he moved across the Channel and opened a small branch of his firm in London. But though he was a brilliant pyrotechnist and worked with the famous Brock fireworks family, the materials used then were not as stable or as safe as they are today and fireworks were frequently banned by the police. Torres could see that print selling was safer and more lucrative. After publishing a number of scientific prints, he achieved his first major success in this field in 1775 with a series

entitled *Caricatures of the English,* which proved popular on both sides of the Channel; indeed, there were three times as many sales in France as in England. As a result of these successes, the firm abandoned its scientific bent and turned to art full-time.

When Torres died in 1780 Paul Colnaghi entered the picture (see figure 23). He came from a distinguished Milanese family, but like Gambart was obliged to go abroad after his father featured in a scandal and died in debt. Colnaghi's first stop was Paris, where he joined the great "rendezvous" at the optician Ciceri's shop. (During the Enlightenment, opticians were at the forefront of the passion for science.) All the intellectuals of the day, including Benjamin Franklin, gathered at Ciceri's, in the rue St.-Honoré, where they were known as "ciceroni." In Paris Colnaghi received an offer from Antony Torres, Giovanni's son, to be Torres's agent as printseller, with a shop in the Palais Royal. This shop opened in 1784 and began by selling Reynolds's portraits in mezzotint, which was then known in France as the *manière anglaise.* The next year Colnaghi moved to London, where Torres's shop was now located at 132 Pall Mall. The two men clearly were compatible; Colnaghi married Torres's daughter, and at the end of the eighteenth century, Torres made over the business entirely to his son-in-law.

As mentioned earlier, trade had foundered during the French Revolution. "It is all over with engravers and publishers," wrote John Raphael Smith. But Colnaghi weathered the storm by publishing the firm's second series of famous prints. This was *Cries of London,* the most famous of all colored stipple prints, showing the charm of eighteenth-century life without ignoring the more somber side. As the Napoleonic wars dragged on, Colnaghi also began to provide the government with views of beleaguered towns. These were invaluable for the army, and it was through contacts built up in this way that Colnaghi came to meet a number of influential and important people, many of whom collected prints. He held a three-o'clock levee, "crowded with beauty and fashion" (Charles Dickens was among the guests). Colnaghi was appointed printseller to the Regent and was also asked to arrange the royal collections before they moved to Windsor.

In 1821, the business was valued at £25,000 ($2.4 million at today's value). The good fortune didn't last, however. Paul had two sons, Dominic and Martin. Dominic, a friend of Constable's, and a patron of Bonington, was successful: a two-volume history of the Crimean War, published in 1855–56, earned the company £12,000 ($1.1 million today). But Martin had turned into a reckless and flamboyant spendthrift. His behavior was so bad that before long the rest of the family got together to buy him out. But this wasn't the end of the problems, for Martin started up on his own and when he met

Dominic at a sale, he would bid ruthlessly against his brother. It was the talk of London.

In the latter part of the nineteenth century interest in prints was waning, owing to the invention of photography (Julia Margaret Cameron had an "arrangement" to sell through Colnaghi in 1864). But now Colnaghi's made the transition to selling paintings proper. Three men in particular were responsible: E. F. Deprez, Otto Gutekunst and Gustav Meyer. The son of an auctioneer in Stuttgart, Gutekunst, the senior man of the three, was as fine a collector as he was a dealer (he divided pictures into "Angel food" and "Big Game") and his own collection eventually went to the Ashmolean Museum in Oxford. The end of the nineteenth century saw some great coups for Gutekunst and his colleagues, among them the sale of more than twenty paintings to Isabella Stewart Gardner, including Lord Darnley's Titian, *Europa and the Bull,* and three wonderful paintings to Frick: Bellini's *St. Francis in Ecstasy,* Titian's *Portrait of Pietro Aretino* and Goya's *Forge.* Many of these works had come on the market because of the Settled Lands Act of 1882. Although most impoverished aristocrats sent their pictures to Christie's, there were many who preferred the more discreet route of selling through such dealers as Colnaghi, Sulley or Agnew.

Agnew and Son go back as far as 1817. In that year Thomas Agnew was taken into partnership by Vittore Zanetti, an Italian émigré who had premises in Market Street, Manchester. At that point, the firm was not only, or even mainly, art dealers. A newspaper advertisement put it this way:

Carvers and gilders . . . Opticians, Ancient and modern English and Foreign printsellers, Publishers, and dealers in Old Coins . . . they always have on hand a very extensive assortment of . . . Bronze Figures, Lamps, Lustres, Telescopes, Microscopes, Opera and Reading Glasses, Mathematical instruments . . . Barometer, thermometer, Hydrometer, and Saccharometer Maker, on the most improved construction, warranted correct. Paintings restored . . . Ancient and modern paintings bought, sold and exchanged.

The young Thomas Agnew had served as an apprentice in this colorful and wide-ranging business since 1810. The Agnews were originally from Wigton-shire in Scotland; John Agnew, Thomas's father, had crossed the border and settled and married in Liverpool.

Zanetti retired in 1828. Print selling, occasionally in collaboration with Gambart, had gradually replaced frame making, but at about this time the picture-dealing side of the business began to prosper and the company's first purchases were made at Christie's in London. One reason for this was yet

another outflow of paintings from Italy, brought about by the anticlerical feeling stimulated by the Napoleonic wars. A number of churches were closed and all the paintings from religious institutions were gathered at two collecting points, in Milan and Venice. According to Frank Herrmann, as many as three thousand Italian paintings left the country in this way, enabling men like Edward Solly and Sir Robert Peel to form their collections. The taste of Colnaghi's at that time was not just for Old Masters but for more contemporary English works: Constable, Turner and Etty. The large fortunes accumulated in the mid-nineteenth century by Manchester merchants gave a tremendous impetus to art collecting in general and to Agnew in particular. Thomas's eldest son, William, followed him into the business and was to develop his ideas on a far grander scale. During the 1850s, while Thomas was taken up with his duties as mayor of Salford, William started making regular trips to London and buying more heavily at Christie's. In 1860 the firm opened in London in Waterloo Place. William had the gift of friendship; he knew Gladstone but also entertained at his home Lord Rosebery when he was prime minister, painters such as Millais, Burne-Jones and Frederick Leighton, and musicians like Hallé and Mme. Neruda. He also joined the board of *Punch,* becoming chairman in 1890; by then he had been elected a Liberal member of Parliament for Southeast Lancashire, which seat he held for six years. Busy as he was, he did not neglect the firm. It was William who fashioned links with the great aristocratic collections in England of Lord Lansdowne, the Rothschilds, Lord Rosebery, Lord Westmorland and the dukes of Newcastle. By the late nineteenth century Agnew and Son was a force to be reckoned with in the art world, easily as prominent as the major auction houses. Indeed, the firm claims that over the years it has been Christie's biggest customer.

The last decade of the century saw William Agnew's greatest achievements, the formation of two great collections: those of Sir Edward Cecil Guinness (later Lord Iveagh) and of Sir Charles Tennant. Over the years, Lord Iveagh bought 240 paintings and drawings from Agnew, including 34 Reynoldses, 16 Romneys, 15 Gainsboroughs, a Rembrandt self-portrait, two Van Dycks and three Claudes.

William Agnew retired in 1895. He would be missed in the salesrooms in years to come, by the journalists as much as anyone. "Christie's was crammed full on Saturday afternoon," ran one account in 1890, "though the sale could have been conducted quite as well in a four-wheeled cab, for Mr Agnew bought nearly everything. Roughly speaking, he spent £50,000 out of £77,000 which the sale produced [£50,000 then would be $5.5 million now]. . . . Mr Martin Colnaghi, Mr Vokins and Mr Davis were the others, but they merely trifled with a paltry thousand or two. . . . You can't see Mr Agnew's

jovial countenance, you can't hear Mr Agnew's formidable voice, but that hat of his holds you like the eye of the ancient mariner. Every bob of that hat means a thousand. It is splendid."

Morland and Lockett Agnew took over the firm in 1895. Agnew's new American clients were George Gould, "Judge" Elbert H. Gary, J. G. Johnson, E. T. Stotesbury, P. A. B. and J. E. Widener, and above all J. Pierpont Morgan, who bought some two hundred oils and drawings from Agnew. The Old Master field remained strong, for two reasons. One was Wilhelm von Bode, "begetter" of the new Kaiser Friedrich Museum in Berlin. Bode understood better than anyone what the Settled Lands Act was doing for the art market; he not only bought copiously in London for his own museum but prevailed on wealthy Germans to take advantage of the situation in Britain. Later, of course, in their wills, they left their pictures to his museum. A second reason was the increasing number of American collectors who were attracted by European art—Old Master painting in all its variety, and Victorian works as well. But in the early 1890s artists of a different kind began to appear on Agnew's books, among them Édouard Manet and James McNeill Whistler. Like William Sutton of the American Art Association, the Agnews did not share Ernst Gambart's aversion to the Impressionists of Paris.

———

With the Impressionists, the modern world arrives. Impressionism was the second, and arguably the most important, development in modern art that had vital commercial implications. The first was the Romantic Movement, which changed attitudes about artists. Thereafter artists took themselves more seriously: they were masters who could not be dictated to; the idea of genius had taken hold. The Romantic painters thus raised the status of dealing, which now provided *access* to genius. The third development would be Cubism, leading to abstraction. In removing realism from the easel, artists would sever an important link with the public and at the same time become more ambitious: the inherent qualities of art became more important than the pictorial, but these values were more difficult to see, so that there was a greater need than ever for interpreters and dealers who "understood" the new art. Thus dealers were not merely associated with genius but helped identify it in the first place.

In between came Impressionism, in the wake of the invention of photography and the collapse of the print market. Who knows if Impressionism, with its fuzziness, its attempt to catch the fleeting aspects of modern life, would ever have occurred if photography had not arrived. But once it had, prints of Impressionist pictures, very difficult to make, would have had no market in any case. The collapse of Gambart's Pre-Raphaelite print market meant,

among other things, that now there had to be a much greater concentration on *original* art. This required quite different selling techniques to appeal to a different kind of customer.

Thus Gambart was the last of the ancien régime in the art market. Fortunately, after him, dealers and auction houses were helped by the growing appetite of the United States and the new schools of art that were proliferating. After the collapse in his field that Gambart lived to see, there was a sense of the world opening up in a quite different way, of more and more people buying original art. Of course there were countless petty jealousies and rivalries, but in general, as notable exhibitions of the late nineteenth and early twentieth centuries show, there was a great deal of international cooperation, and some wonderful collections were formed. It is in this sense, of everyone pulling together, promoting original art, both old and new, that the dealers, collectors and salesroom personalities who followed Gambart may be called the Post–Pre-Raphaelite Brotherhood.

4 | PARIS IN THE GOLDEN AGE: MANET AND THE BIRTH OF MODERNISM

—

If the specific events of 1882 exerted a powerful long-term influence over the modern art market, it is also true that more general events mattered as much. The period between the Franco-Prussian War and World War I, 1870 to 1914, produced many of the ideas that shaped the modern world: from Freud to Marx, from Marie Curie to Einstein. In art it was a no less remarkable period. Most particularly, it was a golden time for Paris. Although Impressionism may be said to have begun with Monet's pictures in the late 1860s—that is, just before this period—the first group exhibition of the "independents" was not held until 1874 (the eighth and last occurred in 1886).

But it wasn't only Impressionism. The group known as Les Nabis, the Prophets—including Vuillard, Bonnard, Denis and others—made their appearance between 1889 and 1899; the next year Picasso arrived in Paris to begin his early "Blue period" works; in 1905 the works of Matisse, Derain, Vlaminck and Rouault were hung together at the Salon d'Automne and Les Fauves were christened; and in 1908 the first Cubist exhibition was held, also in Paris. The world knows this period generally as La Belle Époque, but this familiar phrase hardly does justice to the important changes that were born in Paris. The Paris to which writers, actors, dancers, artists, dealers, collectors and intellectuals of all kinds flocked in this period was a city transformed, both physically and socially, to become the first truly modern

metropolis. This Paris, this exceptional place, had two fathers. One was Baron Georges Haussmann, Napoleon III's master planner in the rebuilding and expansion of the city; the other was that persuasive advocate of modernism, the writer and poet Charles Baudelaire. Without them Impressionism would not have had the flavor that it did.

Haussmann's reforms were badly needed in Paris. The city of Daumier and of Victor Hugo, the city of Gambart until his father was imprisoned, was dingy, dirty and disease-ridden in many areas. And it was getting worse, not better: between 1830 and 1880, the city's population had quadrupled, from 576,000 to 2,270,000. Beginning in 1853, Haussmann's solution was to demolish whole acres of slums in the central and eastern parts of the city and encourage the construction of new housing. He built wide, straight boulevards to provide easy links between the various commercial sectors of the capital and to give access to the new railroad stations that were bringing agricultural workers into the heart of Paris. He improved the drainage and sewage systems to such an extent that Napoleon could boast of having "found Paris stinking and left it sweet." He built large markets at Les Halles and the great park at Bois de Boulogne.

There were critics, Zola among them, who objected that streets of great historic significance were being demolished, and that the demolition of entire neighborhoods displayed an official brutality and indifference to the suffering it had caused. The wide, straight boulevards were also criticized as being a "strategic embellishment" that would facilitate the movement of troops in any future insurrection, which did indeed occur in 1871. On the whole, however, the benefits far outweighed the drawbacks. Certainly the artists who were drawn to Paris loved this new world and made it their own. The grand boulevards, the railroad stations, the new bridges over the Seine, life in the parks—all became subject matter for Manet, Monet, Degas, Renoir, Caillebotte and Pissarro. Most of all they loved the cafés, the café-concerts, the theater and the opera. There had always been cafés in Paris, of course, but it was not until the end of the nineteenth century that they became the very center of its social and cultural life; according to Theodore Reff, in the introduction to "Manet and Modern Paris," an exhibition he curated at the National Gallery in Washington, D.C., in 1982–83, and on which much of this section is based, there were more than 27,000 of these cafés during Manet's day.

Around 1840, Reff says, a new type of café had been added to the familiar *café littéraire*. In the new establishments singers and musicians provided topical, vernacular forms of entertainment. In the following decades, these café-concerts became a familiar feature of Parisian nightlife, at first outdoors on the Champs-Élysées, then indoors along the principal boulevards. Popu-

lar café singers like Thérèsa, Bécat and Demay, all of whom Degas painted in the 1870s, were among the leading celebrities of the day. Manet was to paint several cafés: the fashionable Café Tortoni on the boulevard des Italiens (see figure 13); the more literary Café de Bade, farther along the same boulevard; the Café Guerbois near the place de Clichy; the Café de la Nouvelle-Athènes on the place Pigalle in Montmartre; and the Folies-Bergère. Degas, Forain and Toulouse-Lautrec also favored café subjects, and Renoir made the Moulin de la Galette famous. Reff quotes Huysmans, "They offered [an artist] a synthesis of the age." But of course it went further than cafés, entertainment and the grand boulevards. The railroad stations, the new bridges, the new vistas liberated by the open spaces that Haussmann created all provided the Impressionists with themes and subjects. The Impressionists' Paris *is* Haussmann's Paris.

Baudelaire's influence is less easy to quantify but no less important. It is hard for us today to appreciate how much in thrall to history French culture was, why "history painting"—which represented specific episodes in classical history and mythology in a way that often symbolized the battle between the passions and the intellect—was regarded as the noblest form of art. Without such an appreciation, it is impossible to realize just how revolutionary Baudelaire's ideas were, for they seem so commonplace today. But Baudelaire was the chief, the most poetic and most persuasive advocate of "modernism"— the view that artists and writers "be of their own time." Baudelaire was the first to declare that "the life of our city is rich in poetic and marvelous subjects." What he discovered—and urged Manet to discover—was the "transitory, fleeting beauty of our present life," by which he meant urban life, whose energy and complexity constituted a new source of inspiration.

It was not the smoky, sprawling towns per se that Manet was first to focus upon. In 1848 Théophile Gautier had already argued that "a modern kind of beauty," different from that of classical art, could be achieved if "we accept civilization as it is, with its railroads, steamboats, English scientific research, central heating, factory chimneys." What the painter absorbed from Baudelaire was the essential dynamism of urban life, and how that differed from what had gone before; Baudelaire taught Manet the value of "setting up house in the heart of the multitude, amid the ebb and flow of movement." Baudelaire believed this to be the sine qua non for "the perfect *flâneur*" in his essay "Le Peintre de la vie moderne," published in 1863, when, according to Theodore Reff, he was in almost daily contact with Manet and had recently been "his habitual companion when Manet went to the Tuileries, making studies outdoors." A nineteenth-century English dictionary would have translated *flâneur* as "dandy." Today, "sophisticated socialite" is closer to the meaning.

In this sense, Manet's *Concert in the Tuileries* is his first important picture of modern life, closely followed by *Olympia* and *Déjeuner sur l'herbe*. They are also important because they capture in small, subtle ways "what Baudelaire called the 'heroism' of modern life in a medium and on a scale associated with ambitious salon paintings. Pictures of equally familiar Parisian sites, with figures in contemporary dress, had been shown at the Salon earlier in the century, but the figures had been small and the locations rendered in a merely topographic manner. With Manet the scale and sense of ambition is much greater; the merely contemporary becomes modern." Manet conveys the immediacy, urgency and energy of the *flâneur's* experience.

For Baudelaire painting was important because painters were a special elite. It was in the mid-nineteenth century that the term "avant-garde" was first used—interestingly enough, to describe radical or advanced activity in both the artistic and the sociopolitical realms. Writing in the 1830s, Henri de Saint-Simon specifically listed artists, scientists and industrialists as the elite leadership in avant-garde society.

"Heroism," the word Baudelaire used about modern life, sounds rather grand today, too big a word for the fleeting beauty that the Impressionists went on to paint. But Baudelaire used it because, unlike us, he had grown up with history painting, art that harked back to the heroism of earlier times, art in which it was implicit that present-day life lacked such grand moments, grand deeds, grand opportunities. Now painters looked about them at, in Baudelaire's words, "that vast picture gallery which is life in London or Paris." There was also something else, summed up in yet another phrase of Baudelaire's: "The pleasure which we derive from the representation of the present is due not only to the beauty with which it can be invested, but also [to] its essential quality of present-ness."

There we have it. It was this quality, this "present-ness," that the Impressionists painted in Paris in the last quarter of the nineteenth century, a present-ness that was part of the self-consciousness that always accompanies a great period. Paris was economically, socially, culturally, architecturally, artistically, theatrically and politically not just as good as or better than anywhere else, but *as good as she had ever been*; in a different way, perhaps, but nonetheless the equal of the past. This is what Baudelaire and the advocates of modernism were saying, and this quality of present-ness in Impressionist painting is what we still respond to today. For us it may be a form of nostalgia; nonetheless it is the quality we are buying when we spend $78.1 million on a Renoir.

Baudelaire's influence was felt directly in painting through Manet (see figure 28). The two men were good friends and often went walking together to explore Haussmann's innovations. Beyond the ironies and contradictions

of the subject matter, what ultimately links Manet's images of modern Paris with Baudelaire's is that both understood the distinctly modern forms of life, the modern ways of living, the modern assumptions brought about by urbanism. In order to express this, painter and poet were required to expand the range of their ambition. Baudelaire had to invent a new language, which he described as "a poetic prose, musical without rhythm and rhyme, supple enough and rugged enough to adapt itself to the soul's lyrical impulses, the undulations of revery, the leaps and jolts of consciousness." Manet also needed to break with familiar traditions, the old ways of speaking in paint. This meant fresh rules of composition, perspective and space. "Sensations are recorded in a swift shorthand," important figures are placed off center, or are even cut off by the frame. This was life as experienced in the crowded city, life as mediated by the new mass media.

Both men also shared a deep concern with certain themes. As Theodore Reff says, these were: estrangement or alienation in the midst of conviviality; indifference in the presence of death; and suicide. The later Impressionists did not tackle these primal themes as much as Manet did in his earlier works (or at all, in many cases), but for most of them the idea of estrangement in the midst of conviviality was never far away. Think of the work of Degas and Toulouse-Lautrec especially, and of Picasso later. The pretty landscapes of later Impressionism did not have a great deal in common, beyond technique, with this phase of Manet's career. Alienation is seen in many of his works, and the new cafés, dazzling and opulent, with gas lamps "lighting with all their might the blinding whiteness of the walls, the expanse of mirrors, the gold cornices and mouldings," were his favorite setting for this theme. But again as Reff points out, "this luxury only heightens the poverty of human relationships."

Baudelaire's characters are often doubly estranged, facing a class barrier and their own personality differences. At the same time, says Reff, "Manet's café-dwellers may all belong to the same world socially, but it is a world of strangers adrift in a seemingly limitless space, who are cut off severely at the edges, reflected ambiguously in its mirrors, remote from each other even when seated together, and . . . no more substantial than smoke." A final twist is that many of Manet's works are *blagues,* ironic put-ons. The *blague* was a favorite form of destructive wit of the period, often inflated to gigantic proportions, profaning and vulgarizing the most sacred verities of the times. And of course, a *blague* is itself a form of alienation.

These are some of the reasons why the modern art world, like the modern world itself, begins with Manet. The experiment begun by Manet in 1862 finally reached full artistic fruition in the Impressionist exhibition of 1882, when their achievement was seen most clearly—and when, at last, it began to

be recognized, just a year before his death. In our own day the Impressionists and Post-Impressionists have outstripped all other schools in terms of price. In the process, the Impressionist painters have been accepted as the masters of light, and of a cozy, almost genteel world that has vanished forever. As Lord Gowrie, the chairman of Sotheby's in London, has put it, to us the world of the Impressionists is a world of bicycle rides and home visits by the doctor, safe and reassuring. But Manet—at least early Manet—wasn't like that, or not only that. He and Baudelaire were more serious, more socially conscious, more aware of the world about them. That is what modernism meant to them, and without modernism what followed—from psychoanalysis to Fauvism, from quantum physics to German Expressionism, from Diaghilev to Dada, from Picasso to Pop Art—couldn't have happened. When we wonder why Impressionist and modernist paintings fetch such high prices in the salesrooms, we should remember this fact.

5 | THE STREET OF PICTURES: RUE LAFFITTE AND THE FIRST DEALERS IN IMPRESSIONISM

Although the auction prices of Impressionist pictures attract attention today, in the early days the artists were kept going by a small number of collectors and by dealers, almost all of whom at some stage in their careers had galleries on the rue Laffitte, known throughout Paris as the rue des Tableaux, the Street of Pictures. Père Méry, a painter of birds, would rail at anyone who strolled too slowly along this street; to him, they had come here to buy and had better get on with it.

The Impressionists themselves had mixed feelings about the street. Monet hated going there, for he did not want to know how other painters were faring commercially. But Cézanne liked it and so did Degas, who, according to Vollard, went there from his studio by omnibus. At 16, rue Laffitte was Paul Durand-Ruel, by far the most important Impressionist dealer in Paris and in the history of Impressionism (see figures 25 and 26). He was not merely the first dealer to handle their works; he was also the man who first exported them to America, thereby introducing to the modern art market the love affair of Americans for Impressionism. Durand-Ruel was a reticent man, round-faced with a mustache and a high forehead. He was born in 1831 in the rue St.-Jacques in Paris above a shop run by his parents that sold stationery and artists' supplies. At the height of the Romantic Movement, this shop was a meeting place for many painters, etchers and dealers, among them Arrowsmith, who introduced Constable to France. Paul Durand-

Ruel's father, Jean-Marie-Fortune Durand, became a dealer by adopting the English practice of offering to sell the pictures of artists who bought their colors, canvases and brushes from him. In this way, Jean-Marie sold the work of Rousseau, Corot, Géricault, Delacroix and Bonington.

On one occasion, the Prince de Joinville, eldest of the royal children, bought a canvas by Prosper Marilhat at Durand-Ruel's but was nearly forced to return it when the king found out that Marilhat had been rejected by the salon. After this story went the rounds of Paris, Durand-Ruel's gallery became a kind of Salon des Refusés, a state of affairs that Paul Durand-Ruel would take advantage of later.

According to Anne Distel, on whose authority much of this chapter rests, and whom I quote at length, art was not Paul Durand-Ruel's first love, even though he grew up surrounded by it. He wanted to be a soldier and was accepted by Saint-Cyr, but his bad health ruled out any idea of a military career. A fervent Catholic all his life, he may have considered becoming a missionary. In 1857, however, his father moved his shop for the second time, to 1, rue de la Paix. Art dealing was proving successful; Paul joined his father, and when the father died in 1865 the son took over the running of the business. In 1870 yet another move took place, to a gallery with two entrances: one at 16, rue Laffitte and the other on the rue Le Peletier, both addresses that the Impressionists would make famous. Rue Laffitte was then, and would remain until 1907, when Kahnweiler moved to the rue Vignon, the center of the art trade in Paris. Dealers, appraisers and the "experts" who helped the *commissaires-priseurs* put together the sales at the Hôtel des Ventes in the nearby rue Drouot, all had their offices in the rue Laffitte or the rue Le Peletier. It was a prosperous as well as a colorful area; the Rothschilds lived on the street, as did Sir Richard Wallace. Until it burned down in 1873, the Paris Opéra was also on the rue Le Peletier.

Anne Distel reports that "the first transaction on record took place between Durand-Ruel and Monet in 1871," though the dealer had bought Impressionist pictures from others before that. He had taken some of his stock to show in London, where trade was more normal during the Franco-Prussian war. While there he had come across Daubigny painting by the Thames, and the painter told him that Monet was also in London. The following year, 1872, Durand-Ruel bought his first works by Degas, and shortly after that he "noticed two paintings by Manet owned by the artist, Alfred Stevens." Apparently he liked Manet most of all, for it was following this encounter that Durand-Ruel bought more than twenty canvases from him, for 35,000 francs ($130,000 nowadays).*

*There were then five francs to the dollar and five dollars to the pound sterling.

Throughout his memoirs, Durand-Ruel stressed that a dealer must always do what he could to protect the prices of his artists. Whenever possible, he sought to obtain a monopoly of an artist's oeuvre, buying up works from other dealers or collectors, and even "bidding up" pictures at auction to prevent prices from falling. Durand-Ruel acquired most of his early Impressionists relatively cheaply; according to Anne Distel: "No single painting cost [him] more more than 3,000 francs" ($11,200 at today's values). Even the government, which was always penny-pinching when it acquired salon paintings for museums, paid 12,000 francs for an Alexandre Cabanel and the same amount for a Jules Lefebvre in 1871. In the same year Sir Richard Wallace paid 200,000 francs for a Meissonier (that would be $806,400 today). Durand-Ruel was not blind to these differences; as a commercial dealer, he could not afford to be. He sold works by all of the preceding generation of painters—Millet, Daubigny, Daumier, Courbet—plus a raft of "artists who are quite forgotten now." However, he did give more financial support to "his" Impressionists than to other artists. From the 1870s on, he "agreed to pay regular advances" to several of them and brought their work to the attention of collectors. He himself received financial support from Jules Féder, one of the shareholders in L'Union Générale, a Catholic bank. It was with Féder's help, says Anne Distel, that Durand-Ruel bought up all of Boudin's stock in 1881, a move reminiscent of his tactic with Manet's work. It was also Durand-Ruel's idea to hold one-man shows for Monet, Renoir, Pissarro and the others, so he was soon recognized as the Impressionists' promoter.

Still, Durand-Ruel had problems. Anne Distel found an advertisement that showed that his rent in the rue Laffitte was 30,000 francs a year ($121,000 at 1992 values), and when, in the late 1880s, the Impressionists did not make the commercial breakthrough that might have been expected, his financial situation became worrying; indeed, even in 1884 he was in debt to the tune of one million gold francs. America, says John Rewald, saved him. Hermann Schauss, one of the biggest American dealers of the day, once said of the Impressionists, "These pictures will never be any good for our market," but in 1885 Durand-Ruel was invited to exhibit in the United States by the AAA, and accepted. The painters were suspicious. "I must say," wrote Monet, "that I should be sorry to see some of my paintings go to Yankee-land; and I should like to have certain canvases kept for Paris because Paris, above all, is the one and only place where there is still a little good taste."

Not so. Though his first show in New York could have been more successful, by 1887 Durand-Ruel had opened his own gallery in Manhattan and had rented an apartment on Fifth Avenue. Luckily the building was owned by H. O. Havemeyer, who bought no fewer than forty Impressionists from the

French dealer. By the time he returned from the United States in 1888, Durand-Ruel had turned the corner financially.

However, he was nearly sixty now and not as intellectually flexible as he had been. As Anne Distel says, Pissarro was "under the influence of Seurat," whom Durand-Ruel had never liked; Renoir was approaching his classical phase, and "even Monet's work tended to be ever more allusive"; in addition, Durand-Ruel did not care for Gauguin, "bought works by Cézanne only at the express request of certain faithful customers," and "went so far as to refuse to organise a posthumous exhibition for van Gogh." He held on, however, and shared in the recognition that finally came to the Impressionists in the 1890s. It was then that he held his great Renoir and Monet exhibitions. "Monet opened his exhibition," wrote Pissarro. "Well, barely open, my dear man, all was sold, at 3,000 to 4,000 each!" (That would be $13,200–$17,625 now.)*

Durand-Ruel lived until 1922 and was awarded the Légion d'honneur only in 1920, which helps explain the bitterness he felt at the end of his life toward the authorities, who he thought had not recognized him. He took little part in the developments of Fauvism, Cubism and what followed; instead he always preferred the fresh colors and familiar fuzziness of Monet and Renoir, backing such new artists as Albert André, Georges D'Espagnat, Henri Moret and Maxime Maufra, all of them virtually unknown now.

Although he was a pioneer, Durand-Ruel was perhaps too early on the scene to be a truly fashionable dealer. That title went to others, who feature in the literature of the time—in Proust, for example, or in Zola's novel *L'Oeuvre*. They are fictionalized, of course; in Zola's work the dealers are called Père Malgras and M. Naudet. But Zola's working notebooks have come down to us, and from Anne Distel's research among these it is clear, she says, that his characters are based on three real-life dealers. Hector-Henri-Clément Brame is described by Zola in his notebooks as a "former actor at the Odéon. Looking very chic, English morning coat, carriage at the door, seat at the Opéra." Brame had a magnificent beard and a mustache that cascaded from his upper lip in two large curving folds; he had a long nose, wide-set eyes and a wave of fair hair brushed back off his forehead. He came from Lille and "is rumoured to have acted under the pseudonym of De Lille." He seems to have turned to the art trade simply because in 1865 he married the daughter of a dealer. He and his new father-in-law dealt mainly in Corot, but they also handled Millet, Rousseau, Jongkind and Boudin. At one point

*Perhaps this was when Monet, who loved food, acquired his habit of taking four portions of everything he ate: four pieces of meat, four helpings of vegetables, four glasses of wine.

Brame and Durand-Ruel were partners, and it may have been this association that led him to the Impressionists and into Zola's notebooks.

Hector-Henri was followed by his son, Hector-Gustave, who moved the gallery, then at the rue Taitbout, to 3, rue Laffitte. Of all the Impressionists, Degas was the one the Brame gallery "was especially interested in." Hector-Gustave was renowned for his business tactics; Anne Distel quotes a document of Zola's where Brame's business methods are discussed: he would propose selling someone a painting for 5,000 francs but would include in the deal a signed guarantee to buy back the painting one year later for 6,000 francs. Zola understood what Brame was up to: "He placed a few works in this way during the year; he made prices rise the same way prices for securities go up on the stock market, with such success that, after a year, the collector would no longer want to resell the painting to him for 6,000 francs."

Georges Petit was probably Durand-Ruel's greatest rival at the time when the Impressionists were holding their group exhibitions from 1874 to 1886. Considerably younger than Durand-Ruel, he was born in Paris in 1856, and he too was the son of a picture dealer. His father, Francis Petit, had received a 1,000-franc dowry from his wife, and using it as seed money, he made a fortune buying and selling Meissoniers; Anne Distel says that when he died in 1877, Petit's father left Georges an estate of more than 2.5 million francs (which would be $9.9 million now). Of Petit, Zola wrote: "A flashy dresser, very smart. He himself began to do business at his father's. Then ambition seized him: he wanted to ruin the Goupils, outdo Brame, be the first and foremost. And he had his townhouse built on the rue de Sèze—a palace. He started out with three million [francs] inherited from his father. His establishment cost four hundred thousand francs. Wife, children, mistress, eight horses, castle, hunting preserves."

Decorated in red velvet and marble, Petit's gallery was reached by means of a monumental staircase. The building was inaugurated in February 1882, the year the Impressionists first received any really favorable publicity, and in his new premises Petit thought he was well placed to take on Durand-Ruel. He conceived the idea for an Exposition Internationale, in which "a committee of famous foreign painters" would invite artists of their choice to exhibit. It first took place in May 1882 and was, in its way, only another alternative to the salon. But it was a fashionable success and "raised the Impressionist artists' hopes for a renewal of this clientele, which Durand-Ruel had not managed to bring about."

Though not as adventurous as Durand-Ruel, over the years Petit became a more fashionable and commercially astute dealer (see figure 18). Like Durand-Ruel, he saw the possibilities across the Atlantic, and one of his

employees, Isidore Montaignac, became the Paris link for Thomas Kirby's partner at the AAA, James Sutton. Petit thought in grandiose terms that flattered his customers' taste. "One Hundred Masterpieces from Parisians' Collections" was one exhibition he held in 1883; according to Anne Distel, this "displayed a mixture" of Boucher, Rembrandt and Rubens with Corot, Delacroix and Meissonier. He handled the estate sales of several great early collectors of Impressionism: Théodore Duret in 1894, Victor Chocquet and Count Armand Doria in 1899, and Degas himself in 1918–19. In his later years he was, according to René Gimpel, "a rutting, obese, hydrocephalic tom." When he died in 1921 he was also very rich. On his death, part of the assets of the firm passed to two other dealers, the Bernheim-Jeune Gallery and Étienne Bignou.

Like Durand-Ruel, Alexandre Bernheim started out by selling artists' materials. His first shop, says Anne Distel, was in Besançon, but he moved to Paris at the suggestion of Gustave Courbet, himself from the east of France. In Paris Bernheim prospered, buying and selling Corots, Duprés and the Barbizon painters. His two sons, Joseph (Josse) and Gaston, were both born in 1870 (in January and December) and took over the management of the gallery in the 1890s, when it began to show more Impressionists. They too had premises in the rue Laffitte, but as the Impressionists began to do better they moved to the more fashionable faubourg St.-Honoré and the avenue Matignon. The Bernheim brothers were successful for three reasons. First, they managed to conclude agreements with the earlier generation of dealers (they had arrangements with both Durand-Ruel and Georges Petit). Second, they dealt directly with those Impressionists who were still alive and were not anti-Semitic: Monet, Pissarro, as well as Renoir, who made an exception in their case. Third, they were flexible (though not as flexible as Vollard, who once let a customer choose a picture by having him draw the name of the artist from among several hidden in a hat). Unlike Durand-Ruel, they were open to the work of the Post-Impressionists. Their sister had married Félix Vallotton, one of the Nabis, and the brothers, says Anne Distel, "foresaw fame for young, unknown artists such as Seurat and van Gogh," through the influence of their employee Félix Fénéon (see below, Chapter 11).

The role of Theo van Gogh, the artist's brother, in the Impressionist market has been described in detail by John Rewald, the historian-in-chief of "Manet's Gang." The van Gogh family was in fact well connected in picture-dealing circles. "Uncle Cent," as the first Vincent van Gogh (1820–88) was known, was a partner in the powerful house of Goupil, which spawned Knoedler in America. The firm had started modestly; the first shop was opened in 1827 in the boulevard Montmartre by Adolphe Goupil when he was only twenty-one. He had intended to become an artist but found he could

make more money from publishing meticulously accurate engravings after well-known paintings. The print business so prospered that soon Goupil had ten presses. Though he had begun by engraving the Old Masters—Titian, Murillo, Veronese and Correggio were particularly popular—he also reproduced contemporary paintings, and this led him to buy original pictures. After he had engraved them, he then sold them. The middle years of the nineteenth century were very successful for the firm, which opened branches in New York, Berlin, London, Brussels and The Hague, where Vincent senior was in charge.

Goupil's business in contemporary art was also bolstered by the fact that his daughter married Léon Gérôme, a successful salon painter whose passion for North Africa was reflected in his canvases. Through Gérôme, Goupil gained access to many of the popular contemporary painters, and the firm started to specialize in Adolphe-William Bouguereau, Édouard Detaille, Mariano Fortuny, Jean-Louis-Ernest Meissonier, Alexandre Cabanel, Ary Schaeffer and Paul Delaroche, in addition to many of the Barbizon School. From Holland came landscapes and animal pictures, and artists like Anton Mauve and Jacob Maris proved very successful commercially. By now "Uncle Cent" was highly regarded. Dutch pictures were especially sought after in the United States and London, so that when the second Vincent van Gogh wanted a profession, he was taken into his uncle's shop in The Hague, then sent on to London. The future painter worked as a dealer in The Hague, in London and in Paris for seven years, from 1869 to 1876, but by then he had grown disenchanted with the job and was dismissed. His uncle lost interest in him and transferred his attention to Theo.

Theo enjoyed the life of an art dealer in Paris, and stayed with Goupil even when, because of inheritances, the firm became known as Boussod & Valadon. The business continued with the same stable of painters, but in the early 1880s, influenced by Durand-Ruel, Theo began to buy and sell Impressionists. He started with Pissarro and Sisley, moved on to Monet and Renoir, then finally to Manet and Degas. He managed to turn the mezzanine floor of Boussod & Valadon into a place reserved for Impressionists, making it known as a rival to Durand-Ruel. Theo did well. Well enough in the late 1880s to buy ten Monets at a time directly from the artist for more than 10,000 francs ($44,700 now). He also kept Gauguin going, paying him 150 francs a month in exchange for paintings. By now Vincent was no less dependent on his brother for financial and emotional support. Toward the end of the 1880s, there was talk at Boussod & Valadon of sending Theo to America, where Durand-Ruel's success was envied by other dealers, but it didn't happen. Theo died only a few months after Vincent, in 1890, for reasons that are still not clear.

These were the main dealers in Paris but by no means the only ones. Clovis Sagot's shop was near the Church of Notre-Dame-de-Lorette, and it was here that Braque would first be shown, and that the Steins would stumble on Picasso. Other dealers, nearby, had their specialties: Gérard in Boudin and Diot in Jongkind. A third, Gustave Tempelaere, put his faith in the flower painter and cheese fanatic Henri Fantin-Latour and was amply repaid later on. Louis Latouche sold "fine colors and modern painting" in his shop on the rue La Fayette from about 1867 on. Pissarro was one of his customers and, says Anne Distel, paid in paintings.

The Chinese say that it is a curse to live in interesting times, but one man who would not agree, an early Impressionist dealer who probably had the most interesting time of all, was not French but Scottish. Alex Reid was born in Glasgow in March 1854 and was initally an apprentice in his father's prosperous firm of Kay and Reid, frame makers, gilders, ships' outfitters and dealers in works of art in a small way. The older of two sons, Alex was always interested in expanding the picture-dealing side of the business, but he might never have made the move if his father's factory had not burned down in 1882, leaving him uninsured and therefore ruined.

Though he was more or less penniless, Alex decided that picture dealing was still to be his future and that if he was to be any good he must gain some experience and form his own taste. In 1886 he went to Paris, where, according to Douglas Cooper, he was lucky, getting a job almost immediately at Boussod & Valadon. This was the time when Theo van Gogh had been given the chance to buy Impressionist works, and through him Reid came to know not only the paintings of Toulouse-Lautrec, Gauguin and Bonnard but the artists as well. He tried his hand at painting himself, and Theo directed him to the "free academies" where the Impressionists worked. Shortly thereafter Theo's brother, Vincent, arrived precipitately in Paris and for a while he and Alex shared an apartment at 6, place d'Anvers. On Sundays, Cooper tells us, Reid would accompany Vincent on his painting expeditions to the Paris suburbs, where they would look up Père Tanguy or Signac. On one occasion, on their way to the Gare St.-Lazare to take a train, they passed a greengrocer's shop with a basket of red apples outside, whereupon Vincent announced that he had an urgent need to paint the basket and its contents. "Then why not go in and buy it?" said Reid, who was surprised to hear his friend reply, "I don't have enough money." Reid bought the basket for him and suggested having it delivered to the studio, thinking that Vincent could start painting immediately on his return that evening. But van Gogh wasn't Scottish and sensible; he picked up the basket and took it straight back home, leaving Reid on his own. When Reid returned from the suburbs later in the day, Vincent presented him with the finished work. Van Gogh also painted two portraits of

Reid (see figure 31). Unfortunately for Reid, however, he took them back to Glasgow on one of his visits and left them there. His father, thinking they were no good, accepted the first offer of a passing dealer and sold the two for £10.

Like everything else in Vincent van Gogh's short, tumultuous life, his friendship with Reid did not last. Vincent was continually inventing money-making schemes, and in most of these he saw Reid, the stable, canny Scot, as the source of funds. Van Gogh had hopes that Reid might back both Theo and himself so that they could break away from Boussod & Valadon. Reid was not unsympathetic, intending to become a dealer himself, and he was certainly willing to take back some Impressionist and Post-Impressionist paintings to Scotland on commission. At the same time, however, he had been buying up paintings by Adolphe Monticelli, for whom he knew there was a demand in Scotland. But he overlooked or discounted the fact that the van Goghs had introduced him to Monticelli in the first place and, among their money-making schemes, had themselves at one stage considered corner-ing the market in Monticellis. When Vincent discovered one day that Reid had been doing just this without his knowledge he exploded.

In 1888 Reid returned to Glasgow, bringing with him a number of works by Corot, Courbet and Daumier, but also paintings by Boudin and Degas. The next year he opened a small gallery, the Société des Beaux-Arts, at 227 West George Street, and traded there successfully until he died in 1926. Although he soon became a presence at auctions in London, and although he dealt with the early collectors of Impressionism all over Europe, from Henry Hill of Brighton to Count Isaac de Camondo, he found that his taste—the Impressionism of Degas, Monet, Pissarro and Sisley—fared better in Scotland than in London. Reid also formed a fast friendship with Whistler and dealt in the contemporary school of Scottish Impressionist artists, now known as the Scottish colorists: S. J. Peploe, William McTaggart, John Lavery, J. D. Fergusson and Francis Cadell. He was truly international and went directly to Paris to buy. At home he was the man who introduced the Impressionists to the great Glaswegian shipbuilders and industrialists like William Burrell, W. A. Coats (Coats' Cotton) and J. J. Cowan. In 1926 his descendants joined up with those of that other great dealer, Ernst Gambart, and the firm they founded, Alex Reid Lefèvre, exists to this day in London.

Pierre-Firmin Martin, another of the earlier dealers, leads back to the Street of Pictures and, via Anne Distel's researches, to Zola's notebooks: "Martin, Rue Laffitte, [was] a little old-fashioned dealer, dressed simply, rather badly, rough and ready, democratic. He would go to an artist's studio, purse his lips while eyeing the studies, then stop in front of one. 'What do you want for that? 60 francs? 80 francs? Forget about it. I'm not rich—that

doesn't sell at all. I wanted to do you a favour. . . .' And he ended up by buying at 40 francs. Moreover, he had sold the canvas beforehand. He went around to artists who were starting to be known but not yet highly rated. . . . His whole system was based on the rapid turnover of his inventory. . . . He retired with a private income of about 10,000 francs. Combine *père* Auburg and Martin in my character."

Martin was the son of a farmer. As a young man he became a saddler and, says Distel, quoting his biographer, Henri Rouart, "played the villain in local theatres." (Rather well, one imagines.) He married in 1837 and his bride's uncle was a secondhand dealer, which appears to be how Martin changed careers. As with so many of the others, he started with the familiar list— Corot, Millet, and so on. In 1869 he moved from the rue de Mogador to the rue Laffitte, where he traded especially in the works of Pissarro.

Julien-François Tanguy, also known as Père Tanguy, came from Brittany, where "his father was a weaver and his mother a spinner," a classic Millet or Breton background. "As a young man," says Distel, "Tanguy was a plasterer and then a pork butcher," but in the early 1860s, when he was already near forty, he went to Paris and became a color grinder. He may have met the Impressionists when he was traveling through the countryside trying to sell his colors, but in 1873 he opened his own small shop at 14, rue Clauzel, later moving to number 9. "For twenty years, works by Cézanne, Pissarro, Armand Guillaumin, and the other Impressionists to whom Tanguy supplied paints were shown in Paris in those two shops successively." But he also exhibited the works of van Gogh, Émile Bernard and Paul Gauguin. All the Post-Impressionists visited Tanguy's shop to inspect what he had, and, says Anne Distel, the place became quite famous (see figure 30). Dr. Gachet, Victor Chocquet and Théodore Duret, all important early collectors of the Impressionists, bought from him. "Vincent van Gogh and Émile Bernard left us vivid depictions of Tanguy: a little broad-shouldered man, sitting on a chair, with a flattened face and nose, and close-cropped hair. Tanguy was a virtuous man, almost a saint. . . . For example, on March 4, 1878, Cézanne admitted to owing Tanguy 2,174.80 francs [$8,823 now] for supplies, [a debt] that had still not been paid by August 31, 1885." Given his nature, it was not surprising that when Tanguy died, in 1894, he was in dire straits. An auction was organized to benefit his widow—a "poisonous" shrew, according to van Gogh. Nearly a hundred works were sold, and among the buyers was someone who picked up most of the Cézannes, and would prove to be the most remarkable of the next generation of Paris dealers. He was Ambroise Vollard.

In September 1869 Renoir wrote to Bazille: "I exhibited [portraits of] Lise and Sisley at Carpentier's [another dealer]. I am going to try to stick him for about 100 francs, and I'm going to put my woman in white up for auction. I'll sell it for whatever price it goes for; it's all the same to me." By auction, Renoir meant the Hôtel Drouot (see figures 14 and 15). The Salle des Ventes was more popular than usual at this time, mainly because it had become a sort of permanent museum of contemporary art. Parisians were especially aware of the versatility of Drouot because the representation of modern art in national museums was so paltry. From the time it was created in 1818 until 1928, the Musée Luxembourg was France's national museum of contemporary art, but at the end of the nineteenth century, according to Anne Distel, it housed only about two hundred paintings. Many times that number could be seen in an average week at Drouot.

Another reason for the success of the Salle des Ventes was the practice that had developed in France for the estates of artists to be put up for auction there. These auctions provided an opportunity for collectors and the general public to see important works exhibited together for the last time. And because there were often a large number of works available following an artist's death, prices could be very reasonable. The estates of Delacroix (1864), Millet (1875), Courbet (1881) and Manet (1884) all contained many reasonably priced works. The Courbet sale was notable for the fact that the expert-appraiser was Durand-Ruel, and he followed a practice not uncommon then, but unthinkable now: the paintings were not necessarily sold in the order they were listed in the catalogue but according to an order known only to the expert. To make a sale go well, the expert would discuss the estimates with likely buyers before the sale, as happens today. Then, the most popular were sold first. Along the way, however, if something sold surprisingly well against expectation, the expert might jump immediately to a similar work, in the hope that it would do better on the back of the previous sale. In those days it was by no means unheard-of for living artists to sell their works at auction straight from the easel. Even so, the world continued to laugh at the Impressionists, as they did during the exhibitions. Anne Distel quotes one critic of the Impressionist art coming under the hammer at Drouot: "We call them paintings to be courteous."

The most highly regarded auctioneer at Drouot during those days was Charles Pillet; from 1855 to 1891 he wielded the gavel at all the great occasions. It was Pillet who handled the Delacroix and Millet sales, and the great Demidoff collection. According to a contemporary journalist, quoted by Anne Distel, he had an "agreeable though slightly haughty nature, reserved . . . but never refusing to do a favour and knowing how to be obliging with

tact." Moreover he was not one of those who laughed at the Impressionists—quite the contrary, in fact.

Pillet was followed in 1881 by Paul-Louis Chevallier (see figure 19), who was of the same mold and equally friendly with Durand-Ruel, whom "he often chose as expert-appraiser." Among the big estate sales that Chevallier handled at the end of the century were Secrétan, Meissonier (who died in 1891), Rosa Bonheur (1899) and Sedelmeyer. It was also Chevallier who conducted the Père Tanguy auction, the one where Vollard bought five Cézannes for about 950 francs. In his memoirs, Vollard recalls that after the sale, Chevallier told the dealer that he admired his pluck in holding out against other bidders. Vollard says he took a deep breath and then confessed that it might have looked brave but that in fact it had been foolhardy: he didn't *have* 950 francs; all he could muster was 300. Chevallier let him take the pictures all the same, saying that the dealer could pay him when he was able to. He needn't have worried, for Vollard knew how to sell. When his book on Cézanne was first printed, the subscription price was 65 francs. Certain subscribers backed out, whereupon Vollard put *up* the price to 100 francs. Thinking that the book was selling like hot cakes, the wayward subscribers came flooding back.

—

His Majesty Milan, the former king of Serbia, once said that it was a pleasanter job to be a Parisian than a king. The early collectors of Impressionism would have agreed. The huge sums fetched by Impressionist and Post-Impressionist paintings in our own day have provoked an uncommon interest in the prices of these same objects while the artists were alive, as an indication of how great this extraordinary financial somersault has been. In turn, this research on early prices has revealed a great deal of fresh information about the early collectors. From this it would appear that in the last quarter of the nineteenth century the "market" consisted of about fifty people in Paris who bought Impressionist pictures. In addition, there were some twenty-odd American collectors, a handful of British and about the same number of Russians and Germans. This is more than we have been led to believe, but it was still not enough to provide the painters with a buoyant market during their lifetimes.

Théodore Duret is the natural starting point for this survey of the early customers, for he was more than a mere collector. He was a journalist, a critic, an inveterate itinerant in exotic lands, a "market maker" in stock-exchange terms. He was also a dandy and a friend of the Impressionists, portrayed by Vuillard, by Whistler and, in 1868, when he was about thirty,

by Manet, who painted him with a foppish handkerchief showing in his breast pocket. (In return Duret gave Manet a crate of cognac.)

Duret was born at Saintes in western France, the son of a notary and cognac merchant who was a leading republican. The son worked on the local paper before moving to Paris, where, says Anne Distel, he became a reporter for *Le Globe* and *La Tribune*. "Little by little, he began to specialize as an art critic," and in 1870 Émile Zola, who also contributed to *La Tribune,* wrote him, "I have read your second article on the Salon, which is excellent. You are a bit mild. To speak well of those one likes is not enough; it is necessary to speak ill of those one detests."

The death of Manet in 1883 involved Duret directly, for in his will the artist had written: "An auction of the paintings, sketches, and drawings in my studio will be held after my death. I ask that my friend Théodore Duret be kind enough to undertake this task." The sale was only a qualified success, for a number of works did not reach their reserve price. Anne Distel tracked down the account of Paul Eudel, the recognized chronicler of Paris auctions: "It was a pleasure to see Messrs. Hecht, Faure, Caillebotte, De Bellio, Leenhoff . . . Chabrier, Henri Guérard, Antonin Proust, Théodore Duret fanning the auction's fires with their might. . . . But the Americans they expected did not appear. . . . And the Louvre, which establishes reputations and is a sort of Temple to Glory for artists, the same Louvre which made purchases at the Courbet sale, gave no sign of life."

However, by the early 1890s the Impressionists at last seemed to be winning their battle for acceptance. This was when Monet's shows started to sell out completely on the first day. But then came the crisis of 1894, which turned many of the painters against Duret, the man they had viewed as their long-standing champion. That year there were a number of signs that suggested that an era was coming to an end. Georges de Bellio, another important collector, had died, and his Impressionist canvases were coming onto the market. Gustave Caillebotte died a month after de Bellio and bequeathed his collection, nearly sixty pictures, all but two of them Impressionists, to the French national museums. Although at first the authorities accepted the bequest, they soon had second thoughts and some of the works had to be sold (discussed later in this chapter). These auctions posed a threat to the Impressionists. An auction in which a lot of works are on offer can be a danger in a fledgling market, for it shows publicly how weak prices are. Also, in a small market, the old pictures reappearing become rivals to the new ones the artists have just produced. Therefore when Duret also announced that he would be selling his pictures at the Hôtel Drouot in March 1894, the artists were livid.

"What a shark Duret is," Monet wrote, and Degas refused to shake Duret's hand.

"It is almost certain," writes Anne Distel, "that Duret had to sell his collection . . . to make good the deficit in his [cognac] business. Thus the sale was not purely speculative." He put up forty-two works at auction, including three Cézannes, eight Degas, six Manets, six Monets, four Pissarros, three Renoirs, three Sisleys and a Whistler. The Manets included *Le Repos,* the Degas included *Conversation at the Millinery Shop,* and the Monets included *Woman in the Grass.* As it turned out, the market did not collapse; pictures for which Duret had paid a few hundred francs "now brought prices ten-fold higher."

Interestingly, and unusually for a man of his generation, Duret now started to collect a new raft of painters. He started to drop in at Boussod & Valadon, and he visited Père Tanguy and Ambroise Vollard. "He bought and convinced others to buy Gauguin, Toulouse-Lautrec—and especially van Gogh. Duret acted as a go-between for dealers such as the Bernheim brothers, or for eminent individual collectors; the Havemeyers of New York, Sir Hugh Lane [who died in 1915, on the *Lusitania,* leaving his Impressionist paintings to museums in London and Dublin] . . ." Duret also helped to introduce van Gogh's work to Japan; the book he wrote about the artist was translated into Japanese in 1916. Duret lived until 1928 and continued his writing with a series of monographs: Cézanne (1914), van Gogh (1916), Courbet (1918), Toulouse-Lautrec (1920) and Renoir (1924). There was something pitiful about his end, however. Over the years his eyesight had grown very weak and unscrupulous individuals had taken advantage of this to substitute a number of fakes among his collection. After he died his pictures appeared again at the Hôtel Drouot, but were sold in two batches. The first part, in March 1928, was made up of the "unchallenged paintings. . . . The fakes were auctioned— after the signatures had been scraped away—on November 25, 1931." Anne Distel suggests that Duret may have been the prototype for Marcel Proust's character Verdurin, of whom the author wrote that he had received "lessons in taste from Whistler, lessons in truth from Monet."

In his lifetime, Jean-Baptiste Faure was much better known than any of the Impressionists (see figure 33). In some ways he was the first speculator in modern paintings. His was a spectacular rags-to-riches story. He was born in 1830 in the provincial town of Moulins. "His father became cantor at Notre-Dame in Paris, but died when Jean-Baptiste was only seven." From then on, the boy's voice was the family's sole source of income. His progression was thus necessarily swift; he sang in church, then in the chorus of the Italian Opera (Théâtre-Italien), and when his voice changed to a "golden baritone," he sang in cafés. In 1850 he entered the Music Conservatory, and made his

debut at the Opéra-Comique in 1852. This was followed by his debut at the Paris Opéra and the beginning of the grand period in Faure's life. He was a true international star, one of the first. Meyerbeer attended his wedding and created the role of Nelusko in *L'Africaine* for him; Verdi, says Anne Distel, regarded Faure as the only good singer at the Paris Opéra; he sang at Covent Garden even more than in Paris. "In 1870 Faure sang 'La Marseillaise' after each performance, kneeling on one knee and draped in the French flag"—his way of raising the nation's spirits during the Franco-Prussian war.

In 1876, at the age of forty-six, Faure retired, at least theoretically, though "he continued to give recitals all over Europe." By the end of his career he was earning more than 300,000 francs a year ($1.2 million now) and therefore was someone who could well afford to collect. However, there was an added factor in Faure's approach, something that makes him of special interest today. In March and April of 1860, says Anne Distel, the collection of another singer, the baritone Paul Baroilhet, was sold. A friend of the artist Jules Dupré, "Baroilhet had assembled a very beautiful collection of pictures by the [Barbizon] School of 1830 (notably by Rousseau). . . . The excellent results of that sale ensured financial success for that generation of artists and caused a great stir; it proved that money could be made with paintings." Faure was one who learned this lesson: his first collection consisted of works by Corot, Delacroix, Millet, Rousseau, Troyon and Dupré himself. This was why Faure sold his collection in June 1873, when it "earned him close to half a million francs [$1.8 million now]—certainly more than Faure spent to form the collection." It was a well-organized auction run by Pillet, and the catalogue may have been the first to contain photographs of the pictures rather than engravings.

Now Faure turned to Manet. He started with *The Port of Boulogne by Moonlight,* now in the Musée d'Orsay, and *The Spanish Singer,* now in the Metropolitan Museum of Art in New York. During his lifetime the singer would own, at some stage, no fewer than sixty-seven paintings by Manet. Among the other truly famous paintings he owned were *Le Déjeuner sur l'herbe,* now in the National Gallery in London, and *The Dead Toreador,* now in the National Gallery of Art, Washington. However, Faure was still a speculator at heart, and in April 1878 he held another auction, this time with works by Corot, Diaz, Dupré and Manet. The results were rather different. Despite "the most sumptuous advertising," the sale, says Anne Distel, was "crowned with a complete lack of success." Only six of the forty-two pictures were sold. Faure was undeterred. Indeed, he now turned to the other Impressionists, despite the fact that they were never entirely happy with him "for associating their work so closely with market value." In this next phase Faure eventually owned between fifty and sixty paintings by Monet, including

Boulevard des Capucines, now in the Pushkin Museum of Western Art, Moscow, and *Meadow at Bezons,* now in the National Gallery, Berlin. Then, in the 1890s, Faure began to sell a third time. It would seem that he found it difficult to resist the attraction of the profits he might make. He was seventy when the twentieth century arrived, but he went right on acquiring new works and selling them. Though Faure was undoubtedly a speculator, it should also be remembered that he could not go on making a living as an opera star indefinitely, and that he came from a very poor background. Nor should it be overlooked that he *did* make money out of his speculations.

There also appears to have been an element of speculation in the collecting of Ernest Hoschedé (see figure 32). Hoschedé, as Anne Distel points out, is mentioned in Monet's account book in 1874: "May, impression 800 Mr Hochedé [*sic*] via Durand." This cryptic note means that Hoschedé had bought the very picture that gave Impressionism its name, *Impression, Sunrise,* and that it cost him 800 francs ($3,100 now). When this work was stolen in 1987, it was valued at about $13 million. Hoschedé was well off in his own right but had also married a wealthy woman. Distel again: "From her parents she received 100,000 francs, the customary dowry for young Parisian women of the upper middle class." (That would be $394,000 now.) The couple lived comfortably on the boulevard Haussmann, and therefore were Faure's near neighbors for a time. They also had a castle in Rottembourg, near Montgeron, which Hoschedé's wife had inherited. Ernest used to hire a private train to take his guests, who included Monet, to the castle.

Unlike Faure, however, Hoschedé was not successful in his speculation in pictures. He held three auctions, each less successful than the one before. This may have had something to do with timing, for the fact was that Hoschedé's other business interests were also fading, and in August 1877 he was declared bankrupt, with no fewer than 150 creditors and debts of more than 2 million francs ($7.95 million now). Everything had to be sold, including his wife's castle and his remaining pictures. The auction of the pictures, in June 1878, was a disaster. The various group shows held by the Impressionists had so backfired commercially that they made works by members of the group appear unsalable. At the Hoschedé sale, Anne Distel tells us, "the highest prices were paid for paintings by Manet: 800 francs for *The Ragpicker* and 700 for *Woman with a Parrot."* A Sisley landscape went for a pitiful 21 francs, and three Sisleys, three Monets (including *The Thames and the Houses of Parliament*) and three Pissarros together fetched 700 francs. *Impression, Sunrise,* for which Hoschedé had paid 800 francs, went to Georges de Bellio for only 210 francs. Distel and Rewald both quote Pissarro, who wasn't exaggerating when he said, "The Hoschedé auction killed me."

The sale was bad enough, but now Hoschedé's life took an even more

extraordinary turn. "When Monet, his wife, Camille, and their two sons went to live at Vétheuil, the entire Hoschedé family—Ernest, his wife, Alice, and their six children—shared two houses in succession with the Monets," a *ménage à douze.* Hoschedé found work as a journalist to help support everyone, but the situation was not clarified until after Camille died and the *ménage* left Vétheuil. Alice Hoschedé remained with Monet, and after Ernest's death in 1891, the two were married.

Victor Chocquet was a collector of a very different and rather special kind. Zola, for one, felt as much: Chocquet is thinly disguised in *L'Oeuvre* as Monsieur Hue, described as a "former head clerk," who collected works by Delacroix, Claude Lantier (Manet) and the other Impressionists. Père Chocquet, as Renoir called him, was "the greatest French collector since the kings, perhaps in the world since the popes." He was tall, slender, with a long hooked nose, deep-set brown eyes and a high forehead, and in later years his gray goatee and mustache were very distinctive. He was born in Lille in December 1821, the tenth in a family of either thirteen or fourteen. His first job was in the customs house at Dunkerque, but he then went on to become chief supervisor at the general headquarters of the customs department in Paris. In such a job Chocquet never earned much; Anne Distel reports that he started at 800 francs a year, and when he retired at sixty-five in 1877, he was still earning "only 4,000 francs annually" ($15,900 at today's values). His financial affairs improved when, in 1882, his wife's mother died, leaving a large estate. By 1890 the Chocquets were rich enough to buy a building in Paris near the avenue de l'Opéra, for 150,000 francs ($660,300 now). It was a fitting location for Chocquet's collection but unfortunately the old customs clerk didn't have long to live. The couple had barely moved in when, in April 1891, Victor died. His wife promptly closed up the house and decamped to Yvetot (inland from Le Havre), where she remained until her death in 1899. This meant that Chocquet's collection was hardly seen until it was sold. And then it was a revelation.

"Great artistic event in view," wrote Pissarro to his son, and he was right. Duret wrote the introduction to the catalogue, and the sale took place in July 1899 not at Drouot but at the Galerie Georges Petit. Among the pictures were twenty-three Delacroix, five Manets, ten Monets, and ten Renoirs, but, as Anne Distel points out, the sale was exceptional in that it also included thirty Cézannes. By this time, the very end of the nineteenth century, pictures by Manet, Monet and Degas were all fetching several thousand francs, but Cézanne's, in some ways the greatest of them all, lagged behind. At the Tanguy sale in 1894 they had still been in the 200–300-franc league. At the Chocquet sale, however, "Durand-Ruel paid 4,400 francs for *Mardi Gras* and 2,200 for *The Bridge at Maincy.* The highest price, 6,200 francs [$27,500

now], was paid for *The House of the Hanged Man, Auvers,"* again bought by Durand-Ruel, for Count Isaac de Camondo. In contrast to the Hoschedé sale, the Chocquet auction was a great success; Anne Distel calculated that it netted in all 452,635 francs ($2.004 million now). It was Chocquet who owned the small version of the Renoir *Au Moulin de la Galette* that was sold at Sotheby's in New York in May 1990 for $78.1 million.

These were the collectors of Impressionist and Post-Impressionist paintings who had the most effect on the market and on prices in the early days. They had in common that they knew the artists personally and in many cases were able to do favors for them that put them on an equal footing. There were others who were friends of the artists and collected their works—Dr. Paul Gachet knew Cézanne, Pissarro and Guillaumin, as well as van Gogh; and Georges and Marguerite Charpentier invited Renoir, Manet, Monet, Degas and Sisley to their salons—but they did not affect the market the way Duret, Faure, Hoschedé and Chocquet did.

There was also a secondary circle, more removed but still helping to create a market. Albert and Henri Hecht were inseparable twins, traders in precious wood and ivory and early admirers of Manet and Degas; Georges de Bellio, already encountered, was a "rich Romanian gentleman," according to Duret, another doctor and, like Gachet, a homeopath, who treated Manet, Pissarro, Monet, Sisley and Renoir free of charge; Jean Dollfus was a textile million-aire, a collector of Corot and Géricault who paid 220 francs for Renoir's small *La Loge* in 1875 ($870 now; sold at Christie's in New York on May 10, 1989, for $12.1 million).

There was also Charles Ephrussi, who came from a rich banking family and lived, says Anne Distel, like a "Benedictine dandy." He took up art history and became interested in Dürer, then in Manet, Monet and Renoir; he also helped launch the Impressionists in Berlin in the 1880s. According to Edmond de Goncourt, Ephrussi "attended six or seven receptions every evening [in order] to become a director of the Fine Arts Administration one day." He never made it but instead became manager of the *Gazette des Beaux-Arts,* where he spotted a talented young writer called Marcel Proust. Anne Distel again: "Proust is said to have used Ephrussi as a prototype for Swann."

Count Armand Doria, more accurately Armand-François-Paul Des-friches, Count Doria, was a rich landowner with a scholarly bent, mayor of his small town, who started with Corot, Rousseau, Daubigny and Millet but then discovered the Impressionists, especially Cézanne. Stanislas-Henri Rouart stood out among these collectors, having been awarded the Légion

d'honneur in 1878 for his factory's contribution to the new technology of metal tubes; it was such tubes that enabled the Impressionists to carry their colors in the open air. He too had started with Corot and Delacroix but was then seduced by the Impressionists, particularly by Degas. After his death in 1912, the sale of his pictures created a sensation, fetching just under 6 million francs ($23.5 million now). It was at this sale that Durand-Ruel bid, on behalf of Mrs. Louisine Havemeyer, 435,000 francs ($1.57 million now) for Degas's *Dancers at the Barre,* the highest price ever paid for a work by a living artist. Emmanuel Chabrier was a pianist and composer, the author of *L'Étoile, Gwendoline* and *España.* A friend of Paul Verlaine, he was also close to Degas and Manet, to whose wife he dedicated one of his compositions.

Gustave Caillebotte was different from other early collectors of Impressionist pictures in two notable ways. Unlike Rouart or Gachet, who dabbled in painting, Caillebotte was himself a first-rate artist, accepted as such by the other Impressionists. He was also deliberately systematic in his collecting and though he never bought at auctions, from the first had a specific objective in mind. He set aside a sum to hold what he hoped would be an important exhibition of the artists he called "the intransigents." All the familiar names were specified, with Degas being placed first. At the same time, he bequeathed his collection, not yet fully formed, to the French nation and named Renoir as his executor. Caillebotte's will, drawn up when he was only twenty-eight, showed an extraordinary prescience. On his death eighteen years later, in 1894, his vision proved justified. Renoir took some sixty works of the Impressionists to the committee that was in charge of examining bequests to the French national museums. These included paintings that are now famous: Manet's *The Balcony,* Renoir's large version of *Au Moulin de la Galette,* Cézanne's *L'Estaque,* Degas's *L'Étoile* and Monet's *The Church at Vétheuil, Snow.* But the committee was circumspect, eventually agreeing to accept only forty pictures out of the sixty-five originally offered, and even these, as Anne Distel points out, "were not actually hung up in the Luxembourg Museum" until two years later. The authorities rejected some surprising masterpieces—Cézanne's *Bathers,* for instance, and Manet's *At the Races.* But at last, and in good measure thanks to Caillebotte's foresight many years earlier, the Impressionists were accepted where it mattered, and this clearly affected the market in their works.

Outside France, the collectors of Impressionism were not so numerous. The British had been given a fair chance to see some Impressionist works when Durand-Ruel had his gallery at 168 New Bond Street from 1870 to 1875. Few were impressed, and the earliest recorded sale of an Impressionist painting to

a British collector was in 1872, when Louis Huth bought Degas's *Maître de Ballet*. Anne Distel tells us that Henry Hill, a Brighton tailor, bought seven Degas, including *L'Absinthe,* and Constantine Ionides and the painter Walter Sickert also fell for the same artist. Douglas Cooper looked at the relatively few other names that appear in dealers' records, and discovered that the best known were those of the writer George Moore, who owned two Manets and a Monet; the industrialist William Burrell (Manet also); and the publisher Fisher Unwin (Degas and van Gogh). But it was not until 1905 that Hugh Lane began to put together the first serious collection in Great Britain.

Germany and Russia were more fortunate in each having one or two collectors who were more passionate about the new painting, and more courageous. In Germany the painter Max Liebermann was an early admirer, and he succeeded in firing the enthusiasm of Hugo von Tschudi, who was not only director of the National Gallery in Berlin but wealthy in his own right. Von Tschudi bought pictures by Manet, Monet, Renoir and Pissarro, using his own money, but hanging the pictures nonetheless in the National Gallery. When the Kaiser heard of this, far from being charmed by the director's selfless gesture, he was furious and demanded his resignation. Von Tschudi was immediately appointed director of the Neue Pinakothek in Munich, where he again installed his personal collection. There were also several other early German collectors, including Count Harry Kessler, Carl Sternheim and Paul von Mendelssohn-Bartholdy.

The Russian collectors made up in enthusiasm what they lacked in numbers. The Morozov brothers, Mikhail and Ivan, inherited a fortune made in cotton and spent a small part of it on works by Manet, Degas, Renoir, and Monet, as well as Gauguin and van Gogh. In time, Ivan emerged as the more avid collector of the two, following Impressionism, then Post-Impressionism, then the Fauves and the Cubists. In fact, his collection was surpassed in Russia only by that of Sergei Shchukin. Shchukin's family was also in the cloth business, which took him to Paris, where he discovered first Durand-Ruel, then Manet, then most of the Impressionists. Shchukin followed much the same route as Morozov: he met Matisse in 1905 and through him discovered Picasso in 1907. He also bought a Braque, the only one in Russia.

As Douglas Cooper has pointed out, almost all the early collectors of Impressionism came from the bourgeoisie and were a new breed: unlike the aristocracy, they did not inherit collections; instead, they formed them. Given the radical nature of modernism, this was perhaps inevitable, and it helps explain why, after France, the new painting found so many supporters outside Europe—in particular in the United States.

6 | THE BARBIZON BOOM: TASTE AND PRICES A HUNDRED YEARS AGO

The main problem in analyzing trends in prices in the art market is that salesrooms and dealers can sell only what comes onto the market. Further, all works of art are supposed to be unique, so the problems of making generalizations multiply. Nonetheless, some tentative conclusions are possible.

The first is that a "reasonable price" for a picture in the 1880s—that is, a picture by a well-known artist—was anything from £500 to £1,500 (in present-day values, $53,500–$160,500). Into this range fell works by Reynolds and Constable, Burne-Jones and Alma-Tadema, by Guardi, Perugino, Titian and Fra Angelico, by Holbein and Memling, by Poussin, Boucher and El Greco. Below this range, and therefore, in comparison with their standing today, relatively out of favor, were Stubbs, Guido Reni, Tiepolo, Correggio, Vermeer, Brueghel, van Eyck, David, Fragonard and Goya. Above that range the stars of the 1880s were Landseer, Turner, Gainsborough, Meissonier, Millet, Delacroix, Millais, Leonardo da Vinci, Botticelli, de Hooch, Rubens, Cuyp, Greuze, Watteau and, among the Spanish, Velázquez.

More specifically, three fashions dominated the art market in the early 1880s, as revealed by prices. One was the relatively high sums fetched by Dutch and Flemish paintings. In 1876, for example, Pieter de Hooch's *Mother with a Cradle* fetched £5,400 ($533,400 now), and Albert Cuyp's *Cavalier on a Gray Horse* sold for £5,040. Rembrandt's *Hermann Doomer, the*

Gilder went for £12,400 in 1882 ($1.3 million now), and this at a time when Jan Steen sold for £1,300, Paul Potter for £1,800, and the van de Velde for more than £3,000. The vogue was wide and strong.

The other two fashions at that time were for English paintings and for early-nineteenth-century and even contemporary works. Although Hogarth, Stubbs and Samuel Palmer were shunned in the 1880s, they were virtually the only ones who were underrated among the English school. In 1880 Landseer's *Man Proposes* fetched £6,610 ($682,400 now), and two other pictures by him in the same sale each went for more than £5,000. Turner broke the £7,000 barrier in 1875, when the London dealer Agnew paid £7,350 for his *Grand Canal and Rialto* at the Mendel sale (now $810,000). Gainsborough was above even this: his *Duchess of Devonshire* was bought in 1876, again by Agnew, for £10,605 (now $1.05 million). But Reynolds, Romney, Raeburn and Constable were all strong.

High prices for Rossetti and the rest of the Pre-Raphaelite Brotherhood had been pushed by Gambart, and in a sense this was an artificial market. A high price was often a form of publicity, attracting attention to a painting and making people eager to attend its exhibition and/or to subscribe to a print. But as photography began to make inroads into the print market, the British artists who had benefited most now began to lose value. Rossetti, whose pictures fetched four figures in pounds at auction from 1882 to 1909, slumped dramatically afterward and did not again attain that level until *The Blue Bower* sold for £1,900 in the Dyson Perrins sale in 1959 ($39,300 now). Holman Hunt's pictures had peaked even earlier, in 1874, when *The Shadow of Death* was sold to Agnew, with all rights, for £11,000. His prices remained firmer than Rossetti's, but they too slumped after World War I, not to recover until the late 1950s. Alma-Tadema, Burne-Jones and Millais showed similar patterns.

———

The most popular French painters were those of the Barbizon School—a group including Jean-Baptiste-Camille Corot, Charles-François Daubigny, Narcisse-Virgile Diaz, Théodore Rousseau, Constantin Troyon, Jules Breton, Henri Harpignies and Jean-François Millet—who lived and worked in the tiny village of Barbizon on the outskirts of Paris. In the wake of revolution and prior to the modernism of Baudelaire, attitudes in France exalted the honest peasant virtues of the countryside. But these artists drew attention to the grinding poverty of peasant life and its harshness, and for doing so they were at first branded as socialists and ostracized by the public. They were ostracized by the academy as well, since they eschewed history painting, worked out of doors and regarded modern life as a fit subject for

art. All of this made them controversial in the beginning, but as their vision softened with the years and often became sentimental, their veneration for the countryside at a time when the city was increasingly ugly won them a wide following. Millet, Corot, Diaz and Rousseau all died within a single decade—Rousseau in 1867, Corot and Millet in 1875, and Diaz in 1876—and this coincidence also helped raise the value of their work. Prices for Corot rose accordingly, from £131 6s. in 1873 ($12,270 now) to £16,000 in 1912 ($1.6 million now). They took a dive in the later 1920s after it was revealed that Corot's landscapes had been forged on a large scale (when it was said that he had painted 2,000 pictures, of which 4,000, 5,000 or 8,000, depending on the storyteller, were in the United States). Corot's prices have recovered since World War II.

The prices for Daubigny, Millet, Rousseau and Troyon followed the same pattern, reaching four figures in sterling in the 1870s and 1880s, staying strong for a quarter century or more, but then falling. Millet's prices, like Rossetti's, rose the fastest, with *La Bergère* fetching 1.2 million francs in 1890 ($5.2 million now), but dropping steadily thereafter. Jules Breton and Ernest Meissonier were not Barbizon School painters, though they were both influenced by Millet. However, their prices showed the same arc as those of the Barbizon School and the Pre-Raphaelites. Breton reached four figures in sterling for the first time in 1885 and for the last time in 1909. Meissonier's *Halt Before the Inn* fetched £1,440 ($155,500 now) in 1865, and Cornelius Vanderbilt bought *Friedland* for £13,500 in 1887 ($1.5 million now), making Meissonnier the most expensive living painter of his day. But in his case too, the vogue lasted only until World War I and then vanished. In 1930 his *Advance Guard of an Army* fetched all of £67 4s.

From this analysis of prices in the late nineteenth century, two other things emerge. In the first place, prices in the past, while below today's levels in real terms, were not as negligible as they are sometimes made to appear. Pictures regularly cost the equivalent of six figures in sterling or U.S. dollars at today's values but only rarely crept into the millions. But perhaps the most extraordinary aspect of the taste of those days can be seen in the vogue for the Barbizon School. Here was a group that rejected the academy, that painted outdoors, that flouted the insistence on historical subjects, that had proved controversial but had overcome that reputation—that, in short, seemed to be a direct precursor of the Impressionists. This school fetched high prices as early as 1865, so surely the Impressionists could hope that there would be a market for their art. Not at all; even the Barbizon painters who were still alive, like Rousseau, hated their work.

The early finances of the Impressionists have been picked over as thoroughly as every other aspect of their lives. Monet's account book, the archives of Boussod & Valadon, the *procès-verbaux* of the Hôtel Drouot in the 1880s—all these have been inspected for the light they throw on the early traffic in Impressionist painting. Together, these researches examine about 450 transactions in the quarter century from 1868 to 1894 and show that the taste for Impressionism did not really begin to catch on until roughly 1884, the year in which the sale of Manet's studio was held. From then on, the annual number of transactions gradually increased (from seven sales to ninety-nine), culminating in 1891, the so-called year of Monet. The early ascendancy of Monet is clear from the fact that he is mentioned almost twice as often as anyone else in dealers' accounts and auction records. By the same token, it is clear that Pissarro and Sisley had more money troubles than the others, though there was a time when Renoir was too poor to afford canvas, and when Gauguin moved to Paris looking for a job—any job. Like Monet, Manet and Degas were accepted critically before the nineteenth century was out, but 1888 was probably the first year when all of them sold a fair number of canvases.

Something else to appear from the analysis is that the path to acceptance was by no means a straight line—that is, a matter of a little bit more each year. On the contrary, Manet had a prosperous period in 1872–74, followed by several fallow years; Pissarro had a number of sales in 1874 but then fell back; Sisley showed a spurt in 1887 but then had a lean time until 1891–92. Cézanne and Renoir were mavericks. Cézanne had an occasional—very occasional—sale but did not catch on until late in the 1890s, although all the other Impressionists appreciated his genius. Renoir had some early sales in 1872 and continued with a few regular transactions, but during this period his support did not build in the way that Degas's, Manet's or Monet's did.

To give some idea of value, when Theo van Gogh worked at Boussod & Valadon, he was paid 7,000 francs a year, which would be roughly $31,000 today. Durand-Ruel's rent was 30,000 francs a year ($132,650 now), and the highest-paid civil servant in France earned 20,000 francs ($88,450 now). From those figures one might conclude that civil servants then had much the same value as they do now, whereas art dealers, and perhaps painting, did not.

The earliest transaction for which records exist occurred in 1865, when Durand-Ruel paid 50 francs "and a Cézanne" for a Monet. In 1868, both Pissarro and Sisley were receiving between 20 and 40 francs for their works ($78–156 today). Manet received 3,000 francs ($12,300 now) as early as 1870, and 7,000 francs by 1873 ($26,160 now), though he was still selling canvases for between 210 and 800 francs five years later. This was characteristic of all

the Impressionists throughout the 1870s; they would have a good year, either selling a lot of paintings or getting a good price for a single canvas, but then the support would dissolve. As their letters show, it was very demoralizing.

Some of the Impressionists, notably Cézanne, Degas and Manet, were blessed with private incomes and so were not dependent on sales to the extent that their poorer colleagues were. This does seem to have had an effect. Cézanne seems not to have been really interested in selling his pictures, and this helps to account for their infrequent appearance in the records. Degas and Manet, because of their private incomes, were unwilling to let their pictures go for the minuscule sums that Pissarro, Sisley and even Renoir were forced to accept (one painting by Renoir changed hands in 1874 for 31 francs and another for 42). This must partly explain why, as early as 1870, Manet received 3,000 francs for a work ($12,300 now), and why, two years later, he sold twenty-three works to Durand-Ruel for 35,000 francs ($135,000 now), an average of 1,522 francs each. He slipped back from time to time (100 francs for a pastel in 1879, 120 for an oil in 1884), but by 1890 Claude Monet and other subscribers gave Manet's widow 20,000 francs ($88,000 now) for *Olympia,* which then passed into the hands of the French government.

To put this price into perspective, 1890 was the year when the National Gallery in London paid £35,000 (875,000 francs) for Holbein's *The Ambassadors* ($3.85 million now), and when Millet's *La Bergère* fetched 1.2 million francs ($5.2 million now). Degas, too, held out for more money, and though this seems to have deterred buyers for some years (he had relatively few sales until the late 1880s), his prices were then relatively high—4,000 francs in 1887, several sales the next year of up to 5,200 francs, and much the same in the years immediately following. (Five thousand francs would now be about $22,360.) Degas was a difficult man but one who was well aware of his talent.

Apart from the prices of individual canvases, a crucial factor for the artists' livelihoods was how many pictures they actually sold each year, since that too determined their income. In some years the figure was pitifully low. The records are by no means complete, but it seems likely that at times in the 1870s and early 1880s some of the Impressionists were lucky to earn 1,000 francs a year ($4,000 now). At the other end of the scale, they had good, even sensational, years. As mentioned earlier, in 1872 Paul Durand-Ruel bought twenty-three of Manet's canvases for 35,000 francs ($135,000 now). Monet had much the same good fortune in 1887, when Theo van Gogh bought fourteen of his works for 20,000 francs ($90,050 now), and the next year Theo bought seventeen more canvases, in two batches, for 19,700 francs plus a *"partage"* of half the profits. Boussod & Valadon's ledgers show that Monet's *partage* came to 16,740 francs, giving him a total for the year of 46,440 francs ($200,100 now). In 1890 Pissarro and Degas each sold eight

pictures to Theo, for 5,700 francs ($25,100 now), and 10,050 francs ($46,220 now), respectively.

These are not enormous sums, and it was perhaps only Monet, who was a good businessman, as his *partage* agreement shows, and Degas who made any real money in the nineteenth century. Certainly Pissarro, Sisley and Renoir had to struggle for some years longer.

Nevertheless, according to the financial documents available, from about 1888 on, there were upward of fifty transactions involving Impressionist works every year. It was not a big market, and given what the Impressionists were trying to do and how sure they were of their vision, it should have been bigger. But it was a start.

7 | SIEGFRIED BING, MURRAY MARKS AND THEIR ORIENTAL FRIENDS

"It is a peculiarity of mine," wrote Edmond de Goncourt, "when I am combing my hair or brushing my teeth, to like to have on the wall while I perform these boring operations a gaily-colored bit of paper or some little piece of shimmering pottery which brightens things up and reflects a light like that in the colour of flowers. And that is why my dressing-room is literally covered with porcelains or sketches in gouache."

Edmond de Goncourt numbered among his friends Gustave Flaubert, Théophile Gautier, Émile Zola, Sainte-Beuve and Ivan Turgenev, but there was no shortage of people in late-nineteenth-century Paris who couldn't stand him. They thought him affected and pompous (he found Shakespeare, Molière and Racine "boring"), and felt he took himself far too seriously. He certainly had a pompous way of expressing himself, at least in print. But in their journal the Goncourt brothers were among the first to describe the rue Laffitte, and they were also among the first to fall for the charms of the Far East, in particular Far Eastern art. When the sale of their collection was held in 1897 after Edmond died (Jules had died in 1870), the porcelains and gaily colored pieces of paper in his dressing room were found to consist, like so many of their possessions, of objects from Japan and China. The two brothers were proud of, not to say boastful about, as they saw it, "discovering" Japan for the French.

The cult of the East was especially strong in the last half of the nineteenth

century. It was not the first time that Chinese and Japanese objects had been fashionable; in fact, Chinese ceramics were probably the earliest art objects to be traded internationally in significant numbers. Long before the Portuguese opened up the sea routes to the Far East, ceramics of the Tang dynasty (618–906) were being sent as far west as Persia and Egypt. But the Portuguese bolstered the trade significantly; after they rounded the Cape of Good Hope, the Portuguese king stipulated in 1520 that at least one third of the cargo of homeward-bound vessels should consist of porcelain. According to David Battie, Sotheby's expert in porcelain, some of the Portuguese carracks weighed as much as 1,500 tons, so it was small wonder that by the end of the sixteenth century there were ten shops in Lisbon dealing solely in porcelain.

Some of this must have been sent farther north, at least in small amounts, but the next significant development came at the beginning of the seventeenth century when two Portuguese carracks, the *San Yago* and the *Santa Caterina,* were seized by Dutch privateers and their cargoes sold by auction in Middleburg and Amsterdam. There were some 150,000 pieces in the holds of the two ships, and the excitement caused by the auctions led the Dutch to send vessels of their own East India company to China to purchase porcelain for themselves. For most of the seventeenth century the Dutch competed with the Portuguese and the English for this China trade, or the "Big Melon," as it was later known.

The trade that developed through the East India companies—all European nations had them—was of two kinds. The first, the official trade, authorized by the East India companies, was made up of bulk orders—say, thirty tons—usually for very mundane objects; these orders might be repeated year after year. The second kind was especially popular in Britain, and was the officially permitted private trade. This too was sizable. In the 1751–52 season, for instance, David Battie reports, there were at least sixteen European vessels at the Whampoa anchorage downriver from Canton, a fleet that would have had a capacity of at least 3,200 tons and therefore could have brought back about three million pieces of porcelain (see figure 22). As part of the charters giving them a monopoly on the trade, all East India companies had to sell their imports by auction.

The first wave of China mania now began. Records of the auctions show that even broken china would sell, as would cups without saucers or saucers without cups. The records of the East India companies are very complete and show that prices in Canton were extremely reasonable. One example given by Battie, for 1755, shows that 10,236 blue-and-white plates cost £112. At the auction in England, reserves were set on the plates of between eight pence and one shilling each. With twenty shillings to the pound, the sale could have

grossed £5,118, forty-five times the original cost, though of course the expense of the voyage and taxes would have eroded much of that.*

In the middle of the eighteenth century, the East India companies were allowed to set up their own factories, or "hongs," in China. Among these, the largest and best known was the complex of Jingdezhen in Jiangxi province. Père d'Entrecolles, a Jesuit missionary who went to China, refers to the factory in his letters home. There were, he says, "vast sheds where one sees, in row after row, a great number of jars of earth. In these enclosures there live and work a large number of workers who each have their appointed task. . . . one piece of fired porcelain passes through the hands of seventy workers." Private orders from England were often duplicated in the Canton hongs and the extra goods were carried back to Europe by the captains of the ships that had brought the orders out to China in the first place. These were speculative ventures; the cargoes were sold in London in the coffeehouses. Ironically, the coffeehouses of eighteenth-century London were centers of the tea trade, and notices of available porcelain tea ware were posted there.

The Americans moved into China in the wake of the Europeans, but after the War of Independence they lost little time in catching up. Moreover, as the popularity of porcelain spread throughout Europe, and the German, French and English "manufactories" began to develop their own methods and styles, America began to replace Europe as the main market for porcelain from China.

At the same time, the Dutch had discovered Japanese porcelain. The repeated waves of European missions to Japan—Dutch and Portuguese especially—had led to fears in the Far East that Europe might even invade Japan. Eventually this led to the closure of the country (*sakoku*) in 1639. From then on, only the Dutch and the Chinese were allowed to trade there. Each was allowed one factory, in Nagasaki harbor, on the mudflats. To begin with, the Dutch exported Japanese porcelain only to the rest of Asia, believing that China ware was much superior to anything the Japanese could produce. However, in 1657 a case of samples was sent home, and the enameling that the Japanese were so fond of proved popular. Between 1656 and 1660 the output of the Dutch East India factory jumped from 4,149 pieces to 64,866, and its popularity lasted until the middle of the eighteenth century. By then, Japanese pottery had priced itself out of the market. China ware was much cheaper (since China was not closed, it could produce more), but there was another reason. In France, Madame de Pompadour led the fashion parade, and she loved Oriental objects, especially chinoiserie. The eighteenth-century

*Using the Bank of England's table (which is much less accurate than Dr. Mitchell's but goes back further), £5,118 in 1755 would be $909,000 now.

account books of the Paris dealer Lazare Duveaux were inspected by Gerald Reitlinger. Madame de Pompadour loved not only porcelain but lacquer and bronze and would pay up to £200 in 1757 for an elaborate lacquered writing desk. Using the Bank of England's admittedly less reliable tables, this translates into a 1992 value of roughly $34,750. By comparison, a Canton kneehole lacquer dressing table sold for $2,300 at Sotheby's in 1962, which would be $18,487 now.

The fashion for *objets orientales* crashed, along with everything else, in the French Revolution. Its revival took time, and it was not until the middle of the nineteenth century that serious attention was again paid to the art of China and Japan. The chief problem was that scholarship still had a way to go. Chinese and Japanese history was not fully understood in the West, nor was the practice of stamping earlier reign marks on more recent objects, not entirely fraudulently, but as acts of homage.

The first Protestant missionaries arrived in Canton in the 1830s. Then, in October 1860, a combined British and French task force sacked and looted the Yuan Ming Yuan, the summer palace of the Chinese emperor, in the western hills of Beijing. As a result, certain imperial objects that had never left China before now did so. Auctions followed in London and Paris. There was nothing sensational about the prices, but particularly in Paris, and together with changes in Japan, they fanned the public's interest in Oriental art. It became known as Japonisme and Chinamania (see figure 44).

Japan was finally reopened in the nineteenth century, virtually two hundred years after the great closure. This was partly forced by the Americans; the country was a convenient fueling station between Shanghai and the newly acquired coast of California. As part of the opening up, Eizaiemon Fukagawa reestablished a porcelain factory in the province of Arita, which had been famous as a ceramics center two hundred years before. (His enterprise became celebrated as The Fragrant Orchid Company.) Such factors had an impact on European taste, but Japonisme and Chinamania probably would not have been so strong had it not been for two Western artists who helped to reestablish a taste for Orientalia for the first time since Madame de Pompadour's day. They were Félix Bracquemond and James Whistler.

Bracquemond was an etcher who often dropped in to the shop-cum-factory in Paris that belonged to a Monsieur Delâtre, a printer whose shop became a recognized meeting place for etchers. In 1856 Bracquemond took some plates to Delâtre's to be printed, and while he was there he chanced upon a small red book with a limp paper cover. It had arrived as part of the packing in a parcel of porcelain sent by some of Delâtre's colleagues in Japan. The red book was full of woodcuts, each one beautifully printed, with vivid colors and small but lively figures. Bracquemond was enchanted, but Delâtre

would not part with the book. A year later, however, Bracquemond came across the same book in another printshop and swapped one of his own treasures for it.

The red book with which Bracquemond was so taken contained prints by Hokusai, an artist of the Ukiyo-e school, which had begun in the seventeenth century but was in decline by 1860 because it was a form of art that the Japanese themselves did not value highly. Bracquemond, however, did; he had a good eye and he started spreading the word about the charms of Ukiyo-e.

There were a number of famous dealers in Oriental art in Paris at the end of the nineteenth century, including Tadamasa Hayashi, Philippe and Auguste Sichel and Siegfried Bing. But it was Madame de Soye and Pierre Bouillette's shop, La Porte Chinoise, on the rue de Rivoli with which the artists of the day were most familiar. Besides Bracquemond, frequent visitors included the Goncourt brothers, Baudelaire, James Tissot, Villot (a curator at the Louvre), Degas, Whistler and Zola. The writer was so bitten by the craze for Japanese prints that he had his staircase hung with some of the more unusual varieties. When George Moore first visited him he was struck by the "furious fornications" on the stairs.

The dealer Siegfried Bing was born in Hamburg in 1838; his father, Jacob Bing, had bought a small porcelain factory in France in 1854, and Siegfried took over in the 1860s, making porcelain with the Leullier company. After the terrible year of 1871, when Paris was deserted and no one was buying luxury items, he began to change his tastes, turning toward less expensive items of the Orient, and by 1876 he had collected enough china to mount a sale at Drouot that grossed 11,000 francs. This speculative venture having succeeded, he then opened a shop selling Oriental objects at 19, rue Chauchat, to coincide with the Paris Exposition of 1878, where there was a large Japanese pavilion. His brother-in-law, Michael Martin Baer, had gone to Tokyo in 1870 as part of the German legation and had begun to send objects back. Bing himself first went to Japan in 1880, and after his return he opened a second shop on the same corner, at 23, rue de Provence. Here he organized the first salon of Japanese painting, sponsored by the Ryuchikai, a Japanese association dedicated to the preservation of the country's heritage.

As was true of Durand-Ruel's Impressionist business, the middle 1880s were not good for Bing, but he responded imaginatively, opening premises in Japan, first in Yokohama, then in Kobe in 1887, trying among other things to stimulate an interest in French goods. In 1888 he started a journal dedicated to Japanese art, *Le Japon artistique,* and though it was criticized in Japan for its weak scholarship, the young Vincent van Gogh enjoyed it and was influenced by its illustrations. Vincent worked for Bing for a short while,

selling Japanese prints to fellow artists, and this gave him access to all the objects and pictures the dealer had.

Toward the end of the 1880s, Bing explored the commercial possibilities of Oriental art in Copenhagen, The Hague and, in 1894, the United States, where he held an auction at the AAA. While in America he was received at the Metropolitan Museum in New York by Samuel Avery, and at the Museum of Fine Arts in Boston by Ernest Fenellosa. Bing was also very impressed by Tiffany's products, and after his return to Paris he embarked on a redecoration of his two shops, converting them into one, under the name L'Art Nouveau. His idea was that the art of Japan—its themes, techniques and motifs—could be combined with Western stylistic ideas such as those of Tiffany or of the Nabis, whose flat surfaces lent themselves to the decorative as well as the fine arts. L'Art Nouveau was thus launched, with its shapely wrought-iron gates, glass walls and Bonnier balustrades.

Bing was, in effect, the godfather of Art Nouveau, having as much interest in ceramics, jewelry and wallpaper as in painting proper. He promoted Félix Vallotton, Edvard Munch and Xavier Roussell, among others, and organized an exhibition of Art Nouveau book designs with Samuel Avery. In commercial terms, however, Art Nouveau, though no less controversial than Impressionism or Fauvism, did not prosper as much as Bing had hoped, and he sold the shop in 1904. A liquidation sale was held at Drouot in December of that year, barely nine years after L'Art Nouveau had opened. Bing died in September 1905, after which there were two sales of his private collection, one of them held at the Durand-Ruel galleries.

If Bracquemond was the zealot who sought to convert all of France to the art of the Orient, James McNeill Whistler played the same role in Britain. The painter was aided in his early collecting of Oriental objects by another dealer of taste, Murray Marks. In those days Marks was the chief rival of the Duveen brothers, and between them they were responsible for many of the high prices of the period. In 1860 Marks paid £119 10s for a pair of Japanese jars and covers; by 1882, at the Hamilton Palace sale, prices for identical objects varied from £315 to £420 ($32,550 to $43,400 now).

Like the Duveens, Marks was of Dutch extraction. His father, Emanuel Marks van Galen, had been brought to England at the instigation of Baldock, an eminent dealer in the early nineteenth century and an art adviser to the Prince Regent. Murray Marks conceived an early passion for Chinese goods when his father, not doing well, rented part of his shop to Frederick Hogg and Co., who imported modern Chinese products. Marks asked his father to send him to China, but Emanuel refused, so while his father was abroad Murray started up on his own in Sloane Street with borrowed stock. His father returned to a fait accompli; the son was already prospering.

Eventually, when Emanuel retired, Marks moved back into his father's shop at 395 Oxford Street, and had the architect Norman Shaw revamp the building in Queen Anne style, painted cream all over. According to G. C. Williamson, Marks's biographer, this created a sensation, and henceforth Marks's premises were famous throughout the art world. Rossetti, Burne-Jones and Whistler all became frequent visitors to 395 Oxford Street, as well as good friends. Indeed, Marks's business card, showing a blue-and-white Chinese ginger jar, was designed by no less a trio than Rossetti, Whistler and William Morris. Rossetti also made a drawing of Marks's striking wife.

Later Marks moved to an even more fashionable location, 142 New Bond Street, but by then he had made his name and was prestigious enough to act on behalf of the Victoria and Albert Museum in the salesrooms and to help form many of the great collections of the day, not just in Britain but as far afield as Russia. His expertise ranged from medieval objects to Renaissance bronzes, on which he was regarded as more knowledgeable than Hercules Read at the British Museum and the near-equal of Wilhelm von Bode, whom he assisted on the latter's great treatise on Italian bronzes of the Renaissance. On the strength of this, Marks was selected by Pierpont Morgan to assist in the compilation of his catalogue of bronzes. But Marks was chiefly associated with the cult of blue-and-white Nankin porcelain.

Scholars have wrangled for years about whether Whistler actually started this craze in Britain or merely made more fashionable what was becoming popular anyway. Whatever the truth, the blue-and-white craze was remarkable. In 1876 Lady Charlotte Schreiber noted that the railway station at The Hague was "crowded with people owing to the craze for blue-and-white, now so prevalent in England." (These were Britons looking for bargains in Holland.) This passion, she said, was "truly ridiculous." Perhaps, but several of the big Oriental dealers in existence today, like Bluett, started at this time.

Marks had a hand in the craze, but because of Rossetti, not Whistler. Rossetti bought some blue-and-white porcelain that Marks had, and he asked for more. However, after the dealer had made a special trip to Holland to obtain it, the painter found he could not afford the new batch; instead he persuaded his friends Henry Huth and Sir Henry Thompson to take it. Both were to become distinguished collectors. Marks also helped form the Walters and Grandidier collections, and, according to his archives, obtained two hundred pieces for George Salting.

Marks was stylish in all things. When he was working on the catalogue for Sir Henry Thompson's collection of blue-and-white (the first catalogue of such a collection anywhere) he had Whistler prepare some watercolors as illustrations. He held an exhibition of the collection, sending out a famous invitation to the artists and critics of the day, a drawing that showed himself,

Rossetti and Whistler in his drawing room. In an equally famous response, Sir Herbert Beerbohm Tree sketched the arrival at the showing of George Grossmith, Forbes-Robertson and Charles Wyndham. Marks even arranged a dinner at which people could eat off the blue-and-white plates on display. (Here he took a leaf out of Sir Henry Thompson's book, for Thompson's own "Octave" dinners were famous across London: eight people at eight o'clock eating eight courses.)

Apart from Rossetti and Whistler, Marks's friends included Sir Edward Burne-Jones and Frederick Leyland. At one stage he wanted to form an art union with Rossetti, Burne-Jones, Whistler, and William Morris in order to sell their works. It was to have been backed by Constantine Ionides, but nothing ever came of it. Marks's other friends included Frederick Leighton, whom he met at Drouot when they were competing for the same bronze, Algernon Swinburne, and John Ruskin. The last, says Williamson, often consulted Marks, who designed a cabinet for him in which to display the rocks and jewels which the critic collected. Marks also helped Millais to sell his paintings.

Marks deserves to be better known. His range of friends was much more impressive, creative and intellectual than the Duveens', and his impact on contemporary taste was much livelier. Perhaps his one mistake was that, having been educated in Frankfurt, he looked to Europe too much, and not enough to the United States.

In America the passion for Oriental art preceded the European craze, owing to four men, all of whom shared an enthusiasm for the East. They were Ernest Fenellosa, Edward Morse, William Sturgis Bigelow and Charles Lang Freer. Both Morse and Fenellosa were scholars who settled in Japan and were attached to the Imperial University in Tokyo. Fenellosa taught politics, economics and philosophy and became a Buddhist. He collected a wide range of Japanese and Chinese art, including much that was not highly regarded there. He was so successful in persuading the Japanese that they had neglected their own painting and sculpture that in 1880 he was appointed head of the Imperial Museum in Tokyo and of the Tokyo Fine Art Academy. When he died in London in 1908 his ashes were sent to Japan for burial. His influential *Epochs of Chinese and Japanese Art* was published by his wife after his death.

Morse went to Japan to study brachiopods, and he too taught at the Imperial University. While there, he formed a collection of ceramics at a time when even the Japanese were indifferent to these objects. His collection is now in the Boston Museum.

Like the others, Bigelow also went to Japan and, like Fenellosa, was also interested in Buddhism (Bigelow was a doctor by training and had studied

under Pasteur). Luckily for him, he arrived in Japan in 1881, slightly later than the other two; by then the samurai class were becoming Westernized, saw the value of their art, but were more ready to part with it. Bigelow was in close touch with Fenellosa, who helped him collect paintings, textiles, lacquer and many Japanese swords. His collection of 59,000 objects was given to the Boston Museum in 1911. Like Fenellosa's, Bigelow's ashes were buried in Japan.

The other important American collector of those years was Charles Lang Freer. He was friendly with Stanford White and Whistler, and under the latter's influence he began to take an interest in Oriental art in the 1890s. He met Fenellosa and visited Japan and the interior of China, where he bought on a massive scale. He installed his collection in a gallery he built himself, the Freer Gallery in Washington. Thanks to these four men, Washington and Boston now boast some of the finest examples of Oriental art in the West.

Trade naturally followed these fashions. There were a number of Japanese dealers in New York and Boston at this time, though none of them seem to have been as distinguished or as well known as their Parisian counterparts. The one American dealer of undoubted stature in those days was Dirkan Kelekian. An Armenian born in Turkey, and known to all as Khan or Papa, Kelekian started out as an importer of Near Eastern antiquities and Oriental carpets, on which he was a recognized authority. He was a dealer who rode trends well. In addition to being the chief source of Near and Far Eastern objects for a generation of Americans, he put together a formidable collection of modern European paintings, which would be sold at the AAA in the 1920s.

—

There was one other aspect of the Oriental art world that was to have important ramifications through the years, and it began, curiously, in Japan's Bureau of Astronomy. Nothing could demonstrate more clearly the difference between East and West. At the beginning of the nineteenth century, the Japanese were worried that their country might be invaded by European or American forces. Conscious of the need for a modern naval defense, the shogunate instructed its Bureau of Astronomy to start translating Western books on astronomy so that they wouldn't miss any opportunity to profit from knowledge abroad. After nearly two hundred years of closure, Japan made the study of the West and Western methods a political priority and gave it official status. This attitude spread, and in 1811 a special office was set up for translating foreign books of all kinds. This too proved so useful and popular that in 1855 the Office of Western Studies was opened, to be redesignated a year later as the Institute for the Study of Western Documents.

Among the many Japanese scholars to benefit from the institute was Kawakami Togai, who in 1861 became the first director of a new department in the institute, the department of painting. Kawakami's duties were to study Western painting from books and to teach Western techniques to students. He and his colleagues never regarded Western painting as an art. They always thought of themselves as part of Japan's military machine; indeed, Kawakami later became professor of painting at the Military Academy, working in the map department. But if Kawakami didn't think of Western painting as an art, it wasn't long before others did. The most important figure was Takahashi Yuichi, who was, according to Michiaki Kawakita, "interested in the way they [Europeans] portrayed everything so accurately."

More and more people shared this approach, and in 1876 an official school of art was established. This school was part of a government college, itself part of the Ministry of Industry, whose aim was to stimulate the introduction of Western techniques into Japanese factories. The school invited three Italian artists to come to Japan to teach Western methods, one of whom was Antonio Fontanesi, who painted in a kind of Barbizon School style. The Westernization of Japanese art was thus well on its way by 1882, but it took a decisive step forward in 1884, when Kuroda Seiki traveled to France and became a pupil of Raphael Collin. He stayed in Europe until 1893 and therefore saw at first hand the gradual acceptance of the Impressionists. When he returned to Japan, he took with him their bright colors and their fresh, informal approach to their subjects.

Kuroda's European style proved popular in Japan. Like some of the Impressionists, he painted shadows in purple, and so for a while his type of art became known as "the purple school"; this was meant as a joke, but not a malicious one. Kuroda's painting was especially popular among other artists, with the result that the first truly Western style that the Japanese practiced was in fact a form of Impressionism. It occupied a different place in the canon, of course. Japanese Impressionism—artists like Yamashita Shintaro, Saito Toyosaku and Kojima Torajiro—was not a revolt against academicism, as Impressionism was in France; at first, many Japanese simply assumed that Impressionism *was* European painting.

The extraordinary trail of events that led from the Japanese Bureau of Astronomy to the Impressionists was for the most part accidental. In a later chapter it will be seen that Cézanne, van Gogh, Renoir and Monet had a particular impact in Japan, but this second wave of Impressionist influence on the country would not take place for some time. The important thing to grasp is that Impressionism was the first form of Occidental painting that the Japanese encountered, and this chance occurrence powerfully influenced the country's own art and the taste of its people. It would take a while to have

an effect on the market—much longer than in the West—but that was a result of the late development of Japan's economy. The first Western-style banks were not established in Japan until 1876; the central Bank of Japan was not formed until 1882, when the "capitalist period" is generally understood to have begun; and the country did not go on the gold standard until 1897. With various wars and other disasters afflicting the country in the early part of the twentieth century (the Russo-Japanese war in 1904; the annexation of Korea in 1910; World War I in 1914; the Siberian rice riots in 1918; the Great Kanto Earthquake in 1923; the Manchurian incident in 1931; the war with China in 1937; and World War II in 1941), the Japanese economy did not really have a chance to expand until the settled years following World War II. But when it did, Japanese taste focused on the Western art it knew best, the first Western art it had ever known, and the Western art that had exerted so much influence on its own painting. Impressionism.

8 | THE WIDOWS

When the old century closed in New York, for Thomas Kirby at the American Art Association something else closed with it. From the founding of the AAA in 1882 until 1900, Kirby and his colleagues had a free run because there was little or no competition in art auctioneering in the United States. But in February 1900 John Anderson, Jr., opened a small book-auction house on West Thirtieth Street. Kirby may not even have noticed this development, but he would not remain in ignorance for long. The Anderson, as it became known, moved quickly.

If Kirby was cocky, it was understandable. The years since the spectacular success of the Seney sale in 1885 had seen triumph piled on triumph. Bit by bit, a tradition had been established at Madison Square that collectors, or the executors of the estates of collectors, would send their treasures to Kirby to be sold. Far from retiring, as he had advertised, he now climbed onto the auction rostrum more often and with more enthusiasm than ever before (see figure 20). Among all the sales that came Kirby's way during his years of monopoly, two stood out for the excitement they generated, the personalities and art involved, and the prices that were achieved. These were the Stewart and Clarke collections. Between them they convey accurately the glitter and the paradoxes of America's fin de siècle.

In his lifetime, Alexander Turney Stewart had been one of the three richest men in America and, after William Astor, the biggest landowner in New

York. His fortune also stemmed from the city's first department store, which Stewart insisted be kept open from 7:00 A.M. to 7:00 P.M. Notoriously mean to his employees, he spent lavishly on himself; Wesley Towner reports that it took seven years to build just the stairways of his Fifth Avenue palazzo. His treasures included Rosa Bonheur's *The Horse Fair* and Meissonier's *Friedland, 1807*, for which he paid $60,000 ($1.026 million now). Even in death, Stewart was grandiose and newsworthy. His widow had promised him nothing less than an entire Gothic church as his resting place. The basilica was to have a two-hundred-foot spire and a crypt of snowy Carrara marble. It was a splendid idea. Unfortunately, while Stewart's body lay in a vault, awaiting completion of the crypt, a gang of robbers snatched the cadaver and held it for ransom. Two hundred thousand dollars ($4.4 million now) was demanded.

Here Judge Henry Hilton intervened. A longtime friend of Stewart's, Hilton had been appointed executor and manager of the estate for a handsome fee of $1 million (no less than $22 million now). In order to protect the feelings of Stewart's widow, Hilton pretended that the body had been recovered. It was a bad move, for the grave robbers resisted, and could easily prove their case. They mailed the screwheads from the coffin to the widow, then a piece of velvet torn from the coffin lining, and eventually, the coffin plate itself. Not surprisingly, Mrs. Stewart now treated with the grave robbers herself, and in due course a body was delivered to the newly completed church one night. Whether it was the *real* Stewart who was returned was never made public. P. T. Barnum, the circus master, was later offered a corpse said to be that of Stewart, but he turned the offer down.

Of course this was singular publicity for the sale of Stewart's treasures in 1887. For a month beforehand the best carriages of New York could be seen arriving at Madison Square day and night. The art lovers viewed what was on offer with the aid of another Kirby innovation: sales catalogues literally made to measure. There were atlas-size catalogues for the very rich, folio-size for the merely wealthy, and quarto-size for the well-to-do. "The greatest knocking out contest between Thomas E. Kirby and the Stewart Collection of Pictures began promptly," wrote "The Sport," a column in one of the New York rags: "The voice of the speaker . . . echoed from wall to wall in rebounding roars, suggestive of a dynamite blast on the Harlem rockeries. . . . This symphonic effect so wrought upon the nerves of an elderly lady in the audience that she fainted and had to be sent home at once, a misadventure which cast quite a cloud on the performance, as she was reported to be as rich as the late Mary Jane Morgan and nearly as foolish." Clearly the salesroom coverage then was more than a match for that of our own day.

The Stewart sale was a success, though perhaps no auction could have

lived up to its expectations. The highlights were *The Horse Fair,* bought by Cornelius Vanderbilt for $53,000 ($1.2 million now), and *Friedland, 1807,* bought by Judge Hilton himself for $66,000 ($1.48 million now). Both pictures eventually found their way to the Metropolitan Museum of Art, New York, though before long, when tastes changed, *The Horse Fair* was hidden away in a warehouse and was not displayed again, Towner says, until 1954.

Meanwhile, American art was doing as well as European painting and this was partly owing to the activities of Thomas B. Clarke. He had made his fortune in "collars and cuffs," but by 1891, when he was only forty-two, he felt he had fitted enough necks and wrists. He had always been a fan of George Inness, who had once painted a figure with six fingers on one hand. This didn't matter to Clarke, who thought that Inness was one of a new breed of superlative American painters, and he now turned himself into a full-time connoisseur and proselytizer on their behalf. His own premises became a shop called Art House, and there he set about persuading his fellow Americans that it was not only the Italians of the sixteenth century or the Frenchmen of Barbizon who could produce great art. The crux came in 1899, when Clarke announced that for the first time a "panoramic selection" of contemporary American art was to be sold at a public auction. An old partner of Clarke's had been George Seney, so the AAA was the salesroom chosen. This speculative venture succeeded gloriously, and, at least for a time, "the red barn, the wide plains and the hills of home" as Wesley Towner put it, were established as fit subjects for artists, and George Inness, Winslow Homer, George Fuller, George de Forest Brush and Homer Martin all made prices in excess of $2,000 ($44,260 now). This was some distance from the £100,000 that Pierpont Morgan would pay for Raphael's Colonna Altarpiece a year or so later, but it was on a par with the £420 ($46,480 now) fetched by Renoir's *Au Moulin de la Galette* in that same year at the Chocquet sale. American painting had arrived.

By 1900, the AAA had not simply cornered the American market in art at auction but had undergone a number of significant changes itself, the most important of which was the withdrawal of James Sutton. Until 1895, when Sutton decided to call it a day, the AAA had been a gallery as well as a salesroom, and a distinguished one at that. In 1885, with the Seney sale and its disagreeable publicity still ringing in his ears, Sutton had traveled to Europe because of the rumors he had heard about the so-called Impressionists and Paul Durand-Ruel, the dealer who had backed them. But 1885 was not a good year for Durand-Ruel, or for the Impressionists. Manet's sale had gone well the year before, but in the mid-to-late 1880s prices and sales retreated. Therefore Durand-Ruel responded with enthusiasm to Sutton's

invitation to try New York. In Towner's words, "He seized the opportunity with a determination steeled by despair."

The Impressionists were not confident; why would the Americans be any more sympathetic to their work than the French? Nevertheless, Durand-Ruel assembled 289 paintings and Sutton persuaded the U.S. Customs to let them into the country under bond and without exacting the 30 percent duty on whatever hypothetical value they might have. The pictures went on show at the AAA on April 10, 1886. There were forty Monets (views of Argenteuil, Giverny and Vétheuil), thirteen Manets (including *The Balcony*), twenty-three Boudins, thirty-nine Pissarros, fifteen Sisleys, thirty Degas, thirty-five Renoirs, including his portrait of Wagner, and six Signacs. But as the painters had feared, the press was hostile. A "gallery of colored nightmares," said *The Commercial Advertiser,* adding that the "collection of monstrosities . . . would not be tolerated in a barber-shop." *The New York Times* was more restrained but also more pompous: "The three hundred oil and pastel pictures by the Impressionists of Paris belong to the category of Art for Art's sake, which rouse more mirth than desire to possess it. . . . one is likely to catch the breath with surprise. Is this Art?" Among the masterpieces its critic didn't like was Georges Seurat's *Sunday Afternoon on the Island of La Grand Jatte.* Though this painting failed to sell at that first exhibition, it was sold in Paris in 1891 for $200 ($4,400 now). In 1924 it went for $24,000 ($250,500 now), not a bad increase but nothing like the jump that occurred in 1931, when a French syndicate raised $460,000 ($5.36 million now) in an unsuccessful attempt to redeem it for the Louvre.

So negative was the reception of the Impressionist paintings in New York that the duty-free bond under which they had been admitted to the country was revoked by the customs collector. Rather than pay the 30 percent duty levied on "commercial exhibitions," Durand-Ruel moved the entire show from the AAA to the National Academy just down the block. The only good word came from the New York *Daily Tribune,* whose correspondent singled out Monet and Degas, saying that they might well represent an interesting movement in "foreign art" and advising Americans not to wait to acquire it. Hardly anyone took this advice. Towner reports that only fifteen pictures were sold, for a total of $17,150, to five buyers. On paper, it looked like a disaster, and certainly the venture was a commercial failure. Yet Durand-Ruel sensed even then that Americans were more open to new art forms than were many people in Europe. Only this can explain why, the very next year, he was back in New York and opened his own gallery at 297 Fifth Avenue.

For his own part, James Sutton became an ardent supporter and keen collector of Impressionism. He was devoted to Monet and Guillaumin but

also bought pictures by Morisot, Sisley, Signac and Odilon Redon, all of which were sold when he withdrew from the AAA in 1895 (he lived until 1917). Sutton's importance, therefore, lies not only in his role in the creation of the AAA but also in the part he played in the importation of Impressionist art into America.

Sutton was in some ways a more distinguished and cultured man than Kirby. Certainly he was more interested in art for art's sake. In the early 1890s he tried to lure other contemporary European painters to the AAA, as he had the Impressionists, but none of them fared well. In 1895, while retaining a financial interest in the association, he retired and left Kirby in charge. With Sutton gone, and the old century going, Kirby was free to take the auction road and leave the risks of dealing to dealers. The art market in the United States was expanding, and more and more treasures were arriving from Europe. To cope with this traffic Kirby needed more staff. One of those he employed, in 1896, at the traditional age of fourteen, would prove different from all the rest, though it would be a while before he distinguished himself. He was a Swiss-German named Otto Bernet.

James Sutton and Thomas Clarke were not alone in their passion for contemporary art. Although Americans in the 1890s shared with Europeans a taste for the "Men of 1830," as the Barbizon School was sometimes called, the New World was more open to the experiments of contemporary art, whether European or American. That the United States was different, and not just in collecting, was nowhere more evident than in the fact that, in complete contrast to Europe, two of the strongest advocates of contemporary art and three of the most adventurous collectors were women.

Mary Cassatt, the painter from Pittsburgh, had settled in Paris in 1868, fallen under the influence, and perhaps the spell, of Degas, and had exhibited with the Impressionists four times between 1879 and 1886. Ever since, she had been using her not inconsiderable influence to induce Americans to buy Impressionist pictures. Another forceful woman, Rose Lorenz, known as "Miss Potsdam," from a poor German family, had become the power behind the rostrum at the AAA, Kirby's sole confidante after Sutton withdrew, someone who, says Towner, patrolled the corridors of the association with a cane in her hand, with which she pointed out the genuine and the fake.

However, three collectors, three wives and widows, were to have the biggest impact on taste in America and help it to raise its game in collecting. They came from New York, Chicago and Boston. All were formidable but it is impossible to say which of the three was the most remarkable.

"I believe it takes special brain cells to understand Degas." Doubtless Degas would have agreed, but whether he would have liked the small, plain woman with large eyebrows who made this remark is less certain. Like the painter, Louisine Waldron Elder always liked to have the last word. Her collecting began when, at the age of nineteen, she arrived in Paris with her widowed mother and two sisters on the obligatory tour of Europe. Passionately interested in all the arts, Louisine met Mary Cassatt, who, Aline Saarinen tells us, came from the same social set back home. At the time, according to her memoirs, she was saving up to buy either a Pissarro or a Monet. However, Miss Cassatt took her off to a color shop—possibly Portier or Latouche—and introduced her to the works of Degas. Miss Elder was uneasy with the picture she was shown, a pastel and gouache called *Ballet Rehearsal,* and wasn't sure what to make of the asymmetric composition, unusual lighting effects, and awkwardly cut-off figures. Nonetheless, she allowed herself to be persuaded and paid the asking price, 500 francs ($1,975), by borrowing from her sisters. She never regretted it.

Eight years later Louisine was married to Henry Osborne ("Harry") Havemeyer. A bit jowly, bald and bulky, taller than she but still short, Harry was well acquainted with Louisine before marriage. He came from the same Philadelphia set, before they had moved to New York; he was a sugar refiner whose father had been in business with her father; finally, Harry had previously been married to Louisine's aunt.

After marriage, the Havemeyers produced three children, Adaline, Horace and Electra, who arrived at two-year intervals between 1884 and 1888. In 1887 Harry founded the sugar trust, which was an immediate success; within two years its annual profits had reached $25 million ($429 million now). Their fortune consolidated, the Havemeyers now set about building themselves a very grand town house at 1 East Sixty-sixth Street in New York City and looking for some art to fill it.

Once she had her plans for the house in order, Louisine turned her attention to her husband. Harry had begun collecting the arts of China and Japan, having been introduced to them, like so many Americans, at the Philadelphia Centennial in 1876. He bought what he liked and he bought masses of it. Insistently, however, Louisine steered him away from Oriental objects and toward European painting, specifically Rembrandt, Courbet and Pieter de Hooch. Harry was a fast learner, and soon they were buying in Paris as well as in New York (where they used Knoedler). In Paris, Harry discovered Millet, Delacroix and the Barbizon School. By the middle 1880s the

Havemeyers had a number of Impressionist pictures, and some were lent to the exhibition mounted in New York by Durand-Ruel in 1886. But it wasn't until 1889, when the house was being constructed and they visited the Exposition Universelle in Paris, that the heavy phase of their collecting began.

The Havemeyers preferred Courbet, Manet and Degas, but they also explored the links between modern art and the Old Masters. The collection of pictures that show the relationship between Manet and Spanish painting was perhaps their most successful venture, and that theme, linking Manet to Spain, is what makes their collection intellectually and aesthetically distinctive. In those days there was so little vogue for Spanish pictures that wonderful masterpieces were going very cheap. Aline Saarinen says that Harry was stunned by the splendors of the Prado and always maintained that "after the Spanish-American war the United States should have demanded the Prado as indemnity instead of the Philippines." He particularly fell for El Greco. In fact, thanks to the enthusiasm of the Havemeyers, the market for El Grecos and Goyas revived; eventually they were to acquire twelve pictures by the latter artist. The Havemeyer Spanish collection was second to none, but not all of the paintings were bargains, as Louisine was well aware. "It took some time [for us] 'to do' Granada," she once said, "but it took very little time for Granada 'to do' us."

Henry Havemeyer died in 1907, when he was sixty. Just before his death, he told one of his daughters, "Boss, take care of your mother." It is doubtful whether any woman needed taking care of less. On the trip to Europe that she made after Harry's funeral, Louisine bought three Goyas. She never married again but instead espoused the women's suffrage movement. She lent paintings for a suffragette benefit, which, says Aline Saarinen, outraged her rich friends, some of whom threatened to stop buying at Knoedler's, where the exhibition was held. She sent seventy thousand pots of jam to wounded soldiers in World War I, and once, when addressing a women's rally, sat her grandson on a chair and began, "Friends, if the men of your generation will not grant us justice now, you may be sure that this generation will."

By the time Louisine died, in 1929, she had been honored in France with the Cross of the Légion d'honneur in 1922, then promoted to Officer in 1928 after she had donated Manet's *Portrait of Clemenceau* to the Louvre (now in the Musée d'Orsay). Her first will, made in 1917, left everything to her children. However, that was changed completely by three codicils. The first deeded 113 works to the Metropolitan Museum in New York, the second boosted that by another 29, and the third empowered her son, Horace, to give whatever other works he felt suitable. In fact, the children expanded their mother's gift enormously, from the 142 objects at first specified to 1,972 objects. Even so, there was plenty left. In April 1930, the AAA sold one of

Louisine's Goyas (*Lady with a Guitar*), plus works by Mary Cassatt, Monet, Jacques-Louis David (*Portrait of a Young Girl*), and Cézanne's *L'Enlève-ment*. These were merely the jewels; the sale lasted a full ten days. Henry may have learned his taste from Louisine, but his character had influenced her as well, for at the end she liked buying in quantity too.

—

If Louisine Havemeyer had the biggest hats—and one of the biggest bos-oms—in New York, Mrs. Potter Palmer, it was said, had the tiniest waist in Chicago. It was recorded for posterity, along with the rest of her, by no less an artist than Anders Zorn. His swift, bold brushstrokes carefully chipped a few years from her appearance and added the blush of insouciance to what were very knowing features. The tiara she sports in the picture is as close as can be to a crown.

A queen she was. Berthe Honoré Palmer was a Kentuckian of "distin-guished French" descent who had married the owner of the Palmer House hotel, one of the richest and most powerful men in the city. Potter Palmer was by all accounts a reticent man, but his buildings were not. His hotel, so Aline Saarinen says, was the second in the United States to be lit electrically. Its "parlor" was Egyptian, its dining room a copy of the salon of the Crown Prince of Potsdam, and the barbershop had 225 silver dollars embedded in the floor. (Rembrandt would have loved that.) Rudyard Kipling found it "a gilded rabbit warren . . . crammed with people talking about money and spitting."

Berthe Honoré was no more reticent about money than was the barber-shop floor, but she was not just a gilded butterfly. Charity work among wealthy women was more common in Chicago than on the eastern seaboard, and Mrs. Palmer "led the procession," according to Aline Saarinen, making the annual charity ball the event of the season. These two elements of social prominence—immense wealth and a social conscience—probably accounted for why she was asked to be chairman of the Board of Lady Managers of the World's Columbian Exposition, to be held in Chicago in 1893, to mark the four-hundredth anniversary of the discovery of America. Chicago no longer saw itself as a Wild West prairie town, a place of spitting and spendthrifts, and a feature of the exposition was a loan exhibition entitled "Foreign Masterpieces Owned by Americans." The 126 pictures shown were almost all by French artists from the Barbizon School, but amid all the fashionable and familiar pictures were a few "garish" interlopers: Renoirs, Manets, Pissarros, Sisleys and some "awkward" paintings by Degas. What made these pictures doubly disturbing to fashionable souls, or would-be fashionable souls, was that they had been lent by some very respectable names: the H. O. Havemey-

ers, Alexander Cassatt, soon to be president of the Pennsylvania Railroad, and the Potter Palmers.

Berthe Honoré had needed art objects for the "battlemented monstrosity" she had built in Chicago and called a castle. Her taste was eclectic and wide-ranging but not bad. She had taken the right advice and used the Chicago-based dealer Dirkan Kelekian. The Potter Palmers also used another Chicago dealer, Sarah Hallowell, who had spent fifteen years in Paris and thus was familiar with the contemporary scene. One of the first pictures they acquired through her was a Corot. In those days this was an exceptionally imaginative choice, but Berthe Honoré was even more adventurous than that. Two years before the Columbian Exposition, on a trip to Europe, she had met Monet and bought a painting from him, the first of many—so many, in fact, that, in Saarinen's words, "she was able to form a frieze of them around her ballroom" in the castle. Like the Havemeyers, she also used Mary Cassatt to scout for paintings. In the early 1890s she bought some very fine pictures indeed: Renoir's *The Canoeist's Luncheon,* Monet's *Argenteuil sur Seine,* and Pissarro's *Café au Lait* among them.

Mrs. Potter Palmer bought, in part, because she knew that the exposition was imminent, but also out of a sense of obligation: people in her position were expected to know great art when they saw it, and to have it about the house or castle. But this does not detract from the fact that, just as Louisine Havemeyer was the first person in the East to see merit in the Impressionists, Berthe Honoré Palmer was the first in the Middle West. After the exposition, many other prominent Chicagoans began to collect, and the leadership of Mrs. Potter Palmer is the main reason why the Art Institute of Chicago has been bequeathed so many good Impressionists over the years. When she died she left a hundred thousand dollars' worth of art to the Institute, ceding the choice of paintings to them. By that time tastes had changed and they opted for the greatest Impressionists, who then were not at all controversial.

Mrs. Palmer's life was a remarkable accomplishment. One thing, however, remained unfinished: the painting by Anders Zorn. There may have been a good reason for this. According to Chicago gossip, Zorn had made a pass at her while she was sitting for the picture and had been kicked out. No such scandal attached to Zorn's portrait of another great American female collector, Isabella Stewart Gardner. He painted her one evening in Venice, after they had spent some hours together in a gondola, as Aline Saarinen tactfully put it. The full-length picture shows Mrs. Gardner bursting into a room from a balcony of the Palazzo Barbaro. What stands out in this painting, as in the

portrait that Sargent did of her later (see figure 29), are her dark, piercing, wide-apart eyes. The Venice picture shows Mrs. Gardner with a five-foot rope of pearls about her neck; it is striking, and Zorn himself said, "Alas, all my subjects are not Mrs. Gardner, and the backgrounds not the Canale Grande."

The third of these three great female collectors would have hated to be third on any list. As her friend Henry James remarked, she had "a preposterously pleasant career." It took place in Boston in the 1880s and 1890s and culminated on December 31, 1902, when she opened her mock Venetian palace, Fenway Court. Though Boston was her stage, Isabella Stewart Gardner was a New Yorker. She had met John Lowell ("Jack") Gardner while she was at finishing school in Paris. After their marriage she led a quiet life in Boston, but it was shattered in 1865 when, at the age of two, her long-awaited son died. "It was," wrote Aline Saarinen, "the one cruel blow life dealt her." She left immediately for Europe, so distraught that she had to be carried aboard ship on a mattress. The new environment must have worked for her, because when she came home she was a different person. The shrinking violet of former years had now turned into "a society dazzler."

Over the next two decades Mrs. Gardner gave the Boston newspapers more copy than anyone else. Once, when the Gardners missed a coach to go on a picnic, she persuaded Jack to hire a private locomotive, which she helped drive at eighty miles per hour; she had a lion on a leash; she turned up at a ball in a gown with a train so long that it had to be held by a boy in elaborate costume. Such escapades attracted attention, as they were meant to do, and not a little envy, even hostility, from other women. When she was asked if she would contribute to the Charitable Eye and Ear, a local hospital, she replied that she was not aware there *was* a charitable eye or ear in Boston.

Boston was a serious city in those days—that is, it took itself seriously—and decidedly precious. Intellectual pursuits, including the fine arts, were highly regarded. The French painters were so familiar that a misty morning was known as "a Corot day." But Italian Renaissance culture was regarded as the highest pinnacle, and Boston did what it could to annex Florence and Venice to itself. Aline Saarinen quotes Van Wyck Brooks: "The fact that Boston girls grew up with Botticelli manners made Botticelli almost a Boston painter. . . . Dante, Petrarch, Ruskin and Browning were Boston citizens in their way."

One important reason for this was the presence at nearby Harvard of Charles Eliot Norton, a ferocious intellectual who had lived in England as "a crony" of Ruskin, Dickens, Carlyle and Darwin. He had returned to Harvard

in 1873 as the university's first professor of the history of art.* In 1878 Mrs. Gardner began attending Norton's classes, "and soon her salons became extension courses." The salons were probably more fun than the lectures, for there were people to listen to other than Norton—Henry Adams, Oliver Wendell Holmes, William and Henry James and Norton's best pupil, Bernard Berenson.

It was through Norton and the salons that Mrs. Gardner became interested in Dante, and it was through her interest in this poet that she began collecting rare books. Then, in 1891, her taste received just the push it needed: a legacy. Her father died and left her $2,750,000 ($57,440,000 now). Mrs. Gardner lived surrounded by Botticelli and Boston, and the Impressionists were not for her; she looked not to Argenteuil or St. Remy but to Delft and Siena. Aline Saarinen again: "The year that Mrs. Potter Palmer bought her four Renoirs, Mrs. Gardner bought a *Madonna and Child* by Fra Filippo Lippi that later turned out to be not by Fra Filippo Lippi, and an *Adam and Eve* by Cranach that turned out not to be by Cranach, . . . and . . . a handsome Vermeer, which is still a Vermeer." Her great adventure had begun, but as the "Lippi" and the "Cranach" show, she had yet to hit her stride. However, in 1894, in London, she chanced to meet Bernard Berenson again. He had not yet published his great books, but he had become an "expert," a connoisseur whose eye and judgment were valued, and paid for, by rich collectors who wanted the best but didn't always have the critical faculties themselves. Later on in his life, B.B., as he was known, would look back on this phase of his career with regret. "I soon discovered that I ranked with fortune-tellers, chiromancists, astrologers, and not only with the self-deluded of these, but rather with the deliberate charlatans."

Despite this, Berenson helped Mrs. Gardner acquire many of her masterpieces. In July and August of 1894, when her parties were "keeping the servants up later than Mr. Gardner thought proper," Berenson managed to obtain the Earl of Ashburnham's Botticelli, *The Tragedy of Lucretia,* for $17,000 ($379,250 now). This was an important coup, says Saarinen, because owning a picture of such quality changed Mrs. Gardner. Thereafter she wanted other masterpieces, and only masterpieces, to match the Botticelli. The great years of her collecting were between 1894 and 1900. This was before J. P. Morgan and some of the other industrial robber barons really got going, so that prices had not yet become silly. But the trend was upward, and this mattered to Mrs. Gardner; she was rich, but not on the Morgan or Henry Walters scale. At a time when Morgan's collection was officially valued at $60

*Norton was so affected, it was said, that when he entered heaven he would surely exclaim: "Oh, no! So overdone!"

million ($1.26 billion now), hers was put at $3 million ($63 million). All the more remarkable, then, that despite this, Berenson helped her to acquire portraits by Raphael and Velázquez and five panels by Simone Martini for a mere $2,000.

Like Louisine Havemeyer, Mrs. Gardner had her frugal streak. Toward the end of her life, says Saarinen, she used to send the director of her collection, who was also a kind of official companion, to the corner store every day to buy a single orange. Once, when the director knew he wouldn't be able to make it to the store the next day and in a daring break from tradition asked for two oranges, the saleswoman was overwhelmed: "Is the old lady going to have party?"

Mrs. Gardner's one real extravagance was the museum she created. It was, indeed, her masterpiece. Fenway Court, according to Aline Saarinen, was inspired by the Palazzo Bardini on the Grand Canal. Though officially designed by Willard Sears and Edward Nichols, it was Mrs. Gardner's conception in its entirety. During the building phase she was on the site every day, with her sandwiches in a box, like all the workmen. She changed her mind often, but despite her imperious manner and irritating peccadilloes, Sears was forced to acknowledge that her good taste was instinctive; when her possessions were installed in the house, the juxtapositions—this vase with that picture, this brocade with that marble—proved to be inspired. Saarinen again: "Fenway Court is charming and feminine. . . . [it] has the captivation of caprice."

The caprice was opened to Boston and the world at a New Year's Eve party, on December 31, 1902. The newspapers had been speculating for months about "Mrs Gardner's Eyetalian palace," as the workmen called it, but she kept total control over security. When the time arrived to test the acoustics of the music room, she invited for a trial concert only those singers who could not help but keep her secret: the children from the Perkins Institute for the Blind. The press was banned from the party but several of the more enterprising reporters got in anyway, employed as waiters by the caterers. They saw a horseshoe staircase at the end of the music room, where Mrs. Gardner stood to receive the best that Boston had to offer, but the center of the palazzo, beyond the music room, was the chief attraction. The courtyard was four stories high, lined with balconies and Venetian windows reminiscent of Romeo and Juliet's Verona; it had a mosaic floor, a glass roof, and a multitude of fresh flowers and was illuminated by hundreds of lighted candles. Among these and the Gothic crucifixes, Chinese bronzes and terra-cotta reliefs were the most astonishing jewels of all, "Renaissance Old Masters of a quality Bostonians could only dream of": Giotto, Rembrandt, Guardi and Vermeer. There were even two Holbeins.

But Mrs. Jack didn't stop there. In 1906 she began planning to replace the music room with a "Spanish Cloister," and above it a tapestry room. Even her wall hangings matched her other possessions in quality. For Aline Saarinen, the jewel was a set of sixteenth-century Brussels tapestries from the Barberini Palace in Rome, which depicted the life of Cyrus the Persian. Cyrus's main adversary, Queen Tomyris, was known for her habit of having her servants kidnap passersby so that she could enjoy them as lovers. Once she tired of them, they were thrown from the windows of her castle. It is going a bit far to suggest that Mrs. Gardner was such a tyrant, but no doubt she would have enjoyed the company of such a passionate and powerful woman.

Mrs. Gardner suffered a stroke in 1909, but though she was paralyzed, her mind was as vigorous as ever, and the Spanish Court was finished after ten years. She died in July 1924. In Fenway Court she left one of the most beautiful environments ever constructed by a single individual. But she also left far more. Because of her relationship with Bernard Berenson, she set a taste for Italian art that the multimillionaires of the Morgan era would follow in grand style. It was a taste that helped to create a golden age for dealers in Old Masters.

9 | DU VESNE, DUVANE, DUVEEN

Joseph Duveen was probably the most successful dealer in Old Master paintings who ever lived (see figures 47, 50 and 51). He made enormous amounts of money, had powerful friends, was ennobled and became a trustee of the National Gallery in London. He was colorful, flamboyant, unique. He was also a crook. There are more stories about Duveen's mendacity than there are dots in a Seurat. Once, when one of his American customers dared to think of buying a picture from another dealer, he made the mistake of asking Duveen to look at it. Sir Joseph, as he was by then, walked up to the picture, leaned close to it, took a deep breath and whispered, "I smell fresh paint." Not long before, he had been asked to give an opinion on a painting that a British aristocrat was thinking of buying from Agnew. The painting was actually a masterpiece, and for a moment Duveen was stuck for a comment— but only for a moment. The duke was very religious and very conventional. "Hmm," grunted Duveen. "I suppose you know those cherubs are homosexual." His brother-in-law, René Gimpel, a dealer himself, summed up Duveen perfectly: "He has no knowledge of painting, and sells with the support of experts' certificates, but his intelligence has enabled him to keep up a cracked façade in this country [the United States]."

Joseph Duveen made his debut as an art dealer in 1901 when he bought John Hoppner's portrait of Lady Louisa Manners for £14,732 10s ($1.54 million now), then a record for a painting sold at a British auction. Whether

by luck or by design, Duveen's timing was right on cue. In 1899, J. P. Morgan had bought Fragonard's fourteen panels, *The Storming of the Citadel,* for $310,000. In 1901 Morgan bought Gainsborough's *Duchess of Devonshire,* and in the same year Raphael's Colonna Altarpiece for £100,000 ($10.4 million now), a world record for a work of art. Benjamin Altman was about to start collecting seriously, and Henry Clay Frick was soon to move his collection to New York. By any criterion it was a golden age for dealers, a time when half a dozen top names handled unimaginable treasures. Paris had Seligmann and Sedelmeyer, London had Agnew, Colnaghi and Sulley, and New York had Knoedler. This was just in Old Masters. In contemporary art, in addition to the Impressionist dealers mentioned earlier, Paris had a new generation of men to follow Durand-Ruel and Georges Petit—Ambroise Vollard, Daniel-Henri Kahnweiler, Nathan Wildenstein and Félix Fénéon—who will be discussed later.

In the last years of the nineteenth century in New York, Knoedler & Co. was probably the most distinguished firm of dealers. It dated back to 1846, when Michael Knoedler had arrived in Manhattan from France to act for Goupil, which, like Colnaghi and Agnew, was known for engraving. Knoedler set up office at 289 Broadway, on the corner of Duane Street, where the engraving business brought him into touch with American painters and the wider art world. Knoedler was impressed in the early 1850s that a picture sold in New York for $300 ($6,850 today). He immediately wrote home to France, expressing doubt that a picture "could ever again be sold in New York for as large a sum." In 1854 he returned to France, married, and brought his wife back to New York, where he took larger premises, still on Broadway but farther north. After a few more years he bought out Goupil's interest and thereafter traded under his own name. In 1859 he moved again, even farther up Broadway, and there endured the Civil War, which saw a marked drop in sales.

At this time, art dealing in America was not exactly a gold-plated occupation any more than auctioneering was; indeed, it was so touch-and-go that paintings were usually paid for not with paper money but in gold. Nevertheless, Knoedler was making ends meet and therefore was in at the beginning of the great American collections. His early clients included John Taylor Johnston, the first president of the Metropolitan Museum, and Charles Crocker of California, who bought eight paintings the month after the Union Pacific made its first transcontinental run.

In 1869 Knoedler moved to 170 Fifth Avenue, on the corner of Twenty-second Street. This was considered a daring, even dangerous, move because, as the firm's own history puts it, "it was doubted that the business section would expand so far uptown." But in 1875 the Corcoran Gallery in Washing-

ton bought one of the first acquisitions ever made by an American museum, from Knoedler. Collis P. Huntington and John Jacob Astor were also clients. In 1877, Knoedler's eldest son, Roland, reached his twenty-first birthday and became a partner—not a moment too soon, since Michael died the very next year.

At this point in the firm's history, the names of its clients become very familiar. William H. Vanderbilt bought a Meissonier from Knoedler for the then-record price of $16,000; other collectors included Cornelius Vanderbilt, Henry Flagler of Standard Oil, Stephen V. Harkness, Leland Stanford, the governor of California, John Harper, the publisher, and W. A. Roebling, the builder of the Brooklyn Bridge. Jay Gould bought twenty-two pictures in two days—"an indication," as Charles Henschel says in his history of the firm, "that collectors then had a very different attitude from those of today." But people were keeping up with the Joneses, or the Goulds, even then: "The sales books show that waves of buying would suddenly occur in a given locality and, presumably, one collector would start others buying."

In 1895 Knoedler retraced the steps of its founder and opened a branch in Paris, to be followed shortly by one in London. Charles Carstairs, the first non-Knoedler, was brought in and started specializing in fourteenth- and fifteenth-century pictures, an astute move that appealed to the likes of Andrew Mellon and Henry Clay Frick. The official history of Knoedler continues the story: "At the turn of the century there began that great importation of paintings which now fill our institutions of art, and many of the great masterpieces of Europe passed through our hands in this period when millions of dollars' worth of painting came into the country each year. Intense competition developed between the principal collectors, such as Henry Clay Frick, P. A. B. Widener, Charles Taft and Andrew Mellon." Knoedler remained a family firm, run by Michael Knoedler's grandson, Charles Henschel, until after World War II.

But it was Joseph Duveen above all others who was the Old Masters' master. In this golden age for dealers, only he had the panache to make himself not merely the equal of the millionaires who were his clients but their social superior. Only Duveen was ennobled (the Légion d'honneur was not quite the same thing), and among dealers, only Duveen had Berenson.

—

Berenson was born in June 1865 in Butrymanz, a Jewish ghetto about twelve miles from Vilnius, the capital of Lithuania. Running south from the Baltic, it was the only area of her empire in which Catherine, the Russian empress, allowed Jews to live and work. Even there, however, Jews could not own land; they were not allowed to travel outside the Pale, to be employed in any

of the common professions, or to enroll as students in the Christian universities. Chaim Weizmann, the first president of Israel, who also grew up in the Lithuanian Pale, once described how in his youth Thackeray's *Vanity Fair* was passed around page by page; a newly arrived chapter would take at least three months to be sent around all the avid readers. In 1874, because he was unsure of the sort of future that would face his son in Lithuania, Bernard's father, Albert, decided to emigrate. For security's sake, says Colin Simpson, the tickets—to Boston, where they had relatives—were bought in the name of "Ber und Sohn" (Ber and son), Ber being the Yiddish diminutive for Albert. In Boston, Bernard's intellectual precocity was allowed free rein. Through Harvard, where he was admitted, Berenson met not only Charles Eliot Norton but a whole raft of clever and/or well-connected people who were to help shape his career: George Santayana, Charles Loeser and Logan Pearsall Smith, whose sister Bernard was eventually to marry, and who at the time he was at Harvard shared a house with Gertrude Stein.

Bernard's intellectual abilities, combined with his social contacts, made him a strong candidate for a traveling fellowship on graduation. Norton vetoed this for a variety of reasons, but the social contacts came up with $750 for Bernard to go abroad anyway, and the journey was the making of him. He went to Paris, and then to Oxford, where, says Colin Simpson, he met Lord Alfred Douglas, Charles Bell and Oscar Wilde. In 1888 he forsook what he later called the Brotherhood of Sodomites and arrived in Florence, where he met Jean Paul Richter, part collector, part art dealer, part author. Impressed with Berenson but thinking that the young man needed to see more pictures, Richter recommended that he go to Dresden and Munich, and that he take with him a book by an Italian connoisseur, Giovanni Morelli.

This book also changed Berenson. It was called *Italian Pictures: Critical Studies of the Works in the Galleries of Munich and Dresden,* and when it was published a decade before, it had dramatically changed European art scholarship, reattributing familiar masterpieces to new painters. Morelli had trained as a doctor, but he was rich and was therefore free to pursue other interests, including politics. It was the era of the Risorgimento, and Morelli played his part in helping the emergent Italian nation gain its independence. He was rewarded with an appointment from the newly formed Italian government to head a commission whose task it was to draw up an inventory of all the works of art in the unified country's churches and palaces. Morelli was lucky in that another campaigner in the Risorgimento, Giovanni Cavalcaselle, an engineer and amateur connoisseur, was also concerned at the corrupt chaos that surrounded the world of Old Masters, with fakes and spurious copies everywhere and dealers attributing everything to a small number of well-known geniuses. Morelli and Cavalcaselle each concluded

that the only way to put order into the field was to examine every painting and compare it with others that were definitely by the master in question. As a doctor, Morelli contributed the added insight that each painter has idiosyncrasies that often show up in the anatomical details of paintings, and that are as powerful as signatures in identifying works. For example, Morelli observed that Titian always painted the ball of a thumb in a certain way, and that in pictures by Botticelli the hands are invariably bony, with squared nails. (This oversimplifies Morelli's ideas, and they were in any case an addition to other methods of connoisseurship. Even so, they are now accepted, which wasn't true in Berenson's day.)

B.B. met Cavalcaselle and Morelli. The latter gave him the lists he had prepared for the government—these weren't exactly secret but were available only to serious scholars—and in 1890 Berenson traveled throughout Italy from Venice to Sicily, his itinerary primed by his illustrious mentor. With so many doors opened to him, it was not at all surprising that he should begin to become known as an authority on the art of Italy. To consolidate his fledgling reputation, however, he needed to make an original and sizable contribution to knowledge. It was at this point that he decided to devote his life to connoisseurship and to produce definitive lists of all Italian paintings that would provide benchmarks for other scholars. However, he needed funds. According to Colin Simpson, in an admittedly controversial book, this was when Berenson bought five Italian pictures and put them up for sale at Christie's in the name of J. P. Richter. According to Simpson, who examined the Colnaghi archive, Berenson was now acting as a scout for Richter and for Otto Gutekunst, who, of course, later became a director of Colnaghi's in London. Richter, says Simpson, got first refusal. If he didn't want what Berenson had, he passed it on, either to Gutekunst or Christie's, giving Berenson a share of the profits. Thus from the first Berenson was a dealer as well as an academic.

Though he was becoming a formidable scholar, it is questionable whether Berenson would have become quite so famous had he not burst onto the art scene in a singular way. In February 1895, at an exhibition of Venetian paintings in London, he introduced an extraordinary innovation, the "alternative catalogue." Berenson was familiar with the pictures in the exhibition and took the view that their attributions were extremely dubious. His knowledge enabled him to produce his alternative catalogue very quickly, and it was ready by the third day of the exhibition. Its language was explosive. He began by pouring scorn on the thirty-three "Titians." "Of these," he sniffed, "only one is by the master. . . . of the thirty-two that remain, a dozen or so have no connection whatsoever with Titian and are either too remote from our present subject or too poor to require attention." He did not simply

damn, however, but reattributed where he could, often convincingly. He accepted just three of the paintings attributed to Giovanni Bellini and none of the twenty-one posing as Veroneses. In one stroke, Berenson had exposed the art trade as both ignorant and pretentious. Because of his evident learning, his claims could not be dismissed, but at the same time his captious prose made him few friends. There was one exception. Joseph Duveen wanted to know more about "this Jew from Harvard" and telegraphed his uncle, Henry, to make inquiries.

An artist, said Zola, is someone who lives life "out loud." In that sense Joseph Duveen was certainly an artist. From the moment he achieved control of Duveen Brothers, he lived out loud.

Not to begin with, however. According to Simpson, the name Duveen was "poached" by an impoverished Jewish refugee from Paris in 1810. Rendered bankrupt by the Napoleonic wars, Henoch Joseph moved from Paris to Holland, where he worked as a blacksmith and as an official in the weights and measures department. To confuse his creditors, and because Jews needed non-Jewish surnames in which to be registered, he changed his name to Du Vesne, after one of his wife's grandparents. This was spoken as "Duvane" but in Flemish was written "Duveen." Henoch's son, Joseph, was married twice. His first wife died, leaving him with three children. His second marriage was to a wealthy Dutch woman, but she had no interest in her stepchildren, and they were sent away as soon as possible. The eldest boy, Joel, found work as a salesman for a Dutch firm that exported vegetables to Hull, England; Betsy, Joel's sister, was sent to Haarlem to stay with cousins who owned an antiques business. On one of his trips home with the son of the household where he lodged in Hull, Joel visited Betsy and was taken around the antiques shop. His English companion noted some Chinese blue-and-white cups and saucers of the Nankin pattern, which he thought would sell well on the other side of the North Sea. Joel was less sure but agreed to buy a crate and take it with him on his rounds of greengrocers in Manchester and Liverpool. "Two weeks later," says Colin Simpson, "he was back in Haarlem for more." By the summer he and his English friend were full-time importers of antique porcelain.

Within a short time Joel was importing a range of antiques from Holland and selling them by auction at a firm called Robinson and Fisher. He was ambitious and soon had plans to open up in the United States. He also started accepting paintings for sale, which were sent to him by Gimpel and Nathan Wildenstein in Paris. By now his younger brother, Henry, was old

enough to be taken into the business, and he was packed off to Boston with two trunkloads of samples. Henry was enthusiastic about their prospects in America, but he soon noticed how besotted Bostonians were with Italy and France. Therefore he traveled south to New York, where he started in a room above a shop selling artists' materials. Here he was extremely lucky. One of his first customers was the American architect Stanford White, who took a liking to some delft tiles that Henry had, and on learning that unlimited quantities could be obtained, ordered twenty thousand for a Fifth Avenue mansion he was designing. Through White, Henry Duveen met many of the millionaires who were keen collectors and would become good friends: J. Pierpont Morgan, Collis Huntington, P. A. B. Widener and George Jay Gould.

But, though brothers, Henry and Joel were very different. Joel had wide-ranging interests in Britain, especially in property in the form of shops and flats. Henry, on the other hand, was interested only in the antiques business and in his stamp collection, which was enormous and in time would become the third finest in the world, after those of Prince George (later King George V) and the czar of Russia. Because of his stamps, whenever Henry was in London he was invariably invited to Buckingham Palace. As his relationship with the prince grew warmer, a certain coolness developed between the brothers. This was really due to their temperaments: Joel was first and foremost a businessman, whereas Henry was more a scholar. Still, for a long time they respected their differences, especially since Henry's royal friends were good for business. In 1901 when Edward, Prince of Wales, became king, the Duveens were asked to redecorate Windsor Castle and Buckingham Palace, and to "smarten up" Westminster Abbey for the coronation. It was an honor that didn't exactly frighten customers away.

By now, Joel's sons were also learning the business. In those days strict discipline was applied to dress. Joel and Joseph, his eldest son, wore deep blue business suits, with silk shirts, starched cuffs, "four-inch-high double collars" and patent-leather shoes. The younger sons were given frock coats and top hats, while the other members of the staff wore gray alpaca jackets and bowler hats. According to Colin Simpson, only family members were permitted to wear a fob watch and chain.

In 1890 Joel became seriously ill with double pneumonia. It didn't kill him, but when he recovered he was weak and his ambition was largely gone. As part of his cure, he was required to spend his winters in the sun, and when he was away—for nearly eight months a year—Joseph was left in charge of the business in London. He reveled in it. One of his first acts was to insist that the staff now call him Mr. Joseph; beforehand it had been Mr. Joel and

Master Joseph. His second act was to ensure that his younger brothers, Charles and John, were sent out on the road to scout for merchandise; the subordination of all others had begun.

Joseph Duveen was a tall man with fleshy lips, a long, bulbous nose and a thick black mustache. Though he was as yet some way from his knighthood, let alone his ennoblement, he now began to live like a lord. His cigars were made for him personally; he took a regular private room for his lunches at Claridge's (then just a chophouse with a few rooms), and prevailed on them to stock gulls' and plovers' eggs. He went to Paris once a month. The Duveen legend was being coined.

It was on one of his Paris weekends that Joseph met the picture dealer Nathan Wildenstein, and they soon developed a cooperative arrangement. Wildenstein, then thirty-seven, was from Alsace originally but had opened a small gallery on the Left Bank, where he had done so well that in 1890 he moved to the much more fashionable Faubourg St.-Honoré. To begin with, the arrangement worked well. Wildenstein's rich clients sometimes preferred to pay for paintings with items of furniture; Duveen would take these objects and give the picture dealer good prices. In his turn, Joseph became fascinated by the paintings market: then, as now, the best pictures fetched much higher prices than ostensibly more useful objects like furniture. To the others in the Duveen firm, this was a dangerous flirtation of Joe's. Both Henry and Joel were against any move from antiques into pictures; Henry said they were "the last thing a man buys." Joe bided his time, but then, in 1894, the premises of Robinson and Fisher, auction rooms in Bond Street, became available and the Duveen brothers bought them. They moved everything across to Bond Street, leaving empty the Oxford Street shop, whose lease still had two years to run. Joseph nagged at his father and uncle and urged that they show pictures there. Reluctantly the brothers agreed and another deal was struck, with Wildenstein and René Gimpel in Paris. However, it was not a success. As might have been foreseen, the pictures the Paris dealers sent were not their best. Soon afterward, however, an event took place that was to shape Joe Duveen's career more than any other. A few minutes' walk from the Oxford Street shop was the New Gallery, renowned in London for its important and scholarly exhibitions. In the spring of 1895 the directors of the New Gallery decided to hold an exhibition of Venetian art, for which they hoped leading collectors and owners of stately homes would lend their most beautiful paintings. Joseph was approached by the New Gallery and asked if he would provide introductions to likely owners. Since he had sold furniture and porcelain to these collectors and knew where several great pictures were located, he cooperated enthusiastically.

The exhibition, when it opened on February 2, 1895, was a glittering event.

Pictures by Giorgione, Titian, Bellini, Tintoretto and Veronese were all shown side by side, in a way not seen before by most people. Almost all the pictures had been bought at least a hundred years earlier, when the ancestors of the current owners had been on the Grand Tour of Europe, and the paintings had hung in various stately homes ever since. The pictures were catalogued at face value, which is to say that if a picture had always been called a Titian or a Bellini by its owners, it was labeled as such. Some of the attributions were centuries old. This was perhaps a form of politeness on the part of the New Gallery. They posted only one qualification in the catalogue, pointing out that they were not responsible for the attributions. It was just as well; two days after the exhibition opened, a second catalogue appeared which challenged in an authoritative and yet disdainful way almost every attribution and produced a social and academic bombshell. This was Berenson's rocket.

Although Joe immediately asked his uncle, Henry, about "this Jew from Harvard," the two men did not meet for some time. Henry had to be circumspect in his inquiries, and they needed to be thorough; they even had the Pinkerton detective agency examine Berenson's finances. When the two men did meet, however, they formed one of the most formidable partnerships that the world of Old Masters has ever known. Immediately before their rendezvous, Berenson had been helping Isabella Stewart Gardner to acquire her pictures; he was also acting on behalf of Colnaghi.

At that time all the big Old Master dealers had agents in Italy. Technically, it was already illegal to take Old Masters out of the country without an export permit, but this did not stop the trade. Colin Simpson has chronicled the Berensons' role in the smuggling. In November 1899, for example, Mary Berenson received word that the monks at the chapel of Saint Francis at Assisi were willing to part with one of their pictures, then catalogued as a Piero della Francesca, for $6,000 ($132,800 at today's values). The painting was taken from the monastery at midnight in a cart. It was restored by a noted forger, Icilio Joni, who ran a "factory" for forgers in Siena and had been introduced to the Berensons by Vincenzo Favenza, a dealer. Restored, the picture was smuggled out of Italy in a double-bottomed trunk filled with dolls. The Berensons even concocted a spurious provenance for the picture, saying that it was the private property of a monk in Assisi. It was bought by Isabella Stewart Gardner for $30,000 ($664,000 now), five times what the Berensons had paid. It is now in the Fogg Museum, where it is catalogued as by the Northern Master.

B.B. and Duveen finally met over the Hainauer collection. Oskar Hainauer was a German banker, the Berlin representative of Rothschild's. He collected everything from tapestries and sculptures to jewelry and gold, including early

Italian and Flemish paintings. As he lay dying with throat cancer he had told his wife that if she should ever need money, the collection was worth about $750,000. Thus, when Mrs. Hainauer was offered exactly half that sum by Wilhelm von Bode, the director of the Berlin Museum, she was bewildered. Seeing this, an Austrian adventurer, Godfrey von Kopp, offered to alert the Duveens. Mrs. Hainauer, who was also worried at the time by the rise of anti-Semitism in Germany, agreed. According to Simpson, Duveen took one look at the catalogue of the collection, valued it at $5 million ($104 million now) and set off on the same day with von Kopp to Germany. The collection was eventually spirited out of the country while von Bode was abroad on holiday, and it cost Duveen not $375,000, not $750,000, but $1 million, paid into a Swiss bank. The cash had come from Morgan in exchange for the first pickings, though P. A. B. Widener and Benjamin Altman were also allowed in, and spent more than $5 million on the sculptures alone.*

Now Duveen needed the collection properly catalogued. His first choice was Walter Dowdeswell, who had been a partner in the London dealers Dowdeswell and Dowdeswell until he had fallen out with his cousin. But Dowdeswell felt that his scholarship was not up to the task and Berenson was suggested. With the Hainauer collection, Duveen not only made Berenson's acquaintance but became truly famous throughout the art world. Everything was now in place for him to take on the millionaires of the United States.

The first was Arabella Huntington, née Arabella Duran Yarrington, a statuesque Southerner who had married Collis P. Huntington after being his mistress for years. After Collis died, Arabella surprised everyone by marrying his nephew, Henry Huntington. Collis, a tough, two-hundred-fifty-pound bear, had been feared among the smart set of New York, and as a result Arabella was ostracized even in her widow's weeds. The new couple now sought to obliterate this unpleasantness in the traditional way, through buying art. In the early stages Arabella, who had decamped to Paris when she was shunned in New York, avoided Duveen because she believed he would favor his existing clients, and therefore she opted for Seligmann.

The Paris firm of Seligmann was a fierce rival of Duveen's, and with good reason. In 1901 the two firms had planned to buy jointly a magnificent gold-thread tapestry, *The Adoration of God the Father,* from the Marquis d'Estournelles, for about $50,000. However, the Duveens, who had just been asked to tidy up Westminster Abbey prior to the coronation, learned that Edward VII wanted to borrow the tapestry for the ceremony. Therefore they

*When Norton Simon purchased the remaining stock of Duveen in 1964, part of the Hainauer collection was still there.

conceived the idea of getting Morgan to buy it and then lend what would be "his" tapestry to the king. Morgan consented, and also agreed that he would pay not $50,000 but $500,000 for *The Adoration*. The Duveen brothers then lied to the Seligmanns, saying that there were so many commissions to pay that the price of the tapestry had been raised from $50,000 to $105,000. Not knowing about Morgan's agreement, Seligmann dropped out and Duveen pocketed the entire half a million (which would now be $10.4 million). Still, Seligmann got its revenge. They learned soon enough that Duveen had lied and launched an action in the High Court, alleging fraud and deception and claiming damages. This was hardly the sort of publicity that the Crown relished on the eve of a coronation, especially as the tapestry was already in the Abbey. The Duveens hurriedly settled out of court; it cost them $210,000, double what they had pretended the tapestry cost and, once legal costs had been added in, nearly half of what Morgan had in fact paid. The score was even, but the firms were now bitter rivals.

It was Berenson who wooed Arabella away from Seligmann and over to Duveen. He was acquainted with the minor European royals with whom she surrounded herself in Paris, and with a number of judicious $50,000 bribes to members of her court, she was trapped. In years to come the Huntingtons, the first of the American millionaires to be lured to Duveen, would spend $21 million with the company, according to Colin Simpson, and it was on the strength of the Huntington deal that Berenson got his contract. Joe promised not to buy any Italian picture except on B.B.'s say-so, and to pay him 10 percent of the proceeds on all Italian objects sold. "The artful partnership" had begun.

＝

As the Seligmann affair showed, the Duveens were cunning. But they needed more than guile to create the great dynasty that earned Joe his title. They needed opportunity. That opportunity was, of course, provided in America, where wealth of previously unimaginable dimensions was now being created as a result of the scientific and industrial changes brought about in the nineteenth century and the social changes stimulated by the Civil War. All this created in America a new breed of millionaire.

The first of the great millionaire American collectors was James Jackson Jarves, a man whose name means less today than some of the others. Born in Boston, the son of a glassmaker, Jarves traveled widely but settled in Florence. Here he encountered a singular society—the Brownings, Mrs. Trollope and John Ruskin. It was through them that he acquired his passion for "gold-background pictures" and this is what makes him significant even

today; he was one of the first to rediscover the Italian primitives. His collection of Taddeo Gaddi, Bernardo Daddi, Sassetta, Gentile da Fabriano, Antonio Pollaiuolo and Domenico Ghirlandaio is now at Yale.

But Jarves was not really in the big league, the Duveen league. These were the "great all-around" collectors who acquired first-class paintings from every age. In this group there are seven names: Pierpont Morgan, Benjamin Altman, Collis Huntington (Arabella's husband), the Wideners, Andrew Mellon, Samuel Kress and Henry Clay Frick.

If anyone among this magnificent seven was the senior figure it was J. Pierpont Morgan (see figure 48). Born in 1837, he did not start collecting seriously until the 1890s. He came from a Connecticut family of merchants, farmers and theologians and was very well educated. This may help explain why he began by collecting manuscripts and books. On the other hand, Morgan never seemed to show any scholarly ambition to form a historical collection; rather, he simply wanted the greatest collection of masterpieces of one kind or another in the United States. He was advised by Joe Duveen's uncle, Henry, but he also relied on Hercules Read, keeper of the Department of British and Medieval Manuscripts at the British Museum; on Agnew; and on Bernard Quaritch for books. More than the others, Morgan specialized in buying entire collections: the Gréau collection of ancient glass, the Gaston Labreton collection of faience, the Marfels collection of watches. Among the masterpieces he acquired were the Mazarin tapestry (later in the Widener collection), Fragonard's decorative panels for Madame du Barry (now at the Frick), paintings by Raphael, Rembrandt, and Van Dyck, and a series of English pictures by Reynolds, Gainsborough, Constable and Turner.

Morgan became president of the Metropolitan Museum in 1904 and resolved to make it the home of one of the greatest collections of all time, on a par with the Vatican and other great European institutions. However, the city of New York would not provide the buildings in which to house his purchases. Therefore, though he had brought his paintings over from London, where they had been kept until the American customs law was changed in 1909, when he died in 1913 at the age of seventy-six, most of the works passed to his son. Seventy-six wasn't a bad age for someone who always smoked huge black Havanas (known as Hercules Clubs), and who had been advised by a doctor in 1880 to "stop exercise in every form. Never even walk when you can take a cab." Perhaps Morgan's exercise had been his art collection; in the end it contained Napoleon's watch, some of Leonardo's notebooks, Catherine the Great's snuffbox, first folios of Shakespeare, Medici jewelry, a number of Washington's letters, and Roman coins showing all the Caesars except one. Yet he seemed oblivious to Impressionists and to modern American artists. In his lifetime, and after his death, he was accused

of not really looking at the objects he bought, but perhaps Francis Henry Taylor was right when he said, "In reality [Morgan] was looking into the eye of the man who was trying to sell [something] to him. It was, after all, how he had reached the summit, and it . . . paid off well." Edward Steichen's 1903 photograph of Morgan brings the truth of this home: the eyes are as sharp as shrapnel. Duveen certainly understood this. Morgan once tested his knowledge by setting five Chinese jars in a line and challenging the dealer to identify the fakes. Duveen smashed the two pretenders with his cane, producing his own shrapnel.

Although Morgan's exact contemporary, Benjamin Altman was very different. A recluse who hardly ever went to Europe, he bought mostly through Duveen, Knoedler and Jacques Seligmann. Like Frick, he collected Barbizon School pictures at first but then disposed of them and began collecting Old Masters. He was strongest in the northern schools and, like Morgan, had little taste for primitives.

P. A. B. Widener had a wider range. His son Joseph inherited the collection in 1915 and was responsible for winnowing it down from about five hundred paintings to the hundred or so that were eventually given to the National Gallery in Washington. The Wideners also began with the Barbizon School, turning to Old Masters only later. The family home, Lynnewood Hall, was superbly decorated, its chief feature being a passage gallery occupied solely by Bellini's *Feast of the Gods* (now in the National Gallery, Washington, D.C.).

Samuel Kress created not one but two collections, in each case with a different idea in mind. The works in his New York apartment consisted of 375 paintings and sixteen sculptures; all were Italian and among them were works by Duccio, Giotto, Fra Angelico, Botticelli, Piero della Francesca, Bellini, Giorgione (*Adoration of the Shepherds*), Titian, Raphael and Tintoretto. Only after Morgan died did Kress consent to buy from Duveen.

The other Kress collection was put together much later, after 1939, when the Kress Foundation was established. The foundation's aim was to buy works and place them in eighteen museums around the country, usually in cities where the Kress five-and-ten-cent stores had branches. Italian pictures still dominated this collection, but French and Flemish works were also admitted. It was possibly the largest collection ever formed by one man, and very few people can have seen it in its entirety.

Andrew Mellon (figures 55 and 56) and Henry Clay Frick had similar origins, and their collections seem to have had similar aims, at least to begin with. Both men were from Pittsburgh, were friends and business partners, and derived their wealth from the steel industry. Having made his first million by the age of thirty, Frick set off on a tour of Europe with Mellon, the son

of a judge. Though they were friends, they were still unsure of each other and of themselves. Before they left they advertised for a companion to go with them on their tour. The companion's duties would include "doing the talking." For each man, the European tour proved to be an important event, leading eventually to the creation of both the Frick Collection and the National Gallery of Art in Washington. On this trip, as on later ones, both were impressed by the Wallace Collection in London, and Frick set out to emulate its atmosphere in his own collection. (Some would say he surpassed it.) Mellon did not go this far, but Wallace's taste in Dutch seventeenth-century and English eighteenth-century art also accorded with his preferences. Frick dealt with Knoedler and with Roger Fry, using Duveen only later in life. He was very tough and would not be pushed around by dealers, as befitted a man who, during the Homestead strike, had been shot and stabbed on the same day, when a Russian anarchist had tried to assassinate him.

Like several others of the magnificent seven, Mellon later discarded many of his early purchases. Of Scottish descent, he too was canny and used only a small number of dealers, including Duveen and Knoedler. He was said to be the only person to worry Duveen, mainly because "his conversation consisted almost entirely of pauses."

These, then, were the men, the unique generation of millionaires, who were collecting when Duveen was active. More than anyone else, Duveen instinctively knew how their minds worked, for he was just as much of a buccaneer as were they. They preferred splashes of color and bold gestures rather than subtlety, and so did he. Until 1908, however, Joe Duveen's hands were tied. He was not the head of the firm, however much he might act like it. But in 1908 Joel died at last. Forty and in his prime, Joe was lucky again. The period of greatness was about to begin.

10 | QUARITCH, HOE AND BELLE OF THE BOOKS

━

In 1900, when he established his own auction house on West Thirtieth Street, John Anderson, Jr., was already five years older than Joe Duveen when Joel died. Though he was undeniably bookish, Anderson was also ambitious. He believed that at the turn of the twentieth century, at a time when the United States was hungry for culture and learning, book collecting would eventually outpace everything else. It was this reasoning that caused him to invest $9,000 in 1903 ($187,000 now) in the goodwill of Bangs & Co., the oldest book-auction house in New York. The amalgamated firm became the Anderson Auction Company, soon known simply as the Anderson.

When he could afford it, Anderson traveled to Europe looking for books. It was at the end of one of these trips, when he was about to sail for home, that he encountered Arthur Swann, an assistant in a bookshop in Liverpool. The two men talked for a long while, until Swann let it be known that he was thinking of moving on. "If I ever went to New York," he said, "would I be able to find a job?"

"It would be nice," Anderson replied, "if you could be ready to leave at four this afternoon."

Swann did follow Anderson to New York, though not at four o'clock that afternoon. Once there, says Wesley Towner, he soon showed himself to be his own man. He was in fact less bookish than Anderson, at least in demeanor, and tried to bring an edge to the company and to give it glamour. He believed

that the passion to own books had to be stimulated in people, that it was not something that just happened. This was certainly true, as Anderson found out soon enough. In 1907, he sold the company and went back to Turner prints. It was a mistake, and Anderson must have regretted it almost as soon as the ink was dry on the check. He had sold the company to Major Emory S. Turner, a man who had nothing in common with his artist namesake. The major had only one arm, the other having been shot off in a military skirmish. But though he was used to giving orders on the battlefield, in commerce he was good at listening, and he listened to Arthur Swann, who was kept on. Swann still believed that book collecting needed glamour, and he at last got the chance he wanted in 1909, when there occurred the death of Robert Hoe.

Now, Hoe was a printer, but not just any printer. His father, Richard, had invented the rotary press, which made modern, mass-produced newspapers possible. It also made the Hoes rich. This background perhaps explains Robert Hoe's interest in the printed word. Just as he was no mere printer, Hoe was no mere collector of books. He had been buying them since he was a boy, when he had used even his lunch money for secondhand novels. As an adult he had amassed 16,000 titles, including 150 incunabula (books printed before 1501), first editions of Homer and Euclid, a Gutenberg Bible in two volumes, four examples of Caxton, four folios of Shakespeare plus the famous *Hamlet* of 1611, the letters of Columbus printed in 1493, and the Bay Psalm Book (the first book printed in America), not to mention many contemporary manuscripts, including those of Washington Irving and Edgar Allan Poe. These were names that everyone, not just book lovers, had heard of. Here at last was *glamour*. But the Hoe sale had more. Between Hoe's death and the auctioning of his library, it also acquired that magic ingredient scandal, the one element that Arthur Swann, for all his talents, could not whistle up artificially. Hoe had had a mistress in London, a Mrs. Brown, who lived next door to Hoe's house in a residence that was connected to his by a secret passage. Not surprisingly, when the sale was announced, Mrs. Brown wanted a slice of the millions that the books were expected to fetch.

Over at the AAA Thomas Kirby naturally expected that his firm would be awarded the Hoe business. In fact, he got the Hoe art without any trouble, but the Hoe library was a different matter. The book world was changing. London was still the accepted capital of the auction trade, but many of the biggest buyers—Morgan and Huntington, for example—were American millionaires. The executors of the Hoe will were therefore sympathetic to an American sale, but dithered over the actual choice. This, says Wesley Towner, was when Swann showed his mettle and caused the first dent in Kirby's self-esteem. Swann had kept up his English contacts since leaving Liverpool and he now recalled that in a professional English journal there

had once been severe criticism of the AAA for its conduct of a book sale. Late in the day he tracked down the reference, an article by William Roberts in *The Athenaeum* on March 24, 1900. The occasion had been the Augustin Daly auction, and Roberts's chief point of scorn was the catalogue, about which he wrote: "The whole transaction appears to have been carried out with . . . a fine disregard of the interests of the Daly estate. . . . the catalogue . . . would be a credit to a third-rate provincial auctioneer." Roberts also went on at length about the "many errors and solecisms" in the catalogue. It did not matter to Swann and Turner that the sale had in fact done well in financial terms; to book collectors, details mattered. Turner drew the Roberts document to the attention of the executors of the Hoe estate and then waited to see if his approach had worked or backfired. It was a tense time, but the Roberts article did the trick; the Anderson was awarded the sale.

Now Swann was in his element. An eight-volume catalogue was prepared, listing 14,500 extremely rare books (the total had fallen from sixteen thousand because the pornography had been disposed of privately beforehand). Never before, says Towner, had the European book trade been forced to travel to New York in such large and distinguished numbers. The Hoe sale symbolized the shift in wealth in the world just as much as Duveen's or Morgan's activities. The books sold over an incredible seventy-nine sessions and the proceedings were remarkable for three elements: a man, a woman and a book.

The man was Bernard Quaritch. At the Hoe sale, Bernard Quaritch, Jr., was present. He was a distinguished man in his own right, but his father, Bernard Quaritch, Sr., was probably the most distinguished bookdealer who ever lived. Of German extraction, Quaritch senior was a small, thickset, broad-shouldered bear of immense energy, with a large domed forehead and a huge beard. As a young man of twenty-two, according to Frank Herrmann, he had moved to Britain after working in a Berlin publishing house. In London he started with Henry George Bohn, another bookseller of German origin, best known for his great "guinea catalogue," which was 1,900 pages long and contained 23,000 titles, each for sale at a guinea (£1 1s). Quaritch had a hand in producing this catalogue, but he also dabbled in journalism and was for a time the London correspondent of the *Rheinische Zeitung*. (Two of the paper's contributors at that time were Karl Marx and Friedrich Engels.)

Journalism was a means to an end, however, for Quaritch as well as for Marx. As soon as he had saved up £100 ($10,000 now), Quaritch started out on his own in a shop in Castle Street. This is now part of Charing Cross Road, still a mecca for lovers of secondhand books, but in those days it had the added advantage of being near Puttick & Simpson, the book auctioneers,

and not far from Sotheby's, which was still in Wellington Street. Quaritch hit his stride quickly and soon had a number of distinguished customers, including William Gladstone (who became a good friend), Disraeli, Napoleon's brother Prince Louis-Lucien Bonaparte, and Edward FitzGerald, translator of the *Rubáiyát of Omar Khayyám*. Quaritch's success was due in part to his preference for recondite academic and scientific subjects, and for remote Oriental and Middle Eastern languages.

As he expanded, Quaritch moved to larger premises at Piccadilly Circus (where his neighbor was Bluett), and it was there, Frank Herrmann tells us, that once a year he organized his famous dinner auctions. Guest customers received his catalogue and an invitation to the Freemasons' Tavern, where Quaritch promised "Dinner on the table at 5 o'clock punctually." Champagne was served beforehand, and, says Herrmann, he offered seventeen courses. There was always a guest speaker—perhaps Sir Richard Burton, the African explorer and translator of the *Arabian Nights,* and then, at 8:15, commerce would take over. The wine finished, Quaritch would take out his gavel and the auction of the books in his catalogue would begin.

Just as Agnew was Christie's best customer in those days, Quaritch played the same role at Sotheby's. This was partly because Sotheby's was the preeminent house in books, but also because they allowed him generous credit, which Christie's bluntly refused to do (a difference between the two firms which exists to this day). Quaritch was a presence at all the big book sales at the end of the nineteenth century: the Blenheim sale, the Hamilton Palace sale (which witnessed a fierce tussle with German booksellers), and the William Morris sale. His son, Bernard Alfred, was not the pioneer his father was, but he was so immensely knowledgeable that he retained his father's title as King of the Booksellers. He represented Morgan in Europe and the British Museum in New York.

The honor of representing Morgan in the United States went to the second notable presence at the Hoe sale, Belle da Costa Greene. She was Morgan's librarian, and just as Quaritch was King of the Booksellers, she was Belle of the Books. Belle had a mysterious, exotic background. There were those who said she was Portuguese by birth (she sometimes said so herself), while others thought she was a Creole from New Orleans. What was beyond dispute was that she had been found at Princeton by Junius Morgan, a nephew of J.P., and that the old man had put her in charge of his library. She became his confidante, perhaps his mistress, and read Dickens and the Bible aloud to him. Wesley Towner tells us that she was black-haired and green-eyed, wore very high heels and a plume in her hair, and smoked cigarettes through a long holder. She was more saucy than witty. When a timber millionaire proposed to her, she telegraphed back: "All proposals will be considered alphabetically

after my fiftieth birthday." She posed nude for drawings and is said to have had a four-year affair with Berenson, which had to be kept secret in order not to arouse Morgan's jealousy. All her letters and diaries were burned before her death in 1950. On the first night of the Hoe sale, Belle arrived in a long gown of black watered silk. She looked every inch the kind of woman who could say of someone, as she once did, "If a person is a worm, you step on him."

The third remarkable aspect of the Hoe sale, the book, was a Gutenberg Bible. This is probably the first book ever printed with movable type. The first printed Bible signals the great humanist movement of the Renaissance, that blend of learning and artistic genius that was the cradle of the modern world. Gutenberg Bibles are the first examples of a new art form, and the edition printed in Mainz probably consisted of between 150 and 180 copies on paper, of which thirty-four are known today, and as many as thirty on vellum, twelve of which still exist. At the time of the Hoe sale in 1911 there were seven Gutenbergs in the United States, five of them on paper, two on vellum. Only one copy had appeared at auction in the New World, and it had fetched $14,800 at the AAA in 1891 (that would be $326,000 now).

The Hoe Gutenberg was expected to break that record, and if it did so, the Anderson firm would really be on the map. For a start, Hoe's Bible was on vellum and was described as "the handsomest and most richly decorated Gutenberg Bible in existence." It was, says Towner, peppered with painted capitals and illuminated initials, and many pages had decorations—or "drollery"—in the margins: birds, fruit, monkeys and monsters. Hoe had bought it for $25,000 ($551,000 now) from none other than Bernard Quaritch. This made it the most expensive book ever sold, just ahead of the $24,750 Quaritch himself had paid in 1884 for the Mainz Psalter.

The bidding started at $10,000. This was signaled by G. D. Smith with a wink. Smith was forty-one at the time of the Hoe sale. Book buying was one of his two passions (the other was racehorses), and he had spent a fortune in the previous decade buying one literary rarity after another. He had even evolved a plot to "manipulate" the book market. This hadn't proved possible, but his activities, combined with Swann's, had certainly helped to glamorize book collecting. It was through him that Henry Huntington had started collecting. Smith's bald head, thick mustache and wink were well known at the Anderson. The bidding rose rose rapidly after this to $21,000, then slowed. At $30,000 Quaritch dropped out. At $40,000 Henry Huntington followed him. Smith, Wesley Towner tells us, looked unperturbed and carried on. At $50,000 even Widener had had enough and the hammer fell. Audiences were not as restrained in those days as they are now and voices rang out across the salesroom. "Who's the buyer?" After a moment's pause

the auctioneer announced that Mr. Henry E. Huntington of California was the man who had just doubled the world record for a book. Smith's bidding had been a charade, a device to confuse Widener about who his rival was. Amid applause and whistles, Huntington heaved his frame out of his seat and took a bow. Fifty thousand dollars in 1911 would be $1.009 million now.

The Bible captured the headlines but there was still the rest of the sale to go. Not the least extraordinary aspect of the Hoe auction was the length of time it lasted; the seventy-nine sessions took more than eighteen months to complete. "Each time the hammer fell," says Towner, "the fame of the Anderson Auction house grew a little more." Eventually the end was reached at Thanksgiving in 1912. G. D. Smith had spent nearly a million, either for Henry Huntington or on his own behalf. But the overall total raised by the sale, $1,932,056.60, was even more impressive. Fifty years later, the Streeter sale would "beat" the Hoe sale by raising $3,104,982.50, but in present-day values it didn't come close: the Hoe sale fetched $37,864,845 at 1992 values; the total achieved by the Streeter sale would today amount to $24,957,311. Not until 1990, when the Bradley Martin collection fetched $35,719,750, would the Hoe sale be overtaken in real terms (that figure would now be $39,657,125). It was the longest-standing record in the art market.

At the Hoe sale, Swann's song was heard. Books were now as valuable and as glamorous as pictures, and millionaires were just as interested in them. Equally important in its way was the fact that Kirby and the AAA now had a serious rival.

II | VOLLARD'S PARIS, CASSIRER'S GERMANY

The early years of the twentieth century were dominated by two artistic movements in Paris. At the Salon d'Automne of 1905 the works of Matisse, Vlaminck, Derain and Rouault were hung together. Their pictures, full of distortion, violent color ("water was pink; flesh was green") and flat patterns, created a furor no less marked than that which had greeted the Impressionists. A critic dubbed them (derisively, of course, as was the practice with new artistic movements in Paris) Les Fauves, the wild beasts. The next year Dufy and Braque exhibited with the beasts, but the year after that, 1907, saw the birth of Cubism. In that year Braque submitted to the Salon d'Automne six Cubist landscapes that he had executed in L'Estaque. He had gone south to reinterpret the landscape that had once captivated Cézanne. The salon rejected Braque's pictures. Although Matisse and other artists managed to get two of them accepted later, Braque took umbrage and withdrew them all.

In short, despite the eventual success of the Impressionists, it was no easier for new artists to be accepted in the official circles of Paris. An alternative channel was still needed, one that was naturally filled by dealers. Just as the Impressionists had attracted a raft of commercial galleries, so too did the Post-Impressionists, Fauves and Cubists. Ambroise Vollard, the most famous of this generation of dealers, handled both Impressionists and Post-Impressionists, and was especially fond of Cézanne. Born in 1867 on the French island of Réunion, he was the son of a notary, and had been sent to

Paris to study law. However, he shared the temperament of his grandfather, who had regarded Ingres as "divine," and he joined the art world as a dealer.

Vollard arrived on the scene much later than Durand-Ruel or Georges Petit, but in its day his gallery on the rue Laffitte became an institution. Here Cézanne, Matisse and Picasso all received their first one-man shows. Vollard sat for Renoir, Redon, Rodin, Bonnard and Forain (see figures 34–37), and his gallery was far more than a mere shop. Indeed his *cave* downstairs, where he gave his dinner parties, was just as famous. People came not for the food—the menu was always the same: chicken curry, the national dish of Réunion—but for the company. This varied, although Forain, Redon and Degas were regulars. Though not as well remembered as an artist as, say, Degas or Redon, Forain in particular seems to have been a formidable conversationalist. Seated next to an old lady at one of Vollard's dinners, Forain fixed the seventy-year-old with a glare when she begged him to talk to her of love: "After a certain age, madame, love is an obscenity."

As the dinners implied, Vollard was part of the cultural life of Paris, not just the art trade. He knew Apollinaire, Mallarmé and Zola. Toulouse-Lautrec, who once called on him while the dealer was out, drew a silhouette of himself on the back of a Bonnard by way of a calling card. Vollard's long-term contribution was his support of Cézanne and van Gogh, and his memoirs detail his unsuccessful attempts to have the former's pictures accepted by the Musée Luxembourg. At first Vollard had wanted to work for Georges Petit, but he was given short shrift in an interview that consisted of five sentences. Thereafter he came to an arrangement with Alphonse Dumas, a "dilettante painter" who opened a picture gallery called Union Artistique. Dumas's idea, wrote Vollard, was not to make money but to balance the expense of his own painting by the profit to be made out of selling others' work. Dumas did not want to be considered a dealer. "It's not a shop I've opened," he maintained; "it's a salon."

After an initial fallow period, the gallery began selling works, but they were pictures by artists who are all but forgotten now: Debsat-Ponsans or Quinsac, for example. Once, when he chanced to acquire some paintings by Manet, they sold very quickly, but Dumas resolved never to buy Impressionists. Vollard, who was not being paid much and says he lived on ship's biscuits because they were cheaper than bread, decided to move on. To start out on his own, he was forced to deal in the few paintings he had already collected. His very first deal on his own account showed that he already had a grasp of the psychology of art collecting. As soon as the customer started to haggle, on a drawing by Forain, Vollard *raised* the price. It worked and he was launched. He had a "friendly" banker—friendly in that he lent Vollard money at all, less friendly in that the interest charged was 150 percent.

Still, in 1893 the man from Réunion was able to move from Montmartre to the rue Laffitte. He started at number 39, later moving to bigger premises at 41.

Now Vollard met Manet's widow, Degas and Père Tanguy, in whose shop he came across Cézanne. Later the dealer said that when he first saw this artist's work it was as if he had been "hit in the stomach." This may well be true, but it also appears that he had listened carefully to Pissarro and learned that most of the other painters, with the notable exception of Puvis de Chavannes, thought Cézanne was the greatest artist among them; and that he was the only painter not to have his own dealer.

In his prime Vollard was a print publisher as well as a dealer, and the collectors who bought from him included Isaac de Camondo, Denys Cochin, Chauchard (owner of the Grands Magasins du Louvre), Albert Barnes, Henry Havemeyer, and Claude Monet (who bought three Cézannes and looked, according to Vollard, "like a typical gentleman-farmer").

Though he was au courant in artistic and literary matters, Vollard did not involve himself in politics. It was a time when there was no shortage of political issues to inflame people—the Dreyfus affair, anarchism, uneasy Franco-German relations, assassinations in Russia—but Vollard's memoirs show him to have been consummately tactful and a near-genius when it came to defusing potentially inflammable situations. No doubt this quality helped account for his success as a dealer.

Vollard's character was in marked contrast to that of Félix Fénéon, a uniquely French figure, a dandy and aesthete, an intellectual, a communist and art dealer who regularly appeared in a silk top hat, a purple suit, dark red gloves and patent-leather shoes (see figures 40–43). Passionate about art and literature, he was oblivious to music and food and would frequently dine on chocolate and cheese in his office. He typified Baudelaire's dandy exactly in that "he did not aspire to money but was perfectly content with limitless credit at the bank." Fénéon was born in Turin in 1861, the son of a ribbon salesman from the Charolais in Burgundy who had gone to Piedmont to seek his fortune. Fénéon's upbringing was dominated by the Franco-Prussian war and "that terrible year" of the Paris commune. Educated at Cluny, he took the examination for the War Office and came in first. At the War Office he had access to much sensitive information, but his sympathies were already formed, and some of his earliest writings, published anonymously in anarchist reviews, contained information that had come across his desk. Little magazines thrived in Paris at the end of the nineteenth century, and soon Fénéon became the chief editor of *Libre Revue* and started to become known.

He was particularly attracted by Symbolism. He collaborated on the first Symbolist manifesto and, says Joan Halperin, was a member of the group

that called itself La Courte Échelle (A Leg Up) and met every Monday night at the Café Voltaire in the place de l'Odéon. But it was at the Brasserie Gambinus, on the avenue de Médicis in the Latin Quarter, that Symbolism was really born, and Fénéon became its éminence grise, known to everyone as the Prince of Irony. He also took up with what he called the Neo-Impressionists—Seurat, Signac, Henri-Edmond Cross, and Maximilien Luce. Fénéon's championing of Seurat did not always win him friends—he wanted to establish a "scientific aesthetic," and his prose style, with its short, jerky sentences, was difficult, though it did make him well known in Paris. But what made him famous throughout France, indeed throughout Europe, was something quite different.

Baudelaire once said of the dandy in general that he might commit a crime, "but never in some trivial cause." In other words, it would be a political rather than a petty offense. On April 25, 1894, Fénéon, then working in the War Office, was arrested for leaving a bomb—dinitrobenzene, ammonium nitrate and bullets packed into a flowerpot—on a windowsill of the famous restaurant in the Hôtel Foyot. (It was the favorite spot of the Prince of Wales, who was in town that week.) The bomb caused a lot of damage but severely injured only one diner. Detonators and other explosive chemicals were found in Fénéon's office, and he was duly tried in August of that year. In prison awaiting trial, he became a celebrity; Maximilien Luce made a series of lithographs of him in his cell or taking exercise in the yard. These images were enhanced by the fact that at times Fénéon cut a sinister figure; he had deep-set, brooding eyes and a wispy Fu Manchu beard, as a result of which he was variously likened to Rasputin and Mephistopheles. His bomb—if indeed it was his—was not the only anarchist outrage of the time, and he was tried with eighteen other "militants" and eleven "thieves," all "anarchists," in what became known as the Trial of the Thirty. Twenty-seven of the thirty, including Fénéon, were acquitted. Anarchism never again achieved the same prominence in France, partly because some of its aims were more effectively co-opted by the labor movement. But now Fénéon had a particular kind of celebrity: aesthete, dandy, man of violence. If nothing else, he had the ability to shock.

He certainly shocked his many friends when, in November 1906, he joined Bernheim-Jeune as an art dealer. He had been introduced to the owners of the gallery by Félix Vallotton, the painter, who had married into the Bern-heim family. The plan was for Fénéon to have a gallery of his own, next to the Bernheim-Jeune building, devoted to contemporary art—by which was meant Signac, Cross, Luce and Théo van Rysselberghe, as opposed to Bon-nard, Denis and Vuillard, who were already "established." Signac was among those most surprised at Fénéon's move. Joan Halperin quotes a letter

he wrote Charles Angrand: "Fénéon has joined Monkey-nut Bernheim. I can't work up much enthusiasm about it; I don't see our friend winning out over the boorishness of those industrialists. But the struggle will be interesting. He is suggesting I have an exhibit in January."

Signac changed his tune quickly. On the first day of his show he sold "11,000 francs worth (eleven thousand!)—canvases going for 30 to 2,500." Eleven thousand francs in 1906 would be $45,800 now.

Fénéon was in fact a definite boon and friend to the painters because he arranged contracts for them so that they could concentrate on painting while he hustled their work. He did this for Signac, Cross, van Dongen and, most significantly, in 1908, for Matisse. Matisse was exceptionally touchy, and Fénéon, according to Joan Halperin, in her biography of him, "took particular pains to make the written document conform to the painter's demands." The painter was paid when he left his pictures at the gallery, but he also received a commission when they were resold. It was an arrangement that must have worked, for Matisse was with the gallery for twenty-nine years (Bonnard was there for forty). Fénéon received a salary from his employers, plus a commission on what he sold. At first he received 500 francs a month, later on a thousand, half of which he gave away to a family in need. By 1912 he was earning 19,000 francs a year ($74,000 now). He worked hard, traveling conscientiously to Britain, Germany and Scandinavia to help ensure an international clientele for his artists and always keeping on top of details. He was charming and a good salesman, with as much interest in exhibitions as in sales. He also published a bulletin in the back of the Bernheim catalogues, in which he provided news of painters and writers. Business boomed; the street at the side of the gallery, the rue Richepanse ("Richpaunch"), was well named. It is ironic that for all his hard work and conscientiousness, the Prince of Irony never shook off the image that he was a dandy, "an idler and lazybones." He worked for Bernheim for a quarter of a century and helped to forge its reputation, not to mention its fortune, yet the abiding image in the minds of many who recalled him in later years (he lived until 1944) was of someone who always had to be "coaxed" into the office by being fetched in a taxi.

The abiding image that most people have of Daniel-Henri Kahnweiler is probably Picasso's 1910 portrait of him (see figure 39). This is a fully fledged Cubist work, and Kahnweiler was, above all, the Cubists' dealer. "What would have become of us," said Picasso, "if Kahnweiler hadn't had a business sense?" The dealer's place in the history of art is symbolized by the fact that he was portrayed not only by Picasso but by Derain, van Dongen (see figure 38), Juan Gris, André Masson and André Beaudin. He was not a literary figure like Fénéon, but more in the mold of Vollard or Durand-Ruel.

However, he had a far more tragic life than either of them. Born in 1884 in Mannheim, Kahnweiler encountered German anti-Semitism as a boy but found solace in art; he was passionate about museums. It was, however, his precocious talent for languages that would give him eventual freedom. By the age of fifteen, he was fluent in French and good in English. His family were well off and not unsophisticated. There were uncles in banking in London; he visited them and also went to Paris. London was prosperous, but the whole country, he said, "felt like an office." Paris on the other hand was filled with art and artists. In Paris he saw Claude Debussy's *Pelléas et Mélisande* seventeen times.

Kahnweiler's family had arranged a job for him in a bank. He was bored by it, and the memory of Paris was still magical. His background had given him a certain character: he was in some respects rather stuffy, according to his biographer Pierre Assouline, an élitist where art was concerned, with some notable blind spots (he hated Gauguin's work). During his trips to Paris, however, he made some discoveries. On a visit to Durand-Ruel's gallery, where he went to look at an exhibition of thirty-seven of Monet's views of London, he witnessed two coachmen screaming at the picture in the window and threatening to break the glass, believing the art to be rubbish. Thereafter, he knew that if a modern painting is original it will inevitably shock. But he also observed that despite its shocking nature, or perhaps because of it, contemporary art was booming commercially. For instance, one painting by Monet had sold for 100,000 francs ($414,000 at today's values). More important, perhaps, in February 1904 André Level had set up in Paris an organization called La Peau de l'Ours (the Bearskin), whose subscribers paid 250 francs a year ($885) on paintings. Each subscriber kept a share of the paintings to enjoy for ten years, but then they would be sent to Drouot and sold. It was a way for the subscribers to enjoy art, to help artists, and to make money. Kahnweiler was fascinated and decided that he would be an art dealer.

His father, says Assouline, was furious but the uncles in London proposed that he meet their own dealer. This was Samson Wertheimer, who specialized in the works of Gainsborough, Lawrence and Reynolds, hardly pictures of the kind Kahnweiler enjoyed. The interview was tense as Wertheimer posed the young man his first question: "At the National Gallery which artists do you like?" Kahnweiler actually preferred Velázquez, but, with the coachmen in mind, chose to shock the older man. "El Greco and Vermeer," he said (in those days, neither had really been accepted). Wertheimer put his second question: "But whom would you sell?" "Vuillard and Bonnard," replied Kahnweiler promptly. "Never heard of them," Wertheimer said. Kahnweiler assumed that the interview had been a disaster, but he was wrong. His uncles

gave him £1,000 ($103,500 now) and a year in which to make a go of it. It was understood that if he failed he would go to South Africa as the representative of the family firm. He opened his gallery in 1907. The rue Laffitte and rue Le Peletier were by now identified with the art of the nineteenth century, and Bernheim, Fénéon and Druet had opened up around the Madeleine, where there were some very chic shops and call-girl hotels. Kahnweiler found premises at rue Vignon. After the torment of his interview with Wertheimer and the wait for his uncles' go-ahead, he started in Paris very quickly. In this he was lucky, for in the early days Kees van Dongen walked in through the door and offered some paintings. Kahnweiler also formed early friendships with both Braque and Matisse, whose studio on the quai St.-Michel he often visited.

By the time Kahnweiler opened up, the art world in Paris had expanded and evolved. Durand-Ruel, Georges Petit and Vollard were still there, as were Clovis Sagot (a former clown, an early admirer of, and dealer in, Picasso), Père Tanguy and Berthe Weill. Eugène Druet, who had started as Auguste Rodin's photographer, had opened his own gallery a couple of years before. But the atmosphere in Paris was what was most important. It was an exciting time to be an art dealer because there was a lot of fresh, good art and no shortage of good customers. As in the 1980s, some of them were collectors, some speculators. Kahnweiler was strong on the history of art dealing and was familiar not only with patronage but with speculations in art. He would point out that investing in art had existed in seventeenth-century France, when the Marquis de Coulanges said that "paintings are as valuable as gold bars." In the eighteenth century, Baron Friedrich von Grimm had noted in a letter that "purchasing paintings for resale was an excellent way to invest one's own money." In short, Level's Bearskin was nothing new.

Gradually, Kahnweiler became known for his sympathies for the avant-garde, and people like Roger Fry, Clive Bell and Wilhelm Uhde gravitated toward the rue Vignon. Kahnweiler also became part of Picasso's inner circle. The Spanish artist had arrived in Paris in 1900. In the intervening years he had produced the works of his Blue and Rose periods, and, with Braque, had produced the first Cubist works in 1907, the very year that Kahnweiler opened his gallery. Cubism in general and *Les Desmoiselles d'Avignon* in particular were for Kahnweiler what Leo Castelli would later describe as an epiphany.

Now began what Pierre Assouline calls "the heroic years." Kahnweiler's business sense enabled him to pay stipends to his artists, much as Fénéon was doing, and in return he was given exclusive access to their work. Among the artists he paid in this way were Vlaminck, Derain and Braque. Every day he would make a tour of "his" studios—not to check that the artists were hard

at work, but partly as a constitutional, partly to lend them moral support. He didn't open the gallery until 2:30 P.M.

Sometimes the artists returned the visit. Derain and Vlaminck played chess in the gallery, and one day they all dressed up as workmen, in rough clothes and caps. "Boss," they announced, "we've come for our pay."

Among the collectors who frequented the rue Vignon were Max Jacob, the Russians Sergei Shchukin and Ivan Morozov, now moving on from Impressionism, Vincenz Kramar, a Czech art historian, and Hermann Rupf, who occupied a special place in Kahnweiler's life. Together they would speak German and visit the Café du Dôme on the corner of the boulevards Raspail and Montparnasse. This was where the German community in Paris congregated; they called themselves dômiers. Rupf was in fact Swiss but the two men had met in Frankfurt when both worked in the same bank. Hermann, or Mani, as he was known to Kahnweiler, developed into one of the most adventurous German collectors.

——

In Germany the art market developed later than elsewhere but once it started it grew quickly. Its shape, however, was different from that of the art market in France. To begin with, art enthusiasts did not collect for themselves, via dealers, but instead belonged to art unions, associations of people who bought pictures for display in such public galleries as the Hamburg Kunsthalle. Until the 1840s, Düsseldorf was the center of the German art world, but this mantle subsequently passed to Munich (there was even a thriving trade between Munich and Australia in the 1860s), and Berlin did not take first place until the 1880s. By then most of the regional governments of Germany had been convinced of the need to include art funds in their budgets, and this had two commercial effects. First, there occurred the "museums race," as it was called, which drove up prices in the late nineteenth and early twentieth centuries (Manet's *Breakfast in the Studio* was bought by Georg Schmidt-Reissig for the astronomical sum of 240,000 marks). Second, the number of painters soared, from 8,890 in 1895 to 14,000 in 1907 (Adolf Hitler was one, registered as both artist and architect). This official policy had its drawbacks, but it promoted the art market in much the same way that President Pompidou's initiatives did in the 1970s in Paris. It also helped the rise of German Expressionism.

Before about 1890 German taste was for well-finished, meticulous paintings, but under the influence of Impressionism and a rising Anglomania, pastels and watercolors became more popular and less linked to feminine dilettantism. Tourism was also a factor in the German art market, as it was in Paris, and until the 1893 World's Columbian Exposition in Chicago

(which shifted American taste to French art), many buyers in Germany were American. Even though trade declined thereafter, a gallery like Heinemann, whose archives have been examined by Robin Lenman of the University of Warwick, earned 230,000 marks between 1902 and 1912 from Chicago customers alone.

In 1850 Berlin had only a handful of commercial galleries, though Goupil was there, "fishing for talent." By 1871 there was a "very perceptible" competition between the art unions and the trade, and by 1896 E. A. Fleischmann, the Munich dealer who handled Bonheur and Meissonier, could celebrate his twenty-fifth year in business by selling his ten-thousandth picture (that's four hundred a year, more than one a day). In the early years of the twentieth century, Heinemann moved to grander premises in Munich, from which the firm shipped objects to the United States, the Near East and even to Russia.

The Germans had not been especially interested in Impressionism but were much more taken with the next generation of artists, especially van Gogh, and this was thanks to the efforts of a Berlin dealer, Paul Cassirer (see figure 45). Just as the descendants of the Brame, Bernheim and Wildenstein families are still active in the art business today, so is Paul Cassirer's descendant, Walter Feilchenfeldt, who runs a gallery in Zurich and is an authority on van Gogh. He has written most of what is known about Cassirer. Paul Cassirer's features were dominated by his close-cropped hair, which made him appear younger than he was. He had started in business in 1898, when he formed an art gallery and publishing house with his cousin Bruno. They separated in 1901. Bruno took the publishing house (and the periodical, *Kunst and Kunstler,* which he edited). Paul kept the gallery and became secretary and managing director of the Berlin Secession, a group of artists, led in Germany by Max Liebermann. Secession artists resigned from the official academic bodies to forward the aims of the various (though usually Impressionistic) modern movements.

In Germany at that time the leading modern dealers were Ernst Arnold and Emil Richter in Dresden, Brakl and Heinrich Thannhauser in Munich and the Frankfurter Kunstverein. But Cassirer seems to have had the edge, no doubt as a result of his position at the Berlin Secession. According to Feilchenfeldt, he learned about van Gogh from two people. Walter Leistikow, an artist and member of the Secession board, was enthusiastic about some generally despised foreign artists—Manet, Monet, Cézanne, Gauguin and "a Dutchman about whom nobody has ever heard anything: van Gogh." Cassirer's second source was Walter Leclercq, a French writer, critic and art dealer who knew Johanna van Gogh-Bonger, Theo's widow and therefore Vincent's sister-in-law. She had inherited all of van Gogh's 550 paintings

apart from the three that he sold in his lifetime. Leclercq organized exhibitions in order to stimulate an appetite for van Gogh, and when he died in 1901 Cassirer took over. Between then and the outbreak of World War I, he organized ten van Gogh exhibitions. He formed a close association with Johanna van Gogh-Bonger, who was herself assiduous in developing the van Gogh market, and he also published Vincent's letters in Germany. When Julius Meier-Graefe published his ground-breaking *The History of Modern Art* in 1904, which gave fifteen pages to van Gogh, most of the pictures illustrating this essay had passed through Cassirer.

As Meier-Graefe's book suggests, by this time Germans were keen collectors of avant-garde works. Among them were Walther Rattenau; Dr. Max Linde, a Lübeck eye specialist; Joseph Feinhals, a Cologne tobacco merchant who had his villa decorated by Kirchner; and the Pelikan Pen manufacturer, Fritz Beindorff. As for dealers, Commeter in Hamburg dealt with Munch, and Richter & Gutbier in Dresden showed Die Brücke artists, as did the Tietz department store in Düsseldorf. It was in this city that Alfred Flechtheim opened his gallery in 1913, showing French and German avant-garde work. In Munich, Kandinsky dealt with Brakl, with Goltz and with Thannhauser. But the most popular dealer, Cassirer apart, was probably Herwath Walden, a sort of German Fénéon who nursed potential patrons, fielded problems, organized publicity and assiduously shuttled pictures around the exhibition circuit as far afield as Hungary and Oslo, all for a commission of 10 to 15 percent, much less than the 20 to 30 percent on which galleries like Goltz insisted.

Of course Cassirer was by now identified with van Gogh as well as with the Berlin Secession painters and according to Walter Feilchenfeldt, his collectors included Hugo von Tschudi, the director of the Berlin National Gallery and the man who used his own money for acquisitions until he fell out with the Kaiser, Robert von Mendelssohn, Julius Stern, the artist Carl Moll, E. Thiel from Stockholm, Karl Ernst Osthaus and Count Harry Kessler.

The very first entry in Cassirer's stockbook, Feilchenfeldt says, was listed as *Portrait of a Man.* This picture had been sold by Johanna van Gogh-Bonger in August 1897 to Ambroise Vollard, who in turn sold it to Mogens Ballin, a Danish painter. Cassirer bought the painting from Ballin and sold it to Kessler, a Prussian aristocrat who was the patron of Munch, Maillol, George Grosz and Die Brücke. Kessler sold the picture to the Galerie Druet in Paris in February 1910, and they sold it to the Städtische Galerie in Frankfurt the next year. The gallery deaccessioned the painting just before World War II, when it was acquired by Siegfried Kramarsky. *Portrait of a Man* was in fact *Portrait of Dr. Gachet.*

Important as he was to the van Gogh market, Cassirer was in Berlin, and

Berlin wasn't Paris, which was still the leading city in the art world. Apart from dealers, there were crucial tastemakers there, writers and aesthetes who were uniquely placed to spread the word about modern art. In Paris the great salon of those years, the years of Fauvism, Cubism and Tubism (the name given derisively to the works of Léger), was that held by an extraordinary entourage of four Americans. This was the Stein family.

Gertrude, Leo, Michael and Sarah Stein were a "fearsome foursome," a unique family unit that claimed, often and vociferously, to have discovered modern art. Aline Saarinen tells us that the most vituperative wrangle was over who had first discovered Matisse and bought *Woman with a Hat* at the 1905 Salon d'Automne. Gertrude claimed the honor as hers. Sarah said that *she* had bought it, that she loved its magnificent color and the fact that the woman beneath the hat reminded her of her mother. Leo *did* discover Picasso. He knew Clovis Sagot, the former clown who had started up as an art dealer on the rue Laffitte. During one of their regular discussions about modern art, Sagot had directed Leo to an exhibition of Picasso's drawings and he had bought one.

Both Leo and Gertrude fell heavily for Picasso's art and bought many works of his Blue and Rose periods. They also liked him personally, Gertrude sitting for him as many as ninety times for the portrait of her that is now in the Metropolitan Museum in New York. Gertrude wrote later that, herself apart, she had known two geniuses in her life, Alfred North Whitehead and Picasso. Meanwhile Sarah had formed an alliance with Matisse, who, we are told by Saarinen, regarded her as the "really intelligent, sensitive member of the family." In 1906, she and Michael, her husband, returned to their native San Francisco to see what effect the earthquake had had. Despite the gloomy reason for their trip, they did not travel empty-handed; a load of Matisse canvasses accompanied them, for they were hoping to influence taste.

The Stein family had grown up amid chaos and sophistication in Pennsylvania, Vienna, Paris, San Francisco and Baltimore; both parents were dead by the time Gertrude was seventeen. As the eldest, Michael took over, seeing to it that, like himself, Leo went to Harvard, and that Gertrude went to Radcliffe (where she studied under William James and met Bernard Berenson). Gertrude and Leo were already a "dubious duo" in Cambridge, but later, after going their separate ways for a while (Gertrude unsuccessfully studied medicine at Johns Hopkins), they rendezvoused in Paris in 1903 and she settled into Leo's flat there. In Paris they were no less conspicuous than in Cambridge. In those early days, Ms. Saarinen says, Leo's face was "smothered in a rabbinical beard." Gertrude had a "massive, monolithic body," and

both wore sandals, which, in Gertrude's case, allowed her toes to stick out "like the prow of a gondola." The sandals and the toes annoyed and disturbed the manager of the Café de la Paix to such an extent that he refused to allow the Steins in the place. Hardly less appetizing was the brown corduroy in which both brother and sister were invariably clad. According to Berenson, this gave Gertrude a singular effect. "Her apparently seamless garment made her look like the proto-Semite, a statue from Ur of the Chaldees. I was always in trepidation that it would someday fall down."

Berenson did not really like the Steins. Though their aesthetic interests were real enough, they were much coarser and far less fastidious creatures than he. Nonetheless, it was Berenson who recommended Ambroise Vollard to Leo, and it was at Vollard's that Leo was introduced to the works of Cézanne. Leo Stein's conversion to Cézanne was immediate.

This interest flourished and became known, throughout Paris and beyond it, owing to the Steins' Saturday salon, which took place every week from 1903 to 1910 at 27, rue de Fleurus. These salons were an expression of the Steins' desire to show off and to have others take them as seriously as they took themselves. There was decent food—and plenty of it—but the chief attraction was the paintings, which hung close together in two or three tiers. Soon everyone was coming to see them. According to Aline Saarinen, Apollinaire brought his friend Marie Laurencin, whose "deep, narrow, black eyes" looked exactly like those in her own pictures. Picasso, in those days "a good-looking bootblack," brought Fernande Olivier and met Matisse for the first time at the Steins' in 1906. Derain, Vlaminck and Braque were regulars, as were Vollard and Kahnweiler. So too was Edward Steichen, a fellow American who was to devote his life to photography but would also be a crucial conduit in carrying modern art across the Atlantic.

The Saturday salons made the Steins famous (Picasso would come to regard Gertrude as his "only woman friend"), but in 1910 the atmosphere changed with the arrival of Alice B. Toklas. No doubt it was inevitable. Leo was in the midst of an intellectual crisis. He hated Picasso's Cubist experiments, and was perplexed by and jealous of Gertrude's own writing. When the break came, Gertrude remained at 27, rue de Fleurus and kept most of the Picassos and half the Cézannes. Leo took the Renoirs and his half of the Cézannes to the United States. He was keen to get to New York to try Freudian treatment for the three complexes from which he was now convinced he suffered: an inferiority complex, a castration complex and a pariah complex. The seriousness with which he took himself was becoming farcical.

Gertrude continued as before, but she was writing more and becoming, in the words of one hanger-on, "the mother goose of Montparnasse." Her

massive bulk, her strong presence and the open nature of her salons acted as a magnet for the collecters who trooped through Paris.

After he decamped to America, Leo Stein's influence on the art world declined. Gertrude, however, retained her force. In 1912 her first writings were published in America. These were her portraits of Matisse and Picasso, which appeared in a journal edited by a man who was to spawn the spectacular exhibition that introduced modern art to the United States. It was a show that would change American taste for all time, that would eventually cause modern art to rival Impressionism in the salesrooms, and that in the long run would leapfrog New York over Paris as the art capital of the world. The show was the Armory Show of 1913; the magazine in which Gertrude Stein's portraits appeared was *Camera Work,* and the editor/dealer/entrepreneur/ impresario/photographer was Alfred Stieglitz.

12 | SOTHEBY'S FIRST OLD MASTER

In the early years of the new century, the leading auctioneers of the world played second fiddle to the dealers. In 1901, Raphael's Colonna Altarpiece was sold to J. P. Morgan for a record £100,000 ($10.4 million now), and Van Dyck's Cattaneo family portraits went to P. A. B. Widener in 1906 for another world record, £103,300 ($10.75 million). But these were private sales, made through Sedelmeyer and Knoedler respectively. In the salesrooms there were good collections—the Marquand sale (of every type of object under the sun) at the AAA in New York, for example, and some interesting relics at Christie's in London (Shakespeare's walking stick, a cup given to Nelson by Emma Hamilton, Oliver Cromwell's baby clothes). But for the auction houses the first real development of the twentieth century didn't take place until 1908, when Sotheby's was sold.

Tom Hodge had taken over from his father, Edward, in 1895 and had increased net profits from £6,076 ($685,500 now) in that year to nearly £17,000 in 1907 ($1.75 million now). However, when Edward died in that same year, he left no will, and Tom Hodge, who was not in good health himself and needed to pay his siblings their share of the inheritance in cash, was forced either to find a buyer for the firm or to merge it with another. While he was combing London for a "white knight," he encountered Montague Barlow (see figure 49), a barrister and the brilliant son of the Dean of Peterborough. Hodge, says Frank Herrmann, the official historian of

Sotheby's, looked upon Barlow as an intermediary, a man delegated to find a buyer for Sotheby's. However, the more Barlow looked at the firm, the more he liked what he saw. He ended up by putting together a small group of three backers, of which he himself was the principal. It took pluck for Barlow to abandon his profession at forty-one for an occupation that was so obviously "trade," but Barlow had a twofold vision. Sotheby's was to provide him with the financial wherewithal to enter Parliament (he did so two years later as the Conservative member for South Salford, the borough for which an Agnew had once been mayor); second, as his widow told Herrmann much later, "He was determined to make the art auctioneering business in London a gentleman's business for gentlemen. . . . I remember one of his friends in society saying: 'Oh, *he's* an auctioneer!' He was resolved to remove the slur of the auctioneer business."

At this stage, dealing still had a better ring to it than auctioneering, though there were as many rogues in the galleries as on the rostrum. By 1907, for example, Joe Duveen and Bernard Berenson were well into their partnership, which was considerably less honest than auctioneering was. The first instance of Duveen's dishonesty came about as a result of a 1909 law in Britain that made it compulsory for a company registered there to pay taxes on the profits of overseas branches. Duveen responded by deliberately running down his London company and setting up new ones in Paris and New York. The assets and stock of the London firm were sold for greatly undervalued sums to the new companies. (According to Colin Simpson, stock worth $20 million was valued at $625,000.) What Duveen did in Britain was technically legal, but what was not legal was the undervaluation placed on the works taken to the United States. This might never have come to light except for a junior clerk in the New York office.

The Duveens had used the money they had made from the "restructuring" to buy a lease on the corner of Fifth Avenue and Fifty-sixth Street in Manhattan, where Joe now proposed to build a small version of his favorite building, the Ministry of Marine in Paris. While he and Henry were in Europe looking for fittings for the new palace, the clerk, stung by what he felt was a high-handed ticking off from Ben Duveen (Joe's younger brother), made copies of some of the most spectacular examples of double accounting and sent them, with full details of where the ledgers were kept, to the U.S. Customs. The results were beyond what even the embittered clerk could have hoped for. At 4:00 P.M. on Thursday, October 13, 1910, seven men raided the gallery. At first the staff there thought it was a gang of robbers, but they soon learned the truth when Ben was arrested. As luck would have it, Henry was aboard the *Lusitania,* then anchored in quarantine in the Hudson River. The customs agents took their own cutter to the liner and arrested their second

Duveen in the most humiliating circumstances. Bail was set at $50,000 ($1.01 million now) for Ben and half as much again for Henry.

The case attracted enormous publicity, and not the least diverting aspect of it was the fact, revealed by *The New York Times,* that Henry was the New York customs office adviser and valuer of imported works, and that in the past there had been many complaints about his habit of placing too much value on other dealers' stock and too little on Duveen's own. After a number of plea-bargaining skirmishes, all the Duveens pleaded guilty to three relatively minor undervaluations and were fined a total of $50,000. But that was not the end of it. The customs service commissioned its own valuation of Duveen stock, and this was duly carried out by Knoedler and French & Co., who estimated that over a thirteen-month period from 1908 to 1909 Duveen had evaded duty of $5 million ($102 million at today's values). Customs asked for the usual penalty, twice the amount evaded, but here Joe reasserted his cunning. His firm had many politically important clients, including several senators and even President Taft himself, and he threatened to involve all of these as parties to the action. As Colin Simpson points out, the collector of taxes was himself a political appointee—he was therefore open to negotiation and in due course the assessment was reduced to $1.4 million.

This was a time when conditions in Italy and the United States, as well as the growing stature of art history as a branch of scholarship, combined to produce one of the most venal periods in the art market. Parish priests, nuns, even a mother superior, were convicted of smuggling paintings out of Italy. One dealer gave a ball for border guards (ostensibly to celebrate the coming-of-age of his son, a freight-forwarding agent) on the very night that he spirited a truckload of paintings across the frontier. At times it must have seemed to law-enforcement agencies that the entire art world was corrupt.

Few reputations have suffered such a decline as those of Lord Duveen and Bernard Berenson. In 1952 Duveen was the subject of one of the most celebrated biographies of recent years, by S. N. Behrman. This book, a lighthearted romp around the more entertaining events of Duveen's life, painted him as an irrepressible rogue, a showman who dealt successfully in illusions. "Compared to his clients," wrote Behrman, "Duveen was a child in business, but he almost always had his way with them." Berenson's image was less racy, perhaps, but no less admirable (see figures 61 and 62). He was a fastidious scholar, a friend to aesthetes and literary figures from Edith Wharton to William James; his villa, I Tatti, near Florence, became part museum, part shrine (to B.B. himself), and was bequeathed on his death to his alma mater, Harvard, and became a unique study center. In other words, B.B.'s was apparently a life devoted to scholarship, unsullied by vulgar trade.

The raw truth about both men, however, is more complex and considera-

bly more sordid. The Duveen archives were deeded to the Metropolitan Museum and sealed until the year 2001. Thanks to Colin Simpson's diligence, however, enough has emerged already to show Duveen and Berenson in their true colors. The case of "Doris" is probably the single most revealing aspect of their partnership and of what the art trade had become. The Duveens had a penchant for code names, a habit initiated by Henry Duveen. He himself, says Simpson, was "Zeus," Joel was "Jove" and Joe was "Alexander." (After Joel's death, Joe was promoted to "Jove.") Berenson's code name, "Doris," was hardly Olympian and had in fact been poached from a character in a current Broadway musical because, like Berenson, the character suffered from dyspepsia. But if the reasons surrounding the choice of his code name were trivial, they concealed something sinister. Beginning in August 1912, Berenson's share of the profits on all items of Italian origin sold at Duveen was increased from 10 to 25 percent. Both Berenson and Duveen were bound by extraordinary secrecy in this arrangement; all deals on which the commission was to be paid were recorded in a secret "X ledger," kept by someone known as "X." In fact, Simpson says, "X" was a London firm of chartered accountants who until 1927 were unaware of the identity of "Doris."

Why all this extraordinary secrecy? Two examples of the kind of deal the two parties indulged in should be enough. The first involved a portrait of a young man, said to have been painted by Giorgione. Berenson had come across this picture at the New Gallery exhibition (the one he had "exposed") and had dismissed it as possibly an early Titian, but "probably only a copy." In 1912 the picture had come into the possession of a Florentine dealer named Luigi Grassi, who was also a restorer and forger. He had "treated" the picture and it had "evolved" into a portrait of Ludovico Ariosto by Giorgione. The picture was first sold to Duveen, and then by him to Benjamin Altman; the sordid detail is that Berenson's letter to Duveen suggesting that the work was by Giorgione was, according to Simpson, dated *before* the forger began work on it. Simpson spells it out: "The implication is that Grassi and Bernard were working together. The Metropolitan Museum has recently cleaned the picture and now concedes it to be 'a sad wreck—a ghost.' "

The case of Bertram Boggis is no less sordid. Boggis was a merchant seaman who jumped ship in New York in 1915 to avoid the return trip and a possible rendezvous with a German U-boat. The Duveen firm was advertising for a porter and Boggis applied. Twice he was turned away and twice he rejoined the back of the line, telling a different story at each interview. Duveen was impressed by his persistence, and though Boggis didn't get the porter's job, he was taken on as a commissionaire. Joe took to him and his "bullfrog features"; in return, Boggis honed his skills as a petty criminal. Later on he specialized in obtaining bootleg whiskey for Duveen's favored

clients, but before that he had, with the help of Duveen funds, developed an unsavory network of contacts among the servants, junior staff, valets and bell captains who worked for rich collectors, for the hotels where they stayed, or for the dealers who were Duveen's rivals. Everything from the contents of Mellon's wastepaper basket when he was Secretary of the Treasury to summaries of telephone conversations overheard by hotel operators was sent to Boggis. Colin Simpson describes the most unsavory episode of all, when Boggis produced two Japanese orphans for Carl Hamilton, a rich homosexual collector who liked young boys.

Berenson would have hated to be linked with someone like Boggis. Yet there is no denying that they were both part of the penumbra surrounding Duveen.

Ironically, while Duveen, Berenson and their gang were drumming up trade in a variety of dishonest ways, the market was improving dramatically of its own accord. Indeed, the four years between 1910 and the outbreak of World War I saw a major boom in the art market, culminating in 1913, which in terms of both taste and prices was to be the first of three "miracle years" in this century (the others being 1928 and 1989). Old Masters were still setting most of the records; Raphael's Cowper Madonna (also known as the Panshanger Madonna) went to Widener in 1913 for £116,500, and in 1914 the czar bought Leonardo da Vinci's Benois Madonna for a staggering £310,400 ($30,630,000 today). But the Impressionists were making good headway too; in 1912 Louisine Havemeyer paid $95,700 for Degas's *Dancers at the Barre,* a world record for a painting by a living artist. Paintings by Hals, Rembrandt and Mabuse also fetched huge sums.

Small wonder, then, that Montague Barlow should now think of moving Sotheby's west, from Wellington Street to bigger premises in New Bond Street. Or that when he literally stumbled across some paintings "stacked up in a half-lit corridor" at Wellington Street, as Frank Herrmann put it, he should decide to dispense with the traditional practice whereby his firm passed any paintings it had on to Christie's, and in return Christie's sent Sotheby's any books that came its way. In fact, the pictures Barlow stumbled across had been sent by mistake, but instead of returning them, he took them out into the light for a proper inspection.

Pictures had never been an important part of Sotheby's business. A brief flirtation had been abandoned fifty years earlier; since then such paintings or prints as had been sold had been tacked on to other sales. As it happened, the paintings that Barlow bruised his shins on in that murky corridor included no stars, but would provide the respectable bulk of a very decent sale.

The star was provided quite fortuitously, in the summer of 1913, when a Frans Hals portrait belonging to Lord Glenusk, an eminent book collector, arrived at Wellington Street. Hals had been doing well recently. Duveen had paid £30,000 ($3.1 million now) for *The Artist's Family,* the National Gallery in London had paid almost as much for *The Burgomaster's Family,* and Charles Yerkes had sold *An Old Woman* to Duveen for £28,250, which had then been bought by Frick for £31,000. Lord Glenusk's Hals was therefore particularly eye-catching, but this wasn't the only reason 1913 proved such a watershed for Sotheby's. By another extraordinary coincidence, two other Frans Hals portraits were offered for sale at Christie's on the very day of the Sotheby's auction. It was the first head-to-head contest between two firms that had avoided such rivalry before.

The Sotheby's picture was actually the best of the three, though when Lord Glenusk had bought it at Christie's in 1884 it had cost him a mere five guineas (and an anonymous Flemish still life had been thrown in for good measure). The sale in June 1913 was a revelation for Barlow and the Sotheby's staff. Though they may not set records, some lots in an auction nonetheless attract attention because two people want the same object very much, and it soars beyond expectations. This is what happened with Lord Glenusk's Hals. On one side was the famous British collector Sir Hugh Lane, and on the other, Dudley Tooth, a fashionable dealer. The tussle between these two took the bidding to an astonishing £9,000. It wasn't the £30,000 that Duveen had paid for his Hals, but in 1913 £9,000 was the equivalent of $885,500 now, and, like Duveen before him, Barlow saw that there was the kind of money in pictures that simply wasn't there for other objects.

It was to take Barlow several years to attract enough pictures to Sotheby's to enable the firm to believe itself a match for Christie's. Nonetheless, the rivalry between the two firms that is now so intense may be accurately dated to the Hals sale of June 20, 1913.

━

In New York the Anderson moved more quickly into its rival's territory than Barlow did into his—through the Emilie Grigsby collection. Emilie Grigsby was a potent name in salesroom gossip; the mistress of a very rich man, she was a proven liar and an undoubted adventuress. Despite all this—or perhaps because of it—she had acquired an extraordinary collection that should have gone to the AAA when she decided to sell.

Emilie Grigsby's story starts with the extraordinary man in her life, Charles Tyson Yerkes. In the great tradition of American robber barons, Yerkes had a roller-coaster career matched by a complicated and outrageous private life. Born the son of middle-class Quaker parents in pre–Civil War

Philadelphia, he had his own banking and brokerage house by the time he was twenty-four and had married, fathered two children and amassed a fortune to rival Frick's by the time he was thirty. At thirty-five, Wesley Towner reports, he was in prison. Peculation was Yerkes's peccadillo. "In connivance with the Philadelphia city treasurer, Yerkes had been gambling on the stock exchange with city funds." The two men pocketed any profits; the taxpayers swallowed the losses. Yerkes was given two years and nine months, but through the efforts of his loyal wife he was pardoned after seven months and soon set about recouping his lost fortune. While in prison he had not been idle; he had figured out that trolley transportation was "the business closest to the corruption of cities and was therefore likely to provide the quickest and surest profits." He now repaid his wife's loyalty by falling in love with the first of several mistresses. She was Mary Adelaide Moore, and he took her over as completely as he had taken over the Philadelphia city funds by giving her a new wardrobe and a new name, Mara. By now he had an art collection, and in a sense she was part of it. She belonged to him, and it wasn't long before he wanted legal title, so he compelled his wife, the wife who had helped to win his pardon, to divorce him. In those days this was an even worse crime than peculation, and Victorian Philadelphia was horrified; the jailbird was now a jilter. He had no friends other than Mara, no club would have him, and no one wanted his business. He sold his interests and decamped to Chicago.

There, Yerkes began where he had left off in Philadelphia, in horsecars. Life was easier for him than for the new Mrs. Yerkes. An outcast in Philly, she longed for acceptance in the Windy City. Mara might be twenty years Yerkes's junior, but she knew what to do—or thought she did. The couple traveled to several European cities—Brussels, Amsterdam, The Hague, Paris, and London—where the horsecar king bought four Brueghels, four Frans Hals, two Jan Steens, a Clouet, a Meissonier, of course, three Corots and works by Daubigny, Diaz and Millet. Mara, according to Wesley Towner, bought the latest lavender scarves, "half the topaz in Amsterdam" and several pairs of twenty-six-button *peau de soie* gloves. No doubt the spending was soothing while it lasted, but the art wasn't really bought as a collection; like the twenty-six-button gloves and lavender scarves, it was acquired as kit for social climbing. And *as* social climbing it failed. Chicago, the rough sawdust-and-spit capital of the Midwest, was no more open to Mrs. Yerkes than Philadelphia had been to Mara, the mistress. She was trapped.

Yerkes wasn't. For all his faults, he had a good mind. He was now at the height of his commercial power; he had conceived the downtown Loop and had dug the La Salle Street tunnel under the Chicago River. Both were

bringing him millions, but as his fortune rose, so did his unpopularity. His brand of combativeness might be attractive to women, but not to rival tycoons.

To cope with her social rejection, Mara sought comfort in drink. However, her husband's deep unpopularity could not be washed away with gin, and she demanded another move, this time to New York. It was now 1897. Yerkes's franchises had expired in Chicago, and since he was still hated as much as ever, they were not renewed. He acquiesced in Mara's demands. Wesley Towner describes how the seats were ripped out of a Pullman carriage, "the Brueghels and the Meissoniers were laid in rows on the floor" and the train departed for Manhattan. No one saw them off. Manhattan was more cosmopolitan than Chicago or Philadelphia and therefore more anonymous. This suited Mara; in her huge vaulted dining room she took to holding midnight suppers, where the food was more varied than the chicken curry invariably served at the dinner parties in Vollard's *cave* but the company was less distinguished. The anonymity of Manhattan also suited Yerkes, and soon he had a second house, in which he installed Emilie Grigsby.

Over the years, Emilie Grigsby was variously known as Yerkes's ward or his adopted daughter. She was also one of the most celebrated beauties of the day, and she expected to be treated as such. Though she now belonged to Yerkes, she had been admired, it was said, from as far afield as Egypt and Japan; it was also rumored that she had been given a footstool by King Edward VII, and that Pope Leo XIII had given her a lock of his hair. Emilie was a redheaded convent girl, "a Rossetti figure," in Wesley Towner's words, though her mother ran a brothel in Cincinnati, which is perhaps where she met Yerkes.

By this time Charles Yerkes had moved on from New York to London. After his engineering successes in Chicago he now hoped "to expand the underground railways of the British capital into what he envisioned as the greatest system of urban transportation in the world." Both Mara and Emilie accompanied Yerkes on his visits to London, but they never sailed on the same boat; Yerkes had developed some tact. Emilie had also learned a thing or two. In no time at all she had her own maid, who looked after the contents of her twenty trunks of clothes and inventoried them in a book, which Emilie consulted every morning when deciding what to wear. Of course she needed a house to go with the dresses and the maid. The one that Yerkes bought her on Park Avenue was remarkable. Aside from the solid oak fireplace and the skins of tigers, cheetahs and leopards that lay about the floors, there was a Monet, a Sisley, a Picasso and Anders Zorn's *The Bather*. But the problem with being an adventuress is that while you make a lot of new friends, you

also make a lot of new enemies. Stories began to circulate that the mansion at 660 Park Avenue had a secret elevator and a special room given over entirely to unspecified sexual practices.

Then came the denouement. Wesley Towner tells us with relish that, during a particularly grand dinner, Emilie Grigsby's mother, Susan, was recognized by a former customer from Cincinnati. The Kentucky beauty's mother was a brothel-keeper? This was adventuring on a grand scale, and when it was further revealed that Emilie called Yerkes her uncle in America and her guardian in England, gossips put two and two together and, for once, came up with four.

And then Yerkes died. The London foray had not been quite the success he had hoped for financially because, though not perfect, London was nowhere near as corrupt as Chicago. At the same time, Yerkes learned he had an incurable disease. He returned to New York, where he sank steadily, Emilie and Mara squabbling endlessly over who should tend him. The end came on December 29, 1905. Emilie was not mentioned in the will, but she was not the kind of ward to let such a detail stand in her way. During her sessions nursing him in the final days, she had acquired all sorts of interesting documents, among them a check for $250,000 and a certificate for 47,000 shares in the London Underground. However, while all eyes were on Emilie, awaiting her next move, Mara struck back; within months of Yerkes's death, she married again. The gossips barely had time to assimilate this twist when they were hit by another—after only fifteen days, the marriage collapsed. Mara was ignominiously forced to pay off her new husband, but this still wasn't the end of the farce. In January 1910, five years after Yerkes's death, a London court judged that his estate was liable for $800,000 ($16.2 million at today's values) against stock options that he had pledged. This was a grievous blow. Mara had seen Emilie Grigsby flaunt the documents she had seduced out of Yerkes on his deathbed, and now her own fortunes had sunk so low that only the house and the art collection were left. The U.S. district court appointed a receiver, who called in Kirby and the AAA.

The sale was divided into two parts, the first consisting of the rugs, sculpture, furniture and other "embellishments" to the house, the second of the pictures. The scandal surrounding Yerkes had whetted people's appetites, and on the appointed night, as Wesley Towner has it, Vanderbilts, Whitneys, Goulds and Wideners lined the aisles; most of the big European dealers were there in person. The thirty pictures fetched $1,308,000. More important, however, the Yerkes sale gave an early glimpse of how taste was beginning to change. Corot, Troyon and the other Barbizon School pictures did well, in several cases breaking records, but the craze for Meissonier and Burne-Jones seemed to be over. Meissonier's *The Reconnaissance,* which had cost

Yerkes $13,500, "would not fly higher than $5,300," and Burne-Jones's *The Princess Led to the Dragon,* which had cost $12,500, slipped to a mere $2,050.

On the other hand, earlier pictures rebounded well. Until now, Turner had not been a star in America, however popular he was in Britain. Yerkes had paid $78,000 for *Rockets and Blue Lights,* but American critics, says Towner, had called it "incomprehensible." Incomprehensible or not, it was now knocked down to Duveen for $129,000, the highest price a picture had ever brought at auction in the United States. Yet this record stood for only twenty-four hours. The next night was devoted to Old Masters and though Rembrandt's *Portrait of a Rabbi* was on offer, it was Frans Hals who, as at Sotheby's and Christie's in 1913, set the proceedings ablaze. Again Duveen was one of the protagonists, but this time his adversary was Knoedler, which won *Portrait of a Woman* for $137,000, making *it* the most expensive picture ever sold in a U.S. auction, a record that stood for seventeen years.

Kirby was delighted. With such a handsome sale behind him, with so many records set and broken, he must have thought that when Emilie Grigsby decided on impulse in 1911 to dispose of all her possessions (including Edward VII's footstool), the AAA would be chosen. Instead she opted for the Anderson. She also announced that she was going to England to live, where people were nicer to her. Towner comments dryly that she took only one picture, but all nine servants.

Few sales can have had such value-added notoriety. The House of Mystery, as Emilie's mansion had been dubbed, was about to go public. The notoriety paid off. The Monet and the Picasso apart, the sale was no more distinguished than Emilie Grigsby herself: andirons, a prie-dieu, Oliver Cromwell's blackjack (i.e., tanned leather) tankard . . . these were the kinds of unsensational objects that had cluttered the House of Mystery. Yet though the royal footstool only fetched $36, the andirons, the pictures and the six thousand books combined to produce a total of $200,000. It wasn't the $2 million that Kirby had celebrated at the earlier Yerkes sale, but it was three times what had been expected and as much a triumph for the Anderson as it was for Emilie. In New York, a bookselling auctioneer had successfully invaded the territory of its rival, an art auctioneer. Never again would Kirby be able to boast that the AAA was the only place in America to auction art.

In any case, Kirby himself was no longer the man he had been. He was now in his middle sixties, his hair had become snow white, he was going deaf and his hands were often bandaged because he had developed eczema. The successes of the Anderson were the final blow. Whether Thomas Kirby liked it or not, changes at the AAA had to come.

13 | "291" AND THE ARMORY SHOW

John Quinn once received a letter from a lady admirer on vacation in Naples. "I am sitting here looking at Vesuvius," she wrote. "Vesuvius is looking at me. We are both burning." Quinn was a handsome bachelor ("a profile as fine as that on a Roman coin"), in an age when to be a bachelor did not imply homosexuality. Curiously, he is hardly known today, certainly in comparison with Morgan, Frick or Mellon, but in some ways he was the greatest patron of them all, someone who not only bought paintings but truly befriended many artists and used his skills as a lawyer to help them, to make their art more available and to encourage others to buy. He collected books as well as paintings and, says Aline Saarinen, counted among his friends Matisse, Picasso, Derain, Brancusi, Augustus John, Erik Satie, W. B. Yeats, Ezra Pound, James Joyce and George Moore. When he was sent a first edition of "The Waste Land" by his friend T. S. Eliot, he prevailed upon one of his lady friends who was known for her melodious voice to read the poem to him as he shaved.

Quinn was born in 1870 in Tiffin, Ohio. His parents were Irish, and part of him remained Irish even after he came to know Paris and French art intimately. As a boy he was a voracious reader and a fanatic about the Wild West. Later he became a sophisticated cosmopolitan, but at the age of thirteen he traveled hundreds of miles to see his idol, Buffalo Bill. Four years later his life was already changed. As a knowledgeable boy, he had been

appointed secretary to Charles Foster, a former governor of Ohio. When President Harrison called Foster to Washington as his Secretary of the Treasury in 1891, Quinn went along. Still keen to improve himself, he took night classes, obtained a law degree, and then sent himself to Harvard for a year, studying philosophy and psychology under Santayana and William James. He started his own firm when he was thirty-six.

Quinn joined the New York bar in 1906, a turbulent time when spectacular and widespread insurance frauds were being exposed, and this may have encouraged his combative attitude, which was to stand artists and writers in such good stead. For example, he represented Irish actors in 1911 when police tried to close down J. M. Synge's *Playboy of the Western World.* He defended Margaret Anderson and Jane Heap when the Society for the Suppression of Vice had them arrested in 1920 for publishing episodes from James Joyce's *Ulysses* in *The Little Review.* Most important of all, perhaps, was his role in having the Tariff Law of 1909 amended. Ironically, Quinn had had a hand in drafting this law in the first place. It had removed the excessive import duty on works of art, which hitherto had meant that people like Morgan kept their art in Europe. But the 1909 act gave tax breaks only to art more than one hundred years old, and Quinn believed this was unfair to more recent artists and living artists, as well as collectors of their work. He campaigned to have the law changed again. With his reputation and his powerful friends in Washington and in the arts, he was perhaps the only man who could have succeeded so quickly.

Quinn made his fortune as a powerful and effective lawyer, but it was as a collector and patron that he made his name. He had the gift of friendship, and one of his earliest and most influential friends was Augustus John. The English painter had long been a Francophile, and in 1911 he introduced Quinn to the splendors of France and the delights of Paris. It was through John, says Aline Saarinen, that Quinn met Matisse, Picasso, Durand-Ruel, Vollard and Kahnweiler. Through the dealers, he was introduced to the works of Cézanne, Gauguin and van Gogh. He was buying as early as 1904, when he acquired some Irish pastels by Jack Yeats at the Clausen Gallery in New York. He even succumbed to the Oriental cult, using A. W. Baker of the Montross Gallery as his dealer. But his collecting really came of age with the famous Armory Show of 1913. He became one of a small group of men who with this one show advanced American taste in one huge leap. In America, the artist Quinn was closest to was Walt Kuhn. Kuhn became in Quinn's life the New York equivalent of Augustus John in Europe. It was Kuhn who got Quinn involved in the Armory Show.

The Armory Show in fact began as the rather tame idea of showing the latest developments in American art and it might well have remained that but

for Arthur Davies. Four members of the Pastellists Society—Walt Kuhn, Jerome Myers, Elmer MacRae and Henry Fitch Taylor—had begun informal discussions at the Madison Gallery about a show of that nature, to be held at the Sixty-ninth Regiment Armory in New York, but Davies changed all that. He was a curiously detached artist; far from being a gritty realist, as most American painters were at this time, he was, in Aline Saarinen's words, a specialist in "unicorns and mediaeval maidens." But the point was that Davies was well connected socially, at ease with and accepted by the likes of Gertrude Vanderbilt Whitney, Lillie P. Bliss and Mrs. Cornelius J. Sullivan. These women had the wherewithal to underwrite the show. Davies knew Kuhn, and also Walter Pach, an American painter and critic living in Paris. It was because of Davies that the idea of the Armory Show changed; the three men set themselves loose in Europe, their self-appointed task being to find the most radical pictures the Continent had to offer. In this they were aided by Quinn and another figure, no less distinguished. Among the American artists who had visited the Steins' salon at the rue de Fleurus was Edward Steichen, who divided his time between the new painting and the new art of photography. Today Steichen is famous as one of the great early photographers, but at the time he was also a Paris scout for the New York gallery of his close friend Alfred Stieglitz. In 1907, in Paris, Stieglitz and Steichen had been taken to the Bernheim-Jeune gallery to see some Cézannes. Stieglitz's first impression, says John Rewald, was "of hundreds of pieces of blank paper with scattered blotches of color on them." According to Steichen, they both "laughed like country yokels" at the pictures. When they priced them, however, they were chastened to learn that they cost about 1,000 francs each ($4,110 now). This led to a lighthearted plot for a hoax: Steichen would himself produce in a single day a hundred Cézannes. None of them would be signed, but Stieglitz would announce in New York an "Exhibition of Watercolors by Cézanne." All the pictures would be sold and then Stieglitz would be able to announce the truth and denounce the critics—always worth doing.

This plot in fact gives a misleading impression of Stieglitz, who was both a very serious man and one of the most open-minded when it came to modern art. In those days, "modern" was used interchangeably with "new" to describe all the new ideas originating, mainly, in Paris. Nowadays, in the salesrooms, as was explained in Chapter 1, "modern and Impressionist" sales usually begin with Daumier and cover the main movements from the Impressionists to World War II. The term "contemporary art" has recently given way to "contemporary and postwar art" to allow for the fact that some of the great postwar artists are now dead.

Stieglitz's small Photo-Secession Gallery at 291 Fifth Avenue in New York

was an unusual one, its most distinctive feature being its size—one small room and a hallway. Stieglitz was distinctive too. It was said that he resembled Leo Stein in also being a "compulsive explainer." He displayed modern art as well as photography because he was keen to show how painting had become, in his view, the antithesis of photography. He had met Steichen in 1900, and together they had conceived 291 and *Camera Work,* the magazine that became one of the most effective champions of the avant-garde, not just in photography but in all the visual arts. Artists and photographers would convene on Tuesday mornings around the stove in the back room of 291, in what may well have been America's first salon. The gallery showed many contemporary American artists but also exhibited works from abroad. Toward the end of 1910 Stieglitz opened an exhibition of drawings by Rodin, who had been pressing him to do so for years, and another of lithographs by Monet, Renoir, Toulouse-Lautrec and Cézanne. As a champion of the avant-garde, he still wanted to stage a Cézanne one-man show—he had been impressed by the number of people in Paris who rated the artist so highly—but this proved difficult, says Rewald, because Stieglitz had to obtain pictures from various Parisian dealers who had their own priorities. Hence he instead started talking to Picasso about a show, and this took place in 1911.

Eventually, however, while Vollard dithered, Bernheim-Jeune sent Stieglitz twenty Cézanne watercolors and he was able to open that show in March of the same year. When the shipment arrived in New York, Stieglitz was intrigued to see how he would react to the images he had sniggered at four years earlier. As Rewald reports Stieglitz, "Lo and behold, I found the first one no more nor less realistic than a photograph. What had happened to me? The custom house man looked up; 'My lord, Mr. Stieglitz,' he said, 'you're not going to show this, are you—just a piece of white paper, with a few blotches of color?' I pointed to the house, rocks, trees and water. The appraiser asked, 'Are you trying to hypnotize me into saying something is there that doesn't exist?' "

It was a remarkable change of heart on Stieglitz's part. Nonetheless, Steichen had not forgotten their earlier idea to play a prank on the critics. Later he wrote: "So I painted a fake Cézanne. It was not an imitation of any one picture but a landscape in the style of the Cézanne watercolors. . . . When the exhibition was hung in New York, my fake Cézanne attracted particular attention, possibly because it was more literal. At any rate the Cézanne watercolors drew a very hostile response. People 'laughed their heads off,' critics as well as visitors. Of all the exhibitions we had at 291, this one was probably the most sensational and the most outrightly condemned. Of course, appreciators of avant-garde art thought it was the best we ever had.

Several people tried to buy my fake, but I explained that it was only on loan and was not for sale. I was petrified by the whole experience. I burned the fake as soon as I could get my hands on it."

The several people who tried to buy Steichen's fake, but were refused, were possibly used to such treatment. The 291 was probably the first modern gallery to affect a spartan appearance. Rewald is one of several authors who have remarked that Stieglitz was not really interested in sales. He would refuse to sell to visitors if he didn't like the look of them and would slash prices if he thought someone who was obviously enthusiastic was also poor. Nevertheless, he must have had reasonable hopes that the Cézannes would sell and that sales would mean acceptance of this new art. As it happened, only one picture sold; only one person was convinced enough of Cézanne's genius to put his money where his mouth was. That person was Arthur Davies.

———

Concurrent with Stieglitz's efforts on Fifth Avenue, there were two other precursors of the Armory Show, one in London and one in Cologne. In London, 1910 was a crucial year in the reception of modern art, for it was then that the first great Post-Impressionist exhibition opened at the Grafton Galleries in London, organized by Roger Fry, assisted by Clive Bell. In common with 291, the Grafton was, and was not, a commercial outfit. The Fry exhibition was conceived to introduce the British to all the important sources of inspiration in modern French art. It began with Manet (the last "old masterly" painter, yet the first of the moderns), but then went directly to Cézanne, van Gogh and Gauguin without, in John Rewald's words, "wasting time" on the other Impressionists. In Fry's eyes, Cézanne, van Gogh and Gauguin, at that point virtually unknown in Britain, were the immediate precursors of modern art. Fry was intent on demonstrating the differences between the Impressionists and the Post-Impressionists; for him the later painters were greater artists who took Manet much more seriously than the Impressionists had. He felt that the Post-Impressionists were bent on capturing "the emotional significance of the world that the Impressionists merely recorded." Cézanne was the pivotal figure: his patches of color pointed toward Cubism and abstraction.

Several Parisian dealers lent to the London show, including Vollard, Druet, Bernheim-Jeune, and Durand-Ruel. So did Paul Cassirer of Berlin. There were twenty-one paintings each by Cézanne and van Gogh, and even more by Gauguin. The Steins lent a Picasso and a Matisse, and from Italy Bernard Berenson made available a small Matisse landscape, one of the few modern pictures he allowed himself. The show received its share of brickbats,

which inevitably accompanied the showing of modern art. One shouldn't be misled by this, however; Fry felt encouraged enough to hold a second show two years later.

Yet, the second show was overshadowed by the German "Sonderbund," which opened on May 25, 1912, in Cologne. This was, in John Rewald's words, a "truly staggering exhibition." Unlike the London shows, it took for granted that people were already familiar with nineteenth-century painting and hence felt free to concentrate on the most recent movements in modern art. The Sonderbund was deliberately arranged so as to provoke. The rooms devoted to Cézanne were next to those displaying van Gogh, Picasso next to Gauguin. In addition, the exhibition featured Signac, Bonnard, Derain, Munch, Erich Heckel, Alexis von Jawlensky, Paul Klee, Matisse, Emil Nolde, Max Pechstein, Egon Schiele, Vlaminck and Vuillard. The Sonderbund proved that the Germans were already more at home with the new painting than either the British or the Americans; John Rewald tells us, "Of the 108 paintings in the Sonderbund, a third had German owners; of the 28 Cézannes, seventeen belonged to Germans."

The Association of American Painters and Sculptors was a rather grand name for the small collection of artists who gathered together to prepare the Armory Show, but they had grand aims: "Exhibiting the work of progressive and live painters—both American and foreign—favoring such work usually neglected by current shows and especially interesting and instructive to the public." The more they looked into it, however, the more Davies and the others realized that in Europe the new painting had a depth and a direction that were simply unknown in America. According to Milton Brown, when Davies received the catalogue for the Cologne Sonderbund he was so startled and impressed that he urged Walt Kuhn to cross the Atlantic immediately. Kuhn did so, and his trip brought him into contact with much more than the Sonderbund. He met Munch and persuaded him to participate in the Armory; he went to Holland in pursuit of van Goghs and while there also saw Redon's pastels for the first time. In Paris all the talk was of Cubism at the Salon d'Automne and of the Futurist exhibition that had been held that year at Bernheim-Jeune. Everywhere he turned there was something new.

In Paris, Kuhn teamed up with Walter Pach, dealers being their main quarry. Vollard, Bernheim-Jeune and Druet were all approached and eventually proved amenable, though Vollard was difficult because by now he was lending right, left and center as the new painting caught on; he had pictures on loan in Berlin, Vienna, Munich and London. Durand-Ruel, with a gallery in New York, had more to gain from a successful show there, and agreed to

lend more than a dozen Impressionist paintings. The last port of call was London, where again Davies and Kuhn were lucky: they were able to raid Fry's second exhibition, which was still on.

Now that the preparations were advanced, news about the show began to leak out. The irony was not lost on people that the New York Armory should again house something explosive. In late 1912, Gertrude Stein received a rambling but breathless letter from Mabel Dodge, an old friend: "There is an exhibition coming on the 15 Feb to 15 March, which is the most important public event that has ever come off since the signing of the Declaration of Independence, & it is of the same nature. Arthur Davies is the President of a group of men here who felt the American people ought to be given a chance to see what the modern artists have been doing in Europe, America & England of late years. . . . This will be a *scream*! . . . The academy are frantic. Most of them are left out of it. . . . I am *all* for it. . . . There will be a riot & a revolution & things will never be quite the same afterwards."

Given such a buildup, could the Armory Show be anything other than an anticlimax? Yes. Milton Brown quotes a contemporary U.S. press clipping: "The Armory Show was an eruption only different from a volcano's in that it was made by man. To the American critics it was like a shot in the dark. Unforeseen, it had to be met without preparation." The volcano erupted a few days after Mabel Dodge foretold, on the evening of February 17, 1913. On that night, again according to Milton Brown, four thousand people thronged eighteen temporary galleries bounded by the shell of the armory (see figure 52). The stark ceiling was masked by yellow tenting, and apart from the pictures and sculptures, the cultural feeding of the four thousand was supplemented by a brass band, while potted pine trees sweetened the air. John Quinn formally opened the proceedings: "This exhibition will be epoch-making in the history of American art. Tonight will be the red-letter night in the history not only of American but of all modern art."

This was not mere rhetoric. The Armory Show *was* epoch-making. Of course, there was ribald press comment; no modern art show was complete without it. The Cubist room attracted most of the laughs, and it was soon labeled the Chamber of Horrors. One painting in particular was singled out for attention: Marcel Duchamp's *Nude Descending a Staircase*. Critics and correspondents obviously had a much better time hating the picture than enjoying it. Duchamp's effort was variously described as "a lot of disused golf clubs and bags," "an orderly heap of broken violins," and "an explosion in a shingle factory." Perhaps because of its title, *Nude* became the butt of newspaper badinage, and "the search for the nude" was on, for some reason often conducted in verse. For example, *The American Art News* offered $10

for the best verse "solution" to Duchamp's notorious picture. The winning doggerel was:

> You've tried to find her,
> And you've looked in vain
> Up the picture and down again,
> You've tried to fashion her of broken bits,
> And you've worked yourself into seventeen fits;
> The reason you've failed to tell you I can,
> It isn't a lady but only a man.

No doubt Ruskin would have been pleased at the public's vigilance in the face of such shocking events. Here was not just a pot of paint, but violins, golf clubs and much else being thrown into its face. Parodies proliferated: for example, *Food Descending a Staircase.*

Nevertheless there was no shortage of serious critical attention. Among the newspapers, the *Tribune,* the *Mail,* the *Globe,* the *World,* and the *Times* hated the show. They all applauded the aim of the Association of American Painters and Sculptors to present new art but found the actual pictures and sculptures difficult. Only the *Sun* and the Chicago *Tribune* liked what they saw. With serious critical reception weighted roughly five to two against it and popular hilarity on a scale rarely seen, the show might have been a commercial disaster, but it was nothing of the kind. The opening night was obviously atypical, and attendance was slow immediately afterward. But when the strongly worded reviews began to appear, as many as ten thousand people a day were streaming through the red brick building. Also, despite the general derision, or perhaps because of it, the show as taken up by New York Society and became a succès d'estime. Mrs. Astor, for example, went every day after breakfast.

After New York, the Armory Show traveled to Chicago and Boston, and in the three cities, Milton Brown reports, 174 works were sold, 123 by foreign artists, 51 by American artists. Ninety prints also found buyers. This justified the claims made by Davies and others before the show opened. In all their preparations and negotiations with European dealers, Davies, Kuhn and Pach had underlined the point that America was an untried market.

Two of the earliest and heaviest buyers were John Quinn himself and Lillie Bliss. As he was a friend of Kuhn and Davies and an organizer of the show, Quinn's buying was not unexpected. What was a surprise was his choices. Milton Brown calculated that he spent $5,800 ($114,125 now) on those artists who were the chief subjects of attack: Brancusi, Derain, Duchamp and

Duchamp-Villon. Lillie Bliss was one of the coterie of rich women who doted on Arthur Davies, so her involvement was not unexpected either. However, she had not collected seriously before, and for her the Armory Show was a watershed. She bought two Redons and a score of prints. Later, under the guidance of Davies, and of Kuhn when Davies died, she became a major collector of Cézanne. She owned twenty-six of his works, which later constituted the nucleus of the Museum of Modern Art in New York.

After these two collectors, the largest buyer at the armory was another lawyer, Arthur Jerome Eddy, from Chicago. Eddy was an exceptionally competitive man who was "in love with novelty"; he is said to have owned the first bicycle and the first automobile in Chicago. He was an early buyer of Monet and of Whistler, who painted his portrait. At the armory, he bought pictures by Auguste Chabaud, André Dunoyer de Segonzac, Villon's *Jeune Femme,* Duchamp's *Portrait de jouers d'échecs,* and other works by Picabia, Derain and Vlaminck. No one else spent as much as Quinn or Eddy, but several of the people who became famous later on as American collectors did start or consolidate their collecting habit at the armory; among them were Albert Gallatin, Stephen Clark, Edward Root and Hamilton Easter Field. Walter Arensberg bought a Vuillard but later returned it and settled instead for a Villon. Katherine Sophie Dreier bought a Gauguin and a Redon. In 1920, she was to found the Société Anonyme with Marcel Duchamp and Man Ray. This was a sort of traveling museum of modern art that was strong on Kandinsky, Klee and the Italian Futurists. It disbanded when the Museum of Modern Art opened, and her formidable collection went to Yale in 1941. Stieglitz also bought adventurously at the armory: Archipenko and the only Kandinsky, *Improvisation #27,* which cost $500 and is now in the Metropolitan Museum. Many other artists also bought at the show, but, as Milton Brown points out, not many museums or dealers did. Nonetheless, the Metropolitan Museum paid the highest price at the show, $6,700 for Cézanne's *Colline des Pauvres,* the first picture by the artist to enter an American museum collection. One dealer who did take a flier was Frederic C. Torrey, of the San Francisco firm of art dealers and decorators Vickery, Atkins and Torrey. He it was who bought the notorious *Nude Descending a Staircase* (sight unseen, says Milton Brown) for $324. Knoedler, on the other hand, refused even to advertise in the catalogue for the show because its directors felt that the Association of American Painters and Sculptors was pushing "radical tendencies in modern art."

In strictly commercial terms, the Armory Show almost broke even. Taking into account admission fees in New York, Chicago and Boston, plus catalogues, postcards and pamphlets, the total income was about $93,000 ($1.83 million now), and expenses were approximately sixty dollars more than that

(Quinn met the difference). From the organizers' point of view, therefore, the show was a great success. It had proved as stimulating and shocking as had been hoped and had not been a commercial disaster.

The European dealers, on the other hand, were muted in their reaction. America had been touted as an untapped market, but how had it shaped up? The European trade fell into two groups: Vollard and the rest. Milton Brown reports that the various dealers received monies as follows:

Vollard	$6,441.27
	(*$126,740 today*)
Druet	2,314.25
Artz & de Bois	1,894.20
Kahnweiler	1,314.64
Kapferer	967.98
Uhde	821.88
Goltz	290.40
Thannhauser	55.45

Vollard apart, these were scarcely figures to encourage the European dealers. A letter from Stephen Bourgeois in Paris to Walter Pach, now back in America, summarized the European reaction: "I am happy to learn that your efforts in introducing modern art to the United States have been crowned with success. Only, what astonishes me is that the great French impressionist masters have not received the attention which is due them. Finally, I believe that it is only a question of time before they will achieve it; it will come some day as it did in Germany, which has for several years been buying everything that is best in France. Unfortunately, Americans will begin to form interesting collections of modern art when the prices will have become exorbitant, a situation which in my opinion is not far off. . . . I tell you frankly that I was basically very disappointed by the lack of public interest in Cézanne and Van Gogh who are like giants among all the other painters represented at your exhibition."

Bourgeois was right, more so than is appreciated today. By the time of the Armory Show, European enthusiasm for the Post-Impressionists had pushed their prices well out of the range that Americans expected. Gauguin's *Fleurs sur un fond jaune,* for example, was priced at $40,500 ($797,000 now), which seemed so high to Walt Kuhn that it was at first entered in the show's accounts as $4,050. Van Gogh's *Montmartre,* lent by Artz & de Bois, was priced at $26,000 and Cézanne's *Femme au chapelet* at $48,000. These prices weren't speculative; they were the amounts the paintings were insured for.

But if the European trade was less than ecstatic about the financial results,

the Armory Show did have a commercial impact in the long run. Until it opened there had been little demand in the United States for progressive American art, and none at all for European art. Besides 291, probably the only gallery showing American modern art was the Macbeth Galleries, which had shown "The Eight" (a young group of New York realists) in 1908. Still, the dealers Doll and Richards were also involved in the early planning of the show and so must have had some interest in the new painting.

After the Armory Show, however, a number of new galleries opened up, showing both European and American work. Charles Daniel was first, in December 1913. Daniel, a former bartender who also owned a hotel, and his assistant Alanson Hartpence were to keep going for more than fifteen years, dealing mainly in American avant-garde work. Two months after Daniel, N. E. Montross opened, catering to all forms of modernity, simultaneously with Stephen Bourgeois (who, despite his letter, was optimistic enough to start in New York with an exhibition Pach himself arranged). A month later the Carroll Gallery opened with an exhibition of contemporary American work; this was also thanks to Quinn, who was its silent partner. Finally, in October 1915, the Modern Gallery, funded by Walter Arensberg and run by Marius de Zayas, himself a caricaturist, was launched with an exhibition of Picasso, Braque and Picabia. Modern art had arrived in America, noisily, untidily, controversially, but irrevocably. Each of these galleries had its own character and gave New York an air of optimism in the art world that belied the war gloom in Europe.

However, all this did not mean that Old Masters had been forced out of the limelight by the upstarts. Quite the contrary, in fact, for 1913, the year of the extraordinary Armory Show, was out of the ordinary in many other ways too.

14 | THE £10,000 BARRIER: TASTE AND PRICES ON THE EVE OF WORLD WAR I

—

Jacques Doucet, the famous French couturier, had cornflower-blue eyes and a white beard "clipped like a French garden." In his lifetime he amassed and dispersed several collections. The first was sold under tragic circumstances. He had fallen in love with a married woman and she with him; she got a divorce for his sake but before they could marry she died. An intensely proud man, Doucet was suddenly vulnerable and inconsolable. The sale of the collection was like a farewell for him, but it marked the arrival of an art boom that has been equaled only by that of May 1988–May 1990 in our own day.

Doucet's sale took place in June 1912, and the boom it presaged lasted until the outbreak of war. That first collection consisted mainly of French eighteenth-century paintings, furniture and sculpture, and a wonderful library. Doucet himself paid the finest scholars to prepare the catalogue, and though at the time he was regarded as nouveau riche, he sent invitations for the sale to the chicest people in Paris. His aim, as Michel Beurdeley points out, was to make the sale the social event of the season, but it was the prices of the artworks that attracted most attention. A La Tour that Doucet had paid 120,000 francs for now fetched 600,000, and a Houdon sculpture, also valued at 120,000 francs originally, fetched 450,000 francs. The entire sale, expected to raise about 3 million francs, in fact fetched 13.8 million (that would be $54.1 million now).

This prewar boom was not confined to Paris, but extended worldwide. The

two outstanding deals of the following year, 1913, both involved Italian High Renaissance paintings. The first was Raphael's Panshanger Madonna. Duveen had intended to sell this to Benjamin Altman, but he and Morgan both died in 1913, so it went to P. A. B. Widener instead. He paid £116,500 for it ($11,461,619 million at today's prices). Duveen was also involved in the other sensational deal. He had his eyes on the Leonardo Madonna that belonged to the Benois family; he had paid a deposit, and Frick was said to want it. For once, however, Duveen was bested, by a canny Russian aristocrat who, in bringing it to Duveen, guessed that Berenson would be consulted to authenticate the painting. This is exactly what happened. Armed with this cast-iron opinion from Berenson, which cost her nothing, the woman did her duty—as she was obliged to under Russian law—and offered the czar first refusal. He exercised his right, paying the unheard-of price of £310,000, or $30,629,973 at today's values. Duveen could bamboozle the nouveau riche, but he had a thing or two to learn from old money.

Although these were exceptional prices, they do reflect the fact that Old Masters were very strong in this period. By now, £10,000 was no longer out of the ordinary for paintings by long-dead Italians or Frenchmen (£10,000 then would be about $984,000 now). Among the Italian Old Masters, Bellini, Botticelli, Carpaccio, Piero della Francesca, Ghirlandaio, Mantegna, Pollaiuolo, Tintoretto and Titian had all sold above this level. Bellini had gone to £20,000, Mantegna to £29,500 (nearly $3 million now) and Titian to £60,000. In contrast, the Carraccis, Domenichino, Reni and others of the Bolognese school, which had been much admired at the turn of the nineteenth century, could scarcely be given away—£36.75 for the first named and £9 19s 6d for the last. Giorgione also lagged, as did Canaletto and Guardi. Among the French school, Boucher, Chardin and Fragonard all broke £10,000, with one pastel by Maurice Quentin de La Tour reaching £27,300 ($2.69 million now, and for a pastel). Claude Lorrain and Poussin both were out of favor. The taste for the northern school's Old Masters, which had been so noticeable at the end of the nineteenth century, was not so marked now, though Hals (£30,000), Holbein (£72,000), Rembrandt (£103,000), Van Dyck (£103,300) and Vermeer (£50,000) were still strong. Still, Rubens never topped £7,000, the Ruysdaels and Cuyp never beat £4,200, de Hooch never went over £8,610.

A developing taste for English School portraits and landscapes was under way. Gainsborough led at £82,700, followed by Reynolds (£51,600) and a number of highly priced Raeburns (up to £31,000) and Romneys (£45,000). Lawrence and Constable were both regularly in the £8,000–9,000 bracket, but Hogarth was still unpopular (£2,834). Turner did well in the salesrooms, reflecting his wide popularity, but at this stage had never gone higher than £31,000, and although Stubbs came on the block almost as often, he never

beat £756. Among the Spanish Old Masters, Velázquez led (£82,000), with only El Greco a challenger (£31,000). Murillo, once the most expensive painter at auction, reached £5,040, and Goya was judged even below Hogarth.

Among the nineteenth-century schools, the French were enjoying mixed fortunes. Corot and Millet were the only ones to break the £10,000 mark, Corot more often because many of his pictures came onto the market. Millet, at £31,000 (for *La Femme à la lampe*) held the record by a large margin. Bonheur and Meissonier had collapsed (£241 10s and £681 respectively), as had Breton, who struggled to reach £262 10s. Daubigny was doing better; a lot of his pictures appeared at auction, the top price being £4,515. Much the same could be said for Daumier, Rousseau and Troyon. Delacroix and Courbet hung on. The Pre-Raphaelites had not risen as high as the French schools in the late nineteenth century, and now they did not collapse as quickly. Most of them sold around the £2,000–2,500 mark, with only Millais and Burne-Jones going much higher (£8,190 and £5,040 respectively).

Perhaps the most striking thing about the Impressionists and Post-Impressionists is how many of their works were auctioned in this period. Cézanne, Degas and Toulouse-Lautrec led the way. The only one to go over the £4,000 barrier was Degas, who did so three times, including the sensational £21,000 ($1.57 million now) paid by Mrs. Louisine Havemeyer in 1912 for *Dancers at the Barre* that established a world record for a living painter. Manet and Renoir were the next most costly artists, each selling at times for between £3,500 and £6,000. Monet, Pissarro and Sisley continued to be sluggish, the last two not even breaking £200 at a time when van Gogh and Gauguin were fetching more than a thousand. To judge from reports that William Glackens sent from Paris to Albert Barnes in America, auction prices for Impressionists at this point were not dissimilar from what dealers in Paris could obtain. "I have been all through the dealers' places. . . . You can't touch a Cézanne under $3,000 and that for a little landscape. His portraits and important pictures range from $7,000 to $30,000. I got a fine little Renoir at Durand-Ruel, a little girl reading a book, just the head and arms, in his best period, I paid 7,000 francs for it [then $1,400, now $27,550]. They asked eight but came down. I consider it a bargain."

But this period was not noted, as the 1880s had been, for a special bent in any one direction. In terms of taste and commerce, the period was much more like the late 1980s, when every school of art did well. Modern art then did not have the strength it has shown recently in the international salesrooms; nevertheless, it was on its way commercially. One specific reason for this, apart from the Armory Show, was that André Level's group of young French speculators, the Bearskin, formed in 1904, had now brought their invest-

ments to market. The ten-year waiting period for the members of La Peau de l'Ours was now up, and the sale took place at Drouot, under auctioneer Henri Baudion, on March 3, 1914. Just how well André Level had chosen was revealed by the catalogue: ten Matisses, twelve Picassos, three Utrillos and one work each by Gauguin, van Gogh, van Dongen and Raoul Dufy. Picasso's *Les Bateleurs* fetched 11,500 francs ($45,400 nowadays), "equivalent to the annual salary of a bourgeois Parisian family." This was more than twice the price of van Gogh's *Fleurs dans un vase* (4,100 francs) and Gauguin's *Le Violoncelliste* (4,000 francs). The auction room echoed with the usual derisive catcalls, but nonetheless the sale made 100,000 francs. The collection had cost about 25,000 francs, so the investors, who had enjoyed the art for ten years, were well satisfied.

However, the boom in the art market could not conceal the rumble of war. Major change was on the way, and the safe, comfortable, colorful world depicted by the Impressionists, a world that was beginning to fetch very respectable prices, was about to disappear forever.

15 | WAR AND THE MAJOR

Among art dealers, the first casualty of World War I was Paul Cassirer. On August 3, 1913, German troops invaded neutral Belgium and Cassirer immediately enlisted, lying about his age. It was a mistake and he soon realized it. He managed to have himself demobilized, but it was a difficult, contentious business and he actually spent most of the war in Switzerland, where he was variously regarded as a deserter or a traitor. Neither Durand-Ruel nor Bernheim-Jeune would have anything to do with him, nor did he ever again have contact with Johanna van Gogh-Bonger. Very sad.

Daniel-Henri Kahnweiler was overtaken by events in a different but no less tragic way. Until then his life had been proceeding very well. His artists now included Juan Gris, Vlaminck, with whom he had a share in a sailboat, Braque, Derain and Picasso. The "Picasso business," as Kahnweiler called it, "rested entirely on the support of four or five individuals, a handful of serious collectors who were loyal and regular clients." Still, the business was growing, and even if profits were not exactly sensational, the Bearskin auction, which Kahnweiler had attended, sitting near Vollard, had been a success. He had been unable to match Thannhauser's 11,500 francs for the Picasso but had seen drawings that he had sold for 20 francs a few years before fetch as much as 2,600 francs. He had hurried back to the gallery from Drouot to tell Picasso.

But the war changed this rosy set of circumstances. Though he loved Paris,

and though artistic Paris respected and liked him, Kahnweiler was German, and he couldn't hide that fact. Therefore he judged it prudent to leave France when war broke out, and he was in exile in Switzerland from 1915 to 1920. In his absence his stock was sequestered as enemy property. At first the pictures were held in a damp warehouse in the rue de Rome. Later they were moved to a better location, but by then the Paris art world was aware of Kahnweiler's predicament. Pierre Assouline tells us that other dealers, notably Léonce Rosenberg, owner of Galerie l'Effort Moderne, moved in on Kahnweiler's artists. (In fairness, the artists needed to live.) The future looked bleak, for France was not only anti-German, but anti-Semitic, too. A certain Tony Tollett delivered a lecture at the Academy of Sciences, Literature and Arts in Lyon in July 1915 entitled: "On the Influence of the Jewish-German Corporation of Paris Art Dealers on French Art."

Hence Kahnweiler was forced to remain in Switzerland for some time, writing instead of dealing. Like the United States, Switzerland was much less affected by the war than elsewhere. In the art market there the effects of Charles Montag were beginning to be felt. Montag was a curious character, an inhabitant of Winterthur, a city of rich individuals, a center of painting and music, where his friends included Werner Herold, Richard Bühler, the Reinhardt brothers and Arthur Hahnloser. All of these became successful businessmen, and they also became collectors through Montag, who, having decided to become a painter, had traveled to Paris to study and brought back to Switzerland with him, just before World War I, his new friends Bonnard, Vuillard, Roussel and Marquet. In Switzerland Montag's old set of friends entertained these new ones and bought their works. This, says Germain Seligmann, helped to establish the fashion for collecting modern art among the Swiss, a fashion that was to be consolidated during the war years by such figures as Suilzer, Stoll, Stirlin, and Rosensaft, and culminated in the fabulous collection, housed on the shores of Lake Zurich, formed by the armaments manufacturer Emil-Georg Bührle, "the Swiss Krupp." Bührle was a very busy man, and for this reason he often bought eight to twelve pictures at a time (usually from Wildenstein). Busy though he was, paintings were his passion—especially van Gogh—and he never sold anything. Thanks to Montag's influence (which was quite separate from Dada, then making its appearance in Zurich), there are now almost as many Impressionist and Post-Impressionist pictures in Switzerland as in the United States or France.

In Paris, meanwhile, the art market was still only a semblance of its normal self in 1917, when Félix Fénéon felt it was safe to bring back the stock of Bernheim-Jeune, which had been in exile with a collector in Bordeaux. Léonce Rosenberg, Assouline says, now felt sufficiently confident of the future to give contracts to Braque, Gris and Léger. The auction house of

Drouot was busy again. Danger was not entirely past, however. As late as March 1918 a bomb fell on the rue Laffitte right opposite Durand-Ruel, where all the paintings from Degas's estate were waiting to be auctioned. Kahnweiler, fearful that his business was falling apart in his absence, did what he could. He was unable to return to France until the ratification of the armistice was formalized, and this caused an agonizing, irritating delay long after hostilities had ceased. Léonce Rosenberg and another Paris dealer, Paul Guillaume, were still interested in his artists, and of course this unsettled Kahnweiler. His relations with Braque became strained; the painter was popular with a number of Japanese collectors, but even at a distance Kahnweiler felt that Braque's pricing policy was all wrong. Derain was being wooed by a Swedish dealer, Halvorsen, and Picasso, says Assouline, was silent. In the end, Kahnweiler won Braque and Derain around. Léger and Vlaminck were less of a problem, and together they formed a formidable group, one that should obscure Kahnweiler's Germanness after the war; after all, each of these artists had been honorably discharged from the French army, and *they* accepted him.

It was not until February 22, 1920, that Kahnweiler was able to return to France, having by then reassembled part of his business. But by then he also knew that he would never see his major asset again, for the French government had confirmed that it was seizing all German properties in France as war reparations. These included four art collections: the Heilbronner collection of medieval art; the Worthe collection of Chinese art; the Uhde collection of modern art, and Kahnweiler's entire prewar stock. He had to start again.

René Gimpel's diary gives us a sense of the life that went on in Paris during World War I. (He himself would die in a concentration camp in World War II.) Gimpel records memorably a wartime meeting with Renoir. The old man was lifted downstairs by two nurses. He was very stiff. "He was all unyielding angles, like the unhorsed knights in a set of tin soldiers," and was desperately thin, with fingers like ribbons. As for his head, "His face is pale and thin; his white beard, stiff as gorse, hangs sideways as if windblown. How has it managed that crazy angle?"

Could Gimpel really expect this "amorphous being," as he called him, to answer him? The old man motioned for the dealer and his wife to be seated, then to the nurse to give him a cigarette. She put it in his mouth and lit it for him. He drew on it. "Then Renoir raised his voice and said: 'I have all the vices, even that of painting.' "

Gimpel had a gift for description. Matisse, for example: "Except for his eyes, which are blue, everything about him is yellow: his overcoat as well as his complexion, his boots and his lovingly trimmed beard. As he wears

spectacles, they are, naturally, golden." Gimpel's diary also records some prices achieved in wartime. Sixteen Toulouse-Lautrecs were available to George Bernheim, for 100,000 francs ($237,000 now), while Gimpel himself offered $140,000 for a 1643 Rembrandt portrait of an old woman (that would be $1.66 million now). But most extraordinary was the Degas sale, which took place over two days when the Germans were still advancing on Paris and bombarding her with their long-range cannon. In this atmosphere, Durand-Ruel paid 285,000 francs for two Ingres portraits, of Monsieur and Madame Leblanc, and a Delacroix reached 88,000 francs. In short, no one in the European trade suffered in quite the way that Kahnweiler did.

When World War I broke out in Europe, Thomas Kirby was sixty-eight and his million-dollar voice was beginning to wear a little thin. Kirby's son, G.T., as he was known, had no wish to mount the rostrum at the AAA. (Indeed, it was not certain he would have been able to; when he married in 1906 it was rumored that the wedding contract stipulated that the bridegroom never become an auctioneer.) But he had joined the company, at least, in 1912, and when James Sutton died in 1915, he became half owner. G.T. was aware, as perhaps his father was not, that the million-dollar voice could not go on forever, that a replacement was needed, and that Otto Bernet was emphatically not the right man for the job. By now Bernet was allowed to conduct some auctions, usually at the end of long sales, but his presence on the rostrum was more comforting than imposing. Selling some iron moldings, he might say to the assembled room, "Put them in your kitchen and make the cook happy." He assumed that everyone who bought at the AAA had cooks.

But Bernet's paunch and double chin did not provide the glamour that the AAA needed to maintain its position as the premier auction house in the United States. For that, G.T., now the organizational boss of the company, turned to Hiram Haney Parke. Like Thomas Kirby, Wesley Towner tells us, Parke came from Philadelphia. There he had "cried" auctions for two firms, neither specializing in art, though the first, Garber & Birch, did have a line in "staircase" (i.e., what used to be called in Europe "furniture") pictures. Nondescript as they might be, these pictures gave more scope than most other objects to Parke's growing taste for oratory, and he began to make a name for himself. Even so, Parke's transfer to the AAA might not have occurred had he not grown apart from his first wife and fallen in love with another woman. He was tall, dark and handsome and had acquired the distinguished rank of major after service in the National Guard. He was in effect an officer, a gentleman and an actor. Hence, in addition to offering

Parke a job in New York, G.T., as innovative off the rostrum as his father was on it, offered to pay for Parke's divorce.

Parke may have been the most handsome and most gentlemanly new figure in auctioneering, but he was not the only one. Other changes were overtaking the salesrooms. In the wake of the Armory Show, modern art was beginning to boom on the rostrum, especially modern American art and the Impressionists. To many Americans, the war in Europe was a long way off, and the cessation of hostilities had as little effect on the art market in 1918 as its outbreak had had in 1914. But now the Post-Impressionists began to follow the Impressionists in the price spiral. This trend culminated in the 1922 sale of Dirkan Kelekian's collection by the AAA. Kelekian, it will be recalled, was both a dealer and a collector, a man who, in Wesley Towner's words, combined "in one person, the qualities of a Persian satrap and a properly accredited archangel." An Armenian born in Turkey (though he sometimes called himself Persian), he was the artistic mentor of many better-known collectors, among them Altman, Morgan, Walter and Rockefeller. Kelekian was an authority on almost everything, but especially on Oriental textiles and Near Eastern antiquities. His tastes were eclectic, and he had an extraordinary collection of modern masterpieces. The prices fetched at his auction make fascinating reading now: Derain $1,300; Utrillo $300; Bonnard $525; Vuillard $350; Matisse $2,500; Dufy $75; van Gogh $4,400; Gauguin $7,000; Toulouse-Lautrec $3,100. Clearly Kelekian had a phenomenal eye. John Quinn obviously thought so, for he bought ten pictures at the Kelekian sale, including a Cézanne and Georges Seurat's *Jeune Femme se poudrant,* now in the Courtauld Institute. Lillie Bliss, by now well on the way to acquiring her twenty-six Cézannes, also bought at the Kelekian auction, as did the "terrible-tempered" Albert Barnes, who bought a Cézanne landscape for $12,300. (By 1923, Barnes owned fifty Cézannes.) Edward G. Robinson, the actor, was also at the Plaza Hotel that night. He was one of the first, and in many ways the most interesting, of several Hollywood collectors to enjoy the Impressionists and Post-Impressionists. He bought a Toulouse-Lautrec portrait; like much of Robinson's collection, it was acquired in the early 1950s by Stavros Niarchos.

The prices at the Kelekian sale could not hope to match the record levels achieved by Raphael, Leonardo or even Gainsborough, whose *Blue Boy* had been sold by Duveen to Henry Huntington in 1921 for a remarkable £148,000 ($6.2 million now). Still, Thomas Kirby was more than satisfied. Like many people of his generation, he could appreciate the Impressionists but not those who came immediately afterward. He was by now seventy-six and in recent years had grown cantankerous, prone to reprimand the salesroom audience

and his colleagues with equal scorn. By rights he should have retired, for there were two other auctioneers in the house now: Bernet, who was popular, and Parke, who was allowed on the rostrum only to handle book and print sales. The succession would have been smooth enough, but Kirby didn't want to leave; life was too interesting and he wasn't done yet.

By now it was the Roaring Twenties, the Jazz Age had begun, and this brought changes. Manhattan was moving north again and Madison Square was no longer chic. Indeed, there were times when it seemed dated, never more so than the afternoon when Mrs. Arabella Huntington was in the gallery inspecting some rugs. Suddenly she found she had company, in the form of a well-fed rat. He clearly had an eye on the carpet too, though for a different purpose than Mrs. Huntington; he wanted to eat it. As Wesley Towner noted dryly, the Huntingtons were second to none in their patronage of the AAA, and Tom Clarke, the staff man deputed to look after Mrs. H. that day, turned white. If the rat lost the AAA the Huntingtons' business, Clarke himself might as well turn to salt. No such disaster occurred. Mrs. Huntington was growing old and her eyesight was no longer 20/20, so when she saw the animal she called, "Here, pussy, pussy."

But the old lady might not be taken in a second time, and G.T. saw that a move uptown was inevitable, so he bought a plot of land on Fifty-seventh Street and Madison Avenue. The structure he erected there extended all the way to Fifty-sixth Street and was built in a soft brown-orange stone in the familiar "Boston-Italian" style that Charles Eliot Norton would have approved of and that was in keeping with the fine-art trade's high opinion of itself. Inside, the building was no less grand, with low ceilings and clean, classical moldings. It was easily a match for Christie's celebrated Great Rooms in London, and better by far than anything Sotheby's could boast. It cost $2,250,000 and the move took place in November 1922.

As often happens, one change sparked another. In 1922 Hiram Parke was forty-nine and graying; Otto Bernet was forty and balding. Neither was exactly young. Kirby was as cantankerous as ever and seemed as intent as ever on running the show. No one likes being sat on all the time, and both Parke and Bernet felt that either the old man should leave, or they would. Hearst was sounded out, as were a number of other millionaire collectors. But it was a slow business and, says Towner, while the negotiations were proceeding, the death occurred of Mrs. Florence V. Parsons, a wealthy Massachusetts dowager. The sale of her belongings was handled by her son, Cortlandt Field Bishop, with whom Otto Bernet hit it off. Bishop, no less rich than his mother, had an interest in the arts himself, and the proposal that had been put to Hearst et al. was now put to him. Otto had not misjudged his man, for Bishop said he might well be interested in backing Parke and Bernet.

But even today the art world is a small place, and then it was much smaller. Old man Kirby got to hear of the Parke-Bernet-Bishop negotiations and summoned his minions to his office in a rage; what they had planned, he said, was treason. But at last he delivered the threat they had hoped for all along. "Either buy the business or get out!"

Bishop bought it. He paid half a million dollars for the name and goodwill, signed a lease with G. T. Kirby for the building on Fifty-seventh Street, and offered Parke and Bernet a ten-year contract at $15,000 a year each, plus a share of the profits. The new regime took over on June 1, 1923. One clause in the contract stipulated that Thomas Kirby could not engage in auctioneering for a quarter of a century. Legally, therefore, he would have been free to resume his old calling at 102, but Bishop needn't have worried. Less than a year later, the million-dollar voice fell silent forever.

But by now the history of fine-art auctioneering in America was no longer merely the history of the AAA. The Anderson had changed too, and in some ways its changes were more interesting. In 1915 Major Turner had retired, giving way to John B. Stetson, the hatter's son. He had injected some serious capital into the company and Mitchell Kennerley was brought in as the new president (see figure 57). Kennerley was a pipe-smoking Englishman, a publisher and intellectual with a stylish manner of dressing (he invariably carried a silver-topped walking cane). Like John Quinn, he was on good terms with a number of eminent authors, among them Frank Harris, Upton Sinclair, D. H. Lawrence and Edna St. Vincent Millay. Born in 1878 in Burslem, an area of Britain famous for the manufacture of pottery, he had worked at first for The Bodley Head publishers in London. Sent to the United States as its representative, he found that he loved New York and after four years started out on his own. Not just as a book publisher, however; he also put out a magazine and was proprietor of the Little Bookshop Around the Corner, which soon became well known as a rendezvous for avant-garde writers.

All this was laudable and fun, and Kennerley could have gone on in this fashion for the rest of his life. But then Anthony Comstock intervened and changed everything. Comstock was a crusading populist moralist whose particular bête noire was "degenerate literature." In 1913 he had Kennerley arrested for his part in the publication of a story by Daniel Carson Goodwin called *Hagar Revelly.* Such was Comstock's reputation that his victims usually caved in under his onslaught and paid their fines, but, says Wesley Towner, not Kennerley. He chose to fight and appeared in court before a jury. Against the odds, Kennerley was acquitted. The literary world was short of heroes just then and the Englishman became an overnight celebrity.

It was against this background and at the age of thirty-seven that Kenner-
ley took over the Anderson "with a view to making it the hub of culture
selling in America." Given the firm's history as a book-auction house, Ken-
nerley was a clever choice. "Without books, God is silent," he was fond of
saying. To begin with, he took a leaf out of James Sutton's book; until he
could drum up enough trade to fill the salesrooms, he ran exhibitions. These,
says Towner, were a great success, especially Sir William Orpen's war paint-
ings, and the one-man and one-woman shows of such modern artists as
Georgia O'Keeffe, Aleksandr Archipenko and Alfred Stieglitz. Kennerley
was aware that the Armory Show had been a watershed and was trying to
formulate the Anderson's response. At this stage, the stance of the Anderson
was carefully different from that of the AAA, though it would not always
remain so. The building at Fifty-ninth and Park, opposite where Christie's is
now, was a labyrinth—cozy, less intimidating than the AAA—and all man-
ner of collectibles were being sold there every day at accessible prices. Freder-
ick Chapman, the main auctioneer, did not even sit at a rostrum; instead, says
Towner, he perched on a stool beside the stage. Though bold, Kennerley was
not reckless. He knew that whatever new areas of collecting the Anderson
might explore, it must at all costs keep its preeminence in books. The great
bibliophiles of those years—James Drake, Gabriel Wells, Susan Minns,
Henry Folger and G. D. Smith—were all forceful characters, less likely to be
put off by war in distant lands than by bad manners nearer home.

Of these five, Wells was by far the most eccentric. "His penury was legend-
ary," Towner says. "Though his bank account might contain $1 million, his
restaurants were cafeterias. If he took a business associate to dinner, he
ordered toasted muffins." Yet he was enormously generous when he wanted
to be. He gave money to many libraries, though they didn't always know it;
to maintain his anonymity he would not sign the check himself. He loved
salesrooms and auctioneers loved him, for he was the most unsubtle of
bidders: as the lot he coveted approached, everyone knew it, for his face
glowed deep red.

Wells's main rival, at least in terms of eccentricity, had no interest whatso-
ever in books as such. Miss Susan Minns came from Boston, and her singular
obsession was death in every configuration. For seventy years, beginning
when she was fourteen, she "had chased death from country to country,"
always taking care to dress the part. She had jet black hair, says Wesley
Towner, and invariably wore black lace, black shoes and a black hat. Her
house in Boston was clogged not just with books about death, pestilence and
famine, but with magic formulae for averting death, potions for inducing it,
death masks, mummies and poison cups. There was a special section on her

shelves for all recorded accounts of "passing from nature to immortality." She had more pictures than she could show, each one featuring a danse macabre, and she had almost as many plates commemorating great disasters.

Poetic justice would require that Miss Minns's own demise should bring about the dispersal of her effects. This did not happen. Whether her enthusiasm waned or whether she lamented the fact that she couldn't take it with her to the other side, she decided to sell and called in the Anderson. As Arthur Swann prepared the catalogue, however, the omens for a successful outcome were not good, for not many people shared Miss Minns's necrophilia. Then there occurred an inspired piece of good fortune. Someone recalled that until 1914 the University of Louvain in Belgium had had a gallery not unlike hers, but that it had been destroyed in the war. The idea tickled Miss Minns's imagination and she promptly donated $12,500 to the Committee for the Restoration of Louvain so that they might replace the objects that they missed most. Ironically, then, Miss Minns became the chief buyer at her own sale and her death collection lived on.

—

Outside the auction rooms, trade in America was still buoyant despite the war. Frick was especially active, his collecting more noticeable now that Morgan, Widener and Altman were all dead. In 1915 he bought Titian's *Man in a Red Cap* from Hugh Lane. Priced at £50,000, it had changed hands in 1876 for £94 10s. In the same year he also paid £205,000 (now $17.96 million) for Fragonard's ten panels called *The Progress of Love*. These too had increased markedly in price; Agnew had sold them to Morgan in 1898 for £64,000.

—

The movement of the Impressionists into the United States was now growing, aided by the sales that followed the deaths of Degas, in 1917, and of Renoir two years later. A no-less-important factor was yet another victory over the government by John Quinn. At the Armory Show he had been forced to pay 15 percent duty on the $5,508 he spent on imported foreign works that were less than twenty years old. He did not believe that American art benefited from this protectionism, and in his submission to the government, he lamented that the United States was the "only civilized nation in the world that places a tax upon art." Congress took some convincing, but Quinn had friends on Capitol Hill and in October 1913 he won. Coming in the immediate aftermath of the Armory Show, this had important commercial consequences. Existing dealers were reluctant to gamble on the new art, especially

since Old Masters were doing so well, but modern art had its disciples (a magazine, *Modern Art Collector,* flourished briefly) and new galleries began to open.

Quinn himself was instrumental in opening one, the Carroll Gallery. At first he approached Mrs. Charles Rumsey for funds, but she thought he was not commercially minded enough and declined. Next he persuaded Harriet Bryant to extend her decorating business on Forty-fourth Street. Funds were raised and, says Judith Zilczer, Walter Pach was sent back to Europe as a buyer. The first shows were held between December 1914 and March 1915 and displayed Derain, Dufy, Rouault, Vlaminck and Duchamp-Villon.

In addition, Stieglitz was eventually to own two other galleries besides 291—the Intimate Gallery and An American Place.* At 291, Stieglitz was showing Brancusi, for Quinn bought *Mademoiselle Pogany* there in 1914. From Robert Coady's Washington Square Gallery, which opened that same year, he bought Juan Gris's *The Man in the Café,* and from the Montross Gallery he bought a Matisse painting and some Matisse prints. (This was another show organized by Pach.)

The one gallery Quinn didn't buy from was that of Charles Daniel, who had originally owned a café and a hotel on Ninth Avenue and Forty-second Street. Daniel was impressed by what he saw at 291, and in 1913 he had opened his own gallery at 2 West Forty-seventh Street on the tenth floor. However, he specialized in American art, and this, says Aline Saarinen, did not interest Quinn. Daniel showed Hartley, Marin, Maurer, Demuth and Blume, and though they didn't appeal to Quinn, Lillie Bliss, Albert Barnes and Duncan Phillips were among his best customers. Daniel kept his gallery open throughout the war and moved to 600 Madison Avenue in 1924. The Bourgeois Gallery, which opened in February 1914, was yet another gallery to be advised by Walter Pach. Stephen Bourgeois, the owner, showed Cézanne and Tiepolo together and gave Joseph Stella his first one-man show in 1918. The Folsom Gallery showed John Storrs, and Weyhe, the art book dealer, showed Maurer. Knoedler had also begun to dabble in modern work. Their great days of Old Master dealing were yet to come, but they would never lose their itch for contemporary art. In 1916 the firm held an exhibition entitled "Modern French Pictures," which included two Cézannes. Several French dealers also decided to open branches in New York.

A protégé of Stieglitz's, Marius de Zayas, mounted an interesting but short-lived commercial experiment. The idea behind the Modern Gallery, an

*The first exhibition of photography in a "fine art" context is generally acknowledged to have been that organized by Stieglitz and Photo-Secession at the Albright Gallery in Buffalo in November 1910.

offshoot of 291, was to help needy European artists who had been badly affected by the war. The role of the Modern Gallery was therefore as much propaganda for modern art as it was truly commercial, though its glass windows at Forty-second Street and Fifth Avenue were deliberately inviting, in marked contrast to 291. Links were established, says Ileana Leavens, with Paul Guillaume, Vollard and Clovis Sagot's widow in Paris, and the first show was an assembly of drawings by Braque, Picabia and Picasso, together with works by de Zayas himself and photographs by Stieglitz. Its distinctive contribution was African art, which Guillaume was pushing from Paris. The experiment lasted only three years but dealers remained optimistic about modern art. Other large shows imitated the Armory Show during wartime. Commercial success was not always assured but at least there was activity.

—

In London, the art trade was more seriously disrupted by the war. After the outbreak of hostilities, sales were abandoned altogether at Sotheby's for the rest of 1914. Conscription was not introduced immediately, but many of the men joined up anyway, leaving the company to be run by women. There were some sales in the spring of 1915, but the firm's normal rhythm was not reestablished until the following year, though books and prints held up well.

The situation at Christie's was different. There, according to Percy Colson, it was predicted that the drop in stocks and shares caused by the outbreak of war would bring about a liquidity crisis, and therefore a drop in the price of land, and that this would lead to the failure of yet more estates and the dispersal of many treasures. This prediction could not have been more wrong. After the outbreak of war not a single work of art was sent to Christie's to be sold during the next season. The firm was even beginning to consider closing temporarily when suddenly it was recruited for the war effort. The Red Cross Society and the Order of St. John of Jerusalem were trying to raise money to help pay for the war, and people unable to spare cash were sending jewelry and other gifts. It was a situation tailor-made for an auction. Christie's made available their Great Rooms in King Street and their services free of charge. The king and queen were prevailed upon to lead the way. The king gave a seventeenth-century wheel-lock sporting gun, which fetched £360 10s, and John Sargent was persuaded to do a portrait of the highest bidder, which fetched £10,000, from Sir Hugh Lane. In all, says Colson, the first Red Cross sale fetched more than £37,000. This sum wasn't bad, and the idea of an annual sale caught on. The second lasted for fifteen days and the fourth and last brought in £150,000. Moreover, these sales spawned other ideas; perhaps the most romantic was a sale for which women were asked to contribute one pearl each; these would be made up into a

necklace and sold. The organizers were overwhelmed; pearls arrived in such numbers that several necklaces were made. The most expensive fetched £22,000, and in all the pearl sales raised over £83,000.

Business proper at Christie's resumed in the spring of 1915, and what became immediately clear was that in wartime everyone wanted jewels, especially diamonds. Every stone that came onto the market was snapped up by people who much preferred portable valuables to war bonds. By 1918 a semblance of normality had returned to the trade, but it was hardly buoyant. In that year, however, Christie's was helped by a most unusual sale following the death of Lockett Agnew. His firm, Messrs. Agnew, decided to sell his personal pictures (Gainsborough and Reynolds) at auction, and they fetched £25,000.

Agnew itself had not, as the phrase goes, "had a bad war." Before 1914 the firm had benefited from the boom then raging, and a branch had been opened in Berlin in 1908. In 1910 they had enjoyed a major coup in buying Alexander Young's collection for £190,000. This, according to the firm's official history, consisted of 625 pictures and drawings, and a fleet of vans was needed to bring the sixty-six Corots, fifty-nine Daubignys and fifty Constables from Blackheath. In 1911, Agnew had sold two Turners, *Cologne* and *Dieppe,* which eventually went to Frick for £57,500; in 1912 they had sold a Rembrandt for £63,000, and in 1913 they had sold two Reynoldses for £110,000 and another Rembrandt for £59,000. During the war itself, Agnew's great coup was the purchase for £65,000 of Bellini's *Feast of the Gods* from the Duke of Northumberland (it is now in the National Gallery, Washington, D.C.). Morland Agnew couldn't sleep for two nights because he was so worried about the price. In fact, several distinguished collectors actually began buying during the war, the most significant of them being Samuel Courtauld, who started his collection with the finest watercolors and English landscape pictures from Agnew.

Across town, meanwhile, at Sotheby's, Barlow was hard at work trying to move his auction house into the picture market. His greatest headache was the problem of cataloguing, for he was well aware that if his firm was to succeed in this field, he would have to employ an academically sound cataloguer whom the trade would trust. He now found Charles Bell, who had been Keeper of the Department of Fine Arts at the Ashmolean Museum in Oxford since 1908. On the strength of this he was offered a job and, according to Frank Herrmann, spent Wednesday of every week in Bond Street. However, Bell was far more than an academic; like a character out of Trollope, he was related to almost everyone in the land who mattered: Stanley Baldwin, Rudyard Kipling and Sir Edward Burne-Jones, among others. His friends included Sir John Beazley, the great authority on Greek vases, Howard

Carter, who had discovered the tomb of Tutankhamen, and Sir Edgar John Forsdyke, director of the British Museum. His uncle was Sir Edward Poynter, president of the Royal Academy. Under Bell's guidance, Sotheby's began to make progress at Christie's expense. As the Twenties opened, Old Master pictures began to come to Bell when once they would have been sent automatically to King Street.

And one type of Old Master now started to attract particular attention. It appealed to Americans especially, and throughout the Twenties these paintings would boom as never before. They were English eighteenth-century portraits, a type of picture that Charles Bell knew very well through his many relatives and friends. In terms of price and fashionability, they would become the Impressionists of the Roaring Twenties.

——

In Japan the years spanning the war, 1910 to 1923 (the year of the Great Kanto Earthquake), saw the publication of *Shirakaba* (White Birch). This was a literary journal but it had an arts bias and played a major role in shaping the taste of the country. The magazine published translations of European writings on Cézanne and Rodin, in particular, and also printed reproductions of new European works. Thus it familiarized Japanese readers with Monet, Gauguin, van Gogh, Renoir, and Matisse. In doing this, Michiaki Kawakita says, *Shirakaba* was influenced by a number of Japanese artists who had studied in Europe and returned to the country about 1910— for example, Saito Yori, Takamura Kotaro and Minanni Kunzo. In that same year Takamura translated Matisse's theories on painting, and this excited a great deal of interest among Japanese artists.

Shirakaba's role was not accidental. The aims of the Impressionists and Post-Impressionists coincided with a new development in Japanese art, the search for individualism. This was scarcely a fresh theme in Western art, but it was quite new in Japan. Kawakita again: "The point about Renoir, Matisse, Cézanne, van Gogh, and Gauguin was not so much a matter of the variations in their artistic styles as the insistence of all upon individualistic expression, and in Japan during this age the individualism of these artists agreed with the newest trends in thought and literature." *Shirakaba* was followed by a number of groups—the Absinthe Society, La Société du Fusain, Sodosha—all of which stressed individualism in art and took as their models Post-Impressionism and/or Fauvism.

More and more, through these years, the influence of van Gogh and Cézanne in particular was felt in Japan. The writings of such well-known Japanese artists as Kishida Ryusei are peppered with references to these two artists. With the Nika Society (1914), Japan had its own breakaway group,

which seceded from the Ministry of Education exhibition that year. This was tame by the standards of Paris or Berlin but nonetheless confirmed the identification of Japanese artists with European painters. These developments in themselves did not directly affect the art market, at least not immediately. But they do help explain the strong art market in that country today for contemporary Western-style Japanese painting. To the Japanese this is not simply modern; it *is* Western painting, the first demonstration of individualism. And these movements help explain the obsession with van Gogh: it is a love not simply for his style but for his courage.

One other matter needs to be mentioned for a proper understanding of the Japanese art market, and that is the difference between Tokyo and Kyoto. All that has been said so far applies more strongly to Tokyo than to anywhere else. In Kyoto three artists were especially important: Umehara Ryuzaburo, Yasui Sotaro and Suda Kumitaro. Umehara was notable because he traveled to Paris, discovered the Renoirs in the Luxembourg, visited the painter at Cagnes, and became a disciple. Umehara and a group of painters around him were as enthusiastic about Renoir as the Tokyo painters were about van Gogh, Cézanne and Matisse. Without Umehara, it is unlikely that the Japanese passion for Renoir would exist.

In 1917, the year bread was rationed in Britain, the year the royal family renounced their German names, and the year of the October Revolution in Russia, Sotheby's held forty-nine sales in London. By 1920 the number had more than doubled, to one hundred and fourteen. Such proliferation was due partly to the rise in prosperity after the war and partly to America's increasing interest in the visual arts. In Britain, however, there was another, less pleasant, factor: Prime Minister Lloyd George had increased death duties. This released many more pictures, furniture and other objects onto the market to pay those duties.

At Sotheby's, Montague Barlow recruited another important new face, Charles Des Graz, who was hired to look after the book department. Like Charles Bell, Frank Herrmann tells us, Des Graz came to Sotheby's with contacts: during the war he had worked in the censorship department and afterward at the British Library of Information in the United States.

Books did well throughout the Twenties, partly because of Britwell. Britwell is one of those names that are legendary among specialists but scarcely known outside the charmed circle. The name referred to an extraordinary library, put together mainly by William Henry Miller in the early nineteenth century, which had been housed at Britwell Court in Buckinghamshire. It was sold by his heirs at twenty-one sales between 1916 and 1927, and fetched in all £605,000 ($32.5 million at today's values).

A name that is even less well known is Ruxley Lodge; yet the Ruxley Lodge sale was, in many ways, far more extraordinary even than the Britwell sale. Though it took place more than seventy years ago, it has recently been analyzed by two bibliophiles, Arthur and Janet Ing Freeman, who work for Bernard Quaritch. Their analysis of Ruxley Lodge, on which this account is based, is fascinating for two reasons. First, they show that the auction fell victim to a ring of booksellers that numbered no fewer than eighty-one. Second, in their exposé of the "settlements" (a term that will be explained below) they demonstrate that the book trade was divided into a number of tiers. This is an unusual—and unusually neat—way of explaining the structure of the trade.

Ruxley Lodge was the traditional home of the Foley family at Claygate in Surrey. The sixth Baron Foley died in 1918 and his heir, the seventh baron, who preferred racing to reading, decided to sell the Surrey estate. This consisted of buildings, land and pictures, as well as books, but the library was especially rich. For reasons best known to himself, the seventh baron entrusted the sale to the firm of Castiglione & Scott, of London and Edinburgh, which may have been his first mistake. Castiglione & Scott were good auctioneers but not specialists in books; as a result, the Ruxley Lodge sale was seriously undercatalogued, and this produced a set of circumstances ripe for a ring. Rings have a long history in the British book trade. "Knock-outs," as they were also called, were widespread in Regency London—they are the subject of a satirical poem, *Chalcographimania,* by W. H. Ireland—and were omnipresent during the nineteenth century, even at the Hamilton Palace sale itself. This was not surprising, because although there were critics in the press from time to time, rings were not illegal in Britain, not even at the time of Ruxley Lodge.

A ring is an agreement by some members of the trade to refrain from competitive bidding on any objects in which two or more members of the ring have an interest. The object is then knocked down to one designated member of the ring, usually for far less than it would otherwise fetch. Later these "ringed" objects are put up for sale again at a "settlement," traditionally held in a nearby pub. Say Dealer A pays £100 for the object at auction. In the settlement it then fetches £150, paid by Dealer B. B gets the object but must now reimburse A his initial £100 and pay the surplus (in this case £50) into a kitty. At the end of the settlement the kitty is divided equally among members of the ring. Several goals are achieved by this: first, usually (but by no means always) the object is acquired for less than its market value; second, dealers who refrain from bidding are compensated from the kitty because, in effect, monies that should go to the vendor go to the trade; third, the trade frightens non–ring members away, so that valuable objects remain with the

dealers in the ring. A refinement on all this is that successive settlements may take place after the first one; some less important dealers may be paid off from the first kitty, but there is a "ring-within-a-ring" and the auction goes on among a smaller number of dealers. The Ruxley Lodge auction illustrates all these features beautifully.

For example, Freeman and Freeman calculate that the ring bought 447 of the 641 lots on offer at Ruxley Lodge for £3,161 19s 6d. The first settlement, held among the eighty-one dealers in the ring, added £10,292 16s 6d to the value at auction. In the second settlement 293 lots were sold among twenty-four dealers, adding £3,137 7s to the value. The third settlement involved 157 lots and fifteen dealers and added £1,686 1s. The fourth and final settlement involved twenty-two lots and eight dealers, and added £866. In other words, the 447 lots for which the seventh baron had received £3,161 19s 6d at auction actually raised £19,696 17s by the end of the last settlement. Though the entire procedure was legal, some people thought that the baron was cheated out of £16,535 ($730,000 at today's values). The ring is big business.

The sale gives a good idea of how many dealers there were in Britain at the time and who the big players were. Apart from Quaritch, which was part of the ring, the others in the last settlement were: Percy John Dobell, of Charing Cross Road—the son of Bertram Dobell, he specialized in Restoration and eighteenth-century English literature; Pickering and Chatto—then at Panton Street, now in Pall Mall, and owned by Lord Rees-Mogg, a former editor of *The* [London] *Times;* their specialty was much the same as Dobell's, but less academic; Frank Sabin of New Bond Street—regarded as the bibliophile Dr. Rosenbach's "richest source of supply." At one point in 1907 Rosenbach had owed Sabin £6,500; during the war he had shipped a lot of stock to the United States and left it with such customers as Rosenbach "on approval." There were three Sabin brothers, who at the time of Ruxley Lodge were in fact leading the firm more into paintings and prints, where they remain today. Sabin's was a fashionable firm, and expensive; James Tregaskis, an enthusiastic Johnsonian and sixty-nine at the time of Ruxley Lodge. He was also the perfect ringman. The Freemans found that he bought only one lot at the auction itself but four of the twenty-two lots in the final settlement, mainly a bundle of Restoration plays—*The Late Lancashire Witches,* by Thomas Heywood, and *A New Wonder: A Woman Never Vexed,* by William Rowley, among others—and spent £1,515 15s in all. This lot of plays was a perfect example of what can happen in a ring. It fetched £10 in the auction but in successive settlements rose to £810, £880, £1,090, and finally, the price Tregaskis paid, £1,260; Francis Edwards, the fifth of the finalists, was at Marylebone High Street, where his firm remained until it disappeared in 1989. Edwards specialized in history, travel and the classics; Maggs, then of

Conduit Street, now of Berkeley Square, was only slightly below Quaritch in importance. In those days they specialized in fine bindings, illustrated travel, French literature, and fine and applied art. That all of the main players should have been present in the final ring merely shows that it had the force of tradition and wasn't illegal.*

Nonetheless the injustice was there, and within a few months *Truth* magazine took up the issue, alerted by the first Britwell sales, when several Shakespeare books that fetched around £100 at Ruxley Lodge went for £2,000 at Britwell. The *Truth* articles were taken up by *The Times.* This in turn raised the interest of the government, which had begun to do something about rings before the war, when witnesses (including Roger Fry) had been called before a committee of the trustees of the National Gallery, convened to examine "iniquities in the present-day art market." The committee had suggested that a tax be levied on auctioneers' "excessive" profits, but the issue had died with the outbreak of hostilities. Now the government stirred again. Ruxley Lodge was one reason, but another was that in 1920 the government itself had been the victim of a ring. In May of that year, a ring of three dealers had combined at a sale of government war-surplus material. The tide against rings grew stronger, culminating in 1926, when a sale of six Hepplewhite chairs became the subject of a scandal; on discovering a ring, the vendor refused to deliver the chairs and was sued. The judgment went against him, so outraging sellers (who included not a few lawyers) that the Auctions (Bidding Agreements) Act was introduced to Parliament and went into effect on January 1, 1928. Thereupon the legal ring disappeared in Britain.

—

The success of the Britwell sale had important consequences for Sotheby's. With such bread-and-butter in good supply, Barlow judged that it was time to take the battle to Christie's more forcefully. By now he was convinced that it was in pictures where big money and big publicity were to be found. Charles Bell had set the firm on the right road but left in 1924. However, he did recommend a successor, a Finnish art historian flamboyantly named Tancred Borenius. Like most brilliant art historians—for example, Berenson and von Bode—Borenius had a prodigious visual memory; but, as Frank Herrmann noted, he was also well connected, numbering the royal family, Lytton Strachey and the Sitwells among his circle, and he spoke nine languages fluently. One of Borenius's friends was Lord Lascelles, then intent on enriching Harewood House. After Lascelles's marriage to the princess royal,

*The eighth finalist proved impossible to identify from the documents.

Borenius met her mother, Queen Mary. An enthusiastic collector, the queen often consulted the Finn on pictures.

With such friends, the picture side of Sotheby's flourished during the Twenties, and its gross rose from £33,000 in 1924–25 to £186,000 four years later.

In 1926, Borenius founded *Apollo* magazine. The success of this journal, which looked at collections being formed, at historical aspects of collecting, and at the art trade, was itself a symptom of the booming market. But it also added to Borenius's distinction, and in turn this rubbed off on Sotheby's. The firm's social profile was in any case higher now than it had ever been, thanks to the fact that until 1923 Barlow was a member of the Cabinet as minister for labour. He was ousted in the general election of December 1923 but knighted in 1924. An auctioneer knighted: he had certainly lived up to his boast about making the trade fit for gentlemen. This achieved, Barlow now decided to hand over his prime ministerial role at Sotheby's. It was, he felt, a good time to go.

Throughout the Twenties prices were high, not quite as high in real terms as they had been in 1913, but by 1927 people were again talking of a miraculous year. Nineteen twenty-eight was even better than 1927, for it saw the great Holford sale. The Holford collection, housed at Dorchester House in Park Lane (now the Dorchester Hotel), set a record that would stand for thirty years. In 1929 the boom continued; the National Gallery in London paid £122,000 ($6.6 million today) for Titian's *Cornaro Family,* owned by the Duke of Northumberland. So Barlow was leaving at a good time. Britwell had come to an end, but Borenius had led the firm into the fine-arts world successfully. There was less and less difference between Christie's and Sotheby's, except that Sotheby's kept its ascendancy in books. In fact, Sotheby's was now becoming more profitable than Christie's. To mark his farewell, Barlow gave a dinner for all fifty-five members of the staff. It was held at the New Princess restaurant in Piccadilly, and the eight-course dinner, says Herrmann, was washed down by a 1924 château-bottled Margaux and a 1919 champagne. For many people present it must have been the last time they tasted such luxury, for the dinner took place on April 27, 1929. No one saw what was around the corner.

—

In France, and in Paris especially, the Twenties saw a fragmentation and proliferation of public salons (it should not be forgotten that salons existed first and foremost to sell works). The Salon des Indépendants and the Salon d'Automne were well established, of course, but in 1923 Othon Friesz and

Charles Du Fresne founded the Salon des Tuileries. Access was by invitation only and the salon showed pictures by Gleizes, Lhote, Metzinger, Zadkine and others. According to Malcolm Gee, the Salon des Cent, to which Braque, Picasso and Gris gave their support, never got off the ground; nor did the Salon Unique. However, the Salon de l'Art Français Indépendants and the Salon des Surindépendants, launched in 1929, did.

Dealers were expanding too, especially in the field of modern art. *"Chaque jour,"* wrote André Salmon in 1920, *"nous voyons surgir également un nouveau marchand des tableaux."* ("Every day yet another new art dealer makes his appearance.") Popular locations changed, away from the Madeleine, the Trinité and the rue du Faubourg Montmartre, to farther west around the rue La Boétie, where many of the best galleries may still be found today. It was at this time that the rue de Seine on the Left Bank began to be a center for smaller galleries. According to Malcolm Gee, quoting Greta Ring of the Cassirer Gallery in Berlin, this geographical split was one feature in the success of Parisian painters: "There were two sets of dealers, left bank and right bank. The [former] discovered young artists, gave them contracts, and sold their works at relatively low prices to a small group of collectors. When one of their *poulains* was successful and obtained a contract with a large gallery, the first dealer . . . profitted from the ensuing higher prices." Again according to Gee, the dealers at this time also differed according to whether they tried to sell quickly (as did Berthe Weill) or held on to stock until it appreciated (Vollard, Kahnweiler, Léonce Rosenberg). There were also newcomers who were primarily interested in commerce (Mouradian and Van Leer, cotton traders, who opened on the rue de Seine in 1925) or in aesthetics (André Breton, who was involved in the Galerie Surréaliste from 1926 to 1928).

Kahnweiler was in a sense paralleled by his rival and virtual enemy, Léonce Rosenberg, owner of the Galerie de l'Effort Moderne. Like Kahnweiler, Rosenberg had trained in commerce, in commodities in London, Antwerp and Paris. Also like Kahnweiler, he had contracts with his artists, which he enforced firmly; Malcolm Gee tells us that when Jacques Lipchitz left the gallery in 1920, he was forced to pay back what he owed, though he was in financial straits at the time. Again, like Kahnweiler, Rosenberg wrote about modern art and considered himself more than a dealer. Unlike Kahnweiler's, his views were grandiose, impetuous, and quarrelsome; he even sent circulars to his artists to air his views. His brother Paul thought he was poor at business, as did Kahnweiler, and according to André Salmon, his gallery was "in the one street of Paris unknown to taxi drivers." After the war, although he never rated Cubism, Rosenberg held a series of one-man shows (for Léger, Braque and Gris) and promoted them by means of matinées of poetry and

music. He published books about his artists and then felt justified in raising prices. In 1921, for instance, he charged 3,000–6,000 francs for Braques for which he had paid 600 francs in 1918. He thought he was brilliant at business, and when he wasn't bombarding artists with his theories about art, he sent them newsletters on the economics of the art market.

René Gimpel records visiting Rosenberg's gallery in the summer of 1919. "I was shown upstairs to a large, long room forming a gallery. . . . I stopped in front of a marble ball cut like a Dutch cheese. I asked Léonce what it represented, and he replied: 'It's a woman's head.' I gazed, astonished, and then he added: 'Only the form counts: it makes any representation of accessories—the mouth, eyes, and nose—quite superfluous.' . . . I paused before each of these marbles and struggled . . . to understand what the artist meant to depict. I didn't get there. I asked Rosenberg to explain, but he said defensively: 'Our works keep their secret.' . . . Finally I came to a statue that was all angles; it was marble but gave the impression of being coated in steel, armour-plated from head to foot. I was relieved . . . and I declared with the authority of something seen and clearly understood: 'Now that, that's a knight.' 'No,' replied Rosenberg, 'it's a female nude.' "

It is easy to imagine how galled Kahnweiler must have been when Rosenberg was given the task of disposing of Kahnweiler's collection as part of the postwar reparations scheme. In the postwar period Drouot was a gloomy place, and the *commissaires-priseurs* were very conservative in their tastes. The one exception was Alphonse Bellier, an ambitious young man from Brittany who, says Malcolm Gee, had bought a moribund practice and become a *commissaire-priseur* specializing in contemporary art. By persuading such artists as Dufy, Derain and Suzanne Valadon to part with pictures, he was able to hold several successful sales of modern art "from the easel" in 1923, with proceeds ranging from 20,511 francs to 51,000 francs (the former would be $42,500 now). In 1924 and 1925, however, three of his friends, the Surrealist painter and poet Paul Éluard included, gave him "single owner" collections and this really put Bellier on the map. Thereafter he was identified with the new and successful market in contemporary art where, as one newspaper account put it, there were "sensational and also suspect bids."

Bellier continued as a dominant force in the art market throughout the Twenties and Thirties. In fact, the auctions in Paris in the Twenties resembled those in New York some sixty years later. Says Gee, "The rather feverish excitement generated in auction sales became particularly associated, from 1925 onwards, with sales of modern art, where spectacular leaps in price were common. . . . From the time that the auctions of modern art began to succeed in 1925–26, they were considered as the key to the state of the art market and

the gauge of the boom in modern painting. As prices steadily rose, observers became increasingly suspicious of the way in which high bids occurred. There was a tradition attached to the Hôtel Drouot concerning the sales of antiques, which portrayed a mysterious gang of dealers rigging all the auctions [the *bande noire*]. Now the notion was adapted to interpret sales of modern art—the dealers were accused of buying at inflated prices paintings by artists whose work they had in stock."

But even in this heady and familiar scene, the Kahnweiler auction stood out. He had eventually returned to Paris and opened a new gallery, in September 1920, on the rue d'Astorg. The new premises were known as the Galerie Simon because Kahnweiler now had a silent partner, André Cahen, usually known as André Simon. Artists like Léger, who had a distinguished war record himself, worked hard on Kahnweiler's behalf, but by 1921 it was clear that the German government was reluctant to pay the reparations stipulated by the Treaty of Versailles, and so the French retaliated by seizing all German assets in France "without exception."

The sale of Kahnweiler's stock was set for June 13, 1921. Bellier's auction house would sell it, and Léonce Rosenberg was to be the expert. Before the sale a scene erupted when Braque attacked Rosenberg as the pictures went on view. According to Pierre Assouline, he "shook him by the collar and kicked him." Braque shouted that Rosenberg was a "bastard," and the dealer retaliated by calling the painter a "Norman pig." Matisse turned up in the middle of the fracas, and on being told what had happened by Gertrude Stein, joined in, shouting: "Braque is right. This man has robbed France." No charges were ever filed, although afterward Rosenberg took boxing lessons.

The Kahnweiler sale was important because in many ways it was the first verdict by the auction rooms on modern painting. Everyone was there— artists, dealers, collectors, not only from France but from Stockholm, Zurich, Geneva, Amsterdam and London. Tristan Tzara, representing the Dadaist group, was horrified at the way Bellier mispronounced foreign names. Prices were generally modest. The twenty-four Derains did best, followed by the twenty-two Braques. The seven Légers and six van Dongens sold almost as well, but the twenty-six Picassos and the twenty-three Vlamincks were quite cheap. Kahnweiler was not allowed to bid himself but formed a syndicate with Louise Leiris (his sister-in-law), Hermann Rupf, Alfred Flechtheim and Gustave Kahnweiler, his brother. Bernheim-Jeune bought most of the Vlamincks, while the syndicate concentrated on Braque and Gris.

But that was only the first round of several. The second part of the sale was held in November, and again a brawl broke out beforehand. This time

Rosenberg exchanged insults and traded punches with Adolphe Basler, a Polish painter, who hit Rosenberg across the skull with his cane. At this sale, prices were a good deal below what they had been. Assouline reports, "Collectors of Picasso were gleefully rubbing their hands because they could buy the works of the great man for the price of the stretcher. The art speculators were making a face that what had been three thousand francs a while back now sold for fifteen louis [three hundred francs]—frame included." There was no disguising that the second sale was a failure. The press was openly contemptuous and Kahnweiler himself tried to delay the third sale, scheduled for the summer of 1922. The market in contemporary art was bad everywhere, whereas in 1921 Gainsborough's *Blue Boy* had sold for £148,000 ($6.2 million now). Germany had devalued the mark and the Berlin market in contemporary art was nonexistent.

Kahnweiler's entreaties did no good. The third sale took place as planned, and again failed. ("People no longer protested when employees at Drouot held paintings and drawings upside down.") The fourth and final sale took place in May 1923 and was no better. Assouline again: "Paintings were piled haphazardly, drawings were rolled or folded between cardboard, and others were hidden behind the stage, where they could not be seen, grimy and wrinkled. The auctioneer ridiculed the merchandise."

In all, the Kahnweiler sales provided France with 704,139 francs ($1.46 million at today's values). Most of the country took no notice, for in that year the occupation of the Ruhr began. But think what those paintings would be worth today. In all, Kahnweiler's sequestered stock consisted of 712 paintings—205 Vlamincks, 132 Braques, 132 Picassos, 111 Derains, 56 Gris, 43 Légers, and 33 van Dongens—and the pictures sold for an average of less than a thousand francs each.*

But 1922–23 was the low point in the contemporary market. Speculation was again in the air. A new gallery had opened on the rue La Boétie, the Percier, with a capital of 250,000 francs, created in the same spirit as La Peau de l'Ours. There were six shareholders, mainly bankers or stockbrokers, and André Level was again one of them. In fairness, this was not simply a speculation but also a way to support younger artists.

Among those who bought at the Kahnweiler sale were Paul Guillaume and Paul Rosenberg, Léonce's brother. Rosenberg had a superb eye, concentrated when he could only on masterworks and, in the trade, was chiefly known for his first-refusal contracts with Picasso (1918), Braque (1924) and Léger (1927); according to Malcolm Gee, these dates "mark fairly precisely

*Durand-Ruel had died at the end of 1922; and in his storeroom were 800 Renoirs and 600 Degas. Yet the man himself left the world almost penniless.

the worldly ascension of each artist," which is quite an accolade for Rosenberg. He had inherited his gallery from his father, but Guillaume, who also ended up near Rosenberg on the rue La Boétie, had to make his fortune himself. He had started by selling African sculpture, and through this he met Apollinaire. He was classified as unfit for military service and with Apollinaire's help tried to take over Kahnweiler's artists during the war. He did not succeed but instead started buying Modigliani, again on Apollinaire's advice. In 1919 his African art finally paid off, and a large Art Nègre exhibition that he held at the Galerie Derambez was a great success. Thereafter, Guillaume appears to have turned the corner; he acquired a gift for publicity and his artists became chic. Like Georges Petit before him and Dudley Tooth later, he became a fashionable dealer. Albert Barnes also had something to do with this; the two men got on well, and later Guillaume would call himself the co-creator of the Barnes collection in Merion, Pennsylvania (see figure 60). In 1923 he became Derain's dealer; by now Derain was one of the more reassuring modern painters, and this appears to have suited Guillaume.

This was a time when the Right Bank and the Left Bank in Paris were taking on the character they have today, though some of the names have changed by now. Druet, Bernheim-Jeune, Hessel, Bing and Bignou were grouped around the rue La Boétie, and Pierre Loeb, Jeanne Bucher and the Galerie Vavin-Raspail were on or around the rue de Seine. There were also a number of businessmen who bought into such galleries as Galerie Druet and the Galerie de Sèvres in the hope of making money.

In London after the war, more and more galleries began to show collections of modern art. In 1918 Sir Charles Holmes, director of the National Gallery, had attended the Degas estate sale in Paris, where he had acquired for the nation a group of works by Degas himself, by Delacroix, Manet and Gauguin. Heal's Mansard Gallery showed modern French art, and the Leicester Galleries mounted a series of one-man shows between 1919 and 1925, including Matisse, Picasso, van Gogh, Gauguin and Cézanne.

But if London was beginning to boom, Glasgow was not, and Alex Reid decided to move south. He was nearly seventy and so it was his son who actually made the arrangements. Reid started by persuading Colin Agnew to let him use the Agnew premises for an exhibition. But Reid also dealt with a Frenchman, Étienne Bignou, who had been left a gallery on the rue La Boétie. Bignou liked England and brought paintings there regularly; one of his other clients was Ernest Lefèvre, who was a nephew of Ernst Gambart and was still operating at 1-a King Street. It was Bignou who put Reid and Lefèvre together, and he joined the board of their new gallery when it was

established in 1926. The new management decided to make a break with the Gambart past, and a sale was held at Puttick and Simpson in which the Holman Hunts, Landseers, Bonheurs and W. P. Friths were auctioned.

Now Bignou, Reid and Lefèvre became the center of an important group of international dealers trading in modern French art. Later in the decade Bignou, together with Gaston and Josse Bernheim-Jeune, and with some backing from Reid and Lefévre, bought Georges Petit's gallery, which had declined sadly since the great days of the 1880s. According to Douglas Cooper, it was Bignou who persuaded Vollard to associate himself with this group and make it a formidable international alignment, showing stock that included the best Impressionist, Post-Impressionist and contemporary painters. To this group was added George Keller, who had run the Galerie Barbazanges in Paris but had then become Albert Barnes's European secretary when he was building his famous collection. Bignou opened a gallery in New York, which Keller ran, so the group was now represented in the three major capitals. Together they mounted some wonderful shows, especially of Matisse and Picasso, but were hit badly in the crash of 1929, with the result that in 1933 the Galerie Georges Petit closed.

After Reid and Lefèvre joined forces, one of their best early clients was Samuel Courtauld. He came of French Protestant stock, his ancestors having been expelled following the revocation of the Edict of Nantes. Like Wildenstein's, Shchukin's and Morozov's, his family was in the clothing business—in his case silk. The technical advances stimulated by World War I led to the development of synthetics just after the war, and it was this that gave Courtauld, the "rayon king," his immense fortune. Courtauld was always his own man. (When he was a boy and Queen Victoria patted his cheek, her fingers were sticky; he wondered aloud whether she ate a lot of toffee.) As an adult, he was thought eccentric by many because he collected Impressionist and Post-Impressionist painting, and he was sometimes wounded by this, especially as he was not the first person in the field. (The British lagged twenty years behind other nations in this regard; even so, Frank Stoop, Mrs. R. A. Workman, Gwendoline Davies and Constantine Ionides had all collected before Courtauld started.)

Courtauld began collecting when he saw the Hugh Lane bequest in the National Gallery. After considerable controversy, the gallery had acquired thirty-nine Impressionist and Neo-Impressionist French pictures in 1917. The shock of these works was great but like Vollard and Kahnweiler, Courtauld responded positively to shock, and his collection soon surpassed all others in Britain. His interest in painting was also influenced by the fact that his mother, Sarah Sharpe, was related to Sutton Sharpe, who had been a close friend of many of the great British artists of an earlier generation,

including Flaxman, Fuseli and Opie. Courtauld was in fact attracted by the links between English art, especially Constable and Turner, and French Impressionism. Again according to Douglas Cooper, the first dealer he used was Percy Moore Turner, but as his taste progressed to Cézanne, a previous stumbling block, Courtauld used Reid and Lefèvre. Courtauld's wife was also an important influence. Whenever they had differences, one of them would say, "Let's go and buy pictures," and peace would be restored. Mrs. Courtauld died in 1931, which was such a blow that Samuel gave up buying pictures for five years. For several London dealers, Mrs. Courtauld's death was another sad feature of the months following the 1929 crash.

Cortlandt Field Bishop, who had acquired the AAA from the Kirbys, was a man rich in eccentricities, not the least of which was to date the letters with which he bombarded his subordinates according to the ecclesiastical calendar ("Written on the Vigil of the Blessed Epiphany . . ."). But if this seems to imply that Bishop had an episcopal nature, it is misleading, for in many ways he was the epitome of the Roaring Twenties. There is the hint of a Scott Fitzgerald character in Bishop's passion for long, black, fast motorcars, in his relish for travel in general and for the Paris Ritz in particular, in the vehemence with which he mailed dead insects to people with whom he found fault, or in the gusto with which he sent cheese to those who were in his good books. Wesley Towner reports that Bishop, born in 1871, had inherited part of his fortune from Catherine Lorillard Wolfe, the richest unmarried woman in America, the heir of Peter Lorillard, a tobacco monger, upon whose death in 1843 the newspapers coined a new word, "millionaire." As a boy in Massachusetts, Bishop had a youthful attack of what could be called the Miss Binns syndrome; he would travel forty or fifty miles a day on horseback in search of disasters—fires, floods and train crashes. He must often have been disappointed but his searches were widened in 1897 when he acquired one of the first motor-driven tricycles.

Bishop did not settle down when he took a wife. She was Amy Bend, and she shared his love of movement. They bought ever-faster cars, and in leather jackets and goggles zoomed around the countryside. They spent much of their time in Europe, where they embraced ballooning, zeppelins and airplanes. Bishop even contributed money for the improvement of roads in France, which gave him the privilege of erecting his own road signs, each one annotated "Presented by Cortlandt Field Bishop of New York." By the time he was fifty-two, he had been abroad fifty-one times and according to his own account had spent more than half his life in a motorcar (see figures 53 and 54).

The Bishops had artistic pretensions even before Cortlandt bought the AAA. His father acquired Americana, and his brother, David, who committed suicide, collected timepieces, so it was not out of character for Cortlandt to buy an auction house. Moreover, he was in an acquisitive mood; his mother had died in 1922 and the whole Bishop fortune fell to him. With it, he bought the Ritz in Paris (allegedly because he had once been told the hotel was full when he wished to stay there) and the *Paris Times* (allegedly because he didn't like the *Paris Herald*). He also financed a hotel chain in the Sahara and built a new house in the United States in Lenox, Massachusetts. It was no ordinary home; Wesley Towner says that it took a hundred men two years to build it, and it was named Ananda Hall—Ananda meaning, "in the lexicon of yoga," the abode of bliss and happiness. It had seventy rooms, and in the kitchen was a fifteen-foot-long sink made of German silver.

Bishop started collecting after his mother died, spending $1 million on rare books. The acquisition of the AAA fitted his conception of the way the world was going. His travels in Europe had taught him, he said, that the Continent was being impoverished, and thus opportunities existed to make the AAA on Fifty-seventh Street the greatest auction house in the world. At least Bishop had statistics on his side. According to Treasury figures, the value of antique works of art imported into the United States rose from $478,000 in 1909, the year the import duty on art more than one hundred years old was lifted, to over $21,500,000 in 1919. Many of them, says Towner, were fakes (up to 75 percent, according to one customs appraiser), but Bishop brushed this detail aside and set about organizing what has been called the last great European treasure hunt. He wanted genuine works of art that could be exported to America legally (more and more countries were passing laws to prevent their art leaving), and he wanted enormous quantities of them. He ran the operation himself, from Suite 18 of the Ritz in Paris. Scouts were employed on a scale never known before. A 2 percent commission was paid for fruitful introductions, and foreign dealers who could assemble auctionable collections were paid with advances that sometimes reached six figures in dollars ($100,000 then would be $973,000 now).

The biggest, most important, and most significant was the so-called Chiesa collection. Achille Chiesa, a Milanese coffee importer, had bought art with the idea of leaving the city of Milan a memorial in his name. He had died before realizing this ambition, and his son, Achillito, had filled his shoes. He added to the collection and before he was done, the Old Masters, ivories and religious reliquaries were said to be worth $7 million. This attracted the attention of Bishop and the others, and they persuaded Achillito that there was an alternative to a Milan memorial: a New York sale for which Achillito was guaranteed $1 million.

It took the Chiesa collection two years to come on the block; it had to be catalogued, crated, shipped, uncrated, and recatalogued. As in London, the cataloguing of paintings in New York was improving. Better printing techniques had something to do with this, but at the AAA it was also due to the arrival of Mary Vandergrift and Leslie Hyam, an Englishman, who brought scholarship and style to the prose that accompanied the catalogue illustrations. Hyam and Vandergrift were fitting teammates for Parke and Bernet. By now the major had acquired a commanding style on the rostrum. His voice did not have the drumlike quality of Kirby's, but his presence radiated *gravitas* from the appropriately gothic rostrum that he used. Otto Bernet was different. In Wesley Towner's words, "He was Mr. Pickwick . . . gullible and gregarious, curious and perpetually astonished. . . . he stood in the galleries with his thumbs thrust into his vest pockets; on the rostrum all geese were swans; and the rest of the staff adored him." Still, Otto Bernet played second fiddle to Hiram Parke. The major took all the main sales, and it was chiefly by his brilliance that the AAA was known.

This was the de facto setup, but technically Otto Bernet was the top man. He was general manager, and it was to him, Towner reminds us, that Bishop had entrusted his capital. Bishop was aware of this, of course, and rubbed salt in Parke's wound. Otto Bernet's second wife had once been an ordinary typist, but Bishop put the Bernets up at the Ritz, while the more stylish Parkes were relegated to the Édouard VII. Letters to Parke would sometimes begin, "Sir VP," whereas with Bernet it was "Dear Otto." This streak of cruelty would, in time, come to matter.

But before then, the Chiesa collection finally reached Parke's gothic rostrum. Displayed in the United States, the collection was seen to be nowhere near as good as had been supposed; to make matters worse, the Italian government had prevented the export of the better items. The main objects— pictures, cassoni (carved and decorated matrimonial chests) and majolica— that were allowed to cross the Atlantic were sold in 1925 and 1926. Hearst and Kress were active bidders, but the sale was a disastrous failure. By the cruel alchemy of Bishop's foolhardiness and the Italian embargo, the much-heralded $7 million collection had shrunk alarmingly; although Chiesa collection sales were still being held at the AAA in the Thirties, a total of $698,397, or less than 10 percent of the anticipated total, appeared in the company's accounts.

To make matters worse, at about the same time the Anderson had a sensational success. This was the sale of the Melk copy of the Gutenberg Bible, which took place on February 15, 1926. The Melk Gutenberg, a paper rather than vellum copy, had been in the Benedictine monastery at Melk, overlooking the waters of the Danube in Austria, almost since it had been

printed. The monks had decided to sell, says Towner, because "they had rather more bibles than, strictly speaking, they needed, and rather less cash." Hundreds of people trooped into the Anderson to view the two volumes of the Bible, which were then 471 years old. On the evening of the auction, the salesroom was packed. Belle da Costa Greene was there and made the opening bid—$50,000, exactly the amount that had been the closing bid for Robert Hoe's vellum copy of the same book fifteen years earlier. Thereafter the bidding rose to $83,000, by which time the only two contestants were Gabriel Wells and Dr. Abraham Rosenbach. Abie, or Rosy, as he was variously but always affectionately known, was described as "a plump cross between Falstaff and Buddha," equally at home with Rabelais and rabbinical texts. He spoke classical tongues as if they were living languages, says Towner, and after G. D. Smith's demise, he became "the Napoleon of bibliophiles." On this occasion, he paid $106,000 ($1.1 million today), a magnificent sum, on behalf of Mrs. Edward Harkness, who now removed the Melk Bible to another seat of learning, Yale.

This was not the only coup by the Anderson. Perhaps even more extraordinary was the acquisition by Mitchell Kennerley of the Leverhulme estate in Britain. Lord Leverhulme, founder of the Lever Brothers soap empire, had died, leaving his estate, The Hill, in Hampstead, saddled with about $1 million in death duties ($10.5 million now). At first the estate had been consigned to the English estate agents and auctioneers Knight, Frank & Rutley, but the executors soon grew doubtful about the English market's capacity to absorb so much material. Kennerley traveled to Britain, sifted through the objects and then convinced the executors that the market was bigger and more buoyant in New York. Merely acquiring the rights was a coup, but it was risky because Kennerley was forced to guarantee the estate $1 million. After the debacle of Chiesa, this took nerve.

The guarantee was only one problem, however: the deal was discussed in the House of Lords, where reservations were expressed about the export of so large and distinguished a collection. But the courts refused to intervene. In the United States Cortlandt Bishop was beside himself with anger that the Anderson had landed such a publicity-rich sale—or at least he was until he went to London to see the collection. Then he reported back to "Sir VP" and Otto that Kennerley "had fallen for a lot of junk." Coming from the man who had so misjudged the Chiesa collection, this opinion was not to be trusted. Kennerley transported the 2,336 lots in forty-four vans to Liverpool, where they embarked for New York. Cortlandt Bishop had been right about the publicity value of the Leverhulme collection, but wrong—very wrong—about its value. When the sale finally took place, the British executors of the estate and Kennerley were delighted to see it fetch a grand total of $1,248,503

($13.01 million now), comfortably above the guarantee. The comparison with the Chiesa collection was easy to make, and the Anderson was no longer a weak number two.

No one knows exactly when thoughts of a merger between the two houses first occurred to any of the principals, but it may have been around this time. Though both houses were doing well, it was obvious to Mitchell Kennerley that a merger had a lot to be said for it. The rivalry was draining energy that could be better used elsewhere. Before such a marriage could occur, however, there was another drama to be played out—the introduction to the auction scene of Miss Edith Nixon, who had joined Bishop's domestic staff in 1922 as a companion to his wife, Amy. However, she had soon become far more than that, displaying an organizational brilliance that transformed the household, as well as an ability to make friends that caused the Bishops to enjoy with her a ménage no less unusual than that of Monet and the Hoschedés. Wesley Towner reports that when the Bishops stayed at the Ritz, Edith and Cortlandt, now well into his fifties, played leapfrog while Amy looked on, knitting.

Thus in 1927 Edith was privy to Cortlandt's change of heart about the AAA. What had been a "puppet theater" for him was now becoming a drain on his resources. The Chiesa collection, on which he had lost well over $300,000, was the last straw, and from Venice, Cortlandt wrote pointedly to Otto Bernet ("This is for you and you alone . . . to be shown to no one and its contents not to be divulged to HP") that he had decided to sell the AAA.

Over the years, as the Anderson had grown, so had the parallels between it and the AAA, culminating in the $1 million guarantees. Now the parallels were pushed further, for at exactly the time when Bishop was considering selling the AAA, Kennerley was letting it be known that he might accept offers for the Anderson. With both companies for sale, the price for each was affected, and perhaps Kennerley outwitted Bishop, for instead of continuing to try to sell the AAA, the man from Lenox soon had it in mind to *buy* the Anderson. Towner describes the elaborate gavotte that ensued, neither side wishing to make the first move. The stand-off continued until Parke and Kennerley met in Paris. At that meeting Parke agreed to set up an appointment for Kennerley with Bishop. That was arranged, but to Parke's and Bernet's mortification, neither of them was invited. No wonder, for the merger was never agreed to—in fact, not even discussed. Instead, Mitchell Kennerley pocketed $417,500 ($4.48 million today), which Bishop paid him for the Anderson. But Kennerley did not return to England and to publishing, as he had intended. The quixotic Bishop, having bought the Anderson, now asked Kennerley to stay on and continue to run the company as his employee. Bishop now owned both major auction houses in the United States and intended that they remain separate, and rivals, as before.

René Gimpel described Léonce Rosenberg as "tall, blond and elegant, like a pink shrimp." The gulf between them was exemplified by another visit that Gimpel paid to "the den of Cubism," as he called it. "Here he has displayed cubes of canvases, canvases in cubes, marble cubes, cubic marbles, cubes of colour, cubic colourings, incomprehensible cubes and the incomprehensible divided cubically. What is there on these canvases? Puzzles composed of patches of flat colours." At least Gimpel admired Rosenberg's selling technique. "He keeps his gravity," he said.

Kahnweiler, however, receives not a single mention in Gimpel's memoirs, although they are devoted to the art market between 1918 and 1939. This underlines the fact that there were two groups of important art dealers in Paris in the first half of the twentieth century that overlapped but in general followed different paths. One group was made up of Kahnweiler, Guillaume, Fénéon and the Rosenbergs, dealers in contemporary works, writing and working hard to promote their ideas and their artists and holding exhibitions to create a market. The other was an equally tight-knit but smaller group of dealers who formed the elite secondary market, dealing in Old Masters, bronzes, tapestries, eighteenth-century art of all kinds and, in the Twenties, increasingly in the Impressionists. At the center of this group were Wildenstein, Gimpel and Seligmann. Loosely attached to them were three other dealers in London and New York, Duveen, Wertheimer and Knoedler. Be-

sides their specialization in the secondary market, these firms had in common considerable commercial secrecy and the fact that, though some of them do not exist today, they all managed for a time to pass the dynastic torch successfully from father to son.

Possibly the most successful, and certainly the most secretive, is Wildenstein. Nathan, Georges and Daniel Wildenstein have maintained the strength of their firm for three generations. Not only is its commercial reputation second to none, but its intellectual input into the art world is also assured. In the early Twenties Nathan and Georges bought the *Gazette des Beaux-Arts,* and later the firm was to produce definitive catalogues raisonnés on, among others, Manet, Monet and Morisot.

Nathan Wildenstein was born in 1851 at Ferkersheim in Alsace and became a tie salesman in Vitry-le-François, where his mother had moved after the defeat of France in 1870. His love of beautiful objects was nurtured by the local grandee, Count de Riancourt, whose picture by Jean-Marc Nattier Nathan would eventually own. While making his business trips as a salesman, he liked and looked at paintings and was given his chance when a lady he met fortuitously, surprised by how much he knew, commissioned him to sell a painting she owned. Nathan took the train to Paris, where he was quick to spot that, though Durand-Ruel was having difficulty selling Impressionists, the new upper-middle class, who were taking over the reins of power in trade, politics and finance, were interested in "flattering family alliances," as exemplified by the art of the eighteenth century.

Nathan established himself in 1875 in the rue Laffitte but was not successful enough in the early days to afford the rent and had to wait until dusk before leaving the premises in the hope of avoiding the landlord. He met René Gimpel's father soon after his arrival in Paris and was taken to England with his son. René Gimpel was to marry a Duveen, but the reason Wildenstein and he went to England on that first occasion was that after the Settled Lands Act it was possible to buy French eighteenth-century paintings very cheaply in Britain. In Martin Colnaghi's "back room" Wildenstein bought a Watteau for 10,000 francs and sold it in Paris for 150,000.

When Nathan did begin to succeed, he moved his shop to the more fashionable Faubourg St.-Honoré, the first dealer to do so. His good fortune, when it came, was largely related, says Pierre Cabanne, to his appreciation of the eighteenth century, which was not popular at the beginning of the twentieth century. Nineteenth-century French dealers like Danlos or Guichardot could not sell their Fragonards or Chardins. In 1870 Watteau's *Gilles* was bought by Dr. La Caza, who owned the largest collection of Watteaus in the world, for 16,000 francs ($65,000 now) at a time when Delacroix were going for more than a hundred thousand francs. According to Pierre Ca-

banne, in nineteenth-century Paris even hairdressers hung their walls with Fragonards. It was in eighteenth-century art that Wildenstein first made his mark; after the Watteau mentioned above he went on to buy a Boucher for 200 francs and sell it soon after for 20,000. This made him almost as well known in Paris as his thick Alsatian accent did. By pushing this period he attracted a number of clients, including Edmond de Rothschild, the Ricard family, Simón Patiño (the tin millionaire from Bolivia), the David-Weill family and Nubar Gulbenkian, to his gallery.

Another reason for Wildenstein's success was his close association with Duveen and Gimpel, which made each of these businesses truly international. Together with Gimpel and Duveen, Wildenstein bought the Kann collection. Like Duveen, he rarely haggled, believing that if something was good, it merited a good price. Bought in 1907, the Kann collection consisted of eleven Rembrandts, one Vermeer, six Van Dycks, six Rubenses, nine Ruysdaels, four Franz Halses, three Memlings, three van der Weydens, seven Tiepolos, one Goya, one El Greco, one Velázquez, one Bellini and two Fragonards— and this list includes only the highlights. The total cost of the collection was five billion francs (now $20.5 billion). Nathan's culture was entirely visual. He looked at pictures all the time and, says Cabanne, would stop in front of churches, apparently at random, recalling paintings he had seen years before, and would pop in for another look. He visited Drouot every morning and the dealers on the Right Bank one day, on the Left Bank the next. He forced his son Georges to look equally hard and would present him with objects and demand, "Is this beautiful or ugly?" It seemed to work, for Georges became a supreme connoisseur. He was always present at the four o'clock teas Nathan held every day which soon became a ritual in the art world, attended by customers and experts.

Nathan shared with the other members of the Paris trinity a belief in the United States. Though he himself never crossed the Atlantic, he opened an office there (known at one stage as Gimpel-Wildenstein) and sent over art that he thought would appeal especially to Americans. Here he agreed with Duveen; he believed that in their search for respectability and status, American industrialists, like their French counterparts, would want ancestors—any ancestors. As much as anyone, therefore, he was responsible for the cult of the portrait.

René Gimpel (figure 46) was less secretive than Wildenstein and less brash than Duveen. His diaries are revealing in three important ways. One was that they recorded the witticisms—of Picasso, Degas and Forain, among others— for which he always had an ear. Second was his pen portraits: Berenson,

Frick ("cold eyes, grasping and hard under their genial look"), Christie's ("sheer discomfort"), Proust (a stout schoolboy, "tall for his age"). Third, he captured the flavor of a transatlantic life. Gimpel traveled frequently between Paris and New York, equally at home in either place as he was on the liners of the day. In July 1919 he writes, in one line without amplification, that he has severed his relationship with Wildenstein. Later that same year, after a visit to London, he writes: "There are three great art dealers in London: Agnew, Colnaghi and Sulley, each of very good reputation, but Sulley comes first by dint of his incomparable fairness. . . . [He] is incapable of lying." In London there is no mention of Duveen.

Gimpel's diary is honest and more varied than William Buchanan's in the nineteenth century. The Gimpel firm had opened in New York in 1902, part of the same impulse that took Wildenstein and Duveen there. Business had been very good before the war, especially in New York; the Vanderbilts, Altmans and Wideners had given all of them good profits on parts of the Kann collection. But if Duveen was interested only in Old Masters, Wildenstein in Old Masters and Impressionists, Gimpel was interested in Picassos as well. He records the prices achieved throughout the Twenties, showing the poor state of affairs to begin with, but also the accelerating performances. In June 1921 the Frick collection was valued by the U.S. Treasury at $13 million "instead of $30 million of a year ago, owing to bad business." In January 1923 in New York a landscape by J. van Diem was sold for $8,000. "According to Durand-Ruel it would have brought 15,000 francs—or $1,000—in Paris." In the same year Gimpel records that Wildenstein made five million francs from selling pictures to Americans, including a Fragonard, a Master of Flémalle, a Vigée-Lebrun and a "horrible Greuze of a drunken man." In January 1927 he writes that Duveen, who had been knighted earlier that year, had sold art worth $4 million (that would be $43 million today) to Henry Huntington. Visiting other dealers in New York, he observed that at Scott's there was a van Gogh for $6,000 ($64,440) and at Wildenstein a Cézanne for $60,000. "But since Cézanne can bring [only] 400,000 francs in France [$26,660 then], it's a handsome profit. Cézanne is sold according to the size of the canvas."

With the growing boom in prices, there was also a growth in swindling. This was Gimpel's word and he applied it specifically to the use of certificates of authenticity. The French system of experts associated with the auction houses had produced a proliferation of these "irresponsible creatures," as Gimpel called them. For a price, they would certify on paper that a picture was by a specific artist. To an extent this let the dealers off the hook. "The American collector is prey to the hugest swindle the world has ever seen: the certified swindle. . . . I went to see [Jules] Bache, who pays enormous prices

but has a Bellini, a Botticelli, a Vermeer of Delft, three old pictures which aren't by the masters."

Gimpel was being tactful. As mentioned earlier, he was never taken in by his brother-in-law, Joe Duveen. Nor was he fond of Berenson. On October 21, 1922, he wrote: "After dinner Berenson, that model of integrity, tried to sell me pictures, and very bad ones they were!" In fact, Bache had been sold his fakes by Duveen and Berenson.

Though Duveen had been knighted, his business techniques had not changed at all. In some ways they had become shadier. Shortly after World War I the firm had narrowly escaped a distasteful brush with the limelight after the death of Lord Michelham. The Michelham family had been buying through Duveen since the end of the nineteenth century but, as Colin Simpson has shown, not always to their advantage. On Lord Michelham's death his will was contested, and one of the bitterest bones of contention was the valuation of $1 million placed on the collection by Christie's. Duveen had charged Michelham no less than $6 million for these paintings, so something was clearly amiss. The firm settled the problem in typical fashion. Somehow Ernest Duveen, Joe's brother, learned that the lawyer acting for the Michelhams collected snuff boxes. The man was invited to a lunch where there just happened to be a display of snuff boxes. By the time the meal was over, a settlement had been agreed to, the lawyer just happened to acquire the snuff boxes at more or less his own valuation, and the Michelhams went on buying from Duveen.

But it was the Bache business that took the prize for sheer effrontery. Fortunately for Duveen, Jules Bache had a weakness for titles, and after Joe was knighted, the financier took more interest in him, says Simpson, never tiring of Duveen's blow-by-blow account of his investiture. Bache made a fortune on Wall Street after the war and was just as much of a snob as Duveen—hence his penchant for English portraits that depicted the British aristocracy. This qualified him for the full Duveen treatment. Bertram Boggis was turned loose on Bache's butler, Gilmore. "Did [Bache] prefer to travel on a train facing the engine or with his back to it? What type of cigars, shaving soap and other toiletries were needed?" When Boggis received from Gilmore a copy of a telegram that showed that Bache was interested in a Holbein that Knoedler had, an opportunity arose to con and manipulate Bache in a major way. First, Knoedler's Holbein had to be rubbished; second, Duveen had to find one of his own. He found a malleable Swiss "expert" to cast doubts on the Knoedler Holbein, but to get a rival picture required more elaborate theater. With the aid of Viscount Lee of Fareham, the trap was set. At Duveen's request, Lee wrote Joe to say that he was thinking of selling his Holbein. However, said Duveen to Bache, since Lee was a trustee

of the National Gallery, by rights he should have offered the picture to the nation first; hence the secrecy. The price asked was $110,000 and the painting was a portrait of Edward VI at the age of six. Bache bought Duveen's story, and with it the picture. Yet Joe had himself sold the painting to Lee only five years earlier, and it was virtually impossible for the picture to have been by Holbein. Even the malleable Swiss expert had his doubts and, to cover himself, stated that the picture was a late (and therefore weak) Holbein, "possibly the last he painted." This opinion was curious, however. In Colin Simpson's words, "The young prince's sixth birthday was on October 13, 1543, and Holbein was sick with the plague at that time, having made his final will on October 7. He was buried on November 29, 1543. It is unlikely that in his condition he would have been allowed near the young prince."

But Bache was not taken in forever. The 1929 crash curtailed his buying habits and concentrated his mind. Despite Duveen's later ennoblement, their relationship never recovered its pre-crash closeness. Attitudes to collecting and to money were never the same again after Black Friday.

Jacques Seligmann was the third of the great Jewish dynasties in Paris, equally successful but in a refreshingly different way. His first love was the medieval world, and though he dealt in paintings (and his son, Germain, more so), his tastes ran to tapestries, enamels, reliquaries and ivories from the glorious world that immediately prefigured the Renaissance. He had begun as an assistant to Maître Paul Chevallier, the celebrated auctioneer at Drouot, but then worked for Charles Mannheim, a well-known authority on medieval works of art and an adviser to the Rothschilds. Seligmann's first gallery was in the rue des Mathurins, but in 1900 he opened sumptuous premises at the place Vendôme, where his celebrated lunches for clients rivaled those being served at the Ritz across the way. He too appreciated the importance of the United States, particularly after a disagreeable episode with Morgan, who came into his shop, ordered something and then reneged on the deal. Sensing an opportunity, Seligmann sailed for New York to try to convince Morgan that he knew what he was talking about. He must have succeeded, for he became one of Morgan's chief buying agents in Europe.

In 1909 Seligmann astounded Paris by acquiring the Palais de Sagan, an even more luxurious house near the esplanade des Invalides. Here for many years he held court, surrounded by an entourage of *marchands-amateurs* (including the Marquis de Biron and the Marquis de Castellane) who then populated the Paris art world, sometimes buying, sometimes selling. Seligmann was a main supplier for the French Rothschilds as well as Morgan; he was also known for his contacts in Russia and for his fabulous deal on the

Wallace-Bagatelle collection. The Russians had the best collections of eighteenth-century French pictures and furniture outside France, and the Seligmanns came to know the czar and many other members of the relatively small aristocracy there. This familiarity with the country and its habits would pay off in time.

The Wallace-Bagatelle collection was celebrated in part because of its relationship to the Wallace collection in London. Sir Richard Wallace, who had inherited the collection from Lord Hertford, left everything to his wife, Lady Wallace. However, while deeding the London collection to Britain, she left the French collection to the man who had helped her during her widowhood, Sir John Murray Scott. After his death there was a sensational court case about his will, from which Lady Sackville-West, the mother of Victoria Sackville-West, emerged victorious. She sold the collection to Seligmann, who bought it in the spring of 1914 for nearly $2 million *sight unseen* (that would be $39.5 million now).

With its business at a standstill in Paris during the war, Seligmann traded successfully in New York, where the firm had offices at Fifth Avenue and Fifty-fifth Street and sold $1 million worth of Houdons, Vigée-Lebruns and Giovanni da Bolognas in one season. At the end of the war, Jacques was part of the official French team that evaluated the Habsburg tapestries seized in Vienna with a view to selling them for war reparations. Ironically, though these tapestries had changed hands for $500,000 each, there were so many of them in Vienna that the market would have been depressed, and the sale never went through.

Jacques died in 1923, by which time his son, Germain, who had served in the army in the war and met many Americans, was living in New York. In the Twenties he modernized the firm, showing more paintings and more modern works. In 1926, Germain held an exhibition entitled "Manet to Matisse," and in 1929 he gave Modigliani his first one-man show in the United States.

With links in Europe and Russia, Seligmann witnessed an unattractive side of the art speculation that occurred in the Twenties. A number of Germans, banking on the continuing devaluation of the mark, struck large deals with art galleries using deferred terms of payment—that is, they took delivery of the art immediately, but paid some of their bills later in devalued marks. Several German dealers were forced into bankruptcy as a result of this. A second scam occurred when German speculators tried to buy foreign currency in the same way, but when banks proved wise to this the Germans again turned to art. The chief culprit was Fritz Mannheim, who headed the Amsterdam branch of the well-known Berlin bank Mendelssohn & Co. He was especially interested in Dutch pictures, Renaissance bronzes and Gothic

tapestries, and succeeded in exploiting a number of Dutch and French galleries before going spectacularly bankrupt himself in the Thirties. But Seligmann also saw the beginnings of speculation on a future war even before the crash of 1929. This affected the art market because a number of German industrialists—Ottmar Strauss, Otto Wolff, Hugo Stinnes and Fritz Thyssen—who were making money from Germany's industrialization and rearmament, put part of their proceeds into art. Thyssen first visited Seligmann in 1928, when he bought a Fragonard.

In his memoirs Germain wrote that he much preferred dealing with genuine collectors, people like François Coty, the cosmetics genius, who, like Christian Dior, was interested in art and collected tapestries. But world economic events and politics never leave the art world alone for long. In 1928 Seligmann was approached about a deal from an unlikely source. Once again it involved making a trip to Moscow, only this time, of course, it wasn't the czar's Russia that he would visit.

18 | THE CULT OF THE PORTRAIT: TASTE AND PRICES ON THE EVE OF THE GREAT CRASH

Shortly after World War I, Joe Duveen tried to interest Henry Clay Frick in a Van Dyck. It portrayed two young men full length, and he hung it in the Frick mansion on approval. It was not approved of by Mrs. Frick, who disliked intensely the long faces of the men, the prominent eyelids and especially their strongly curved noses. She declared that she "couldn't bear to have those Jewish noses constantly before her eyes." The "Jewish noses," together with the long faces and prominent eyelids, in fact belonged to the Stuart brothers, nephews of Charles I, King of England.

But if Joe Duveen had a problem with these portraits, it was a rare hiccup in what became, as the Twenties progressed, an increasingly lucrative trend. The age when Gainsborough, Lawrence, Raeburn, Romney and Hoppner became sought after by the millionaires of the day is of particular interest at the end of the century, because the heady cult for these English artists shares important features with the fashion for Impressionists in our own time. Hence, the ultimate fate of the portrait market is tantalizing.

The vogue had its origins as far back as the middle of the nineteenth century. As Gerald Reitlinger has pointed out, there was at that time a "mania" for the eighteenth century, reflected also in a passion for the novels of Thackeray and the popularity of the Queen Anne style in architecture. This was when Lionel Nathan de Rothschild paid £3,150 ($365,000 now) for Reynolds's *Miss Stanhope,* and Ferdinand de Rothschild paid the same price

for Gainsborough's *Mrs. Sheridan*. Until these purchases, however, Reynolds had been preferred to Gainsborough, and the latter's landscapes were favored over his portraits. Prices then rose rapidly; in 1876 Agnew paid 10,100 guineas, or £10,605, for Gainsborough's *Duchess of Devonshire*; exactly ten years later, Nathan Mayer Rothschild, the first Lord Rothschild, paid £20,000 for Reynolds's *Garrick Between Tragedy and Comedy*; ten years after that, Isabella Stewart Gardner offered £40,000 for the Duke of Westminster's Gainsborough *Blue Boy*, and was refused (£40,000 in 1896 would be $4.5 million now). In short, prices were doubling every ten years.

In the 1890s American buyers became interested in Lawrence, Romney, Raeburn and Hoppner for the first time. Morgan bought two Gainsboroughs, one in 1901 and the other in 1911, and Frick followed two years later. The fashion continued, and in 1921 *The Blue Boy* was at last sold in the United States for £148,000. (This is the picture that had been bought by the Duke of Westminster's ancestor in 1796 for £68 5s.) Both Frick and Henry Huntington were hungry for Gainsborough and Reynolds. Indeed, in 1925 Huntington (who bought *The Blue Boy*) went on what can only be described as a Reynolds binge. He bought four at once from the Spencer family at Althorp: *Lavinia, Countess Spencer,* the *Little Fortune Teller, Lady Bingham* and the *Duchess of Devonshire*. The first three are believed to have cost £50,000–60,000 each and the last £70,000, making perhaps £250,000 in all ($13 million now). Note the preponderance of women as subjects. This was a subsidiary but important feature of the portrait vogue; Reitlinger calculated that portraits of women were three times as expensive as those of men.

The rivalry between Frick and Huntington accounted for much of the price appreciation in this field; even so, by the Twenties Reynolds could no longer keep pace with Gainsborough. In 1921, the year he paid £148,000 for *The Blue Boy,* Huntington also paid £73,500 for Reynolds's *Tragic Muse*. This price, the highest ever paid for a Reynolds, was not equaled until the Sixties. No painting illustrated this vogue better than Gainsborough's *Harvest Wagon,* which changed hands as many as eight times between 1841 and 1941. In that first year, it was bought at a sale for £651. In 1894 it was acquired by Sir Lionel Philips for £4,725. Duveen got it in 1913 for £20,160 and made a neat profit when he sold it to Elbert Gary for £34,200. At the Gary sale in New York in 1927 Duveen bought it back again for £74,000 and sold it for a second time, to Charles Fisher. By the time the painting reached the Museum of Ontario, via Frank Wood of Toronto, in 1941, it was valued, says Reitlinger, at £80,000–90,000.

Between the first and third decades of this century the number of British portraits coming onto the market exactly doubled, and from research in the

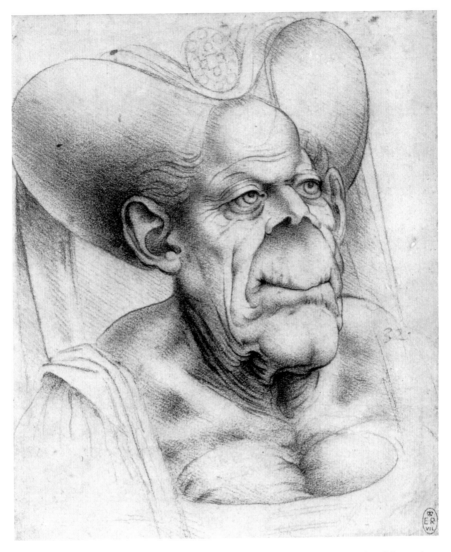

1. *Duchess Margaret of Tyrol*, by Leonardo da Vinci. "Pocket-mouthed Meg, the Ugliest Princess in History." Will the art trade ever make her beautiful? (Copyright, Her Majesty the Queen)

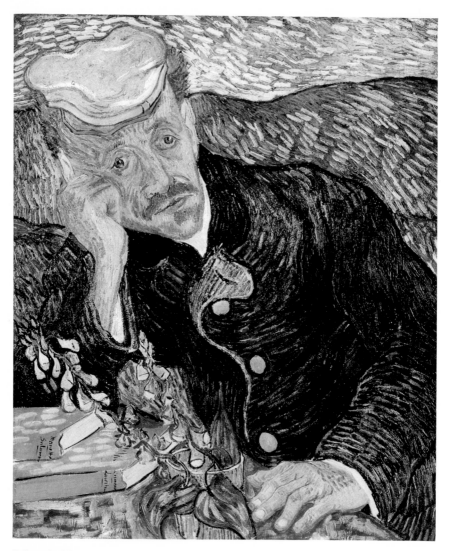

2. *Portrait of Dr. Gachet,* **by Vincent van Gogh.** (Christie's)

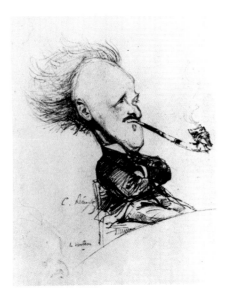

3. *Dr. Paul Gachet,* **by Charles Léandre.**
(The Louvre, Department of Graphic Arts)

4. *Cézanne Engraving beside Dr. Gachet,* **by Paul Cézanne, 1873.** (The Louvre, Department of Graphic Arts)

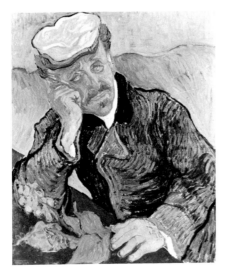

5. The other *Dr. Gachet* **by Vincent van Gogh, 1890.** (Musée d'Orsay, Paris)

6. *Dr. Paul Gachet,* **by Norbert Goeneutte, 1891.** (Musée d'Orsay, Paris)

7. *Portrait of James Christie* (1730–1803), by Thomas Gainsborough. The artist produced the likeness on condition that it be hung in Christie's salesroom as an advertisement for Gainsborough's studio, which was next **door.** (Collection of the J. Paul Getty Museum, Malibu, California)

8. A contemporary engraving of Christie on the rostrum. (Christie's)

9. *John Sotheby,* Samuel Baker's nephew, by an anonymous artist. Baker founded the company, but Sotheby's name stuck. (Sotheby's)

10. *The Auction, or Modern Connoisseurs,* 1758. (Lewis Walpole Library)

ELOQUENCE

OR THE KING of EPITHETS

Let me entreat —Ladies—Gentlemen— permit me to put this inestimable piece of elegance under your protection,— only observe,———The inexhaustable Munificence of your superlitively candid Generosity must HARMONIZE with the resulgent Brilliancy of this little Jewel.! — ! — .)

Pub.ᵈ Jan.ʸ 1.ˢᵗ 1782 by H.Humphrey N.° 18 New Bond Street

11. *Eloquence, or The King of Epithets*, a satire on James Christie. (Lewis Walpole Library)

12. *Le Commissaire-Priseur*, by Honoré Daumier, 1863.

13. *Boulevard des Italiens*, by Eugène Guérard, 1856. The Café Tortoni, where Manet and Antonin Proust used to meet, may be seen at the right. (Paris, Carnavalet)

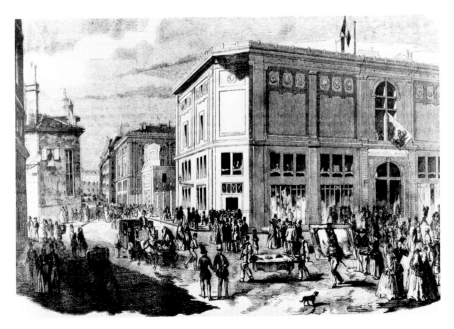

14. "L'Hôtel Drouot à l'époque des crinolines." An engraving showing the outside of the auction house, on the corner of the rue Drouot and the rue Rossini, about 1852.

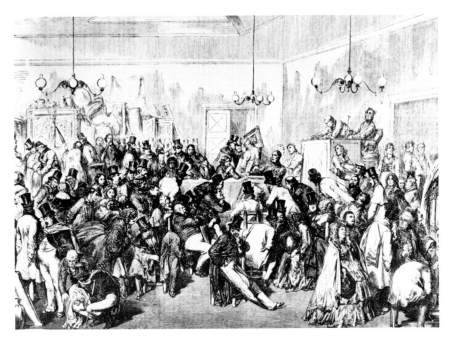

15. Inside Drouot at roughly the same period, from a drawing by Gustave Doré.

17. *Le Marteau sans maître (The Hammer without a Master),* **by Nicolas Dusseire.** (Paris, Réunion des Musées Nationaux)

16. *Maître Alphonse Bellier,* **commissaire-priseur.** (Silhouettes de l'Hôtel Drouot, by Pierre Vérité)

18. A sale of jewelry at the Galerie Georges Petit, conducted by Maître Lair-Dubreuil. (Croquis de Jean Lefort)

19. *Maître Paul Chevallier,* **commissaire-priseur, caricature.**

20. Thomas Kirby at the age of seventy-five.

21. The first home of the American Art Association: 6-8 East Twenty-third Street, New York City (on Madison Square).

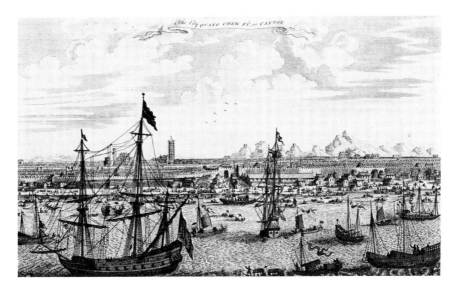

22. Canton harbor in 1750. At anchor in the following season were at least sixteen European vessels, which could have carried more than three million pieces of porcelain. (Mary Evans Picture Library)

23. *Paul Colnaghi.* (P. & D.
Colnaghi, London)

24. An eighteenth-century
satirical view of antiquari-
ans. A dog, symbol of exces-
sive devotion, urinates on
several books, symbol of
true learning, while the
"connoisseurs" examine the
beauty of a cracked chamber
pot. (British Museum)

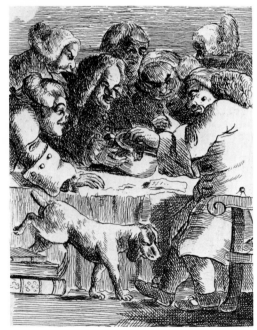

25. The first great dealer in Impressionists: Paul Durand-Ruel. (Collection Durand-Ruel, Paris)

26. *Paul Durand-Ruel,* by Pierre-Auguste Renoir. (Private collection)

27. Ernst Gambart and Rosa Bonheur, photographed in Nice. (Jeremy Maas)

28. *Portrait of Édouard Manet,*
by Henri Fantin-Latour, 1867.
(Chicago Art Institute)

29. *Portrait of Isabella Stewart*
Gardner, **by John Singer**
Sargent. (Isabella Stewart
Gardner Museum, Boston/
Photo: Greg Heins)

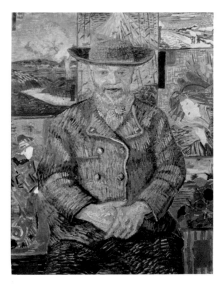

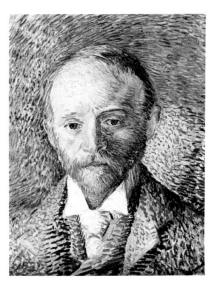

30. *Le Père Tanguy,* by Vincent van Gogh. (Edimedia, Paris)

31. *Portrait of Alex Reid,* by van Gogh.

32. A speculator who failed: *Ernest Hoschedé,* **by Marcellin Desboutin, 1875.** (Bibliothèque Nationale, Paris)

33. The first great speculator in Impressionists: Jean-Baptiste Faure as Hamlet, painted by Manet, 1877. (Essen, Folkwang Museum)

34. *Portrait of Ambroise Vollard,* **by Cézanne.**
(Paris, Petit Palais/Photo: Lauros-Giraudon)

35. *Ambroise Vollard,* **drawing by Pablo
Picasso, 1915.** (Metropolitan Museum of
Art, New York)

36. *Portrait of Ambroise Vollard,* **by
Pierre-Auguste Renoir, 1908.** (Courtauld
Institute, London)

37. *Portrait of Ambroise Vollard,* **by Pablo
Picasso, 1909.** (Pushkin Museum, Moscow)

38. *Portrait of M. Kahnweiler,* **by Kees van Dongen, 1907.** (Petit Palais Musée, Geneva)

39. *Portrait of D. H. Kahnweiler,* **by Pablo Picasso.** (Chicago, Art Institute/Photo: Giraudon, Paris)

40. *Félix Fénéon à La Revue Blanche,* **by Félix Valloton, 1896.** (Josefowitz Collection, Switzerland/Photo: Giraudon, Paris)

41. *The Reading*, by Théo
van Rysselberghe, 1903.
Félix Fénéon is standing at
the back with his hand on
his hip; Henri-Edmond
Cross has his back to the
spectator; André Gide is
third from the right, with
his hand to his face; and
Maurice Maeterlinck is at
the extreme right. (Musée
des Beaux-Arts, Ghent/
Photo: Giraudon, Paris)

42. *Portrait of Félix
Fénéon*, by Paul Signac,
1890. (Private collection,
New York/Photo: Giraudon,
Paris)

43. *Profile of Félix Fénéon,*
by Paul Signac, 1890.
(John Rewald Collection,
New York)

44. Japonisme and Chinamania. The Japanese court at the International Exhibition, 1862.
(The Mansell Collection)

45. Paul Cassirer in 1910. (Photo: Ullstein)

46. René Gimpel. (Gimpel Fils
Gallery)

**47. Sir Joseph and Lady Duveen, with their daughter,
on board the *Aquitania*, June 1922.** (Hulton-Deutsch
Collection. BBC Hulton Picture Library)

48. John Pierpont Morgan, Sr. (Hulton-
Deutsch Collection)

49. Sir Montague Barlow. (Sotheby's)

50. The House of Duveen in New York
(New York Public Library)

51. Lord Duveen. (Tate Gallery Archive, London)

52. Gallery H, Armory Show.

53. Cortlandt Field Bishop on his snow tractor in Lenox, Massachusetts. *(Berkshire Eagle)*

54. Cortlandt Field Bishop, with mules and friend, in the Libyan desert in 1930. *(Berkshire Eagle)*

55. Andrew Mellon in 1924. (Popperfoto)

56. Secretary of the Treasury Andrew Mellon. (Photo: Paul Popper)

57. Mitchell Kennerly *(right)***, seen with Christopher Morley.** (New York Public Library)

58. Charlotte Horstmann.

59. Edward Chow.

60. Albert Barnes and Bertrand Russell at the Barnes Foundation, 1941. (Temple University Libraries)

61. Bernard Berenson visiting the Carracci exhibition in Bologna, 1956. (Hulton-Deutsch Collection)

62. Bernard Berenson just before his death in 1959. (Hulton-Deutsch Collection)

63. Peggy Guggenheim, with silver sculpture by Alexander Calder, December 1961. (Photo: Paul Popper)

64. Peggy Guggenheim with Calder mobile, December 1964. (Popperfoto)

65. *Portrait of Betty Parsons,* **by Henry Schnakenberg.** (Collection of Sue Tifft, Marion, Massachusetts)

66. *Betty Parsons,* **self-portrait.** (Photo: Nathan Rabin)

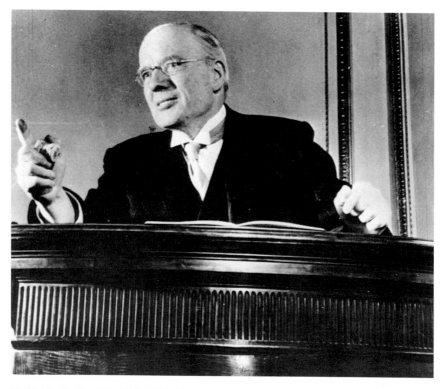

67. Sir Alec Martin, of Christie's. (Christie's)

68. Peter Chance, of Christie's. (Christie's)

69. Georges Wildenstein. (Wildenstein Foundation)

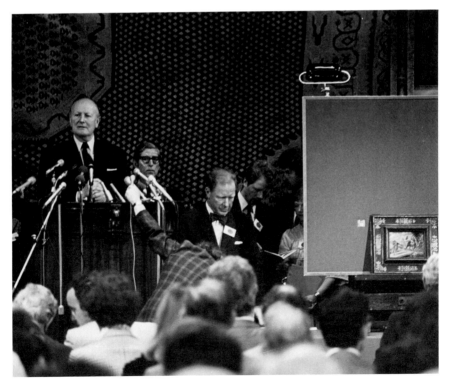

70. Peter Wilson at the von Hirsch sale, 1978. (Sotheby's)

71. Leo Castelli, by Robert Mapplethorpe. (Leo Castelli)

72. Leo Castelli and his artists, 1982. Castelli is seated center. Jasper Johns stands at the back to the right of Castelli. Robert Rauschenberg is seated to the right of Castelli. Andy Warhol is next to Rauschenberg. (Leo Castelli/Photo: Hans Namuth)

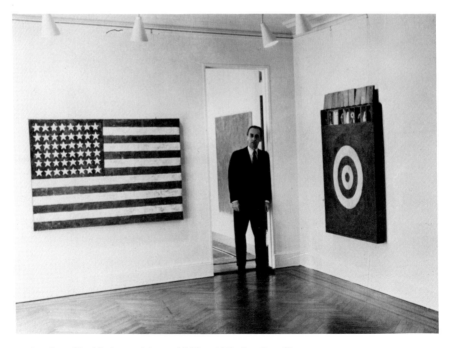

73. Leo Castelli at his Jasper Johns exhibition, 1958. (Leo Castelli)

74. *Leo Castelli*, by Andy Warhol.

75. *Portrait of Ivan C. Karp*, by Andy Warhol, ca. 1972.
(Photo: D. James Dee)

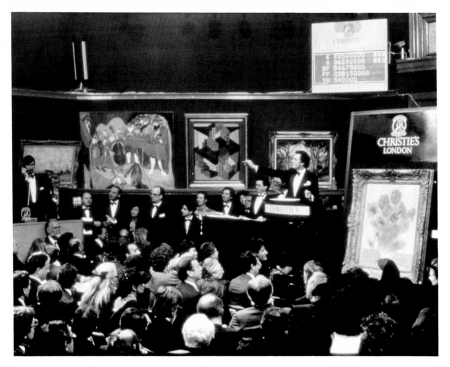

76. Charles Allsopp auctioning van Gogh's *Sunflowers*, March 30, 1987, when it fetched $39.9 million. (Christie's)

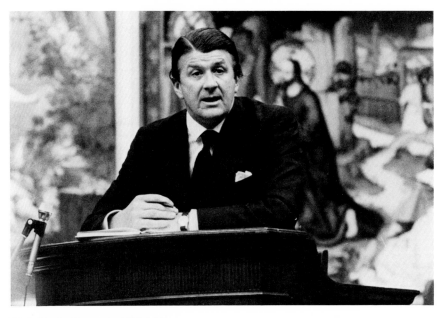

77. Jo Floyd taking a sale. (Christie's)

78. A. Alfred Taubman. (Sotheby's)

79. Michael Ainslie. (Sotheby's)

80. John Marion. (Sotheby's)

81. *Arnold* **[Glimcher],**
by Chuck Close, 1979.
(The Pace Gallery)

82. André Emmerich, Los
Angeles, April 3, 1982, by
David Hockney. (Copyright
David Hockney)

83. Mary Boone. (Photo:
Timothy Greenfield-
Sanders)

**84. *Thomas Ammann,*
by Andy Warhol, 1978.**
(Thomas Ammann)

85. Yasumichi Morishita, of the Aoyama Gallery, Tokyo.

86. Ryoei Saito, president of the Daishowa Paper Company, who bought van Gogh's *Portrait of Dr. Gachet* and, two days later, Renoir's *Au Moulin de la Galette*. For the two paintings he paid $160.6 million.

records carried out for this book, it is clear, for example, that the average price for a Gainsborough rose from about £11,000 to £50,150. For Reynolds, the equivalent increase was from £6,275 to £19,300. But it wasn't only Gainsborough and Reynolds who did well. At the Michelham sale in 1926, Romneys fetched 40,000 guineas and more, Hoppner's *Lady Louisa Manners* fetched £18,900, up £4,000 from the price it had fetched in 1901, and Lawrence's *Pinkie* was bought by Duveen for £77,700 and sold to Henry Huntington for about £90,000 (that figure would now be $4.7 million).

Why did this vogue occur? What did those predominantly American millionaires think they were buying? In searching for an answer, it is tempting to draw parallels with the Impressionists in our own day. Like the French Impressionists, the English portraitists were a small, finite group of painters who flourished at a particular time and recorded a stage in the world's social development. They depicted a sumptuous world that is now gone forever, but that many are nostalgic for. Each of the painters in the school has his own distinctive style, and for people interested in power and prestige a Gainsborough on the wall was just as readily identifiable then as a Renoir or van Gogh is now. Usually, the provenance of these paintings was well known and obviated any problems about authenticity. But these English portraits had another quality that even Impressionist paintings lack. In buying pictures of the British aristocracy, American millionaires were aligning themselves with these illustrious and glamorous figures from the past. Surely it is implicit that Frick, Huntington and the others saw themselves as the aristocracy of their day—and in a sense, they were.

This also helps to explain that other vogue of the 1920s: the incredible popularity of John Singer Sargent. An American by birth, Sargent had gone to Paris on the advice of Whistler; there he studied under Carlos Duran, described by Percy Colson as "the Frans Hals of the rue de la Paix"—a phrase that could almost apply to Sargent himself. Though he had success in Paris, Sargent moved back to London, and it was there that his portraits achieved a fantastic response. With a studio in Tite Street that had once belonged to Whistler, he counted Max Beerbohm, George Moore, Henry James and Sir Edmund Gosse as friends. His first foray in London, however, was not a success: in a poll organized by the *Pall Mall Gazette* to decide which was the worst picture of the year, one of his was chosen. Despite this, fashionable London took him up, and by 1915 he could command £15,000 for a commission (that would be $1.3 million now). His fellow Americans also responded to his work and compared him with Gainsborough and Romney. Sargent's peak—his beatification, in Percy Colson's words—was reached at the sale of his estate after his death. Colson again: "In July 1925 Christie's saw what was, perhaps, the strangest sight it had ever witnessed in

its long life; the apotheosis of social popularity in the person of John Sargent. On view-day the salerooms resembled a private view at the Royal Academy in its great days, at the moment when royalty arrived. . . . Duchess clasped the hand of Duchess; celebrities and society leaders jostled one another on every side, crowding round their favourite pictures and speculating on the prices they would fetch, while dominating the general clamour was the American voice, upraised in joy and wonder. How had Sargent managed to *imposer* himself on the art—or rather the society-art-world of London?" So great was Sargent's popularity in his lifetime that a word had to be coined to describe it: "Sargentolatry." Osbert Sitwell caught the mood well: "Some painters are said to have 'painted' a picture or 'exhibited' a picture. Not so Sargent. He 'vouchsafes' a picture; a word hitherto confined to the deity."

Sargent had his critics, of course, who disliked his "wriggle-and-chiffon school of portraiture," but they had no effect on the estate sale. The top price was £20,000 for his portrait in oil of Madame Gautreau, but oil sketches that came under the hammer that day exceeded £7,000, and even watercolors topped £4,500. His brushwork might be "rhetorical," as another critic put it, but his prices clearly were not.

In and around 1913, it will be recalled, many painters broke the £10,000 barrier (a figure that would be $984,000 today). Perhaps the most important thing about the art world on the eve of the great crash was that, portraiture apart, very few paintings reached that level, at a time when £10,000 represented only $540,500 at 1990s values. This only makes the performance of eighteenth-century portraits all the more remarkable.

Among the Italian Old Masters, only Botticelli, Lorenzo Lotto, Tintoretto, Titian and Raphael managed to beat the £10,000 mark, the latter doing so spectacularly in 1929 when Duveen sold the larger Panshanger Madonna to Mellon for £172,800 (now $9.4 million). Among the Northern School Old Masters prices were slightly better overall, with Cuyp, van Eyck, Hals, Hobbema, de Hooch, Memling, Steen, Van Dyck, van der Weyden and of course Rembrandt (who reached £87,406) all comfortably topping £10,000, though Holbein, Rubens and Vermeer did not. Among French Old Masters, Boucher's pair *La Pipée aux oiseaux* and *La Fontaine d'amour* reached £47,250 in 1926. Poussin, Claude and Ingres all lagged. The French nineteenth-century schools, the Barbizon Men of 1830, were fading fast by now; Millet never topped £2,000, Troyon never beat £600 and Meissonier's prices dropped throughout the decade, from £5,250 in 1920 to £1,470 in 1927, and then to £315. Rosa Bonheur fared even worse; in 1929 her *Pâturage nivernais,* which had fetched £4,410 in 1888, went for a derisory £48 3s. All this was

despite the fact that there were far fewer paintings by this school on the market; the low prices hardly encouraged people to sell. The Pre-Raphaelites were also fading, though not as fast as their French contemporaries, and not without some successes. Both Leighton and Millais achieved record prices during this period—£3,255 and £10,500 respectively. However, Rossetti, who had regularly sold for more than £2,000 before 1913, was now lucky to fetch £400. The same applied to Burne-Jones and Alma-Tadema. Only Bonington had improved; he was up from three figures before World War I to four figures sterling in the late Twenties.

The Impressionists and Post-Impressionists had strengthened. There were not noticeably more pictures being traded, but by now there were hardly any low prices: £52 for a van Gogh and £95 for a Gauguin but, these apart, the Impressionists and Post-Impressionists had overtaken many of the School of 1830 and the Pre-Raphaelite Brotherhood. At this point, £1,000–2,000 could in general buy you anything from van Gogh or Monet to Correggio, Giorgione, del Sarto and Cranach. What was also fresh about this period was the first appearance at auction of Matisse, Picasso and Utrillo. However, the real star in the Twenties was neither Picasso nor Matisse but Seurat, whose works fetched £1,300, £1,900, £3,917 and £6,000 (for *La Grande Jatte*) respectively. This partly reflects the fact that Seurat died at thirty-two and painted very few pictures. Nevertheless, in real terms the price of *La Grand Jatte* was not equaled until the late Sixties.

Overall, and with hindsight, taste in the mid- to late Twenties can be seen to have been narrow, marked by the obsession for portraits and by a decline in interest in many other works of the distant past. The swagger of Gainsborough and Sargent in particular appealed to the growing self-confidence of Americans. However, the market for contemporary art and that of the immediate past was also growing in confidence during the Roaring Twenties. One culmination came in the form of the Museum of Modern Art, which opened in New York in November 1929 with an exhibition of Cézanne, Gauguin, van Gogh and Seurat. The arrival of these painters—their apotheosis, if you like—could not have come at a worse time. In normal circumstances the MoMA show would have had important commercial consequences for all four artists. As it was, the opening occurred less than a month after Black Friday, when the stock market lost $26 billion in value ($282 billion now). Like everything else, the art market was devasted by the crash.

II | 1930-1956

THE UN-GENTLE ART
OF MAKING ENEMIES

19 | THE GREAT CRASH

The great crash of 1929 began on Black Friday, October 25. Four days later, in his diary, René Gimpel made no mention of the disaster but instead recorded a story about Chaim Soutine, the Expressionist painter from Minsk who had moved to Paris in 1913. Soutine had been to a butcher to buy a calf's head in order to paint it. Any old calf's head wouldn't do, however. "You do understand," he told the butcher, "I want a calf's head of distinction." In Gimpel's diary the great crash is mentioned only rarely, and never in much detail. Either Gimpel tried to ignore it, or it really did have little effect on trade at his level. This may have been true, for Germain Seligmann also reports that whereas some of his American collector-clients committed suicide in the wake of the crash, trade in Europe carried on.

Germain mentions in his memoirs a big financial deal in 1929 or 1930, when a Viennese collector was trying to raise money and wanted to use his collection as collateral. The Berlin banks that the man approached did not turn the deal down just because there was a recession on, but they did ask Seligmann to look at the art. He reported that the art was weak—weak as art, irrespective of the slump—and the deal didn't go through, for ordinary financial reasons unrelated to the current economic climate. On the other hand, Seligmann says that several of his American clients asked if he would take back works he had sold for the sum that had been paid. He declined because he didn't have the cash. Thus, as in the case of Gimpel, the impres-

sion is of reduced trade but not disaster. For Kahnweiler, on the other hand, the impact was horrific. Trade remained bad for six years, though the period of 1929–33 was the worst; Pierre Assouline says that the Galerie Simon did not organize a single exhibition during that time. During these years Kahnweiler had loan facilities with the Banque Franco-Japonnais, and before the end of 1930 he was forced to request a rescheduling of his debt repayments at least five times.

The tone of Gimpel's diaries sometimes implies that France was in some way insulated, or at a distance, from what was going on in the United States and elsewhere, but this was not Kahnweiler's experience. On the contrary, he found that the French seemed to be the most affected; as the Thirties wore on, he began to see American, German and even English buyers returning to the market, but not the French. Several Parisian galleries disappeared— Théophile Briant, Henry Bing, the Georges Petit gallery, Katia Granoff and even Christian Dior, who was not yet interested in haute couture and had opened a gallery in 1927 with Jacques Bonjean (the uncle of Étienne Bignou). Léonce Rosenberg remained in business, but in very reduced circumstances. When Nathan Wildenstein died in 1934 the firm's London and New York branches were on the point of closing. But Georges had been secretly buying up Impressionist and Post-Impressionist pictures and these helped rescue the business. (He also supported the Surrealists.) As an idea of how much prices could fall, a Utrillo that changed hands at Drouot shortly before the crash for 50,000 francs now sold for 4,000.

As usual, there were people who swam against the tide. One was Pierre Matisse, son of Henri Matisse, who had moved from Paris to New York in 1925 to become an art dealer. Born in 1900, Pierre Matisse was at school with Yves Tanguy and, through his father, naturally met all the major School of Paris painters. His father had hoped he would become a virtuoso violinist, but since he didn't begin lessons until he was twelve, there was little hope of that (though Henri, who hadn't begun painting until late, didn't see why not). Similarly, attempts to turn Pierre into a painter, with lessons from Derain, also failed.

He moved to New York at the suggestion of his father, but Henri did not want him to be an art dealer. "My father didn't like it at all that I became an art dealer," Pierre said later. "He thought it was a distasteful occupation. In fact, he wanted me to change my name so that the name Matisse would not be associated with such a profession. It was only later, when I was not just his son but already Pierre Matisse, that he came to terms with it. Still, early on he would not allow me to show or sell his work. I remember asking him for some paintings to show in my New York gallery. When he refused, I decided to show some watercolors by Raoul Dufy. Well, when he heard

that, he was furious once again, because at the time he held a grudge against Dufy."

In New York Matisse began by selling prints through E. Weyhe, Inc., on Lexington Avenue and learning the trade at the Valentine Dudensing Gallery. He opened up for himself in the depths of the Depression, in 1932, on East Fifty-seventh Street. He had an early shock one St. Patrick's Day when a number of Irishmen saw that he was showing the works of Dufy. "Suddenly they all said 'Duffy! Duffy!' with one voice, and they came pouring out of the elevator to see what they believed to be the work of a fellow Irishman." Despite the Depression, Matisse persevered, and indeed he remained in the same building until he died, in 1989. During those years he gave Miró thirty-six exhibitions, Chagall fifteen, Dubuffet twelve, Balthus and Tanguy seven each and Giacometti five.

Another formidable figure swimming against the tide in those years of Depression was Douglas Cooper, who in 1931 started building his collection of Cubist art. Kahnweiler himself formed a temporary alliance with Wildenstein. For dealers, at least dealers in modern and contemporary works, the slump didn't bottom out until 1935. Curiously, however, the bad years did not last as long in the salesrooms. In the pre-crash 1927–28 season, according to Frank Herrmann, Sotheby's had made a record profit of £63,000 ($3.4 million now). This was exceeded in 1928–29, when profits rose to more than £70,000. After the October crash, however, according to Herrmann, Sotheby's found that "business with America ceased abruptly and almost entirely. The profit for 1929–30 was still a respectable £35,000, but the following year it had fallen to £12,000 and in 1931–32 it came down to an all-time low (at least since the cessation of sales in 1915) of £4,000." After Barlow's departure, Sotheby's was run by Major Felix Warre and he, says Herrmann, had the unpleasant job of laying off the staff. "Many former employees wanted work for just as long as it took to earn the fare to emigrate."

Trade did not cease entirely; deaths do occur, estates do have to be settled, and in a slump there are bargains to be had. But between 1930 and 1934 the art market was to all intents and purposes dead in the water. In the 1931–32 season a Frans Hals that went for £3,600 was the most expensive picture to be sold in London (£3,600 then would be $213,360 now). Gerald Reitlinger calculated that the number of pictures reaching 1,400 guineas ($88,000 now), regarded as the watershed price, was 130 in 1927, 63 in 1930, 13 in 1931 and 8 in 1932. Geoffrey Agnew joined his family's firm in that year and later wrote: "Not a single buyer would cross the threshold for months at a time. . . . when the market goes down, it's not that you're selling at lower prices, you're not selling at all."

Those paintings that did sell were bought at bargain prices. Sargent was badly hit; his prices had dropped as low as £115 10s in 1931, but bottomed out in 1940, when an oil portrait fetched £38. Gainsborough and Lawrence were helped by Andrew Mellon, who went on paying high prices (£50,000 in 1936 for *Mrs. Sheridan*). But otherwise Gainsborough's prices plummeted also, from £74,400 in 1928 to £3,465 in 1935 and £798 in 1942. Reynolds dropped from £19,425 in 1927 to £304 10s in 1937 and £270 in 1941. The others followed suit.

The most evocative indication of the seriousness of the slump was the fact that, as Frank Herrmann discovered, in 1933 Sotheby's and Christie's began to think about amalgamation. After World War I Christie's had enjoyed a boom, with profits in 1920 of £147,000 ($5.6 million now). In 1926–1927, on the eve of the crash, the firm's profitability was more than double that of Sotheby's: £59,000 as against £27,000. But then the ratio began to even out; in 1928 Christie's made £70,000 to Sotheby's £63,000, and in 1930, Sotheby's earned £35,000 to Christie's £29,000. (These figures were put together by Frank Herrmann.) In 1931 and 1932, while Sotheby's kept its head above water, Christie's actually had a small loss, which turned into a substantial one of more than £8,000 in 1933. By then Sotheby's had turned the corner, but the general picture was so bleak that each firm took the merger talks seriously. Under the proposed amalgamation Sotheby's would vacate Bond Street and join Christie's in newly enlarged premises at King Street. There were to be five directors from Christie's and four from Sotheby's, but Felix Warre of Sotheby's was to be chairman. Christie's wanted the profits split 58–42 in their favor, while Sotheby's made a counterproposal of 51–49 in *theirs.* This reflected Sotheby's worry about Christie's performance in the previous three years and may have had something to do with the fact that the merger went no further at that time.

As an alternative to auctioneering, Sotheby's now developed the evaluation side of the business. This helped to produce an unexpected bonus: house sales, with the auction at the owner's home. The changes brought about by the 1929 crash meant that a new group of owners were forced to dispose of their works of art in order to raise cash. They delayed and delayed, but by 1933, after three years of the slump, they could wait no more. Nineteen thirty-three was the watershed; no fewer than seven sales took place at "stately or semi-stately" homes. In pioneering this move, which helped Sotheby's out of its own slump, the firm poached further into Christie's territory of furniture and pictures and took the lead in one form of auctioneering, a lead it believes it has kept ever since.

Sotheby's also responded to the depression by looking outside Britain and the United States for business. It concentrated on Germany, partly because

that country had some of the best antiquarian book dealers in the world, but also because of the Anglophilia of many upper-class Germans. Frank Herrmann reports that at the time many luxurious Berlin apartments had "English" rooms full of Adam or Chippendale furniture, English portraits and landscapes. Moreover, in the wake of World War I, inflation in Germany gave rise to a strong demand for foreign currency. Two vice presidents, Messrs. Geoffrey Hobson and Tom Lumley, went to Germany to develop Sotheby's contacts and it was on this trip that the firm first made the acquaintance of the Berlin banker Jakob Goldschmidt. Originally a stockbroker, Goldschmidt had developed an amazing aptitude for successful speculation. With anti-Semitism growing in Germany, some time after meeting Hobson and Lumley in Berlin, Goldschmidt went to London, ready to sell his collection of porcelain since there was precious little else he could get out of his homeland. Unaccountably, Sotheby's was inflexible in the negotiations for the sale, and Goldschmidt took himself off to Christie's. The two-day sale fetched £25,000 ($1.5 million now), and with the proceeds Goldschmidt emigrated to the United States, where he made a second fortune investing in Chrysler. After World War II Sotheby's was lucky to meet the Goldschmidt family again and have another chance.

The German venture was a modest success for Sotheby's, one of the ways the firm recovered from the depression. Not everyone had such good fortune. For many dealers the depression lasted till World War II, and in France it was exacerbated by the growth of anti-Semitism. Though it was nowhere near as widespread as in Germany, anti-Semitism was not negligible in France and hit the art trade especially hard since, as the Jewish dealer Pierre Loeb remarked, "four dealers out of five were Jewish." Because of this, Kahnweiler, for example, was forced to adopt business practices he had long shunned and ask another dealer, Pierre Matisse in New York, to share his contract with Miró.

In the United States, Cortlandt Bishop's fortunes before, during and after the crash were not much different from everyone else's—merely exaggerated, as one would expect. Throughout the late Twenties he had continued to run the AAA and the Anderson as rivals, a set of circumstances that gave his irascible, unpredictable self plenty of scope. He railed against all opposition. "I wish all dealers eliminated," he complained, though he really did not have much cause for complaint; in 1927 he presided over one of the greatest sales ever, that of the estate of Judge Elbert H. Gary.

Gary, a "judge turned financial hero," had helped to form the U.S. Steel Corporation with J. P. Morgan. Duveen had offered $1.5 million for the

judge's collection intact, but the auction far outstripped this. So many people wanted to attend that it had to be held in the grand ballroom of the Plaza Hotel in New York. About 3,600 people turned up, and because there were no tickets, young men from the YMCA in rented tuxedos were recruited to hold the places of the mega-rich latecomers. Tips of $50 were not unknown, says Wesley Towner, but this was chicken feed that night. Fragonards went for $52,000, Hoppners for $90,000, and Gainsborough's *Harvest Wagon* went for $360,000 ($3.9 million now). When the arithmetic was completed, the Gary sale totaled $2,293,693 ($24.6 million), a figure that put even Duveen in his place.

Still the band played on. Next was the library of Jerome Kern, the songwriter. Kern was a lucky man; he had missed sailing on the *Lusitania* because his alarm clock had failed to go off. In 1928, he decided to sell his 1,500-book collection of first editions and all his stocks and shares. The books were sold at the Anderson, where they fetched $1,729,462.

Both houses were doing well. The AAA, for instance, grossed $6.25 million in 1928 ($67.28 million). On the other hand, would the two firms not do even better if they merged and shared the overhead costs? Impulsive as ever, Cortlandt Bishop chose to do just that. He closed the Anderson, retired Kennerley and replaced him with someone new to run the consolidated AAA. Milton Mitchill, Jr., was a businessman not interested in art, but he accepted the job. Parke and Bernet were again bypassed, and the merger and new pecking order were announced formally at the end of September 1929. One month later came the crash.

As in Britain, the effects of October 1929 were not felt immediately in New York salesrooms. Although American trade with Britain slumped, in the United States there was a thriving vogue for Americana. The death of Mrs. H. O. Havemeyer also provided some high-quality objects. Her best paintings—the Degas, Manets and Monets—had been bequeathed to the Metropolitan Museum, but this still left the Cézannes, El Grecos and Davids, which were sold in the 1929–30 season. However, after that the rot set in. Collections consigned for sale were withdrawn as vendors worried about low prices, or were sold privately to dealers. Mitchill tried to follow Sotheby's example and drum up business from other countries, notably Italy and France, but his inexperience showed, and in desperation he accepted objects whose quality was suspect. Some pictures in the collection of Marchesa Piero Ricci, for example, went for as low as $25; money had been advanced and the sale fell short by $19,000 ($212,175). Another example, says Wesley Towner, was the collection of the Comtesse de la Béraudière, whose Lancret portrait of Madame de Pompadour fetched a derisory $400. "I spit on you," the comtesse shouted at the auction house staff. "I spit on Parke! I spit on all of America!"

But the AAA-AG (to give the firm the cumbersome designation its proprietor used) had another problem, one Bishop wasn't aware of. As the depression deepened, Milton Mitchill took to the bottle. Like many alcoholics, he drank furtively, and his secrecy spread in other directions. Soon he would not divulge the financial situation of the company to anyone, particularly not to Parke or Bernet. But when Bishop returned from a trip abroad in February 1933 Mitchill took a boat to meet the ship at quarantine and to explain the situation. Unfortunately he was drunk at the time, which made a bad situation worse. The firm had unpaid obligations of $200,000, the deficit for the previous year was $152,000, sales were pathetic and, says Towner, several dealers who had been allowed deferred payment terms had gone bankrupt. Worst of all, Mitchill himself owed the AAA-AG $73,827 and a few months later declared himself a voluntary bankrupt.

Bishop was now forced to call in Parke and Bernet. Their ten-year contracts, dating from 1923, were now fulfilled and it was time for plain speaking. They pleaded their case: they knew the business better than anyone else; they had been loyal; now they wanted their head. Bishop gave in—sort of. Parke became president, Bernet was vice president, Mitchill was given a lump sum to leave. For working capital, Bishop arranged a bank loan of $162,000, though the interest had to be paid out of the firm's earnings. Then Bishop left again on his travels. Before doing so, however, he gave Edith Nixon power of attorney. He was no longer a young man and he respected her more than anyone else. Miss Nixon's appointment seemed innocuous at the time, but before long it would prove the exact opposite.

For the time being, however, Parke and Bernet at last had the show to themselves. Fierce economies were introduced. The AAA lowered its sights and accepted for sale objects that only a few years earlier it would have rejected. Bit by bit, the bleak situation bottomed out, and in 1934 the AAA moved into profit for the first time since 1929–30. The corner had been turned.

It is one of the deepest ironies of modern art-market history that while the world was going through the convulsions of the depression, a deal was secretly taking place that would count as the most controversial in the twentieth century and yet the finest exchange of rare Old Masters.

In the spring of 1930, Andrew Mellon, who as secretary of the treasury was the man many would blame for the crash, spent $7 million (now $78 million) of his personal fortune on twenty-one supreme masterpieces from the Hermitage Museum in Leningrad. The collections of the Hermitage dated from the eighteenth century, when Catherine the Great and other Romanovs

were the great collectors of the world. Many nations in Europe had been impoverished by the Seven Years' War, and the Russians used the opportunity to snap up scores of treasures. Throughout the Twenties, in the wake of revolution, rumors circulated that these fabled artworks might be for sale. Then in the autumn of 1927, Germain Seligmann was astonished to receive a visit from some Russians interested in a "commercial venture." He was invited to Moscow to examine works of art that might be available to foreign buyers. At the time, however, Seligmann and the Russians could not agree; he didn't want the writing desks and malachite tables that were on offer. Then, a few months later, he was approached again. This time the Russians wanted him to take charge of a massive series of auctions that would sell entire trainloads of objets d'art. But both Seligmann and the French government were worried that the large numbers of Russian émigrés then in Paris would sabotage the sales, since so much of the material had been confiscated from them. The second deal was turned down. The Russian officials now turned to the art trade in Germany and at the end of 1928 held two great sales of art objects, one at the Rudolph Lepke auction house in Berlin and the other at the Dorotheum, the Austrian government's auction house in Vienna. The sales, which charged a 15 percent commission to the buyer, produced disappointing totals and, sure enough, provoked a bitter reaction from Russian émigrés, which helps to explain the course and secrecy of later events.

Armand Hammer and Duveen now tried to benefit from the Russians' predicament. They each used the same approach, which was to make concrete offers for known masterpieces ($2 million for Leonardo's Benois Madonna, for instance). But they met refusal. Next came Calouste Gulbenkian. The head of the Iraq Petroleum Company, Gulbenkian was a bald-headed, hawk-nosed collector of impeccable taste whose private collection in Lisbon was one of the finest in the world. He was more successful. He sent his own experts to Russia to inspect the objects he wanted. Beginning in April 1928, he bought twenty-eight pieces of French gold, mostly from the collections of Catherine the Great, negotiating with Antikvariat, the main office of Gostorg USSR for buying and selling antiques. In 1930 he made another offer, this time from the famous gilded service crafted for the czarina Elizabeth Petrova. Gulbenkian also managed to dislodge seven paintings, all masterpieces (works by Rubens, Watteau and Rembrandt), and a statue of Diana by Houdon, for a total price of £325,000 ($18.1 million now). He kept only one of the paintings, Rembrandt's *Pallas Athenée*; the others went to Georges Wildenstein. The deals with Gulbenkian broke the ice, and it became clear that the Russians *would* part with masterpieces.

Enter Andrew Mellon. In 1930, he was seventy-five years old and had been treasury secretary since 1921. His father had been a Pittsburgh banker who

had loaned money to Frick and Carnegie and had controlling stock in Alcoa, Gulf Oil, Union Steel (later U.S. Steel), the Standard Steel Car Company and the New York Shipbuilding Company. Andrew Mellon was also president of the Mellon Bank, and by 1930 his family had an estimated $2 billion in assets ($22.3 billion now). Mellon served as treasury secretary under three presidents, Harding, Coolidge and Hoover, and his policies made him a dominant force in Republican politics in the Twenties. He decreased the income tax and reduced the national debt by $8 billion, but his low federal spending (especially in such areas as farm relief) and his loans to Germany are today generally held to have been partly responsible for the depression, an event he did not foresee.

Mellon was a soft-spoken and physically undistinguished man of medium height, with gray-blue eyes. His marriage had ended in divorce before World War I, and his private life since then had been given over to art. Since the beginning of the century he had been collecting in friendly rivalry with Frick, using Knoedler at first, and Duveen later. When he died, his collection, valued at $35 million ($425.6 million now), would pass to the National Gallery of Art in Washington. Its main jewels came from the Hermitage.

The Mellon deal had one extra element that added a twist to the transaction. Because of its own special problems, and in the wake of the 1929 crash, the Russians made many commercial enemies by dumping goods on the international market—selling them well below the going rate, even below cost, in order to raise foreign currency and to corner the market in such commodities as asbestos, manganese and lumber. As secretary of the treasury Mellon was constantly under pressure from American businessmen to resist this practice because it was putting Americans out of work. On the other hand, he was secretly about to take personal advantage of this same policy, for in effect the Soviets were dumping art on the market just as they were dumping other materials. Robert Williams, in his account of the Hermitage deal, calculated that the total weight of art objects exported from Russia rose from 100 tons a month in 1928 to 185 tons a month in 1930. During that year, Mellon imposed a series of embargoes on Russian asbestos and lumber to satisfy the business community, yet at the same time he was secretly buying art from Russia for himself.

This huge deal was handled not by Duveen but by Knoedler, which was then run by Charles Henschel in New York. His link to Mellon on the one hand was Carman Messmore, and his connection with the Hermitage came from Otto Gutekunst and Gus Meyer at Colnaghi in London through the Matthieson Gallery in Berlin. Once the rumors had solidified, Henschel sailed for Russia. While on board ship, he received a telephone call saying that the Russians had sent a representative to Berlin and were now willing to

part with van Eyck's *Annunciation* for $500,000. Henschel phoned Messmore in New York, Messmore took a train to Washington, and before the ship had docked in Germany, had confirmed to Henschel that Mellon would buy the painting. This picture was the first one to be handed over to Henschel at the customs house in Berlin. He then moved on to Leningrad, which he found unpleasant but profitable. He was kept hanging around in his hotel for days on end, waiting for the Russian authorities to call back. He knew no Russian and the only food and drink available, caviar and vodka, soon palled. But in the end the deal was done: twenty-five paintings for $7 million. And what paintings. Even today they have lost none of their allure: works by Frans Hals, Rubens, Rembrandt, Van Dyck, van Eyck, Raphael's *St. George and the Dragon* and the Alba Madonna, Velázquez's *Portrait of Pope Innocent X,* Botticelli's *Adoration of the Magi,* paintings by Veronese, Chardin and Perugino, and Titian's *Venus with a Mirror.*

The successful purchase of these works marked the end of one saga but brought about the beginning of another. With the effects of the depression to be seen everywhere, Mellon feared it would seem inappropriate that one man should spend so much money on works of art. Therefore the deal was kept secret; but when it was revealed four years later, it produced an explosion.

The Mellon deal was the biggest and splashiest of this period, but it was far from the only one. A number of other auctions of Soviet treasures were held in Leipzig and Berlin, the most notable of which was the Stroganov Palace sale in May 1931. Like others, this provoked bitter reaction and even lawsuits from Russian émigrés who believed that the state was selling material that had been illegally confiscated. The great Soviet sales of 1929–33 were one indication of what was happening in Russia. Stalin was herding millions of peasants onto collective farms, or into factories to combat the failing economy, and the art sales were a desperate attempt to shore up the crumbling Russian balance of payments with hard currency.

—

"For Mr Whistler's own sake, no less than for the protection of the pur-
chaser, Sir Coutts ought not to have admitted works into the gallery in which
the ill-educated conceit of the artist so nearly approached the aspect of wilful
imposture. I have seen, and heard, much of Cockney impudence before now;
but never expected to hear a coxcomb ask two hundred guineas for flinging
a pot of paint in the public's face."

Written in 1877 by John Ruskin, this statement led to one of the most
celebrated libel trials ever held. The courtroom was crowded with celebrities,
who saw Whistler win but be awarded only a farthing in damages. The
painter was bankrupted by the costs of bringing the action, and the contents
of his house had to be sold off at Sotheby's.

The art world is no stranger to the courts; even so, the early Thirties stands
out as a period when the bench, rather than the rostrum, was the great
decider. As usual, Duveen led the way. His appearance in court had been
some time in the making. On June 17, 1920, a reporter from the *New York
World* had told him that Leonardo da Vinci's *La Belle Ferronnière,* an
original oil, was en route to Kansas City. The painting was now owned by
a Mrs. Andrée Hahn and had a certificate of authenticity issued by a French
expert. Without seeing the picture, Duveen at once denounced it: "The
painting sent to Kansas City is a copy . . . Leonardo never made a replica of

this work. His original *La Belle Ferronnière* is in the Louvre. . . . [The] certificate is worthless."

Coming from such a source, this naturally had the effect of killing any sale of Mrs. Hahn's picture, and she sued; a summons was issued in November 1921. Expert opinions about the two paintings were sought in London, Paris and Amsterdam. Witnesses included Langton Douglas, director of the National Gallery of Ireland, Bernard Berenson and Roger Fry. The case finally came to court in the first weeks of 1929, nearly a decade after Duveen had made his remarks; in the interval, Mrs. Hahn maintained, it had proved impossible to sell her picture. The trial lasted eighteen days, during which time the picture itself was wrapped in a paper bag, leaning against the court railing, waiting to make its appearance. Duveen took the stand on the first day and confidently asserted to the court that he had never made a mistake, at least not since his youth. He was followed by several other witnesses. Collectively, however, they apparently only confused the jury, because even after stern admonitions from the judge, it was unable to agree on a verdict. A retrial was ordered for May 1930. Then reports began to appear to the effect that in the interim Mrs. Hahn had gathered new evidence in Italy and France that would discredit Duveen. He grew nervous and attempted to have the trial postponed; he had just been operated on for a hernia and there had been complications. However, the court-appointed physician found Duveen to be "in excellent physical condition" and declared that he could appear in court in a month. It never happened. On April 11, 1930, Duveen settled out of court, paying Mrs. Hahn $60,000 ($544,000 today).

There was a curious epilogue to the story. Fifteen years later, after Duveen had died, Harry Hahn published *The Rape of La Belle*. The book was a vicious attack on Duveen, who, Hahn said, "headed an international plot by art dealers to control the market," and Duveen's array of experts, no better than "fortune-tellers, clairvoyants and two-bit prophets," were mere puppets in his "defense clan." Berenson, declared Hahn, was the "major-domo of the Duveen clan." An intemperate tone, certainly, but the phrase about fortune-tellers and clairvoyants bears a remarkable similarity to one that Berenson had used about himself when he compared his role with the deliberate charlatan among "clairvoyants and necromancers." Could it be that the evidence Mrs. Hahn was supposed to have discovered was much the same as that which Colin Simpson later discovered—namely financial collusion between Duveen and Berenson? Such evidence would have been much more damaging to both men in 1930 than it was in 1986, when both were dead.

There was chicanery in Britain, too. In July 1934 a book appeared with the seemingly innocuous title *An Enquiry into the Nature of Certain Nineteenth-Century Pamphlets*. It was written by two very young antiquarian booksell-

ers, John Carter and Graham Pollard, and far from being a dull treatise, it was in fact a sensational exposure of a classic crime. The book charged that Thomas James Wise, the most eminent book collector of the day, was a forger and had been faking on a massive scale first editions of works by Tennyson, Thackeray, Dickens, the Brownings, Robert Louis Stevenson, Swinburne and Kipling. He had invented ingenious but utterly spurious provenances, and these attributions had shaped the world of books for a decade.

It is hard to exaggerate how respected Wise had been until this point; as Frank Herrmann points out, he had been president of the Bibliographical Society and was an Honorary Fellow of Worcester College, Oxford, and a member of the Roxburghe Club for bibliophiles. "His judgment was respected everywhere; indeed, his word was often law." At the time Carter and Pollard's exposé appeared, Wise was seventy-five and had an extensive book collection, the Ashley library, which he had catalogued himself in eleven volumes. (The library was bought after his death by the British Museum for £66,000.) He had begun collecting books when he was very young, hanging around the famous book barrows in Faringdon Road. As he grew and prospered, he realized that his expertise would be valuable to many wealthy book collectors across the Atlantic, who could not often attend the auctions in London. This distance may have helped spawn his fatal idea.

Wise's technique was to establish a high price for a book by putting it up for auction himself and instructing two separate dealers to bid for him against each other. Although he had to pay a commission to both the auction house and to the successful dealer, he nonetheless established a false high price for that particular book. He would then produce fake copies of the book and point out to his American clients the high price it had fetched at auction. Not everything was an outright fake; often he would buy imperfect copies and cannibalize one or more in order to produce a perfect version that he could sell across the Atlantic. Wise's manner did not make him an easy man to challenge. On one occasion he confronted a bookseller who was advertising some Shelley letters. Before the man's eyes Wise tore the letters to shreds, crying, "Now sue me if you dare!" He thought the letters were fake and this was his method of dealing with the problem.

Thus, the evidence that Carter and Pollard listed was all the more astonishing. According to Herrmann, the paper Wise had used for some of his bogus pamphlets was made at least forty years after their alleged publication; some of the typefaces were anachronistic; in the case of some Robert Browning letters dated 1847, Wise's examples used details that Browning himself could not have had access to until 1852, and so on. The matter was proved beyond doubt when it was shown that Wise had actually stolen a number of title

pages from valuable books in the British Museum and had used them to perfect his own copies of these books. Wise called Carter and Pollard "sewer-rats" but the affair left a nasty taste in the book world for years to come.

While this scandal was still bubbling, Duveen was back in court again, though this time as a witness. The central character now was Andrew Mellon. He had resigned as treasury secretary to head off an attempt to impeach him over conflict of interest regarding government use of his own ships. President Hoover promptly appointed him ambassador to London and there the matter might have ended, except that after Roosevelt was elected president, in November 1932, the Democrats sought to convict Mellon of tax fraud. The Internal Revenue Service claimed that Mellon owed $3,075,103 ($35.9 million now) in unpaid taxes for 1931. Mellon was incensed and counterclaimed that instead he was owed $139,045 in tax refunds.

The discrepancy arose from the taxable status of Mellon's art collection. According to him, he had first thought of turning his private collection into a national museum in 1927. To that end he had created a trust and had contributed monies and paintings to it since 1930. By the spring of 1935, according to Mellon, the trust had cash, securities and paintings worth more than $20 million. The question was whether all this was true, or simply a clever scheme to defraud the taxman. The case began in March 1935 and it was only then that the great Hermitage deal at last came to light officially. Duveen and Charles Henschel of Knoedler both testified in Mellon's behalf. Duveen confirmed that Mellon had indeed discussed the museum idea with him, and Henschel testified about some of the prices paid by Mellon. The millionaire's image suffered further when it became clear that the deal had been made via Berlin because at the time the U.S. government did not recognize the Soviet government, and if Mellon had paid in dollars he would have been breaking the law. As it was, the fact that the secretary of the treasury had secretly evaded his own government's currency restrictions was hardly edifying. Eventually, after what seemed to be endless delays, the Board of Tax Appeals upheld Mellon's version, but the government, far from being convinced, started new actions against him. It was only when Mellon wrote a personal letter to Roosevelt in which he donated his paintings to the National Gallery of Art that the charges were dismissed. It was none too soon, for that summer Mellon died. It was a sorry end for a great collector, and a controversial beginning for a great public institution.

The final instance of this outbreak of bad blood in the art trade concerned the AAA. It was the longest-running saga and in the end the most serious.

Shirley Falcke was a wiry Englishman, a captain and professional soldier in the Blues, one of the regiments that make up the Royal Household and take part in the changing of the guard at Buckingham Palace. Wesley Towner

reports that Falcke was once described as "a Georgian nobleman with a long feudal past and more human charm than any other man alive." Falcke had arrived in the United States in 1925, at the age of thirty-six. Having been raised amid beautiful objects, he had no difficulty in becoming associated with the AAA as a free-lance expert. Eventually he was given a full-time job, and in 1930 Mitchill sent him back to London, where, it was felt, his ease with and knowledge of the British aristocracy might help drum up trade during the depression. Falcke spent a summer at the Ritz, and as well as befriending the British aristocracy he courted Cortlandt Bishop, arriving for their first meeting with a brace of grouse. Bishop, to whom no one ever gave presents, was charmed, and Falcke was soon a part-time member of the Bishop court.

To add to his undoubted social success, Falcke scored an early commercial coup by luring the Lothian collection to the AAA. The eleventh Marquis of Lothian was forty-nine when he inherited the title and had to raise £200,000 to pay death duties. Partly because he knew one of Lothian's sisters, Falcke charmed the Lothian library from under the noses of the British auction houses. When it heard of Lothian's decision, Sotheby's described it as "disastrous." The British Museum said it was "very much upset." But Lothian stuck to his decision and the books crossed the Atlantic. Bishop then took a hand in the affair, and his intervention was characteristic. The sale was scheduled for January 1932, when the depression was still in full flood, but Bishop had no intention of letting the sale fail after all the fuss in Britain, so he concluded a secret arrangement. A bookdealer, Barnet Beyer, was instructed to bid up any lot in the sale that threatened to fetch a low price. Anything he was forced to acquire would be paid for by Bishop, and at a later date, when the books were eventually sold, the profit would be split between Beyer and Bishop. It was nothing less than an attempt to rig the market, and it was a notable success. The Lothian sale raised $410,545, which was much more than Lothian had expected (although Beyer had to spend $80,000 to keep up prices). Shirley Falcke's reputation was boosted further by this, even though his expenses at the Ritz so far amounted to $9,750. After the sale, the idea was born that he should open a London office of the AAA. This duly came about, and Falcke and his family, plus six servants, moved into 77 Brook Street, opposite Claridge's, to live "above the shop." With all expenses met by the AAA-AG, they lived on a lavish scale, entertaining aristocrats whom they hoped would one day consign their treasures for sale in New York.

For a time things went well. By the summer of 1933, however, the expenses of 77 Brook Street were beginning to hurt. The crunch came, says Towner, with the sale of twenty paintings belonging to Sir Albert James Bennett of Kirklington Hall, Nottinghamshire. These included eleven eighteenth-cen-

tury portraits which, though they were no longer the stars they had been before the crash, might still attract the likes of Mellon. Falcke was so pleased with this coup that he traveled to the United States himself to see the sale. It was a mistake. The auction actually brought in $125,000, which in that difficult year seemed good enough to Bishop, Parke and Bernet. It then emerged, however, that Falcke had agreed to secret reserves with Sir Albert, and most of the pictures had to be bought in. The whole business had been a charade, and this prompted a closer look at the London operation. In two years it had cost $50,000, while earning commissions of only $28,600. This was hardly good business, and a decision was taken to close 77 Brook Street.

But now Falcke turned on his employers and refused to accept the terms he was offered. He returned to London and, since the lease still had months to run, remained there as a squatter, running up bills for everything he could think of. Falcke's fury knew no bounds. His tactic was to make so much fuss that the AAA-AG would pay him off. He asked for $15,000 ($183,400 nowadays), just to keep quiet, hinting that he knew enough about malpractices to have the AAA-AG suspended from business. Parke and Bernet stood firm, so Falcke turned his venom on Bishop, sending so many threatening telegrams to the Ritz in Paris that the manager refused to accept any more on the grounds that he would not be a party to blackmail.

Meanwhile, Bishop was ill. A visit to a French dentist had brought on the decline; the man had pulled an ulcerated tooth and the infection had spread, leaving Bishop feverish. In November 1934 he suffered the first of several heart attacks, but he was determined not to die until he had disposed of his tormentor, "and Falcke would not go just to make Bishop's dying easier." Falcke then contacted the Board of Aldermen of New York, repeating in official circles his allegations of malpractice at the AAA-AG. Amid these unpleasant circumstances Bishop died, on the evening of March 30, 1935. Wesley Towner reports his last words, "I never thought I would die so young—sixty-four. . . . Count to sixty-four and I am dead."

The Falcke case came to court in London the following June. Otto Bernet had been chosen to be the AAA-AG's main witness. He was mortified about having to appear but turned out to be a great success, his honesty shining through. In strong contrast, Falcke was inarticulate, shifty and at times plainly ridiculous. At one point he was cross-examined about an item of his expenses: "Supper for a dog . . . 7s 6d." He was asked, "Is that what it costs for a dog to have supper at the Ritz?"

"I cannot say," replied Falcke, at which point the spectators burst out laughing.

The cross-examination continued: "Evidently the dog was off his feed a bit on a later date, when the charge was only five shillings. Am I not correct?"

Falcke shrugged. "I am not going to charge the company for my dog."

"Was it a large dog?" the judge inquired.

"No," Falcke replied. "A Yorkshire terrier."

The court dismissed all of Falcke's monetary claims against the AAA-AG except for two months' salary because of his premature dismissal. Parke and Bernet were relieved that it was over, and the rash of appearances in court by the art trade at last seemed to have ended. But it wasn't the end of Falcke.

21 | THE MATHEMATICIAN AND THE MURDERER

Awful as things were in the depression, few people in the art world fared as badly as Rembrandt. In the Thirties a Dutch student who claimed to be a descendant of Saskia van Uylenberg, Rembrandt's first wife, petitioned the court in Amsterdam to have his distinguished ancestor rehabilitated. Rembrandt had died an undischarged bankrupt, but, said the student, in view of the prices his pictures were now selling for, the court should rescind the order and restore the artist's good name. Showing that lack of a sense of humor for which the burghers of Holland are famous, the court refused. Today, more than 320 years after his death, Rembrandt remains a bankrupt.

In 1934 the Chester H. Johnson gallery of Chicago also went bankrupt. The gallery had been ordered to liquidate its stock by the courts, and for modern art aficionados there were bargains galore. At the sale, held in November, a Juan Gris went for $17.50, a Braque still life for $185, the top price for a Léger was $60, and even Picasso's *Supper Party* raised only $400. Wesley Towner tells us that W. P. Chrysler, Jr., Ben Hecht, Elmer Rice, Bernard Reis, George Gershwin and Pierre Matisse were all buyers. The presence of Pierre Matisse was especially good news. He, Sidney Janis and Edith Halpert were bucking the trend; they had all opened galleries recently and seemed to be surviving. Matisse's gallery, on East Fifty-seventh Street, then comprised two pokey rooms. It was next to the Christian Science Reading Room and was considerably less busy than they were. Despite his

illustrious father, Matisse was painfully shy, often too shy to talk with the few customers who did visit the gallery. Still, in time he would become the great American dealer of the Surrealist generation. From their point of view, he left Paris exactly on cue.

In Paris, the city Pierre Matisse had left, the art scene was still bleak economically even in 1936. On March 7 Hitler denounced the Treaty of Locarno, which had specified the details of Franco-German reconciliation and reparations, and the stock market fell. "Again it became impossible to sell anything." Pierre Assouline reports that Kahnweiler terminated his contract with Georges Wildenstein (Nathan had died in 1934), but initiated two alliances in New York, one with Nierendorf and the other with Curt Valentin, who then worked at the Buchholz gallery.

Germain Seligmann continued to find that Paris was not as badly affected by the depression as the United States. Tapestries declined in the same way as English portraits had, and have never really returned, but trade in the eighteenth-century decorative arts went on, and in 1934 Seligmann felt confident enough to open a new gallery on the rue de la Paix. Later in the decade he found that interest in modern painting was picking up. This was when Seligmann bought van Gogh's *Irises,* and when he held his pioneering shows on Picasso, "Blue and Rose Periods" in 1936 and "Twenty Years in the Evolution of Picasso" in 1937.

In London, too, things were better than in New York. By 1936 the pound had recovered and normality more or less returned. The relative burgeoning of London was signaled in the salesrooms when twenty-two paintings by Boudin were sent to Sotheby's from Paris and fetched an unprecedented £7,430 ($448,460 now). Further change was occurring in the balance between Christie's and Sotheby's. Christie's still held its preeminence in pictures; in Gerald Reitlinger's lists of notable paintings and drawings sold between the wars, Christie's is mentioned nearly four times as often as Sotheby's. But Alec Martin, Christie's chairman (see figure 67), was beginning to antagonize dealers by seeking to coerce sellers to come straight to him rather than going through the trade. He also tried to interest museum curators in buying directly from Christie's, which was then unusual. John Herbert says that Agnew was so upset by this that it abandoned the close links it had enjoyed with Christie's (Peter Chance, a later chairman of Christie's, was related to the Agnew family) and dealt more and more with Sotheby's.

At Sotheby's the book and manuscript department continued to provide gems in an area where Christie's was weak. The star in 1936 was the sale of a major portion of the handwritten pages that Sir Isaac Newton had left at his death in 1727. At that time the papers had been valued at £250; they had remained with the mathematician's heirs until 1872, when a large number of

scientific documents were given to Cambridge. However, the rest had been kept, and included Newton's writings on alchemy, chronology and theology, as well as the bundles written during his three decades as Master of the Royal Mint. There were letters to and from Boyle, Locke and Samuel Pepys and an entire series of exchanges with Halley, who had been responsible for publication of Newton's most important work, the *Principia.* There were also papers concerning Newton's invention of calculus and the correspondence with Leibnitz about its origination. It was a specialized treasure, perhaps, but one that fired the imagination.

The Newton papers, says Frank Herrmann, had been kept at Hurstbourne Park in Hampshire, just one of the residences of the earls of Portsmouth, who were Newton's heirs. The sale was held partly because of the need to pay heavy death duties and partly because of a costly divorce. Despite the fact that the catalogue for this sale was itself regarded as a collector's item, only a small number of dealers and collectors were prepared to bid at such a specialized sale. Among them, however, were John Maynard Keynes and his brother Geoffrey, who between them bought 39 of the 332 lots. Later Keynes bequeathed these papers, along with others of his own, to his college at Cambridge, King's, after he had written a famous paper, *Newton, the Man,* based on the documents he had bought at the Sotheby's sale. In this paper he described the great mathematician as "the last of the magicians . . . with one foot in the Middle Ages and one foot treading a path for modern science." For Keynes and one or two others, the Newton sale was a fantastic opportunity. However, despite its unrivaled importance to scholarship, the auction raised a mere £9,030 ($545,000 now). This too was one of the great bargain sales of history.

The following year, 1937, saw the coronation of George VI, a relief for all concerned after the tribulations of Edward VIII's abdication. Sotheby's celebrated the event with a magnificent house sale at 148 Piccadilly, home of the Rothschilds. The house had recently passed to the young Victor Rothschild, who was to achieve fame as a distinguished biologist, book collector and chairman of the British government "think tank" between 1971 and 1976. The house had been the creation of Baron Lionel Nathan de Rothschild. Emma Luise, wife of the baron's son, had bought many of the pictures to help create one of the most sumptuous homes in the country. The lease on the house was about to fall due, and Victor Rothschild, a realist, was worried that a war might be looming. The sale set at least one precedent when BBC radio decided to broadcast the auction of the Rothschild objects "live," the first time this had ever been done.

The Dutch pictures attracted enormous interest, but, says Frank Herrmann, several of the French dealers tried to denigrate the furniture, querying

its authenticity. This was a classic French tactic, as old as Drouot itself, designed to bring down expectations, but it didn't work. The silver was also of great interest (240 solid-silver dinner plates and 66 similar soup plates) and fetched nearly £40,000 ($2.33 million now), at the time a record for a Sotheby's silver sale. It proved particularly popular among a number of Indian maharajas and grandees who were in London for the Coronation.

The Rothschild sale brought in a total of £125,262 ($7.3 million now) and was counted a success in every sense. The lean years were over and a time of plenty was beginning—or appeared to be. On March 12, 1938, German troops marched into Austria and Hitler annexed it to Germany. The art market in Europe reacted immediately; both the Paris and Swiss markets collapsed, having barely recovered from the depression. Over the next months the situation deteriorated further. In 1939 Duveen died, as did Ambroise Vollard, killed one weekend in July when the steering wheel of his car broke and the chauffeur lost control. His last words were "A lawyer, a lawyer" (he had not revised his will since 1911). He left four thousand paintings.

In June of that year the Nazis held their notorious sale of "degenerate" art, consisting of 125 pieces of modern painting and sculpture removed from German museums and private collections. Hitler, the failed art student, and his cronies regarded artists like Picasso, Klee and Braque as "degenerate." The auction, held under the auspices of Theodor Fischer at the Grand Hotel in Lucerne, raised a storm of protest, not just because of the Nazis' appalling taste but because the works had been confiscated. Fischer tried to pretend that the proceeds of the sale would be used in a good cause, but few believed him.

—

When Otto Bernet returned to New York after the Shirley Falcke trial in 1935 his triumph was remarkably short-lived. On April 8, 1935, Cortlandt Bishop's will had been filed, and to Parke and Bernet's consternation they found that once again Bishop had let them down. Full control of the firm passed to Mrs. Bishop and to Edith Nixon.

Parke and Bernet were furious. In addition to everything else, Mrs. Bishop and Miss Nixon had also inherited Cortlandt's habits and were about to depart for Europe again. Wesley Towner says that Parke, disgusted, was all for leaving the company in the lurch: "This time, *I'm* running away to Never Never Land." Otto Bernet persuaded him to stay. For the next two years, Edith Nixon played Cortlandt Bishop's role, writing to Parke from wherever she happened to be—Madrid, Milan or Mesopotamia. She was less prolix than Bishop but no less irritating.

Then came the fatal twist. Not surprisingly, the two ladies' itinerary took them to London, and there Edith Nixon received a letter from Shirley Falcke. Falcke, it seemed, was contrite and longed to make amends for the bitterness that had developed. Miss Nixon replied by a handwritten note suggesting tea. Falcke's answer suggested a tea-time drive in a horse-drawn carriage. He had lost none of his charm, and on the drive it emerged that he was now divorced. It also emerged that he and Miss Nixon enjoyed each other's company and conversation, so a second meeting was arranged. Falcke's next move was to send Miss Nixon a bundle of letters he had exchanged with Otto Bernet during the recriminations that had resulted in his dismissal. He was sure that Miss Nixon would see that he was the innocent party, and it certainly seemed so from the letters—at least those that Falcke released. It appeared that Bernet had even referred to a "Falcke-Bernet" partnership if the London office should ever be severed from New York. Falcke also included letters in which Bernet had slighted Cortlandt Bishop. Charmed as only a spinster can be, Edith Nixon took his part: Otto Bernet must go, and the AAA-AG, now hers as much as anyone's, would have to be refashioned. When she advised Mrs. Bishop of the circumstances, Cortlandt's widow was immediately won over. The two women returned to New York in a determined frame of mind, arriving in early October 1937.

Wall Street had begun to fall again. Lord Halifax had visited Hitler and the policy of appeasement had begun. The ladies, however, were not in an appeasing mood. Their first move was to marshal support, and to that end they brought back Milton Mitchill. It was an extraordinary move, an atavistic step, but this time Hiram Parke stole a march on them. Whether or not he knew something was in the wind, he offered formally to buy the AAA-AG from the two ladies. He had Bernet and Arthur Swann on his side.

Miss Nixon was surprised by this offer but said she would have nothing to do with Parke unless he shed Bernet. The major refused. By this time, moreover, the two ladies had conceived a liking for another old face, Mitchell Kennerley, who was still friendly with Falcke in London. To them it mattered not at all that Kennerley still owed the AAA-AG $70,000 ($850,000 now) and was being sued for it. They thought he would make an excellent president, a position he had occupied before, and was therefore the ideal man to pull the AAA-AG together. Mrs. Nixon called a board meeting to formalize all this, but at that meeting, Wesley Towner reports, Parke would not compromise; if the board would not accept his offer, he would resign. Resign he did, taking with him Bernet—"You're a stone around my neck but you're coming"— and forty loyal staff. He had been trampled over by one Bishop or another for too long.

It was a brave decision. Parke was already sixty-four and did not have any

capital to speak of. But he moved quickly; Mitchell Samuels, the proprietor of French and Company, rug and tapestry dealers, provided temporary accommodation, and overnight Parke raised sufficient capital to form a corporation from people he knew who were either dealers or collectors. Duveen and Harry Winston, the jeweler, were among those who volunteered unsecured loans. On the very next day, Saturday, November 13, 1937, Parke-Bernet was born.

Within two months Parke was able to announce their first sale. On the death of Jay Carlisle, the husband of Mary Pinkerton, daughter of the founder of the great detective agency, his heirs were persuaded to try the new firm. By now Parke had found more permanent premises, still on Fifty-seventh Street, at the corner of Fifth Avenue; his success or failure would be in full view of the AAA. The sale got off to an emotional start; the four hundred seats were filled an hour ahead of time, and when Parke appeared on the rostrum he was presented with flowers. There was even a speech by Gus Kirby, who gave the new house his imprimatur. Kirby also made sure that he was the first person to buy something at Parke-Bernet, spending $225 on four cocktail glasses worth about a tenth of that. In the heat of the moment, it didn't matter; the firm was launched. The Carlisle sale was a huge success and written up widely in glowing terms. More important, Parke and Bernet were deluged with business and trade was filched from their former employers.

Meanwhile those employers were in disarray. Mitchell Kennerley was back, but, Wesley Towner says, he was a changed man. He had lost a lot of his old energy and this hurt the firm badly; uneventful sales were followed by failures. Even Cortlandt Bishop's own library, which certainly had quality and depth, fetched barely half what it was worth—or at least what Kennerley and the ladies had hoped for. Worse, farce was piled on pathos, for Kennerley began to behave oddly. Sometimes he would hide on sale days; sometimes he would appear disheveled in public, without his tie or wearing trousers that were "much too large and could not possibly belong to him." His mental state was clearly deteriorating. Nonetheless, in 1938 the two ladies returned to London and renewed their acquaintance with Shirley Falcke. By the time the women returned to New York, Miss Nixon and Shirley Falcke, with Mrs. Bishop's blessing, were married.

This bizarre trio returned to a situation that was no less extraordinary. By now Mitchell Kennerley had grown so unstable that when Milton Logan, the AAA's company secretary, had offered him $185,000 earlier in 1938 for a controlling interest, he had accepted on both his and the ladies' behalf. The final tragic chapter had begun.

In 1938 Milton Logan was forty-seven. Born in Brooklyn, he had met

Cortlandt Bishop when he was the superintendent of one of Bishop's buildings. The millionaire had liked him and only weeks later made him his private secretary, and the company secretary. Not surprisingly, therefore, Logan did not have the $185,000, not even the $10,000 deposit, that he had promised Kennerley. However, a friend of his, John Geery, did. The two men, says Towner, had been close since their Sunday school days in Brooklyn. Geery sold his shares in the Brooklyn Dodgers to raise money to buy the AAA-AG, and together they formed a holding company. Mrs. Bishop and Mr. and Mrs. Falcke at last bowed out.

At first things went well. In April 1939 the company had a minor coup when *The Madonna of the Pinks,* the only "Raphael of unquestioned provenance ever to be offered for auction in the United States," was sold by Logan.* It fetched $65,000 ($731,000 now), sold to a woman who took it away, says Towner, wrapped in a brown paper bag. But already Logan was playing tricks to balance the books. Later in 1939 Geery began to get seriously worried when months passed and he never received a single dividend from his AAA-AG stock. Eventually he examined the books himself and found that Logan's bookkeeping was, in the accountants' words, a "senseless show of figures scattered upon ledgers." While he was examining the books, Geery hit upon an extraordinary rescue plan—a plan, in fact, that was to be the single most extraordinary episode in the history of the modern art market. The following paraphrase is based on the gripping, much more detailed account in Wesley Towner's book.

Geery noticed that at times Mitchell Kennerley had taken out life-insurance policies on the lives of important collectors for the duration of big sales in which they had a major interest, and this set him thinking. His first move was to tell Logan that he had a great friend, a former German U-boat captain, who "now and then" smuggled Chinese antiquities out of mainland China, and who had agreed to ship to the AAA-AG a load of porcelain worth somewhere between $7 million and $10 million. As an apparent afterthought, Geery added that since Logan would be the auctioneer at the all-important sale, it would be prudent for the firm to insure his life for the sale's duration. Logan readily agreed, and Geery immediately took out a $100,000 policy.

Before any other part of Geery's plot could be enacted, however, the unexpected intervened: The AAA-AG's license was suspended when four creditors claimed that the auction house had not paid its bills. It now also emerged that the AAA-AG had not paid its rent, and it was therefore without a home. Next, Logan was indicted for defrauding more than sixty of the AAA-AG's clients of some $65,000. (Among these was Baron Felix Lachov-

*In fact, the real *Madonna of the Pinks* was discovered in Alnwick Castle in Britain in 1991.

ski, who had been paid only $20,000 of the $65,000 his Raphael had fetched.) Two days after Logan was arrested, Geery was arrested too, as an accomplice. Both were allowed bail, and the trial was set for March 1940.

The story now shifts from the pathetic to the squalid. From time to time Geery had confided in a certain John Poggi, who had a newsstand near where Geery lived. Poggi had once been arrested for robbery, and his brother was a notorious East Side gangster serving a life sentence in Sing Sing. Geery's slide into crime was nearly complete. In the next few weeks, with Poggi's help, Geery made three separate attempts on Logan's life. Once, Logan was persuaded to drive to a "job interview" (set up by Geery) in the prospective employer's chauffeur-driven car. When the "chauffeur" (Poggi) stopped at a drugstore and told Logan to wait, Logan became suspicious, got out of the car and took the subway home. On the second occasion, Logan and Geery walked to the subway together after a legal conference. At the top of the subway stairs, Geery made an excuse to turn back, and Poggi came up behind Logan and gave him a shove. Logan screamed as he fell down the iron-edged steps but miraculously escaped serious injury. He did not see Poggi and apparently did not suspect that Geery was involved. In the third attempt, after another legal meeting a few weeks before the trial was due to begin, Geery offered Logan a lift home in a borrowed car and then, on a pretext, picked up Poggi. This time Poggi pulled a piece of metal piping from under his coat and struck Logan with it again and again while Geery drove the car. When they judged that Logan was dead they dumped his body onto the highway.

Geery and Poggi now split up, and Geery went to the Waldorf-Astoria, where he was to meet his family to celebrate his twenty-first wedding anniversary. When he arrived, he appeared dazed and told the assembled guests that he and Logan had been attacked. He repeated the story to his lawyer and to the police, then asked to be driven home. There he said he found the house freezing and went down to the basement to put more fuel in the furnace. A few minutes later his wife and son heard a shot. Geery had put a revolver in his mouth and killed himself.

Logan, however, was not dead. His skull had been fractured, but he had not lost consciousness and a police patrol car had passed by shortly after the attack and rushed him to a hospital. Though Logan was hazy about many things, he had the license plate of the car written down. It was traced to John Poggi.

In October 1940, Poggi joined his brother in Sing Sing, sentenced to ten to twenty years for his part in the attempted murder of Milton Logan. Logan had to face trial too, and in March 1941 he was convicted on nine counts of grand larceny, the offenses for which he and Geery had originally been

indicted. He was given ten years probation, escaping the maximum thirty-year jail sentence mainly on account of the ordeal he had undergone in the preceding months.

It was a sordid, squalid end to the AAA-AG after so many years in the fashionable limelight, and it left the field clear in the United States for the new house of Parke-Bernet.

In June 1939, Fernand Léger, back from a visit to the United States, met René Gimpel at Louis Carré's new gallery in Paris. "We Cubists are beginning to win through," he told the dealer. In his journal Gimpel commented, "As Léger is my age, I could say to him: 'Your youth is past, your adolescence too, you've entered on ripe years, we're at the gates of old age, and that's when you are beginning to be appreciated! But success has never come so late to a school! The public has never been so slow, and it's very sad!' "

It was true; the public *had* been slow. This may have had something to do with the political and economic situation of the Thirties. Above all, what stands out about the art market of 1934 to 1940 is its sluggishness. Even though the depression was over technically, and though the main salesrooms were again profitable from 1934 on, the turnover in pictures was still 40 percent down from the golden period before 1929. This fall was especially marked in the field of Italian Old Masters. There were some exceptional prices: £103,300 for a Ghirlandaio, the same for a Pollaiuolo, £37,400 for a Fra Angelico (£100,000 then would be $5.7 million now); but generally prices were either static or had declined. Carpaccio, who had exceeded £10,000 before World War I, was now stuck at around £3,000; Crivellis fetched hundreds of pounds, not thousands; Mantegna, as high as £29,500 before the war, could not now break £5,000. The Bolognese school—the Carraccis, Domenichino, Reni—were still sometimes selling for less than £100. There

were signs that Canaletto was improving. French school Old Masters had all but dried up; there were no sales of Chardin, David, Poussin or Watteau. Bouchers, selling for £18,900 or £47,250 before the crash, now barely fetched £4,000. Almost no other generalization is possible, since so few works appeared. A record was set for an Ingres, but among the northern school, Rembrandt, who in the Twenties had exceeded £30,000 seven times, did not do so now even once. Rubens fared better, but most of the others—Hals, Hobbema, Holbein, de Hooch, Mabuse and Memling—were stationary. Rare jewels still fetched the best prices; for example, van Eyck's *Three Maries* was sold by Sir Hubert Cook to Daniel George van Beuningen for £300,000 ($13.9 million now) in 1940.

Daniel George van Beuningen was a Rotterdam shipbuilder who lived in private splendor at Noorderheide, a brick mansion surrounded by vast moors and forests, where, Pierre Cabanne tells us, he hunted wild boar and mouflon. He was a self-taught connoisseur and collector of the old school; starting out with Dutch nineteenth-century pictures, he gradually refined his taste. In his lifetime (he died in 1955) he bought 5,000 pictures and sold 1,500, always upgrading. He bought in the salesrooms, taking his private plane to London, Paris, Vienna or wherever an auction happened to be, but also made regular use of the Dutch dealer Goudstikker, and N. Beets and Cassirer in Berlin, from whom he acquired Brueghel's *The Tower of Babel.* The main purchases in his life were the Auspitz collection from Vienna (Veronese's *Supper at Emmaus,* Tintoretto's *The Annunciation,* Rubens's sketches), the Koenigs collection of Old Master drawings (confiscated by the Nazis, this was later taken to Russia, from where, as this book went to press, attempts were being made to return it to Holland), and the Cook collection.

Van Beuningen was inordinately proud of the fact that he was self-taught, and that though he could afford the best advice, he took it only when it agreed with his own opinions. To begin with, this stood him in good stead, when he was proved right in a number of acquisitions, but it let him down badly in 1941, when he paid 1.6 million florins to an Amsterdam dealer for *The Last Supper* by Johannes Vermeer. As Pierre Cabanne has pointed out, six Vermeers were to come to light between 1937 and the end of World War II "in circumstances—in particular the isolation of Holland under German occupation—which prevented these remarkable discoveries from receiving the publicity they deserved." A few experts were made uneasy by this sudden crop of new pictures, but no less an authority than Dr. Abraham Bredius, the foremost expert on Vermeer, had authenticated the first rediscovery, *The Disciples at Emmaus,* and helped to pay for its acquisition by the Boymans Museum. The director of the Mauritshuis in The Hague also considered the picture genuine. It was not; it and the others had been forged

by Hans van Meergeren, who proved his case by turning out still more Vermeers under police supervision. Curiously, van Beuningen was not convinced by this seemingly incontrovertible evidence; indeed, he sued one of the experts who had cast doubt on his "Vermeer." The case had still not come to trial at the time of his death.

Van Beuningen was much luckier with his acquisitions from the Cook collection, especially the van Eyck *Three Maries.* Several times he had tried to persuade Sir Hubert Cook to sell certain pictures. At last, in 1939, before the outbreak of war, Sir Hubert appeared ready, but now the National Gallery in London stepped in and refused to let the pictures leave the country. By April 1940, however, the Bank of England was in dire need of foreign currency, and the government was forced to lean on the National Gallery to abrogate its ban on the export of works of art. Van Beuningen made his move immediately. Cabanne says that he had one of his friends, "who was a director of KLM [the Dutch airline] send a special plane to fetch the paintings. However, the doors of the only aircraft available were too narrow to accommodate the *Three Maries.* Three days after the other pictures arrived in Rotterdam, Holland was invaded and the city blitzed," but the van Eyck was safe in England.

Compared with what they had fetched before the crash, English eighteenth-century portraits were off by perhaps 50 percent, but they had done better than other schools. Turner had contracted; Stubbs had dropped back again. The decline of the French nineteenth-century school continued. For the most part, even Corot had ceased to break the £1,000 barrier. A solitary Meissonier, *Cavalier Taking Refreshment,* sold for £105. The Pre-Raphaelites fell too. The chief casualty was Millais, who had peaked at £10,500 in the Twenties; one of his pictures now went for £54. Bonington held up better than most, but Alma-Tadema fell to £52 10s.

Like everything else, the Impressionist market had also dried up. Cézanne was strong—up to £9,700, compared with £5,000 before the crash; during this period he was one of the few painters who had more works on the market. Degas was also consolidating; his prices had not retreated and his pictures were still circulating. Renoir had slipped back badly, but prices for van Gogh, although, or perhaps because, there were fewer works of his available, improved. All of his paintings that came on the market were comfortably in four figures, the top price being £4,000. Thus he was more expensive than Bellini or Canaletto, Cranach or Claude, and no nineteenth-century French painter, Cézanne apart, came near him.

The modern school was the only area where trade increased. Artists ap-

pearing at auction for the first time during the 1934–40 period were Braque, Chagall, Modigliani, Soutine and Vuillard. The highest price for a modern school picture was £700, paid by the Tate Gallery for a flower piece of Picasso's painted in 1901, whereas Chagall's *The Dream* was sold at Christie's in 1939 for £10 10s. No one matched Seurat's prices of the Twenties.

In hindsight, the art market accurately reflected the mood of the Thirties. Unlike the Roaring Twenties, when people, whether or not they knew much about art, knew what they liked, now they were worried and buffeted by uncertain international forces. It was not a time to take risks.

—

"August 24, 1939, Geneva. The conflagration is not far from bursting upon us. We have been here for forty-eight hours to see the Prado exhibition. . . . Death hangs over our heads, and if it must take us, this last vision of Velázquez, Greco, Goya, Rogier van der Weyden, will have made a fine curtain." This was to be the next-to-last entry in René Gimpel's diary, a diary that covered twenty-one years. Back in Paris on September 3, he wrote just three more words: "We're at war."

Death *did* take Gimpel. He and his sons were active in the Resistance; he was interned by the Vichy authorities for his underground activities and later sent to a concentration camp in Germany, where he died in 1945, a terrible end after the sophisticated, well-connected and joyous life he had led.

Kahnweiler almost lost the will to live. In the early days of the war Picasso visited him in his office. Pierre Assouline records the incident: "He seemed calm and self-possessed, but after discussing stories . . . about people who had been arrested and interned in concentration camps, he said of the Nazis: 'If these people succeed, I know that in perhaps two hundred years they will rediscover everything that we have loved. But as for me, I should just drop dead. I would prefer to die." At least he had the energy and sense to move his stock. Some was sent to his brother-in-law Elie Lascaux in the countryside near Limoges. Other paintings were shipped on consignment to New York, though the cost of doing this had soared because insurance rates had risen to

6 percent of the value of the object being insured, as against 0.5 to 1 percent normally. In Paris the art market, familiar with collapse throughout the Thirties, now suffered again. Only Hans Arp found something to smile about. He had been in London for the opening of an exhibition of his works and was delighted to see how well the gallery had promoted the show: his name could be seen on buildings everywhere. After a while he understood: ARP meant Air Raid Precaution.

In London, a great many of Sotheby's and Christie's staff enlisted immediately, including Charles Des Graz, Vere Pilkington and Peter Wilson, who, according to Frank Herrmann, all went into postal censorship. The declaration of war, followed by the "phony war," when the anticipated air raids did not materialize, killed trade so thoroughly that before the end of 1939 the British Antique Dealers' Association launched an energetic advertising campaign to regenerate interest in collecting and mounted an exhibition. An upper limit of £350 was arbitrarily settled on, and 10 percent of the proceeds went to the Red Cross. Works by van de Velde, Mabuse, Sano di Pietro, Jongkind, Dufy, Constable, Stubbs, Vuillard, Picasso and Braque were on offer, but though, as Herrmann reports, "almost every painting, drawing and antique was a coconut [a winner]," the show was not a great success.

Apart from the much-reduced turnover, a significant change brought about by World War II was in the type of object sent to auction. The peacetime mix at Sotheby's had been:

Books	30 percent
Works of art	
(ivories, bronzes, silver, etc.)	48 percent
Pictures, coins, etc.	22 percent

In war, that changed to:

Books	15 percent
Works of art	72 percent
Pictures, coins, etc.	13 percent

In short, serious collecting ceased, and instead people traded objects they were not especially attached to in return for ready money.

As the phony war came to an end, the dark days began. And yet in 1940, "at what was possibly the most fearful moment in English history since Sotheby's began," as Frank Herrmann vividly puts it, the dispersal of the George Eumorfopoulos collection took place. Eumorfopoulos was a Liverpool-born banker of Greek parentage, and his passion was chiefly Oriental

works of art. This was a field that had really begun in the West in the early Twenties, when the Oriental Ceramics Society was formed by the "Twelve Dragons"—twelve major collectors and dealers—who formed their own club under Eumorfopoulos's presidency. Since then, the passion for Oriental art had grown, and by the outbreak of war the OCS numbered its membership in the hundreds. "Eumo" had sold his first collection in the mid-Thirties, partly to the Victoria and Albert Museum, and the rest to the British Museum. What was sold at Sotheby's in 1940 was therefore a second collection, amassed because, like all true collectors, Eumo couldn't bear to stop. Even so, Herrmann tells us, it was by far the best collection of its kind ever to appear at auction; many of the objects on offer had already appeared in reference works on the subject. They ranged from the Shang Dynasty in the second millennium B.C. to K'ang-hsi vases of the eighteenth century. It would have been understandable if no one at all had turned up for the first session of the sale, which took place on the very day that Belgium capitulated, but no, "the galleries were crowded," says Herrmann. Bids had been sent from all over the world, including France and Japan. The second day of the sale coincided with the start of the evacuation at Dunkirk; even so the crowds remained. In all, the Eumo collections raised almost £50,000 ($2.3 million now), a healthy sum, though a bargain for those brave enough to buy. Several of these items have reappeared at auction since then and sold for a thousand times the 1940 prices.

Thereafter, however, the market was flat in London. People anticipated vast destruction and mass evacuation and believed that commerce would be limited to a narrow range of necessities. Even when it was realized that the worst fears were unfounded, sales didn't pick up. Capital and credit were in short supply, and there was a general view that it was wrong to buy fine things amid such widespread destruction and sacrifice. According to Frank Davis, who was writing a series in the early 1940s on "The London Art Market in War-Time" in the *Burlington Magazine,* prices were down to a quarter of what they had been in 1937. Prices in the salesrooms stayed at these levels until the landings in Italy in the autumn of 1943.

In these circumstances, the notion of a merger between Sotheby's and Christie's was again considered. Once more King Street was to be the headquarters, and once again the plans foundered, in part, according to Herrmann, because the Young Turks at Sotheby's, and Peter Wilson in particular, opposed the idea. In a way it was a lucky escape; on the night of April 16, 1941, the King Street headquarters of Christie's took a direct hit from a German incendiary bomb.

If this was the low point, prospects did begin to improve a little in 1943. The reason for the small recovery was ironic. As the war went on, the

salesrooms in London began to see a new kind of collector with a perceptive eye for what was beautiful: refugees, particularly German and Austrian and particularly Jewish, who had been able to bring with them only their jewels, postage stamps or miniatures. Many spoke only broken English and, says Herrmann, needed the salesroom staff to vouch for them when they registered as "enemy aliens" at Scotland Yard. But they boosted trade.

In the meantime, there had been no dark days in New York; the season ending in 1941 was in fact the best since 1929. A Goya portrait was sold for nearly $35,000 ($394,000 now), and a Matisse fetched more than $10,000. Otto Bernet had retired from Parke-Bernet in 1943 because of ulcers. He was much missed, says Towner, not merely for his optimism and bad jokes, but because he had proved successful at attracting into Parke-Bernet those smaller collectors who in the early days had been crucial to the firm's survival. However, by 1943, when prospects were at last beginning to improve in London, the United States was itself fully at war all over the world. As a result, the two years up to 1945 were no better in New York than they were in London.

As he later put it, Kahnweiler was "in paradise in the shadow of the crematorium." Of Jewish origin, openly anti-Nazi and a promoter of "degenerate art," he lived deep in the French countryside near Léonard-de-Noblat. Every day, Pierre Assouline says, he walked four miles to the village and back for news and groceries. The political news was not good, nor was the news of the art trade. In the area of Paris where most of the good galleries were located, the policy of Aryanization was being actively prosecuted. The Paul Rosenberg gallery was now managed by Octave Duchez. The Bernheim-Jeune Gallery had been sold to "a notorious anti-Semite" who was the manager of the Office of Jewish Affairs. This business, valued at fifteen million francs, had been sold to him for two million. Wildenstein was in the hands of Roger Decquoy, a former employee and agent for many German collectors. (Georges Wildenstein was in exile in New York, part of the "Resistance on Fifth Avenue," helping to organize the French University in New York and resuming publication of the Gazette des Beaux-Arts.) Kahnweiler had taken the precaution of selling his gallery to his sister-in-law, Louise Leiris. She was not Jewish, and though she had some problems with the authorities, what remained of the Kahnweiler stock in Paris was not sequestered.

There were some people, however, who did very well during the war. According to Assouline, Martin Fabiani, who had left France for Portugal with his car loaded with pictures, returned with the paintings later and, by arrangement with a Jewish gallery-owner, took over the gallery and sold his stock there very successfully. He gave back the gallery at the end of hostili-

ties. Louis Carré, whose funds were trapped in the United States, made the same arrangement with André Weill. Carré held exhibitions and sold the work of Dufy, Matisse, Rouault, Vuillard, Maillol and others. He said later that 1942 was "a wonderful year for business."

The continued activity of the art market was, in part, a kind of whistling in the dark, a way of keeping spirits up. Exhibition themes generally tended to exalt France ("French Landscape from Corot to the Present," etc.), and the openings of such shows were well attended as a form of patriotism. Even the auctions at Drouot were stable. In November 1942, on the eve of the Allied landings in North Africa, a Picasso fetched 32,000 francs, and the top wartime price for a Cubist work in France was 100,000 francs ($945,000 now). Another reason for the prosperity in the art world was, as Pierre Assouline points out, the "Otto Office," the Gestapo economic office that monitored the black market. This was later revealed to be a cover for the Abwehr counterintelligence services (shades of seventeenth-century Rome again), but because the Abwehr had such massive liquid funds, a lot of money was spent in the art market. A number of German officers are known to have frequented galleries in plain clothes, and a large network of collaborationist middlemen sprang up, so that after the war many dealers could put their hands on their heart and swear that they never had sold directly to the Nazis. In the last days of the war, this tricky subject was the concern of the Allied officers from the Monuments, Fine Arts and Archives Commission, whose job it was not only to protect works of art that might suffer during the Allied offensive but also to trace art looted by the Nazis. This brought them into contact with collectors and dealers who had been mistreated by the Nazis in a variety of countries, and a singular story began to unfold.

Throughout their time in power, the Nazis took a particular interest in art. No doubt this had to do with Hitler's personal failures as an artist, with his desire to make Linz his cultural memorial, and with Herrmann Göring's pretensions as a collector. But advising these two were a number of people who, in one way and another, helped to distort the art market for nearly a decade.

Hitler's collecting had started, brutally and typically, in the spring of 1937 with the arrival in Italy of the German Government Commission for the Acquisition of Works of Art, led by Prince Philip of Hesse. Hesse, who was married to Mussolini's daughter, was sent to interpret the Führer's desire that some of the best Italian art be brought north. Hitler was fairly conventional in his tastes and would want familiar names. On that first trip, Hesse settled on sculptures by Myron and paintings by Rubens and Memling. It

was an ambitious shopping list, but to Hesse's delight the Mussolini government agreed to let him buy everything he wanted. The art world was not directly involved in these transactions, but the Hesse commission produced such glamorous results so quickly that the appetite of other senior Nazis was whetted.

Göring was the dominant force in all this. Unlike Hitler, he had time for almost daily contact with paintings. After the experience of Philip of Hesse with Mussolini in Italy, it was clear that simple confiscation was always a last resort in wartime, and there were to be times when it was the first resort as well. Of course confiscation applied most of all to Jewish collections inside Germany and Austria, and in Holland, Belgium and France after those countries fell. Under the Nazi racial laws such collections simply became "ownerless." However, Göring at times preferred at least the semblance of legality in his art dealing. This may have been a matter of conscience, or he may have realized that, had he not done so, the supply of treasures would have dwindled; even in war, business has its long-term rules. Therefore Göring soon surrounded himself with a number of advisers, members of the art trade who helped him to make his acquisitions. Among these were Walter Andreas Hofer, Karl Haberstock, and Kajetan Muhlmann.

The Reichsmarschall's first transaction of any consequence that involved the art trade concerned the Goudstikker collection in Holland. This acquisition took place in the summer of 1940 and was arranged by Alois Miedl, a Bavarian dealer who had known both Görings for several years. Goudstikker was Jewish, a successful art dealer himself, with a moated castle at Nyrenrode and a collection that included works by Gauguin, Cranach and Tintoretto. After Hitler invaded Holland, he decided to leave for England and transferred all his assets to a dummy firm, to be run by a Gentile friend. Sadly, however, the friend died, and Goudstikker himself, upon embarking for England, fell down an open hold, broke his neck and died. The Dutch banks foreclosed, and Goudstikker's widow, a former Austrian chanteuse already living in exile in New York, was forced to wind up the estate. This was done with a certain amount of license. According to David Irving in his biography of Göring, the collection, which included furniture and other objects as well as paintings, had originally been valued at 1.5 million guilders. By the time it was brought to Göring's attention, however, he was asked to put up 2 million "to make up the 3.5 million purchase price." Göring agreed, provided he could have the pick of the collection. Like a true middleman, Miedl cheated Mrs. Goudstikker and Göring equally.

In France the wartime art trade with the Nazis was much more extensive and better organized than what occurred in Holland. We know this thanks to two sets of documents. One was produced by the Art Looting Investiga-

tion Unit of the OSS, which set up an interrogation unit in Berchtesgaden at the end of the war, when three art historians, Lane Faison, Theodore Rousseau and James Plaut, were given exceptional powers to extract information about art looting from anyone they thought might have been involved. The reasoning behind this was that the Allies wanted evidence quickly for the Nuremberg trials, which were due to start fairly soon. There was also a fear, soon discounted, that looted art might be sold on the black market to raise funds so that leading Nazis could escape capture. The OSS unit produced three reports, one on Göring's "collecting," one on Hitler's plans for a Linz museum complex and a third on an organization (to be discussed below) in Paris called the Einsatzstab Reichsleiter Rosenberg, or ERR.

Another set of documents concerning art trade in France during the war was produced by two British officers attached to the Monuments, Fine Arts and Archives Commission. These officers were Douglas Cooper, the distinguished collector, historian of Cubism and friend of Picasso, Gris, Cocteau and Kahnweiler; and Cecil Gould, later to be deputy director of London's National Gallery. Their report, known as the Schenker Papers, was derived from a study of the documents found in the Paris office of the firm of Schenker Internationale Transporte. In essence these papers confirmed that the art that left France for Germany, whether from public galleries or private dealers, was funneled through ERR, and that many art dealers in Paris did business with the Germans.

Alfred Rosenberg was officially the philosopher of the Nazi party, but he had also been given the job by Hitler of "securing" the "ownerless" treasures abandoned by fleeing Jews—ownerless because they had been "forfeited" because their owners had not paid the refugee tax. The ERR was big (the personnel list produced by the MFA&A showed 366 names). It was headquartered in Berlin and divided into two branches for the Eastern and Western territories. There were sections to deal with the fine arts, music, science, antiquities and ethnology. In addition, Section Six ("Miscellaneous") contained the names of seven art dealers "known to have been dealing in works of art looted by ERR." These were Dr. Erhard Goepel, Hans Bammann of Düsseldorf, Walter Andreas Hofer of Berlin, Alois Miedl, Gustav Rochlitz of Baden-Baden, Dr. Hans Wendland of Geneva and Dr. Karl von Perfall of Neuss.

While it existed, the ERR in France confiscated 203 French private collections containing some 21,000 works of art. "This was a carefully conceived operation," said the OSS report, "aimed at the cultural debilitation of the strongest of the fallen nations, since France's purest heritage lay in the hands of her enlightened collectors." Though the ERR was supposed to be independent, and though over the years it forwarded many works of art to all parts

of Germany (not least to Linz for the Führer's planned museum and art gallery there), Göring soon interfered and changed the organization for his own purposes. He provided Rosenberg's staff with armed guards, Luftwaffe trucks, and specialist art historians like Bruno Lohse, who was released from air force duty. Hofer, Hans Posse and Karl Haberstock all made frequent visits to Paris. A certain Lucie Botton, formerly employed by Seligmann, led the agents to Jewish caches that often hid paintings and jewels as well as currency.

Göring himself paid his first visit to Paris in September 1940 "to get the feel of the art market." On November 5 he was back to tour the Louvre, taking a fancy to three hunting sculptures, including the *Diane de Fontainebleau* (he ordered Rudier's, the Rodin foundry, to cast copies in bronze for him). Later that same day, in the Jeu de Paume, he was shown 302 objects confiscated from the collection of Lazare Wildenstein. Göring chose four and ordered the remainder to be auctioned off. This process would be repeated in the years to come with many collections, including those of the Hamburger brothers, Sarah Rosenstein, Madame P. Heilbronn and Dr. Wassermann. To add to the spurious legality of it all, an obliging French professor and artist, Jacques Beltrand, was ordered to appraise the items. Not surprisingly, he set very low valuations. In one instance he valued two paintings by Matisse and portraits by Modigliani and Renoir at $500 each; in another case two Picassos were valued at $175 and a Watteau at about the same. Later in the war, barter exchanges were made using such valuations as the basis for the arithmetic underlying the deals.

The procedure quickly became established. Whenever Göring visited Paris during the Occupation, Baron Kurt von Behr, director of the ERR office in the French capital, would have about forty-eight hours' advance notice, just enough to set up an exhibition of the latest "acquisitions." Between November 1940 and January 1943 Göring visited the Jeu de Paume for the express purpose of choosing new loot some twenty-one times. As Irving put it, he was there a week before the bombing of Coventry, three days before Pearl Harbor and two weeks after the landings in Africa. His fabled train played a key role on these visits, for he liked to take back with him the treasures he had chosen. Occasionally he took objects on board for Hitler, but of the 21,903 recorded confiscations, approximately 700 paintings were earmarked for the marshal. At his trial in Nuremberg, Göring always maintained that he had made "determined efforts to pay" for the looted masterpieces he acquired. This was disingenuous, as another report by the Monuments, Fine Arts and Archives Commission makes clear. Entitled "Looted Works of Art in Switzerland: German Methods of Acquisition," this report reached three important conclusions. One was that Hofer always disputed Beltrand's already absurdly

low valuations, usually getting him to reduce them by as much as 50 percent; therefore the prices agreed upon were utterly false. Second, no hard cash was ever sent to the dealers or owners. Third, however, the MFA&A report concluded that between February 1941 and the end of 1943 the ERR did carry out twenty-eight formal exchanges of confiscated paintings with six individuals in Switzerland. In most cases Old Masters were exchanged for French Impressionist paintings, which the Nazis regarded as "degenerate." Eighteen of the twenty-eight exchanges, all of which took place with the knowledge and consent of Göring, were arranged with Gustav Rochlitz, a German dealer living in Paris. The other exchanges were carried out on behalf of Hitler, von Ribbentrop or Bormann.

In Switzerland, the exchanges were chiefly with two galleries, the Galerie Fischer of Lucerne, and with Dr. Hans Wendland of Geneva. They provided Old Masters, from stock, and received Impressionists or other confiscated works in return. The first transaction in February/March 1941 is as typical and as revealing as any. Hofer visited Fischer on Göring's behalf and selected four Cranachs and two other German pictures. These were collectively valued at 153,000 Swiss francs. At first Göring agreed to pay in cash, but then he decided it would be too difficult to obtain the necessary currency and proposed an exchange. In return for the four Cranachs and two other German pictures, Fischer received twenty-five paintings that had been confiscated from French and British collections (i.e., belonging to Britons living in France). The works included four Corots, a Courbet, a Daumier, five Degas, two van Goghs, a Manet, a Renoir and three Sisleys. These exchanges continued until November 1943 and involved the Florentine dealer Eugenio Ventura, Alexander von Frey of Lucerne, Max Stoecklin of Paris, the Galerie Neupert of Zurich and Albert Skira of Geneva. According to the MFA&A report, however, Hans Wendland and Fischer were the most important characters. Wendland headed a syndicate of German dealers in Paris who used a Madame Bondy as forwarding agent. Wendland was close to Fischer, and it was even suggested that Galerie Fischer was a sort of holding bank for Germans during the war.

The exact collaboration of the French art trade has never been assessed. In the Schenker Papers, Cooper and Gould provide an index of Parisian art dealers who sold works of art to German museums and private German individuals. The list runs to nearly 150 names and includes Durand-Ruel, Fabre, Lebrun, Rostand, Voltaire, Fabiani, Heim, and Knoedler. Some of them may have been forced sales (those from Paul Rosenberg's gallery certainly were), and dealers had to live. But there was clearly quite a lot of collaboration.

—

After Pearl Harbor, the art market in Shanghai collapsed and dealers sold off what they could. Very soon, however, the reverse happened, when people saw that it would take time for America to respond to the attack. Prices then rose rapidly as dealers tried to buy back, at higher prices, what they had sold.

The Shanghai art market was centered on the Canton Road and was known as the Jade Market, though there was never much jade sold there. It operated on principles (and practices) rather different from those of European markets. Judith and Arthur Hart Burling, who were living in the Swiss consulate in Shanghai during the war, report that they once saw a sign on a Shanghai dealer's door that read, "Closed for reason of a family quarrel." When a dealer died, all the other members of the trade would buy at least one piece at the estate auction, to provide funds for his widow.

The three main effects of the war on the Shanghai market stemmed from the fact that all excavations stopped, so there were no new objects and quality therefore fell; from the arrival of the Japanese; and from the departure of so many British and American residents, a development that released a few objects of very high quality onto the market and thereby helped the general rise in prices as the war went on.

The arrival of the Japanese had a more complicated effect. They were especially interested in Sung porcelains, whereas the Chinese themselves preferred the later Ming, K'ang-hsi and Ch'ien Lung. This difference in taste produced a number of collaborationist dealers in China (much as happened in Holland and France), who themselves made a great deal of money during the war speculating on Sung. The noncollaborationist Chinese dealers felt no qualms about cheating either the Japanese or the collaborationists, and as time went by, fakes proliferated. This showed up at the lower end of the trade, where chaos reigned and not even the dealers could distinguish the genuine from the false. The Burlings report an incident in which Sir Percival David, the great collector of Oriental art, was shown a succession of objects by a Shanghai dealer, but each time he offered to buy something, he was told it wasn't for sale. Because David wanted it, the dealer knew the object had to be genuine—the dealer was using him as a quality control.

The other boom area in Shanghai in wartime was in old Chinese pictures. This came about because there was at that stage no museum in the city, and only people from old, distinguished families, who had pictures of their own, ever saw this form of art. With the disruption caused by the war, which brought the belongings of old families to the market, there was a rush for these paintings, and their prices rose by as much as 800 percent above prewar levels. One famous picture by a Ming artist *had* been offered on the market

before Pearl Harbor, for $30,000. (Prices for important pictures were actually quoted in *lahks,* one *lakh* being about $100,000.) After Pearl Harbor this painting was priced at three *lakhs.* As elsewhere, war played havoc with the Shanghai art market. Some people made money but in general the process was demeaning.

Shameful as all this was, the war had some positive effects on the auction market. In 1945, Geoffrey Hobson of Sotheby's wrote a summary of the situation at the end of hostilities. It makes instructive reading for, in Frank Herrmann's words, the firm's finances were "extraordinarily healthy." The book department had suffered, partly because its staff had been called up, but also because the book trade was more international than other branches of the trade. That apart, Hobson wrote: "It has been possible to get on without giving more than a fraction of the usual credit; books debts are lower than ever before; we have not had an overdraft since January 29, 1942, and credit balance has sometimes been over £100,000 for some weeks at a time; on February 16 it was £53,311 after paying Income Tax due January 1945, and providing £15,000 advance payment for Income Tax due January 1946. . . . in every way the firm is in a far stronger position financially than in 1939."

If Sotheby's benefited during the war from refugee collectors, the United States, and New York in particular, benefited from refugee artists. Those in Manhattan naturally congregated around native painters and sculptors, and the result was a new school of art and a new generation of dealers. Under cover of war, as it were, the center of gravity of the art world had migrated. This migration was epitomized by one woman whose fortune, character, collection and galleries linked the avant-garde of Europe with that of the United States. She was Peggy Guggenheim (see figures 63 and 64). Peggy Guggenheim was born in 1898 in New York. Her father was one of five Guggenheim brothers, each of whom, according to Jacqueline Weld, left an estate of between six and sixteen million prewar dollars, thanks to the family's mining interests. Her mother was Florence Seligmann, from a family that was more established in New York Jewish society but less spectacularly wealthy. Weld again: "Most of the Seligmann brothers . . . left between two and five million dollars apiece. This isn't hay, but it isn't John Hay Whitney either."

Despite her wealth, Peggy's childhood was unhappy, which helps explain why, in 1920, at the age of twenty-two, she bolted for Paris. There she met Laurence Vail, a charming, handsome, blond-haired boulevardier and would-be writer. Through Vail, whom Peggy married in March 1922 after he had proposed at the top of the Eiffel Tower, she met all the well-known

American exiles in Paris: Hemingway, Dos Passos, Malcolm Cowley, E. E. Cummings, Virgil Thomson, Man Ray, Ezra Pound, Ford Madox Ford and Gertrude Stein. She also met the other writers and artists who jammed the pavement cafés and nightclubs, among them Joyce, Stravinsky, Matisse, Picasso, Marcel Duchamp and Cocteau.

To begin with, Peggy Guggenheim's contribution to Parisian life appears to have been her sexuality. Throughout the Twenties and Thirties she had affairs with a variety of more-or-less famous men—Yves Tanguy (whose wife threw fish at her in a restaurant) and Samuel Beckett in particular. But in 1938 she opened an art gallery in London. Various influences were responsible for this, not least the announcement in New York in 1937 by Solomon Guggenheim that he was creating a Museum of Non-Objective Art. A more long-term influence, however, was Marcel Duchamp, the lover of a friend of hers. Among international cities, London was very much the laggard in avant-garde art, and Peggy, encouraged also by Herbert Read, thought she stood a better chance with a gallery in London than in Paris. Nor should it be overlooked that by 1938 the situation on the Continent was growing increasingly ugly.

Peggy had little formal knowledge of modern art, and this was where Duchamp helped, conceiving ideas for shows and directing her to important artists. The gallery she bought at 30 Cork Street was the third gallery of modern art to open there. Cork Street had once been a place of moneylenders and tailors, but the three galleries that existed in 1938 (the others were the Mayor and the London) would eventually change its character. The Mayor Gallery had started life as a cigar shop run by Freddie Mayor. Douglas Cooper interested him in art, and they had shown Miró in 1933 and Klee a year later. The London had been started by Lady Norton, the wife of a diplomat, Sir Clifford Norton, and had shown Munch before the Nortons were posted abroad. Roland Penrose had reopened it in 1937 as a gallery specializing in Surrealism. *The Times* called the Cork Street galleries "three little bethels devoted to 'fancy religions' in art." These three, plus the New Burlington Galleries, which had held an "International Surrealist Exhibition" in 1936, constituted London's modern-art market.

If any of them took the lead, it was the London Gallery, which issued a magazine, the *London Bulletin,* in addition to mounting shows. All the other galleries advertised in the *Bulletin.* Peggy's gallery—called Guggenheim-Jeune, a play on Bernheim-Jeune in Paris—opened with a show of Cocteau's drawings and scenery. In the first year it also held exhibitions of Kandinsky, modern sculpture and Geer van Velde, a painter who was a friend of Beckett's. After her openings, Weld tells us, Peggy would take everyone to dinner at the Café Royal. Guggenheim-Jeune did not thrive commercially (it lost

£600 in the first year) but it was a success socially. Everyone in London came to see the latest pictures, even though hardly anyone bought. At this point artists such as Mondrian, Gabo and Kokoschka had links with England, and the wholesale emigration to the United States had not yet begun. The losses of the gallery were not serious for someone with Peggy's fortune, but that wasn't the point. She said that if she was going to lose money she would rather do so on a grander scale, and for something that was "really worthwhile," a comment that rather denigrated the social and intellectual role of the gallery. By spring 1939, her heart was set on starting her own museum. Accordingly, says Weld, she decided to close Guggenheim-Jeune in London at the end of the season in June. In such ways is history made. Still acting under Duchamp's advice, Peggy began buying contemporary art for herself as the final days of the gallery ran out, all of it intended for her museum. This took her, of course, to Paris, where she snapped up "a picture a day." And so she was in France when war broke out.

Only gradually did Peggy understand that she would have to return to the United States. The retreat took place in 1941, by which time she was accompanied by another celebrity, the painter and Surrealist Max Ernst. In New York they joined a community that already consisted of Breton, Dalí, André Masson, Kurt Seligmann, Amédée Ozenfant, Léger, Mondrian, Josef Albers, Jacques Lipchitz, Chagall and Pavel Tchelitchew. In turn, the Surrealists and other exiled painters were mixing with such American counterparts as Theodoros Stamos, Rothko, Clyfford Still and Baziotes. The Chilean Surrealist Matta played an important part in this mixture. He organized evenings of "surrealist experimentations—games and automatic drawings"—which were attended by Jackson Pollock and Robert Motherwell. Matta introduced the American painters to the ideas of Rimbaud, Apollinaire, Breton and Dalí. It cannot be said that Abstract Expressionism would not have occurred without the presence in New York of the European Surrealists—after all, many of the American painters had been working at their ideas for ten years and more—but it probably was true, as Sidney Janis said, that without the Surrealists, Abstract Expressionism would have been very different.

In this climate, Peggy realized that her "art center" could act as a catalyst. So it proved, but in the process it became a gallery. Designed by Frederick Kiesler, Art of This Century, as the gallery was known, opened on October 20, 1942. The loft space Peggy had found on Fifty-seventh Street was transformed, Weld says, into "a recreation park of modern art, full of gadgets, inventions, protrusions, serpentine walls, roaring sounds, and even light shows." There were four areas: the Abstract/Cubist Gallery, the Surrealist Gallery (with pictures on cantilevered arms and "amoeboid chairs"), a pas-

sageway with Klees on a conveyor belt, and the Daylight Room, where new artists were to be shown. This presentation was commercially successful and so many people came to gawk that Peggy decided to charge admission. The enduring achievement of the gallery, however, lay not in the use of serpentine walls or amoeboid chairs, still less in the admission charge, but in the roster of artists shown there. Several young artist friends of Matta were given a chance, including Ad Reinhardt, William Baziotes, Robert Motherwell and someone listed in an early catalogue as Jackson Polloch. Their work appeared beside that of Ernst, Grosz, Picabia and Gris.

Apart from Knoedler, Wildenstein and Duveen, who dealt in Old Masters and Impressionists, the New York art market at this time was barely bigger than London's. "There were maybe a dozen galleries in all of New York," Sidney Janis told Calvin Tomkins, and most of them focused primarily on European art, including Pierre Matisse, Valentine Dudensing, Paul Rosenberg (in exile from Paris), Curt Valentin at the Buchholz Gallery, Karl Nierendorf (from Cologne) and J. B. Neumann of the New Art Circle. Julian Levy established himself by showing Ernst, Dalí and Tanguy.

But it was Peggy Guggenheim who had the idea for a spring salon with a jury (Mondrian, Alfred Barr and others), and it was she who gave Pollock his first one-man show. These were fifteen paintings in all, and their violence and energy caused a sensation and put Pollock and Peggy on the cultural map. "The public wrote obscenities in her guest book," says Weld, "but Peggy realized she had stumbled onto something great." She was never to sell a Pollock for more than $1,000, but they did sell. "People always bought a little bit."

In 1944, partially because of the success of Pollock, Peggy began to show more American artists, as well as Europeans. She was not keen on Rothko but was persuaded to give him a one-man show in January 1945. Motherwell sometimes gave lectures at the gallery (on, for example, the links between Freudianism and art), but her refusal to give him or Baziotes a contract like the one she had with Pollock (she paid him $150 a month, which would be $2,232 now) led to their defection to Sam Kootz. Between 1945 and 1947, when Art of This Century closed, the new names kept coming: Clyfford Still, Robert de Niro (father of the actor), Louise Nevelson, Joseph Cornell, Adolph Gottlieb, Alexander Calder, and Willem de Kooning all had one-man shows at the gallery. "It was like a sudden burst of flame," said Peggy, speaking of the genesis of Abstract Expressionism. The critic Clement Greenberg acknowledged her role. "What happened . . . ," he wrote in *Art and Culture* "was that a certain cluster of challenges was encountered, separately yet almost simultaneously, by six or seven painters who had their first one-

man shows at Peggy Guggenheim's Art of This Century gallery in New York between 1943 and 1946."

That all this should have happened in wartime was surprising but understandable: otherwise the mix of European and American artists would not have occurred. It was also understandable that when hostilities ended, the Surrealists and others in exile should return to Europe. Julian Levy closed his gallery and André Breton went back to Paris. With war and the restrictions it imposed now over, the sense of community in New York, that atmosphere of "critical mass," was dissipated. For Peggy as well, the allure of Europe beckoned, and among the attractions was Venice. Once more she decided to move on, and several of her artists transferred to Sam Kootz or Betty Parsons.

Art of This Century closed on May 31, 1947. "Peggy did not shed a tear," Weld says. "She was too fatigued." She dismantled Kiesler's designs and sold off the walls, the wheels and the amoeboid chairs. Among the buyers was Sidney Janis, a neighbor three doors down Fifty-seventh Street. His chair cost him three dollars.

One man who was sad to see Peggy go was a European making a journey very like Peggy's, but in the opposite direction. Born in Trieste, he knew Venice and its surrounding lagoon well, but he thought the future was in the United States. Moreover, just when Peggy was giving up the art trade, he was becoming more and more involved with it. He didn't have his own gallery yet, and he was as calm and as cautious as Peggy was impulsive and headstrong. His name was Leo Castelli.

—

Immediately after the war the press in France announced that the Existential-
ists were about to open their own university in Paris, and that large sums had
already been raised for this purpose. Jean-Paul Sartre was to be the dean, and
among the professors were Maurice Merleau-Ponty, Raymond Aron, Si-
mone de Beauvoir and D. H. Kahnweiler. Kahnweiler and the art world he
represented were now accepted, part of the intellectual tradition of the West.
And yet commercially the new painting—now not so new—was less success-
ful than could have been hoped. In fact, with a few exceptions, the world art
market remained in the doldrums well into the Fifties.

Still, it was true that the London auction houses had done better during
the war than they could have anticipated in the dark days of 1940 and 1941.
In 1946, for example, Sotheby's grossed £1,556,700 ($54 million now), but it
never reached this figure again until 1955. (In comparison, Parke-Bernet's
turnover in the 1946–47 season was $6,019,153, which would be $87 million
now.) Books were hardest hit, but in London all areas were affected. Frank
Herrmann concludes that in Sotheby's picture department, for instance, the
average price of paintings was £41 in July 1946. Paper was rationed, so
catalogues looked awful. Currency restrictions were not lifted in Britain until
1954, which meant that the London auction houses, Sotheby's in particular,
looked to the United States for growth and activity. The man who spear-
headed this development and was the first to see the real possibilities in the

New World, was Peter Wilson (see figure 70). He had worked in the United States during the war and had been impressed.

Peter Cecil Wilson was nothing if not well connected. Born in 1913, he was the third son of Sir Matthew Wilson, a soldier turned Conservative MP and the fourth baronet Wilson in a line that was 150 years old. His mother's family was from even more distinguished stock. The Honorable Barbara Lister was a daughter of the last Lord Ribblesdale, master of the buckhounds, a senior official in Queen Victoria's household and a trustee of the National Gallery. This was the man who had been painted by Sargent as a handsome, arrogant, ferocious figure in hunting boots caressing a whip. (When this painting was shown at the Paris Salon of 1904 the crowd had been fascinated by "ce grand diable de Milord anglais.") PCW's grandmother on his mother's side was the eldest of the famous Tennant sisters, the most notorious of whom, Margot, had been the wife of Prime Minister H. H. Asquith. Thus he had familial links to both Buckingham Palace and Downing Street.*

In her memoirs, published in 1937, Barbara Wilson's first mention of her son Peter describes him in a blue linen tunic "like a speedwell or a periwinkle flower." Hardly a robust image but not inappropriate, since according to Frank Herrmann, PCW liked flowers even more than art. At Eton he made no impression except for "assembling the finest collection of wild flowers gathered from the neighbourhood." He had two brothers, Martin (the present baronet) and Anthony, but he was closest to his mother; both were "heartlessly witty," according to one of the other brothers. There was never any real warmth in the Wilson home, but instead an atmosphere in which, as one of Peter's brothers put it, "I care more about things than people." This applied equally to Peter Wilson, and it showed at Oxford, where he read history. According to Herrmann, he was remembered at New College "as shy, awkward, unformed." In fact, he left the university after only a year, having failed his preliminary exams, and went to Paris to learn French (his mother hoped he would become a diplomat). Then, to everyone's surprise, he got married. He had moved from Paris to Hamburg, where he was learning German in the house of a professor. A fellow boarder was Helen Ranken, a feminist five years older than he, and a teacher who was able to bring him out of himself. She changed him, helping him to acquire a confidence in himself that hadn't been there before.

Not that Wilson moved quickly. In the mid-Thirties the depression was

*It was Margot Asquith who had the celebrated encounter with Jean Harlow. At a dinner they both attended, Harlow kept referring to Margot as Margot*t*. "No, no," Mrs. Asquith finally replied sweetly, "the *t* is silent, as in Harlow."

still in force and jobs were not easy to come by. He started at Spink, then a small auction house specializing in coins, but Nicholas Faith says he found it "cold, snobby and beastly in atmosphere." He moved on to Reuters but was fired because he wouldn't learn shorthand. Next was *The Connoisseur,* then a small academic magazine owned by Hearst but edited in London. Wilson was in the advertising department there, but his preferences for the arts in one form or another were becoming clear. Thus the Sotheby's job was a natural next move, though it came by accident, when he and his wife met Vere Pilkington at a weekend house party. Wilson had to start at the bottom as a porter, handling and numbering a wide variety of objects. Nonetheless he loved it from the start. "I couldn't wait to get back to it on Monday mornings," he once said, and "I had nightmares of getting the sack." He didn't get the sack, but like many others he had to leave and fight in the war. He spent the war years in intelligence, which added to his mystique later on, when it was rumored that he had been part of the Cambridge spy ring of Blunt, Philby, Burgess and Maclean. When he returned to Sotheby's in 1946 his first job was to look after new appointments and salaries. This was more important and less dry than it sounds because new blood was essential for the expansion expected now that peace had returned.

In 1948, Wilson took over the picture department, which already had seen changes. Borenius had suffered a nervous breakdown, and withdrawn from Sotheby's. He was replaced by two people, one of whom was Hans Gronau, an art historian and son of another, Georg Gronau, who, back in Germany in the Twenties, had crossed swords with von Bode. Gronau, Herrmann says, had been suggested by Kenneth Clark, then director of the National Gallery. The second person was Gronau's wife, Carmen, also an art historian. There was much to be done, for pictures was an area where Christie's still had the lion's share. But the real fight was to improve the market all around. In his history of Sotheby's, Frank Herrmann writes: "The startling fact which emerges from a close study of Bond Street fine art sales held between 1945 and 1949 is that in absolute terms the prices were no higher—and, indeed, often lower—than those that had prevailed in the twenties." For example, *From The Nore* by Turner was sold for £1,785 in 1945; yet a very similar picture from the same series had fetched £4,305 in 1893. Hence trade in the United States was very important.

Wilson's initial spur was to see whether he could get the Brummer Gallery collection for Sotheby's. At the beginning of 1947, Joseph Brummer, head of the firm, which was one of New York's foremost dealers, had died intestate. Brummer dealt in medieval works of art, antiquities and modern paintings and sculpture, and the stock was said to run to 200,000 items. Peter Wilson even contemplated holding the sale in New York. (He didn't land the busi-

ness on this occasion, though some of it was sold by Sotheby's years later.) However, while pursuing the Brummers, Wilson made his first tentative approach to acquire Parke-Bernet. The signs were good, for Parke, now more than seventy, wanted to get his money out in order to help look after his much younger wife, and he made it clear that he thought Sotheby's was a suitable purchaser. But when Wilson arrived back in London, armed with Parke's formula for evaluating the firm (assets plus three times the current year's earnings of $125,000, or $750,000 in all), he found that Sotheby's had received yet another approach about a merger with Christie's. A day was set aside to discuss both matters. However, although Charles Des Graz supported Wilson's ambitions in regard to Parke-Bernet, feeling that it would be insurance against the uncertainty of Britain's impoverished condition after the war, in the end neither scheme went ahead. The Christie's scheme was a familiar chestnut, and the Parke-Bernet idea was ahead of its time.

Parke-Bernet had changed since the war, but not in a way that anyone had anticipated. Otto Bernet had died in October 1945, and after his death the kinds of sales he had enjoyed most—"barnyard rallies," as Wesley Towner called them—became far fewer and less colorful. As a result, writes Towner, "Parke-Bernet lost the common touch. . . . There were no more polished red apples brought to lovely secretaries. . . . Suddenly the atmosphere at Parke-Bernet took on a kind of chilled impeccability."

Parke was still not much interested in books, but it was a book that brought the firm the sort of publicity it had not had since before the war. This was the 1947 auction of the Bay Psalm Book, *The Whole Booke of Psalmes Faithfully Translated into English Metre.* This volume is hardly beautiful, but it is important because it was the first book printed in the Colonies. Seventeen hundred copies were printed in 1640, but by 1947 only eleven were left. None had been on the market since 1879, when the very same book, now being sold by Cornelius Vanderbilt's heirs, was acquired by the admiral himself. Not since that night in February 1926 when the Gutenberg Bible had been bought by Dr. Rosenbach for $106,000 had there been such a glamorous event in book circles. "Rosy" himself was to be a bidder, although he already owned one of the eleven copies. Another bidder was Cornelius Vanderbilt Whitney, a trustee of the educational charity of which the book was an asset, who was seeking to buy what in effect had been his mother's book.

The auction world needed a high price. As mentioned earlier, the book trade had been disrupted during the war more than any other area of the art market, and pictures were still at 1920s levels or worse. Bidding on the Bay Psalm Book started at $30,000 and the contest turned into a classic tortoise-hare tussle. Several times Whitney tried to rout the opposition by calling out increases of five times the usual amount. Always the man bidding for Rosen-

bach came back quietly to up the bidding by $1,000. In this manner the record level, $106,000, was eventually reached. For a time, Whitney seemed subdued, at least until the bidding stood at $145,000, when he suddenly called out $150,000. Quietly, Rosenbach's man bid again. When the auctioneer asked if anyone would bid $152,000, there was a silence. "To Rosenbach."

The victor again, Rosenbach said only that he thought the record price "very reasonable." What "unreasonable" would have been was anyone's guess, but Wesley Towner reports that the best comment of the night came from one of the art-world groupies present. "Imagine," she trilled. "The price of thirty Cadillacs!"

Parke retired at the end of the 1948–49 season. Just as Peter Wilson and his cohorts were the coming team at Sotheby's, so a new generation were taking over at Parke-Bernet. Leslie Hyam, Lou Marion and Mary Vandergrift were the new blood in New York. They had all been working for Parke-Bernet for some time, but it was only now that they were given their heads. Marion and Hyam showed their mettle during the Brummer sale. Not only did they keep it away from Sotheby's, but the cataloguing was superb and the sale grossed $739,510. As Wilson had instinctively understood, the New York market was coming back to life before the European ones. When Marion, Hyam and Vandergrift took over from Parke, they inherited not only the firm but a brand-new building, a sort of mock Egyptian temple at 980 Madison Avenue, opposite the Carlyle Hotel. A champagne reception launched the new gallery on November 10, 1950. Though it was attended by two thousand art-world notables, there was a distinct worry, soon proved groundless, that the new building was too far uptown.

Meanwhile Sotheby's was still interested in the U.S. market, but if it was going to succeed, it needed to move to New York. The man sent to accomplish this was John ("Jake") Carter, half of the pair who had exposed Thomas Wise in the Thirties. Carter knew the United States well; he had worked for Scribner's, been personal assistant to Sir Roger Makins, the British ambassador in Washington, and had an American wife, the journalist Ernestine Carter. Carter became Sotheby's "associate" in America, with a permanent office and secretary in Manhattan, but made two six-week sweeps across the country every year to look for business. Christie's had a similar idea, and Sir Alec Martin, its chairman, announced to the trade press that he would be in the United States and Canada for a month every year.

But Carter worked full-time. At the start, his main weapon was the much better commission rates that applied to auctions in London as compared with Paris or New York. Frank Herrmann says that Carter frequently used the sale of a Cézanne or Chardin as an example. A painting by either of them would fetch the same amount—say $100,000—in all three cities "because the

same half a dozen people . . . will be the high bidders." But, he then asked the potential customers, "what does the owner pocket *when the dust dies down?*" The arithmetic strongly favored London, where the owner would receive $90,000. In New York he would pocket between $75,000 and $80,000, depending on the deal Parke-Bernet struck, and in Paris, after commission and taxes the owner would receive just $65,000. But Carter also delivered a series of lectures across the United States, organized by the English-Speaking Union; this certainly made Sotheby's better known, and by the 1956–57 season, Hermann calculates, American consignments were responsible for more than 20 percent of Sotheby's gross.

Carter received frequent reinforcement from Peter Wilson in the early years, and it was on one of Wilson's trips in 1957 that the two men traveled to Scarsdale to inspect the collection of Impressionist paintings that belonged to William Weinberg. The sale of this collection not only delivered the first serious blow to Parke-Bernet but ushered in the last phase of the modern auction world as we now know it. The Weinberg auction would make salesroom history (see Chapter 26), but by then New York was no longer simply a battleground for Sotheby's and Parke-Bernet. The art world that Peggy Guggenheim had helped to spawn in Art of This Century had gone on expanding and diversifying to such an extent that New York had replaced Paris as the home of avant-garde art. In this milieu a new art trade grew up.

Apart from Peggy Guggenheim's gallery, modern art had been kept alive and available for the few people who collected it in the United States in the Twenties and Thirties by a small number of dealers: the Valentine Dudensing Gallery, for example, which had given Matisse a retrospective show in 1927; J. B. Neumann; the Brummer Gallery, which held a celebrated Brancusi show; the Pierre Matisse Gallery, as well as the Ferrargil Galleries. Julian Levy's gallery had been showing Surrealists since 1932 and gave Arshile Gorky his first exhibition in 1945. Leo Castelli would become the most famous art dealer of the postwar world, the apparent heir to Durand-Ruel, Vollard, Fénéon and Kahnweiler, but in fact he was late in opening his own gallery, in 1957. By then a triumvirate of other dealers had made their mark, reflecting well before Castelli the new ascendency of Manhattan. It was with the opening of Charles Egan's and Sam Kootz's galleries in 1945, and Betty Parsons's in 1946, that the contemporary art market may be said to have started.

Egan, who had worked before the war at Wanamaker's and at Ferrargil, was, says Calvin Tomkins, an amusing companion to the artists who at that time used the Waldorf as their watering hole. He dressed in a bohemian way

and was wayward in his habits; he kept unusual, even unsociable hours, and many who visited his gallery found it closed when it was supposed to be open. Artists also respected Sam Kootz, a tall, genial southerner who in 1943 had published *New Frontiers in American Painting* (like Sidney Janis, he had started as a writer/journalist). Kootz had also been responsible for a massive exhibition of contemporary work at Macy's, and when he opened his gallery, he took over Baziotes and Motherwell from Peggy Guggenheim. This was shrewd, for, as Tomkins points out, Kootz knew that Alfred Barr of MoMA liked both of these artists, as well as Adolf Gottlieb, whom he already represented. (In an interview with the Archives of American Art, Kootz pointed out that he kept his back room stocked with Picassos for the sake of turnover, which was also very canny.) There were few sales of New York School works at this time, and the prices were hardly sensational. *Black and White Show* by de Kooning, the only picture he sold in 1949, went for $700.

The third dealer respected by the artists was Betty Parsons (see figures 65 and 66). "Saul Steinberg," wrote Tomkins in *Off the Wall*, "once drew a portrait of Betty Parsons as a dog. The likeness is uncanny and not at all unflattering—the spaniel ear transformed into her straight, smooth hair, the high forehead instantly recognizable. 'It is the philosophical forehead of Leonardo,' according to Steinberg, 'and of babies, and of spaniels. Like all the best art dealers, Betty has a fictitious quality, even physically. She looks like a photograph from a different period—you know who it is but you're not quite sure. If you look closely at Betty you see the Sphynx, the Garbo-like quality. And strictly *entre nous,* the Sphynx *is* doggy."

Betty Parsons was well connected and on friendly terms with many patrons of MoMA; coming from a rich family herself, she was familiar with the way the "collecting classes" thought. As a young woman she had rebelled against her background and gone to Paris to divorce her drunkard husband and to learn about art. She loved the intellectual, artistic and sexual freedom of the city, met Brancusi and Giacometti, who was in the same art class as she, and studied with Antoine Bourdelle and Ossip Zadkine. Alexander Calder made a wiry brass fish to hold the lavatory paper in her apartment. She wrote poetry:

> A thousand orchids shining in the rain
> how beautiful will be this harvest.

She also fell in love, with a woman—Paris allowed that—and found the true emotional direction of her life.

In 1933, however, she was forced to return to the United States, the depression having seriously depleted her funds. Back home she went to

Hollywood, where she gave art lessons, worked in a liquor store and played tennis with Greta Garbo, "for whom she was sometimes mistaken." She tried to earn her living as a portrait painter and came into contact with many of the stars and fashionable hangers-on in the golden period—Tallulah Bankhead, Dick Cromwell (who proposed marriage), Robert Benchley and Dorothy Parker. From time to time she studied under Aleksandr Archipenko.

In 1935 she moved back to New York, where Benchley introduced her to Alan Gruskin, owner of the Midtown Galleries. He agreed to show her paintings and shortly afterward asked her also to work in the gallery, installing exhibitions and selling pictures on commission. The work was not arduous, and she found she liked it. However, she never earned much money, even though her own first two shows were near sellouts. Matters improved a little when she met and was hired by Mrs. Cornelius J. Sullivan, who had a gallery at 460 Park Avenue. Mrs. Sullivan, one of the founders of the Museum of Modern Art in 1929, was a much tougher figure than Gruskin and forced Betty to work long hours with hardly a lunch break. According to Betty's biographer, Lee Hall, she liked that, too.

In 1939 a quite different woman entered her life: Rosalind Constable, an Englishwoman who worked for Henry Luce at Time-Life as a sort of "culture scout." It was Rosalind who introduced Betty to the Wakefield Bookshop at 64 East Fifty-fifth Street. The plan here was to have a gallery within the bookshop, and Betty was asked to run it. For the first time she was given independence as a dealer, and it was then that she began to develop her own stable—Joseph Cornell, Theodoros Stamos, Saul Steinberg and Hedda Sterne.

Yet another new love, Strelsa von Scriver, came into her life. Then, according to Lee Hall, the imminent closure of the Wakefield Bookshop at the end of 1944 proved a decisive influence. At just this time, Mortimer Brandt, a well-known Old Master dealer, decided to expand and made Betty the director of his contemporary section: she had arrived on East Fifty-seventh Street. Just over a year later Brandt moved back to Britain. He had occupied the entire fifth floor at 15 East Fifty-seventh Street and Betty was given an option on the space. She rented half of it to Sam Kootz, borrowed a thousand dollars from four friends, including Saul Steinberg, and opened the other half herself in September 1946.

Parsons was one of those who pioneered what became known as the loft look—white walls, bare wooden floors, no decoration or ornamentation. "A gallery isn't a place to rest," she told Lee Hall. "You don't come to my gallery to be comfortable." Like Peggy Guggenheim, she had a male mentor, Barnett Newman, then a writer and not yet an artist. He helped organize her opening show, "Northwest Coast Indian Painting," and shows by Still, Hofmann,

Reinhardt, Stamos, and eventually himself followed. In 1947, the year Betty really "arrived," her exhibitions were: February, Stamos; March, Rothko; April, Still. Later that year she showed Reinhardt, and in January 1948, Pollock. There were problems, of course—holes were punched in the canvases and obscenities scrawled on them by an unsympathetic public, who certainly did not feel comfortable in her gallery—but gradually, progress was made. Even Elsa Maxwell paid her a visit and wrote her up in her syndicated column: Betty was in danger of becoming fashionable. More important, Betty's artists were picked up by Dorothy Miller and Alfred H. Barr at MoMA for a series of shows.

It was Parsons's sense of fair play and justice that won her the respect of her artists, especially after they and their way of life had begun to receive media attention. She agreed with Still and Rothko in particular when they said they wanted to control not only their careers, but those of their paintings, rather than merely bending to the whim of museums and collectors. At first this was not easy to do, and the gallery was not a commercial success. Calvin Tomkins reports that Pollock never sold a painting for more than $5,340 in his lifetime, and that even though he moved from Parsons to Sidney Janis in 1952, "he never sold enough to alter his status as a poor man." Rothko's top price in his first show at Parsons was $150, and very few were sold. She herself said, "Most of the artists don't think I'm tough enough, that I don't go out and solicit, call people up all the time. I don't. I know how people hate that sort of thing because I hate it myself, so I don't do it."

One evening in the early Fifties Parsons had a visit from four artists, much like the visit Vollard had received from four of his painters in Paris, when they had dressed as workmen and come "for their pay." Rothko, Still, Pollock and Newman "sat on the sofa in front of me, like the Four Horsemen of the Apocalypse, and suggested that I drop everyone else in the gallery, and they would make me the most famous dealer in the world. They were right, too, probably, but I just didn't want that. I told them with my nature I liked a bigger garden, and they understood." No doubt this was true, but as Calvin Tomkins has pointed out, "all four left her eventually, and their financial success (posthumous in Pollock's case) followed their leaving."

As has been noted by Lee Hall, "The early dealers in advanced American art include[d] Betty Parsons, Bertha Schaeffer, Marion Willard, Martha Jackson and Eleanor Poindexter. . . . Suggestion for pondering: after artists prospered under the nurturing of women dealers, did they move on to male dealers who, in the general understanding of roles in society, offered a more businesslike and success-oriented management? To a degree, the history of the Betty Parsons Gallery suggests this possibility."

Betty did not feel she was faltering, but, after the defection of "the giants,"

as she called them, the artists she took up—Kenzo Okada, Calvert Cogge-shall, Lyman Kipp, William Congdon—were not of comparable stature. Worse, she started discovering artists "at an alarming rate," and before long Ad Reinhardt was mocking her:

> ParsonsgiftShoppe
> antiquesjewelry
> workesofarte
> forthe
> upperlowbrow

Temporarily, she had lost her way.

—

One artist who did not have a dealer at this point was de Kooning. For reasons best known to himself he refused to have a one-man show anywhere. However, he could not help becoming part of the New York art scene. At the time, according to Calvin Tomkins, there were around fifty artists in New York, all of whom knew each other. They had studios around Tenth Street and used to meet at the Cedar Street Tavern, where the barman let them drink on credit, and at the Waldorf Cafeteria at Sixth Avenue and Eighth Street. These regular meetings led eventually to the formation of The Club, when a number of artists, among them de Kooning, Kline and Pavia, found a loft where they could gather to discuss painting in more privacy. The Club was a refuge for artists, necessitated by the hostile reception the Abstract Expressionists were still receiving at the hands of the public. In 1949 *Life* had run a two-page color spread on Pollock headed: "Jackson Pollock—Is He the Greatest Living Painter in the U.S.?" Though this made Pollock famous, it "did nothing for his sales."

Nevertheless, as the Fifties got under way the prices of the New York School did begin to move, at long last, and Pollock even began to think about living from his painting. Rothko was still forced to teach, but his prices at the Parsons Gallery had risen from $150 in 1946 to $300–600 in 1949, and to a top price of $1,500 at his 1950 show, when he sold six works. Clyfford Still's career was almost parallel, and by 1950 his prices ranged from $650 to $2,200. Barnett Newman had risen even faster. His first one-man show took place in 1950, at Parsons, with prices ranging from $750 to $1,200. By 1954 they had reached $3,000. One shouldn't exaggerate the speed of change, however, as these figures may appear to do. In 1954 Eleanor Ward had opened a gallery in an old timbered stable which, Calvin Tomkins found, "still smelled agreeably of hay and leather" and exhibited the work of 150

painters, including Pollock, de Kooning, Kline, Motherwell and Baziotes. There was no shortage of attention from the press, but there were also no sales.

In some ways New York at this time could be compared roughly with Paris in an earlier age. The Cedar Tavern and the Waldorf Cafeteria were Parisian-style cafés, where the artists met to discuss their art, and one particular show in 1951 had elements of a salon in which work was accepted by a committee of artists. This was held on Ninth Street in a former Greenwich Village antique shop vacated because the building was soon to be demolished. Leo Castelli stumped up the money to have the walls whitewashed and for a poster designed by Franz Kline. There were sixty-one works by sixty-one artists, "a brave display," says Tomkins, "and the first chance anyone had had to see the full extent of the Abstract Expressionist conquest." Alfred Barr came and took Castelli aside, asking him to explain the work of these artists, most of whom Barr had never heard of. Barr was escorted by Castelli afterward to The Club, where a victory party was under way. As the two men arrived they were "greeted by a spontaneous round of applause." Yet there were no sales at this show either (Castelli later said that only fifteen of the artists were of lasting "interest"). Impressionism hadn't been popular at first in Paris, but at least there had been *some* collectors. The critic Harold Rosenberg once told Calvin Tomkins, his successor at *The New Yorker,* "The art world is a comedy." Not in New York in the early Fifties; in fact, not anywhere at that time.

25 | SHANGHAI TO SUEZ, VIA HONG KONG

Nineteen forty-nine was a momentous year in politics. It was the year the Berlin blockade was lifted; it was the year the German Federal Republic, Eire, Vietnam and NATO came into being. Israel was admitted to the United Nations, apartheid was introduced in South Africa and the USSR tested its first atomic bomb, instituting the Cold War. For the art market, however, the crucial event was none of these but was the fall of Tsientsin to the Communists. Chiang Kai-shek resigned as president of China and a people's republic was proclaimed under Mao Tse-tung.

Throughout history, war and revolution have always produced a mass movement of art objects, and the upheavals in China were no different. Dealers in Canton, Peking and Shanghai packed up their stock if they could and fled to Hong Kong. Today the Hollywood Road in Hong Kong is just as famous for its antique shops as Bond Street or Madison Avenue, but Hong Kong as a center of the Oriental art trade really dates from this time. Though the street today is mainly a Cantonese outpost, many of the early and most important dealers—T. Y. King, Joseph Chan, Edward Chow, Robert Chang—were from Shanghai. The most colorful of the dealers, however, the one whose family story most vividly illustrates the tragic history of the Chinese art trade, was from Peking. This was unusual, but even more so was the fact that the dealer was a woman. Charlotte Horstmann was in some senses an Oriental Peggy Guggenheim (see figure 58).

Born in Berlin in 1908, the daughter of a Chinese banker and a German mother, Charlotte Horstmann spent her youth in both Germany and China. In 1924, however, her father fell out with the head of his bank, resigned and opened a small hotel, the Fu Lai Fandian (the Approaching Prosperity Hotel), which soon became a sort of literary salon. Many distinguished foreigners stayed at the Fu Lai, including the Swedish explorer Sven Hedin, who remained there for a month while he prepared his expedition to discover the lost cities and treasures of the Old Silk Road. Another, more important, visitor was Dr. Otto Burchard, the foremost European dealer in Oriental art in the Twenties and Thirties, who traveled to China on buying expeditions twice a year, during which time he needed an interpreter. On one of these visits, according to Robert Piccus, Charlotte acted in this capacity; they got on well and her interest was soon kindled. Through Burchard, Charlotte was introduced to some of the other important dealers in Oriental art, men such as Yamanaka, a Japanese dealer with galleries in Paris and New York, and C. T. Loo, who also had galleries in these cities and had amassed a formidable personal collection of Chinese antiquities. These three were intensely competitive; Burchard would slump in despair if, on arriving at a dealer's, he found Loo's car outside, and he would wait in a side street until his rival had gone.

Before Mao's revolution, most of the art trade in China was carried out in Tsientsin, Peking and Shanghai, the gateway to the West, where the tastes were for imperial ware, stone sculpture and bronzes. In contrast, the more southerly Cantonese taste was for pottery and celadon ware, the Cantonese being especially superstitious about anything to do with burial as both sculpture and bronzes could be. Early collectors from the West, in the period of the last emperor (1908–12), were predominantly French, and interested in imperial taste, though firms like Bluett in London had been in existence since the 1880s. The first real boom occurred, however, in the Twenties. This was when Grandidier, Percival David and Eumorfopoulos put together their collections, when the Oriental Ceramics Society was formed and when C. T. Loo was buying up entire excavations and transporting them to Europe. The boom culminated in the great Berlin sale of 1929, by which time the major Oriental traders in the West had become set: Bluett, Spink and Sparkes in London; Beurdeley, Edward Chow and C. T. Loo in Paris; and Chait, J. T. Tai and Fran Caro (who was linked to C. T. Loo) in New York.

In Peking the art market was clustered around the Liu Lee Chung area, where C. T. Loo and Yamanaka had galleries, and in the Twenties it and the Fu Lai were often visited not just by dealers but by archaeologists, art historians, other scholars and collectors who were all trying to impose order on this exploding field. The social order being what it was then, Charlotte

Horstmann was not expected to work; indeed, her father had refused to let her attend a university. Nonetheless, through Otto Burchard she kept in touch. He was involved in the great exhibition of Chinese art held at Burlington House in London in 1935–36. This was an epochal event, the first time certain major items from the imperial collection were allowed to leave China. The familiar names of Percival David, George Eumorfopoulos and Oscar Raphael were all on the organizing committee.

Charlotte, who had been married in 1928, had four children by the outbreak of World War II. The Japanese occupation was a trying time, and this probably contributed to the breakup of her marriage. In 1945, when hostilities ended, she decided at the age of thirty-seven that the time had come to work in the only field she knew, and she became an art dealer. She began in the Marco Polo shop, run by Arthur Parker, an Englishman, but soon started out on her own, taking over a gallery in the Hôtel des Wagons-Lits near the railway station. No sooner had she done so, however, than the Communist takeover occurred in 1949 and she lost the shop. For a time, says Robert Piccus, she lived in the house of the Sinologist C. P. Fitzgerald and conducted her business from there. Though she had lost her shop, the Liu Lee Chung antique market in Peking still existed. Each of its narrow streets had a specialty—jade, porcelain, bronzes and so on—and thanks to the political turmoil a lot of good objects were appearing on the market. Charlotte Horstmann started to buy more than she sold, building up stock with a view to leaving and trading elsewhere.

Her departure took place in 1951. She packed her belongings into sixty-eight crates, describing many art objects as household goods (a Xuande dish was a "kitchen plate"), took the train from Peking to Shanghai and sailed for Hong Kong. As a stateless person she was allowed to remain in Hong Kong for only two weeks, after which she settled in Thailand. In Bangkok she joined the expatriate community and opened a shop. While there she met Jim Thompson, the legendary figure responsible for the commercialization of the Thai silk industry, and improved her knowledge of Southeast Asian art. However, as soon as she was able to obtain a German passport she returned to Hong Kong. By then it was 1954, the time of the Korean War. The colony was filled with Chinese refugees who had brought works of art with them; at the same time there was an embargo by the United Nations on all goods from China, which meant that a certificate of origin was needed for all objects sold to Americans. This severely limited trade and promoted smuggling; nevertheless Charlotte began doing business in a shop she shared with a jeweler. Robert Piccus tells us that at first the space was so crowded that she and the jeweler were forced to work on alternate days.

The art market in Hong Kong was not created overnight, though most

dealers did arrive there precipitately as a result of the events of 1949. T. Y. King, for instance, who had a shop in the Canton Road in Shanghai, caught the last Pan Am flight out of the city before the airline ceased operating in China. Shanghai had been an important art center because it was a port, with many people passing through, and because it was near many archaeological digs. According to Warren King (T. Y.'s son), it used to be the practice in China for a dealer and a collector to have dinner together before any objects were displayed. Hong Kong would never be that leisurely. T. Y. King was able to take a few things with him. He sold these in Hong Kong and was allowed to send remittances home. His relatives would then send him more pieces, and in this way the business was built up. To begin with, he operated out of two hotel rooms; it took him five or six years to get all his Shanghai stock to Hong Kong, and only then did he open a shop. Warren King recalls that in those days—the mid- to late Fifties—peachbloom plates were fetching HK$1,200. "Now they are nearer a million."

Joseph Chan's family had been in the wine business, but his grandfather had sent his father to Shanghai to learn the antique trade. There Joseph had opened his own shop in the Ming Kuo Road. In 1949 he was able to escape by train. He took almost no stock with him but bought from other refugees in Hong Kong.

Eugene Lai, of C. C. Lai, is Cantonese, and that market was much smaller than the one in Shanghai and its tastes very different. The Canton Fair, which used to be a major antique fair, declined in 1950 in the wake of the Communist takeover, partly because the Communists sold only what they felt was unimportant.

The most famous dealer from the Shanghai–Hong Kong group was Edward Chow (see figure 59). He became a dealer as a young man of twenty, numbering Percival David, Barbara Hutton and King Gustav of Sweden among his clients. After 1949 he moved to Hong Kong, where he lived in Happy Valley, near the racecourse. Gerald Godfrey, who became Charlotte Horstmann's partner, remembers Chow, who died in the early Eighties, as a man with "a great eye, great taste, a great temper and a great vanity." He was equally at home in the old Dorchester Grill in London and in Hollywood Road, except that in Hong Kong he used to disguise himself in Cantonese clothes in an effort to hide his identity from other dealers, who would otherwise have raised their prices when they saw him coming. His life was art; little else mattered. It was said that he named his seven sons in alphabetical order so that he could remember their names. But in those early postwar days even Chow sold mainly to Western collectors and dealers. The dominant characteristic of the market in Hong Kong in the Fifties was that the Chinese were either refugees, and therefore sellers, or else dealers. In time, this would

change; indeed, the somersault in the Oriental market since World War II almost rivals that of the Impressionists.

—

Across the world, at much the same time, another set of political events was having a no less profound effect on the art world. This, too, involved a revolution, a fundamental redirection of an entire country and culture, and art was thrown onto the market without warning. The country was Egypt and the art was the Farouk collection.

In 1952 General Muhammad Naguib had seized power in Egypt, and King Farouk abdicated, but in 1954 Colonel Gamal Abdel Nasser overthrew Naguib and seized power himself. His revolutionary government decided to sell off the fabulous treasures of the palace collection that the king had been forced to leave behind (he was able to take only jewelry with him). Sotheby's was offered the contract. Given the complex political situation, the legal details were formidable, but Sotheby's path was cleared by Max Harari, a charming Anglo-Egyptian, an old-fashioned amateur of the arts who later became the head of Wildenstein in London. Harari's family was well connected in Cairo, and such influences were necessary because Sotheby's faced stiff competition not only from Parke-Bernet but also from a syndicate of French dealers headed by Maurice Rheims. In the words of Frank Herrmann, the rivalry almost reached a "point of open warfare."

Amid all the complex infighting the two main problems were startlingly simple. Would the former king challenge the legality of the sale, and were there any objects in the royal collection that should be kept for Egypt's national museums? Sotheby's was at least given satisfaction on the issue of legality; the revolutionary council enacted immediate legislation that dispossessed not only the ex-king but also, according to Herrmann, "three ex-queens, fifty-nine ex-princesses and twenty-seven ex-princes." The other problem was less easy to settle, since first one official, then another, would decide that a particular object should be withdrawn. Often this decision would not be made until after the cataloguing had been completed, because only then would the officials realize how important an object was. As a result all the antiquities and furniture that had been in the original contract were withdrawn.

Another nightmare for Peter Wilson arose from the fact that the sale had to take place in Egypt, which meant that large numbers of experts needed to be sent to the Middle East. The most difficult job of all was the cataloguing of the former king's collection of stamps and coins (8,500 gold and 164 platinum ones). What caught the attention of the press most, however, was his "objects of virtue," for which he had a mania. His taste was often vulgar,

and his collection included two thousand gold watches, Swiss automata, half a dozen Fabergé eggs, enough Gallé glass to fill a pyramid and an equal amount of glass paperweights. (Farouk had been largely responsible for the boom in paperweights at that time—a boom that disappeared as soon as he was deposed.)

In the interval before the sale, conditions in Cairo were tense. The government was still being difficult, there was a lot of anti-British feeling among ordinary Egyptians and Farouk was making belligerent noises in exile. One episode in particular, says Frank Herrmann, made everyone sweat. The Sotheby's staff had been assigned Farouk's own quarters in the Koubbeh Palace near Cairo as their base of operations. Many of the former king's belongings were still there, including his collection of early aspirin bottles, erotica and pornography filling twenty rooms, ten thousand neckties and many suits and uniforms. One day a handful of Sotheby's people were discussing an aspect of the sale with the palace staff in the immense entrance hall of Koubbeh when suddenly "a portly figure in a resplendent white uniform" appeared at the top of the stairs. It was Farouk. What had happened? A reverse coup that no one had heard about? The palace staff fell to their knees and the Sotheby's people began to look for the exits. Then the portly figure in the white suit winked. An actor who was to play the king in a film had tried on one of the uniforms to see whether he looked the part. He did.

The Farouk sales were scheduled for early 1954. As an added inducement Egyptian officials promised that anyone spending more than £5,000 would be allowed to see and bid for parts of the collection of erotica and pornography, proving that the new government was no less vulgar than the old one. Farouk's lawyers tried to halt the sale right up to the last day, and because Naguib and Nasser were now locked in their battle for power, several collectors and dealers preferred not to risk traveling to Cairo. This was a pity, for the setting, as described by Frank Herrmann, was perfect: the royal palace itself, with delightfully green lawns despite the great heat, bougainvillea everywhere, iced drinks on hand for anyone who wanted one and a brass band playing in the garden throughout the auction. But this was as far as perfection went. The total raised, £750,000 ($18 million now), was looked upon as disappointing by Nasser's government, which accused Sotheby's of not properly publicizing the event and refused to pay the firm. If the sum was disappointing—although many objects fetched more than their estimates—it may have had a lot to do with the fact that many Egyptians were reluctant to be seen paying large sums for items that had belonged to a recently deposed regime that might conceivably someday return. It made no difference; the government regarded all explanations as excuses. Then, says Herr-

mann, the undersecretary at the finance ministry with whom Sotheby's had been dealing was arrested. Claims and counterclaims went on for months. At last the Suez crisis erupted, the British became even more unpopular in Egypt and Sotheby's had to write off the whole affair.

Yet this was not the end of Nasser's effect on the art market. In 1956 he was elected president of Egypt. The British and Americans had withdrawn their support for the Aswan Dam project, and in retaliation he nationalized the Suez Canal, closing it with sunken ships and mines. Two thirds of the canal traffic consisted of oil tankers that had been accustomed to taking the short route to the United States and Europe; now they were forced to take the much longer route around the Cape of Good Hope. This had the effect of creating a demand for tankers, and there was a boom in shipping, which in turn put huge sums of money into the pockets of shipowners, particularly the Greeks. It was the Greeks who helped to create the first postwar art boom—in fact, the first real boom since the 1929 crash. Thanks to the shipping boom inadvertently created by Nasser, the Greeks were the first to bid enormous amounts in the salesrooms for Impressionists and Post-Impressionists.

III | 1957 –
IMPRESSIONISM, SUNRISE

Curt Valentin, the New York dealer, died in the summer of 1954 and was buried in the Italian town of Pietrasanta, just north of Viareggio. The funeral was especially moving because he was buried with a sculpture by his beloved Picasso and the eulogy was delivered by Daniel-Henri Kahnweiler. Since the end of the war Kahnweiler had at last been granted the respect and honor due him. He now wrote for *Horizon,* Cyril Connolly's magazine in Britain, and translations of his articles were also published by John Rewald in the United States. In France he published *Juan Gris: His Life and Work.* He lectured at Harvard, Yale and the Chicago Art Institute. Fernand Léger, who died a year after Valentin, said to his wife one day, knowing that the end was near, "Don't listen to anyone else, and don't work with anyone other than Monsieur Kahnweiler. . . . He is the one who discovered me, who encouraged me. . . . It's thanks to Kahnweiler that I'm Fernand Léger."

Kahnweiler had become in effect a wholesaler, selling exclusively to other dealers. He was listed as the "technical director" of the Galerie Louise Leiris, but in fact he was the heart and the head of it. Any dealer who wanted a Masson had to go through the Leiris gallery. Léger was shared with Aimé Maeght, as was Braque, whose prices were now too high to be borne by one dealer. Then there was Picasso. Kahnweiler had known the artist since 1908, nearly half a century, but only recently had he won the painter's complete trust. The two men could not have been more different, one German and

serious, the other Spanish and playful. One day Picasso telephoned Kahn-weiler to say that he had bought Mount Sainte-Victoire. The dealer wanted to know exactly which of Cézanne's views it was; only later did he grasp that Picasso had bought the land itself.

By the end of the war the works of both Picasso and Braque, but especially the former, were in great demand, and both men were rich enough not to need to sell anything. In fact, both were reluctant to do so, which did not make matters easy for dealers. In the year immediately following the libera-tion, Picasso did not give anyone the exclusive right to sell what works he chose to part with. He used several dealers, Kahnweiler and the Louis Carré gallery more than most. He played on their rivalry and, says Pierre Assouline, would keep Kahnweiler waiting in the hallway while he saw Carré. He also played Kahnweiler off against the New York dealer Sam Kootz. Kootz was in some respects the stereotypical American—bold and brash, cigar-loving, convinced that money could gain him any entrée. It worked with Picasso, who was delighted one day when Kootz turned up with a brand-new Oldsmo-bile and gave the artist its keys in exchange for a canvas. Kahnweiler hated being bypassed in this way, but there was little he could do; Kootz did a good job of selling Picassos in the United States, and to the artist this was all that counted.

This attitude of Picasso's went back a long way. From his earliest days in Paris he had, like Duchamp, regarded dealers as swindlers and exploiters, and at first he regarded Kahnweiler as no different from the rest. "He threw temper tantrums on principle," says Assouline. Gradually, however, over the years, Kahnweiler's utter inflexibility on points of principle, his unflagging support of Cubism and his patience won the artist over. In 1947 Kahnweiler finally got an exclusive contract with Picasso. Now he became the artist's ambassador, and he introduced a routine that never varied. Every time he had a new consignment of paintings from the artist, a meeting of dealers was called at the rue d'Astorg. The paintings would be put up on an easel and he would name a price. The dealers who had been invited had only a few moments to decide whether they wanted a work or not.

Even at this late stage in his life, Kahnweiler's business grew. He employed new people and in 1957 opened a new gallery. He was, as he used to say, chief executive of "The Picasso Business." His approach was straightforward, says Assouline. "He would buy everything the artist wanted to sell." Picasso was still producing at a fantastic rate and sometimes would part with as many as a hundred paintings. (On one occasion, at dinner at home in Mougins, Picasso confessed to Michel Leiris that he had produced seven paintings that day.) By the Sixties, the artist was receiving all sorts of requests almost daily: to provide a cover for the program of a charity event, to do a television

interview, to donate a drawing to a youth movement. Kahnweiler handled everything, making sure that Picasso was rationed in just the right amounts. By then he had also become the artist's mouthpiece. Though Picasso had an ebullient nature in private, it was now Kahnweiler who did his public speaking for him. This suited Picasso, but it was good marketing too, for it meant that the master was both available and rare.

Outside his dealings with Picasso, however, Kahnweiler's inflexibility was leading him in some unusual directions. In his writing he had two messages. One was to rail and rant against abstract art, which the dealer saw as little more than calligraphy, an alphabet incapable of producing a language of its own. Though abstract art had been born in Paris, it did not really take hold until after World War II, when a new crop of galleries—the Galerie de France, Louis Carré, Aimé Maeght, Denise René, Heinz Berggruen, Daniel Cordier and René Drouin, Leo Castelli's partner—emerged on both banks of the Seine. Kahnweiler hated all of it, Assouline says, and had since the beginning, when he had castigated Gauguin for being an "ornamental" painter, as well as Kandinsky, whom he regarded as "a brave man but a bad painter." Naturally he found the American Abstract Expressionists uninteresting, on the grounds that all their experiments had been tried by the Cubists and even the Surrealists, and then discarded.

Kahnweiler's second message was about Paris itself. He was convinced that with the end of the war Paris would reemerge as the art capital of the world. He simply refused to consider what was happening in New York, or to take it seriously. For a serious man this was a serious mistake, though there were reasons why he was misled. In the first place, Paris in the Fifties had a much livelier art market than either London or New York did. For example, at the Charpentier Gallery on May 14, 1952, Maître Alphonse Bellier had sold the collection of Gabriel Cognacq. Cognacq's uncle, Ernest, had founded the great Parisian department store Samaritaine, and with his wife, Louise Jay, had been a notable collector, starting with Impressionists (acquired through Bernheim-Jeune), then works of the eighteenth century (bought mainly through Édouard Jonas). Like other great French art collectors of the nineteenth century—Marmottan, Jacquemart-André, Cernuschin—the Cognacq-Jays established their own museum, which they left to the city of Paris. Gabriel was a greater connoisseur than either Ernest or Louise, but he led a disappointing life. First his son Philippe refused to succeed him in the business, preferring to become a pilot. Then, when World War II broke out, Gabriel, whose trucks from the department store were used to evacuate artworks from museums, accepted a post as president of the board in charge of all the national galleries and the "more delicate" job as head of the Secours National. This brought him close to the Vichy govern-

ment, a tactical mistake, for despite the fact that in World War I he had been mentioned in dispatches for his bravery, toward the end of the second war he was accused of collaboration and treason. In August 1944 he was acquitted, but by then Samaritaine's committee "for the elimination of political suspects" had demanded his arrest, and the "Friends of the Louvre" had withdrawn his membership card. Angered and humiliated, Cognacq tore up his will, in which all his pictures were to have been left to the Louvre. The 1952 sale was the result. Prices were remarkable: 4 million francs for Renoir's *La Modiste,* 33 million for Cézanne's *Pommes et Biscuits* (sold to Madame Walter, widow of Paul Guillaume), 6.85 million for Courbet's *Le Repos* (bought by the Marlborough Gallery of London). In all, Pierre Cabanne reports, the seven-day auction realized the magnificent sum of 302.5 million francs ($75 million now). By rights it ought never to have happened.

There was also a great vogue for contemporary art in Paris in the Fifties, one that has been compared with "earlier enthusiasms" in Florence in the late fifteenth century, Holland in the seventeenth century, or Paris in the 1770s. This may seem a little exaggerated to us, but the comparison was made by Raymonde Moulin, a French sociologist who studied the Paris market at that time. Kahnweiler was partly responsible for the preeminence of Paris, in that the exclusive artist-dealer contract he insisted upon had become popular, and this of course encouraged dealers to promote their own artists. Another factor was the absence of a capital-gains tax in France then. What is particularly interesting about Moulin's account of the market for contemporary art in Paris in the Fifties is that many of the names she focused on as great successes at the time are all but unknown today, certainly outside France. Bernard Buffet was highly regarded then. Though his canvases changed hands for 1,000 to 5,000 francs after the war, they had risen to 50,000 francs by 1948, and at the Buffet retrospective held at the Galerie Charpentier in 1958 the smallest paintings sold for between 800,000 and 1 million francs. Alfred Manessier's work rose from about 570,000 francs in 1954 to 10 million in 1959; Henri Michaux, Jean Fautrier and Jean Dubuffet all did well in much the same way, as did Antoni Tàpies and Jean Atlan. According to *Réalités,* in 1958 the following artists were "successful enough to sell their works for 500,000 to 1,000,000 francs: Borès, Brianchon, Carzou, Chapelain-Midy, Clavé, Derain, Desnoyer, MacAvoy, André Marchand and Pignon." One million francs in 1958 would be about $210,000 now.

In the light of history, it might have seemed natural at the time that Paris would reemerge as the capital of the art world, but this view neglected the changes that had taken place during the war years. The art world in France was disrupted by the hostilities, and when the war ended the market had changed. Moulin writes: "New dealers who opened galleries in the ebullient

1950s and 1960s were driven to engage in short-term speculation by artists clamouring for money, collectors bent on quick profits, and by their own greed. It was a time for hasty decisions rather than long-term calculation, for a strategy of wheeling and dealing rather than waiting." This could well account for the success of so many second-rate artists and may have led to the collapse of the Paris scene in 1962, at the very moment when the situation in New York and London was beginning to improve.

London began modestly in the Fifties. Victor Waddington had arrived from Ireland, a factor that would shape Cork Street in years to come. Andrew Patrick had joined the Fine Art Society opposite Sotheby's and in time would prove important in the promotion of modern British art. In 1958 Giuseppe Eskenazi arrived in London to study Oriental art and in 1960 opened a London branch of his family's distinguished Milanese firm. Eskenazi's London premises eventually became one of the most impressive commercial galleries in the world.

Compared with London, however, much more important movements were afoot in New York, for what was happening in Manhattan was the antithesis of what was happening in Paris. There was nothing short-term about the activities of the artists and dealers there. Whatever reservations Kahnweiler might have about abstract art, most Abstract Expressionists had started in the years of the depression and had refused to compromise. For them the war years had been an exciting time, when the influx of European Surrealists had provided stimulation and competition. Dealers like Sidney Janis had also been around since the early Thirties, sometimes as writers and critics as well as traders; like Kahnweiler, they had an intellectual input into the art world. Thus the New York market had been decades in the making. Unlike the postwar opportunists who flourished briefly in Paris, the New Yorkers were serious, patient and cautious. Ironically, they had all the virtues of Kahnweiler, and none more so than Leo Castelli (see figure 71).

After what must count as the longest gestation period in art-market history, Castelli finally opened his own gallery in New York in 1957. One could have been forgiven for not noticing. The gallery was the living room of the Castellis' apartment, on the fourth floor of 4 East Seventy-seventh Street. Calvin Tomkins reports that the Castellis' daughter, Nina, was away at Radcliffe College, so her room was used as an office. There was no sign outside; one simply had to know the gallery was there. The opening exhibition was a mixed show of European and American artists: Léger, Mondrian, Dubuffet, Giacometti, de Kooning, Delaunay, Pollock, David Smith and others.

By this time Leo and Ileana, his wife, had been collecting for many years. Indeed, Leo was now almost fifty, a late starter in the art trade. Castelli had

spent his childhood in Trieste, which before 1919 had been the main seaport of the Austro-Hungarian empire. The Castellis were Leo's mother's side of the family; his father, a successful banker, was Ernest Krauss, and for a while the family was known as the Krauss-Castellis. Leo had a leisurely upbringing; he told Tomkins that his main interests were literary and sporting (rock climbing and tennis), but, like Kahnweiler, he was gifted at languages. He studied law for four years at Milan University, and then, in 1932, went to Bucharest to work for a branch of an Italian insurance company. In Romania he met and was attracted to Eva Schapira. However, when Eva's sister Ileana returned from Paris, Leo fell even harder for her. As soon as she turned eighteen they were married. Now prewar life became even sweeter. Ileana's father, one of Romania's leading industrialists, sometimes lent the young couple his chauffeur-driven Chrysler, and in this splendid way Leo and Ileana did a lot of traveling—to Paris, St. Moritz, touring antiques shops for the Meissen china they had begun to collect. Paris especially appealed to them, says Tomkins, and with the connections Leo was now acquiring, he landed a job in 1935 with the Banca d'Italia in the French capital. The couple were immediately taken up by society, and among the people they met there was René Drouin, an interior decorator who was now the husband of an old school friend of Ileana's. After he had helped decorate their apartment, Drouin suggested to the dapper Castelli that they open a gallery together. He had his eyes on a site, Knoedler's old premises on the place Vendôme near the Ritz and Seligmann's den of antiquities. Leo, who had never had much enthusiasm for insurance or banking, was interested. More important, his father-in-law wanted Leo to find something that would fire his enthusiasm and agreed to provide funds—500,000 francs ($270,000 now).

At first, they did not plan a gallery of contemporary art. Leo had studied art history at school but cheerfully admitted to Calvin Tomkins that at this stage he had read only one book on contemporary art. Their plans changed rapidly, however, when Leo met an old friend from Trieste, the painter Leonor Fini, who belonged to the Paris Surrealist group. When Leo let slip one day that he was opening a gallery, he was immediately pursued by Max Ernst, Pavel Tchelitchew, Salvador Dalí and Meret Oppenheim. The first show that took place at the Gallerie René Drouin, as it was called, consisted of a single painting by Tchelitchew illuminated by candlelight. In no time at all the gallery became fashionable and Castelli and Drouin must have thought they were on their way, because when summer arrived they, like most Parisian dealers, shut up shop and headed for the beach. Before they could return, war broke out.

During the *drôle de guerre,* the Castellis went first to Cannes, Tomkins

reports, taking their three-year-old daughter, Nina, to stay with Ileana's father. But after the fall of France they crossed to Casablanca and tried to get visas for the United States. This took time, and they did not arrive in New York, via Cuba, until March 1941. Ileana's father was already there, and he found them their apartment on Seventy-seventh Street, which they filled with Victorian antiques. Leo studied at Columbia University for a while, then enlisted, but by the time he had finished his army training the mission he was destined for was obsolete. Instead, he was asked to return to Bucharest as an interpreter for the Allied Control Commission. It was a nostalgic assignment that was to have a profound influence on his future. On one of his leaves Castelli went to Paris and looked up René Drouin, who still had the gallery but by now dealt only in modern art: Kandinsky, Dubuffet, Mondrian. Drouin, along with the Galeries Maeght and Carré, was an important figure in Paris, but little was selling at the time and Drouin was worried. However, the experience had an impact on Castelli, for when he returned to the United States he turned down the commission in the army that he had been offered and resolved to become Drouin's partner in New York. This was easier said than done, for he had a lot to learn. He was a great admirer of Alfred Barr's exhibitions and catalogues at MoMA, and he began hanging around Peggy Guggenheim's gallery. Julian Levy offered him a job but he turned even that down. Both Castellis were also frequent guests at The Club, says Tomkins, two of the few non-artists admitted. Leo was not yet a dealer on his own account; if anything he was a collector, though Ileana bought more than he did. His father-in-law had helped him in yet another business, this time knitwear. However, Castelli did begin some dealing on the side. Drouin would send him a Kandinsky from time to time, when he could find a helpful airline pilot to bring it over. This brought Castelli into contact with another gallery, the Nierendorf in New York, whose director, Mrs. Prytek, dealt in Kandinskys and Klees.

By the late Forties, Castelli and Ileana were very friendly with many artists: Tomkins reports that the de Koonings stayed with them at their East Hampton house on Long Island during the summer, and others came to their noisy parties. Castelli's reluctance to become a dealer may have been due to a faded European notion that it was "trade"; more likely it was because Ileana's father had lost a lot of his money in emigrating to the United States and art dealing was felt to be too risky. In any event, when Sam Kootz offered his space to Castelli in 1948 after he had decided to give it up, Leo turned it down and the gallery was taken by Sidney Janis instead. But Castelli knew Janis, of course, and after the gallery reopened the two men worked together, collaborating on a group show of young European and American

artists in 1950. In the early Fifties it was Janis who was making waves: Pollock left Betty Parsons in 1951, Kline and Rothko moved over in 1953, and Motherwell a year later.

Castelli still did not open a gallery, but his life was now almost entirely taken up with art. He had sold his knitwear business and was using the proceeds to buy paintings. Tomkins says that de Kooning and others pressed him to do more than collect for himself, but he would not be rushed, and it was another two years before he put on the first show in his flat. It was a gallery of sorts, but even then he did not show the Abstract Expressionists. Most of them were now with Janis, who was proving to be a clever marketeer. Janis showed de Kooning and Pollock beside such established Europeans as Léger and Mondrian, and this "helped cut down buyer resistance in America."

However, during his first season, Castelli did show some second-generation Abstract Expressionists—Paul Brach and Norman Bluhm. But in the last show of his first year, before he closed the gallery for the summer, he indicated the new direction he might take. In this show, says Tomkins, there were "two unfamiliar and highly disturbing pictures." One was by Robert Rauschenberg and the other by Jasper Johns. Rauschenberg was already the enfant terrible of the art world and was better known in Europe, where he had shown at the Daniel Cordier Gallery in Paris. Calvin Tomkins again: "He was interested in pushing the great twentieth-century aesthetic question 'What is art?' beyond the limits of what most people considered sensible." He had already had three one-man shows, at Betty Parsons, the Stable and the Egan Galleries, and they had aroused hostile comment from the critics, who had objected to his plain white canvases "on which no images impinged but the shadows of whatever moved in front of them." The critics had objected equally to his red paintings, which were also collages into which mirrors, comic strips and reproductions of Old Masters were pasted. For Castelli, however, Rauschenberg's red paintings were, as he later told Tomkins, "an epiphany—an astonishing event that at the time did not seem to me related to anything else."

Castelli did not have a gallery at that stage, but in 1957, when he did, he visited Rauschenberg's studio to decide whether he would take on the painter's work, and it was on that occasion, through Rauschenberg, that he experienced a second, and greater, epiphany when by chance he saw the work of Jasper Johns. As Tomkins tells it, Rauschenberg happened to mention that he was going downstairs to get some ice from Jasper Johns's refrigerator, "whereupon Castelli seemed to forget all about his reason in coming to see Rauschenberg, and asked instead to meet Johns." Ileana said later that the

studio below looked like a one-man show. "Many, many marvellous paint-
ings—paintings of targets, of flags, of numbers, all very strange and very
beautiful. We were overwhelmed."

Castelli held Johns's first one-man show as soon as it could be arranged,
in January 1958 (see figure 73). It was a spectacular success for both artist and
dealer. *ARTnews* put one of Johns's *Targets* on its cover, and Alfred Barr
came in on opening day and, says Tomkins, stayed for three hours; eventu-
ally he bought three paintings for the Museum of Modern Art. Only two
works were unsold, in marked contrast with Rauschenberg's show a few
weeks later, which created a furor but resulted in only two sales. (His *Bed* was
said by one critic to "represent the scene of an axe murder," and almost
everyone found something to be offended by.) MoMA bought nothing from
Rauschenberg's show, but both Johns and he were included in an exhibition
there organized the following year by Barr's assistant, Dorothy Miller. In
fact, within a year Castelli, Johns and Rauschenberg were launched. Curi-
ously, Castelli's next move was to search for undiscovered painters in
Europe, and he hit upon Viseux in Paris (through Drouin), a Hungarian
named Hora Damian and the Italian Capograssi. They were nowhere near
the instant success Rauschenberg and Johns had been.

A few months later, in 1959, the apartment two floors below became
available and the Castellis moved the gallery down. At the same time, says
Tomkins, Ivan Karp arrived as general manager. Karp could not have been
more different from Castelli. Whereas Leo is elegant and soft-spoken, Karp
is casual and bohemian, an irreverent, wisecracking New Yorker. Born in the
Bronx and brought up in Brooklyn, he had been *The Village Voice*'s first art
critic. A socialist of conviction even today, in the mid-Fifties Karp, together
with Richard Bellamy, had managed the Hansa Gallery, an artists' coopera-
tive on Central Park South. He told Tomkins, "Dick and I had code names
for all the art-world figures, and we called Leo the Count—he was always
well dressed, and he always had clean fingernails, which you seldom saw then
in the art world." From the Hansa, Karp moved on to the Martha Jackson
Gallery, where Leo came across him and hired him. Though different, the
two men got along famously. "One bond between us was that we both loved
women. Leo has a great sense of amorous style. He's not in any way a sexist;
he treats women with great respect and really admires them." In fact at this
stage there was a cooling between Leo and Ileana, but they still worked
together.

In 1958 Castelli's eyes were still as firmly fixed on Europe as on America.
In that year he had been to Paris for a Jasper Johns show at Jean Larcade's
Rive Droite Gallery and while there had met a group of avant-garde French

artists who were stabled with the remarkable Iris Clert: Arman, Tinguely, Raysse and Yves Klein. By no means all of these were to become household names.

In the autumn of 1959, Castelli was joined by Frank Stella, whose works the dealer described as another epiphany. Alfred Barr agreed and bought a Stella for the museum. Castelli was now gaining confidence, says Tomkins, and as he did so he followed the avant-garde more and more enthusiastically. Each artist he took on was, in some measure, "difficult." Cy Twombly was a good example.

Of course a successful dealer needs to attract collectors as well as artists, and in his early days Castelli was fortunate in that four keen sets of collectors liked his artists. They were Emily and Burton Tremaine, Victor Ganz, Philip Johnson and Robert Scull. The Tremaines bought most of their Abstract Expressionists from Janis, but they also bought Johns from Castelli. Scull, who owned a fleet of taxicabs, liked Johns and Rauschenberg. After his years of hesitation, Castelli's rapid ascent made him a magnet, and scores of artists in and around New York wanted to be part of his stable (see figure 72). Today artists send their slides to a gallery, but in those days Castelli and Ivan Karp used to enjoy touring the artists' studios. In Paris in the early part of the century Vollard and Kahnweiler would visit their artists once a day, but once a week was enough for Castelli and Karp. Another reason for Castelli's popularity was that he introduced the European system of paying his artists a monthly stipend, whereas the usual American system was to pay the artist 60 percent when a work was sold.

Karp's arrival was fortunate for many reasons. In 1960 the Castellis were divorced. Castelli confirmed to me that in the early years he had depended a great deal on Ileana. He had more factual, art-historical knowledge and could place artists in context, but, as Rauschenberg said to Tomkins, Ileana was more instinctive, more sensual, in the end more imaginative. After divorcing Leo, she married Michael Sonnabend and decamped to Paris, where she opened a gallery. In Manhattan Leo and Ivan Karp operated the gallery jointly. It was Karp who began to bring in the newer, younger artists, including John Chamberlain, who had been at Martha Jackson. Then one day, as he was showing a group of art students around the gallery, another artist arrived with a load of pictures under his arm. When the students started to snigger, Tomkins reports, Karp sent them away and examined the art in more detail. "They were really strange, unreasonable, outrageous. I got chills from those pictures. I decided that I had to show them to Leo." Karp was nervous. The chilling, disturbing paintings were inspired by comic strips, and the artist's name was Roy Lichtenstein. Pop Art and the Sixties were about to explode on the world.

But 1957 was not only the year in which Kahnweiler opened his new premises in Paris, and in which Castelli finally launched his gallery on East Seventy-seventh Street. It was also the year of four great auctions that baptized the postwar art market in spectacular style. All four sales produced huge prices for the Impressionists. The day of van Gogh, Renoir, Monet and Manet had finally arrived.

It arrived first in Paris, and it began with the Greek shipowners who had benefited so much from the Suez embargo. The international Greeks—the Livanoses, Goulandrises, Embiricoses and Niarchoses—who now tend to make their homes in London or New York at that time preferred Paris. (That also helps explain why they liked the Impressionists.) In May 1957, at the Galerie Charpentier in Paris, a Gauguin *Still Life with Apples,* part of the collection of Mrs. Margaret Thompson Biddle, was sold to Basil Goulandris for $297,142 ($2.65 million today). This was three times what it had been expected to fetch, a fact that owed something, said Mollie Panter-Downes in *The New Yorker,* to "a sudden desire to acquire the canvas which ignited simultaneously in the bosom of Mr. Goulandris and Mr. Stavros Niarchos, another Greek shipowner, causing an explosion of human nature that blew the roof off the international art market."

Whatever explosion was occasioned by the Biddle sale in Paris, it was as nothing when compared with the Weinberg sale in London in July of that same year. William Weinberg was a German financier who had emigrated to Holland soon after World War I. In 1940 he had been in Paris on a business trip when the Nazis marched into Holland. He had been prudent enough to send some of his possessions, including his paintings, to the United States but not wise enough to do the same for his wife and three children. Frank Herrmann reports that despite dramatic attempts to rescue them, Weinberg never saw his family again. From his forced exile in Paris, he emigrated to the United States. He was inconsolable, and eventually collecting pictures replaced his family as the passion of his life. His collection was the result of many years of systematic effort. Early on he had used as his adviser J. B. de la Faille, who was the compiler of the catalogue raisonné on van Gogh and the man who had been taken in by some celebrated forgeries in the Twenties. But together the two men had landed some fine real van Goghs; Weinberg had ten works by the artist. These ten pictures were exceptionally well known, having been used in the 1956 film about van Gogh, *Lust for Life,* based on the novel by Irving Stone. Combined with Weinberg's own life story, this served to give the sale a natural drama.

Today it is difficult to grasp what a watershed the Weinberg sale was. In

that pivotal year of 1957, Peter Wilson became chairman of Sotheby's. He was an Englishman who instinctively understood the United States and relished the new world that was emerging after the gray days of the war and rationing. He also recognized the quality of the Weinberg pictures, and some months before the sale he persuaded Sotheby's board to spend considerably more than usual on publicity. J. Walter Thompson, the advertising agency, was employed for this purpose and, according to Herrmann, the auction received more presale publicity than any other up to that point. One particularly notable coup was the arrival to view the pictures of Britain's young queen. This was as unexpected as it was welcome; an invitation had been sent "cold" by Raymond Baker of J. Walter Thompson. But when the directors of Sotheby's saw the words "The Queen" on the guest list, they assumed it was a reference to the magazine of that name.

Salesroom hype probably came of age with the Weinberg sale as well, but this shouldn't obscure the fact that it was a very good collection. For a start, many of the pictures had extraordinary provenances. Theo van Gogh, for instance, had once owned the Cézanne portrait of his wife that Weinberg had acquired. It was also a serious collection because it was accompanied by Weinberg's collection of rare annotated catalogues of early Impressionist exhibitions in Paris at a time when those artists were ridiculed. The sale, says Herrmann, thus attracted attention on all levels: popular, serious, specialist. Given this, it was not surprising that it became such an event. Sir Thomas Bodkin, keeper of the Barber Institute in Birmingham, wrote in the *Birmingham Post*: "I have attended two fabulous auctions in the past. . . . The first was that of the collection of Rembrandt's friend, the Burgomaster Six, held about thirty years ago in Amsterdam. The second was that of the contents of John Sargent's studio at Christie's soon after his death. As a fashionable occasion, as an exciting and exhausting experience, the Weinberg sale surpassed them both."

The Weinberg sale did not set a record, though the total of £326,000 ($787,400 then) had been exceeded only once before at a London auction of paintings, the two-day Holford sale of Old Masters at Christie's in 1928. But in organization and publicity, the sale was like nothing that had gone before. Most important of all, it was superbly timed. Fortunes were being made again after the war and because of Suez, and the American government had introduced legislation that allowed rich collectors to write off a portion of the current value of their art against their income tax if it was to be left to a public museum on the owner's death. The Weinberg sale was even mentioned in Parliament, for when the House of Lords debated that year's purchase grant for the Tate and the National Gallery, the amount voted—£10,000 and £12,500 respectively—seemed absurdly small. Several peers were not much

concerned, however, for like such experts as Denys Sutton, editor of *Apollo,* they were convinced that the price levels achieved at the sale could not be sustained, and that once fashions changed the national galleries would again be able to pick up these pictures at prices they could afford. Not for the first time, or the last, the experts were sensationally wrong.

Weinberg was only a beginning; within months it was surpassed by the Lurcy sale in New York. Like Weinberg, Lurcy was a European, a French national from Alsace who had originally been named Georges Levy. He had started collecting in Paris before World War II and then escaped to the United States. Lurcy physically caressed the works in his possession, says Wesley Towner. "The priceless temptation of art gives one everything," he once said, "delectable stings, a hint of pepper and sun, the effortless crunch of the teeth into a morsel of canteloupe." He began buying art in his late teens, and by the time he was an executive at the Banque Rothschild in Paris he was already a serious collector. He would spend exactly one year studying each painting in his collection, researching the location if it was a landscape, reading what the artist had to say about it in his letters, and locating the pictures that immediately preceded or followed it so that he could understand what it had grown out of or was leading to. When the year was up, he would move on to the next painting. He didn't have an enormous collection—sixty-five works—but their quality was what counted.

In 1937 Lurcy married an American, Alice Snow Barbee from High Point, North Carolina. As he put it, "She was exquisitely feminine and slightly poor, as I hear all southern young ladies are. . . . I warn you she is the only luxury of my life I do not share." When war came, he cut his European links and left his château at Meslay le Vidame to the local village, stipulating that it be turned into a sanitarium. By 1945 he was installed with his wife and art collection at 813 Fifth Avenue in New York. The city was something of a shock. Towner reports him as saying, "Compared to Paris, Manhattan is diseased, and Fifth Avenue from the Fifties to the Sixties is the only habitable area. It is a city where aviaries and caged trees are an absolute necessity." Unhappily, by 1950 Georges Lurcy was himself diseased, and he died of cancer in 1953. He had foreseen "what a beautiful auction" his pictures would make; the sale was set for November 1954. This time it was Parke-Bernet's turn to do the honors. However, Lurcy's widow, the southern belle, objected to the speed of the sale, and for a while the courts supported her. For four years she remained on Fifth Avenue with the Matisses and Monets, but then the executors became convinced that the cost of the upkeep of the house and the care of the collection was a drain on the estate's assets. This time the court agreed with them and ordered that a sale take place, in November 1957.

Easier said than done, for at first Mrs. Lurcy refused to let the Parke-Bernet staff into the apartment to do the cataloguing. Then she refused to let the public in to see the pictures. Finally she broke down, saying that she loved the pictures as much as she had loved her husband. With difficulty, the pictures and furniture were removed and Mrs. Lurcy lapsed into a bitter silence, attending neither the previews of the sale nor the auction itself. For her there was nothing beautiful about it.

On the night of the sale, a Thursday in November, New York's "upper two thousand" were all in place by seven P.M., an hour early. Towner reports that Eleanor Roosevelt sat beside Helena Rubinstein—"Miss Rubinstein dressed as a rich gypsy, Mrs. Roosevelt as the most stolid librarian." Around them were gathered Rockefellers, Fords, Vanderbilts, the Goulandrises, the Dillons, the Chester Dales, the Lehmans, Mrs. Niarchos and Charles Durand-Ruel from Paris. Mrs. Niarchos was forced to sit on a chair in the wings of the stage. Lou Marion, father of John Marion, the current chairman of Sotheby's in the United States, was the auctioneer. Under his guidance, picture after picture "soared beyond all previous economic tributes," as Towner put it, to the artists under the hammer. Seventeen of the twenty-four painters represented in the sale established new world records, and the sixty-five pictures sold that night earned $1,708,500 ($15.25 million now), the highest total ever recorded for an auction of paintings. When the furniture was sold at two later sessions, the total came to $2,221,355. Yet such was the atmosphere of those days that this figure was surpassed within months by a still more spectacular sale.

Sotheby's challenge to Parke-Bernet was building but the New York house was not as worried as it should have been. Though it hated losing business overseas, it thought there was enough to go around. But this was lazy thinking, and Sotheby's successes continued: Herrmann lists them—the Pierpont Morgan Library's early Italian pictures; the Landau collection of Rowlandsons, snatched from under Parke-Bernet's nose in New York; the Flesh group of Barbizon School pictures from Ohio; the Herschel Jones collection of Americana from Minneapolis; the White-Emerson collection of William Blake from Massachusetts. However, all of these were eclipsed by the Goldschmidt sale. Indeed, the whole auction world was changed by the Goldschmidt sale.

Jakob Goldschmidt was well known to Sotheby's. The firm had been in touch with him when it was courting Germany in 1931 during the dark days of the depression. As mentioned earlier, he had offered to sell his porcelain at Sotheby's in London in 1937 but had been rebuffed. Hence his collection was not an unknown quantity, at least to specialists. Like Weinberg, Lurcy and Siegfried Kramarsky, Goldschmidt was a Jewish banker. Unlike them,

he had postponed his departure from Europe so long that he had been able to bring only part of his collection to the United States; the rest was seized by the Nazis and sold at a special auction organized by the German Ministry of Finance in 1941. Jakob died in 1955, and his estate passed to his son Erwin, who spent a lot of time and energy—sometimes successfully—in seeking restitution of the canvases that had been seized and dispersed. As this shows, Erwin was no pushover. When he first thought about selling, the other big sales had not taken place, and since the first pictures he thought about disposing of were Old Masters he wondered whether they would be better sold in Europe. First he tried Paris and Maurice Rheims, but the arithmetic that Jake Carter had used in his lectures to American audiences still applied at Drouot: the French system would have reduced Erwin's share by 35 percent.

Therefore, says Herrmann, Goldschmidt moved on to London, which occasioned an encounter celebrated in the annals of the art market. He, his wife and their attorney took rooms at the Savoy hotel. They had with them fourteen paintings in heavy wooden cases. At their first encounter, Erwin gave Peter Wilson and Carmen Gronau a rough time. He showed them lists of pictures and prices and asked for their reactions. While they were pondering, he and his attorney left the room. When he returned, he was heard to say, "Die hier gefallen mir viel besser." Carmen Gronau understood German, so she knew what he was saying: "I like this lot much better." It was only then that Wilson realized Erwin had been talking to Sir Alec Martin of Christie's in another suite. Sotheby's won, and the fourteen paintings were included in a sale of Old Masters on November 28, 1956. There was a Corot, a Cuyp, two Delacroix, an El Greco *Virgin,* a Murillo, and *Two Heads of Negroes* by Van Dyck. Since all the pictures were well documented, comparisons with earlier prices were relatively easy. For example, the Corot, which had gone for £12,500 in Paris in 1884, now sold for £27,000. The Murillo, for which Goldschmidt had paid £6,300 and which had gone for £5,880 at the Holford sale in 1928, now sold for £25,000. The El Greco, which had cost £1,350 in 1927, fetched £14,000. The sale grossed £224,411 ($4.9 million now), the highest since Holford, but the main point was that the fourteen Goldschmidt pictures had earned more than half of that, £135,850. Erwin Goldschmidt returned to New York more than satisfied.*

But this, as Frank Herrmann points out, was just the beginning. After the spectacular success of the Weinberg and Lurcy sales, Erwin Goldschmidt decided to sell his father's seven great Impressionist paintings. There were

*It was Erwin Goldschmidt who steered the Weinberg sale in Sotheby's direction because he handled their insurance.

three Manets: a self-portrait; a portrait of Madame Gamby, *Au Jardin de Bellevue*; and his famous street scene *La Rue Mosnier aux drapeaux.** There were also van Gogh's *Jardin public à Arles,* two Cézannes and Renoir's *La Pensée.* The Weinberg sale had shown Peter Wilson what could be done, and the Goldschmidt sale would consecrate this. Sotheby's did not have to contend with Parke-Bernet on this occasion, but there were other rivals. A consortium of London dealers made an offer for the entire collection, which was turned down. Then one day in late spring Goldschmidt called Wilson from New York. "Are you sitting down?" he asked quietly, and then told him that a Greek shipowner (almost certainly Stavros Niarchos) had offered him £600,000 ($12.85 million now) for the seven pictures. This was an immense sum, and Goldschmidt was obviously tempted. Wilson remained sitting down and made the traditional auctioneer's response—that if the Greek shipowner was willing to offer that much in private, it was only because he thought the pictures would fetch more at auction. The sale went ahead.

Although there were only seven paintings in the collection, Erwin Goldschmidt wanted the auction to be devoted exclusively to these works, a maneuver with which Peter Wilson entirely agreed. Moreover, Wilson proposed two other innovations. The catalogue would be the first ever to show all the pictures offered, and in color. Second, the sale would be a black-tie evening event. This was not uncommon in New York, but it was the first time it had been done in London since the eighteenth century and the great days of the first James Christie. A specialist public-relations firm was called in, and they turned Erwin, who was passionate about vintage cars, and his wife, the languid Madge, into a Scott Fitzgerald couple. They let it be known which celebrities had applied for tickets—Dame Margot Fonteyn, Anthony Quinn, Kirk Douglas and Somerset Maugham, among others.

In short, a lot of energy was expended on a sale that took a mere twenty-one minutes, but the brevity of the evening served only to highlight the drama. On that night, October 15, every record in the book was broken. Herrmann says that Wilson climbed onto the rostrum a few minutes late, which must have petrified the television crews who were filming the proceedings live. All the celebrities turned up, but they were eclipsed by the pictures. The first, Manet's self-portrait, went for £65,000, £20,000 above its reserve. The portrait of Madame Gamby went for £89,000 against a reserve of £82,000, and *Rue Mosnier* was sold to George Keller of New York's Carstairs Gallery for £113,000 against its reserve of £90,000. As £100,000 was passed, it was reported, "the grey head of Somerset Maugham shook slowly in amazement." The next-to-last picture sold was Cézanne's *Garçon au gilet*

*This painting was sold at Christie's in 1989 for $26,400,000.

rouge. Its reserve was £125,000 and the bidding started at only £20,000. The contest quickly became a fight between two dealers from Manhattan, George Keller, and Roland Balay of Knoedler, and they soon lifted the bids to a phenomenal £200,000. At £220,000 Wilson surveyed the room. "Two hundred and twenty thousand pounds," he said. "Two hundred and twenty thousand pounds." He paused, according to Herrmann, then added with an astonished air, "What, will no one offer any more?" Keller won, though only in a manner of speaking: he was bidding for Paul Mellon.

That left the Renoir, *La Pensée,* which was the only picture bought that night by an Englishman. Eddie Speelman paid £72,000 for it on behalf of the Birmingham property tycoon Jack Cotton. Speelman's bid brought the overall total for the sale to £781,000 ($16.7 million now) and into the history books. The Goldschmidt sale confirmed what Weinberg and Lurcy had started: high prices and the mania for Impressionism were here to stay.

But the Goldschmidt sale also confirmed something else. London might be the place to sell great art, but much of it was being sent from the United States, and most of the Goldschmidt Impressionists returned there. Between the sale of those seven pictures and the following July, when the season ended, Sotheby's sold American property worth nearly £6 million ($128.5 million now), a total virtually double that reached by any other auctioneer. It was clear that the firm needed a full-time office in New York.

27 | SOTHEBY'S
VERSUS CHRISTIE'S

—

Sometime in late 1957 or early 1958 Sir Alec Martin, the chairman of Christie's, had seen a picture "up a back passage of some great house." It was then sent to Christie's for sale and was catalogued as from the "Veronese school," meaning it might have been the work of any number of minor painters, from Bonifazio de' Pitati to Stefano da Zavio. Only after the catalogue was printed and days before the sale was scheduled to take place did doubts arise. Just in time a major scandal was averted: the painting was in fact *Christ Healing the Blind* by Doménikos Theotokópoulos, better known as El Greco.

Great paintings are always sneaking through salesrooms masquerading as something else. For many dealers this is part of the excitement of the art trade, the opportunities it offers for the discovery of lost works. The Veronese–El Greco, however, was more than just another lost Old Master. The fact that it had been misattributed by the chairman of the company was symptomatic of the low point to which Christie's had sunk in 1957. That year, in which the Impressionist mania was born, and when Leo Castelli at last opened his own gallery, also saw a historic event in the salesroom saga: with the Weinberg and Goldschmidt sales, Sotheby's finally overtook Christie's.

It had been a long time coming. Christie's had actually sold the first Impressionist in Britain as early as 1892, when Degas's famous *L'Absinthe*

(then catalogued as *Figures at a Café*) went to the Société des Beaux-Arts for £180 (it is now in the Louvre). Alec Martin had been friendly not only with Hugh Lane but with Samuel Courtauld in the Twenties, and with Oliver Brown, who ran the Leicester Gallery, a prime source of Impressionists and Post-Impressionists in Britain from the beginning. But these links were misleading; according to John Herbert in his history of Christie's, Alec Martin never really liked modern art. Moreover, whereas Sotheby's continually renewed itself, bringing in new blood, from Montague Barlow to Tancred Borenius to Charles Des Graz, Christie's had not felt the same need. When James Christie IV had retired in 1869 the family connection was ended. The effects of the Settled Lands Act and the art boom that preceded World War I offered Christie's prosperity without its having to seek it out. In the same way the Twenties boom was a bonanza, giving Christie's, among other things, the Sargent and Holford sales. The firm had even benefited from the crash because in hard times notable families automatically sold through it, or used it to approach Duveen discreetly, as happened several times. But between the wars, Christie's was coasting. It was run by a close-knit coterie of like-minded men—"in-bred," in John Herbert's apt term—who tended to assume that the firm would always have a monopoly on Old Masters and great furniture by virtue of its pedigree and close links with the best families. Even World War II did little to change this.

In 1940 Christie's had become a private limited company. With many men off fighting, Alec Martin had brought in a close friend, R. W. Lloyd, as chairman. He was a tough businessman whose policy, says Herbert, was: "Low pay, no expansion and no experts." Even after it was bombed, the firm was able to use Lord Derby's house off Oxford Street, and then Lord Spencer's house overlooking Green Park, until King Street was rebuilt and reopened in 1953. Christie's appeared not to mind that Sotheby's, with Tancred Borenius's help, was developing its picture department, and that with Carmen Gronau's arrival women were admitted to the upper levels. All this changed after the Weinberg and Goldschmidt sales and the El Greco fiasco. The latter was doubly important because it was in pictures, in Old Masters above all, that Christie's was supposed to have the upper hand. A mistake like this was a blow not only to Christie's reputation, but to its self-esteem.

In the wake of these developments, Sir Alec was persuaded to stand down. A new company was formed with Ivan (Peter) Chance as chairman (see figure 68). Further, Christie's announced that it was expanding into Europe, and that its American representation would be more systematic. This was fine as far as it went. It set the pattern for future years, when Sotheby's would be in the lead and Christie's would follow more cautiously—and sometimes more

successfully. But an auction house is only as good as its people, and the new board was setting out to look for new blood more than a decade after Peter Wilson had been given this specific task at Sotheby's.

However, the real turnaround at Christie's, which had to begin in the picture department for psychological and historical reasons, came with the appointment of David Carritt. Carritt was unique. Not only did he have a marvelous eye, but he had a great nose for discovering "lost" works. Born in 1927, he had a puritanical Scots upbringing, one feature of which was that his father did not allow him to read before six in the evening. Despite this restriction, Carritt eagerly scanned pirated copies of *Country Life,* inspecting the pictures. At Rugby and Oxford, where he got a first, Herbert says that he spent his afternoons bicycling to nearby great houses to visit their collections. His most remarkable coup concerned some lost Tiepolos. In 1962 the catalogue raisonné on Tiepolo had been published by Professor Antonio Morassi, and among the pictures was *Allegory of Venus Entrusting Eros to Chronos.* This was listed as "London: formerly Bischoffsheim Collection," and the description mentioned an article in 1876 in which the main pictures and four small grisailles formed part of the ceiling of "one of the grandest homes in Mayfair, London, present whereabouts unknown."

His interest aroused, Carritt found that Henri-Louis Bischoffsheim had in fact lived at Bute House, 75 South Audley Street, Mayfair, and that in 1923 his widow had sold the house to the Egyptian government for its embassy. Carritt promptly asked the cultural attaché there if he could examine the works of art in the building. Permission was readily given, whereupon, says Herbert, "the great Tiepolo was found together with the four smaller ones." The Egyptians were surprised, delighted and not a little horrified at the risk this masterpiece presented. They decided to sell, and the pictures were acquired by the British National Gallery for 390,000 guineas ($6.7 million now).

Carritt did this sort of thing several times in his career, but he was also responsible for the hilarious yet fraudulent practice of inventing amusing names of artists for pictures that were so bad that no obvious candidate suggested him- (or her-) self. Van Essabell, for example, was not the Dutch flower painter he sounded like but Vanessa Bell of the Bloomsbury Group. A picture that was "an absolute bastard" became Laurence Bâtarde, an "Italian piece of piss" became Urini, and so on. This sort of fun, though not exactly harmless, was at least a sign of the improving morale and self-confidence at Christie's. Carritt was still nominally number two in the picture department, after Patrick Lindsay, one of the few old guard still at King Street, but it was the activities of the number two that the art world watched. It was also owing to Carritt that Christie's came to specialize in Impressionist

and modern pictures, for though his eye in Old Masters was unrivaled, he was not blind to other forms of art or to the future. John Herbert says that it was at Carritt's suggestion that David Bathurst joined the firm, from Marlborough. Soon the rivalry between Christie's and Sotheby's was beginning to take the form we recognize today. Still, Bathurst had his work cut out for him; in the very year he arrived at Christie's, 1963, there was another attempt by Sotheby's to acquire Parke-Bernet in New York.

—

Peter Wilson's choice to open the Sotheby's office in New York was Peregrine Pollen. Educated at Eton and Christ Church, Oxford, Pollen was twenty-nine at the time. Slender and presentable, he had traveled the world doing odd jobs that included being a nurse in a mental hospital and playing the organ in a Chicago nightclub. However, he had also filled more substantial positions, one of which was as ADC to the governor of Kenya, Sir Evelyn Baring. It was Baring who wrote to Lord Crawford to request an introduction for Pollen to Christie's. This was sensible, for the young man had family links there; Patrick Lindsay was his cousin. By all the old rules, therefore, Pollen should have been an obvious choice. Yet for some reason, possibly family rivalry, he was turned down. He immediately applied to Sotheby's, where he was snapped up.

Symbolically, Pollen arrived in New York on the Ides of March, 1960. Not that Parke-Bernet wasn't wary, and in one of the first important head-to-head contests under Pollen's leadership, Parke-Bernet won hands down. This was the Alfred W. Erickson collection, which was sold on November 15, 1961, and which included Rembrandt's *Aristotle Contemplating the Bust of Homer,* as well as works by Perugino, Holbein, Hals, Cranach, Van Dyck and Gainsborough. The Rembrandt was not only the greatest of the pictures but also had the most fascinating history. Joe Duveen had bought it in 1907 from the Kann collection in Paris and sold it to Mrs. Collis P. Huntington. After her death, Duveen bought the picture back and sold it to Erickson, cofounder of the McCann-Erickson advertising agency, for $750,000. After the stock market collapse of 1929, Erickson needed cash and sold it back to Duveen for $500,000. When business recovered, he bought it a second time in 1936 for $590,000.

The Erickson sale, says Wesley Towner, offered Lou Marion, the auctioneer that night, an opportunity he had always longed for—to open the bidding for a single lot at a million dollars. He got it almost immediately, but it was not the only watershed that night. For perhaps the last time in a big auction a museum was triumphant. James Rorimer, director of the Metropolitan Museum, bought the painting for $2.3 million, an auction record.

But if Pollen lost the Erickson Old Masters, he was more successful in other fields, including the Impressionists of Walter P. Chrysler, Jr., and George Goodyear, the drawings of John Rewald, the historian of Impressionism, and Jacques Sarlie's twenty-nine Picassos. However, according to Frank Herrmann, the turning point proved to be the Fribourg collection. Of Belgian stock, René Fribourg died in 1963. His money came from a large grain business in Chicago founded in 1813. Before World War II he had lived in Paris and like many others was forced to emigrate to the United States. Though he spoke excellent English, his culture was entirely French, and in New York all his staff were French, including a marvelous chef. Besides pictures, his house was full of French eighteenth-century furniture (including, Frank Herrmann tells us, Napoleon's bed), porcelain, carpets and tapestries, gold boxes and faience. At his death the art world prepared itself for a battle, and Peter Chance of Christie's and Lou Marion and Leslie Hyam of Parke-Bernet attended his funeral. It did no good; Sotheby's, which had only sent flowers, got the business.

When the Fribourg material arrived in London on a specially chartered aircraft, the trade was astounded by its quality. Therefore no one was surprised when the first sale, that of porcelain, raised £180,950, "far and away the highest sum recorded for ceramics of this character," according to Frank Herrmann. The furniture went higher, raising £324,520, and even the gold and enamel boxes fetched £142,187. In all, the Fribourg sale grossed more than $3 million. This was a relief for Sotheby's, since the fifteen-page contract had stipulated that no commission was payable up to $1.5 million but that it would be 15 percent thereafter.

The success of the Fribourg auction coincided with another significant event. On September 10, 1963, Leslie Hyam, Parke-Bernet's English-born president and chief executive, was found dead in his car. The windows were closed and the cause of death was given as carbon-monoxide poisoning. Hyam's demise was therefore, as Wesley Towner put it, "quite possibly not accidental." Whatever the reason, this grisly event set in motion the final dance that led to Sotheby's takeover of the U.S. auction house that Hyam had led. At the time of his death, Parke-Bernet was ripe for a takeover. Approaches had again been made by Sotheby's a year earlier, as well as by Christie's and by a consortium of French auctioneers led by the ubiquitous Maurice Rheims.

When Hyam died, Peter Wilson was in Japan. Pollen phoned him there and Wilson flew to New York immediately. Negotiations dragged on, for with the exception of Wilson and Pollen, neither suitor was sure of the other. Parke-Bernet was a very different kind of auction house. Sotheby's had better connoisseurship, but Parke-Bernet gave a better presentation (for example,

they employed an interior decorator for the display of objects prior to each sale). Their auctioneers were more theatrical, their catalogues more sumptuous and also more dignified. Most important of all, Parke-Bernet's approach had produced a business in which there were more private clients and fewer trade elements than was true in Europe.

Peter Wilson was eager to enter this world, of course, but some of his colleagues were less keen; in fact, says Herrmann, the Sotheby's board was fairly evenly divided. The deadlock was broken by Jim Kiddell, who argued that the views of the younger board members should prevail because they had more of a stake in the future. With this solved, the main stumbling block shifted to New York. Colonel Richard Gimbel was a Parke-Bernet shareholder, and he was determined not to sell his shares, whatever anyone else might do. He was "fiercely xenophobic," but that apart, his stand was rather magnificent; at one board meeting he opposed eighteen motions single-handed after trying to have the election of new directors declared null and void. However, other resistance in Parke-Bernet crumbled when Sotheby's let it be known that if the acquisition did not go through, they would open up their own auction premises later in the year. Since at this stage the value of works sent from the United States to Sotheby's in London already exceeded Parke-Bernet's gross, anyone could see where the future lay. Still, Colonel Gimbel kept resisting, and the American press rallied to him. But finally he was persuaded; he sold his shares for nearly three times what he had paid for them three years earlier and was given various privileges regarding catalogues. At last the way was clear for Sotheby's in the United States. Parke-Bernet cost just under $2 million.

‗

Whereas in London and New York 1957–58 marked a turn for the better, the exact opposite was true in Paris. As mentioned earlier, the early Fifties there had been marked by much speculative buying of art, and Kahnweiler had expected the title of "capital of the art world" to return to the city. But when the franc was devalued in 1958, the year of the Goldschmidt sale, the game was up. Most affected was the art in which there had been the greatest speculation in the early part of the decade. Small Left Bank "try-out" galleries, showing brand-new untried art, continued to do just that. Established galleries selling established—and mostly dead—artists also survived. Those that crashed, noted Raymonde Moulin, were the galleries selling new artists who had recently become popular and therefore expensive. A further twist in this was the Wall Street slump of 1962, which had particularly bad repercussions for France, resulting among other things in the 1963 "stabilization plan" designed to steady prices. This was successful in France in containing

the inflationary psychology that was threatening to take hold, but it was bad for both salesrooms and dealers; prices at auction slumped to a tenth of what they were in private galleries. It was in this period, 1958–63, that the fall of Paris as an art center really became apparent. With a few exceptions, the French art market did not recover until the late 1980s.

One of the exceptions—in fact the greatest—was Wildenstein. In 1959, at the very time that Paris was being toppled from its position, a famous article was published in the French magazine *Réalités* on Wildenstein. It was one of the few grand old galleries left and was functioning as well as ever. Duveen, Seligmann, Wertheimer, Sulley and Gimpel had all disappeared or been amalgamated into other firms. (Duveen was bought by Norton Simon.) In the Fifties James Byam Shaw had led Colnaghi's. He was much respected, as much a connoisseur as a dealer, but by 1960 the firm was no longer the power it had been. Of the old firms only Agnew, Knoedler and Wildenstein retained anything like their former luster, and of these Wildenstein was by far the most impressive. Just how impressive was revealed by the *Réalités* article.

Georges Wildenstein (see figure 69) had been groomed by Nathan; he had met Bernard Berenson as early as 1906 and had written his first articles for the *Gazette des Beaux-Arts* before he was twenty. He had made his first major discovery during his national service when he had cleaned a portrait of Napoleon that hung in the office of a general at the Invalides, where Georges was posted: under the grime, according to Pierre Cabanne, he found the signature of Ingres. However, the single most startling aspect of the Wildenstein story was the gallery's stock, said in the *Réalités* article of 1959 to consist of four hundred primitives, one Fra Angelico, two Botticellis, eight Rembrandts, eight Rubenses, three Velázquez, nine El Grecos, five Tintorettos, four Titians, twelve Poussins, seventy-nine Fragonards and seven Watteaus. As for modern pictures, the firm was said never to have fewer than twenty Renoirs, fifteen Pissarros, ten Cézannes, ten van Goghs, ten Gauguins, ten Corots, twenty-five Courbets and ten Seurats. Until recently, the article said, Wildenstein always had 250 Picassos in stock as well, but these had been sold, for Georges Wildenstein was one of the few people who didn't like Picasso's style.

Wildenstein himself was not impressed by these numbers. "If I were a shoe-maker, I would have two hundred pairs of boots, one hundred moccasins . . . fifty Wellingtons." His own taste, which he carefully distinguished from the decisions governing his stock, was for miniatures, illuminated manuscripts, Lorenzo Monaco and Luca di Paolo Veneziano, and these works decorated his ground-floor office with its eight windows opening onto a private yard. His amazing inventory was achieved partly as a result of some bold acquisitions, usually of entire collections, and this he had learned from

his father. Cabanne tells us that Nathan Wildenstein's coups had included the Merowski collection (two Gauguins, two Renoirs, two Pissarros, three Matisses, two Utrillos, three Sisleys and a still life by Cézanne); the Rudolphe Kann collection, estimated in 1907 to be worth five *billion* francs (that would now be $20.56 billion); and the Foule collection, bought in 1927 (one Filippo Lippi, one Veneziano, a group of fifteenth-century primitives and the colossal choir screen from Pagney).

Georges had all but matched this. His coups were the Oscar Schmitz collection, bought in 1936 (four Boudins, six Cézannes, two Corots, two Courbets, five Daumiers, five Degas, seven Delacroix, five Monets, two Manets and six Renoirs); the David-Weill collection, bought two years later (four Bouchers, seven Chardins, eleven Fragonards, two Goyas, three Guardis, four Davids, seven Hugh Roberts, four Watteaus, two Delacroix and two Degas); and finally the Henry Goldman collection, bought in 1940 (one Holbein, one Rubens, one Van Dyck, one Frans Hals, one Clouet, and Rembrandt's *Saint Bartholomé*). The *Réalités* article hinted at the Wildenstein wealth. "He puts a cheque for [FF] 300,000 on the table [say $620,000]; nobody bats an eyelid. Everyone knows that he's got it, . . . that his fortune is immeasurable . . . and that money no longer counts once he has decided to buy a painting or a collection."

The other impressive aspect of Wildenstein was and is its library and the way it did and does business. In 1959, the library contained 300,000 books, 100,000 photographs and 100,000 sales catalogues. The *Réalités* article again:

> He can instantly establish the composition of an unknown Polish collection, or the value to the nearest million of a private gallery in Bogotá. Renoir, for example, created 6,000 paintings. Wildenstein has 5,500 photographs kept in eighty boxes, each catalogued according to subject with a bibliography, notes and articles for each one of them. He receives three catalogues of each important sale. Two are cut up for the files; his employees are much busier with documentation than with sales. He has acquired the personal libraries and files of a number of distinguished scholars and researchers. He buys 1,000 books a year. . . . Beginning in 1955 he decided to methodically examine the archives of all the notaries in France prior to 1850, for any mention of paintings in wills, etc., that might have got lost. It was estimated that this task might take three generations, but that didn't bother him. He soon discovered two le Nains in a chapel which had appeared on notaries' lists but had since "disappeared." . . . Every morning he receives about forty letters containing information or asking for instructions. They come from Germany, South America, Italy and Japan. All the photographs he is sent are examined; then telegrams are sent out. "Go up to twenty million," "Not interesting," "Buy . . ."

More than any other art dealer, Georges Wildenstein, who liked to say that he was born in the eighteenth century, was master of an empire. Pierre Cabanne reports that he even likened himself to a dictator. "During the Korean war people were weighing up the possibilities of a generalized conflict. 'There won't be any war,' assured Georges. 'Why?' 'I know how Stalin thinks. I think in the same way he does. At the bottom line Stalin is a bit like me.' " This was said only partly tongue-in-cheek, for by 1959 Wildenstein was a real force in France. In 1955 his vice president in New York, E. H. Roussek, was convicted of wiretapping a rival. At about the same time, Wildenstein provided recommendations for the French culture budget, which was unanimously adopted by the National Assembly's committee on the arts. Wildenstein's unique quality was his masterly style. In March 1963, at the moment when the art trade was suffering most in France and one dealer after another was going under, he was elected to the Académie des Beaux-Arts. The firm now had branches in Buenos Aires and Tokyo as well as in London and New York. When Georges died in June 1963, his son, Daniel, took over the firm.

—

In the summer of 1961, Ileana Sonnabend, who had remarried and was living partly in Europe and partly in New York, first heard about James Rosenquist's work—paintings and sculpture made from advertising materials, spaghetti look-alikes, automobile fenders—and went to see it at Coenties Slip, near the Battery on Manhattan's southern tip. She told Ivan Karp about the artist, and he visited Rosenquist, then also took Castelli. By this point Castelli was aware of both Lichtenstein and Andy Warhol, and he had taken on the former but not the latter. (When Warhol visited Castelli's gallery to buy a Jasper Johns drawing, he saw a Lichtenstein in the back room and remarked, "I do paintings like that." Castelli, Tomkins says, thought Warhol's images too weak. Pop Art was being made, but none of these three artists knew about the other two.)

Rosenquist wasn't taken on by Castelli either, and eventually he joined Richard Bellamy's Green Gallery, which was financed by Robert Scull. Other Pop artists were making their mark now, among them Claes Oldenburg, Jim Dine, Tom Wesselmann and Robert Indiana. Bellamy was to them what Castelli had been to Johns and Rauschenberg and Kahnweiler had been to the Cubists. Yet despite his eye for new talent, Bellamy's Green Gallery was never a success commercially and it was left to Sidney Janis to produce the next shock, a show of Pop Art held in the spring of 1962 which he originally called the "New Realists." This, says Tomkins, produced the biggest furor in New York since Castelli's first Johns and Rauschenberg shows in 1957 and

1958. The Abstract Expressionists were no less appalled than anyone else, and all of that them except de Kooning left Janis's gallery. They were just as critical of Castelli for having taken on Lichtenstein. Interestingly, although initially the media and critics were outraged by Pop Art, Rauschenberg, who had won the International Painting Prize at the Venice Biennale in 1964, and Johns soon changed their minds about it. The main collectors in New York— the Tremaines, Scull, Richard Brown Baker and Count Panza—never needed to change; they all bought the work straightaway.

By this time Betty Parsons was a famous dealer, going her own way. She had inherited money in 1959 and that may have removed some of the pressure. She continued to paint, and indeed, galleries in the United States, and the Whitechapel in London, gave her exhibitions. She became interested in Eastern philosophies. She took Sidney Janis to court in a wrangle over gallery space; she lost, had to move and never spoke to him again. Her stable of artists included Ellsworth Kelly, Agnes Martin, Eduardo Paolozzi, Alexander Liberman and Ruth Vollmer. According to Lee Hall, Jack Tilton, one of Betty's assistants, believed that she preferred young unknown artists: "She wanted no possibility of being overshadowed by giants." Although she was still a presence in the art market, she was not quite the formidable power she had been in the Fifties.

On the other hand, the arrival of Pop Art showed Castelli's flexibility and receptivity to change, qualities that distinguished him from Durand-Ruel and Kahnweiler. Tomkins calculates that Rauschenberg's prize in Venice meant that his prices rose from the $2,000–4,000 range in 1963 to $10,000–15,000. But by 1964 Castelli's main earners were Stella and Lichtenstein, as well as Warhol and Rosenquist, who both moved to his gallery that year. Castelli could sense the way art and the collecting public's taste was going. Rosenquist had come from Richard Bellamy's Green Gallery, which by now had closed. Bellamy had discovered many artists—Oldenburg, Rosenquist, Robert Morris, George Segal, Larry Poons and Donald Judd—yet the numbers never added up, and he had offered Castelli first choice of his artists. Besides Rosenquist and Warhol, Castelli chose Poons, Morris and Judd. Colorfield painting and Minimalist art were given a leg up, though even Castelli conceded (much later) that it had been harder to sell Minimalist and conceptual art than other styles.

With Karp's help, Castelli now instituted another innovation. Tuesday-night openings were then a prominent feature of the New York art world. Castelli, however, held its openings all day on Saturdays, "with no booze," in Calvin Tomkins's words, "and no special invitations." This suited the mood of the times and helped to create a more serious atmosphere at the gallery. Barbara Rose, the wife of Frank Stella and a perceptive critic and

journalist, told Tomkins that what she thought Castelli created was "a sense of art history being made right there and then." To Leo his artists were in the same league as Cézanne, Matisse and Picasso, "and he made collectors believe it too." In an interview with the author Mary Boone agreed, saying, "Leo's most important contribution was that he made a climate for the collector." Castelli's was a very soft-sell approach; Victor Ganz said he could not recall his ever making the slightest effort to "sell" a painting. In fact, Ganz told Calvin Tomkins that Castelli never even discussed a work in aesthetic terms, although Tomkins wrote that "once, not long after he [Ganz] remarked to Castelli that a Johns painting on the wall reminded him of a late Beethoven quartet, he happened to overhear Castelli tell another visitor that Johns's paintings were like late Beethoven quartets."

Artists used to refer to Castelli as Mighty Mouse, though not to his face; this was not altogether flattering, but neither was it particularly damaging, unlike the rumors in the late Sixties (and since) that at auctions he would "buy in" works of his own artists at prices above what they had been fetching on the market in order to drive up their prices. This has been a stock allegation against dealers and a stock tactic of dealers through the ages; Castelli has always vehemently denied that it applied to him.

Sidney Janis, the early dealer for the Abstract Expressionists, had not been terribly interested in exporting their works abroad. As the Sixties progressed, Castelli and his former wife, Ileana Sonnabend, took a different attitude with their artists and made sure they were well displayed in Europe, which was eager to see the Americans and had a flourishing Pop Art school of its own, especially in Britain. Los Angeles was relatively slow to catch up at first, but Castelli formed a network of friendly galleries in Los Angeles, San Francisco, St. Louis and Toronto that helped decentralize the market and spread the word. Then, in 1971, Castelli made another move that changed the shape of the game. Together with André Emmerich and John Weber, Leo and Ileana moved into a renovated paper warehouse at 420 West Broadway in SoHo. Ileana needed a presence in New York, for the Paris art market was not what it had once been. SoHo was a new and exotic area for galleries in Manhattan, but it would not remain so for long.

—

"Friday, March 19th. Rembrandt, lot 105, Portrait of Titus. When Mr Simon is sitting down he is bidding. If he bids openly when sitting down he is also bidding. When he stands up he has stopped bidding. If he then sits down again he is not bidding until he raises his finger. Having raised his finger he is continuing to bid until he stands up again."

This complicated agreement made between Patrick Lindsay of Christie's and Norton Simon, at a twenty-nine-minute meeting early on the morning of March 19, 1965, was to spark one of the great salesroom controversies of modern times. The arrangement concerned the sale of Rembrandt's *Portrait of Titus,* which had been part of the Cook collection of Old Masters. This was one of the most important private collections in Britain, begun in the nineteenth century by Sir Francis Cook, whose fortune came from ladies' "foundation garments." Sir Francis's descendant, also called Sir Francis, was in tax exile on the island of Jersey and decided to sell five important pictures, partly because he believed—rightly, as it turned out—that the Labour government intended to introduce a capital gains tax. The other four pictures were almost as magnificent: Velázquez's *Portrait of Don Juan de Calabazas,* Dürer's *Road to Calvary,* Turner's *Brentford Lock and Mill,* and Hogarth's *A Family Party.* The standard of the paintings was so high that the 1965 season was conceivably the best Christie's had held since the Holford collection in 1928 (thus confirming the doldrums the firm had been in during the interim).

However, the interval before the sale was nerve-racking because Sir Francis was obsessive about security and refused to let the pictures be flown to London commercially. A special aircraft had to be chartered, says John Herbert, and both the plane itself and the pilot were to be approved by Sir Francis. Patrick Lindsay, who flew his own Spitfire, recommended a Dakota. Two "minders" for the paintings were dispatched to Jersey, armed with posh leather-covered blackjacks specially bought at Swaine and Adeney in Piccadilly. On the flight to London a violent thunderstorm broke out, but the Dakota landed safely and the weapons were not needed.

Nerves of steel were. Norton Simon, the California founder of the Hunt Food Corporation, had let it be known that he wanted a private viewing of the picture. Charles Allsopp was delegated to meet him at Heathrow, carrying a copy of the *Financial Times*, "a white carnation and a pair of dark spectacles" as identification. Simon's plane was very late, touching down just before midnight. Nevertheless, Allsopp, in a hired Rolls-Royce, took him straight to King Street. It was after Simon had seen the picture, by which time it was well into the small hours, that he insisted on his complicated bidding arrangements.

Simon's late arrival and his bidding habits were not the only colorful aspects of the sale. There was also the romance of the Rembrandt's discovery. In 1825 a certain George Barker, a British picture restorer, had missed his boat home from Holland and been forced to spend the night at a farmhouse near The Hague. When he awoke next morning, he noticed a portrait of a boy hanging above his bed, and over breakfast he admired it so much that the farmer gave it to him. When it reached England, the picture was also admired by Lavinia, the wife of Barker's patron, Lord Spencer. Her enthusiasm was not misplaced, for it was *Titus*.

The five Cook pictures were sold at the end of an Old Masters sale of 105 paintings. John Herbert was there. The bidding on lot 105, the last, he reports, began at 100,000 guineas, and within six seconds, the amount had risen to 300,000 guineas. This sum was called out by Norton Simon, who therefore with his first bid broke his agreement with Patrick Lindsay. He called out five more bids before appearing to drop out at 650,000 guineas. The bidding went on between Agnew and David Somerset (now the Duke of Beaufort) of the Marlborough Gallery, reaching 740,000 guineas. Peter Chance, the auctioneer, then turned to Geoffrey Agnew and asked him if he would bid again. Agnew declined. Next, Chance turned to Norton Simon and asked him eight times if he would bid again. Simon said nothing and the picture was knocked down to the Marlborough. Only then did Simon speak. "Hold it," he said, "hold it." While the bidding had reached its climax, he had been standing, so under the terms of his agreement with Patrick Lindsay

he was not bidding. Yet now he claimed that he *was* bidding. Norton Simon, Herbert says, pulled the agreement from his pocket to justify himself, but it only made the confusion worse. In the end Chance decided he had to do his duty by the vendor—in those days the only commission came from the vendor—and the bidding was resumed. Not surprisingly, David Somerset was put out and refused to go any higher, which meant that Simon got *Titus* for 760,000 guineas, or £798,000 ($13.95 million now).

In retrospect, as John Herbert says, Christie's was probably wrong to accept such a complicated bidding arrangement in the first place, but Chance could scarcely ignore the bids from such a rich man. The situation was farcical and was well summed up by cartoonist Osbert Lancaster, who in his cartoon in the *Daily Express* the next day showed an auctioneer selling a Rembrandt with the caption "Don't forget that by private arrangement Lady Littlehampton is still in the bidding as long as she is standing on her head."

This should not obscure the fact that the Rembrandt went for a marvelous price, as did the entire sale, which fetched £1,170,529 ($3.2 million, now $20.46 million), the highest sum ever for any picture sale in Britain. And in fact 1965, the year of this sale, was when Christie's turned the corner. In 1962 they had actually had a small loss of £6,000, but in 1965, in addition to the Cook collection, the firm sold sixty-six drawings by Tiepolo, Alfred Morrison's collection of Oriental porcelain and coins, Sir David Salomon's collection of Breguet watches, and pictures and furniture from Harewood House, including a Chippendale desk.

Others were making the most of the boom now getting under way, and in familiar style. One of the other collections sold at Christie's that year came from Northwick Park, a house near Moreton-in-Marsh in Gloucestershire, which contained pictures, antiquities, furniture, porcelain and silver amassed at first by John, the second Lord Northwick, and then by Lord Edward George Spencer-Churchill. Some felt it was the most important British collection to be sold since World War II, the paintings consisting of works by Hogarth, Gainsborough, Reynolds and Romney. But though the paintings and the antiquities did well enough, it was the end of the sale, the items sold on the premises—everything from walking sticks to footstools—that attracted the most attention. This part of the sale grossed £68,597, a pitifully small sum—which was part of the point, for the Northwick Park sale was hit by a massive ring second only in size to the one involved in the Ruxley Lodge sale.

The Northwick Park ring was particularly sensational for two reasons—first, because it was infiltrated by a London *Sunday Times* journalist, Colin Simpson, who tape-recorded the entire proceedings and published them a few days later; and second, because it involved not just some disreputable back-

street dealers but the very cream of the British furniture trade. The cabal was held in the back room of the Swann Inn in Moreton-in-Marsh, Gloucestershire. Simpson's microphone was tucked up his sleeve, connected by a pocket transmitter to his "control" monitoring the events in a nearby van. There were about fifty dealers in the conspiracy, some of whom were on the council of BADA, the British Antique Dealers' Association, and one of whom, Major Michael Brett, a dealer from Broadway, Worcestershire, was its president. The resulting three-thousand-word article in the *Sunday Times* caused a scandal, questions were asked in the House, and more than a dozen members of BADA's council were forced to resign. Northwick Park proved what many people had long suspected—that the change in the law brought about by Ruxley Lodge had not abolished rings, merely driven them underground.

Despite this exposé, the ring continued to flourish, as an even more celebrated case some years later was to prove. In March 1968 the contents of Aldwick Court, Somerset, were sold by Bruton, Knowles of Gloucester. Among the pictures was one, a *Madonna and Child,* that was catalogued as "Sienese School, fifteenth century." There appeared to be little interest in the picture and it was knocked down for £2,700. However, among those present was a London dealer, Julius Weitzner, who won the settlement held later (this time at the Paradise Motel, Cowslip Green). Weitzner promptly announced that the "Sienese school" picture was in fact a lost Duccio and that he had sold it to the Cleveland Museum in Ohio for £150,000. At this juncture the government's review committee on the export of works of art stepped in and delayed delivery of the picture for six months in order to give the National Gallery in London time to come up with the purchase price. The money was raised and today the picture is in the National at Trafalgar Square. Another scandal followed, but Weitzner kept the £150,000.

While Christie's was recovering in London, Sotheby's moved ahead in New York. The first example of the skill of Peter Wilson and Sotheby's, and of the growing passion for the Impressionists and Post-Impressionists, was an inaugural splash in the spring of 1965, after some months of ironing out the differences between Sotheby's and Parke-Bernet's styles. For once, two sales were planned for a single night, with something special in between. The first, which began at six-thirty, was an auction of some fine Impressionist and Post-Impressionist works. The prices were astronomical, one Degas fetching $410,000 and a van Gogh, *Les Déchargeurs* (*The Dockers*), bringing $240,-000. This sale was also a first for Lou Marion's son, John, today such a pillar in New York (see figure 80). He was on the rostrum that night.

After this, everyone present, staff and public alike, adjourned for an imagi-

native dinner that Wilson had conceived. The whole third floor of the Parke-Bernet building at 980 Madison Avenue had been decorated to resemble the Café de la Nouvelle-Athènes, the famous brasserie on the place Pigalle, favorite of both Degas and Manet, where in 1876 Degas had set one of his most famous pictures, *L'Absinthe.* John Rewald, the distinguished historian of Impressionism, was persuaded to collaborate, ensuring that the details were authentic.

After the dinner, there was another first, for, having at last obtained his New York license, Peter Wilson conducted the second sale. However, this sale was also a first in other, more important, ways. The Philippe Dotremont collection contained forty-three works, most by contemporary artists, French and American. Many of the paintings, according to Herrmann, were barely five or ten years old, and this was the first time that canvases by these artists had come under the hammer. Robert Rauschenberg's *Gloria,* painted in 1956, was only the second work of his ever to be offered at auction. That night a Jackson Pollock went for $45,000 and a Calder mobile fetched $10,000.

These two sales not only confirmed the strength of the Impressionists but suggested the promise of the contemporary market; the Dotremont collection totaled $510,000, in comparison with the $2,345,000 raised before dinner.

But if Sotheby's led the way in New York, Christie's was now just as active in countries that would prove equally important commercially, even if they were less newsworthy. Those countries were Japan and Switzerland. In 1966 Christie's had taken on John Harding as its Japanese expert. His knowledge had been acquired when he was a merchant seaman and his ship was stranded in Tokyo for several months with engine trouble. John Herbert reports wryly that Harding's first sale in London, of Japanese prints, was a disaster, conceivably the worst since World War II, the total reaching only £200. As a result, however, instead of being fired, he was sent back to Japan on a fact-finding tour. One of the facts he came across was that Sotheby's had been invited to mount an auction there during "British Week" in 1969. The embassy staff refused to let Christie's in on this, so Harding evolved a plan to hold a rival Christie's sale at the Tokyo Bijutsu Club.

This was a sensible idea, for at that time neither Sotheby's nor Christie's was exactly a household word in Japan, whereas the Bijutsu Club was known throughout the trade. Also, art auctions in Japan are rather different from what they are in the West. Japanese auctioneers do not specify an estimate or make public any reserve price, though, surprisingly to Westerners, they do fix a *maximum* figure. Further, if several dealers want the same object, they discuss it among themselves and will even draw straws to determine who wins. Only the seller pays a commission, 10 percent, so, all in all, the auctions

are heavily weighted in favor of the trade. Another difficulty, to Western ways of thinking, is the requirement that auctioneers submit to the police the names and addresses of all customers a week *before* the sale. This is intended to help the auction houses guarantee that stolen works will not be traded, but of course it has the effect of driving away many private customers who, for tax reasons, don't want the authorities to know what they are buying. (This particular provision would prove a stumbling block later on, when both Christie's and Sotheby's wanted to hold their own auctions in Tokyo.)

Christie's overcame these difficulties, however, and the sale was held in May 1969, before the Sotheby's auction, and had two parts: Oriental works of art and arms and armor, conducted by a Japanese auctioneer, Keizo Mitani; and paintings, with Peter Chance holding the sale, as was Japanese custom, says Herbert, in his socks. Many of the lots were consigned by the British trade, who watched the auction by closed-circuit television at King Street in London. They saw Renoir's portrait *Madame Henriot,* which had sold for £5,500 in 1962, now go for ¥29 million ($504,000 now). The Japanese love affair with Impressionism had been rekindled.

Switzerland was no less important than Japan and jewelry hardly less profitable than Impressionists (indeed, the collectors often overlap). Christie's first jewelry sale in Switzerland was a collection of forty-six pieces belonging to the late Nina Dyer, a former model who had led a fairy-tale life but ultimately a tragic one. Married first to Baron Hans Heinrich Thyssen-Bornemisza and then to Prince Sadruddin Khan, she had committed suicide at the age of thirty-five. The sale of her diamonds, John Herbert says, more than doubled the previous record for a jewelry sale.

The Bijutsu sale and the Dyer sale took place in the same month of 1969, and their success did not go unnoticed. Indeed, the profitability of its jewelry sales in Switzerland was one of the reasons why Christie's would go public in 1973, well ahead of Sotheby's. It had taken more than a decade since the Goldschmidt sale for Christie's to scramble back to Sotheby's level, but at last it had done so.

–

In the early months of 1967 stories began to appear in the American and European press of an art-forgery scandal of epic proportions. Three individuals were involved. The most well known was the victim, a Texas oil millionaire, Alger Hurtle Meadows, who, it was alleged, had been sold forty-four fake French masters by Dufy, Degas, Picasso, Derain, Vlaminck and Modigliani. The villains in the piece were two dealers, Fernand Legros, a naturalized American, and Réal Lessard, a Canadian. The value of the forged works—that is, their value if they had *not* been fakes—was said to be $2

million. At this stage the identities of Legros and Lessard were not revealed in the press for legal reasons, but on the art-world grapevine their names were well known. The rumors were amplified by allegations of a "factory" in the south of France where the forgeries were turned out, but no action was taken at the time. Then, a few weeks later, a further scandal erupted, this time at Pontoise, near Paris. There, some paintings put up for auction—two Dufys, two Vlamincks and a Derain—were denounced by the police as forgeries, and their ownership was attributed to Fernand Legros. Only a week later, a Socialist member of the Japanese Diet brought up the question of the authenticity of a Dufy, a Derain and a Modigliani acquired in 1963 and 1964 by the Japanese National Museum of Western Art in Tokyo. The pictures had been bought with public money, and once again the seller had been Fernand Legros.

So began one of the most celebrated forgery scandals of this or any other age. What emerged in the following weeks and months was that Legros was the exclusive dealer for the works of a master forger, a Hungarian named Elmyr de Hory. It also emerged that de Hory had been faking pictures of one sort or another since 1946, and fooling collectors and dealers as far apart as Buenos Aires and Biarritz, Los Angeles and Lausanne. More incredible still, he had been found out a number of times, but because of swift action on his part in changing his name and moving on, as well as a lack of coordination on the part of the art trade and the police, he had never been caught.

De Hory was a forger, not a salesman, and Legros, whom he had met at a party, fitted the second role perfectly; he was able to invent a provenance for de Hory's work with plausible certificates from French experts (who in many cases were taken in), or in some cases from the widows or other relatives of the dead artists themselves. Over the years, de Hory made a comfortable living, but Legros and his assistant and lover Lessard became millionaires. The trade was taken in on a widespread scale: Knoedler sold a de Hory "Matisse" for more than $60,000 and was so proud of the fact that it advertised the sale, with a photograph of the painting, in *ARTnews*. In addition, Legros held an exhibition at the Galerie Pont-Royal Hotel in Paris entitled "Homage to Raoul Dufy," in which twenty-six of the thirty-three pictures were by de Hory. On another occasion Kees van Dongen authenticated one of de Hory's paintings as his own. De Hory was eventually jailed, but not before he had become a picaresque hero to many who hate the pretensions of the art world.

The de Hory scandal was a child of its time, for as the Sixties came to an end a fresh twist was overtaking the art market. Wall Street was now enjoying a boom, and thousands of upwardly mobile Americans—and, to a lesser extent, Europeans—started to spend their spare cash on art. In doing so, they

were annulling what had been known as the "twenty-year rule." In 1926,
H. C. Mariller, one of the historians of Christie's, had written, "The work of
the younger man active at the time [i.e., contemporary artists] does not come
on to the market, but remains with the original purchaser on an average for
twenty or twenty-five years. . . . such pictures as do come up in a sporadic way
are as a rule minor ones which pass unnoticed and have no effect." But now
life moved faster, and contemporary art was being actively traded. At the
same time, however, many people felt divorced from contemporary art. As
Tom Wolfe pointed out in *The Painted Word,* in the Sixties there was a
shrillness about art criticism, a didacticism that was bent on telling people
what was important and what was not. Some people swallowed what the
critics said, but to others, contemporary art seemed merely ugly or, as in Pop
Art, banal. For many this produced a retreat into the softness, safety and
subtlety of Impressionism.

Hence, for the first time since before World War I, as Nicholas Faith has
pointed out, the art market saw a boom in the works of both living and dead
artists. This was good news for the trade, but it could not obscure the other
important change that now became apparent. As a result of the growth in
publicity associated with auctions, together with the social changes in the
wake of World War II that had created a new, more prosperous, more
adventurous middle class, many people who might once have gone to dealers
now went to salesrooms. By this time there was more rivalry between sales-
rooms and dealers than ever before, and the growth of specialized fields was
partly responsible for this. Hitherto, dealers with specialized knowledge
would always have swamped Sotheby's or Christie's, but as the auction
houses employed more and more experts of their own, this familiar landscape
began to change. Of course dealers were benefiting from the added publicity
the auction houses were bringing to the market, but the boom in the late
Sixties created conditions not dissimilar from those in the late Eighties: prices
were rising so fast that dealers were sometimes left behind. Nicholas Faith in
his book on Sotheby's quotes the most celebrated example, which occurred
at a sale of modern art when a Henry Moore bronze, a family group, was sold
for £6,500. In the middle of the auction a well-known dealer suddenly rose
from his seat and dashed for the door. Later he explained that he had a
similar bronze in his gallery, priced at £900, and that he had to phone his
partner to hide it before it was "given away."

The end of the Sixties saw two other developments that were indicative of
later trends. At Sotheby's Peter Wilson had been extending "special arrange-
ments," the name given to guarantees that were demanded by an increasing
number of American estate lawyers. And at Christie's, David Carritt was on
the move. He had been persuaded to join Artemis, a new art-investment

company set up by Baron Léon Lambert of the Banque Lambert, Brussels, and Baron Elie de Rothschild of Paris. Their plan was to buy the best works, lend them to museums for a while, and then sell them at a profit. The philosophy of the Bearskin had never died in France.

As Carritt left, however, the picture department of which he was such a distinguished member saw its greatest triumph ever. This was the sale of Velázquez's portrait *Juan de Pareja.* In a survey of art historians, museum curators and connoisseurs in the Eighties, Velázquez was named as the experts' favorite painter. This had not always been so, as the story of *Juan de Pareja* shows. In the eighteenth century it had belonged to Sir William Hamilton, British ambassador to Naples and the husband of Emma, Nelson's lover. After his return from Italy, he was forced to sell the picture, at Christie's in 1801, for the princely sum of 39 guineas (approximately $200). A decade later it passed into the family of the Earls of Radnor for £151 14s 5d ($610), and it remained with them until 1970. The reason for the sale now was a familiar one, massive death duties following the demise of the seventh earl.

Patrick Lindsay was the auctioneer at the sale, and though there were several bidders to begin with, these were soon whittled down to two people: Geoffrey Agnew and a young man in the second row whom, says Herbert, Lindsay either didn't know or pretended not to know. The bidding passed the million mark without slowing and did not falter until it reached double that. At 2,200,000 guineas ($32,287,000 now) Agnew dropped out and the young man had won. Across the road from Christie's the young man's father was already starting lunch in Prunier's. Daniel Wildenstein had given his son, Alec, instructions to buy the picture whatever the price. As usual, Wildenstein's boldness paid off. Before long the Velázquez was in the Metropolitan Museum in New York. Between *Titus* and *Pareja,* Christie's had come back in style. The record price of the Velázquez would last for ten years.

In London, postwar art-dealing had some instructive parallels with New York. In 1957, the year of the Weinberg sale, the year when Peter Wilson took over at Sotheby's and Leo Castelli opened in Manhattan, Victor Waddington opened his first gallery in London at 2 Cork Street. Waddington, who had previously owned a gallery in Dublin, saw the potential in contemporary art, and in the British Isles Cork Street was London's street of pictures. Dudley Tooth was the Paul Guillaume of the day, the society dealer, dashing, elegant and well-connected. The Lefèvre Gallery had virtually closed during the war, and its old premises at 1A King Street had been bombed in 1943. Willy Peploe, son of the Scottish "colorist" S. J. Peploe, had joined in 1949 and helped to revive the gallery, aided by Gerald Corcoran. They had begun by showing such British artists as Moore, Sutherland, Bacon and Lanyon. There was a brief vogue for Ben Nicolson, to whom the gallery gave one-man shows in 1950 and 1954, but then the gallery found more international artists—Calder (1951 and 1955), Buffet (1951) and Magritte (1953). Lefèvre formed links with such European dealers as Paul Brame, Louis Carré and Heinz Berggruen and by 1958 was taking on the flavor it has today.

Agnew's main problem at the end of World War II was to revive its American trade, "which in 1946 had fallen to precisely nothing." The firm

made the important decision that because of the promise of commercial jets in the future (for both people and pictures), frequent travel by directors could replace expensive foreign branches. The main clients this new approach landed were Mr. and Mrs. Paul Mellon, who with Agnew's help formed a magnificent collection of English art, and also a number of North American museums, especially the National Gallery of Canada.

Of the British dealers, however, three stood out, each in quite different ways. These were Leslie Waddington, Marlborough Fine Arts, and Jeremy Maas. Leslie Waddington, Victor's son, had studied art history in Paris but did not win a good enough degree to teach. Back in London, he found that artists like Elizabeth Frink, Ivon Hitchens and Patrick Heron were hungry for a dealer who would push their work and try to expand the "frighteningly small" group of people interested in contemporary art. Leslie's father, however, was still absorbed in his traditional loves, such as works by Jack Yeats. Accordingly, after four years father and son separated. Leslie reckoned he needed about £50,000 to start, and here he was fortunate in knowing Alex Bernstein, who became his partner. "Alex in fact offered me £35,000, but I said I needed only £25,000. The entire deal was done on the telephone. Alex is still my partner, even today."

Waddington's commercial success has been remarkable. From 2 Cork Street, he took over numbers 31–34 in 1969, number 4 in June 1981, number 11 in 1983, number 5 in 1988 and number 12 in June 1989. He was also the first British dealer to give his artists Kahnweiler/Castelli-like contracts offering them regular stipends. By 1990 his turnover was £80–90 million and he could draw on £25 million from his bankers.

The only threat Waddington has ever felt, he says, has come not from the auction houses but from Marlborough. The mastermind behind this gallery, Frank Lloyd, began life as the owner of a chain of service stations in Austria. He was forced to flee and as a refugee during the war he joined the British army, earning a reputation as an army cook. Marlborough was founded on a collection of old books and manuscripts owned by another refugee, Harry Fischer, who became Lloyd's partner. After the war the two men opened the first Marlborough Gallery and moved out of books, Fischer scouring Europe for art, which was then easy to pry loose from people devastated by the fortunes of war. Meanwhile Lloyd was concentrating on British art and, more important, acquiring rich and influential clients and backers, people like Bruno Haftel of Argentina, Giovanni Agnelli, the Fiat mogul of Italy, Assis Chateaubriand of Brazil and the French Rothschilds. Lloyd had a feel

for such postwar tycoons, just as Duveen had in the Twenties and Thirties. In the Sixties, as Waddington started buying up Cork Street, Marlborough actually beat Sotheby's to New York by opening a gallery there in 1963.

In New York Marlborough repeated its London tactics, buying up Abstract Expressionists much as it had acquired British artists in London. As John Bernard Myers has said, this "had an enormous effect on the New York art scene. . . . All the important Abstract Expressionists except de Kooning joined with Lloyd to create the first large-scale international market for American painting and sculpture. . . . Marlborough's success during the next ten years set up a new style of competition." But New York was not Lloyd's only expansion; he opened branches in Liechtenstein, Zurich, Rome, Tokyo, Toronto and Montreal. Usually he acquired an existing gallery and later bought the local partner out, as he did in Manhattan, where the company was originally called Marlborough-Gerson. This approach produced critics. One familiar charge in the United States was that Marlborough never tried to identify new talent but instead picked up artists who had already arrived: Jacques Lipchitz, Larry Rivers, Robert Motherwell and Mark Rothko, for example. Others felt that Lloyd really preferred dead artists to live ones. Though there is some truth to these charges, they neglect the fact that Lloyd was able to seduce artists away from their former galleries because he offered them, or the executors of their estates, more money. He had to earn that money, and this is where his skill lay. Like Duveen, Lloyd knew how to sell.

But also like Duveen, he was to become embroiled in scandal. The biggest was what became known in court parlance as "The Matter of Mark Rothko, Deceased." This artist committed suicide on February 25, 1970, at the age of sixty-six. He had been depressed for some months, had moved out of his family home, and lived alone in his loft studio. In a way he seemed to invite death. As was widely reported at the time, he drank a bottle of vodka a day and couldn't sleep without pills and Valium. Whatever it was that drove him to his final depression, a mystery that has never really been solved, he eventually swallowed a large dose of sleeping pills and slashed the veins in both arms. Apart from the shock that a man at the top of his profession would commit such an act, Rothko's suicide led to one of the most extraordinary trials in the postwar art world.

Rothko was born in Russia in 1903 and emigrated to the United States with his family when he was ten. After dropping out of Yale, he studied painting at the Art Students League, where he met Jackson Pollock and Willem de Kooning. His early pictures were Surrealist, but as the Forties passed, he evolved a highly personal nonrepresentational style. This was refined and developed in the Fifties, and by 1961 he was accorded a major retrospective exhibition at the Museum of Modern Art in New York. Ac-

cording to the writer John Hess, the exhibition bitterly divided the experts, not all of whom shared the view of Peter Selz, who wrote the MoMA catalogue; in one passage he stated that the artist had "given us the first, not the sixth, day of creation."

When Rothko died he left 798 paintings, $330,000 in cash and debts of $9,000. There was also the family house, where 44 of his pictures hung on the walls. The problems began when the will was probated. Rothko had made a will in 1968 which was drawn up not by a lawyer but by Bernard Reis, an accountant and art collector who had a professional relationship with both Marlborough and Rothko; indeed, the painter had been introduced to Marlborough and Lloyd by Reis. Rothko named three executors in his will: Reis, Theodoros Stamos, an Abstract Expressionist and friend, and Morton Levine, a professor of anthropology. Under the terms of the will, a tax-free foundation would receive most of his paintings; this foundation had five trustees, the three men who were executors of the will, plus two others who would change from time to time.

In 1968, the year when all these documents were drawn up, Rothko's agreement with Marlborough had expired, and two other dealers, Arne Glimcher of the Pace Gallery in New York and Ernst Beyeler of Basel, had jointly offered Rothko $500,000 for a selection of eighteen works. In the end the painter declined this offer, but it is important because it shows that in 1968 two top international dealers were prepared to offer Rothko an average of $28,000 for each of these canvases. In 1969, having turned down the Glimcher-Beyeler offer, Rothko made a new contract with Marlborough in which he accepted $1,050,000 for eighty-seven paintings, an average of only $12,500. The statistics are crude but they make the point. This apparent inconsistency, in which Rothko acted against his own financial interests, has never been explained.

After the probating of the will, Rothko's widow contested its provisions, claiming that half the estate should belong to her. The court agreed, but a month later she too died. One of Rothko's daughters now asked for the return of half of the estate, which had still not been made available to the family despite the court order. She also said that she wanted paintings, not cash. Even then, says Laurie Adams in her account of the affair, the daughter did not receive a single picture, and it was not until her lawyers pressed the matter that she was told, two years after the event, of certain secret deals made by the trustees of the foundation. It was these deals that caused lawyers for the Rothko children to petition the court, claiming that the three executors and Frank Lloyd were guilty of "conspiracy to defraud Mark Rothko's estate and to waste its assets."

What emerged from more than 23,000 documents that were presented at

the trial, held in 1974, was that the executors of the estate had entered into two contracts with Lloyd. First, on behalf of Marlborough AG, Lloyd agreed to pay $1,800,000 for 100 paintings, but payments were to be made without interest over thirteen years. In other words, the trustees, who had a fiduciary responsibility to the Rothko heirs, were letting this first batch of paintings go for roughly (when the lost interest payments are included in the calculation) $12,000 less than what Rothko's paintings were currently selling for at market value. A second contract gave Lloyd the other 698 paintings on a consignment basis at a commission rate of 50 percent. In effect, the bulk of Rothko's estate had been handed over to Lloyd for an initial payment of only $200,000, and none of the beneficiaries of the trust knew anything about this for nearly two years.

It was a celebrated trial, with no fewer than seven sets of lawyers, but Bernard Reis, possibly the chief actor in the saga after Lloyd, was absent. His doctor had advised him that his health might not take the rigors of a trial. This convenient illness did Reis no good. After ten months, the judge removed all three trustees of the estate, denying them commissions, and the contracts for all the sales and consignments were set aside. Further, Reis, Stamos and Marlborough faced damages of $9,252,000, and Levine and Marlborough were found liable for damages of $6,464,880.

But the case was interesting not simply because it concerned fraud or conspiracy but because of Frank Lloyd's performance in the witness box. Throughout his testimony he addressed himself to finance and lectured the court on the difference between Rothko's importance as an artist and the market for his paintings. Much of the court's attention focused on the bulk purchase by Marlborough of the hundred paintings immediately after his death. Lloyd claimed that he was entitled to a discount for bulk; he also defended the appraisal value of $750,000, which valued the pictures at $7,500 each, only months after Glimcher and Beyeler had valued eighteen of them at $28,000 each. Other experts at the trial, says Laurie Adams, gave markedly different appraisals for the same one hundred paintings, ranging from $4,000,000 to $6,420,000. It was also pointed out in court that Lloyd was not really building a market, as he claimed, since in some cases he had merely stashed paintings with European affiliates. This meant that he sold them to the affiliates cheaply, passing on the correct percentage (but of a low total) to the estate, then bought them back from the affiliates and resold them for much higher prices. One example mentioned in the testimony was a sale of thirteen paintings to three galleries in Paris and Liechtenstein, from which the estate received $248,000. But Lloyd bought back just two of these pictures and sold them on to the Mellon family for $420,000.

There were two sequels to the Rothko case. One was Lloyd's punishment:

besides the whopping fine, he was barred from doing business in the United States until he had completed a course of community work. The other sequel was that for once mud really did stick. Even today, twenty years after the event, almost the only fact the art world remembers about Marlborough, still a force, is their massive dishonesty in "The Matter of Mark Rothko, Deceased."

—

"Scholars are a right load of snobs. The eighteenth-century way of life seemed so infinitely agreeable to contemplate, whereas the nineteenth century meant iron masters, textile kings and their kind of art." Jeremy Maas could not be more different from Frank Lloyd or Joe Duveen, though like the latter he is of Dutch extraction. Maas has made no fantastic feature of his gallery— on Clifford Street, appropriately enough, between the Old Masters of Bond Street and the contemporary art of Cork Street. Indeed, though it is in the West End, his gallery is modest compared with Waddington, Agnew or Spink. But Maas's achievement is no less, for it has been intellectual. New movements and fashions are rarely the work of one man. The 1950s, we should not forget, was the decade when the Victorian Society was founded; Carl Dreppard, an American author, had written in 1950 that Victoriana was "the Cinderella of antiques," and the word itself, according to Asa Briggs in his book, *Victorian Things,* first "began to be used generally only around 1951, the time of the Festival of Britain which, in retrospect, was more of a landmark in relation to the appreciation of the nineteenth century than it was in relation to the making of the twentieth." Nonetheless, Maas has played a major role in helping the modern world appreciate the beauties of Victorian art.

Maas, a tall, graying, academic figure, ascribes his rediscovery of the Victorian masters to the fact that there was no department of art history at Oxford when he went there to read English. "I taught myself art history," he told me. "Had there been a proper course I would have been steered away. The interest would have been driven out of me. But I remained undefiled." In the Fifties in London, he says, the art trade "was very much trade. . . . Galleries were run by professional gallery managers. I remember the Fine Art Society was run by a Mr. Grouse, who lived in Temperance Hatch in Eastbourne. At the time I thought of joining the trade, a number of graduates— Andrew Patrick, Godfrey Pilkington, Peyton Skipwith—had the same idea and it began to change. There were always Victorian paintings around, but we never used that word; it was a killer."

After a short spell in advertising and an even shorter spell at Bonham's, the smallest of London's four main auction houses, Maas opened his gallery in

1960. His first show, held the next year, was on the Pre-Raphaelite Brother-
hood, whose meticulous depictions of objects, so reminiscent of the seven-
teenth-century Dutch masters, Maas admired. But public tastes change
slowly, and Maas had to work at it. In 1965 he published *Victorian Painters,*
which sold slowly at first but has since gone into six editions. Later, when he
wrote a biography of Gambart, the great Victorian dealer, so little was
known about him that Maas had to travel to the cemetery in Nice to find out
the dates of his birth and death.

Toward the end of the Sixties the Victorians at last began to catch on. This
was partly helped by a Royal Academy show in 1968 to mark its bicentenary;
among the painters on view, the Pre-Raphaelite Brotherhood stood out. Also
in that year Maas dared to hold the first show with "Victorian" in the title.
He remembers that the exhibition was especially popular with hippies; they
liked the symbolism in Victorian painting. "I also remember that all the
people from Sotheby's picture department came, and six months later they
opened Sotheby's in Belgravia." It is fair to say that the public museums and
auction houses allowed commercial galleries to lead the way with Victorian
art; it is also true that Maas was but one of a small number of people who
had been trying to lead taste back to the nineteenth century. Among the
others, as Nicholas Faith points out, were Sir John Betjeman in objects, and
Sir Nikolaus Pevsner in architecture. At Sotheby's an important figure was
Howard Ricketts, who had been commissioned to write a book on "objects
of virtue"—art objects displaying the skill of craftsmen; in the course of his
research, he had consulted back numbers of the *Art Journal,* a Victorian
periodical. Frank Herrmann reports that Ricketts noticed what Maas had
spotted before him: that while much of the material discussed in *Art Journal*
probably still existed, almost none of it ever appeared at auction. Sotheby's
response was imaginative—to establish an entirely separate auction house,
physically distinct from the main building in Bond Street, that would deal not
just in second-rate material but in first-class objects from this new field.

Which is how Sotheby's Belgravia came about. The site was chosen simply
because the firm already occupied a building known as the "Pantechnicon"
in Motcomb Street. The Pantechnicon itself had an interesting nineteenth-
century history. It had been built in the 1830s to house the carriages and to
stable the horses of the many rich families who lived nearby, and also to
provide a storeroom for furniture when people moved away temporarily—
for example, on diplomatic assignments overseas. It had a Parthenon-like
façade and was a well-known landmark. (It was also, for obvious reasons, the
origin of the word "Pantechnicon," as applied to moving vans; Betjeman
himself pointed this out in an article he wrote for Sotheby's annual review in
the early Seventies.)

The general principle of Sotheby's Belgravia was that objects made after 1840 would be sold there. Naturally, the greatest head-scratching went on about pictures. Herrmann says there was never any question of taking the major Impressionists away from Bond Street, but Michel Strauss, the head of that department, allowed the minor Impressionists and the Barbizon School pictures to move, along with the Pre-Raphaelite Brotherhood. This was important because it meant that the Belgravia branch made its mark very quickly. Lots flooded in, says Herrmann, especially furniture. The traffic was so heavy that sales soon became more specialized, and English paintings in particular made their mark. Artists who had been forgotten were quickly reestablished and are viable today. Up to 80 percent of the objects at Belgravia were "new" in the sense that they had never appeared at auction before.

Some of the "collectible" areas that are still with us date from this time— musical instruments, for example, or postcards. Naturally this conversion of ordinary objects into art had its critics, not least among the Sixties' satirists who were then so popular. At one stage the magazine *Private Eye* advertised a sale of "Highly Important Sausages," including one "highly important Polish garlic sausage by Topolski (slightly chewed) . . . exceptionally fine pair of English hand-made cocktail sausages in perfect condition, uncooked by John Wells of Piccadilly, with matching carved oak sausage-sticks, both mounted on mint doily and disposable cardboard plate."

But the glory of Belgravia, and ultimately the crowning achievement of the whole Victorian revival, was in its pictures. The first major test came in November 1973 with the sale of thirty-five paintings by Sir Lawrence Alma-Tadema owned by Alan Funt. In some ways Alma-Tadema typified all the shortcomings of the Victorian age: his work was meticulous but uninspired, an anachronistic attempt to re-create the Classical Age all over again— Grecian-robed figures with modern faces. Alan Funt was hardly the epitome of the scholarly collector, being the man who devised the television program *Candid Camera,* in which ordinary people were faced with highly improbable scenarios and their reactions covertly filmed. Nicholas Faith reports that a dealer had once asked Funt if he wished to see "a picture by the worst painter who ever lived." Funt regarded Alma-Tadema as a challenge and tried to find someone who was worse but gradually acquired a feeling of sympathy for the artist. As he himself put it, "Because I have received my share of brickbats from the critics, I enjoyed sympathizing with Alma-Tadema."

The sale was a particular challenge because it took place in early November 1973, a matter of weeks after the outbreak of the Yom Kippur war and just when the full impact of the "oil shock" was sinking in. The dollar had been devalued for the second time in two years and inflation was pervasive

everywhere. Funt was selling not because he judged the time was right but because he had to: he had discovered that his accountant had embezzled $1.2 million and that he was left with, as Faith put it, "everything a rich man has except cash."

Hence, by all criteria the sale ought not to have succeeded. And, initially, it didn't look good. "The dealers just sat there, looking at each other." But then the fireworks began, and by the end of the sale Funt had made $425,000 ($1.93 million now) from his thirty-five pictures, almost double what he had paid for them. The sale showed that the market in Victoriana was big enough to absorb a large collection. This was good news in the long run, but in the short term the picture was not bright, for soon after the sale the oil shock really took hold. In 1974 economic growth slowed to near zero in most industrialized nations, the Dow Jones index fell to 663, its lowest level in four years, America was rocked by the possible impeachment of President Nixon, a spy scandal forced the resignation of Chancellor Brandt in Germany, and in Britain Edward Heath's government, which had imposed a three-day week, lost a general election to Labour. Against this background all markets, including the real estate and art markets, collapsed.

—

Ironically, there was a modest renaissance among art dealers in New York in the early Seventies at a time when prices elsewhere were trembling. It was reminiscent of what had happened in Manhattan during World Wars I and II. The main factor was the opening by four established dealers of a gallery building in an area of town new to the art trade: SoHo. (For those who don't know it, SoHo is located South of Houston Street in lower Manhattan, a district formerly occupied by warehouses.) The four dealers who opened in a converted soap warehouse at 420 West Broadway in 1971 were Leo Castelli, Ileana Sonnabend, André Emmerich and John Weber. But though their arrival en masse put the area on the cultural map, they were not, strictly speaking, the founders, the innovators of this downtown idea.

Paula Cooper was the pioneer of this neighborhood. Born Paula Johnson in 1938 in Springfield, Massachusetts, she was the daughter of a naval officer, and her family moved frequently (by the age of thirteen she had been to twenty-three schools). As a young woman she saw a lot of art in Europe, and she studied art history at Goucher College in Maryland but left without finishing her degree. ("I was bored looking at slides of all those paintings that I knew so well.") Her first jobs after she moved to New York included being a telephone operator and receptionist at Chanel, but after a few months she began serving a two-year apprenticeship at World House, a gallery on Madison Avenue selling, among others, Giacometti, Ernst and Dubuffet. She also

went back to school, at New York University's Institute of Fine Arts. After meeting her first husband, Neil Cooper, who sold limited editions of reproduction sculpture, she opened her own gallery in 1964, operating out of her home on East Sixty-fourth Street. She was never interested in Pop Art, preferring Minimalism and Conceptualism instead. This first venture lasted a short time, and she worked next at the Park Place Gallery, an early artist-run cooperative. This folded in 1968, but she stayed in the SoHo area; taking a $3,000 bank loan, she worked from a Prince Street loft. Her opening show included works by Donald Judd, Dan Flavin, Carl Andre and Robert Ryman. The days of apprenticeship were over.

Cooper was followed to SoHo by Ivan Karp, Leo Castelli's erstwhile partner, who opened the O.K. Harris Gallery in 1969 (see figure 75). Karp is the antithesis of the smooth, sophisticated art dealer, and his office today is stuffed with old baseball paraphernalia and ancient typewriters. In the early Fifties he had started at the Hansa Gallery "at $12 a week plus 10 percent of whatever I sold. . . . I had no success for two years." This was at a time when, according to Karp, the New York art world consisted of "one hundred artists, forty to fifty fans, three to four collectors, two to three dealers and journalists, and that was *it*. . . . Every opening was the same: Pollock making a disturbance, Barnett Newman pontificating, Rothko being spiritual and Kline drinking too much. . . . It was not an optimistic atmosphere. . . . I remember someone saying at one opening, 'Why does no one ever answer that phone? It could be a sale.'" Karp moved to Martha Jackson's gallery, then to Castelli's, which he says was not successful for some years but was supported by Ileana Sonnabend, "who had money."

According to Karp, the atmosphere in Manhattan changed around 1963 or 1964. "By now there were perhaps twenty-five collectors. Openings were different. A younger set, lots of kissing, wine instead of beer or whisky. Around 1966 Leo started to make money. But though Rauschenberg and Johns were doing well, Warhol and Twombly weren't. Stella started to sell between 1964 and 1966, and by 1967 Leo was on the top of the heap. I was still the front man and Leo was traveling a lot. After that we started showing Minimalism—Donald Judd and Bob Morris—and then Leo announced that he was going to show Dan Flavin. It was the first time that I had not been consulted, the first sign of a schism, and we parted in 1969."

At first Karp intended to write a novel, but a backer made him the right offer and he found a space on West Broadway. "I was right there on the street—seven thousand square feet of me. I may well have been the largest gallery in the world at that point, and for only $250 a month." (Now the rent is $1,400 a month.) Within six months, Karp says, five other galleries joined him in the area, but it was probably the arrival of Castelli *et al.* two years later

that consecrated SoHo, and West Broadway in particular, as the late twentieth century's Street of Pictures.

When Ileana Castelli divorced Leo in the early Sixties she married a scriptwriter, Michael Sonnabend. They decided to try Rome for a year (it was the time of *La Dolce Vita* and Cinecittà), where Ileana's idea was to interest Europeans in American art. But Rome was not a success. She and Michael made plans to return to New York, but on the way they stopped off in Paris, where she met her old friend and Leo's onetime partner, René Drouin. He impressed on her how different Paris was from Rome, and he was right. Ileana opened her own gallery there and stayed for eighteen years, until 1980. She traveled often to New York, and eventually had galleries in both cities. Ironically, when she opened in New York in 1971 she found just as much resistance there to European art as she had found to American art in Rome.

André Emmerich (see figure 82), who occupied the converted soap warehouse with Castelli and Sonnabend, was born in Frankfurt but, like William Weinberg and Siegfried Kramarsky, was raised in Amsterdam and emigrated to the United States in 1940. His grandfather was an art dealer, specializing in Renaissance works in Paris and selling to J. P. Morgan, among others. Emmerich studied art history at Oberlin College, Ohio, working his way through school by typing catalogue labels—a job he was given because he spoke French, German and Dutch. After graduating, he became a writer and editor, but at twenty-eight he decided he was not a budding Hearst and returned to art. He opened his first gallery in 1956 on East Seventy-seventh Street (on the same block as Castelli's), dealing in pre-Columbian and classical antiquities, which reflected his long interest in archaeology. Gradually he moved into contemporary art, in part owing to the links he had established as a journalist. He had met Robert Motherwell when they had served on a UNESCO committee, and the painter introduced him to Pollock, Still, Rothko and Gottlieb. From these friendships Emmerich developed his interest in such "colorfield" painters as Helen Frankenthaler and Kenneth Noland. Emmerich, like Leo Castelli, feels that, since the flurry of excitement and creativity of the Abstract Expressionists and the colorfield painters, there have been "very few major new artists" who "hadn't already been noticed by the end of the Sixties." He draws a parallel with other periods, like the first quarter of the nineteenth century, when there was "Goya, David, if you wish, but not much else." Emmerich is as much a scholar as a merchant and has written several books on pre-Columbian art. He will never push a work. Pushing a painting, for him, means "[it's] not art; it's merchandise."

–

There was an irony to all this activity in and around West Broadway. There is no question but that the move of these dealers was a social and commercial success. According to Calvin Tomkins, by 1971 there were nearly a hundred new galleries in New York dealing in contemporary art, up from a dozen or so in 1957. The presence of so many of them undoubtedly helped the downtown area of Manhattan south of Houston Street to prosper, especially as a residential area for young, culture-conscious individuals. At the same time, both art-world observers like Calvin Tomkins and dealers like Emmerich believe that the Seventies and Eighties were a relatively "sterile period in terms of emerging talent, new visual ideas, great painting being done by new people." For all its trappings of commercial success and stylishness, the West Broadway experiment has not been a great success in terms of the artistic innovation it might have fostered. In that sense it does not begin to compare with the rue Laffitte.

The sale of *Juan de Pareja* at Christie's and the opening of Sotheby's Belgravia seemed to be great triumphs. So too did the successful return, after many decades, of the market in English portraits. In Christie's sale of June 1972, *The Gower Family* by George Romney went for 140,000 guineas ($1.75 million now), which beat a record that had stood for this artist since 1926. English pictures were now back at prices worthy of Old Masters, and Gerald Reitlinger wrote a piece in Sotheby's annual review entitled "The Return of the Duveen Market?"

Still, there were worrying events that were disturbing the balance between the two great salesroom rivals. The 1969 slump on Wall Street was partly to blame. The first to go and hardest hit was silver. This had been a particular area of speculation in the late Sixties, peaking at the Norman Hurst sale in March 1969. According to John Herbert in his history of Christie's, Hurst's silver gave him a 245 percent return on his investment, but the most interesting aspect of this sale was that the vendor had given Christie's strict instructions that the auction be held before the start of the new financial year, April 1. Sure enough, in that year's budget the Labour chancellor, Roy Jenkins, made works of art liable to tax if sold within three years. As a result, in 1970 silver sales were off by 30 percent.

Sotheby's was even more badly hit. Overall, its objects not meeting their reserve price more than doubled, from around 10 percent to nearly 25 per-

cent. Moreover, new taxes in the British government's budgets hit jewelry and books especially hard. Of course books were a traditional strength of Sotheby's, but because Christie's rivalry was weaker in this area, Sotheby's had become lax in administration: Frank Herrmann says that in the Sixties book collectors and dealers had been given more credit than they were used to. In consequence, the unsold rate on books at Sotheby's rose from an average of 3 percent to an alarming 25–30 percent. To this were added the costs of Belgravia.

As 1973 approached, therefore, the two main houses found themselves in an anomalous position. Sotheby's sales were still more than twice those of its rival: £71.7 million in 1972–73 as against £33.8 million for Christie's. At the same time, whereas Christie's profits had risen from £90,000 in 1969 to £1,113,000 in 1972, Sotheby's were still around £1.4 million. Thus, as Christie's was able to contemplate going public in 1973 (when in fact it did so), Sotheby's was in financial turmoil. In 1966 Rothschild's Investment Trust had bought 20 percent of Sotheby's for £3 million, no doubt with a view to the firm's going public at a later date and was watching affairs keenly. Peter Wilson was a factor in Sotheby's predicament; he was great in getting business but was a poor administrator. Sotheby's was also obliged to admit that it had been offering guarantees on certain collections. This admission was forced on it in New York because disclosure rules were stricter there than in London; in effect, the company had an interest in certain properties it was selling: it was no longer purely an agent. This too produced problems because though guarantees ensured that such business went to Sotheby's rather than Christie's, it followed that the firm stood to lose more if the lots didn't sell. In the climate of those times, as Nicholas Faith has pointed out, estimates fell to ensure sales, and profits shrank accordingly. It was not a happy time for Sotheby's, and the firm's distress cannot have been eased when Christie's stock offering, on October 15, 1973, was eleven times oversubscribed. This may have been one reason why Peter Wilson brought in Peter Spira, the vice chairman of Warburg's, as group financial director.

Christie's flotation took place exactly two weeks after the outbreak of the Yom Kippur war, but the hostilities did little to dampen demand. On the day the crisis erupted, October 1, 1973, John Herbert reports, a gramophone went for £1,050 ($11,500 now), the first time such an object had ever fetched four figures. Four days later, on October 5, a painting by James Tissot set a record, and on October 9 there was another one for a piece of Viennese porcelain. On November 15, Sotheby's held its first sale in Hong Kong, and this too was a spectacular success: a Ch'eng Hua blue-and-white dish, which had been delivered to Sotheby's in an old newspaper, fetched £160,000 ($1.75 million now).

But cracks were beginning to appear. There was a dearth of Japanese buyers at a sale of Chinese wares in London in October, and while high prices were obtained for the best netsuke, there was little competition for middle-of-the-road items. More dependent on Middle East oil than any other developed country, Japan was turning away from the art market. This trend accelerated over the next few months. Art prices fell by an average of 15 percent during the months after the oil shock but were still above their level of autumn 1972. The quadrupling of the oil price, which OPEC had introduced in the wake of the Yom Kippur war, caused inflation in Britain to reach 27 percent, manufacturing was hit and the stock market fell to 60, causing a secondary banking crash and a real estate collapse. Britain was on a three-day week.

For the art market this had two important effects. The first was a dramatic crash in the Oriental porcelain market. In the late Sixties and early Seventies porcelain prices had risen almost as much as those of silver. One healthy reason for the rise was that with the growing prosperity of the Far East, many Japanese and "outside Chinese"—mainly from Hong Kong—were buying back their heritage. It was this that led Sotheby's to open an office in Hong Kong in 1973 and to initiate sales there. But a far less healthy reason was the activity of speculative buyers. One was Lampa Investments, a firm headed by Hugh Moss, a London dealer backed by the property magnate Jim Slater. When the Slater property empire crashed, Lampa went with it. At the same time, another porcelain dealer, Mrs. Helen Glatz, was bidding aggressively at almost every auction. (In April 1974, for instance, she spent £845,000 at one sale.) Of German origin, Mrs. Glatz had come to London after her release from a concentration camp. She was bidding not for herself but, as Nicholas Faith points out, for a Portuguese collector, Manoel Ricardo Spirito Santo, a member of the Spirito Santo banking family. In April 1974 revolution broke out in Portugal when a group of young army captains overthrew the government. An embargo on foreign exchange was introduced immediately, Manoel Ricardo was unable to pay for his purchases and Sotheby's had to put many of the objects "sold" in April back into its July sale. The shock of these two failures caused Oriental ceramics to lose two thirds of their value over the next year.

A second effect of the rise in oil prices was to cause the auction houses to reexamine their finances. Within months of its successful stock offering, the situation at Christie's was already bleak. Pretax profits had slipped to £1.55 million, compared with £2.17 million the year before. The decline was due mainly to what was happening in Britain, since, as John Herbert notes, overseas sales had in fact improved from £696,000 to £754,000. But the forecast was that in the next year profits might be as low as £250,000 on sales of a hundred times that. Moreover, the firm's shares had slumped to an

all-time low of 23p (they were 700p in 1987), and it fired thirty-one people. At Sotheby's sales slumped by 30 percent, debt jumped from £1.6 million in September 1972 to £7.5 million two years later, and twenty-six people were let go. Peter Wilson, of all people, now considered merging with the opposition once again, but the solution lay in another, much more controversial, innovation: the buyer's premium.

The antiques boom of the early Seventies, which had been helped by the devaluation of the pound in 1967 and the silver panic that followed, contained an uncomfortable paradox. One reason that antiques were popular was that they were felt to be a hedge against inflation. (This was especially bad in Britain, where at one point the nationalized post office tripled the cost of phone calls in a single step.) But inflation creates problems in a labor-intensive business such as an auction house, where expenditure can be cut back only so much. As the post–oil shock world emerged, therefore, it became clear that the salesrooms badly needed to increase their revenue. The surest way to do so would have been to increase commission rates. But the low commissions in London were its traditional weapon, so to have increased the rate would have risked London's advantage over the Continental auction houses. Worried by inflation and what it could do to profitability despite the apparent continued enthusiasm for buying and selling art, Peter Spira, Sotheby's new financial director, flirted with the only other way to increase profitability: by charging the buyer. Inside the firm it was felt that this would be bitterly resented by the trade, but what now happened was the subject of much wrangling, legal argument and court action for almost a decade (it wasn't resolved until 1981). According to Frank Herrmann in his official history of Sotheby's, a decision was eventually taken to introduce the buyer's premium, but the implementation of the decision awaited Peter Wilson's return from a long trip to Tehran and Monte Carlo (where the firm held its first sale in 1975). Then, out of the blue, Jo Floyd, who had become chairman of Christie's in 1974, rang up one evening as a matter of courtesy to say that on the next day his firm was going to announce the introduction of a 10 percent buyer's premium. This, of course, was in addition to the seller's commission. Christie's had arrived at its decision, Floyd said, after considering the practice of some of its opponents on the Continent, who already levied a charge on the buyer. Two days later, Sotheby's made a similar announcement.

The trade saw collusion and counterattacked. The battle was led by the silver dealers, who boycotted the first few minutes of the year's silver sales. Then a number of trade associations took the matter to the Office of Fair

Trading. Peter Wilson was furious with Christie's for the high-handed way they had made their announcement; Herrmann says he had always planned to soften up the trade in advance. Christie's tried to smooth matters over by offering to double the commission they paid to dealers who introduced lots for sale, but the damage had been done and they were not mollified. The matter was not finally settled until 1981, when the dealers finally agreed to withdraw their litigation.* In practice, and apart from a few dealers who resisted, opposition sputtered out pretty quickly. Nicholas Faith was probably right when he said that the real cost of the buyer's premium was in the personal relations between the dealers and salesrooms. Many friendships were poisoned irrevocably.

With so much bitterness in the air the auction houses might have been expected to lie low for a while. Not a bit of it. At precisely this moment, Sotheby's chose to announce another venture that further incensed the trade: the investment activities of the British Rail Pension Fund. The decision to invest pension money in the art market was, according to Susan Buddin, the current secretary of the fund, the brainchild of Christopher Lewin, a mild-mannered, mathematically minded actuary who believed that with inflation in Britain at 27 percent, art investment was one of the best ways to maximize profits. Lewin also happened to be a collector himself (of manuscripts and books), so the idea of investing in works of art came naturally to him. Before parting with any of the fund's precious assets, however, he embarked on what Nicholas Faith described as "the single most thorough analysis of trends in the art market ever undertaken." According to Buddin, Lewin used the figures in Gerald Reitlinger's *The Economics of Taste* but excluded exceptional prices—those that were ten or more times the average. Despite this he concluded that most categories of "traded art" had proved sound investments in the long term. He also concluded that in the fifty years from 1920 to 1970, "only tapestries and arms and armor had failed to keep up with inflation." On behalf of the fund, he could afford to take a long view, since he did not envisage having to sell inside twenty-five years. He had also worked out that the annual turnover of the art market was in the region of a billion pounds. He intended to spend about 3 percent of the fund's annual cash flow, some £4–8 million, in a diverse way so as not to disrupt prices. With these provisos, he recommended to the fund's trustees that they make the leap.

Lewin needed an expert, and for this he turned to Sotheby's. Peter Wilson took to the scheme immediately, despite the fact that it compromised the

*Phillips stood out for a while, charging only the vendors, and to begin with they got a lot of silver and furniture trade. But after three years they too came into line.

neutrality of which auctioneers had always been so proud. He appointed Annamaria Edelstein, the Italian wife of a dress designer, to look after the fund's collection on a day-to-day basis. She had worked on *Art at Auction,* Sotheby's annual review of the market, so she had a smattering of knowledge of the whole field. In practice the fund itself kept a tight eye on its investments. Proposed purchases had to be submitted by Annamaria to the Works of Art Subcommittee of the fund's trustees, complete with a photograph and price comparisons. It was a clumsy modus operandi that took time, and because of this, bargains were occasionally missed.

Of course the art trade hated the scheme. Here was a major buyer not buying through dealers, and thus depriving them of influence and commissions. The plan was announced just after the buyer's premium had been introduced, and so the fund had to pay it to Sotheby's. Worst of all, Sotheby's was in the enviable position of knowing what a vendor wanted for an object and what a rich collector was willing to pay for it. The trade thought this gave the firm and the fund an unfair advantage. They also suspected that Sotheby's would be able to dump unwanted works of art on the fund. In practice it didn't work out this way. For a start, the fund bought not only at auction but also from such galleries as Tooth's and Knoedler's. In addition, Annamaria proved her independence by using dealers to bid, so that Sotheby's could never be certain when the fund was interested in a lot. Even so, the fund's investments attracted much hostile comment. The press, members of Parliament and the leader of the National Union of Railwaymen all criticized it. Nicholas Faith reports that in 1977 the comptroller and auditor-general, the government's toughest financial policeman, had the fund's art investments in mind when he expressed his concern about pension funds' "almost unfettered powers of investment." Months later there was an official hearing by a committee of the House of Commons. On top of everything else, no one—in Britain, at least—liked the close link between art and investment that the fund's approach signified. On the one hand it disturbed people's sensibilities; on the other, too close a link might show how poorly art performed when looked at in a purely mercenary way.

According to Annamaria Edelstein, the conflict of interest was real, but she resisted it. She told John Herbert that Peter Wilson tried to use her. "I used to have the most terrible fights because they didn't like my suggestions, and I threatened to resign three times." In retrospect it would appear that Edelstein did keep her integrity, and that the wall between herself and the rest of Sotheby's was maintained. But initially this was virtually by default; to judge from the pressures applied to her, no one at Sotheby's, Peter Wilson included, expected her to be so independent. The worries about a conflict of interest were fully justified.

An equally important reservation stemmed from the fact that the fund planned to collect across the board. The enterprise had the flavor of a corporate collection: the objects were not being amassed to be enjoyed, no single individual stamped his or her passion on them, they would never be housed together or conceived of as a coherent vision. On the whole, the fund's involvement in the art market was an unhappy experience for all concerned. The sale of the art objects came sooner than expected, during the art boom of the late Eighties, and it renewed controversy over whether the investment had really worked.

Despite the litigation, the bitterness and the British Rail Pension Fund, the introduction of the buyer's premium was a success from the salesrooms' point of view. It was not so important for Sotheby's as for Christie's, because the former's main strength overseas was in New York, where there were no rivals to speak of, and none that charged a buyer's premium. But it was Sotheby's who reaped the juiciest benefits from Christie's action. Indeed, within two years Peter Spira was able to recommend to Sotheby's board that the company go public. In retrospect, this may appear as an inevitable move, especially as Christie's had taken the same route four years earlier. But this was not how it seemed at the time. Although the slump that followed the oil–rise shock had bottomed out, by the time Sotheby's was floated no other company had gone public for three years. Worse, on the eve of the offering, as Nicholas Faith reports, British Petroleum released an immense number of shares onto the market and Sotheby's move had to be postponed. Still, when the offer did take place it was oversubscribed twenty-six times, and in the first eighteen months its price rose from the issue level of 150p to 380p. The offering also revealed that the three largest shareholders in Sotheby's were Peter Wilson, Peregrine Pollen and the Rothschild Investment Trust. This was no surprise, but it confirmed that the offering was the beginning of the end for Peter Wilson. As with many businessmen whose companies go public, he began to think about getting his money out.

The success of Sotheby's Belgravia experiment was due only in part to the vogue for Victoriana. While Wilson and many others were fascinated primarily by the growing prices at the top end of the market, many ordinary people were becoming no less absorbed by objects that, though less valuable, were to them no less beautiful. Here again the British claimed the headlines but the Americans got there first. The "collectibles" market had essentially been the bailiwick of Otto Bernet, but since his death during World War II it had been moribund. After Parke-Bernet was acquired by Sotheby's, it had done something to revive the practice, opening a smaller salesroom, PB 84, for this

purpose on East Eighty-fourth Street in 1968. But the systematic promotion of collectibles really dates from 1975, when Christie's took over the long-established business of Debenham and Coe and revamped its salesrooms in South Kensington into an auction house specializing in cheaper objects. John Herbert says that many senior people at Christie's were worried about Christie's South Kensington, fearing that vendors would feel snubbed at having their goods sold in what was obviously a secondary salesroom. They were wrong; the firm had, in fact, stumbled on a new market, one that was not even tapped by Belgravia. The new branch developed its own specialties: costumes and embroidery, toy trains (the "Trains Galore" sale, held before Christmas, is now a major attraction), and Victorian photographs. In its first twelve months its turnover surpassed that of Belgravia, by then four years old. There were other signs of the collectibles boom: markets like the Portobello Road in London and an antiques "roadshow" organized by Christie's in Hereford, which was so successful that within two years the BBC had turned it into a hugely popular television program. Sotheby's colonized the provinces of Britain, taking over local auctioneers in several towns from Chester to Torquay.

However, it was a much more pointed colonization that had the biggest long-term impact on the art market overall, to bring about the fiercely competitive art world as it is today. This was Christie's arrival, together with the buyer's premium, in New York. The firm acquired a prime site, the ballroom of the Delmonico Hotel, on the corner of Fifty-ninth Street and Park Avenue, for a low rent in a deal that extends to the twenty-first century. The move to Manhattan came not a moment too soon, for after Sotheby's went public, anyone who could read a balance sheet could see just how important the United States market was. Sotheby's offering had forecast a profit for the year 1977 of £4,600,000. This was exceeded easily, and by 1978 pretax profit stood at £7,024,000. Even more interesting was that exactly half of Sotheby's gross (though not its profits) came from sales held outside Britain, and of that 50 percent the United States contributed three quarters. By now, Sotheby's was stretching itself in the United States, with offices in eight cities, including Boston, Philadelphia, Honolulu, Palm Beach and Los Angeles, the last of which had been launched with a sale of props from the nearby studios of 20th Century Fox. Sotheby's expansion across the United States produced the idea of Heirloom Discovery days. Lots of people brought to Sotheby's "clinics" their American-heritage items, and since previously there had been no obvious market, a vogue for Americana was thus initiated. However, many people who had objects to sell did not wish to wait the considerable time it took to mount an auction. Therefore Sotheby's began to buy items, from single objects to entire collections, and give the

sellers the cash immediately. Lots bought in this way were sold at auction later as Sotheby's property. At this, says Faith, another outcry ensued—led by the trade, naturally, which was hardly disinterested. Yet the United States, still a puritan country in many respects, did not take to the idea of a business in which the auctioneer had traditionally been an agent and was now becoming a principal. For the time being, at least, this tactic was quickly abandoned.

Christie's first sale in New York and Sotheby's offering on the London stock exchange took place within a month of each other, in the spring of 1977. Together they neatly symbolized the end of the difficult period that had begun with the Yom Kippur war and the oil crisis. Clearly the future lay in New York—but not just yet. Britain still had a couple of kicks in it.

31 | THE APOTHEOSIS OF PETER WILSON

Over the years the paths of the Rothschilds and of Sotheby's have crossed repeatedly. Baron Edmund de Rothschild had bought the two most expensive books at the Yates Thompson sale in 1919; Victor Rothschild had sold the contents of 148 Piccadilly in 1937; and Jakob Rothschild's Investment Trust had bought 20 percent of Sotheby's itself in 1966. But no encounter was as momentous as that of 1977, when Sotheby's handled the biggest house sale in its history: Mentmore Towers. However, Mentmore was more than just a sale. The house owed its opulence to the fact that its creator, Baron Mayer Amschel de Rothschild, was the youngest of four sons and much more active as a connoisseur than as a banker in the family firm. His only daughter had married Lord Rosebery, and the demise of their son ninety-six years later brought about the dispersal. The house was 120 years old in 1977 and represented a life-style that had long since disappeared. The seventh earl of Rosebery, who had inherited the house on his father's death in 1974, was faced with a bill for death duties of £4.5 million ($10.53 million now). The earl attempted to negotiate with the Labour government of the day in the hope that the house could be made over to the nation in its entirety as a museum, with the taxes settled at the same time. Unfortunately, the sum offered by the government, £3.6 million, did not meet the death duties—and in fact at the last moment the government withdrew even that offer. This unleashed a storm of protest from the conservationist lobby, but the govern-

ment refused to rescue Mentmore because it was, said a spokesman, "politically and economically impossible," and the sale went ahead.

The auction lasted a full ten days. It was a triumph despite the fact that many of the objects at Mentmore did not live up to the image that had been created for them. The best objects—the Watteaus, the three Titians and the Canaletto drawings—had been sold at earlier Rothschild auctions, and what was left was in poor condition. Whatever was left, however, represented a way of life. There were wooden coat hangers and towel rails, brass and copper hot-water jugs, nursery cradles. As Nicholas Faith put it, Mentmore was like a prop sale for *Upstairs, Downstairs,* the popular television series. Even this may have been exaggeration. Writing in *The Times,* Peter Conrad found the house "a wasteland of peeling paint and gilt tat . . . it is difficult not to feel slightly exhilarated at the dispersal of this pile of geegaws and hideous rarities."* The power of nostalgia and envy was proved by the fact that the catalogue, printed in five volumes and costing £30 a set, sold out its 11,000 print run in three weeks and a paperback issue had to be hurriedly produced. Such was the draw of a bygone age. Nor did people attend simply to watch; in all, the contents fetched £6,390,000 ($35 million now), almost double what the government could have had it for and well above the death duties the earl needed to pay.

At least Mentmore provoked the government to improve the laws designed to preserve the nation's heritage. In 1980 Margaret Thatcher's new cabinet established the National Heritage Memorial Fund, a sum of money, a board of trustees and a staff whose brief was to preserve such parts of the nation's patrimony as were threatened, to the extent they could afford to do so. By then, Mentmore had been eclipsed.

Robert von Hirsch was a German leather manufacturer who had bought art since 1905, using as a mentor Georg Swarzenski, medievalist and director of the Städel Museum in Frankfurt. Nicholas Faith reports that within twenty-four hours of Hitler's coming to power, von Hirsch had asked Göring, then gauleiter of Prussia, if he might emigrate. Göring had agreed on the condition that von Hirsch donate to the German people a picture by Cranach, the *Judgment of Paris.* Göring and half of Germany were already aware of von Hirsch's collection, and of its quality. Von Hirsch moved to Switzerland, where over the decades he built an unrivaled collection of medieval and

*Among the geegaws, however, David Carritt found a Fragonard catalogued as a Van Loo. He bought it for £8,800 and sold it to the National Gallery in London for £500,000 ($2.8 million now).

Renaissance works of art. Some of his objects came from the Hermitage in Leningrad, and from the Guelph treasure in Brunswick, Germany. There were enamels, reliquaries, fantastic ivories, unrivaled Venetian glass, watercolors by Dürer, drawings by Rembrandt, Brueghel and van Gogh, and paintings by Guardi and Cézanne, as well as a large number of Toulouse-Lautrecs. The collection was of museum quality, and before the Nazi era von Hirsch had intended to bequeath it to a German museum, but after he died in 1977, at the age of ninety-four, the collection was sold.

The collection was sent on tour, a marketing device that was to grow throughout the Eighties. It was shown in Zurich, at the Royal Academy in London and in Frankfurt, where a number of German museum directors got together to work out a common purchasing strategy. This was coordinated by Dr. Herman Abs, the retired head of the Deutsche Bank, and a confidant of Konrad Adenauer's. As a result the German government made available a sum in the region of DM 15 million ($20 million now) and dealers throughout Europe were commissioned to act on Abs's behalf.

The appeal of the von Hirsch collection was unusual and sophisticated. The objects were small, intimate and packed with detail that repaid repeated inspection. This was something the press might have been expected to overlook, but in fact von Hirsch got more publicity across Europe than Mentmore had in England. The Dürer, expected to fetch about £200,000, reached £640,000 "in bidding so rapid it took only thirty seconds" and was sold to Marianne Feilchenfeldt, a Swiss dealer and descendant of Paul Cassirer. Rembrandt's wash drawing of Shah Jahan, which Duveen had paid £680 for in 1926, went for £160,000. One of the few Raphael drawings still privately owned was bought by Eugene Thaw for £95,000 ($434,000 now).

The high point, says Frank Herrmann, came in the sale of medieval antiquities, particularly with lot 22, a "wonderfully luminous armilla" (bracelet) that had belonged to Frederick Barbarossa, Holy Roman emperor in the twelfth century, who led the Third Crusade. The bidding took only nineteen increments to reach £1.1 million ($5.03 million now), the highest price ever paid at auction for something that was not a painting. But there was scarcely time to dwell on this; within a few minutes it had been surpassed when a Hanover dealer, Rainer Zietz, paid £1.2 million for a circular Mosan enamel medallion. Ten years before, von Hirsch had questioned the high valuation Sotheby's had put on these two objects for insurance purposes. That figure in 1967 had been £30,000.

One measure of the success of the von Hirsch sale is the list of museums who bought: the Basel Museum bought the Urs Graf drawing; the Karlsruhe Museum bought the pen-and-ink Dürer drawing *Christ on the Mount of Olives*; the Cleveland Museum bought the Rembrandt; the Norton Simon

Foundation bought the Branchini Madonna by Giovanni di Paolo. A second measure is more traditional; the total was an astounding £18.5 million ($84.6 million now), an unprecedented figure. Sotheby's had organized a massive publicity machine and, as Nicholas Faith observed, for once the return could be precisely calculated. Among the von Hirsch pictures was a Cézanne water-color, *Nature morte au melon verte,* which sold for £300,000 ($1.4 million now). In the same week, at a sale in New York, a second Cézanne still life was sold. According to Eugene Thaw, the New York dealer, it was "also of melons, of the same size and date, fresher in color and preservation." It too came from a famous Swiss collection, the Hahnloser. It went for only $350,000 (or £190,217).

For Peter Wilson, however, the von Hirsch sale was more than a commer-cial triumph. To a large extent his own success had rested on the collections amassed by Jewish refugees from Nazi Germany. Von Hirsch was from the same stable as Weinberg, Lurcy and Goldschmidt, and his collection was the most impressive and most satisfying of all in a scholarly way. After von Hirsch there was nowhere for Peter Wilson and Sotheby's to go but down.

━

After Christie's first sale in New York in 1977 there was nowhere for them to go but up. On what turned out to be a disastrous first night, twenty-three out of fifty-one Impressionists failed to sell, and the press coverage, in John Herbert's words, was "horrendous." In fact, Christie's did not make any headway into Sotheby's territory for some time. One reason may have been the buyer's premium; Christie's had brought it with them, but Sotheby-Parke-Bernet held out against it. Another reason was soon appreciated by Christie's new president in New York, David Bathurst. Though the firm prided itself on its distinguished pedigree stretching back more than two hundred years, in the United States it was "the new kid on the block." Bathurst told John Herbert that the turning point didn't come until 1980, when ten pictures were sent for sale by Henry Ford. An earlier Ford, Henry I, had been much amused by an approach he had received from a consortium of European and American dealers who had professed surprise that he had no collection of note. To help him rectify this the dealers had compiled a sumptuous book with lavish illustrations of the works they wished to sell. Ford's response was laconic: "But gentlemen, why would I want to buy any pictures when I have such a beautiful book?"

Henry II was different; he enjoyed paintings, had a lot of them, and used Christie's to value his pictures for insurance purposes. Bathurst used to stay with him for the weekend. "It was most remarkable," he told John Herbert, ". . . nearly everybody including our host was sloshed the entire time. During

some of the moments one was sober one looked at the pictures and they were sensational." In 1980, however, Ford got divorced. Though he always claimed that he didn't sell his paintings to pay for the divorce, he did move into a smaller house. He didn't sell all his pictures, just ten very good ones, among them a Manet, a Cézanne, a Renoir, two van Goghs, a Gauguin, a Degas, a Picasso and a Modigliani. This was one of the first sales where the buyer's premium allowed Christie's to be flexible on the seller's premium, and Ford paid only 4 percent. Though very low for 1980, it is not uncommon today.

The interval before this sale was especially nerve-racking because Christie's was approached by the New York dealer William Acquavella, who revived an old Duveen tactic and offered $5 million for one of the van Goghs and the Picasso. Since the combined reserves on these two pictures was $4 million, David Bathurst and Christopher Burge were tempted. In the end, however, they did as Thomas Kirby would have done and refused because they thought the remaining eight pictures, without these two stars, would make a much weaker sale. They were vindicated triumphantly. The firm had put a presale estimate on the ten pictures of $10 million. Including the buyer's premium, they fetched $18.3 million. Henry Ford didn't attend the sale because there was a strike on in Detroit, the car workers demanding more pay, and he thought it would look bad if he had gained $10 million or more while "he was telling the auto constructors to get stuffed for $1.5." Immediately after the sale, Bathurst called him with the good news, only to have to do it again the next morning, John Herbert says, because Ford had been so drunk the night before that he couldn't remember.

But if the ten Ford paintings were a rollicking success, eight other paintings that were sold just a year later were a turning point in a different way. A few months after the Ford sale, Bathurst had lunch with a certain Dimitri Jodidio, who ran a Swiss-based art-investment company called Cristallina, and who told Bathurst that he wished to raise $10 million by selling certain paintings. As a result, Bathurst visited Lausanne in February 1981 and examined the paintings. Eight were chosen: van Gogh's *Mas à Saintes-Maries,* Renoir's *Buste de femme croisée d'un chapeau,* Monet's *La Seine à Rouen,* van Gogh's *Deux rats,* Cézanne's *La Maison abandonée,* Berthe Morisot's *Apollon visitant Latone (after Boucher),* Gauguin's *Nature morte aux mangues,* and Degas's famous *Portrait of Eugène Manet.* The sale was to take place in May 1981, along with several other Impressionist and Post-Impressionist works, and during the intervening months three things happened. The most important was a rise in interest rates, which touched 20 percent in some places that spring. The second was that Jodidio arranged for a glowing write-up of his pictures in *Connaissance des Arts,* a French arts magazine that

he owned. And third, according to Jodidio, Wildenstein, his erstwhile partners, tried to influence some people against his pictures. All three events were later given in explanation for the disaster that took place at Christie's on the night of May 19, 1981, though Bathurst himself told John Herbert that high interest rates were solely to blame.

Bathurst had no idea what was in store for him as he approached the rostrum that night. The van Gogh painting of two rats was hardly an appetizing subject, but that apart, the pictures were good ones and the salesroom was as crowded as ever. Once the sale began, however, it was obvious that something was wrong. On several of the lots there was no bidding at all, and none of the rest reached their reserve price, so Bathurst reached the last of the Jodidio pictures, the Degas, without having sold a single painting. He had left the portrait of Eugène Manet to the end because he had thought it would be the hardest to sell, but it turned out to be the only one of Jodidio's pictures that did sell, and for $2.2 million, a record for the artist. After the Cristallina pictures, the rest of the sale was equally bleak. For instance, one lot consisted of eight works by René Magritte that had decorated a restaurant. They were being sold on behalf of the Belgian government, but since they were very large, there was not a single bid, and they too were unsold. In fact, that night was as bad as Christie's first big sale in New York and ended with 60 percent of the work unsold.

As Bathurst left the rostrum, John Herbert reports, he was surrounded by journalists smelling an "art market collapse" headline. Bathurst did not speak to them immediately, but instead conferred with Christopher Burge, telling him that he proposed to say that two pictures that had not sold, the better van Gogh and the Gauguin, *had* sold. This is what he later did say.

Bathurst's "erroneous" statement, as his lawyer later described it, took several years to exact its toll. By then Bathurst was back in London and chairman of the company. But though Jodidio had at first seemed unperturbed about the failure of the sale, he later took Christie's to court, claiming negligence and fraudulent misrepresentation. The matter took four years to come to court and was settled privately. However, the whole truth was made public and Bathurst had to resign from Christie's. It was a pathetic end to a silly mistake, but his plight was of his own doing. Of course, the firm suffered from some bad publicity temporarily, but it was not otherwise damaged or changed in any material way. Profits remained stationary for a year, but then resumed their near-vertical ascent.

The same could not be said for Sotheby's. In 1981 its profits took a tumble for a very specific reason. The firm lost someone who was even more important to it than David Bathurst was to Christie's: Peter Wilson.

Three days after the Ford sale in May 1980, Christie's auction of contemporary art set a record of $2.6 million, with Jackson Pollock's *Four Opposites* fetching $550,000. (These sums seem tiny now, but they were records then.) The contemporary art world had gone on expanding during the Seventies. Lawrence Rubin had returned from Paris and joined Knoedler in 1972 to expand its modern and contemporary holdings; Irving Blum and Joe Helman had formed a partnership in 1974; Holly Solomon had opened up on West Broadway in 1975 and Marion Goodman on East Fifty-seventh Street two years later. But as Calvin Tomkins pointed out in 1980, "It is frequently observed that no major new artists emerged in America during the nineteen seventies." Brooke Alexander, whose gallery on East Fifty-seventh Street had opened in 1969, makes a related point, saying that "modernism died (and therefore the art world changed) towards the end of the 1970s."

Other changes were economic: Margaret Thatcher was elected in May 1979 and President Reagan in November 1980, though the Wall Street boom they helped bring about did not really begin moving until 1982. The economic changes, as so often before, affected the art world. In May 1980 Calvin Tomkins published a piece in *The New Yorker* called "A Thousand Flowers." His subject was Saturdays in SoHo, where fiddlers, banjo players and "two young women dancing on stilts," were "accompanied by a young man with a harp," providing "the best free show in town."

However, these were only the passing show. The permanent attraction in SoHo was now the galleries. Whether there was new talent emerging or not, art was now, in the words of Arne Glimcher of the Pace Gallery, "a major industry." In the early Eighties both *Horizon* and *Art & Auction* (itself a sign of the times) featured the galleries on Fifty-seventh Street as a "phenomenon." According to *Art & Auction,* in the Fifties there were barely a dozen art galleries on the street, but "today there are almost sixty . . . stacked in four blocks between Park and Seventh Avenues." When SoHo and Madison Avenue were taken into account the figure topped one hundred (and was four hundred by 1987).

Glimcher, at Pace, was himself becoming a celebrity (see figure 81). One observer foresaw that artists would "become the rock stars of the Eighties." Glimcher was always eclectic. In Boston he had worked first as an artist, occasionally as an actor, then as an art historian (but he "had trouble writing papers"). In 1960 he borrowed $2,400 and opened a small gallery on Boston's Newbury Street, then moved to Manhattan three years later. "If you wanted to be a major dealer, that is where you had to be." In fact, he says, he did

it too late. Warhol and Oldenburg had shown with him while he was in Boston, but by the time he arrived in New York most artists had steady relationships with other galleries. "I ferreted out artists who were somewhat unique and didn't seem to fit into a category—Lucas Samaras, for example. My gallery started to build up with more eccentric artists—artists who were not part of a single movement. I did it out of necessity, but of course it's my personal sensibility. . . . It was a weakness of the Sixties and the early Seventies and it became a strength of the gallery in the Seventies and Eighties. A mature artist does not want to be seen as a cog in a movement." Until the Eighties Glimcher knew three quarters of his clients personally; thereafter, he says, the proportion he knew fell to 25 percent.

Paula Cooper confirms that about 1980 there was a discernible change in the market. In October/November of that year she found that the demand for Jonathan Borofsky's work was, in her words, "hysterical. . . . One frantic buyer telephoned from Europe before the opening to reserve a piece—any piece."

Another factor that brought about this new climate was the development of Neo-Expressionism. In a way, Minimalism and Conceptualism, the art of the Seventies, had taken abstract art to the limit, and it was not a direction favored by collectors, quite a number of whom had given up buying in the Seventies. Frank Stella drew attention to this in a lecture he delivered at Harvard in 1983, when he argued that there had been a hiatus in the development of art in the previous decade because abstract art had not fulfilled its promise. In his view the reason was simple but profound: abstractionism "had not come up with a really viable substitute for the human figure." Whether or not one agrees, it is interesting to note that around 1980 Neo-Expressionism peaked virtually simultaneously in Italy, Germany and the United States. This art was above all figurative, huge and crude but deliberately so. It was immediately controversial, a sure sign of life if nothing else, and truly international; in 1982 Calvin Tomkins reported that eighteen New York galleries were showing young French artists in the same month. The artists of this movement included David Salle, Robert Longo and Erich Fischl from the United States: Sandro Chia, Francesco Clemente and Enzo Cucchi from Italy; and A. R. Penck, Georg Baselitz, Anselm Kiefer, K. M. Hödicke, Rainer Fetting and Helmut Middendorf from Germany. In Manhattan they showed at a new group of galleries: Annina Nosei, Xavier Fourcade, Marion Goodman and the Sperone Westwater Fischer gallery that had been opened in SoHo by colleagues of Castelli's from Frankfurt and Turin.

But one artist and one dealer above all epitomized the "new spirit" in painting (the title of a Royal Academy show in London in 1981). The artist

was more controversial than any for a long time, and the dealer also had some original ideas of her own. This duo was Julian Schnabel and Mary Boone (see figure 83). Schnabel was twenty-eight when Mary Boone gave him his first one-man show in February 1979. That he evoked the same kind of hysterical interest as Borofsky may be seen from the fact that he had his second one-man show in the same year, in November, with paintings executed on a ground of plaster and broken plates. Over the next decade Schnabel's plate paintings would divide critics and the public as thoroughly as any art controversy, culminating in Robert Hughes's hilarious poem "The So-Hoiad," published in *The New York Review of Books*:

> And now the hybrid child of *Hubris* comes—
> JULIAN SNORKEL, with his ten fat thumbs!
> *Ad nauseam,* he babbles, whines, and prates
> Of Death and Life, Careers and Broken Plates . . .

Interestingly, Hughes reserves the same spleen for Mary Boone:

> The monstrous Ikon, decked in gold and blue
> Rolls ponderously down the avenue,
> Dragged by twin chains, dependent from its cage,
> The first one drawn by Youth, the next by Age.
> The former by the hands of MARY SPOON,
> Part secretary, part goblin, part *Racoon* . . .

Mary Boone was born in Pennsylvania in 1952, the daughter of immigrants from Egypt. Her father died young and her mother took the family to California. They lived with an aunt in Pasadena, where there was "warm rain and tropical colors" but no money. "Everyone was blond, the Aryan dream. . . . The other children used to ask if I was an Eskimo. I really suffered because I didn't have a little nose and blond hair. Eventually I bought myself a little nose, but the blond hair I was never able to get." She went away to school, first to Detroit, then to the Rhode Island School of Design, where she hoped to become an artist. By the time she was nineteen she was in New York and in 1971 was working for the Bykert Gallery. She started dealing for herself privately and opened her own gallery in the 1977–78 season. Bykert had shown Minimalist art and was a casualty partly for this reason, closing in 1976. But Mary Boone knew what she preferred, and Schnabel and David Salle were it. The response was enormous, and within three years, by 1982, all of them—Schnabel, Salle and Boone—were famous.

In an interview Mary Boone said that the difference between herself and

a dealer like Leo Castelli was that whereas "Leo made his collectors rich, I made my artists rich." That is to say, she had a conception of the careers of artists; hence Hughes's jibe in "The SoHoiad." She introduced fine cataloguing, even for brand-new artists, with notes by such people as Gore Vidal or Robert Rosenblum; she bought back works by her artists to maintain high prices; and she ensured they had rights in subsequent sales of their works. This was a clever move, for it kept alive the link between artist and collector, and, because an owner had to pay a commission on subsequent sales, he or she would ask more, assuring higher prices. Boone says of Castelli, "Leo was formed under the Eisenhower and Kennedy years. I am post-Watergate, post-Vietnam, post-modernism, so I think I'm more in tune with what America wants. We are wiser now, less chauvinistic." She sees herself as part of a tradition of dealers as tastemakers and compares herself with Betty Parsons, Julian Levy, Sidney Janis and Frank Lloyd.

Betty Parsons died in July 1982. In the last decade of her life there had been criticism that she had lost her eye, but it would be more true to say that her priorities had changed; in any case some people continued to misjudge her. In the 1970s she told an interviewer that it was important for a dealer, as for an artist, "to dignify the work," to keep to the values that artists have when young, before they are seduced by money. This is why she stuck with an artist like Kenzo Okada, whom she knew the critics hated; why she still preferred to show new artists rather than to stock the giants she had helped create. She hated art critics and she had no time for art history. The fact is she continued to believe in the new and the offbeat—she herself turned to wood sculpture in her later years. Betty Parsons kept herself open to the new until she died. She did not go the way of Durand-Ruel, Vollard, or Kahnweiler.

Mary Boone is not the only post-modern dealer, nor did the boom in contemporary pictures affect only Julian Schnabel. But the two of them were definitely critical factors in the contemporary boom that flourished after 1982. It is also worth noting that the boom in the contemporary market did not begin in the salesrooms. Though the Scull auction in 1973 had drawn attention to contemporary art and its rising prices, and though records were set at Christie's contemporary sale in 1980, the auction-house bonanza did not really erupt until after the 1982 Wall Street bull market. By then Lawrence Rubin, Arne Glimcher, Paula Cooper and Mary Boone, to mention only four, had already made their mark.

32 | THE FALL OF SOTHEBY'S AND THE RISE OF ALFRED TAUBMAN

In the autumn of 1979 Britain was absorbed in a scandal involving the art world but for once not the art market. On the afternoon of Thursday, November 15, Prime Minister Margaret Thatcher told a packed House of Commons that Sir Anthony Blunt, formerly surveyor of the Royal Collection and director of the Courtauld Institute of Art History, had been the "fourth man" in Britain's infamous troop of Cambridge-educated and homosexually inclined spies. The others had been Guy Burgess, Donald Maclean and Kim Philby. This came as a shock to most people, though the security services had known about it since 1963. All sorts of names had been rumored previously, among them Peter Wilson's, doubtless because of his MI6 activities during World War II.

Wilson delivered his own bombshell to Sotheby's just four days later, when he gathered the staff together and, with a thunderstorm raging above, announced that he was retiring. The shock was compounded by his naming David Westmorland as his successor instead of Peregrine Pollen, who had been brought back from New York as the heir apparent. Wilson was retiring not because he wanted to go but for financial reasons. He had a home in France, and if he continued to hold his job in London, his children, on his death, would have to pay death duties in both France and England. But if the move suited his offspring, it didn't suit him. "He had had no real life except Sotheby's since he was young," his brother Martin told Nicholas Faith. "He

had to be irreplaceable—and he was." Wilson soon realized that he couldn't bear to quit his beloved auction house completely. He suggested a permanent and dedicated phone link between Bond Street and his house, Clavary, in the south of France. When this was derided he became very bitter.

Ironically, the atmosphere at the firm was no less bitter, for though Westmorland was nominally Wilson's successor, few expected him to last long. Surrounding him were half a dozen strong personalities jockeying for position. An article in *Fortune* at the time put the picture dramatically but did not exaggerate: "Marcus Linnell didn't get on with Graham Llewellyn or Peregrine Pollen," said one anonymous director. "Llewellyn didn't get on with Pollen; Pollen didn't get on with Peter Spira; Spira didn't get on with Llewellyn; I've never experienced anything like it."

But it wasn't merely a question of clashing personalities; Sotheby's was weaker than it looked. In his last years, Wilson believed instinctively that increased sales would bring increased profitability, and so he had not worried unduly about costs. But the plain fact was that by the early Eighties costs were out of control. In the six years up to 1981 Sotheby's staff worldwide had increased by 50 percent, to 1,900. Partly as a consequence of this, the firm's profit margins had fallen. In 1978–79 it had netted £8.2 million from sales of £186.4; two years later it was making just £7 million from sales of £321 million. The biggest expansion of all took place in New York, where Sotheby's moved from Madison Avenue to a new and much bigger space on York Avenue at Seventy-second Street. This cost $8.4 million, and a healthy expansion in sales was needed to pay for it. Unfortunately, this was the time when Christie's started to flourish in New York. It was lucky—or clever— with its American appointments. One, Stephen Lash, a former banker from Warburg's, was well known in New York and a reassuring presence in discussions with the executors of estates. A second, Ralph Carpenter, was a world authority on the traditional American furniture made in Newport, Rhode Island, and helped Christie's to acquire a large chunk of the United States market. While Sotheby's was taking on the characteristics of a big corporation run by organizational types, Christie's became more intimate, more closely tied to art, run by people who knew their fields and their customers.

The situation was made worse by the recession of 1980–82. This wasn't as bad as 1974–75, but it was hardly good news for Sotheby's in its extended and vulnerable state. Matters came to a head at the end of 1981, when the figures were released for the first half of the season. Christie's sales stood at £70.84 million, up by half a million pounds. Sotheby's, however, refused to release its figures, claiming that there had been no sales in late 1981 to

compare with what it had done in 1980. Of course nobody swallowed this.

Westmorland was still in charge in Bond Street. Knowing that something out of the ordinary was called for, he turned to Gordon Brunton, chief executive of the Thomson Organization, a Canadian conglomerate with oil, mining and newspaper interests. Brunton thought of himself as a hardheaded businessman, but he was also the man responsible for selling *The Times* and *The Sunday Times* to Rupert Murdoch for a mere £12 million. Westmorland asked him to compile a report on the company's problems and Brunton set to it with gusto. In six weeks at the beginning of 1982 he interviewed sixty senior executives. His report, delivered in March, concluded that the art market was still a growth area and that the firm was not seriously stretched financially, but he also made it clear that he was shocked by the individual power bases arising from personal ambitions; that there were bitter divisions between experts and managers; and that the European staff, while contributing almost 50 percent of the firm's London sales, felt like second-class citizens. He concluded that the organization as a whole resembled "a Gilbert and Sullivan farce."

Brunton thought that Sotheby's should have a new board. He also felt that its problems were so urgent that no time should be lost looking for new board members with managerial ability; therefore he suggested promoting experts from within the firm, experts who had a name for honesty and integrity. This is how Graham Llewellyn, a jewelry expert, came to be the chief executive, and Julian Thompson, a porcelain scholar, was made chairman of the company that ran sales in Britain, and of a second company that operated in Europe and the Far East. Belgravia was closed; its staff were given only a weekend's notice, which produced more than a whiff of panic. Cuts were announced in the provinces at Chester and at Torquay, where the salesroom was bought back by its management for a fraction of the price they had sold it to Sotheby's for a few years earlier.

New York faced similar surgery. Nicholas Faith reports that John Marion called the staff together and told them that two hundred people had to go, thirty every Friday. The low point was reached in February 1983, when the figures for the year 1982 were released. Sotheby's in New York appeared to have lost the magic touch Peter Wilson had given it, for business had not followed it to the new premises on York Avenue and Seventy-second Street. Sales there had declined from $90 million to $56.6 million. Indeed, the unimaginable had happened: Christie's was now outselling Parke-Bernet in New York and was even ahead worldwide. It was the first time this had happened since the early Fifties, when Peter Wilson had taken proper command. Sotheby's was still a glamorous name, but it was not the creature it

had been. And Brunton was not the only person in the world with a business brain; other people could see what he could see: Sotheby's had become the perfect target for a takeover.

There was no shortage of suitors. Steve Ross, chairman of Warner Communications, was one. He impressed John Marion but not Gordon Brunton and was turned away. Leonard Sainer, of Sears Holdings, made an offer but it was a low one. Interest from American Express was taken much more seriously because it was felt that Amex's and Sotheby's customers had similar life-styles. But there were predators, too; in mid-December, just as the deal with American Express looked likely, two other American financiers, Marshall Cogan and Stephen Swid, announced that they had acquired 14.9 percent of Sotheby's stock for $12.8 million. Everyone could see what was coming.

At first no one knew who "Toboggan and Skid" were, but the directors were forced to find out. Swid had teamed up with Cogan ten years before, in 1973, and previously had been a researcher with a couple of American investment houses. Cogan had founded his own stockbrokerage, Cogan, Berlind, Weill and Levitt; that eventually merged with Shearson Hammill, which in turn was bought by American Express. By then, however, Cogan had broken away; having been bought out, he was sitting on a reservoir of cash. Together Cogan and Swid had taken over GFI Industries, makers of carpet felt, a material that has wide industrial uses (in motor vehicles, for example), and the pair's cash reservoir increased. Then they took over Knoll, the well-known furniture manufacturer. Cogan and Swid's record was impressive; according to Faith, when they had bought Knoll, thirty out of the company's thirty-one designers had threatened to resign, but the two men talked them out of it. Their first approach to Sotheby's was friendly, but when they were given short shrift they were forced to make a hostile bid. Later they were to get a bad press, but in purely business terms their approach was straightforward. Sotheby's had been badly run—everyone knew it—and was underperforming, whereas Cogan and Swid had a proven record of turning businesses around. Moreover, they were both collectors of modern art, and Cogan was chairman of the American Council on the Arts.

Cogan and Swid's full bid came on April 15, 1983. The price, £5.20, was sweetened by the proposal that Lord Harlech serve as chairman. He had been suggested by Morgan Grenfell, the bank Cogan and Swid had hired to handle the takeover. As a former Tory minister and ambassador to Washington, Harlech seemed an impeccable choice. He might well have been, but what the snobs at Sotheby's objected to was Toboggan and Skid themselves. Echoing the Knoll takeover (not to mention Hiram Parke and Otto Bernet), all the department heads threatened to resign if Cogan and Swid succeeded in their

ambitions. Although sheer snobbery was part of it, in fairness to the experts there was also a worry that because the two financiers were borrowing so much to buy the firm, and then promising (or threatening) to run the business themselves, the nature of Sotheby's would change.

As it turned out, the chief weapon against the New York financiers was their need to borrow, for this took time. Another weapon was Brunton, who was no more in favor of their attentions than he had been of Steve Ross's. He would not allow Cogan and Swid even to meet the department heads, a crucial maneuver since Cogan and Swid were convinced that they could have won over enough of them to make their bid viable. Brunton brought in Warburg's, specifically Hugh Stevenson and David Scholey, its chairman, to help defend Sotheby's. Their strategy was twofold: first to trash the Cogan and Swid bid, and second, to have the deal referred to the Monopolies Commission. It was not easy to denigrate the bid itself, so Warburg's main hope was the lack of credibility of Cogan and Swid because of their unfamiliarity with the art market and of a brush that Cogan had had with the SEC in New York. (On that occasion, while not admitting guilt, Cogan agreed to allow himself to be disqualified as an investment adviser.)

But none of this was likely to cut much ice. Most of Sotheby's shareholders at the time were institutions or arbitrageurs who were in it only for the profit. As long as Cogan and Swid paid what they promised, the shareholders didn't care what happened afterward. If there were no sound commercial reasons for rejecting the bid, there were no better reasons for referring the deal to the Monopolies Commission. Initially, this decision was in the hands of the Office of Fair Trading. Its officials knew the art market quite well, as Faith points out, having recently dealt with the allegations of collusion about the buyer's premium, so it didn't take them long to conclude that the proposed bid did not constitute a monopoly or anything like it. Accordingly, this recommendation went forward to the OFT's political master, the secretary of state for trade, Lord Cockfield.

Even so it was clear to Brunton and the other directors of Sotheby's that their only hope lay with the Monopolies Commission, simply as a delaying device while a white knight was sought. Statistically a third of all takeover bids lapsed while they were being considered by the commission, and another third were turned down. Inertia is a powerful force, and Sotheby's now embraced it. Nevertheless the inconvenient fact remained that the OFT had recommended that the bid be allowed to proceed. As it happened, two other factors could work in Sotheby's favor. The first was the relevant minister himself: Lord Cockfield was one of the more unpredictable forces in British politics. A tax inspector by training, he had once run Britain's large chain of pharmacists, Boots, but had entered public life when Edward Heath, then

prime minister, had asked him to run the Prices Commission, the watchdog body over consumer prices. Cockfield could rule against Sotheby's as easily as for it, but with him holding the key to the offer there was everything to play for.

Sotheby's also made use of an entity that Cogan and Swid probably never knew existed: the British establishment. This is a beast hard to describe even when you are familiar with it, but the way Sotheby's was now defended provides, as Nicholas Faith says, one of the best definitions ever drawn. The procedure was as magnificent as it was disgraceful. The first move was to enlist the aid of paid political lobbyists, then a new phenomenon in Britain. The firm used was known as GJW, taken from the initials of its main partners, Andrew Gifford, Jenney Jeger and Wilf Weeks, three young lobby-ists each close to a different political party. This trio began with some plain speaking. Sotheby's, they said, had been so aggressive and high-handed in the past that it couldn't rely on the art trade for help. Instead, and given GJW's political contacts, the solution lay with Whitehall and Westminster—that is, they had to sow seeds of doubt about the propriety of the takeover in the minds of senior civil servants and politicians.

This appealed to Sotheby's sense of self-importance. In the House of Commons, these lobbyists first nobbled Patrick Cormack, a Tory MP. A flamboyant backbencher who lists his hobby in *Who's Who* as "fighting philistines," Cormack initiated a debate in the House. At Whitehall, where the main tactic, in Nicholas Faith's words, was to "muddy a superficially simple picture," their chief ally was Edward Heath. The former prime minis-ter had known Sir Alec Martin, the chairman of Christie's, was close to Earl Jellicoe, a member of Sotheby's board, and had stayed with Peter Wilson in France. Heath was brought in by Weeks, who had once been his personal assistant. (The establishment was really working overtime now.) Jellicoe, Wilson and Weeks persuaded Heath to see Paul Channon, the minister for the arts. In no time, Cockfield found himself bombarded on all sides: by Heath, the former prime minister to whom he owed his public position, by a raft of MPs led by Cormack, by fellow ministers like Paul Channon, and by former ministers like Jellicoe. It was a formidable team, though nakedly partisan.

Faced with this array, Cockfield gave way. Buried in the OFT's report, there was a brief phrase referring to "the importance of London as the centre of the international art market and the position of Sotheby's in relation to that." Cockfield ignored the fact that Cogan and Swid had promised to let the firm's headquarters remain in London, and on May 4 he referred the bid to the Monopolies Commission. The net effect was a breathing space, and

this provided the opportunity for another rival, one more suited to Sotheby's high opinion of itself, to be found.

Among the friends of Sotheby's in London was David Metcalfe, an insurance broker and son of Edward "Fruity" Metcalfe, aide-de-camp to Edward VIII during the abdication crisis and best man at his wedding to Mrs. Simpson. Metcalfe's links to Sotheby's went back to the Fifties, when he had attended the Goldschmidt sale. Subsequently he had married Alexis Korda, widow of the film producer Alexander Korda, and her Impressionists had been sold at Sotheby's in the early Sixties. Metcalfe was particularly close to Lord Westmorland, who was godfather to one of his children, but his importance as a link man was also due to his familiarity with the United States. After Alexis died, Metcalfe had married an American and was well known in New York and Palm Beach, where he had become friendly with Max Fisher, a Detroit millionaire and former chairman of United Brands. Through Fisher, Metcalfe had met A. Alfred Taubman; in fact Metcalfe's wife had introduced Taubman to Judy Rounick, who would become his second wife, in New York. A few months before the Sotheby's crisis flared up, Taubman had casually mentioned to Metcalfe that soon he would have a lot of cash available because of a deal that was maturing; he added that he would be interested in backing any schemes that Metcalfe was himself interested in. Metcalfe forgot all about this, but when Westmorland mentioned that Sotheby's was looking for a white knight, he immediately thought of Taubman (see figure 78).

Taubman is a big, bluff man whose appearance is against him in the precious confines of the art world, but in his way he is every bit as creative as Peter Wilson. The son of a builder, he had trained as an architect, and this had a lot to do with his vision, no less original than Wilson's, that in the postwar world the car and the traditional city were incompatible, and that something needed to be done to enable them to coexist. His answer, still controversial to planners, if not to the shoppers who throng them, was the shopping mall, in effect an artificial main street with the traffic taken out.

Born in Detroit of German immigrant parents, Taubman left architecture school without graduating. In fact, he says, he was an indifferent student and had to overcome both dyslexia and a stutter. His first job was as a shoe salesman, but in 1950 he borrowed $5,000 and began life as a contractor, building storefronts. In time this led to shopping centers and a lifelong friendship with Fisher, who in 1957 gave him a contract to build two hundred gas stations for the Speedway 70 chain Fisher had just acquired. Early on, however, Taubman saw that it was better to be an owner than a builder, and this was one of the reasons why, as the Sixties wore on, he began building

shopping malls. One reason for his success was his foresight in producing larger malls than was prudent according to the prevailing wisdom. Equally important was his insistence on quality. Unlike many others, his malls featured such top stores as Brooks Brothers, Saks and Bloomingdale's, and his rents were usually twice the national average. Retailing was his life, and his son Robert recalls that on weekends the family would go for picnics—on the firm's newest construction site.

By the mid-Seventies, with some twenty malls under his belt, Taubman was a millionaire many times over but was virtually unknown outside the real estate business. However, he became better known through the Irvine Ranch deal, which was both a dream and a nightmare. The ranch occupied some 78,000 acres bordering the Pacific Ocean and was within easy commuting distance of Los Angeles. The Irvine family had developed barely 5,000 acres, with much of the rest left as orange groves. It was a prime site for development, as Joan Irvine Smith, granddaughter of the Scotsman James Irvine, who had bought the land, well appreciated. She was a feisty blonde, four times married; *Forbes* listed her wealth as arising from "real estate and law suits." She certainly appeared to enjoy litigation, especially against the "bozos," as she called them, who ran the foundation that owned the ranch and were, in her view, preventing its development. In the end, her twenty-year battle to gain control was aided by a group of Detroit businessmen whom Taubman put together, and which included Henry Ford and Max Fisher. But they were not the only people after the ranch; Mobil wanted it too, as did a Canadian conglomerate. Nevertheless Taubman acquired it, and in 1982, after five years, sold out, giving himself and his group a gigantic profit; what they had bought for $375 million they sold for $1 billion. This masterstroke made Taubman, alongside his friends Ford and Fisher, one of the richest men in the United States. He also became one of those who could afford the $100 million needed for Sotheby's.

Whereas Brunton had had little in common with Cogan and Swid, he was at home with a man like Taubman. After all, his own bosses for many years, Roy and then Kenneth Thomson, were rich Canadians with the same buccaneering attitude. Also, the more that people found out about Taubman, the more suitable he appeared. True, he was said to spar every morning and was excited about the football team he owned, but he was also a trustee of the Whitney Museum and of the Smithsonian. He had even been a customer of Sotheby's (and, it should be said, of Christie's). After Metcalfe's original approach, he was introduced to Westmorland.

In an interview later, Taubman said, "We talked and I said we would look at the figures, which we often do when we are seriously exploring a deal. When I did, I could see that Sotheby's would certainly lose five to six million

in 1982. Yet they had nearly four hundred million in turnover. Then I got a call from Peter Wilson, whom I didn't know well, and we met in my New York apartment. There he convinced me, as only he could. The more I looked, the more I was impressed by the quality and loyalty of the staff—and by the terrible working conditions. People were grossly underpaid and their pride was wearing thin. There wasn't a lot of debt, but they did have a credibility problem.

"Then I went to see John Marion, who had a painting that had been owned by Edsel Ford. I had been offered this picture by the attorney representing the Ford estate, and though I wanted to buy it, I told him to put it up for auction. I said I would bid for it, that it would be cleaner, and that we would all feel better about it. This was an important experience for me. I bought it at auction but the Marion meeting made me want to own the business. For the first time I saw clearly the similarities with my own company. The more I analyzed it, the more it seemed to be a people-oriented, service-oriented business—exactly what I had been doing. It had a lot in common with the retail business; I sensed that immediately. However, basically objects were consigned, so there was no necessity for a large inventory or big capital expenses, both of which are inherent in retail businesses."

At this point Taubman started buying Sotheby shares in the market. Cogan and Swid had expected the price to fall after their bid was referred to the Monopolies Commission, but because of Taubman's interest the price dropped only a pound before starting to rise again. Suspecting that someone else was stalking them, Cogan and Swid then made a second offer, of £6.30 a share, more than a pound above what they had originally promised. However, the momentum was now with Taubman, and by the end of June, he agreed to buy their shares for £7, giving them a profit of £7 million for their trouble. Cogan used his profits to buy "21," one of New York's best-known restaurants.

Now the referral to the Monopolies Commission was shown up for the fix that it really was. With Cogan and Swid out of the way, its deliberations became a mere formality. Still, Taubman told the commission that for tax reasons he would turn Sotheby's into a privately owned company based in the United States. So much for Cockfield's pious worries about London's being the center of the art world.

Taubman's first move was to meet the staff at Bond Street, gathering them together in a room in the book department. "I told them that I wanted them to know I had been mistreated for years at Sotheby's and Christie's. I said that if I was going to buy the company, I wanted them to pledge that their manners would improve, that they would say 'please' and 'thank you' to customers, that they would offer good service and show that they cared about

what customers thought. Their expertise and scholarship were beyond question, I said, but they were in a service business and if they couldn't behave properly, they didn't belong. Then I flew back to New York on the Concorde and gave the same speech to the people in Manhattan." The transatlantic approach was significant—not surprising, but significant. Taubman was of German-Jewish extraction like Weinberg, Lurcy, Goldschmidt and Kramarsky, but he was also an American, like Kirby, Cortlandt Bishop and Hiram Parke. The shuttlecock that had been the AAA, the AAA-AG, Parke-Bernet and Sotheby-Parke-Bernet would now finally shift back to Manhattan.

33 | THE NEW SOTHEBY'S
AND THE NEW COLLECTORS

While Sotheby's had been through the wringer, its traditional rival had been going from strength to strength. In 1982 Christie's had shot ahead of Sotheby's for only the second time since the war with a £3 million profit, against a loss of about £3 million at Sotheby's. Just as important, sales at Christie's in New York now equaled those in London. That the firm was now winning the battle between the big two showed itself plainly in the disposition of the Gould estate. If 1882 may be said to be the start of the modern art market, and if 1957 was the year when the market took on its current form, then 1984, the year of the Gould sale, was the beginning of the fabulous period that culminated in the sale of *Dr. Gachet* for $82.5 million.

Florence J. Gould was the widow of Frank J. Gould, the younger son of Jay Gould, one of the original American robber barons. Gould had made his money from the Missouri Pacific railway and with the profits had built up the "Gould System" of private railways in the South, before acquiring the Western Union Telegraph Company and the elevated railways in New York. His son Frank was more cosmopolitan. He married Florence in 1923 and they settled first in Paris, then in the South of France, where he built casinos all along the coast and was largely responsible for making Juan-les-Pins fashionable. Florence was a good match for him; she enjoyed gambling and, according to John Herbert, "would appear at Frank's casinos in her Hispano-Suiza car and wearing silk beach pajamas and dark blue sunglasses, a few chips

clacking away in her hand." Her fingers were covered with jewels; she was passionate about stones and displayed them whenever she could. Herbert again: "She wore them in her hair, on her shoes, she wore them at breakfast," and her collection rivaled that of the Shah of Iran. She was even festooned with jewelry when she visited Cambodia to explore the ruins of Angkor Wat.

But Florence wasn't merely flashy. In her youth she had hoped to be an opera singer, and after her marriage to Frank she retained her interest in the arts. In Paris, after World War I had ended, her Thursday salon on the avenue Malakoff became famous; frequent guests included Marie Laurencin, Jean Dubuffet, François Mauriac and Jean Cocteau. She also founded the Prix Max Jacob for poetry, and for this and other literary efforts was awarded the Légion d'honneur. After Frank's death in the mid-Fifties, she collected paintings, mainly Impressionists, through Daniel Wildenstein, though a few were acquired at Sotheby's. When she died in 1983, at eighty-seven, leaving an estate worth $123 million, her passing truly marked the end of an era.

By rights Florence Gould's effects ought to have gone to Sotheby's, since one of her closest neighbors in the South of France was Peter Wilson. But Wilson wasn't well at the time, and in any case the executors of her estate were concerned by what was happening inside Sotheby's. As a result the Gould effects were split into three parts—jewelry, furniture and pictures—and the jewelry was given to Christie's, mainly owing to the efforts of François Curiel, a charming Frenchman who had built up Christie's business in New York. In view of Mrs. Gould's American origins, a sale in New York was envisaged, with a tour of half a dozen cities as part of the pre-sale publicity. It was here that Christie's came unstuck. They planned to sell the jewels in April 1984, but on January 20 of that year, while the Gould and other jewels were on display at King Street in London, three men with sawed-off shotguns raided the firm and in broad daylight forced Christie's staff and potential buyers to lie flat on the floor while they smashed the display cases with a sledgehammer. Nothing was ever recovered. Luckily, only one piece of substantial value, worth £750,000, was taken, and it was not one of Florence Gould's. Despite this (or perhaps because of the added notoriety), her jewels sold for $8.1 million when the auction eventually took place in the spring. At the time this was a record for a collection owned by one individual, and it was well over the $7 million that the trustees of the estate had expected.

Even so, the robbery had an effect, for when it came to selling Florence's Impressionists, Sotheby's was given a chance, and it was with this sale that Taubman decided to make his mark. Once he had taken over at Sotheby's he had moved swiftly, and he had also been lucky. Certain pictures belonging

to the Havemeyer family, the final remnants of Louisine's travels, had already been consigned to Sotheby's for sale in 1983. To this was added the manuscript of Stravinsky's *Rite of Spring*. These helped Sotheby's to turn in a modest ($7 million) profit in Taubman's first year of ownership, which made the "new broom" appear efficient and fostered the impression that the worst was over. Though he had several other companies to attend to, Taubman devoted much of his time that year to Sotheby's. Staff cutbacks continued. "We got the company down from around two thousand to thirteen hundred and forty." Taubman also appointed as chief executive officer Michael Ainslie, a good-looking Bostonian who had been head of America's National Trust for Historic Preservation and therefore knew something about the art world and something about cultural politics (see figure 79). He soon proved himself equally at home in the business world. John Marion was kept on; indeed, his role was strengthened, as were those of the other experts who had a feel for business, David Nash (Impressionists, New York) and Julian Thompson (Oriental works of art, London). However, the main internal promotion was that of Diana D. Brooks. She had joined Sotheby-Parke-Bernet in 1980, and her rise in the company throughout the Eighties matched the rise of the art market itself; she became an executive vice president in 1985, president in New York in 1987, and chief executive officer in the United States in 1990.

But Taubman's most publicized gambit was to flood Sotheby's board with a raft of rich friends and acquaintances—socialites, in many cases—whose job it was to bring in business and create the impression in the minds of prospective sellers, at least in the United States, that Sotheby's was a sort of club, membership in which conferred social status. Some of these board members, like Henry Ford and Max Fisher, had been partners with Taubman on the Irvine Ranch deal. On the face of it, the three made an incongruous trio. Ford, who died in 1990, was a coarse man, beer-swilling and hedonistic, who had three wives, each worse than the last, according to his friends, who dubbed his progress as a move "from class to brass to ass." Fisher, on the other hand, was much less flashy, though he was chairman of United Brands when it was convicted and fined $15,000 for bribing Honduras government officials in exchange for tax breaks. Still, Fisher was chiefly known for his enthusiastic fund-raising for Jewish and Israeli charities. He was more politically aware than either Taubman or Ford, and wrote Op Ed–page pieces for *The New York Times*.

Besides these two, Taubman invited retailers such as Leslie Wexner of The Limited and Seiji Tsutsumi of the Seibu department-store group in Japan to join the Sotheby's board, as well as rich industrialist members of the international jet set with a proven interest in art, such as Baron Hans Heinrich

Thyssen-Bornemisza, Giovanni Agnelli and Ann Getty. The final layer consisted of minor royalty and people with connections who could open doors: Sir Angus Ogilvy (Princess Alexandra's husband), HRH the Infanta Pilar de Borbón, Duchess of Badajoz, and (plain) Carol Price, the wife of a former U.S. ambassador to London. No wonder that the New York columnist Michael Thomas called the Sotheby's boss "Lord Taubman of Treasure."

This mix, of art, industrial muscle, royalty and the occasional political connection, was to prove irresistible in the Eighties. For a time the club atmosphere worked. In fact, there was only one problem: several of the new board members—Thyssen, Getty, Ford and Taubman himself—were trustees of museums, and critics began to ask if this was not a conflict of interest. After all, back in the old days, Lord Duveen had been thrown off the board of the National Gallery in London for this very reason. That apart, everything was in place by 1984, when the boom in the world's stock markets began to influence the art market. This was to be the first of several remarkable years when some extraordinary works of art came onto the market, including the Gould Impressionists, which Sotheby's was to sell in 1985 after a lengthy promotional buildup, discussed later in this chapter. But the flood began with the sale of the Gospels of Henry the Lion at Sotheby's in December 1983. This was important because it was the first time since the Renaissance that a book had eclipsed a painting as the world's most expensive work of art. The manuscript had been illuminated for Henry the Lion (*ca.* 1129–1195), described in the catalogue as "Duke of Saxony, Duke of Bavaria, conqueror and crusader, ruler of unbelievable wealth, founder of Munich and cousin of Emperor Frederick Barbarossa." This was impressive enough, but the manuscript was especially rare in having forty-one full-page pictures, as John Herbert put it, "of amazing complexity in brilliant colours, silver and gold. It forms a complete art gallery of Romanesque painting. When he ordered the manuscript, Henry the Lion had just returned from the Holy Land and Byzantium, where he had been entertained by the emperor at East Constantinople in 1172, and this is a key document for the reception of Byzantine art into northern Europe."

Before the sale there was some hilarity at Sotheby's when they received an inquiry about "Henry the Lion" from an American zoo, but there was nothing funny about the bidding, which opened at a million pounds and in just over two minutes had reached £7.4 million, which, with the 10 percent buyer's premium, took the total to £8,140,000 ($11,314,600 then, $24.8 million now). The book was bought by Quaritch and Kraus on behalf of the West German government. Five weeks after the sale a camouflaged military plane was sent from Berlin to collect the Gospels and carry it back to Lower Saxony, the dukedom of Henry the Lion.

No sooner had the Gospels been sold than Christie's announced it was to sell a fabulous collection of drawings from Chatsworth in Derbyshire. The Chatsworth Old Master drawings collection had been put together mostly by the second Duke of Devonshire at the beginning of the eighteenth century. Legally the drawings were the property of the present duke's trustees, but, John Herbert reports, he had successfully argued that he needed to sell some of the drawings in order to raise funds to preserve the collection as a whole and to endow Chatsworth, to preserve it for the nation. Seventy-one works were selected with the aid of Noel Annesley of Christie's. They included Raphael's *A Man's Head and Hand*, Holbein's *Portrait of a Scholar or Cleric*, Mantegna's *Saints Peter, Paul, John the Evangelist and Zeno*, and works by Rubens, Van Dyck and Filippino Lippi, among many others. After due consideration, Annesley valued the drawings at £5.5 million.

Now there occurred one of the most unfortunate salesroom controversies of all time. Through his lawyer, the duke approached the minister for the arts, Paul Channon. The natural home for the drawings was the British Museum, but £5.5 million was well above its purchase grant, which, in 1984, was less than £2 million. Therefore the museum sought the help of the National Heritage Memorial Fund, which was endowed for precisely this sort of situation. But the fund's practice on such occasions was to call in a third party to provide an independent valuation. For the Chatsworth drawings, the third party chosen was Agnew. This firm disagreed with Christie's, especially in regard to the Rembrandt drawings, of which the British Museum already had many, and the duke was offered £5.25 million. In retrospect £250,000 seems a tiny sum to quibble about, but the duke refused the British Museum's offer and a sale was set for July 3, 1984.

It was a unique auction. John Herbert says that one of Noel Annesley's reasons for setting what he thought were conservative estimates on the drawings was that they had "cerebral appeal"; in other words, their attraction was chiefly to connoisseurs and art historians familiar with the context and provenance of the drawings, rather than to millionaires. But in fact the sale was packed that night, with people stretching down the main corridor of Christie's and into the street. The plain truth was that the Chatsworth sale was a once-in-a-lifetime opportunity to acquire material of great quality and rarity, and the bidding reflected this. The top price was for Raphael's *A Man's Head and Hand*, bought by Mrs. Seward Johnson for £3.5 million ($4.7 million then). A page of Vasari's diary brought almost as much, £3.2 million ($4.3 million then), sold to Ian Woodner. Hence, just two of the seventy-one drawings surpassed the duke's asking price for all of them. The Getty Museum bought five lots, including Holbein's *Portrait of a Scholar or Cleric* for £1.5 million ($2 million) and the second Raphael, *St. Paul Rending*

His Garments, which went for the same amount. It took Noel Annesley less than two hours to sell the drawings and it must have given him some satisfaction to add up the total: in all, the drawings fetched £21.1 million ($28.3 million then, $61.28 million now). There were red faces at the British Museum and at Agnew, but the sale showed that there was big money available for the best art. It was only a foretaste of what was to come.

Lord Clark's Turner, *Seascape: Folkestone,* was no less wonderful, in its way. Kenneth Clark had led a distinguished career as director of the National Gallery, surveyor of the king's pictures and chairman of the Arts Council, and he was a collector all his life. However, Turner's late oils, many of them unfinished like *Seascape,* were almost entirely neglected until the twentieth century. Indeed, Lord Clark himself was the man who had discovered a batch of neglected Turners in the National Gallery in 1939, "some twenty rolls of canvas, thick with dust, which I took to be old tarpaulins." *Seascape* was one of the pictures that Turner had never exhibited, so when it sold in July 1984 for £7,370,000 ($10,244,300 then, $21.4 million now), a world record for a painting, the auction completed a turnaround for him similar to what had happened with the Impressionists.

Amid these peaks there was a sad event: Peter Wilson died on June 3, 1984, from leukemia. By then he had made his peace with Taubman, even though he had always worried that after he was gone Sotheby's would become, in Nicholas Faith's words, "a bauble on the arm of an American millionaire." In his address at the memorial service, held in St. George's, Hanover Square, across the road from Sotheby's back entrance, Earl Jellicoe said, "His last act, as he slipped into unconsciousness in his final illness, was, when the telephone rang beside his hospital bed, instinctively to stretch out his hand to grasp it." "After singing the Nunc Dimittis," wrote Geraldine Norman, George Redford's distant successor as the *Times*'s salesroom correspondent, "the assembled company poured out into George Street to gossip, trade, invite each other to lunch and keep Mr Wilson's creation, the art market, alive and well."

In fact, the market had never been better, if record prices were anything to go by. On April 18, 1985, Christie's sold Andrea Mantegna's *Adoration of the Magi* from the collection of the Marquess of Northampton. Painted in tempera and oil on linen laid down on canvas, and executed between 1495 and 1505, it shows the Virgin and Child and Saint John with the three Wise Men bearing gifts. The expressions on the faces of all the figures—tender, joyous but touched with sadness as if, in their wisdom, the Wise Men know what fate awaits Jesus—evoke a response in almost everyone who sees the painting. It was easily the most important Old Master to appear at auction since the Velázquez in 1970, and Tim Bathurst of Artemis, on behalf of the

Getty Museum, paid £8.1 million ($10.4 million then, $22.17 million now) for it, setting a new world record for a picture sold at auction, a distinction that Turner's *Seascape* had achieved only months before.

The Mantegna was not the only good news for Christie's. Two weeks before the sale, at the annual general meeting, pre-tax profits of £17.2 million ($22.3 million at the time) were announced, nearly double the £9.7 million ($12.6 million) of the year before. The almost vertical ascent of the art market, which was to last until *Dr. Gachet,* had begun.

Sotheby's also was prospering. By now Taubman was beginning to put his own gloss on the art market in New York by offering a wide array of financial services. People who were planning to sell art were given advances against these sales. This was heavily criticized but was in fact no more than an attempt to counter the single advantage that dealers had over auction houses, namely that they could offer cash immediately, whereas an auction involved a delay of six months or so. Of course vendors had to pay for this privilege, usually 3 to 4 percent above the bank rate. For buyers, for certain buyers anyway, Sotheby's offered an equivalent service: customers were given a year's credit, again at 3 to 4 percent above bank rate.

A split between Sotheby's and Christie's was beginning to emerge, one that would grow as the Eighties progressed, for Christie's never liked financial services. A short while before these financial services were introduced, Taubman had made a much-repeated remark to *The Wall Street Journal*: "Selling art has much in common with selling root beer. People don't need root beer and they don't need to buy a painting, either. We provide them with a sense that it will give them a happier experience." People tended to remember the first, deliberately crass, sentence and to ignore the more interesting second and third sentences and their implications. Developing its financial services not only helped Sotheby's to make money on the margins; almost as important, it helped to create the impression that art was bankable.

At Christie's, Jo Floyd took the opposite line. In his annual report that year, he wrote: "We will resist the temptation to branch out into quasi-related financial services, lest they should provide an undue influence on demand and create an artificial level for works of art." Later Floyd added that he would be willing to lose business to Sotheby's rather than to follow their financial lead because he thought it could be inflationary to the art market. Eventually, in 1990, Christie's—though not Floyd himself, who by then had retired—had to eat these words and join Sotheby's in offering guarantees to vendors simply because they were losing too much business. But Floyd's remarks about inflation now appear prescient, for 1985 was when the very big price rises got under way.

Financial services played a part, but only a part. Just as important were the

aggressive marketing techniques that Taubman, Ainslie and Brooks now employed with expensive pictures at Sotheby's. Since they had lost out on the Gould jewels, and the Mantegna sold at Christie's in London had wrested back the world record for a painting from Turner's *Seascape,* the Gould Impressionists, which Sotheby's were to sell only a week after the Mantegna in New York, were all-important. Sotheby's had to show what they were made of in the United States. The firm spent fully $1 million on what John Herbert called "five months of intense partying." The pictures traveled to London, Tokyo, Lausanne and around the United States. The auction house in New York was itself turned into a theater for the occasion, with a series of boxes, each with a telephone, for bidding. At the sale itself, held April 24 and 25, connoisseurs of auctions were nonplussed, for this was not a Weinberg or Goldschmidt crowd. There were no film stars, as there had been at the Havemeyer sale and the Gould jewel sale. Instead Nicholas Faith found that "there were faces 'remarkably new to us' . . . bidding with borrowed money, it seemed, lent by the new Sotheby's."

There were two reasons for this. One was the pictures themselves (175 of them). Though the artists were top-rated names, the pictures, with one or two exceptions, were not the best. As a result, the Gould collection did not attract that blend of museum scholars and the very rich who together make a great sale. The second reason for the new type of audience that night was that Sotheby's had invited them. With the aid of various financial research outfits, Taubman, Ainslie *et al.* had concluded that the traditional auction audience had tapped barely 1 percent of American millionaires; there were plenty more who had never once set foot in either Sotheby's or Christie's. For them the Gould sale was made to measure; the artists were known names, there was no dispute about the authenticity of the pictures, and without much hype, Florence Gould could be portrayed as a colorful American patron of the arts in Europe.

The paintings sold for $32.6 million. The star of the evening was van Gogh's *Landscape with Rising Sun,* which Florence had bought from Robert Oppenheimer, the physicist who had played such a crucial role in the development of the atomic bomb. It went for $9.9 million, just shy of the Mantegna record. The total was neither a resounding triumph nor a disgraceful defeat, but the auction was important for two reasons. In the first place it anticipated the hard-sell approach that was to emerge as the Eighties progressed. Second, it was rumored for months after the sale that the buyer of the van Gogh was none other than Alfred Taubman himself. He always denied this, but as the years went by he was to find that being the rich owner of an auction house carried with it the eternal suspicion of rival art dealers

who were always prepared to infuse with their own doubts the anonymity that many collectors prefer.

—

In retrospect, the proximity of the Mantegna and Gould sales was prophetic, for that one week in 1985 symbolized the change that had come over the market. It was the last time an Old Master would hold the world record for a picture sold at auction, and it was the first time that the new collectors appeared in the salesrooms in any numbers.

The Eighties boom was now in full flood, and the two principal auction houses were the most visible part of the boom, though not the only one. In the world of high finance, people have always been fond of lists of the very rich—e.g., the *Fortune* 400 and *Forbes* lists. In 1984 various art magazines such as *ARTnews* and *Art & Antiques* (known in the trade as *Art & Antics*) adapted this idea and began publishing lists of top art collectors. These were instructive. In the first place, they showed that, for some reason, in the late twentieth century collectors who are couples appear to be far more common than in the past. A second point to emerge was the predominance of Americans—just over 60 percent—followed by the Japanese and Germans. Third, the strong preference in these lists was for contemporary art—46 percent, compared with 20 percent for modern pictures, 12 percent for Old Masters, 8 percent for Oriental works of art and 14 percent the field. This was not necessarily a new trend, but the magazine lists made it more obvious. Contemporary art was increasingly popular, and more and more of it was being sent for auction. It was only a matter of time before contemporary painting, especially contemporary American painting, made a splash.

Before that, however, the Impressionists and Post-Impressionists were to make their mark. In the Gould sale, van Gogh's *Landscape with Rising Sun* had come within $500,000 of dislodging Mantegna's *Adoration of the Magi* as the world record holder. In December 1986, Christie's sold Manet's *La*

Rue Mosnier aux paveurs. This picture, mentioned in Zola's *Nana,* shows the view from the artist's studio, where he worked from 1872 to 1878. It had once belonged to Samuel Courtauld and then was inherited by Courtauld's daughter, Mrs. Sydney Butler, first wife of "Rab" Butler, a cabinet minister in Harold Macmillan's government in the Fifties and early Sixties. When she died, Butler was given a lifetime interest in her pictures, which he hung first in his rooms at Trinity College, Cambridge, where he was Master, and then in the Fitzwilliam Museum, also in Cambridge.

The Manet did not disappoint; in fact it went for an interesting price. With stock markets booming and financial and commercial deregulation the political orthodoxy of the day, exchange rates were fluctuating continuously, sometimes by large amounts. As a result, although *Rue Mosnier* fetched only £7.7 million in sterling, below the van Gogh and the Mantegna, in U.S. dollars it actually beat both, going for $10.9 million, as against $9.9 million and $10.4 million respectively. Obviously, in this climate it would not be long before the world record was decisively broken in all currencies.

The art market was now on a roller coaster. No sooner had the Manet been sold than Christie's announced in January 1987 that it would sell in London Vincent van Gogh's *Sunflowers.* Pulses quickened. Van Gogh produced seven *Sunflowers* paintings during the fourteen months he spent in Arles from 1888 to 1889. The one Christie's was to sell, from the Chester Beatty collection, came on to the market as a result of the death of his widow, Helen; it was believed to be the last one the artist painted and was the only version in private hands. (Others are in Munich, Amsterdam, and London's National Gallery.) With prices now passing the ten-million-dollar mark for single paintings, business-getting was more important than it had ever been for the auction houses. In this case, when Christie's was invited to bid for the business it moved very quickly, producing a dummy catalogue inside a week (thanks to the fact that it owned its own printers), and this, according to John Herbert, especially impressed the Beatty trustees.

The interval before the sale, held on March 30, van Gogh's birthday, proved controversial in a particularly British way. When Christie's first received the painting, the in-house estimate was £5–6 million. This jumped to £10 million when the catalogue was published, and then, a couple of weeks before the sale, to "£10 million, maybe more—and maybe a lot more." The fact was that some three weeks before the sale Christie's suddenly became nervous that they had mistakenly advised Mrs. Beatty's heirs—Mrs. Harry Thomson Jones, Lord Brooke and Lady Charlotte Fraser—to sell the picture at auction. At about this time, Mr. Richard Luce, the government's arts minister, accepted John Constable's *Stratford Mill* for the nation at an agreed-upon value of £10 million. This was so close to the estimated price of

the van Gogh that it was frightening. Under the British government's "acceptance in lieu" scheme, a tax break is offered the donor of exceptional works of art in order to encourage other owners of such works to give them to the nation. In early discussions with the Museums and Galleries Commission about *Sunflowers,* a figure of £10 million had been mentioned as a reasonable valuation. Had this been agreed to, the calculation of the tax breaks would therefore have been as follows: the government would have taken 60 percent of the valuation in tax—that is £6 million—leaving £4 million. But the government would then have repaid 25 percent of the tax (£1.5 million) as a sweetener, leaving the heirs with £5.5 million net, all tax having been paid.

At auction, however, the arithmetic was very different. Works of art such as *Sunflowers* are subject to a combined inheritance tax *and* capital gains tax of at least 60 percent. On top of this, Christie's would take its commission. This figure was never made public, but assuming that Christie's took its full commission, 10 percent, *Sunflowers* would have had to sell for a staggering £18 million to even approach the "acceptance in lieu" figure. The arithmetic is as follows:

Sold for	£18,000,000
Less 60 percent tax	10,800,000
Less 10 percent commission	1,800,000
Balance	£5,400,000

Further, even if Christie's took only a 4 percent commission, the minimum then practicable, *Sunflowers* still would have had to sell for £15 million.

Sold for	£15,000,000
Less 60 percent tax	9,000,000
Less 4 percent commission	600,00
Balance	£5,400,000

Therefore Christie's was taking an enormous gamble in selling *Sunflowers* at auction, and this may explain why the estimate on the picture jumped so much in the weeks before the sale.

The night of the auction felt like a great occasion, and Christie's rooms were packed. Among the celebrities, some of whom could even afford the picture, was a Sotheby's director, Baron Heini Thyssen, whose collection included Holbeins, Cranachs and several Impressionists. Charles Allsopp was at the rostrum and opened the bidding at £5 million. As an auctioneer

Allsopp is rather quick, and the bidding rose rapidly, in half-million-pound jumps. There were bids not only from the main hall but from the side room and over the telephone. At £20 million, spontaneous applause broke out. From then on there was a telephone duel, which was to become a familiar sight in the years ahead. James Roundell was on one phone, John Lumley on the other—between them, they run Christie's Impressionist department in London. Five bids later, Roundell proved the victor. Adding on the 10 percent buyer's premium, *Sunflowers* sold for £24,750,000 ($39.9 million at the time, $62.9 million now), an amazing sum that was more than three times the previous world record.

Two days after the sale it was announced that the picture had been bought by Yasuda Fire and Marine Insurance, a Japanese corporation with its own museum. Curiously, though the Japanese were by no means newcomers to the art market, it was only now that the general public became aware of their heavy presence. The sale to Yasuda was a combination of luck and hard work on the part of Roundell. It so happened that his brother, Peter, an insurance broker with Lloyd's of London, was on good terms with Hajime Abe, Yasuda's director of foreign relations. One evening in 1986, when the two men were having dinner together in Tokyo's enormous Imperial Hotel, Abe remarked that he had been given the task of acquiring some Impressionist pictures. Like many Japanese corporations, Yasuda had its own museum; the president, Hajime Goto, believed it was his duty to provide his staff with great art in "their" museum. By coincidence James Roundell also happened to be in the hotel when this conversation took place. Understandably, Peter Roundell put Abe in touch with his brother. This, says John Herbert, led to a successful sale in 1986 of two pictures to Yasuda, both bought at Christie's. The Japanese firm was also the underbidder on Manet's *Rue Mosnier aux paveurs.* When Abe told Roundell that he was looking for "a centerpiece" for the collection, James identified *Sunflowers* as that centerpiece. Goto took independent advice, and then settled on a limit of £21 million. Abe was sent to London, arriving at 6:30 A.M. on the morning of the sale. There he was told by Roundell that the most serious competition was from the Australian tycoon Alan Bond. Roundell couldn't be certain, of course, but he now thought that £21 million wouldn't be enough. As it turned out, a London private dealer, Billy Keating, acting for Bond, dropped out at £22 million, and *Sunflowers* went to Abe.

After the *Sunflowers* sale the market adjusted rapidly to these new price levels. Within three months the Mantegna price had been beaten again, by another van Gogh, *Le Pont de Trinquetaille,* which went for £12.6 million ($20.2 million), in which Keating, still representing Bond, was again the underbidder.

Despite the record price of £24,750,000, the beneficiaries of the *Sunflowers* sale may have received as little as £3,435,000 from the auction. This surprisingly small figure shows how complicated sales at auction can be in Britain, contrary to what auction-house publicity would have us believe. From the £22.5 million hammer price, Christie's commission of 10 percent would have brought the figure down to £20.25 million. Capital gains tax at 30 percent would then be due on the difference between this sum and the government's "acceptance in lieu" valuation of £10 million. Thirty percent of £10.25 million is £3.075 million, bringing the top figure down to £17,175,000. Then comes the complicated part. Because the painting had already been conditionally exempted from inheritance taxes in 1952, at the time of an earlier death in the Chester Beatty family, the estate was now taxed not at the normal 60 percent rate but at a variable rate between 65 percent and 80 percent. If the tax was the full 80 percent, £13,740,000 would have been deducted from the remainder, leaving £3,435,000. Furthermore, this was the tax payable only on the painting. The heirs still had to meet a tax bill on the rest of the estate of £5 million. Of course the actual figures were confidential, but that the calculation offered here is not far off is shown by the fact that some months later the family was forced to part with another picture, a Cézanne, to settle its tax bills. Still later, yet another picture, the third, was offered to the nation in lieu of taxes, and when the Chester Beatty heirs finally sold pictures on their own account, they did so at Sotheby's and not Christie's. It has never been definitely determined whether the Beatty heirs were advised correctly by Christie's before the *Sunflowers* sale, and none of the parties concerned will discuss it. As late as spring 1992 Christie's was suing the heirs for unpaid commissions—so the whole transaction went very sour. But it is certain that if the heirs had chosen the government scheme, *Sunflowers* would never have come to auction, and if *Sunflowers* had not come to auction it could not have fetched such an enormous price, and if it had not fetched such an enormous price . . .

But *Sunflowers did* sell for an enormous sum, and it was purchased by a Japanese. As so often in history, a single event symbolized what had been occurring for some time. The Japanese had certainly not been blind to non-Japanese, and non-Oriental, art. Mayuyama & Co. had moved from Peking to Tokyo in 1916, specializing in ceramics and tea ceremony objects, and produced many important exhibitions in the post–World War II period; and Kojiro Ishiguro had taken advantage of what he called the "glorious market" in Tehran in the late Fifties and early Sixties to buy Middle Eastern antiquities. But several other old, established Tokyo-based dealers, men like Kazuo Fujii or Etsuya Sasazu, who have been around since the Fifties, when the world opened up again after World War II, say that by the late Sixties

or early Seventies the Japanese were ready to collect Western art on a much larger scale but were prevented from doing so in part by Western dealers who kept the better paintings for their own clients. One thing that changed this was the rise in oil prices in 1973. An old Japanese proverb says, "When you have enough food and clothes, learn gentility." Until 1973 the country was concerned with rebuilding, "with food and clothes." Then after the oil crisis, says Etsuya Sasazu, "Japan's thoughts turned from the impermanence of business to the permanence of culture." Between 1973 and Yasuda's purchase of *Sunflowers* in 1987, some *five hundred* museums were built in Japan. Every prefectural district, every borough, built one, and many corporations did so as well.

It is common for Japanese to work for one company all their lives, and this loyalty on the part of the worker is reciprocated by the corporation, which takes an interest in its employees' well-being outside areas that would be regarded as legitimate in the West. Company art galleries are an example. These different traditions and habits have produced in Japan opportunities to experience art quite unlike those in North America or Europe. Many companies display their collections in galleries in their headquarters buildings for the benefit of their employees and the public. Golf courses, another Japanese craze, are also sculpture parks. Department stores like Seibu or Mitsukoshi have become blue-chip art dealers. Henry Moores and Rodins dot the lobby of at least one Tokyo securities firm's office. Masahiro Takana, president of the Green Cab Company, keeps his collection of Marie Laurencins, the world's largest, at a distant mountain resort; over the years, visitors have so increased that 160,000 people are now making the trip annually. Many of them stay in a nearby hotel owned by Takana.

Another factor is the long historical association with French Impressionism, mentioned earlier. But many Japanese are interested in their own art too. The Kasama Nichido Museum of Art is a case in point. Opened in 1972, it was built with the private funds of the founder of the Nichido Gallery, Inc., Jin Hasegawa, and his wife, Rinko, to celebrate their golden wedding anniversary. Jin died in 1976, but his son has carried on the tradition, and today the museum houses Impressionist and contemporary Western works, calligraphy, Japanese lacquer works, and eighty self-portraits of modern Japanese painters.

Throughout the Seventies many Japanese museums acquired Western art, and in 1980 Sotheby's appointed Kazuko Shiomi its representative in Tokyo. Knowing how business was conducted in Japan, she did not expect the firm to start auctions there for ten years because it would take that time to build up a reputation. No doubt Taubman's offer in 1983 to Seiji Tsutsumi of the Seibu Group to join Sotheby's board hastened the process. The taste for

Western painting was clearly growing in Japan. This burgeoning appetite was aided by tax breaks for the sponsorship of art exhibitions. Both the *Mona Lisa* and the *Venus de Milo* were loaned to Japan for exhibitions, as was Millet's *The Sower,* which went on display in the Yamanashi Prefectural Museum in 1978 and was likened to a holy relic. "With its mixture of saintliness, naturalism and high sentimentality," said Sasazu, *"The Sower* tweaked more Japanese heart strings than any Western painting before or since." This exhibition broke all attendance records in Japan and set a standard by which shows are still judged today. The taste for Western painting was so great that a British journalist in Japan for a week in the mid-Eighties found exhibitions of Modigliani, Rubens, van Gogh, Henry Moore, Constable, Yves Klein, Dürer, Cranach, Courbet and Rodin all running virtually simultaneously.

Amid this catholicity, however, Impressionism was preeminent. This was partly for historical reasons, but it may also reflect a natural affinity for certain aspects of Impressionist style. This is shown by the popularity in the Seventies, Eighties and Nineties of two schools of native Japanese painting. The first is Nihonga, a twentieth-century hybrid of Edo images and Western techniques whose subject matter, to Western eyes, is cloyingly sentimental, even mawkish; a wistful nude or solitary, lonely, heroic figure is a traditional image of the genre. According to Jin Hasegawa, it points "insistently, repeatedly, obsessively, to some great sadness at the heart of the Japanese experience"; in any case, Nihonga artists are millionaires. The second school of painting is essentially Western-style Impressionism with Japanese ingredients thrown in. Here too such sentimental themes as children and animals are popular.

Thus, as a force in the art market, the Japanese are neither new nor minor. Nevertheless some new factor was needed to help create the circumstances where a *Sunflowers* explosion was possible. This was provided by the International Plaza Agreement, which was reached by the finance ministers and central bankers of the five great economic powers at the Plaza Hotel in New York in the autumn of 1985. Their agreement effectively revalued the yen, which rose by 45 percent over the next twelve months, and by nearly 100 percent against the dollar by 1987. This huge increase in Japanese wealth showed up in the art market almost immediately. Within months of the agreement, the Matsuoka Art Museum in Tokyo, virtually unknown in the West until 1986, bought thirty-eight Monets, Renoirs, Chagalls, Pissarros and a Modigliani, spending $4.25 million in all. Another Tokyo museum paid $802,400 for Millet's *Antoinette Hébert Looking in the Mirror.* By the end of 1986, the value of paintings imported by Japan had almost doubled over the

previous year, from £125 million to over £230 million ($212 million and $391 million). This rate of increase was maintained in 1987.

Something else very Japanese was added: *medama.* The literal meaning of *medama* in Japanese is "eye," but it is used colloquially to mean "highlight," or "loss leader" in the retail business—something that has more value than the price asked. Despite the record prices being achieved in the salesrooms, the revaluation of the yen meant that for many Japanese, even pictures bought for unprecedented prices could be bargains. *Sunflowers* had come along at just the right time, and *medama* ensured that *Sunflowers* was not a climax, but a beginning.

35 | VAN GOGH, INC.,
AND *KANEAMARI GENSHO*

Three days after the van Gogh sale at Christie's in London, Sotheby's offered the Windsor jewels in Geneva. The Duchess of Windsor had died in Paris on April 23, 1986, and for legal reasons the jewels had to be sold within a year of her death. The Windsor auction had a lot in common with the Gould sale in that the background was exotic and glamorous but among the 306 lots there were only about ten "world-class" stones. The *medama* factor, as the Japanese would have put it, lay in the provenance of the objects.

This was only one of the marketing problems Sotheby's faced. Another was that, as Marcus Linnell, the Sotheby's director in charge of special projects, put it at the time, "There is a generation, in Britain anyway, who didn't like the Duchess and what she did." The sale ran the risk of opening old wounds, and that could have spoiled things. To help avoid this, the catalogue described the "David and Wallis" romance through the jewels and avoided altogether any mention of the abdication, and the collection, in its presale travels (which were by now obligatory), steered clear of Britain. The duchess herself hadn't wanted the jewels to visit Britain, and that suited Linnell. As it was, 279 newspapers worldwide featured the sale, none of them nastily. The catalogue broke new ground, too, if that isn't too grand a phrase. The decision was taken to emphasize what appeared to be historically significant, even if the "significance" was only the couple's tenth wedding anniversary or the commemoration of the death of a dog. Much of the jewelry was

inscribed, which gave an intimacy to the stones that they might otherwise have lacked.

The auction also highlighted the problems that can arise over the timing of sales. Under French law, the executors of an estate lose some of their powers exactly one year after the death of the deceased. This meant that everything had to be decided on and sold in the four months between the signing of the contract on December 8, 1986, and April 23, 1987, a year after the duchess's death. But Sotheby's did not want to spoil their St. Moritz sale in the third week of February. This had grown in importance in recent years thanks largely to Nicholas Rayner, a Sotheby's jewelry expert who was also a bobsled enthusiast. In his annual visits to the Cresta Run, he had noticed that "jewelry-buying types" all gathered in St. Moritz in February and that a sale at that time might succeed. He was right; by 1987 the St. Moritz sale was grossing £8.8 million ($15 million). Details of the Windsor sale could be released only after the St. Moritz sale had taken place, which was cutting it close.

As it turned out, Sotheby's needn't have worried. The Windsor sale brought in about $50 million, and among the buyers was the actress Elizabeth Taylor and the famous American divorce lawyer Marvin Mitchelson. In the long run, however, the most significant purchaser was the company that bought the most expensive item, a flamboyant diamond ring, which cost just under £2 million ($3.4 million); like the firm that bought *Sunflowers,* this buyer was Japanese. As 1987 wore on, the Japanese presence made itself felt more and more. In addition to *medama,* a new phrase now began to be heard: *kaneamari gensho,* meaning excess money. Whether this meant money over and above what the spender really needed or sums with which to commit excesses was never made clear. Both meanings applied.

Despite Taubman's undoubted successes in turning around Sotheby's and helping to polish its marketing abilities, by 1987 it was Christie's who had sold many of the most expensive works—not just *Sunflowers,* but also Manet's *Rue Mosnier aux paveurs* and Mantegna's *Adoration of the Magi,* and in July they did it again when another van Gogh, *Le Pont de Trinquetaille,* sold for £12.6 million ($20.2 million then). Between 1986 and 1987 Sotheby's profits had again overtaken Christie's, but Christie's was still selling the record breakers. However, in the middle of the year Sotheby's issued an announcement that threatened to change this: in November they would sell van Gogh's *Irises,* owned by John Whitney Payson. When the announcement was made, there was widespread speculation about how much the picture was worth. It certainly had *medama,* being a far more striking

image for many people than *Sunflowers*. As summer shaded into autumn the price began to creep up; *Irises* could well become the next world record holder.

But the autumn of 1987 was to become known for something other than the sale of *Irises*. On Friday, October 16, Britain was assaulted by the worst gales in living memory, with hurricane-force winds uprooting thousands of mature trees and literally changing the landscape in many counties. One effect of the gales was to prevent large numbers of people from getting to work, including brokers on the stock exchange, who were therefore not at their desks to see Wall Street slide alarmingly that day. Black Friday, as it became known, was bad enough, but over the weekend people talked themselves into a panic, so that Black Monday saw the London stock exchange drop 300 points, and another 300 the following day, in the most catastrophic collapse of the world's financial markets since 1929.

The crash hit the art market as well—or at least it appeared to. Christie's shares fell, along with everything else, from 700p to 293p. Fortunately for Sotheby's, *Irises* wasn't being sold for three weeks, not until November 11, the eleventh day of the eleventh month, and there were some important sales in the meantime that would let them test the nerves of the market and perhaps change the way the sale would be presented.

In fact, it was Christie's who had to confront the crash sooner. Just two days after Black Monday the firm held a jewelry sale that included a 64.83-carat D-flawless diamond (D is a measure of clarity). Who would buy such a rock at such a time? No name was ever released, but whoever it was paid $6.38 million for it in an auction that produced, in all, $23.6 million, the highest total ever for a jewelry sale. Did this mean the art market was going to be unaffected by the stock market crash? No one could believe it. But, two days later, at Christie's again, a Gutenberg Bible from the Estelle Doheny library went for $5.9 million, making it the most expensive printed book ever sold. Clearly the art market's nerves had held.

All this only added to the atmosphere on York Avenue in New York on November 11, 1987. Records were still being set in the art market, but Black Monday was fresh in everybody's mind and none of the records that had fallen had been anywhere near the level of *Sunflowers*. John Marion, who was to be the auctioneer that night, described *Irises* as "the most important work of art ever to be auctioned in America." Considering the Bay Psalm Book or Milton Logan's Raphael, this seemed hyperbolic, but some people agreed with him. Harry Brooks, of Wildenstein's New York office, predicted a record: "I've known *Irises* for ages. It's a marvelous picture—forty to fifty million dollars, I'd say."

By now Sotheby's had developed its big auctions into theatrical experiences. Tall, alluring women were employed on these evenings to show the serious bidders to their seats. Yuppie spectators were provided with standing space behind blood-colored ropes. Since the salesroom at York Avenue was so large, "barkers" were stationed at each of the pillars to spot bids and shout them out.

Like so many "star lots" in a big sale, _Irises_ was about a third of the way through the list of one hundred paintings to be sold that night. Finally the turntable revolved and the picture appeared. There was a stifled gasp in the room as Marion opened the bidding at $15 million, and though there were more than two thousand people present, only two were ever in the bidding—and both of them were on the telephone. One was talking to David Nash, the head of Sotheby's Impressionist department in New York, and the other to Geraldine Nager, of the bid department. The price rose steadily in million-dollar jumps. No one knew it at the time, but John Whitney Payson's reserve was $34 million. At $40 million, a new world record, the large room grew hushed. The million-dollar jumps came a little slower now, but not much. Forty-five was passed as firmly as forty, but suddenly, at $49 million, Geraldine Nager pulled out; perhaps $50 million suddenly looked quite terrifying to her client. As Marion brought down his gavel, a massive explosion of applause burst over the room.

Irises was not the only record set that night; there was a record for a Monet and for a Beckmann, and seventy-five out of the one hundred works were sold for a massive $110 million, also a record total for an art auction. But it was _Irises_ that was on everyone's lips. Sidney Janis, now ninety-one, was there that night. "I never thought I'd live to see a painting sell for such a price," he said. "I wonder if there is any painting in the world that could sell for more." Daniel Wildenstein declared himself more pleased than surprised. "I think it was a wonderful sale. I hope it and everything else in the art market will continue, as the mother of Napoleon used to say, 'as long as it can last.' "*

*Coming down the stairs after the sale, I bumped into Billy Keating, an elegant, hard-drinking American from the South who lived in London, where he had a private house in Chelsea from which he operated a private gallery in partnership with Angela Neville, a well-connected English-woman. I had dined with Billy and Angela the evening before, so I knew she was in town, and it seemed odd that they were not together at the sale. "Where's Angela, Billy?" I asked, then added cheekily, "Upstairs?" Billy looked coy, so I assumed I was right and that Angela had been bidding in one of Sotheby's private rooms above the main floor. I knew better than to press Billy any further, but he didn't look excited, so I almost forgot the exchange. Forgot it, that is, until I attended the press conference later, when Sotheby's announced that _Irises_ had been sold to "a European agent who was bidding for an unidentified collector." This was not Sotheby's usual way of describing someone, but it fitted Angela. Moreover, everyone in the art world knew that Billy

In retrospect, 1987 was a much odder year than it appeared at the time, and this was because two big question marks hung over both of the record-breaking van Goghs. *Sunflowers* was undoubtedly good for Christie's and the art market as a whole, but it does not, as far as one can tell, appear to have been very good for the vendors. In a very real sense, *Sunflowers* came to the market by accident: the Beatty heirs would have been better advised to donate the picture to the nation and take advantage of the tax breaks, rather than to sell it at auction. And it was the record-breaking price achieved by *Sunflowers* that influenced John Whitney Payson to sell *Irises*. Later it was revealed that Alan Bond had borrowed half the purchase price for *Irises*, from Sotheby's itself, and it was further disclosed in 1990 that he couldn't pay for it, so it was acquired by the Getty Museum. Thus there was something not quite aboveboard about both of these van Gogh sales. To an extent, the era of huge prices had been induced artificially.

—

Sunflowers and *Irises* in one year was unprecedented, but the art market, having shrugged off Black Friday, was now booming as it had never boomed before, and the next two years, especially the fifteen months between October 1988 and the end of 1989, were the most sensational that the art world has ever seen. Of the twenty-seven most expensive works of art ever sold, all for over $14 million, twenty were auctioned between November 10, 1988, and December 1, 1989. Moreover, a new phenomenon appeared: the Picasso passion. By the end of 1989 the ranking of the top pictures went as follows:

Irises by Vincent van Gogh	$53.9 million
Pierrette's Wedding by Picasso	$51.3 million
Self-Portrait: Yo Picasso by Picasso	$47.9 million
Au Lapin Agile by Picasso	$40.7 million
Sunflowers by van Gogh	$39.9 million
Acrobat and Harlequin by Picasso	$38.5 million
Portrait of Cosimo by Pontormo	$35.2 million
Rue Mosnier with Flags by Manet	$26.4 million
Mirror by Picasso	$26.4 million
Motherhood by Picasso	$24.8 million

By 1989 there were more Picassos among the top twenty-seven than there were van Goghs—nine vs. five—and Picasso's pictures had gone for a total

and Angela were helping Alan Bond to form his collection, and that they made frequent trips to Australia, where they had a flat. In Sunday's London *Observer* a few days later I floated the idea that Bond had bought *Irises*. This was later confirmed.

of $279,042,623, as against $134,411,750 for van Gogh's. Still, too much should not be made of this; Picasso lived until he was ninety-two and remained an inventive and fecund artist until the end. There are a lot more good Picassos around in private hands than there are van Goghs.

The preeminence of these two artists, however, may owe something to the fact that between them van Gogh and Picasso represent everyone's romantic idea of what an artist should be. In a lecture on van Gogh, held at the National Gallery in London to celebrate the centenary of his death, the art historian Griselda Pollock argued that the high prices achieved by the Dutchman can be attributed in part to his tragic life. She also pointed out that he was well served by his heirs: successive generations have sought to perpetuate his name, have enthusiastically supported and promoted exhibitions, assisted scholars and helped establish the van Gogh museum in Holland.

The biographical argument can be applied to Picasso as well. He may not have cut off his ear or gone mad, and he didn't commit suicide, but he led a colorful and romantic life, and most people know a great deal more about it than they do about, say, Manet's, Braque's or Matisse's. Van Gogh fits our idea of the solitary, tragic artist; Picasso, on the other hand, fulfills the equally romantic notion of the artist who overcomes his problems and his poverty to become financially, intellectually, socially and even sexually successful. Arguably, Picasso is the towering twentieth-century artistic figure, a mirror to the modern world's image of itself.

Whatever the reason, the passion for Picasso was one of the most notable features of 1988 and 1989. But in truth the roller coaster was going off in all directions. Nothing illustrates this better than the Andy Warhol auction. It was an extraordinary affair and perhaps reflects that this artist was as typical of the twentieth century as was Picasso, though in a very different way. Warhol had died unexpectedly while still in his fifties, and Sotheby's went to town with his "collection." The quotation marks are necessary in this instance because by no stretch of the imagination can his possessions be called distinguished. There were some good paintings, by Cy Twombly and Roy Lichtenstein, for example, and some reasonable American primitives by artists such as Joseph Stock. But the great mass of ten thousand objects (catalogues sold in boxed sets, for $95) was junk—or, as some wag described it, bric-à-Braque. There was wartime jewelry, fairground objects, sets of unused plastic plates, sauce boats and salt cellars. There was a kitsch model of Leonardo's *Last Supper,* airport furniture, silly teapots, and 150 cookie jars.

Warhol used to say to his friends, usually on a Sunday morning, "Let's go shopping for masterpieces," and if the irony of the remark was not lost on them, it certainly was on the people who bought at the Warhol sale. They

came in droves, some arriving by limousine, others on bicycles. Some came as Warhol look-alikes, in white wigs and powdered faces. Dubbed a "Manhattan event," it certainly was that. Taubman, by now well into his stride at Sotheby's, had always seen celebrity sales as an opportunity to bring in new faces, new blood and new money to help make Sotheby's as accessible and friendly as Bloomingdale's or Macy's (of which he was a director). With the Warhol sale Taubman succeeded spectacularly. A large percentage of the visitors were brand new to the auction business, and crowds followed in the wake of Sotheby's sirens like geese, submitting themselves to lectures on the meaning of "reserves," "estimates" or "prints." Others hunted in packs of their own, concentrating on the transparent plastic bags in the basement, each one containing a medley of Bakelite powder compacts, cigarette boxes, napkin rings and silver bracelets. Groups bid as a unit for these and then divided the booty among individual members. Though there were those who came to mock, the most revealing comment was made by a young man in a pink shirt and pony tail. "Gee," he said, "these oyster plates are really ugly. I love them."

The official estimate on the objects was put at $15 million to begin with, since Sotheby's was uncertain of the allure of the Warhol provenance. As the sale approached, however, they said that they expected the sale to make two or three times the original estimate. By the eve of the auction, the book of order bids on the cookie jars alone was four inches thick, "with every cookie jar having at least twenty-five bids." Secondhand cookie jars that you could find at any flea market in New York for $2 went for $30, even $60, and one sold for $100. Sotheby's may not have known how much the Warhol provenance was worth, but they did print the dead artist's image on all the labels that gave the lot numbers. Many a successful bidder left the label on after the sale—designer art to go with designer sweat shirts or Perrier water.

Warhol and Taubman were about as likely a team as whiskey and tonic, or gin and soda, but the event was a triumph of American salesmanship, yet another apotheosis of marketing. Some people were carried away by it even outside the salesroom. Ronald Feldman, a New York dealer who sold Warhol paintings, thought the auction showed that "we now have a new concept of art." As the ten-day event got under way, the most subversive thought was floated by a new Manhattan magazine, *Seven Days,* which aired the view that the collection was not Warhol's at all, that his friends were merely pretending that he had collected all this junk so that they could unload their own kitsch at exorbitant prices. It said something for the mood of the times that few people were bothered by such doubts; New Yorkers *wanted* the Warhol sale to be an event. "Oh my," someone said about the *Seven Days* allegations, "how Andy would have loved that."

If the Warhol sale tried to extend the boundaries of collecting, the very notion of what was art, Sotheby's Moscow sale extended the market in another way, the political. It also refocused minds on what might happen in the future. As this book has demonstrated throughout, the art market is sensitive to world political and economic developments, and the advent of *glasnost* and *perestroika* following Mikhail Gorbachev's rise to power in the mid-Eighties was eventually felt in all aspects of life.

The Sotheby's Moscow auction followed one held by the Russians themselves in 1987. This had taken place in a refurbished palace on Karl Marx Street, and the auctioneer was a man "who specialised in selling horses" (a sort of Russian Colonel Gutelius). He had a vigorous manner, by all accounts, but the sale was not a great success commercially. In some ways, Sotheby's saw Russia as the last great untapped art market, now becoming available thanks to Gorbachev. A few dealers in Paris, London and New York had kept alive the small market in Russian avant-garde art following the Revolution, and other, newer dealers also foresaw a trend. In London, for instance, Roy Miles, who had dealt in Victorian art in the Seventies, now switched to Russian art.

The Moscow sale was a great publicity coup and was engineered partly by Sotheby's deputy chairman in Europe, Simon de Pury, and partly by its chairman in London, Lord Gowrie. Before joining the firm de Pury had worked for Heini Thyssen, helping to arrange a number of loan exhibitions with Russia, and therefore had some excellent contacts in Moscow and Leningrad.

The Earl of Gowrie, Alexander Patrick Greysteil Hare-Ruthven (pronounced Rivven), has the most glamorous background of anyone in the art world. Brought up in the Norman tower at Windsor Castle, where his grandfather was deputy constable, he took tea with the queen from an early age, but he also had a wild Irish streak inherited from his great-aunt, along with a "debt-laden château" in Dublin. He was already collecting contemporary art at Eton and at Balliol College, Oxford, where he was elected to buy its pictures. After graduating he became a tutor at Harvard and assistant to the poet Robert Lowell. Back in London he turned to politics, an option always open to a bright, good-looking aristocrat in the House of Lords, where there are no time-consuming elections to win and no boring weekends in one's constituency.

Edward Heath promoted Gowrie, but Mrs. Thatcher was the one who made him Opposition spokesman on economic affairs. When the Conservatives came to power in 1979, he became arts minister (and a member of the

cabinet, which is not invariably the case). He was regarded as a great success, initiating the Business Sponsorship Scheme, but perhaps revealed more about himself in his way of leaving: he complained that no one could live in central London on a cabinet minister's salary of £33,000 a year. Since this was three times the national average wage, the statement earned him not a few critics. Actually, however, Gowrie was offered the Sotheby's job before he made his controversial statement, so it would be truer to say that he left his post because of Taubman's offer of a £100,000 salary, plus 150,000 shares option, than because of his low politician's salary. Gowrie did not have de Pury's contacts in Russia, but he was familiar with contemporary painters in that country, had developed his negotiating skills while in government and was known to some prominent Russians because of the introduction he wrote to the catalogue for the 1987 Francis Bacon show in Moscow.

The Moscow auction was a hodgepodge. The work of contemporary Russian painters—names like Ilya Kabakov, Grisha Bruskin and Igor Kopystriansky—was not well known in the West, and the avant-garde pictures, the Rodchenkos and Popovas, were few in number. The sale lost money, but Sotheby's appeared not to mind. To date there has been no repeat, but the firm and the other main auction houses hope that the whole area of Eastern Europe and Russia may one day open up, as a source of both supply and demand. Sotheby's has four people who regularly travel in Russia, and in 1991 it held its first sale in Berlin, hoping to attract collectors and sellers from what used to be East Germany. Christie's has explored Czechoslovakia, Bulgaria and Hungary, and Phillips has appointed a recent Russian émigré to run its Russian pictures department in London. Now that much greater freedom in travel is allowed, he finds that many Russians are bringing paintings out with them. A high proportion are fakes, he says, but the country is huge and has been closed for seventy years, so there are still many discoveries to be made. Nevertheless, to date the Russian art boom has been disappointing and has not lived up to expectations.

The links between van Gogh and Picasso are closer than might at first appear. In 1888 the Dutchman had written, "I have tried to express the terrible passions of humanity by means of red and green." Picasso, who had visited Paris in 1900, returned there in 1901 and changed the focus of his work. He was still in turmoil after the suicide of a friend, the Spanish painter Carles Casagemas, with whom he had shared a studio. Now Picasso too concentrated on the solitude and pain of humanity, in his case using a predominance of blue. His criticism of Matisse, the contemporary closest to him in talent, was that he was "van Gogh without God." In the Thirties, well after he had become famous, he painted a series of variations on van Gogh's *L'Arlésienne.* Pictures by both van Gogh and Picasso formed part of the Peau de l'Ours auction at Drouot in 1914, when the Spaniard's *Saltimbanques* was sold for 11,500 francs. This was not only a spectacular sum in itself; it was 7,500 francs more than the van Gogh went for.

In 1988 there were no important van Goghs on offer, but there were three Picassos. These were *Birdcage,* to be sold at Sotheby's in New York on November 10; *Maternité,* to be auctioned at Christie's in New York four days later; and *Acrobate et jeune Arlequin,* to be offered at Christie's in London on November 28. As the Bearskin sale of 1914 showed, Picasso has always had a following. These three pictures were expected to do well, not least because, Diana Brooks of Sotheby's said, in the previous five years the

number of private clients—as opposed to dealers and museums—bidding at auction had quintupled. Her estimate was that there were now 100,000 serious collectors in the United States alone.

Attention was focused primarily on *Maternité*. This was partly because of the image, partly because it was from the artist's Blue period, and partly because it came from the William and Edith Goetz collection. Their twenty-nine pictures had been amassed in the Thirties, Forties and Fifties, and the collection was in the tradition of Hollywood collecting, following the precedent set by Edward G. Robinson, Billy Wilder, Greta Garbo, Ava Gardner and Kirk Douglas, among others. Goetz was himself a Hollywood producer, and Edith was the daughter of Louis B. Mayer. The attention on *Maternité* was even greater after *Birdcage* sold for $15.4 million, for clearly the Goetz picture was a much better work and ought to go much higher. It did. On the evening of the auction every one of the Goetz pictures sold, seven new auction records were set and the sale totaled $84.9 million, another record, the highest sum ever fetched at auction by the collection of a single owner. *Maternité* put everything else in the shade, going for $24.75 million, to make it the most expensive twentieth-century picture ever sold and the third most expensive picture in history at that time. But the painting was also notable for something else. It was sold to Aska International, a Japanese firm owned by Yasumichi Morishita (see figure 85), but only after a fierce duel with another Japanese, Shigeki Kameyama. The Japanese interest in twentieth-century art was new. Historically they had liked Fauvism, but Picasso had no part in that school. On the other hand, the craze for Nihonga painting reflected an interest in themes of the sort Picasso dealt with in his early works. Apparently tastes in Japan were changing. When, in the summer of 1988, sixty private Japanese collectors were asked what kind of painting they would most like to buy, Picasso came out on top.

After *Maternité,* the scene shifted to London, where *Acrobate et jeune Arlequin* was to be sold. This was a large work in gouache, and in some ways it was more important than *Maternité*. "Importance" is an overused word in the art market, but for once it was appropriate. *Acrobate et jeune Arlequin* was a Rose period work with a more tender feel to it, though still with inherently tragic images. At this period of his life Picasso's mistress was Fernande Olivier, and together they would visit the Cirque Médrano in the place Pigalle several times a week to escape the Bateau Lavoir studio, where they lived in terrible circumstances. *Acrobate et jeune Arlequin,* one of twenty paintings that Picasso made of circus people, shows a listless and somewhat feminine harlequin staring at an acrobat, who may just have finished performing and looks ready to collapse. His eyes are in shadow, his cheekbones stick out too much, and the skin is too tight over his jaw. The purpose of

performers in a circus troupe is to give pleasure and amusement, but Picasso seems to be saying that in private they are desperate, and that all they have is their companionship.

Apart from the image, *Acrobate et jeune Arlequin* had had an interesting history. It was the first Picasso to be shown in Guillaume Apollinaire's magazine *La Plume,* in 1905; it was the first Picasso to be sent to an international exhibition, the Venice Biennale in the same year; and it was the first Picasso to enter a museum, the Städtische Museum in Elberfeld in 1911. It left the museum in circumstances familiar to readers of this book. The Nazis considered it a prime example of *entartete Kunst,* degenerate art, and confiscated it. It was sold at the famous *entartete Kunst* auction held at the Galerie Fischer in Lucerne, where it was bought by a Belgian, Roger Hanssen, for 80,000 Swiss francs, and since then had changed hands several times. The picture had made the by-now-obligatory world tour, and so great was the enthusiasm for it that James Roundell increased the firm's estimate from £10 million to £13 million. The day before the sale, more than a thousand people trooped through Christie's to look at it.

On the night of the auction the bidding started at £5 million and almost immediately rose to £12 million. Thereafter the bidding was between a Christie's staffer on the phone to the United States and a Japanese. The bidding rose past the *Maternité* level to £14 million, then paused slightly at £16 million. At £19 million there was much discussion on the line to the United States; with the 10 percent buyer's premium the price was now £20.9 million ($39.7 million). Perhaps that individual's limit was £20 million, for he or she dropped out, which meant that once again a Japanese had won what was now the most expensive twentieth-century work, and the third most expensive ever. However, the buyer was not Yasumichi Morishita or Shigeki Kameyama, but Akio Mishino, the art director of the Mitsukoshi department store in Tokyo, who was buying on commission for one of Mitsubishi's customers. As the struggle for *Maternité* had hinted, the Japanese were widening their tastes.

—

The Japanese art world is unique. There are "regular" dealers, as they would be recognized in the West, in Osaka, Nagoya, Kyoto and especially Tokyo, where they tend to cluster in the area known as the Ginza. But it is the aspects of Japan's art world that are special to the country that require explanation, for more than any other factor, they help to illuminate what has been happening to taste there.

Japan has forty-seven prefectural areas, each of which now has its own museum, in which the prefectures take great pride. The Japanese identify

with the prefectural areas in which they live, just as they identify with the companies for which they work. In return, the prefectures are aggressive in pursuing the interests of their inhabitants, and this attitude is reflected in the activities of art museums. In 1988, for example, the city of Nagoya paid $2.2 million for Modigliani's *Girl with Pigtails.* What British or American municipality would raise funds like that, then travel halfway around the world to bid for such a work at auction? Under its director, Fumio Hayakawa, the Yamanashi prefectural area was an early buyer at auctions. Mito City, in Ibaraki Prefecture, about an hour and a half north of Tokyo, has built a $71 million "art tower," which was established with public money but will be managed privately.

This figure says something about the current Japanese enthusiasm for the arts. It is related to Japan's economic prosperity, of course, but there are also historical reasons for it. Japan did not experience religious wars like those that caused the movement and trading of art in the West. Also, until 1873 there was really no such thing as capitalism in Japan, and the "collecting classes," as Thomas Kirby might have called them, were confined to the Daimyo (the nobility) and the Samurai (the warriors), whose interests, by and large, centered on tea-ceremony ceramics and scrolls. In the absence of religious wars or a middle class, religious art tended to remain in temples and shrines and was not traded.

Capitalism began incubating in Japan with the Land Tax Reform Act of 1873. The Bank of Japan was established in 1882, and the Meiji constitutional promulgation came in 1889, from when modern Japan may be said to date. During this time, from 1873 to 1926, the beginning of the Showa period, a new brand of collector appeared, generally the rich owner of a private company. Some of these men were interested in contemporary painting and, according to Kazuo Fujii, there was a late-nineteenth-century vogue for portraits, but most collectors wanted Oriental antiquities.

As in China, there has been a tradition of collecting tea-ceremony objects for hundreds of years in Japan. Beyond that, the art trade as we would come to know it developed in the nineteenth century partly as a result of American interest in Japan, when the first Japanese dealers thought it important to keep precious paintings at home. Auctions had been known in Japan since the Edo period, but they occurred only after death or bankruptcy and usually took place on the owner's premises. However, at the turn of the century some Tokyo dealers conceived the idea of starting their own auction house, and in 1907 thirty-four of them got together to buy an old Japanese inn by the Simida River, and the Tokyo Art Club was opened. The dealers each had to put up 150,000 yen in capital, a lot of money then, and three thousand shares were issued. Thirteen hundred of them were subscribed by one man, the

founder of the Tobu Railroad in Tokyo, Nezu. The Tokyo Art Club has always had its own special gloss because the public is not allowed to attend its auctions; only members—that is, dealers—can buy and sell there. It is in effect a kind of wholesale redistribution center, an official but private ring, where specialist dealers can sell merchandise to other specialists who are able to dispose of it more easily. This worked well for the trade, and in those days to be a member of the Tokyo Art Club was immensely prestigious. Understandably, at the same time the public was suspicious. Just as in the countries of the West, but for different reasons, the art trade in Japan was not as highly regarded as it would have liked to be.

After the Showa period began, and after the country recovered from the Great Kanto Earthquake in 1923, business started to change. Many people had been killed in the catastrophe, and so private and family-run firms gave way to ones in which the president was paid a salary rather than simply taking the profits because he owned the company. Whereas the owners of private companies tended to be older when they took over from their fathers, and saw themselves as closer to the nobility than to the middle class, the new breed of president was younger and more contemporary in taste.

As a result, though antiquities remained popular, Western painting and Western-style Japanese painting now attracted more attention. In the years between Showa and World War II, the first Western-style dealers and collectors began to appear. Among the latter were Magosaburo Ohara, president of the Kurastiki radio company; Matsukatu Kojiro, who helped Rodin in 1917 when bronze was in short supply; Hara Sankei; Nezu; Hisanori Munakatu, who worked for the Bank of Japan in Europe and was a big buyer of Kandinsky, Klee and Alexei Jawlensky; Shigetaro Fukushima, who was a friend of Matisse and Rouault, and started the journal *La Forme* in Paris and whose Forum gallery is still run by his daughter; and Haksuda of the White Crane sake company also stood out. Among dealers, the Sasazu, Setsu and Nichido galleries were established in Tokyo, each of them in the field of Oriental antiquities. Today Nichido, with a second gallery in Paris, is given over entirely to Japanese Western-style painting, and is the world expert on Foujita. Setsu still deals in antiquities but added American Abstract Expressionism in the Sixties. Sasazu handles 90 percent antiquities and 10 percent modern art. But the longest-established gallery in Japan may be the Toda Gallery in Kyoto, which for eight generations has dealt in tea-ceremony ceramics.

Most of the pre–World War II collectors established their own museums, but all nine of those that opened before 1940 were devoted to antique Oriental art. Three public galleries devoted to modern art were established in Tokyo and Kyoto in 1921, 1933 and 1936, but they didn't really flourish until

after the war. One effect of World War II was to render the Japanese relatively poor. Their defeat, combined with the superpower status of the United States, made American culture very popular in Japan. At the time, American Abstract Expressionism had not yet caught on internationally and was much cheaper than Impressionists or Old Masters. As a result, galleries like Iwao Setsu and Fujii bought Jasper Johns, Sam Francis, Jackson Pollock and Yves Klein. But for fifteen to twenty years after World War II, life was hard for the defeated nation, and matters were not improved by the Korean War in the early Fifties.

The Sixties were much better. Both Iwao Setsu and the Nichido Gallery moved into Impressionism and Western-style Japanese painting beginning in 1960. Travel to Europe became easier, and the Vietnam War, unlike the Korean War, gave a boost to the country's developing electronics industry. This might well have produced consequences for the art world sooner had it not been for the rise in oil prices, which hit Japan much harder than either North America or most of Western Europe because the Japanese were (and are) so dependent on Middle Eastern oil. In fact, although trade continued to improve throughout the Sixties and Seventies, it was not until 1980 that sales of Japanese ceramics and bronzes to the United States and Europe were overtaken by sales of Western art to Japan. Kazuo Fujii had dealt in traditional Japanese and Western-style Japanese painting until 1969, when the Christie's and Sotheby's auctions took place in Tokyo, but he too discerned a change in the market about 1979, when there was a mushrooming of securities companies. This was also the time when Sotheby's concluded its agreement with Seibu.

However, it was the International Plaza Agreement, which raised the value of the yen in 1985, that created the real thrust, converting the Japanese into big spenders and helping the trade to flourish as never before. New collectors appeared, people like Michimasa Muraichi, who became a yen billionaire when he sold his family's paddy fields. (By 1988 Tokyo real estate in the Ginza was $290,000 a square meter and a bottle of whisky was $119.) Muraichi put together one of the finest collections of Barbizon School pictures, with ten Corots and ten Courbets, and installed them in his furniture store in a Tokyo suburb. Hikonobu Ise was another prominent collector. He made his millions by selling eggs, becoming known in Japan as "the king of eggs who wants to become the king of art," and his collection included Monets, Cézannes and Magrittes. Kosuke Nagashima used the profits of his pinball-parlor empire to amass more than forty Renoirs, Picassos and Chagalls; Masahiro Takana, mentioned earlier as the president of the Green Cab

Company, acquired the world's largest collection of Marie Laurencins, and Morimasa Okawa, a real-estate developer, was drawn to de Kooning, Lichtenstein, Sam Francis and Hans Hofmann.

According to the Tokyo Customs House, by the time of the November sales in 1988, Japanese art imports had risen to $1.398 billion, up 40 percent from the previous year's total, which itself was double the 1986 figure. However, a confidential Christie's report indicated that the 1988 total was actually much higher than that, nearer $2.47 billion, and constituted 53 percent of the world auction business in Impressionist and modern works (see p. 412). Etsuya Sasazu told me there were by now two hundred or three hundred dealers in the Japanese-European market, but only twenty or twenty-five of these really mattered. *Japan Economic Weekly* listed the top ten in terms of profitability as follows:

Gallery	Profits (¥)	Increase for 1988
Nichido	3.117 million	30.9 percent
Aska International	1.041 million	(not available)
Wildenstein	637 million	112.3 percent
Nakamiya, Osaka	575 million	151.0 percent
Tamenaga	497 million	60.0 percent
Fujii	436 million	211.0 percent
Timego	349 million	3.6 percent
Art Point	151 million	228.0 percent
Yoshi	141 million	66.0 percent
Funabashi	124 million	110.0 percent

This list does not include the two leading Japanese department stores, Mitsukoshi and Seibu. In the West it is unthinkable that a department store could be a credible art dealer, but the Japanese make no such assumption. Sotheby's has appreciated this since 1979, of course; hence its relationship with Seibu.

Seibu did not spend as much as Mitsukoshi at the November 1988 sales; nevertheless they bought Monet's *Nymphéas* for $10.9 million and Renoir's *Tête de femme au foulard bleu* for $3.76 million. A few months later Seibu, in conjunction with the Fuji Bank in Tokyo, introduced a loan scheme in which collectors who left their artworks with the department store could borrow up to 80 percent of the agreed-upon value at 3 percent per year below the U.S. prime rate. This scheme encouraged people to buy more art, and Masahiro Nagayasu, vice president of the Fuji Bank in New York, forecast that it would be grossing $8.5 million a year before long. A similar plan was

JAPANESE IMPORTS VS. WORLDWIDE
AUCTION SALES
(1988 £ MILLION)

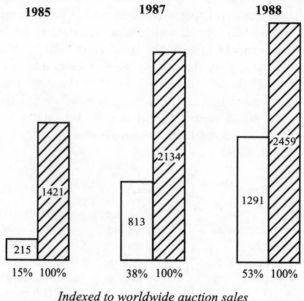

Indexed to worldwide auction sales

☐ Japanese imports ▨ Worldwide auction sales

Sources: MITI Statistics, ASI database, Dun & Bradstreet, Christie's
sales and knockdown comparisons, press releases

also instituted by the Lake Company, Ltd., of Osaka, and by its subsidiary,
Art Funds of Ginza, Ltd.

Three Japanese dealers have become particularly prominent in the last few
years. They are Susumu Yamamoto, whose role is examined in a later chap-
ter, and the two men who fought it out over *Maternité,* Yasumichi Morishita
and Shigeki Kameyama.

Morishita, a small man with wavy black hair and large ears, has a colorful
past and is known in the Japanese press as "the viper." The son of a shop-
keeper in Aichi prefecture west of Tokyo, he opened a textile business after
leaving school, expanded into finance and real estate, and then in 1968, at the
age of thirty-six, formed Aichi Company, a stock speculator and money
lender. In Japan, apart from banks, there are 38,000 *machikin,* which lend to
small companies, and *sarakin,* which lend to individuals. By law these firms
are allowed to charge up to 54.75 percent and 36 percent interest respectively.

JAPANESE IMPORTS OF FINE ARTS AND ANTIQUES
MORE THAN 100 YEARS OLD
(£ MILLION)

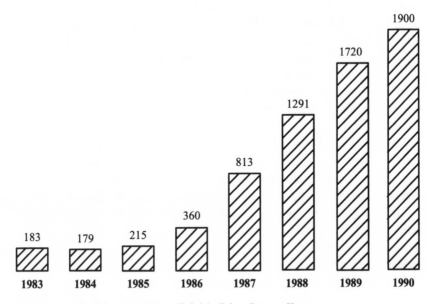

Sources: MITI Statistics, Mars & Co., Christie's, Tokyo Customs House

Despite this usurious rate (at least by Western standards), Morishita fell afoul of the law and in the late Sixties and early Seventies received a ten-month suspended sentence from a Tokyo court for violating the money-lending law and for double accounting. Later he was arrested again, three times, but not indicted—for assault, unlawful confinement, fraud, forgery and extortion. He says that this is all in the past and is now suing the Japanese weekly *Shukan Bunshun* for a story it ran in November 1989 that labeled him "the king of shady money."

By the Eighties Morishita's business interests included Aska International, which sold violins, Italian furniture, golf equipment and helicopters, in addition to operating nine golf courses in Japan and the Desert Falls and Mesquite country clubs in California. In November 1988 he opened the Aoyama Gallery with the intent of making it "the most famous specialist gallery of Impressionist and Post-Impressionist art in the world." One intriguing move was that the gallery, which has purple walls, was located not in the Ginza but in the monied Aoyama residential area of Tokyo. A second gallery was opened in February 1989. Aska International, which owns Aoyama and is itself 51 percent owned by the Aichi Company, went on a spectacular buying

spree to ensure that the Aoyama Gallery would open with a stock of two hundred paintings. By 1990 one observer in *Business Week* estimated that the firm accounted for 30 percent of all buying on the international Impressionist market. Even if this is an exaggeration, Aska's buying was impressive; its inventory in 1990 was reported to consist of six hundred paintings valued at $450 million and included twenty Renoirs and twenty Monets. In October 1989 Morishita spent $23 million in one session at Sotheby's, buying seven pictures, including a Picasso, and the very next month Aska International spent $100 million on one hundred paintings. Morishita's assistant, Kiyotaki Kori, who manages the gallery, needs to refer to his boss only for acquisitions above $10 million.

With such spending power Morishita should be popular, but dealers as far afield as Paris are loud in their dislike of his attitude and distance themselves from him. In September 1989 he paid £33 million ($52 million then) for a 6.4 percent stake in Christie's and a shiver went through the firm at the thought that they were about to suffer a takeover trauma. So far this has not materialized, and people still look down their noses at what they consider to be the many second-rate Renoirs and Monets in which Aoyama seems to specialize. At the same time, the list of top pictures he has bought in the space of three or four years has a certain Duveen-like quality to it:

		Bought for
van Gogh	*Carrière près de Saint-Remy*	$11.55 million
Picasso	*La Maternité*	11.20 million
Gauguin	*Entre les lys*	11.00 million
Picasso	*Au Moulin Rouge*	8.25 million
Vuillard	*La Table de toilette*	7.70 million
van Gogh	*L'Homme est en mer*	7.15 million
Gauguin	*Petit Breton à l'Oie*	6.83 million
Monet	*Fin d'après-midi, Vétheuil*	6.55 million
Renoir	*Portrait de Gabrielle*	4.62 million
Monet	*Bords de la Seine,*	
	un coin de Berge	3.74 million
Caillebotte	*Pêcheurs sur la Seine*	2.06 million
Monet	*Promenade*	1.43 million

Morishita claims to have sixty large clients—individual companies, brokerages, banks and insurers—and makes profits ranging from 3 percent to 50 percent. The best of his ten houses, a flamboyant red-brick affair, is in the smart Denenchofu district of Tokyo, and so for some people he has lived down his controversial past.

If Morishita is the modern-day Duveen of Japan, Shigeki Kameyama (in English the name means "Mountain Tortoise") is more in the tradition of the great *marchands-amateurs* of the past, for he is both a collector and a dealer. Kameyama is a collector of maverick tastes for a Japanese, with a penchant for modern and contemporary works—Egon Schiele and Cy Twombly as well as Rothko and Picasso. He is very private, an elusive figure who grants no interviews (his fortune apparently comes from real estate), and is known in the Japanese trade as a fierce haggler over price, to such an extent that dealers, at the start of negotiations, routinely put *up* the price of objects he wants, in order to protect themselves. Kameyama is also a maverick in that he likes to bid himself at auction, to cut out the dealer's commission. He collected mainly American works throughout the early Eighties, then became a dealer. He was first noticed in the auction salesrooms when he almost acquired *Maternité*. His day would come.

37 | FALSE START?
THE MARKET IN
CONTEMPORARY ART

Paralleling the passion for Picasso that flared in New York, something equally dramatic was happening simultaneously—indeed on occasion at the same sales. The prices for contemporary art also shot upward. This boom began at Christie's on November 9, 1988, when thirty-two works from the collection of Burton and Emily Tremaine were sold. Burton Tremaine had made his money from industrial lighting, and Emily had been one of the handful of collectors who had bought Jasper Johns's work at his first one-man show at Castelli back in January 1958. Along with the Albert Lists and Count Giuseppe Panza di Biumo, they had moved into Pop Art in the Sixties, and together with Philip Johnson and Robert Scull, they had been among the first to buy Warhol's early silk-screen pictures turned out at "The Factory" on Forty-seventh Street.

Contemporary American works had been traded consistently at auction only since the Scull auction in 1973. Scull owned a fleet of New York taxis ("Scull's Angels") and was known as a rough, tough, coarse character. Most people in the art world believed that Max Kozloff was referring to Scull when he wrote in *Art International* in 1962 that the new breed of collectors were "pin-headed . . . gum-chewers, bobby soxers, and, worse, delinquents." But Scull had backed Richard Bellamy's Green Gallery by agreeing to buy eighteen thousand dollars' worth of paintings a year. When he sold off most of

his collection in 1973, many of the artists were shocked, in much the same way that the Impressionists had been shocked by the Duret sale.

Robert Rauschenberg had turned up at the auction, drink in hand, and had proceeded to punch Scull afterward, at least according to Scull's wife, Ethel. He thought the Sculls had profiteered at the artists' expense. So the Scull auction had something in common with the Kahnweiler sales—where there had also been fisticuffs—as well as with the Duret auction.

The Scull dispersal had started a process that Tremaine confirmed. It showed that it no longer took artists a generation or more to transfer from dealers to salesrooms: 1973 was just fifteen years after Castelli's early shows. Sotheby's gave the sale much the same PR treatment that would become routine ten years later: they arranged for Les Pléiades, the art trade's watering hole on East Seventy-sixth Street, to serve *Médaillon de veau Robert Scull* ("medallion" being an important word in the cabbie lexicon) and also advertised that Castelli would be giving a dinner there on the night of the sale, with some of the Abstract Expressionists invited.

Seating was as important at the Scull auction as it was at the *Dr. Gachet* sale. Tamenaga, from Japan, had five seats, Marlborough attended in force. Some things had not changed. The lots were still presented by black men in white gloves, a touch Thomas Kirby would have relished. Estimates were *not* printed in the catalogue and were revealed (and piecemeal at that) only to people who could convince the auction house that they were bona fide buyers. Cabbies protested Scull's wage rates outside the salesroom, alongside feminists protesting that there was work by only one woman in the sale.

But, inside the auction house, nothing could dampen the enthusiasm of the evening and the Scull auction set high levels for contemporary works, giving this new market a flying start. *Thaw,* by Rauschenberg, which Scull had bought for $900 in 1958, went for $85,000, and Johns's *Double White Map,* priced at $10,000 in 1965, went for $240,000. Overall, the sale made $2,242,900, including the Jasper Johns cast of a couple of Ballantine's Double-XX ale cans, which fetched $90,000, reconfirming, if it was needed, that Castelli could make anything "art."

After the Scull sale, contemporary art was at last taken seriously by the salesrooms. This was important in trade terms for it meant that Sotheby's and Christie's would now consider trading in artists in mid-career, and it therefore marked a further change in the relationship with dealers and collectors. Though this was not new in Paris (where contemporary art had been widely auctioned at the time of the Impressionists and in the Twenties), it was new for the Anglo-Saxon countries and its eventual success would lead Peter Wilson to say that he, and Sotheby's, would "bury" the art dealers. Perhaps

he was aware that Cortlandt Field Bishop had said much the same in the Twenties.

Since the Scull sale, contemporary pictures had moved fast but had not yet attracted the attention they were about to at the Tremaine auction. The star of that collection was a Jasper Johns composition called *White Flag*. It was one of the original five works that Castelli had seen in Johns's studio that afternoon in 1957 when he had stopped by Robert Rauschenberg's apartment to look at his works, then found out that Johns was only a floor below. Physically the picture resembles "the ghost of the American flag," as one observer put it, because it is in various shades and textures of white and is fashioned from newsprint, wax and inks.

At this point the record for a living artist was held by Johns's *The Diver*, which had sold for $4.18 million the previous May. *White Flag* trounced it convincingly, fetching $7 million and going to Hans Thulin, a Swedish real estate developer. Thulin was delighted with his prize and informed the trade and press that he intended to form a collection of twenty works, two each by the ten most important artists painting between 1950 and 1980. Naturally this drew attention to what he might buy the following day, for by yet another bit of remarkable symmetry, Sotheby's had a sale of contemporary works that also featured a Johns and works from the collection of an American couple who had been early supporters of contemporary artists.

Mr. and Mrs. Victor W. Ganz had started with Picasso, buying large numbers of important works when the Spaniard was on the verge of his controversial late period. In the Fifties they had bought directly from Kahnweiler. Then they had moved on to Johns, Rauschenberg and Stella. On this evening the main drama surrounded a Jasper Johns. Johns's work had changed dramatically soon after his first show at Castelli's. He now used oils rather than encaustics, and he had veered away from flags, targets and numbers to painted patches of color with stencils over certain areas. Whereas Rauschenberg used bits of the everyday world in his pictures, Johns went in the opposite direction, being concerned only with paint, color and form. The first step in this new direction of Johns was *False Start*.

The bidding began at $3 million and in no time had passed the $3.6 million paid for Johns's *Out the Window* in 1986, the $4.18 million for *The Diver* in May 1988, and the $7 million paid only the day before at Christie's for *White Flag*. But it didn't stop just because those records had been broken. There was a bidder in the room and a bidder on the telephone—a dealer—and the tussle went on and on. In the end the dealer on the phone won. He paid a sensational $17 million, and his name was Larry Gagosian.

The Tremaines and the Ganzes, and others like them such as Karl Ströher, who also sold his collection of Pop Art that month, were all as distinguished

in their way as the Havemeyers, Jean-Baptiste Faure and John Quinn, for they had the appetite and eye for new work. It was fitting that their collections should be sold when a great art boom was under way; it set the seal on their taste and knowledge.

━

The taste and knowledge of the new collectors was a subject of great speculation in the Eighties. It was as if no one quite knew whom they were dealing with—neither the auction houses nor the dealers. The connoisseurship of these new players was an especially touchy subject. Art-world professionals, especially in the auction houses, did not wish to be thought snobbish or arrogant in calling the new collectors ignorant, for this might frighten business away. After all, many collectors in the past had started off ignorant but learned rapidly once bitten by the bug. Nevertheless the feeling remained throughout the Eighties, and especially in the late Eighties, that many of the new collectors were speculators rather than true art lovers. Observers wrote about this as if it were brand-new. The scale of it may have been modern, but the motive was ancient, as this narrative has shown.

By the end of the Eighties, Michael Ainslie, the chief executive officer of Sotheby's, estimated that there were roughly 400,000 serious collectors worldwide—"serious" meaning that they spent at least $10,000 a year in the art market. This is too large and too disparate a group to be studied systematically; the best one can do is to fall back on the lists of collectors published by the art magazines. Allowing for overlap and changes from year to year, these lists provide a microcosm of between 250 and 350 *very* serious collectors, whose collections are worth millions. What generalizations about them are possible? The most obvious is that collecting contemporary art is twice as popular as collecting modern—that is, twentieth-century—art; three times as popular as collecting Impressionists and four times as popular as collecting Old Masters. Good Old Masters are much harder to come by these days, of course, and the religious content of many Old Masters is unappealing to many buyers. The high price of Impressionist and modern works probably accounts for some but by no means all of the appeal of contemporary art. Many of these collectors—Edye and Eli Broad from Los Angeles, for instance, or Mara and Donald Rubell of New York—like to know the artists whose work they buy. Others, like Adrian Mnuchin of New York, are associated in some way with museums. Collecting contemporary art, especially in the United States, is a social and sociable activity and recalls life in Paris in the 1907–14 and 1918–29 periods. Other forms of collecting seem to be more private.

This difference is so marked that one could assert that serious collectors

today may be divided into three categories, collectors of contemporary art being the first and largest. Collectors in the second group are not at all interested in contemporary art and have the funds and the appetite to acquire the very best in their chosen fields. Among these more old-fashioned collectors are, in no particular order, T. T. Tsui (Hong Kong, Oriental porcelain); Heinz Berggruen (New York, Impressionist and modern art); Stavros Niarchos (London, Switzerland, New York and Paris, Impressionists and Post-Impressionists); John Paul Getty II (London, nineteenth-century European painting); Fred Koch (New York, rare books); Sotaro Kubo (Osaka, early Japanese art); Leonard Lauder (New York, Cubism); K. S. Lo (Hong Kong, Oriental ceramics); Paul Mellon (Upperville, Virginia, English painting and sporting art); Jaime Ortiz Patiño (Geneva, rare books and manuscripts); Norton Simon (Beverly Hills, Impressionists and Old Masters); Hans Heinrich Thyssen-Bornemisza (Lugano, Old Masters and Impressionists); Walter Annenberg (Palm Springs, California, nineteenth- and twentieth-century painting); Barbara Piasecka Johnson (Princeton, New Jersey, Old Masters); Gloria and Richard Manney (New York, rare books); Clarice and Robert Smith (Arlington, Virginia, European paintings); Lana and Michael Schlossberg (Atlanta, Georgia, drawings); and Peter Ludwig (Aachen, Germany, the only world-class collector who may be said to collect everything, though his medieval holdings are arguably his best).

The third group of collectors is characterized by the idiosyncratic nature of their collections. They have the funds, the appetite and the eye but have confined themselves to a smaller canvas than the second category. This list is not exhaustive, but they include Richard Ketta (Los Angeles, aboriginal art); Ann and Gilbert Kinney (Washington, D.C., Asian statuary); Thomas Monaghan (Ann Arbor, Michigan, Frank Lloyd Wright); George Way (Staten Island, New York, English oak furniture); Mitchell Wolfson (Miami, propaganda arts—advertising, political art, etc.); and Charles Zollman (Indianapolis, ancient masks).

According to *ARTnews,* in 1990 the three greatest collectors of American contemporary art were all non-Americans: Charles Saatchi in London, Peter Ludwig in Aachen and Count Giuseppe Panza di Biumo of Varese, Italy. Despite this, there is a good deal of nationalism in collecting; for example, many American collectors of American contemporary art extend their holdings into American folk art rather than into the contemporary art of other countries. Britain, France and Germany all have strong local markets. Alexander Apsis of Sotheby's realized in the Eighties that the Scandinavian countries had strong economies, and he and Sotheby's were very successful for five or six years in promoting Scandinavian art.

There was something, if not false, then *forced,* about the nationalist ap-

proach to contemporary and modern art, and in some ways the most extraordinary example of this trend has occurred in Australia. Of course there are Australian collectors with international collections, among them Warren Anderson (Perth, Old Masters and English pictures); William Bowmore (Newcastle, Old Masters and Impressionists); René Rivkin (Sydney, Oriental art); Penelope Seidler (Sydney, contemporary art); and lastly the man who did—and did not—buy *Irises,* Alan Bond. In general, however, Australian collectors tend to stick to their own artists: Arthur Boyd, Sir Sidney Nolan, Fred Williams, Russell Drysdale and Brett Whiteley. Australians themselves are the most outspoken critics of this situation, pointing out that in the Eighties their country became a particular victim of the "Yuppie" culture, and that a lot of arid corporate collecting made the situation worse. That said, the most distinguished collection in Australia that this writer has come across belongs to Joseph Brown, a Melbourne dealer. His houseful of Australian art, beginning in colonial times and extending to the present day, not only contains examples of every Australian painter of note but has some of the most historically interesting pictures as well. His home is already a private museum and someday ought to become a public one. It shows at its best the rewards of being a dealer.

By 1992 collecting contemporary art had turned on its head. It used to be that this field took nerve and involved going out on a limb, but in the Seventies and Eighties this changed. More and more people were at home with newness and thrived on change; the shock of the new was less and less disconcerting. At the same time, it began to appear that the collectors who were most adventurous, most curious, most likely to go out on a limb, were the people who collected Old Masters and antiquities—in short, the art of the past.

—

Another kind of new collector was the corporation. Some such collections go back a long way: for example, the Atcheson, Topeka and Santa Fe Railroad in 1896 began collecting oils showing the populating of the West; IBM began collecting American contemporary art in 1939. But the most authoritative survey of corporate collecting, published in 1990 by Rosanne Martorella, confirms that 90 percent of such collections in the United States have been formed since World War II, 80 percent since 1960, and that the main growth has been since 1975.

The impact of corporate collecting has been mixed and paradoxical. One reason may be that companies collect with their heads rather than their hearts. If Rosanne Martorella is to be believed (and her survey of 274 corporate collections is much the most thorough to date), most corporate

collections were started by enthusiastic chief executive officers who invariably had a specific interest, but whose pioneering influence eventually gave way to an "acquisitions committee." As often as not, this was made up of people anxious to please the CEO but with few qualifications in the field of art, and who therefore appointed a corporate art consultant. This is a new specialty, for theoretically an art consultant in this context is part connoisseur, part curator and part dealer. In practice many art consultants are trained in art history and therefore resemble curators more than connoisseurs or dealers. Rosanne Martorella reports that many of them have been disappointed, on taking over corporate collections, to find that though there may be a handful of fine works, most of the collection is made up either of works by unknown living painters or of prints and posters. Up to 90 percent of the work has been thrown away by the consultants or, in their words, "should have been."

Corporate collections, Martorella tells us, are of three types. There are a few that consist of first-rate names, usually of contemporary American masters. There is a slightly larger second group, which are "documentary collections"; for example, Coleman's collects mustard pots and Iroquois Brands collects tea caddies. Third, the vast majority consist of agglomerations of pictures by local artists from the area where the company operates who do not necessarily have any discernible merit. In addition, according to Rosanne Martorella, many corporate consultants are in reality interior decorators, and the pictures they recommend are generally idealized figurative pictures, often "serene landscapes." The paradox is that corporate art now accounts for 20 to 30 percent of the business of New York galleries who sell contemporary art and as much as 40 percent elsewhere, but such purchases have had no impact whatsoever on the avant-garde. Indeed, Rosanne Martorella concludes her study by saying that the overall importance of corporate collecting has been much exaggerated. It too has had a false start. This is confirmed by many dealers, who confess that there is a certain type of art they don't even show to corporations, and by art consultants, who acknowledge that many companies shun work that is "politically or psychologically inappropriate." Art collecting by corporations has become a form of nationalism, a subtle kind of propaganda, and suffers accordingly.

Only one set of corporate collectors have had an important effect on the mainstream art market, and of course they are the Japanese ones. But here too the effect has been paradoxical, though in a quite different way (see Chapter 41).

Exactly one month before the Karl Ströher sale consecrated the boom in contemporary art, on April 4, 1989, the British Rail Pension Fund auctioned off its collection of Impressionist and modern pictures. Among the paintings sold were van Gogh's *Mas à Saintes-Maries,* Picasso's *Jeune homme en bleu,* Cézanne's *Nature morte au melon vert,* and Monet's *Santa Maria della Salute et le Grand Canal.* Twelve days later the fund sold its Ming porcelain in Hong Kong. With such an art boom in progress, and since the fund had officially decided against investing in art in the early Eighties, it was no surprise that it now began to sell its collection, even though the original intention had been to hold on to it for twenty-five years. In fact, the fund had already sold some drawings and medieval and Renaissance objects in 1988. But the Impressionist and modern works were the most eye-catching; the great jewels of the greatest investment collection were coming onto the market, and all eyes were on them.

They performed magnificently. A Pissarro portrait that the fund had acquired at the von Hirsch sale in 1978 for £330,000 went for £1.32 million ($2.5 million); the Monet, which had cost £253,000 in 1979, went for £6.71 million ($12.75 million); and a Matisse bronze, *Deux négresses,* bought in 1977 for £58,240, brought thirty-nine times that, £1.76 million ($3.34 million). In all, the twenty-five objects that the fund sold that day had cost £3.4 million and now realized £35.2 million ($66.88 million). The investment had grown at 20.1 percent per year, or 11.9 percent when adjusted for inflation. In announcing these figures, Sotheby's said that a portfolio of shares invested at the time of the various purchases could have been expected to yield 7.5

percent. On the face of it, then, the fund's experience was a very successful one and seemed to confirm what everyone could see for themselves, and that had presumably fueled the boom of which the fund was now taking advantage: art was a very good investment.

But though the British Rail Pension Fund's results look spectacular, the Impressionist and modern pictures were only part of their portfolio.

In an interview for this book, Susan Buddin, company secretary of the fund, and Lady Damaris Stewart, the fund's current works-of-art consultant, provided information never previously released on the exact figures regarding their investment in the art market. Until January 31, 1992, the fund had sold 1,842 of the 2,232 objects it had bought. These, it calculated, had provided a return of 13.93 percent cash rate of return, or 6.07 percent when inflation is taken into account. This figure included direct costs, such as restoration, but makes no allowance for administration, transport, etc.

The fund says it has now made its own calculations comparing art investment with the stock markets, and it finds that it came out some 1.5 to 2.0 percent better than Treasury bills over time, but of course a good deal worse than equities.

Most important of all, perhaps, is the fact that although in terms of number 75 percent of the collection has been sold, by value only 50 percent has been sold, with major works by Van Dyck, Tiepolo, Chardin, Canaletto and Hobbema still in the fund's possession. Given that we have lived through the best art boom we are likely to see in our lifetime, the figures for the fund's performance are now likely to be at their best, and can only decline from here on.

This is underlined by the fact that the rise in the Impressionist market is much greater than that in other sectors of the market. For instance, according to Robin Duthy, whose research is discussed later in this chapter, since 1975 French Impressionists have performed seven times as well as Dutch pictures, three times as well as English sporting pictures and more than twice as well as pictures from the School of Paris. In one sense, then, the spread of the fund's collection means that its message for others will actually be limited. If you collect in one area alone (as 80 percent of the serious collectors discussed in the last chapter do), you may get it spectacularly right, or else sensationally wrong. Only art investment funds are likely to buy across the board as the fund did.

But even allowing for the fact that the fund did much less well overall than it did with the French Impressionists alone, there are other factors that reduce the value of the investment, and these are not always mentioned by the auction houses. Over ten years, insurance, which usually averages 0.5 percent of the value of the objects, would lop about 5 percent off the return, removing art's lead over Treasury bills. The fund also ignored the fact that works of art, when

considered as investments, produce no dividend, as most ordinary stocks and shares do. In Britain, pension funds enjoy tax benefits on these incomes—a benefit the fund could not take advantage of with art. This was another hidden cost of its art investment and may have had something to do with the decision to end the experiment. Susan Buddin also said that the fund had come under the scrutiny of the Internal Revenue Service, which was concerned that a pension fund should not *trade* in art.

This is not to say that in the fund's own terms the investment was not a wise one. At the time it took the plunge, inflation was shrinking money at a terrifying rate, especially in Britain, and the fund chose to put a relatively small part of its resources into an area that at the time seemed to be holding its value. It is also important to understand that the fund's attitude was a corporate one. It could afford to take the long view, to purchase the very best and to collect in many fields in order to spread its risk.

For individuals who are collectors, as well as for corporations that specialize in a single field, or a few, the investment potential of art has been studied by three groups of people, each more sophisticated than the last. The pioneer was Gerald Reitlinger, whose three-volume *The Economics of Taste* (1960, 1963 and 1970) contains the raw data from which many others work. Reitlinger scoured auction records and the memoirs of collectors and dealers for the prices of paintings, porcelain, furniture and many other objects from the beginning of the eighteenth century to the early Sixties. In his introduction he tried to show how present prices related to those in the past, but he gave no real basis for his calculations and in the main let the costs of the objects speak for themselves. The tables in his book are impressive, and contain some vivid examples of art which has risen in value, along with some equally startling cases of objects where prices have collapsed. Here are just three examples:

Titian	*Venus and Adonis*	1798	£420
		1884	1,764
		1899	420
		1925	2,415
Reynolds	*The Tragic Muse*	1790	735
		1795	336
		1823	1,837
		1921	73,500
Rubens	*Lot and His Daughters*	1886	1,942
		1911	6,825
		1927	2,205

Such variations in the worth of individual paintings are fascinating, but few generalizations are possible from Reitlinger's books.

The second source is a mathematically minded British writer, Robin Duthy, whose book *The Successful Investor,* published in 1986, was a statistical examination of prices for paintings, furniture, silver, diamonds, books and so forth. Duthy's technique was to include only the central 80 percent of prices. Excluding the top and bottom 10 percent, he felt, prevented exceptional prices from distorting his conclusions. His master table, reproduced below, is instructive:

Sector	1975	1986
American Impressionists	1,000	7,210
18th-century English portraits	1,000	6,208
FT 30 share index (net income reinvested)	1,000	5,509
English watercolours	1,000	5,455
English sporting painting	1,000	5,354
American painting (1910–1940)	1,000	5,149
French Impressionists	1,000	4,699
19th-century American painting	1,000	4,564
Chinese porcelain	1,000	4,359
Old Master prints	1,000	4,206
17th-century Dutch and Flemish painting	1,000	3,735
German Expressionists	1,000	3,697
Victorian painting (British)	1,000	3,647
New York School	1,000	3,646
School of Paris	1,000	3,609
FT 30 share index	1,000	3,595
Surrealists	1,000	3,438
UK Consumer Price Index	1,000	2,885
Barbizon School	1,000	2,700
Gold price index	1,000	2,293
Dow Jones Industrial Average	1,000	1,994
Diamonds	1,000	1,220

Dr. Mitchell's index from Appendix B recalculated to match this table (i.e., 1975 = 1000) — 3,372

This table is useful because the period it covers, 1975–86, saw both bad times (high inflation, the wake of the rise in oil prices) and good times (the post-1982 boom). But it also shows that the investment performance of art objects often depends on one's starting point. For example, the French Impressionists were already expensive by 1975, which is why their improvement isn't more dramatic. Even so, with net income for shares reinvested in

the stock market, only a handful of art sectors do better than conventional investments.

In May 1990 Duthy updated his table, which was now as follows:

	Index in 1975	1990
American Impressionists	1,000	21,000
French Impressionists	1,000	21,000
18th-century English portraits	1,000	9,500
English 19th-century watercolours	1,000	9,300
New York School	1,000	8,400
School of Paris	1,000	7,900
German Expressionists	1,000	6,950
English sporting painting	1,000	6,700
Nikkei average	1,000	6,300
Surrealists	1,000	6,300
Victorian painting	1,000	6,100
19th-century American painting	1,000	5,900
Barbizon School	1,000	5,850
American painting 1910–40	1,000	5,450
FT 30 share index	1,000	3,840
17th-century Dutch and Flemish painting	1,000	3,350
Dow Jones	1,000	1,850

Comparing these two tables shows how big the changes were in only four years, especially in the fields of French Impressionism, American Impressionism and the New York School, which improved, and American painting from 1910 to 1940 and Dutch and Flemish pictures, which slipped in their rankings. Writing from Britain, Duthy concluded that during 1989, "prices for Western art rose by 58 percent . . . the fastest rate yet recorded. In U.S.-dollar terms the market was up by 50 percent, and in terms of the yen by 52 percent." Over the longer term, however, Duthy's figures show that the performance of paintings depended on the currency in which their prices were calculated. For example, for the British investor, paintings overall had risen by 870 percent since 1975, which compared well with the 384 percent rise in the *Financial Times* index of thirty leading shares during the same period. For the American investor, the art market's jump of 650 percent was even better in comparison with the Dow's 185 percent improvement. However, the picture was reversed for the Japanese; there art rose by 240 percent but the Nikkei average rose 630 percent (though in 1989 art rose by 50 percent in yen, compared with the 20 percent rise in the Nikkei).

On the face of it, these figures contain a paradox. According to the information in Duthy's tables, in the last decade and a half the British should have

been among the heaviest investors in the art market, with the Japanese much less so. Yet as anyone in the art world will tell you, and as is obvious from the last few chapters of this book, the precise opposite is the case.

Why is this? For an answer we should turn to the academics, the third group of people who have studied investment in the art market. Since World War II some seven or eight groups of scholars, usually economists and generally German or American, have examined the economic performance of art. There has been a certain overlap in their methods and conclusions and we need spend time on only two, which together embrace the others' conclusions.

William Baumol, writing in the *American Economic Review* in 1986, studied 640 paintings bought and sold between 1652 and 1961; Bruno Frey and Werner Pommerehne, of the Free University of Berlin, published a discussion paper in 1988 examining the performance of 1,198 paintings between 1635 and 1987. As sources they used Reitlinger, but also auction records in Germany, Switzerland and France. Their results were remarkably similar:

REAL RATE OF RETURN (PERCENT PER YEAR) ON PAINTINGS BETWEEN 1635 AND 1987

	Mean	Median	Minimum	Maximum
Baumol	0.5	0.8	−19	+27
Frey & Pommerehne	1.5	1.8	−19	+26

In fact, as the Frey and Pommerehne paper makes clear, no study of art as investment has ever shown that it outperforms either the stock markets or inflation. Over the period covered by the table above, government securities would have returned 4.2 percent a year, which, when adjusted for inflation, is reduced to 3.2 percent per year. In other words, over this long period, 352 years, art as an investment was slightly less than half as good as government securities. A twist is added to this dismal picture by Frey and Pommerehne, who went on to divide their study into what might be called the past, 1635–1949, and the present, 1950–1987. This is what they found:

REAL RATE OF RETURN (PERCENT PER YEAR) ON PAINTINGS BEFORE AND AFTER 1950

	Mean	Median	Minimum	Maximum
1635–1949	1.4	1.6	−15	+26
1950–1987	1.6	2.0	−19	+16

The differences are small, but the authors feel confident enough of their data to say that investing in art has become *"relatively* more attractive since the second world war," mainly owing to the fact that inflation is now a fact of life, whereas for long periods in the past it was absent. Even so, the figures for the 1950–1987 period are still pretty dismal when compared with long-term securities, which yielded more than 3 percent; even the stock markets, yielding 7.5 percent, come down to 2.5 percent when inflation is taken into account (inflation averaged 0.5 percent in the 1635–1949 period, but averaged 5.2 percent from 1950 to 1987).

Thus, there is still a need to explain why the art boom of recent years has occurred despite such terrible figures. One answer, of course, is that the art market is not, never has been, never will be, and perhaps never *should* be a wholly rational market. Take away the passion for painting or porcelain and you take away the point. Another reason is selective attention; all of us, the press especially, love records, perhaps because they are the only form of good news that gets into the papers these days. But as Robin Duthy's tables show, there are always losers as well as winners, whole areas in the art market where real prices fall. The academics' statistics simply iron out all these differences and give the overall, far-from-flattering picture.

But something else becomes clear in the following table, also from Frey and Pommerehne. They looked at the economic performance of paintings according to the amount of time between transactions.

REAL RATE OF RETURN ACCORDING TO HOLDING PERIODS (PERCENT PER YEAR)

Holding period (years)	Mean	Median	Minimum	Maximum	Standard Deviation
20–39	1.7	2.1	−19	+26	6.3
40–59	1.1	1.3	−12	+13	5.0
60–79	1.1	1.4	−9	+12	4.4
80–99	1.9	1.9	−5	+8	2.8
100–119	1.7	2.0	−3	+6	2.4
120–139	2.2	2.6	−1	+5	1.6
140–159	1.8	2.2	−2	+4	1.9
160–179	1.1	0.8	0	+4	1.3
180–199	—	1.5	+1	+2	—
200–219	—	2.0	+1	+3	—
265	—	—	+2	+2	—

In some ways, this is the most revealing table of all, for what it shows, in effect, is that art may be a poor investment, but that it is and always has been a speculator's market. In the short term the risks are great, but the gains outweigh the losses more than at any other time. I should point out that the conclusions drawn from these tables are mine, and not Frey and Pommerehne's. They did not look at pictures bought and sold within twenty years, a truly speculative time period; had they done so, then, extrapolating from their table, the results might have looked like this:

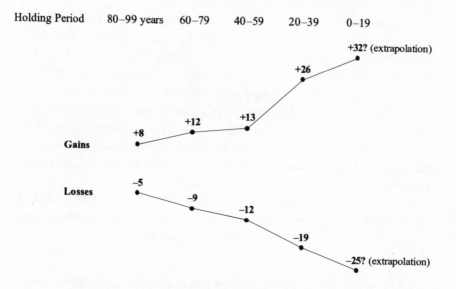

Holding Period 80–99 years 60–79 40–59 20–39 0–19

+32? (extrapolation)

+26

+13
+12
+8
Gains

Losses
–5
–9
–12
–19
–25? (extrapolation)

In other words, in the short term, the risk is greater but so are the rewards, and the shorter the time, the greater the risk and the greater the rewards. Over the last 350 years, painting has been a poor investment unless the pictures were bought and sold within a relatively short time span. For most people, thirty or forty years is quite a long time, especially if you don't begin collecting or investing until you are in your late twenties or early thirties. The fact is, of course, that most people do not buy pictures with their descendants in mind. There are people who buy pictures without any thought of their disposal: we call them collectors, and they may or may not be "investors." But there are also speculators, people who buy with a view to dispersal within the foreseeable future. The point is that throughout history, and not just in the late twentieth century, as Frey and Pommerehne's figures show, works of art have lent themselves to speculation. Put it down to fashion, intellectual fad, the cycles of history—it makes no difference. There is something about art that makes it susceptible to speculation, and the gains marginally out-

weigh the losses. This is not to argue that people do not lose when investing in art, but the figures show that in the short term (20–39 years), the benefits just outweigh the drawbacks—by 7 percent, one in fourteen—and this appears to be enough to keep people buying.

There are three other points to be made. One concerns contemporary art, including American art and the School of Paris pictures discussed by Raymonde Moulin (see above, Chapter 26). We should never forget that by no means all artists whose pictures were bought and sold in the past are bought and sold now and that very often such painters are left out of the reckoning in attempts to calculate the financial performance of art. In other words, there is a whole level of art not good enough to feature at auction at Sotheby's or Christie's.

This helps explain why auction houses have become so popular in recent years. By definition they are public events and therefore legitimizing authorities. A dealer might sell you privately a work by a complete charlatan. An auction sale, on the contrary, is an open process, and that is reassuring to many people.

A final point concerns the misleading nature of auction success. This has been referred to before but bears repeating here, especially in light of the *Sunflowers* sale. The price the picture fetched, £22.5 million ($39.9 million at the time), was spectacular. Yet consider the tax the sellers had to pay, which may have left them with barely £3.5 million. At the end of the day, *Sunflowers* brought a magnificent price and was terrific publicity for Christie's, but for British sellers with a heavy tax liability (which you cannot ignore if you are financially sensible), it was a very poor investment. Bruno Frey and Werner Pommerehne also quote an example that is worth thinking about. The highest real rate of return—around 10 percent per year—they say, "applies to paintings by Cézanne, Gauguin, van Gogh, Manet, Matisse, Monet and Renoir"; the largest losers in financial terms include Sir Lawrence Alma-Tadema, Rosa Bonheur, William Etty, Holman Hunt, Sir Edwin Landseer, Frederick Lord Leighton, Sir John Millais, Sir Henry Raeburn, Sir Joshua Reynolds and Constant Troyon. Frey and Pommerehne overlook the fact, but their lists name no fewer than five painters who were knighted for their art but who turned out to be failures in terms of investment. In other words, if painters flourish during their lifetime, it is obviously harder for their pictures to increase in value afterward, if only because their prices start from a higher level. On the other hand, the work of painters who are unsuccessful in their lifetime may become valuable after their death. (This *was* true; whether it is true now, when buyers are so much more knowledgeable, is difficult to judge.) It is also worth adding that some painters do well both in their lifetime *and* after it. Titian was a rich man, as was Velázquez. Rem-

brandt's genius was recognized, even though he died bankrupt, and Leonardo's pictures, according to documents unearthed in Milan and published in 1991, were valued at his death at the price of a fashionable home in Renaissance Milan—roughly $1 million at today's values.

These are the conclusions I draw from all of the above.

First, in the long term, art as investment performs about half as well as other forms of investment. Since the price of good pictures has never been negligible in real terms, this 50 percent "opportunity cost," as economists call it, is the financial price one pays in order to collect. It is, in short, the price of pleasure. This may also help explain why, historically, relatively few wealthy people have collected.

Second, from time to time throughout the last 350 years there have been "art booms." There was the import boom in Britain in the 1680s, the passion for porcelain in the late eighteenth century, for prints in Gambart's era, for Turner in the late nineteenth century, for *everything* before World War I (the time most analogous to our own day), for eighteenth-century English portraits in the Twenties. Sociologists talk of "moral panics," when a society suddenly reacts en masse to a perceived—and always exaggerated—threat. To an extent, art booms are the reverse of this. The promise, the opportunities, are perceived, and then a collective reaction sets in. This time the promise, rather than the threat, is exaggerated.

Third, since World War II, with inflation at a historic high for many years, art has offered a real rate of return that is better than before. Though the rate is still way below what could be earned elsewhere, it has meant that the cost of collecting has been less than heretofore. With better education, in a society that places much more emphasis on the visual and has a much more efficient system of distributing price information, people have been far more aware of the speculative benefits of art. Auction houses have made the whole art market more accessible than ever before, and people have taken advantage of this—as they were meant to. In other words, I am trying to underline Frey and Pommerehne's evidence that there is, in effect, no money to be made from buying and selling pictures except by selling what you have bought relatively soon. If you wait long enough to eliminate your risk, you eliminate your chance of a profit. Forget "investing" in art. If money is all you are interested in, look upon the art market as a speculator's market. Wait for a boom and then act quickly. This may not be a very attractive position to take, morally or aesthetically, but it is what the evidence suggests.

39 | MANHATTAN TO THE MARAIS: THE REVIVAL OF EUROPE

The spring season of 1989, May and June, was in money terms way above what even November 1988 had been. The highest price was for the aforementioned *Yo Picasso*. Second was Pontormo's *Portrait of Cosimo*, which had hung in the Frick for several years and now went for $35.2 million. But it was one of only four Old Masters in the list of ninety-three works that sold during that season for $1 million or more. This list was itself a measure of salesroom gall; traditionally the auction houses had been, if not reticent, at least tactful about money and art. No more: the times were too good, and the prices totally unprecedented. In the 1988–89 season—that is, the selling period ending in June 1989—Sotheby's and Christie's sold 402 works for more than $1 million. Impressionist and modern paintings led the way, of course, with Gauguin's *Mata Mua*, Monet's *Le Parlement*, Renoir's *La Loge*, even Derain's *Bateaux dans le port*. But art in almost every category was breaking the magic barrier; a Nicholas Brown desk sold for $12.65 million, a fancy pink diamond of 21.06 carats for $6.05 million, a 1975 Aston Martin DBR2 for $3.67 million and a Benin bronze head for $2.08 million.

When, therefore, it was announced in October 1989 that Charles Saatchi had sold up to one hundred paintings from his collection of contemporary works, the art world reacted strongly, for the disposal had much in common with events more than a hundred years before, when, for example, Théodore Duret and Jean-Baptiste Faure had sold their collections and the artists had

felt betrayed. At least one artist criticized Saatchi publicly; Sean Scully, a Dublin-born artist who lived in New York, said he was "horrified" at the way he had been "duped" by Saatchi. The artist claimed that he had sold Saatchi his work only because he "thought it would eventually be left to the nation . . . I thought Saatchi had good intentions. Now it turns out he is only a superdealer [who] used the Tate as a showroom." In response, Saatchi said through a spokesman that he was "rationalising and refining" his collection of six hundred works. This too was disputed because of the number of paintings sold and the fact, for example, that he had sold as many as seventeen paintings by Sigmar Polke, a German artist he had hitherto much admired.

The affair Saatchi rumbled on, with New York dealers accusing him of cashing in on the boom, until in 1990 it became clear that Saatchi and Saatchi, the advertising agency Charles owned with his brother Maurice, was in financial trouble. With the benefit of hindsight one notes two significant aspects of Saatchi's dispersal that were not aired at the time. One was that unlike many American collections, Saatchi's contained contemporary art from several countries, not just from the United States: a good thing. The second was that Saatchi did not at first auction his works but sold them through a New York dealer. That Saatchi should sell via a dealer was not surprising; he wanted secrecy and at first he got it. The art world was thick with rumors for months about his "de-accessioning" before it was finally confirmed. What was more surprising was that he should sell to a relatively new dealer, Larry Gagosian.

It remains true that, despite his undoubtedly extensive collection of contemporary art, Charles Saatchi's place in the art world is not fully resolved or understood. It is still not clear whether he is a collector in the classical sense, an *amateur* who likes to trade on occasion, or a hoarder. There is also a persistent doubt as to whether his former wife, Doris, has the "eye" or they both do.

As a young man, Charles (born in Baghdad in 1943) started collecting *Superman* comics, then jukeboxes. He bought one of the last three Jaguar E-type cars ever made. There certainly appears to be something of the obsessive about him. Both he and Doris were strongly affected by the London Royal Academy exhibition "The New Spirit of Painting" in 1981, which introduced them to many new artists. But the fact that he once allowed the Tate Gallery to use a whole batch of his Schnabels while himself serving on a Tate committee fueled the feeling that he was using his position to improve the reputation of the artists whose pictures he bought. His practice of buying large numbers of works by contemporary artists irrespective of whether they show the development of those painters also suggests that he is a hoarder

rather than a true collector, at least in the old-fashioned sense. Saatchi is clearly someone with a gargantuan appetite for buying art—but maybe his chief fault lies in the fact that he is doing so when, as several critics have noted, there is little great contemporary art to buy.

Outside the auction houses, the New York art market did not change radically in the Eighties, despite the boom. It expanded, of course, but Leo Castelli, Ivan Karp, Paula Cooper, André Emmerich, the Pace Gallery and Mary Boone were all still there. Sidney Janis had retired but still attended auctions (he died in 1989). Rauschenberg had moved to Knoedler, now almost entirely devoted to contemporary art. SoHo was still an important area for galleries; whole warehouses were now taken over by as many as eight dealers. But rising prices had forced many young artists out of the neighborhood, and they migrated to the East Village, a small area between Fourth Avenue and Avenue A, and between Fourteenth Street and Houston Street. In 1983, in the immediate aftermath of the first Wall Street boom, the number of galleries in the East Village could be counted on the fingers of two hands; three years later it was closer to a hundred.

One feature of the East Village was disco art; the name does not refer to a formal movement or school but reflects the fact that the discotheques of the area—the Palladium, Limelight, Arena—displayed both new and familiar artists on their walls. Palladium, run by Steve Rubell and Ian Schrager, commissioned Henry Geldzahler, the former curator of twentieth-century art at the Metropolitan Museum, to organize its opening show. He chose Keith Haring, Kenny Scharf and Jean-Michel Basquiat. Larry Rivers, Andy Warhol and Francesco Clemente also showed works in East Village nightclubs. This was a symptom of the art boom and does not seem to have marked a major change of substance in the market, but it may be too soon to tell.

Among the new dealers in New York, Pat Hearn made a name, collaborating with Castelli. Marketing became more aggressive, as epitomized by Meyer Vaisman, a dealer and artist. He is co-owner of International with Monument, an East Village gallery showing the works of Peter Hallery and Jeff Koons, who had once showed with Mary Boone. Their works, and the East Village in general, have been supported by one of the most influential of the new breed of art advisers, Estelle Schwartz. When interviewed, she was at pains to point out that in many cases avant-garde art had survived in New York because of unexpected economic factors. In the Seventies she wrote for *Cue* magazine, but when it was swallowed up by *New York* she started lecturing and giving art tours of Manhattan to out-of-town suburban wives referred to her by Barbara Guggenheim, another art adviser.

Estelle Schwartz found that these housewives had the time and the capacity and desire to work at understanding difficult art, and they also had some

money—not much but some—to spend on paintings and sculpture. Because of their low budgets, says Schwartz, her classes could afford avant-garde art only and this meant that she and her groups got to know the galleries that bought new work. She says that she and these women were early fans of Richard Prins, David Salle and Julian Schnabel. Over the years, her influence has grown, she says, and now, in addition to being paid by her class, she receives a commission from the galleries when she introduces a collector to them. This is and is not really a new role. It can perhaps more accurately be seen as a modern version of the private dealer, one who has no gallery but has instead a personal following of collectors. It is new in the sense that for Estelle Schwartz's group collecting has become a group activity. Schwartz and others like her appear to play an important role in making avant-garde art—art on the cutting edge, as it is often called—more acceptable more quickly. This is partly for budgetary reasons but it is also because Schwartz's tours-cum-classes are a new kind of art experience. She has survived for more than a decade.

However, the two most recent names in the Manhattan art world are those of the dealers Jeffrey Deitch and Larry Gagosian, the man to whom Charles Saatchi sold his pictures. Like Estelle Schwartz, Deitch calls himself an art adviser, although they are as different as Manet and Monet. The suburbs are not for Deitch, and he has offices in Trump Tower, Manhattan. Art has been his life, but so has money: in this sense he is the quintessential late-twentieth-century figure. He opened his first gallery while still in college in an inn close to the summer home of the Boston Symphony Orchestra, in Lenox, Massachusetts, the original home of Cortlandt Bishop. Deitch recalls being stunned at the numbers and types of people who stopped by the gallery on their way to concerts. "I never dreamed I would have access to such people. It was an amazing social, intellectual and aesthetic experience, and I made a lot of money." After graduating he tried to apprentice himself to Leo Castelli; he failed but was accepted by John Weber, whose gallery was in the same building. Weber was then dealing in Minimal and Conceptual art (Carl Andre, Sol LeWitt, Hans Haacke), and Deitch found that he enjoyed the social side of the art world even more than he had in Lenox. "[Andre] would wake up at three in the afternoon and come to the gallery at five to pick up his mail and make some phone calls. It was an incredible perspective at twenty to meet people and understand how it all worked." But though Deitch may have seemed well launched on a classic gallery career, he soon left New York and entered Harvard Business School. "I wanted to get a firmer conceptual understanding of applied economics, intellectually merge that with my own kind of private and haphazard study of art, then ultimately develop my own unique perspective of art from this new vantage point."

Deitch found Harvard a shock. "My classmates thought the world had stopped in the Fifties. Advanced culture had not yet become the consumer commodity it is today." His case study at Harvard was New York's Whitney Museum, at that time economically weak and the center of much artistic controversy. One of his first papers, delivered to the college art association in 1978, was "Andy Warhol as a Businessman." After Harvard his first job was as director of a small museum in Lincoln, Massachusetts, which he took because he had been struck by the "significant role" small museums have played in Europe. More important for the long term, in the late Seventies he sensed that there was going to be an "intense market for art, something that banks and brokerage houses would want to get involved in." He began contacting corporations to see if anyone shared his view. First he tried Merrill, Lynch, without success, but then Citibank commissioned him to design an art-marketing advisory program. It was not an easy assignment. "It began as a liaison between Sotheby's and Citibank. Sotheby's art-investment scheme was ill-conceived; they thought Citibank could simply channel $300 million in trust and pension funds into the art market." Instead, Deitch developed a more complex service: advice to collectors on market conditions, curatorial matters (condition, need for restoration), how much to pay, how to choose what to buy and so on. But the hard years began to ease, Citibank put Deitch on the payroll "and in 1984–85 we became an important entity in the art market." The loan side of the business also started to take off after Deitch had been approached by the artist Christo, who wanted funds for an enormous project to wrap eleven islands in Biscayne Bay, off Florida. Deitch let him have the money, using Christo's own artwork as security. This extraordinary project was reported in *The Wall Street Journal,* "and new customers began to line up." Ever mindful of his career, Deitch left Citibank at the crest and set up for himself in 1988. He remains on Citibank's payroll as a consultant but also serves as an adviser to clients across the world.

Tall, good-looking, with close-cropped iron-gray hair, Larry Gagosian plays a more traditional role as a dealer in the current Manhattan art market, and is in many ways more typical. He was born into a poor family of Armenian background in Los Angeles, and when he was young the family moved to the San Fernando Valley. "It's a very isolated place to grow up. There's no culture there. I never went to a museum. I didn't know what the art world was." In his teens he moved to the beach, near Venice, California, and after a variety of jobs rented the patio of an old building in Westwood Village, where he sold posters that he had bought at five dollars apiece. "That really launched me as an art dealer. I wasn't buying Lichtensteins, you understand. I really didn't know who he was. I bought corny seascapes and

pretty girls, really forgettable stuff. I framed them and sold them for twenty dollars and I'd move thirty or forty of them a night."

Two years later, in 1977, Gagosian opened his first proper art gallery in a Hungarian restaurant that had just gone out of business. He started with photos by Ralph Gibson, who had shown with Castelli Graphics. Gagosian didn't know much more about Gibson than he knew about Lichtenstein but he called him out of the blue to say that he was opening a gallery and would like to show the photographer's work. The two men got on well over the phone, so Gagosian made his first visit to New York to choose the prints. He liked Manhattan so much that he returned a year later and bought a loft opposite Castelli on West Broadway, paying for the space by trading a painting. Gagosian's timing was perfect. The painters who appealed to him were Brice Marden, Richard Serra, Sol LeWitt, and David Salle. Along with Annina Nosei, he gave Salle his first show, in 1979. He was moving fast, and this gave him a surge of self-confidence. His next move was also a masterpiece of timing or luck. He had rented a new gallery on the ground floor of Sandro Chia's loft building on Twenty-third Street, near the Hudson River, and wanted to open with something eye-catching. Just as he had done with Ralph Gibson, he called up Burton and Emily Tremaine and asked if they would be willing to sell a painting by Brice Marden that he knew belonged to them. They agreed, and he was able to open the new gallery in New York with a selection from their collection.

Since then Gagosian, or Go-Go, as he is called, has maintained his cleverness and his "cold-calling" technique. This has put him in touch with some of the great collectors of contemporary works, among them Peter Brandt, Ronald Lauder, Charles Saatchi, and Samuel (Si) Newhouse. He left Los Angeles and has lived in New York full-time since 1987. Gagosian has an open face and a forceful, even pushy, manner perfectly suited to an entrepreneurial role as a secondary dealer, putting seller and buyer in touch with each other. In many ways he is reminiscent of Duveen; he has the same ability to remember where a work is, to prise it away from its owner (usually by offering more than the owner ever dreamed it was worth), and then to place it in the hands of the one person who really wants it. It was Gagosian who, on November 10, 1988, bid $17.1 million for *False Start* on Si Newhouse's behalf.

Such a rapid rise has not been without its problems. Many of the more private collectors resent being "cold-called." More serious, other dealers claim that he has either reneged on deals or sold paintings of theirs that he had on loan. Again these charges are remarkably similar to those made against Duveen.

Like Knoedler and the AAA before him, Gagosian has moved uptown:

from West Broadway to Twenty-third Street and, most recently, to the very building on Madison Avenue that Sotheby's vacated when it transferred to Seventy-second Street and York Avenue. On Madison Avenue, he has mounted a number of shows that even his critics concede have been impressive: Jackson Pollock's black enamel paintings, Brancusi's sculptures, Lichtenstein's Picasso paintings. He has moved up socially, too; his latest house on the Upper East Side has an indoor pool, a screening room and a steam bath, and he drives four cars, including a rare Ferrarri F40. Perhaps his greatest coup is that he has opened another gallery, on Thompson Street, in partnership with Leo Castelli. In the less heated atmosphere of the Nineties, he says he is now specializing in "barter" arrangements—virtually straight swaps between collectors where little money changes hands and the dealer takes only an introduction fee or commission. Duveen would not have approved of this, but it shows Gagosian's self-confidence and how well he knows his customers.

The fact that the two most recent caliphs in the Manhattan art world are not primary dealers and have made no discoveries underlines what has already been hinted at in these pages: that no significant artist of stature, and certainly no American artist, has emerged in recent years. As a consequence, no new dealer or network of dealers has developed. In fact, in the Nineties the single most important reality in the art world is that New York is no longer the dominant capital that it was from the Sixties to the Eighties. It is still the place where the most happens, still the place where Saatchi sells his collection (or some of it), but other cities are growing in importance.

—

The London market, though still not as interesting or as large as New York's, is busier in 1992 than it has ever been. Leslie Waddington is still the biggest London dealer in modern and contemporary art, with four galleries in Cork Street, a print gallery around the corner in Clifford Street, and a turnover that has reached £80 million. After Waddington, arguably the most commercially successful British dealer is James Kirkman, who operates from home and handles only two British artists, John Piper (who died in 1992) and Lucien Freud. Anthony d'Offay started dealing in modern works in 1962, married Anne Seymour, a curator at the Tate in 1977, and turned to the international avant-garde. In 1980 he opened a gallery in Dering Street with a show of Joseph Beuys, and he has had a higher profile ever since. He now represents, among others, André Baselitz, Willem de Kooning, Gilbert & George, and Anselm Kiefer. The d'Offays now have three galleries in Dering Street.

The new London dealers are perhaps best symbolized by Matthew Flowers

and Nicholas Logsdail. Matthew Flowers is now the managing director of the Angela Flowers gallery, which moved from Tottenham Mews to a much bigger 4,000-square-foot space in Hackney in 1987. The gallery, renamed Flowers East, has kept its largely American clientele and gone public. The stable includes Amanda Faulkner, Patrick Hughes, Nicola Hicks and Michael Rothestein.

Nicholas Logsdail's Lisson Gallery has probably divided London's art world more than any other, with some very controversial shows. The gallery itself is hardly new, having started in the Sixties, but Logsdail came to prominence with his shows of British sculpture by Tony Cragg, Anish Kapoor, Richard Deacon, Edward Allington, Julian Opie and Roland Wentworth.

In the Old Master field, London still retains its preeminence over New York, although Manhattan has David Tunick, probably the world's most flamboyant dealer in Old Master drawings, and Piero Corsini, a Florence-born discoverer of lost Old Masters. Eugene Thaw, one of the few old-fashioned connoisseur-dealers, who is equally at home with Renoir or Raphael, is the New York member of an informal international network of dealers—Ernst Beyeler in Basle, Desmond Corchoran and Martin Summers of Lefèvre in London and Artemis—who often buy art together. Artemis shares premises with David Carritt, whose firm since his death has continued to deal in the best Old Masters. Colnaghi and Agnew are still very active in London, as is Leggatt Brothers. Though it started in 1820 and is almost as old as the other two, its history has not been as distinguished or as colorful.

One area of new blood in London is Harari & Johns. Philip Harari is the son of the late Max Harari, head of Wildenstein in London and the man who helped secure for Sotheby's the Farouk sale. Derek Johns, the son of Ernest Johns, who ran Knoedler in London, started at Sotheby's as a porter but rose to be head of the Old Masters department. The two men each put £30,000 into the business in 1980, and since then Johns has rivaled Piero Corsini as a discoverer of lost Old Masters, uncovering in the space of five years a Carracci, a Canaletto and a Van Dyck. He also sold a picture by Dirk Bouts he discovered to the Getty for $7 million, and in a survey of dealers was said to have the best eye in London.

The all-around best dealer in London, again chosen by his peers, is Giuseppe Eskenazi, whose Oriental gallery in Piccadilly regularly offers museum-quality objects, and whose contacts are the envy of the trade.

In Paris the Faubourg St.-Honoré and rue de Seine galleries continue as before. Elsewhere, however, there has been a major change, prompted by two

politicians (perhaps this could happen only in France). The first was Georges Pompidou, who, as president in 1969, made the historic decision to build a new museum of contemporary art, the Pompidou Center, which opened in 1977. Then in the early Eighties the Socialists under François Mitterrand came into power and put money into museums and contemporary art. At the time, collecting and the art market in France were at a low ebb, and the reason why French galleries have played such a big role in the development of art fairs is that they had to travel to find business. But the advent of the Socialists helped the art trade to recover. The Pompidou Center also played a part, for around it in the Marais area of Paris a new group of galleries grew up in the Eighties. Moreover, new magazines, such as *Eighty* and *Galerie Magazine,* started, and what the French call the "art push" was on.

Today the main French galleries include Daniel Tomplon, Yvon Lambert (close to Castelli), Michael Durand-Dessert, Ghislaine Hussenet and Marianne Nahon. Parisian dealers feel that their collectors are more international in their taste than collectors in New York, but if that is true, it has happened only since 1984 or 1985, when the market really burgeoned in Paris. It was a rapid expansion; for example, Marianne Nahon has seen a three-fold increase in turnover since then. The first wave of contemporary art that was fashionable in this period was the Trans-avant-garde—Palladino, Kuki and Chia from Italy, Baselitz, Kiefer and Penck from Germany, and Combas, Boisrond and di Rosa from France. So great was the pull of Paris in the Eighties that only two galleries outside the capital—Pietro Sparta in Chagny and Roger Pailhas in Marseille—had any following, and foreign dealers, from Cologne's Karsten Greve to Los Angeles's Glabman-Ring, opened branches in the capital. In fact the Marais has now become so fashionable and so packed with secondary dealers (almost a term of abuse in the Marais) that dealers in Paris are moving to the Bastille area. Durand-Dessert is only one of several well-known galleries that have made this transition.

The other main feature of the Paris art market has been the revived fortunes of its auction houses. This has stemmed chiefly from the activities of two men, Guy Loudmer and Jean-Louis Picard. The auction business has been so dominated by Anglo-Saxons that it is difficult to believe, as Picard claims, that until about 1954 Étienne Ader's salesroom in Paris grossed more than any other auction house in the world. At the time the local market in France was so strong that its auction houses had no need to expand overseas. However, while Christie's and Sotheby's were expanding in the Sixties and thereafter, the French houses slipped badly because they were crippled by higher commissions, the collapse of collecting following the devaluation of the franc, the fall of the School of Paris, and an old-fashioned system that

produced more and more mixed sales at a time when the market wanted increased specialization.

In the 1950s, Loudmer, of Russian ancestry, bought into the business of Alphonse Bellier, the third biggest *commissaire-priseur* in Paris at the time (after Lair-Dubereuil, which in 1933–34 became Ader; and Beaudouin) and famous as the man who conducted the Kahnweiler sales. In the Fifties and Sixties, hampered by higher commissions, which meant less business, the Paris auction houses, Loudmer says, were not very profitable. Also, the fact that the French system prohibited Parisian auctioneers from operating in other French cities curtailed their profits further. But Loudmer and Ader have gradually changed the rules. As of a meeting held in 1991, the geographical boundaries are to be broken up. Until then Loudmer or Ader could not operate in Bordeaux, for instance; the best they could do was to advertise that they would see clients in a room at the British consulate, which was British territory and outside French jurisdiction. Both auction houses gradually became more specialized. Loudmer, who has twenty employees, specializes in modern art, primitive art, twentieth-century rare books, Judaica and twentieth-century sculpture. But he can and does employ other experts—John Rewald on Cézanne, Philip Brame on Degas—when he needs them. He has recently created a wine department.

Ader, Picard & Tajan is bigger, with seventy employees and specialists across the board. Picard was employed by Étienne Ader as a young man, working on the inventory of Countess Greffulhe, a model for Proust's Madame de Guermantes. He recalls that she had an enormous house in the place St.-Augustin, with ninety rooms full of furniture and objets d'art. After two and a half years in the navy, he took the auctioneering exam and in 1964 became the youngest auctioneer in France, working alone with one secretary. One day, while conducting an auction in the suburbs of Paris, he received a phone call during the sale. "I couldn't take it. It would be like a priest taking a phone call during mass. But I asked who it was." It was Étienne Ader. This was like God calling the priest during mass, and he accepted the call. Ader was not well and wanted Picard to take over immediately. It was a fantastic opportunity; even so, Picard's wits did not desert him. With the audience in the room listening to his end of the conversation, he argued with Ader. "Étienne," he said, "I am young and have to promote my own name." Ader took the hint and suggested that they become Ader Picard. As Jean-Louis now puts it, "One day I was the last auctioneer in France; the next I was . . . not the last." Ader Picard & Tajan (Jacques Tajan joined the firm in 1972) maintained its position as having the largest volume in the country until the partners split in early 1992 in a much-publicized disagreement. Picard says that the Japanese presence has been a force in Paris longer than elsewhere;

Japanese art has always been popular there, and French art, especially Marie Laurencin, has been popular among the Japanese. He knows the Japanese media well and has long advertised in them.

The growth of the art trade in France in the Eighties is shown by Ader Picard & Tajan's turnover, which rose from 35 million French francs in 1985 to 474 million in 1989. During these years the Impressionists and the modern art market has, Picard says, paralleled what happened at Christie's: "It was 13 percent of our turnover in 1985 and 41 percent in 1989." Ader Picard & Tajan's gross was third in the world in 1991, after Sotheby's and Christie's and ahead of Phillips or the German houses. In other ways, however, it was ahead even of Christie's: it opened a New York office in 1973 and started branches in Tokyo, Lausanne and Monaco in 1979, and in Brussels in 1988. Picard believes that one future strength of Paris, and Belgium, will be tribal art. Both countries posted politicians and diplomats all over Africa, "and we are now beginning to see the richness of what they brought back." He also thinks that the artists of Eastern Europe are more likely to decamp to Paris instead of London or New York. He foresaw that in France there would be a trend away from furniture and toward modern paintings. "Apartments are less ambitious, and grand furniture doesn't fit. The culture of today's youth is visual but less and less developed. Pop Art was the watershed. Many people are simply not at ease with art before the Fifties. Modern painting is a logical product of many cultures—Japan, Africa, Oceania, American Indians. Together they make a kind of visual Esperanto. . . . In the Fifties our customers were French, British and Americans. Now they are as likely to be Lebanese, Iranians, and new money from America—people who want 'gold before old,' as we say. Furniture dealers have suffered more than anyone else in the French art market since the war."

At times the art market seems to be so proud of itself as an international entity that it is easy to overlook the strength and importance of local markets. This is especially true in France, where the expert, an animal extinct elsewhere, continues to thrive. A good case in point is the diminutive Eric Turquin, who gave up his post as Sotheby's head of Old Masters to return to Paris and start his own firm in the rue de l'Université on the Left Bank. Turquin is an "authority" on Old Masters, but "expert" means both more and less than this term. Ninety-five percent of Turquin's business is dealing with French auction houses, but not merely with Loudmer or Ader Picard & Tajan, for he deals with salesrooms all over France. His duties fall into three areas. First, he drums up business. Second, he produces catalogues for the sales of the auction houses. This is particularly important in France, since the old law still applies and all works of art sold at auction are guaranteed as genuine. Third, and unique to France, his gallery and those of other experts

like him in Paris are used to show Old Masters coming up for sale at salesrooms all over the country. Thus collectors and dealers from other areas of the country or from abroad can use Turquin's premises as a central viewing point. In short, Paris and the French system have a lot of special virtues, which means it is far from certain that when the European Economic Community harmonizes its laws in 1993, the large Anglo-Saxon auction houses will trample all over the smaller competition.

——

A survey of the Italian art trade, published by *Censis* in 1991, shows a surprisingly small expansion compared with that in other countries. The number of art dealers rose in the decade by just 75 throughout the country, an increase of 4.3 percent, to 1,793, and antique dealers increased by 283, up 9 percent, to 3,400. In strong contrast, the overall auction business rose by 44 percent, with two Italian houses, Finarte and Semenzato, outpacing Christie's and Sotheby's. These rankings reflect the strong local market in Italy. The country's strict laws regarding the export of art objects were also highlighted by *Censis*'s survey, which reported a 32 percent jump during the decade in the theft of paintings and a staggering 229 percent increase in the theft of archaeological objects. Italy's fierce laws against the export of artworks have prevented the establishment of a strong international market there. But Italian dealers are a prominent factor in salesrooms in the rest of the world.

——

The other main international art-dealing network at the moment is the Swiss-Germanic one, a sort of rectangle that links Zurich, Basel, Cologne and Stuttgart. The main dealers on this circuit are Thomas Ammann and Bruno Bischofberger in Zurich, Ernst Beyeler in Basel, Karsten Greve in Stuttgart and Rudolf Zwirner in Cologne. The Raab Gallery in Berlin might also be included. But though they form a loose network, in some ways the Swiss and the Germans are very different. Ernst Beyeler has been a leader of taste in Europe; it was he, for instance, who was first convinced that Rauschenberg was a modern master, the equivalent of the Impressionists, and he exerted a big influence on other European dealers. For some years German dealers did not make as much impact outside their country as they should have, one reason for this being that many of their countrymen, according to the Munich furniture and tapestries dealer George Bernheimer, preferred to travel to buy their art. Bernheimer himself opened a second gallery in London rather than in Germany. The reunification of the country has introduced

a new element. Sotheby's opened an office in Berlin in 1990 and held its first auction there a year later.

Switzerland acts as home to many rich collectors who are not Swiss, which is why Sotheby's and Christie's have for long held their jewelry sales there, and why Zurich is usually a stop on the presale itinerary of any great painting being auctioned. A dealer typical of this part of the market is Thomas Ammann of Zurich (see figure 84). Born in 1950 in the Appenzell area of Switzerland, Ammann always wanted to be a painter and spent his youth copying van Gogh, his favorite. However, he realized that he did not have much talent and started dealing. First he tried furniture and the works of Lemmler, an early-nineteenth-century Expressionist painter. Thrown out of school at about seventeen, Ammann met Bruno Bischofberger, and through him was able to open a gallery selling Swiss naïve art in Zurich (mainly pictures of cows and mountains). This taught him the business, but within eighteen months he was back in Bishofberger's main gallery dealing in contemporary art. This time he stayed for six years, until he was approached by someone who offered to be a silent partner in a gallery run by Ammann. It prospered, and after five years he bought out his partner. In fact the gallery did so well that in 1984, when Ammann was still only thirty-four, he went public.

Ammann's tastes now conform almost exactly to those of his clients. About 20 percent of the time he deals in Impressionists ("the great pictures are harder and harder to find"), and the rest is devoted to twentieth-century art. (He has an extensive private collection of Warhol and Twombly.) In winter he rents the Aga Khan's former chalet for the season in Gstaad and fills it with his paintings. Guests, who range from the designer Valentino to the Goulandrises, drop in and out, and the pictures are there to be bought if they like them. His biggest deal of recent years was the sale of van Gogh's *Portrait of Postman Roulin* to the Museum of Modern Art. Ammann headed a syndicate of dealers in a transaction involving both money and a part-exchange of other paintings. Simply getting a picture of this stature and keeping it away from an auction house was a triumph. Surprisingly, he never even considered Japan as a place to sell it.

Ammann attributes the art boom to *Sunflowers*. "Eight years ago at dinner, there was very little art talk, but now every New Jersey housewife is an art dealer. It's so hard to find good Impressionists that contemporary art naturally becomes the most exciting area. After New York, Cologne is the best city, but there's really no one gallery that stands out. All the artists there are in debt to Beuys or Sigmar Polke. . . . Oddly enough, I think Taubman has changed the market more than Peter Wilson did. I hate speculators in the

art market as much as the next man, but you have to understand that a large number of them turn into collectors. They can't help themselves. I think both Wilson and Taubman understood this, but Taubman did more about it. By 1989, however, it was beginning to get out of hand. Before then there had been a certain agreement on prices, but not anymore."

Ammann was referring to the autumn season of 1989, the period between the end of October and the middle of December, when the art market finally ran out of superlatives. Everybody in the art trade was at the sales—the Japanese, Europeans and Americans—and they spent money as it had never been spent before and may never be spent again. It was a billion-dollar binge.

40 | CLIMAX: THE
BILLION-DOLLAR BINGE

The binge (there can be no other word) began on October 18, 1989, with the Dorrance sale. John T. Dorrance, Jr., was the son of the founder of the Campbell's Soup Company and its chairman for twenty-two years. He had collected for several decades, buying at least half his collection from the Acquavella Galleries in New York. At his death in 1989, Dorrance was also president of the board of the Philadelphia Museum of Art. His house and its grounds outside the city were full of sculpture, furniture, ceramics and silver. At the center of the collection, however, was a group of Impressionist, Post-Impressionist and modern pictures which linked the 1860s to the 1920s—Fantin-Latour through Manet, to Picasso and Matisse—which were to be sold.

A season has never had a better send-off. The pictures included Matisse's *Femme avec l'ombrelle rouge, assise de profil,* Monet's *Meules, effet de neige, le matin,* Picasso's *Au Moulin Rouge* and van Gogh's *L'Homme est à mer.* In all there were six Monets, four Pissarros, three Sisleys, three Bonnards, two paintings by Picasso, Renoir and Cézanne and one each by Fantin-Latour, Matisse and Gauguin. Amazingly, all of these pictures, plus two others, sold on that Wednesday for $1 million or more, the Matisse fetching $12,375,000 and the Monet for $8,525,000. The whole collection, sold over three days and including Old Masters and furniture, totaled $131 million, the highest price ever for a single collection. This was thanks in part to Aska International, the

Japanese dealers, who spent $25 million. It was now exactly two years since the stock-market crash in October 1987, and as if to prove its virility and independence from other economic factors, the art market now embarked on a roller-coaster ride that is no less extraordinary in retrospect than it was at the time.

In that remarkable autumn, million-dollar pictures were almost as common as scandals on Wall Street, which was riding a roller coaster of its own. At the sales of nineteenth-century art a week after the Dorrance auction, four pictures made the magic $1 million, and another three did so in the Old Master sale two days later. On November 7 and 8 came the contemporary sales. Christie's auction included Robert B. Mayer's collection, and that night thirty-six artists' records were broken, thirteen pictures sold for $1 million or more—a Francis Bacon going for $5.72 million—and the total for the evening was $83 million. The sale the following night at Sotheby's did not break as many records—only twelve—but the new ones that were established counted for more. For example, lot sixteen, Willem de Kooning's *Interchange,* was estimated in the catalogue at $4–6 million, but at $1.7 million, a voice suddenly cried out "Six million dollars!" John Marion, the auctioneer, frowned, then smiled. Was auction history being made? The drama did not end there. The next bid should have been $6.2 million, but now another collector, this one on the phone, went straight to $7 million. Thereafter the bidding settled down, with just these two competitors edging each other up to $15.8 million. They were Mr. Bo Alveryd, a bearded Swedish art investor who resembles the lugubrious heroes in the films of Ingmar Bergman, and Shigeki Kameyama, Mr. Mountain Tortoise himself. At $15.8 million the bidding jumped again, to $17 million. This was a mistake, however, and John Marion recognized it as such, so the bidding came down to $16 million. Then at $16.8 million the bidding jumped a fourth time, to $18 million. Kameyama simply wasn't paying attention, and again he was corrected. Of course he won in the end. With the buyer's premium, Kameyama bought his de Kooning for $20.9 million, a world record for a work by a living artist.

The same night eighteen other works went for more than a million dollars, including Jasper Johns's *Two Flags* ($12.1 million), Stella's *Tomlinson Court Park (2nd Version)* ($5.06 million), and Rothko's *Black Area in Reds* ($3,520,000).

All this was sensational enough, but on the following Sunday the art market began its most extraordinary month. On twenty-five of the next thirty-four days, somewhere in the world a sale was held in which paintings or other art objects worth more than a million dollars were sold. Here is the record of that remarkable period:

Date	Type of Art	Location	Number of Objects Fetching $1 Million
12 November	Impressionist and Modern	Hapsburg Feldman New York	5
13 November	Impressionist and Modern	Christie's New York	7
14 November	19th-century and contemporary	Christie's New York	47
15 November	Impressionist and modern	Sotheby's New York	52
16 November	Impressionist and modern	Sotheby's New York	6
17 November	Old Masters	Christie's London	5
18 November	Impressionist and modern	Ader, Picard, Tajan Paris	4
19 November	Impressionist and modern	Loudmer Paris	1
20 November	Impressionist and modern	Drouot Paris	3
21 November	Contemporary	Drouot Paris	5
22 November	19th-century	Sotheby's London	1
24 November	Impressionist and modern	Berlin	2
27 November	Impressionist and modern	Christie's London	24
28 November	Impressionist, modern and American art	Sotheby's London and New York	27
29 November	Impressionist and modern	Christie's London	2
30 November	Impressionist and modern	Paris	5
1 December	Old Masters	Sotheby's Monaco	5
2 December	19th-century	Christie's Monaco	2
3 December	19th-century	Sotheby's Monaco	2
6 December	Old Masters	Sotheby's London	10

Date	Type of Art	Location	Number of Objects Fetching $1 Million
7 December	Contemporary	Christie's New York	3
8 December	Old Masters	Christie's London	6
11 December	Old Masters	Drouot Paris	1
12 December	Old Masters	Ader, Picard, Tajan Paris	1
15 December	Impressionist and modern	Drouot Paris	2

The table shows that there were two other peaks after the contemporary sales; on November 14 and 15 in New York, and on November 27 and 28 in London and New York. One million dollars wasn't out of the ordinary at these sales; well over half the pictures were estimated in seven figures. Indeed, Christie's sold thirteen pictures for over $5 million, and Sotheby's fourteen. Christie's top offering was Manet's *La Rue Mosnier aux drapeaux,* painted in 1878, which came from the collection of Mr. and Mrs. Paul Mellon. Actually, half of their pictures did not sell that week, mainly because they had placed such high estimates on them, but the Manet, at $26.4 million, and everything else, went through the roof. Van Gogh's *Le Vieil If* (1888) fetched $20.35 million and Renoir's *La Liseuse* brought $14.3 million. The art world was awash with talk of the high prices, and all eyes were on Sotheby's the next night. The cover of *Time* that week was given over to Picasso's *Au Lapin Agile,* which was to be sold by Sotheby's. Both historically and aesthetically this was a very important painting. Sold by Linda Roulet, the sister of the man who had sold *Irises,* it showed Picasso himself dressed as a harlequin, with Germaine Pichot, one of the three models Picasso and his young artist friends Casagemas and Pallarès had met soon after their arrival in Paris. Casagemas fell deeply in love with Germaine, but the affair was so one-sided that he committed suicide in February 1901. Picasso was deeply affected and painted *Au Lapin Agile* four years later.

In French art the clown or harlequin has a long tradition, from Gillot to Watteau, Daumier, Degas, Seurat, Toulouse-Lautrec and Cézanne. For Picasso, however, the spectacle interested him less than the offstage private life. In *Lapin,* as in *Jeune acrobate,* the artist is in a somber mood; he himself is shown brooding but estranged from Germaine, who stands next to him at the bar. We know the bar is the Lapin Agile because Frédé Gérard, the

owner, is strumming a guitar in the background. Picasso gave him the picture, and contemporary photographs of the bar, which was the haunt of Cocteau, Max Jacob, Suzanne Valadon, Marie Laurencin, Apollinaire and Modigliani as well as Picasso, show the picture hanging on the back wall. Technically it was painted at the time that Picasso's Blue period merged into his Rose period. More important, however, the handling of the paint looks forward to *Les Desmoiselles d'Avignon,* painted only two years later.

Au Lapin Agile headed an extraordinary flock of Picassos that were sold that week. There was *Le Miroir,* estimated at $20–30 million. This was interesting too, for although it was not fully abstract, it was the first important work executed after his Blue and Rose periods to come onto the market. In addition there were three other Picassos valued at $15 million or more, and six at $2 million–plus. In all, Picassos valued at $155 million were sold that week, and they did not disappoint. *Au Lapin Agile* went for $40.7 million, and *Le Miroir* for $26.4 million, bought by Shigeki Kameyama, three other Picassos beat $15 million, and works by Gauguin, Mondrian, Miró, Bonnard and de Chirico all sold for more than $5 million.

After exertions of this nature, the art market might have been expected to take a break, but not in the month of the binge. The next day, in Sotheby's sale of less important Impressionists, six topped $1 million. The day after, in London, at Christie's sale of Old Masters, a portrait by John Zoffany, *John, the 14th Lord Willoughby de Broke,* sold for $4,866,400, together with four others which broke the $1 million mark. That weekend, Paris showed that it was not to be left out; five works beat $1 million, including Matisse's *Odalisque au fauteuil, Nice,* which fetched $4,594,800 at Ader, Picard & Tajan.

The London sales of Impressionist and modern works were only marginally less impressive than those in New York. Christie's sold twenty-four works above $1 million, the stars of which were Cézanne's *Pommes et serviettes* at $17.16 million, Léger's *Contraste de formes,* at $14,586,000, and Picasso's *La Maternité* at $11,154,000. The following night Sotheby's responded with twenty-seven works above $1 million, including Monet's *Le Bassin aux nymphéas* at $8,980,400, Modigliani's *Filette au tablier noir,* at $7,944,200, and Gauguin's *Petit Breton à l'Oie,* at $6,908,000. Everywhere one turned, records were being broken. But it was in Paris and Tokyo, on the last day of this golden month, that the biggest surprise came.

In terms of turnover and publicity, the French firm of auctioneers owned by Jean-Claude Binoche and Antoine Godeau was third, behind Ader Picard & Tajan and Guy Loudmer. But like the other two, they were not slow to exploit the Japanese market, and like Loudmer, they make use of a clever Japanese dealer, Susumu Yamamoto, president of Tokyo's Fujii Television Gallery, one of the most Westernized in Tokyo. Yamamoto began in Osaka

in 1957 at the Fujikawa Gallery. This was at the time of currency controls, and if one was dealing in Western art, simply staying in business in those days was an achievement. In 1969 he went to work for Nobutaka Shikanai, a collector and chairman of the Fujisankei Communications Group, which has a well-known open-air gallery and sculpture park in Hakone. Later, Shikanai suggested opening an art gallery, which Yamamoto began running in 1970. Like Kazuo Fujii, Yamamoto at first found Western dealers condescending, if not downright fraudulent in trying to pass off bad work. Gradually, however, he became known in the West as someone with a good eye and he earned the respect of the American and European trade. So much so that in 1988 he joined forces with Guy Loudmer for the first simultaneous transmission to Japan—not just Tokyo, but five cities—of Loudmer's important Paris auctions. There have since been about a dozen of these, the most famous of which turned out to be one devised by Yamamoto not for Loudmer, but for Binoche-Godeau, on November 30, 1989. Yamamoto can claim much of the credit for familiarizing the Japanese with Western methods, and for familiarizing Westerners with Japanese customs. (At auctions, for instance, most Japanese are agents' agents, since principals and dealers want to remain anonymous for tax reasons. Also, the Japanese actually *prefer* the French auction system because of the guarantees it brings with it.) Yamamoto realized the need for education after a survey had shown that even in 1988, 60 percent of the forty best-established Tokyo dealers had never attended a Western auction.

Binoche-Godeau's star in Paris, like Sotheby's in New York and Christie's in London, was a Picasso, *Les Noces de Pierrette*. Like *Au Lapin Agile,* this was a 1905 painting, and moody in a similar way. Owned by the Swedish financier Frederick Roos, it was allowed to leave France only in exchange for his donation to the Louvre of another Picasso, the Blue period *La Célestine.* The bidding took four minutes, across ten thousand miles, and in the end was a triumph of technology, for the picture was not only bought over the telephone, via satellite from Japan, but was purchased by someone who was throwing a party at the time. Tomonori Tsurumaki, forty-six in 1989, was giving a party for five hundred people at a Tokyo hotel when he made his winning bid. This may account for the fact that he paid an incredible price, one that put *Lapin, Le Miroir* and *Maternité* in the shade. *Les Noces de Pierrette* cost him 300 million francs, or $51,660,000, second in price only to *Irises.*

Tsurumaki's enormous purchase not only drew attention to him but also provoked criticism from museum curators in his country, on the grounds that not even Japanese museums could compete with private collectors, and that these buyers were purchasing only Impressionist and modern masters,

thereby neglecting Japanese art. This was similar to the criticism leveled in the United States, where Robert Hughes, the art critic for *Time,* drew attention to the fact that the Metropolitan Museum had seen fit to change the heading in its annual report from "Notable Acquisitions" to "Recent Acquisitions," suggesting that in the United States as well, museums could no longer outbid wealthy collectors for the most "notable" works. This had an important effect on the art market, particularly in the United States and Japan, where museums are still building collections. (However, the criticism in Japan overlooked the point that *Les Noces de Pierrette* had, in effect, been "bought" by the donation of another Picasso to a museum.) Elsewhere in the trade there was some concern about how Japanese aesthetics were affecting the market: although the Japanese did buy the most expensive, sophisticated and important paintings, they also paid too much for works regarded in the West as poor or atypical—that is, sketches, studies and experiments that were considered failures by the artists themselves. This looked like a new aesthetic rather than carelessness. In retrospect, there was a quite different reason for it, as discussed in the following chapter.

Paris-Tokyo and *Les Noces* was followed on the very next day by Monaco and its Old Master sales. Over three days, nine works sold for more than $1 million, the most spectacular of which was Francesco Guardi's *View of the Giudecca Canal,* from the collection of the late Martine, Comtesse de Béhague, which went for $15,341,463. But still the season and the excitement were not over. On December 6, in London, Sotheby's sold the collection of Old Masters that had belonged to Joseph Benjamin Robinson, a pioneer in South Africa, who had kept his pictures in London and in 1923 had instructed Christie's to sell them. On the eve of that sale, he returned to Britain for a last look and fell for them all over again. At his death, the pictures passed to his daughter, Ida, Princess Labia, but after she died it proved impossible to keep the collection intact and they were at last sold, this time at Sotheby's. Although few of them were by famous artists, they had not been on the market for decades and ten of them reached the million-dollar mark. The highest price, $7,994,800, was for Bartolommeo di Giovanni's *The Argonauts in Colchis*; then came the Master of 1487's *The Departure of the Argonauts,* which brought $7,150,000.

Paintings, drawings and sculpture led the way in that incredible autumn, but there were other spectacular sales as well. In books the first notable sale was of the library of Henry Myron Blackmer II, an American who had made his home in Greece and had formed an unrivaled collection of books about the eastern Mediterranean. It consisted of watercolors, accounts of voyages by travelers to that part of the world and diplomatic memoirs—a specialist library, but one with breadth and depth. In all it went for $13 million. But

this was overshadowed on November 9 and 10 when the Garden Collection was sold in New York. Conceived by Haven O'More and funded by Michael Davis, both of Cambridge, Massachusetts, The Garden Ltd. "had as its goal nothing less than to illustrate the whole history of ideas by gathering together the world's greatest and most influential books, in their first and finest forms." The auction consisted of 309 lots, ranging from a Japanese sutra dated A.D. 730 to Albert Camus's corrected proofs of *The Plague*. The star was a complete set of the four Shakespeare folios, which went for $2.09 million to a New York collector bidding against a Japanese. The entire collection sold for $16.22 million. A week later the George Abrams collection of books printed in the fifteenth and sixteenth centuries was sold for $10.7 million; the highlights were Boccaccio's *De claris mulieribus* (1473), Cicero's *De officiis* (c. 1464) and Balbus's *Catholicon* (?1475). A few days later the autograph manuscript of Robert Schumann's piano concerto in A minor (Op. 54) was auctioned in London. The work is possibly the most popular piano concerto after Beethoven's, and this copy was almost entirely in the composer's hand. It fetched $1,640,000.

After the Dorrance sale, but before The Garden, Sotheby's held the Patiño jewelry sale. Luz Mila Patiño, Countess du Boisrouvray, was the youngest daughter of the legendary Bolivian tin millionaire Simón Patiño. He and his son-in-law were passionate collectors of gems—above all, emeralds, for which South America is famous. Though robbed of her own jewels in Paris one day, Luz inherited her mother's, and her husband, Guy, gave her many more. The Patiño jewels were very formal; the couple always dressed for dinner, even when alone. At the sale, on October 26, 1989, the star was a 32.08-carat ruby, mounted as a ring with two diamonds, fashioned by Chaumet of Paris. It fetched $4,620,000. A ruby-and-diamond pendant-brooch necklace by Van Cleef and Arpels went for $3,080,000, as did an emerald-and-diamond necklace made by Cartier of London in 1937. Two other lots broke the million-dollar barrier and the whole sale totaled $17 million.

━

Across the world in Hong Kong the binge continued. In its sale of Chinese art held on November 14, the same day that Christie's in New York was auctioning Manet's *La Rue Mosnier aux drapeaux*, Sotheby's sold an imperial *famille-rose* cup 3.125 inches in diameter, of the Yongzheng period and mark, for $2,112,676. A 16.5-inch vase of the same period went for $1,549,296, a Ming blue-and-white dish from the early fifteenth century went for $1,436,620. The next day, the day that Picasso's *Au Lapin Agile* sold in New York, a pair of jadeite bangles just over 2.5 inches in diameter from the

late Qing dynasty fetched $1,577,465, and a day later a pair of jadeite *Meiren* (female figures), 17 inches high, brought $2,183,099.

In New York, on December 6, *Ten Views of a Fantastic Rock* by Wu Bin, a hand-scroll of ink on paper, "each view of the rock inscribed by Mi Wanzhong, the owner of the rock," dated 1610, went for $1,210,000.

The British Rail Pension Fund brought up the rear. On December 12 a *soucari* glazed pottery figure of a caparisoned Feregham horse of the Tang dynasty sold for $6,133,600, and a bronze ritual wine vessel and cover from the twelfth to eleventh century B.C.—a *fangyi* from the Shang dynasty—went for $1,172,600.

Whether one was exhilarated or disturbed by the prices fetched in almost every category, the November binge of 1989 was impressive. Sotheby's New York office produced a document that, in its way, is as historic as anything in the history of the art market. Known as "The Million-Dollar List," it is twenty pages long and reveals that 58 works sold for more than $5 million, and 305 for more than a million during this single month. Picassos worth $377 million changed hands, and during the season Aska spent $122.3 million at Christie's, Sotheby's and Habsburg Feldman. However, despite these record levels, some people claimed to see a downturn in the market; the Japanese especially, it was said, were becoming more selective. Still, everybody agreed that it had been a record season and would remain unbeaten for some time. Maybe for all time.

However, Christopher Burge of Christie's knew something that almost no one else did. As he left for his Christmas vacation, he packed a draft press release into his briefcase. It concerned the sale of Vincent van Gogh's *Portrait of Dr. Gachet.*

41 | ANTICLIMAX:
THE ART OF *ZAITEKU*

▬

The long-predicted break in the bull run of the art market was nowhere near as clear-cut as had been expected. For example, at the end of April 1990, when the world's stock markets were already showing signs of trouble, Sotheby's and William Acquavella, a New York dealer in nineteenth- and twentieth-century art, announced one of the biggest deals of all time. Together, they acquired the estate of Pierre Matisse, who had died the previous August, for a massive $142.8 million. The Matisse Gallery's inventory included 2,300 works by Miró, Giacometti, Dubuffet, Chagall and Tanguy. There was some doubt expressed by rival members of the trade as to how many "great" Mirós Matisse had left, but in general there was admiration for the deal.

Acquavella's father, Nicholas, had founded his gallery in 1921, dealing mainly in Old Masters and eventually acquiring the old Duveen building at 18 East Seventy-ninth Street. William, the son, who entered the business in the Sixties, preferred modern pictures and eventually counted Henry Ford II, Paul Mellon and Walter Annenberg among his collectors. In 1965, Aqcuavella made his first coup when he bought twenty-two paintings from the estate of Paul Bonnard.

Acquavella's plan, and Sotheby's, was to sell only a small portion of the Matisse pictures at auction and to "place" the others around the world in a selling process that was scheduled to last five years. The economic downturn

that occurred after the spring of 1990 will not have helped this project, but perhaps its most significant aspect was that it involved Sotheby's in acquiring inventory. Back in 1983, the fact that Sotheby's had no need for inventory had been one of the things that attracted Alfred Taubman to the company (see above, Chapter 32). It must have been bitterly ironic for him that at the precise moment he *did* acquire some inventory the economy headed down. This was becoming clear within a month of the announcement of the Matisse deal.

As noted at the beginning of this book, the sales of May 1990 featured paintings that sold for prices that put all previous records in the shade: $82.5 million for van Gogh's *Portrait of Dr. Gachet* and $78.1 million for Renoir's *Au Moulin de la Galette.* At the same time, the month was worrying because the percentage of objects that did not meet their reserve price was increasing. There were still firecrackers, but overall the market was cooling, and everyone could feel it. As also noted in Chapter 1, the trouble had begun as early as February, when the Tokyo stock market fell by 2,569 points, 6.9 percent down for the week and its steepest fall since October 1987. The Tokyo slump was echoed in Taiwan, and this was immediately followed by a sale of contemporary Russian art in London in which 76 percent of the lots were unsold. Admittedly this was a special case, a single-owner collection about which there had been allegations that forged pictures were being offered for sale privately. But soon after came the news that Alan Bond had sold *Irises* to the Getty Museum for an undisclosed sum, which virtually ensured that he had taken a loss.

At the beginning of May in New York the contemporary auction at Christie's fell $10 million below the firm's worst expectations ($50 million), and twenty-six of the seventy-seven pictures failed to sell. At the Sotheby's sale two nights later, thirty-three out of eighty-seven works did not meet their reserve, and the total of $55.9 million was well short of the expected $87–113 million. Yet the news wasn't all bad; at the same time ten artists' records were set. Sotheby's stock went down (though Christie's didn't) and worries intensified after Habsburg-Feldman's dismal sale the evening before the *Dr. Gachet* auction, when 85 percent of the paintings were bought in. Suddenly November 1989, the month of the great binge, seemed a long way off.

The Impressionist sales, which included *Gachet* at Christie's and *Galette* at Sotheby's, produced mixed results; there was quite a high unsold rate, but overall totals were still high. For example, the Sotheby's auction totaled $286.2 million, a record for any sale and more than the total for its department during the whole of the calendar year of 1987.

In retrospect May 1990 was the last point when the good news outweighed the bad, enabling Sotheby's to report a record year for 1989–90, with total

sales of $3.3 billion, up by 39 percent over the year before, but still hollow-sounding in view of the recent failures. Sotheby's press release put it this way: ". . . a three-day series of Impressionist and Modern auctions . . . brought $426.4 million (£253.8 million), a 13-fold increase from the $32.4 million achieved for the same series of auctions five years ago, and 67 per cent over the same series the previous year. . . . Sotheby's auctioned 367 works world-wide for over $1 million, significantly more than the 258 works which sold for over $1 million in 1988–89. Fifty-six works sold for over $5 million each, nineteen works brought over $10 million and five over $20 million." There were also signs of fresh blood in the market. In September 1990, in the Peacock Room of Tokyo's Imperial Hotel, Tatsuo Hirano held Japan's first Western-style public auction. Nearly 1,200 people turned out for the event, organized by the Shinwa Company, owned by Hirano and four other dealers. They saw art worth $41 million change hands, with 20 percent selling above the estimate.

These developments made news, but so did others whose message was far less optimistic. At the sales of contemporary art that autumn, a year after the binge, works by Dubuffet, Warhol, Schnabel and Stella all went unsold. Stories began to appear in Japan about companies using art for financial skulduggery, in effect using false valuations of paintings to shift money around in order to avoid taxes. The invasion of Kuwait by Iraq crowned everything. The tide was going out, and just how fast was revealed in December 1990, when the auction houses released their figures. Sotheby's reported a 17.5 percent decrease from the previous year but pointed out that although Impressionist and modern works had not done well, books and manuscripts, antiquities and tribal and ethnic art had held their own. They also ascribed the decline in part to the absence of single-owner collections and the publicity they always bring. Single-owner collections would not have made much difference, however, for the autumn figures, lacking a *Gachet* or *Galette* to boost them, were significantly worse. Sales dropped at Sotheby's by 50.2 percent, and at Christie's by 50 percent if measured in sterling, 39 percent if in U.S. dollars. Sotheby's even reported a loss for the last quarter of 1990, but Michael Ainslie tried to sweeten the figures by pointing out that "with the perspective of history the sales explosion of 1989 will be viewed as the exception, and the levels of 1990 seen as the beginning of a return to normalcy. An historical look at the art market, [hereby] defined as Sotheby's and Christie's sales combined, shows a compound growth rate of 19 percent annually from 1972 to 1987. Applying that 19 percent rate from 1987 onwards, our 1989 sales would have been $2.0 billion instead of the $2.9 billion actually recorded, and by 1990 we would have expected sales of $2.4 billion—which is in fact what Sotheby's did achieve this year." This sounds like

special pleading and probably was. By the end of the year, David Nash, Sotheby's head of Impressionists in New York, was talking about a return to 1988 levels. By the middle of 1991, a return to 1986 levels was being contemplated. At the time of writing, we are not yet back to the levels of 1985, the year of the International Plaza Agreement. Were that to occur, it would be an important psychological blow, suggesting that the whole Japanese-fueled boom of the late Eighties was merely an aberration in the market. Still, Michael Ainslie did have a point when he tried to explain away the poorer results of 1990: 1989 *was* exceptional.

As the Gulf War started in earnest at the beginning of 1991, both firms began to lay off staff, more than a hundred in each case, and to close branches. Sales volume and quality continued poor. However, good objects were still put on the market, and art fairs were still well attended, even if fewer people were buying. This is an important point, for it appears that the recent surge in enthusiasm for the visual arts did not vanish simply because the economic boom was over and the Gulf War claimed everyone's attention.

But whatever the details, the record prices of May 1990 now appear as a natural ending point after the fantastic successes and excesses of the Eighties. That there had been excesses no one could now deny, and this became even clearer as 1991 wore on. Indeed, "excess" is not really strong enough to describe what had been happening in Japan—a better word would be one that has recurred throughout these pages: "scandal."

The art scandals that surfaced in Japan in 1990 and 1991 dwarfed all the others, certainly in the value of the works concerned. They involved the fraudulent use of thousands of paintings to launder a slush fund of billions of yen, possibly to the benefit of organized crime and one or more political parties. What this strongly suggests is that much of the recent art boom, certainly as far as the Japanese are concerned, has been artificially generated.

Japan is no stranger to art fraud or to "unusual" accounting practices. In 1986, for example, the troubled Heiwa Sogo Bank lent an affiliate company 4.1 billion yen ($33.8 million at the time) to buy a Japanese gold screen worth ¥400–500 million, creating a slush fund of ¥3.5 billion ($28.9 million). The bank's management-controlled affiliate tried to use the funds to buy the bank's stock in a takeover battle and to bribe influential politicians in the hope of getting government support for the management buyout plan. The ploy was unsuccessful and Heiwa Sogo was eventually absorbed by the Sumitomo Bank. But a precedent had been set.

At the same time, the Japanese government's official accounting procedure allows paintings by, say, van Gogh or Renoir that have been bought at auction in New York to be credited as imports from Europe, on the grounds that that is where they were painted a hundred years ago. Given the value of

Impressionist pictures, this has seriously distorted the balance of Japan's trade with the European Economic Community, to the latter's fury.

These practices show how pragmatic is the attitude of many Japanese toward art, even within the government. The art market is, for many Japanese, little more than a highly flexible way of moving money around—or of appearing to. Moreover, art deals in Japan have traditionally been cloaked in secrecy as a way for people to avoid paying taxes. According to Susumu Yamamoto, of the Fujii Television Gallery, art dealers are widely regarded as "people who pay no taxes." This general attitude should be put alongside the events of October 1987, specifically Black Friday and Black Monday. It will be recalled that those days occurred just before several big art auctions, at one of which, to everyone's amazement, a 64.83-carat D-flawless diamond was sold for $7.3 million in a sale that totaled $24.7 million, Christie's highest ever for jewelry. To even greater astonishment, van Gogh's *Irises* was sold— in a manner of speaking—to Alan Bond for $53.9 million only two weeks later. It appeared that alone among the world's markets, the art trade was thriving.

This fact was not lost upon many leading businessmen, especially the speculators in Japanese real estate. Kazuko Shiomi, head of Sotheby's in Tokyo, confirms that it was following the crash of 1987 that she first noticed such people becoming involved in art in a big way. In an interview she said, "The fact is that despite the huge amounts some pictures fetch, these sums are not that large when compared with property deals. Real estate people are among the few in this world not intimidated by such numbers." But the stock-market crash of 1987 was only one reason why property speculators turned to art. Strange as it may seem, another reason had to do with golf. Some of the most lucrative Japanese property deals have involved golf courses, but these have also brought the realtors into contact with one of the oddest speculative ventures of all, the twentieth-century equivalent of the Dutch tulip mania three hundred years ago: golf-club memberships. The Japanese are passionate about golf, so fanatical that they will pay anything to be a member of a good club. As a measure of this passion, the average golf-club membership fee in the early Nineties is $243,000, and in the snobbish Koganei and Yomiuri clubs it is 440 million yen ($3.6 million). Moreover, there is now an entire stock exchange given over to golf-club memberships, on which these entities are traded as commodities. Now, because the value—or at least the price—of these memberships has varied so much, they have become a useful form of bribery; a company will sell a membership to, say, a politician on the understanding that it will buy back the membership in six months' time for many times what the politician has paid. In time, this gambit was used in the case of art.

A final cause of the scandals was the fact that in April 1989 the Japanese government, in an attempt to curb the rocketing price of land in the country, passed a law limiting the amounts banks could lend on real estate and the profits that could be taken; this was along the lines of its curbs on stock-exchange variations, which are limited to 100 yen per share, up or down, in any one day. Well-intentioned as it may have been, this measure was a final inducement for the speculator to use art in spectacularly dishonest ways. Exactly how it worked in detail was shown by the Itoman affair.

Itoman was an Osaka-based textile trading house, which originally opened for business in 1883. It was conservative, it had the Sumitomo Bank (the world's third largest) as its main backer and for many years it prospered. In the mid-Seventies, however, in the wake of the rise in oil prices, it got into trouble. Here the traditionally close relationship that many Japanese companies enjoy with their main bank paid off. The Itoman rescue was handled at Sumitomo by Ichiro Isoda, then a vice president of the bank, who placed a protégé of his, Yoshihiko Kawamura, within the company. The results were excellent, astonishingly so. Kawamura cut Itoman's dependence on textiles, moving into food and machinery, even into sponsoring ladies' golf tournaments. By the mid-Eighties, Itoman was returning profits of $107 million a year. Unfortunately, Kawamura and Itoman were also seduced by what became known in Japan as the "bubble economy," whose main ingredient in the mid-to-late-Eighties was land. Taking advantage of the cheap money in the country, Itoman under Kawamura, and with the approval of Ichiro Isoda, who was by now Sumitomo's president, borrowed more and more to invest in property. The firm bought land in the swank Aoyama district of Tokyo, where it planned to build a new headquarters, in California and in Honolulu. Then, in 1988, Itoman took over Sugiyama, a developer of one-room flats. Corporate takeovers are rare in Japan, except when rescue is necessary; therefore it was relevant that at the time it was bought Sugiyama owed 250 billion yen. It was also relevant that Sugiyama was another client of the bank's. The suggestion was later aired that Sugiyama was taken over to spare Sumitomo and Isoda any embarrassment in a culture where embarrassment is anathema.

The Sugiyama deal was important for two reasons. First, it showed how close Itoman was to Sumitomo; second, it added to Itoman's debt. At its worst, Itoman owed ¥1.3 *trillion,* or $10.3 billion. With such numbers, with the restrictions on land deals introduced in 1989, and with the art market outperforming everything else in the wake of the 1987 crash, it was almost inevitable that Itoman would turn to paintings as a way out of trouble. What happened next is not clear in detail but involved two new characters: Isoda's daughter and a forty-six-year-old Korean-Japanese, Ho Young Chung.

Isoda's daughter had an art gallery in Osaka, which she ran with her husband. One day in November 1989 she rang Kawamura to tell him that she was eager to sell a picture by Toulouse-Lautrec and to ask him to look out for a buyer. Anxious to please Isoda, who was his mentor and in many respects his boss, Kawamura said that if he could not find a customer, he would buy the painting for Itoman. This he soon did, paying $4 million. Only days later Ho Young Chung appeared and said he would take the Toulouse-Lautrec off Itoman's hands. He paid $6 million for it and bragged that he could sell it for $10 million.

Whether this was fraudulent, no one is saying. Balding, bespectacled, and on the heavy side, Ho is a flashy man who drives a Bentley, and the local papers have openly linked him to organized crime. His main interests were newspapers and broadcasting, companies that were to figure prominently in other art scandals. However it was engineered, Kawamura appeared to have been impressed by the Toulouse-Lautrec deal and the easy money to be made in the art market. Accordingly, in February 1990 he recruited Suemitsu Ito, a forty-six-year-old wheeler-dealer property developer and friend of Ho's. Two months later Ito was on the Itoman board.

It was these three men, Kawamura, Ho, and Ito, who put Itoman into art in a big way. Over the next months, Itoman acquired no fewer than 7,343 paintings, including works by Picasso, Degas, Renoir, Chagall, Modigliani, Andrew Wyeth and a Japanese artist, Matazo Kayama. The sheer number of acquisitions was astounding and raised suspicions that Itoman had bought in such amounts in order to manipulate the market. In other words, it sought to buy on a scale large enough to push up prices overall. But a second reason for these purchases was that Itoman needed art to sweeten its many real estate deals, which were otherwise limited by government curbs. The system appeared to operate in exactly the way the golf-club-membership scheme did. Sellers of land would be "sold" a Renoir or a Chagall on the understanding that for accounting and tax purposes it would be "bought back" from them a few months later for perhaps ten times what they had paid. The price of paintings in the auction houses in 1989 and early 1990 was so unpredictable that in theory the scheme could work. Masanori Hirano of Shinwa, Noritsugu Shimose of Galerie Tamenaga, and Susumu Yamamoto of the Fujii Television Gallery have all confirmed to this writer that they were aware of such deals.

But this by no means exhausts the suspicious uses to which art was put. Two hundred and nineteen of the paintings bought by Itoman for a total of ¥55.7 billion ($470 million) were acquired from the Osaka-based newspaper *Kansai Shimbun*, from the MI Gallery in Osaka and from Fukoku Sangyo, all of them companies owned by Ho. Later it transpired that the true value

of these paintings was in fact nearer to ¥16.9 billion, and that the appraisal certificates, produced by an employee of the Seibu department store, had been forged. The 7,124 lesser works were acquired for ¥12 billion from Pisa, a subsidiary of Seibu. Seibu and Sotheby's mounted joint auctions in Japan, and Seiji Tsutsumi, president of Seibu, was a Sotheby's board member. Was a slush fund being created by these false valuations and, if so, for what purposes?

Unfortunately for Kawamura, Ito and Ho, their major art deals coincided with an economic setback in Japan. Interest rates doubled, to 8 percent, and the Tokyo real estate market softened significantly. At the very time it was buying art, therefore, Itoman began to be squeezed on its land deals and was making smaller profits with which to finance its greater borrowings.

Under these circumstances, a mysterious letter was mailed to the Japanese Finance Ministry in June 1990. Signed simply "Itoman staff," the letter exposed the company's financial mismanagement and provoked an official inquiry. It was the beginning of the end for Kawamura and the others. The scandal hit the headlines in November 1990, when Isoda suddenly announced that he was resigning as president of Sumitomo, ostensibly to take responsibility for a quite different criminal offense by a member of his staff. In fact, his resignation was widely regarded as having been precipitated by the Itoman scandal, a suspicion that was reinforced a few days later when a key Itoman executive in charge of the art purchases committed suicide. Now the story started to unravel rapidly, and the deal that has attracted most attention is that involving Ho's *Kansai Shimbun,* for although this company made a theoretical profit of ¥38 billion on paintings, it went bankrupt not long afterward. Where the missing money went, no one knew, but now a man named Tamanaki Fukimoto makes his entrance. Years ago he was a political aide to the secretary general of the Japanese Liberal Democrats when Sato was prime minister. Next Fukimoto emerged as an art dealer of the Fujii International Gallery, and later still as president of Kinki Broadcasting, owned by Ho and with links to *Kansai Shimbun.* The Osaka police have said that they suspect Fukimoto of being involved with the forged appraisals of the 219 works of art, and this is why people suspect that the missing money, or slush fund, may have been channeled into politics. Indeed, two politicians were actually named in the Osaka press.

When the news about the *Kansai Shimbun* paintings deal was first made public, Ho and Kawamura reclassified the "sale" as a "loan." It made little difference; *Kansai Shimbun* went bankrupt in April 1991 without repaying any of the "loans." Months later two other Ho-owned companies also failed, and none of the missing millions were paid back.

By the beginning of 1991, attention had turned to Kawamura; would he do

the honorable thing and resign as Isoda had? He did not. In fact, it emerged that he had used some of the "loan" money to buy Itoman shares in order to protect his position on the board. It did him no good. In January of 1991 he was fired by the Itoman board, the first president of a major Japanese company to suffer this ignominy for nearly a decade.

Until then the authorities had not acted. However, the scandal spread in April, when Osaka police raided fifty-seven locations in search of evidence that criminal fraud had taken place at Itoman or at the Ho companies. Another seventeen locations were raided in May, and a further thirty-six in June. By the first week of July 1991, 140 addresses had been visited and 15,000 documents seized. Itoman and Pisa, the Seibu subsidiary, had their art dealer's licenses suspended, for ten days and seven days respectively. This does not sound severe, but in a culture that abhors shame it is demeaning. In addition, two Ginza galleries, Gallery Kiku and Taimei Garo, were found to have evaded ¥700 million in taxes as a result of the Itoman scandal. Kawamura's house was seized, there are grounds for believing that one of the Modiglianis Itoman bought was a fake, and police have found that one art work, a Korean Buddhist sutra, was bought for 1,400 times its true value. There seemed to be no end to the financial double-dealing that Itoman indulged in with art, and the first arrests followed shortly afterward.

Until this matter is cleared up, the Japanese art market is in disarray, but some consequences of the affair are already plain for all to see. If it does turn out that Itoman was trying to inflate prices in modern and Impressionist pictures, or was using paintings as bribery in land deals, there will be drastic effects on the art market. It seems clear that the prices Itoman paid were artificial and bore little relationship to the pictures' real worth. The paintings were merely a tool in what the Japanese call *zaiteku*—financial engineering.

Secondly, if Itoman could do this, how many other companies have done it? Masanori Hirano, whose family runs Shinwa, the first Japanese-owned Western-style auction house in Tokyo, has confirmed that to his certain knowledge at least one other major company operated in the same way as Itoman. He would not name the firm but said it was "one of the five or six biggest trading groups in Japan." The company had an art-gallery arm, just as Itoman did, and, like Itoman, it was run by people who knew nothing about art. He also said that the moment the news about Itoman leaked out, this other company immediately closed down its own operation.

The spotlight is also being turned on Aska, the art dealership run by Yasumichi Morishita. Like Itoman, Aska has been a prominent buyer in recent years of mid-level Impressionist paintings.

Two final developments have also been worrying the art trade in Tokyo. One was the Mitsubishi affair, in which the trading giant admitted that it had

failed to pay ¥1.6 billion ($12 million) in taxes on one of its art deals. Originally, Mitsubishi and Soko Gakkei, a Buddhist sect that controls the Clean Government Party, the third largest in the Japanese Diet, claimed to have bought the same two Renoirs, _Woman after a Bath_ and _Woman Reading,_ on the same day, but from different people and for different amounts. Mitsubishi said it had paid ¥3.6 billion ($27 million) to two Frenchmen; the two were never found and did not exist, according to the Japanese immigration service. Soko Gakkei claimed it paid ¥2.1 billion ($15.8 million). That Mitsubishi later agreed to pay taxes on the missing money appears to confirm that funds were secretly channeled to Soko Gakkei, which has awarded many contracts to Mitsubishi for the development of large cemeteries. In this case the political link has been proved. The political role of art was also confirmed by a Sanwa Bank official, who said, "Corporate use of valuable paintings as a donation to a politician to skirt regulations is a common practice in Japan. Later the corporations buy back the paintings at ten times the original cost."

The art boom of the late Eighties was led by Impressionist and modern works, and the Japanese, according to some reports, bought 40 percent of them. No one is suggesting that all their art purchases were artificial, but a significant percentage appear to have been. These scandals also help explain why, as mentioned earlier, so many mediocre or weak Impressionist paintings were bought by Japanese in the late Eighties. At the time articles were written about a "new aesthetic" among Far Easterners, but it would seem that "new ethic" is a more apposite phrase.

Nor is this all. This amazing situation was made worse by the bankruptcy of a number of other companies dealing in art. Chief among these was the Gallery Urban of Nagoya, run by Masahiko Sawada, whose main business was a Toyota distributorship. This firm, which also had premises in Tokyo, Paris and opposite Christie's in New York, went bankrupt in the spring of 1991, owing ¥118 billion ($887 million), with the result that between two thousand and four thousand paintings, owned now by Citibank, Urban's backers, went back on the market. They were told firmly by Christie's and Sotheby's that if all these paintings were put up for sale at once the art market would collapse. In addition, two corporations, Nanatomi & Co. and Azabu Jidosha KK, both with extensive art collections, went bankrupt. Two others, Orix and Asahi, still appeared healthy but were not adding to their collections, and Maruko Inc., a Tokyo real estate developer which in 1990 started a "partners in art" scheme in which citizens could invest in eighteen prestigious paintings that would be sold after seven years, was by 1991 seeking protection from the Tokyo District Court while it restructured itself financially. As Shimose of Tamenaga said in an interview, "The prospect of ten thousand paintings coming onto the market at once does not exactly fill me

with pleasure." Wide-ranging as all this was, Kazuko Shiomi at Sotheby's said she was convinced that there was still more to be revealed.

There are two bitter ironies to the bizarre situation in Japan, one of which has not yet been fully understood in the West. The first is that though many people claimed that the art market was "overheated" in the late Eighties, no one other than the culprits spotted what was actually going on in Japan. The second is that the art world loves to think of itself as smart and sophisticated; yet compared with the real estate world it is a babe in arms. The real estate developers used the art market for their own purposes while the dealers and auction houses had not the faintest idea—at least for several months. As Sachiko Hibiya, the head of Christie's in Japan, put it, "The market in Impressionists will never be the same again." This is the sword of Damocles poised over the art market in the post-*Gachet* world.

EPILOGUE
THE POST-*GACHET* WORLD

Life after *Dr. Gachet* is different from life in the years that went before. But as this history has shown, the art market has always been responsive to world events, political, economic and social, and despite setbacks, some of them prolonged, the market has grown throughout the last five hundred years. Looking back over that period, and especially across the last century, can we see any long-term trends?

We can, I believe, extrapolate forward in three general areas, where the evidence is fairly consistent. In one area the news in general is good, in the second the news is bad and in the third it is good news for collectors and dealers, less good for auction houses.

In the first place, I would refer readers to Appendix A of this book. This shows the *real* (1992) prices of record-breaking paintings ever since systematic records began in 1715. This graph is instructive for, essentially, it is this shape:

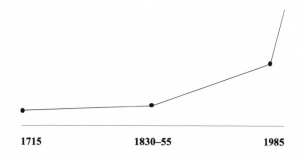

| 1715 | 1830–55 | 1985 |

That is to say, the graph appears to be divided into three periods, each one represented by a sloping but basically straight line. The first segment runs in a straight line from 1715 to the period 1830–55 or thereabouts, recording an increase, in simple terms, of $13,870 a year. From 1830–55 until 1985 the graph again runs in a straight line but at an incline indicating a steeper rate of increase, namely $128,000 a year, or almost ten times what it had been. Between 1985 and 1990 the rate of increase has escalated again—by just how much is too soon to tell at this moment, but I will return to the issue later in this epilogue.

The first turning point, that of the 1830–55 period, makes sense because of the changing nature of society in those years. The upheavals of the Napoleonic wars were over and Western Europe at last was moving away from being a predominantly agricultural society. The Industrial Revolution was taking hold, empires were being rapidly expanded and a new middle class was on the rise. Most important for the art market, a new type of wealth was being created that had much greater liquidity; it was no longer tied up in land. Because of these factors buying art became easier, and therefore more popular, so prices surged. The upward slope over the following 130 or so years was remarkably consistent, a fact of significance for the future. The best works of art became steadily more attractive in real monetary terms over this period, despite the political, social and financial ups and downs that occurred. In addition to the new forms of wealth created in the nineteenth century, our increasing appreciation of, and reliance on, art for aesthetic and spiritual nourishment have helped bring about this steady rise. This section of the graph strongly suggests that the art market will continue its progress. The graph is based only on record-breaking pictures, but insofar as they are the best, they are the most reliable for this discussion.

The break in the graph in 1985 looks suspiciously like the consequence of the International Plaza Agreement, which was itself the result of years of economic progress in Japan and other nations of the Far East. Whether it represents a genuine change in the shape of the graph we cannot yet tell. In fact, by mid-1992, art market statistics tended to suggest that the 1985–90 period was unusual, and that the market overall had returned to the 1830–1985 incline. If my explanation of the last break, 1830–55, is correct (changes in the type of wealth available to buy art), it could be that the electronic revolution, on which Japan's vast resources rest, is an equivalent systematic change in the world. This is plausible, but it may be *too* neat. The Japanese scandals obviously play a part, but it will be a while before the true pattern emerges.

The graph also illuminates the discussion in Chapter 38 on art and investment. In fact, when one takes into account Appendix A, along with certain

tables in Chapter 38, one can explain not only the art-as-investment conundrum but also the psychology of the art market. On the basis of these charts we can draw three salient conclusions:

1. The very best works of art will continue to do well in real financial terms.

2. Art below that level is not a good investment.

3. Overall, art is risky as an investment in the short term, but if you choose wisely, the benefits are much greater than the dangers are if you choose badly.

The performance of paintings at the top end of the market explains why there are always rich, clever people willing to spend unprecedented sums: in the long run rare and important art is the only category to buy if you want to make a lot of money. This also explains the auction houses' reliance on these works for publicity. Records have a special fascination for people; in addition, the art-as-investment picture is always rosiest at the top. But the message of all three conclusions above is that any effort to portray the art market as similar to other markets—that is, over the long run steady and predictable—is misplaced. Viewed as a whole, as we saw in Chapter 38, art is a poor performer, not quite holding its own with inflation. It is, in fact, much more exciting, and indeed proper, to look upon it as speculation, an arena where you risk large losses but also stand to make huge gains. In this sense, the speculators—including the Japanese with their *kaneamari gensho* (excess money)—have the right attitude. It may be distasteful and unpopular to say so, but art *is* a speculative market.

The second clue to the future arises from the impact of Pop Art, as Jean-Louis Picard noted in Chapter 39. Pop Art had important consequences for the art market—far more, I believe, than any other form of painting in recent decades—mainly because it was the first form of painting since the middle of the nineteenth century that did not exclude large numbers of people. At the time of the popularity of the print, artists were rich and famous in Britain and France, and there was a close link between them and their public. The salon may have been divided intellectually, but it was always crowded and was a vital cultural institution. But beginning with the Impressionists, art became more exclusive. It was this, among other elements, that helped to spawn a distribution system other than the salons and produced modern dealers like Durand-Ruel. But in the context of this discussion it is more important to grasp that Impressionism led to Post-Impressionism, then to Fauvism, Cubism, Abstraction, and all the other avant-garde forms of art that dominated painting and sculpture in the first six decades of this century. The important characteristic that all these shared was their relatively limited appeal, the

sparseness of their following, and the fact that large numbers of the general public were cut off from the elite, the artists, dealers and collectors who had kept each other going for generations. This may be difficult to grasp today, but what runs through every account of the art world before, say, 1960 is its *smallness*.

Pop Art changed all that, for its images and techniques were familiar to everyone. In a way it celebrated the heroism and nobility of everyday life in the Sixties, from Coca-Cola cans to hamburgers, just as Baudelaire had advised Manet, a hundred years before, to celebrate the new features of life in Paris. There were no difficulties of abstraction, symbolism or art history to overcome. There was also a generational factor; it was the art of people who belonged to and rejoiced in the postwar world—the plentiful world of television, fast food, rock music, advertising slogans and cheap mass-produced goods. Pop Art was controversial at first, but it was soon accepted by the art world. However, its more important aspect was not what the elite thought about it but the effect it had on the public in general. With the arrival of Pop, more people became more interested in art than ever before, and some even started to collect it. Pop Art took itself seriously but it had a sense of humor. With its arrival, people started to go to galleries again, and in large numbers; they lost their anxiety about art as a highbrow activity and started to look. The movement drew attention to the world around them in a way that allowed people to join in. They were helped in this by the artists themselves, who became famous, familiar and accessible, something that hadn't happened since the mid-nineteenth century. The Pop artists were themselves postwar creatures who understood the way the world was going and were able to make the most of it. None more so than Andy Warhol, who was the most famous, if not the most eminent, artist of the school.

All this was good. But a less positive effect of Pop Art is that, as Jean-Louis Picard pointed out, it has become a sort of break point in our culture. Since it flourished, many people have become enthusiastic about contemporary art but at the same time are unable to see much merit or enjoyment in what preceded it. Picard's metaphor—that the influence of Japan, Oceania and Native American culture has produced in contemporary art a sort of visual Esperanto—is all the more striking for the fact that though it is relatively new, Esperanto is, to all intents and purposes, already dead.

I believe that a whole book needs to be written about aesthetics in the wake of Pop Art; its significance has not yet been fully digested or understood. Still, from the perspective of this volume the important point is that despite the general enthusiasm for contemporary art, in the opinion of many serious critics, dealers and other observers the Seventies, Eighties, and Nineties have

so far produced no great painter or great school of painting. The most popular area of collecting is that whose quality is most in doubt.

One finds oneself asking whether Pop Art, in taking us back to the popular art of the nineteenth century, is perhaps reviving the wrong part of the nineteenth century, when artists earned enormous amounts of money in their lifetimes but did not produce lasting work. Could it be that Warhol, Schnabel and Beuys are the Bonheur, Meissonier and Landseer of our day? Collectors are spending enormous amounts of money on art that many serious observers do not rate highly. It is hard to escape the impression that if any art is overpriced, it is contemporary art, and that it has the bleakest future. Remember that remarkable finding of Frey and Pommerehne, mentioned in Chapter 38, that the worst investments in the art market, according to their statistics, had been five artists in Britain who had been so successful in their lifetimes that they had been knighted. Now mark these wise words of Eugene Thaw, writing in *The New Republic* in 1985: ". . . the 'hottest' of all art market commodities today, as always in the past, are the big names of contemporary art. Common sense must warn us, therefore, that soon others will become the big names, with only a small fraction of today's high-fliers surviving at all, and only a fraction of that fraction surviving with increased value." I can put it no better.

———

In the Seventies, another major change took place that was no less important for the future, and it concerned the auction houses.

It should not be forgotten that auction houses have been around for as long as dealers; they fulfill a natural function, just as painting, sculpting, and art dealing do. This narrative also makes clear what is and what is not new in salesroom behavior in recent years. For a start, guarantees and credit are not new to the art market. Extensive credit was given in the nineteenth century (admittedly mainly to book dealers), but this did not create the kind of market that has appeared recently. Guarantees were in use in America long before Peter Wilson or Alfred Taubman was criticized for employing them; they are as old as the bills and receipts Cortlandt Bishop issued in the Twenties and Thirties. Nor have the auction houses recently introduced the nouveaux riches to collecting; there is nothing nouveau about this class's interest in art. However, it may be argued that modern salesrooms have refined marketing techniques in ways not known before and that the extent of credit, the range of guarantees, the sheer volume of nouveau-riche collecting in our time have changed the nature of

the market. It has been argued also that one effect of the great increase in prices has been to denude museums. There is some truth to this charge, but it has been overstated. The Getty, admittedly the world's richest museum, has used market conditions to make some very valuable additions (Pontormo, Manet, van Gogh). Similarly the National Gallery in London has been astute, and the Louvre in Paris benefited from the sale of Picasso's *Les Noces de Pierrette* because a condition of sale was that another work had to be donated to the French nation, a novel and imaginative idea. American museums may have suffered most (though Walter Annenberg announced in 1991 that he was giving his collection, much of it bought in the 1980s boom, to the Metropolitan Museum). But Japanese museums, both private and public, have been much enriched recently. I would suggest, however, that concentrating on guarantees, credit and financial services in general, and the effects these are supposed to have produced, has blinded us to more important developments in the salesrooms, changes that have had, in my view, a more widespread and subtle effect.

The most important systematic changes that have occurred in the two big auction houses are that in the Seventies both companies went public, and both introduced the buyer's premium. Once a company is public, it has much more stringent fiduciary duties than before. Its accounts, and therefore its reputation, are public. Once a company issues stock, its obligations are much more nakedly commercial than before. Therefore the flotation of Christie's stock led directly to the adoption of the buyer's premium.

Further, it was really the buyer's premium, not Alfred Taubman's purchase of Sotheby's, that created the situation in which the salesrooms went "retail." After the buyer's premium was introduced, the salesrooms' source of income began to change—to the point where, in the Eighties, it was the buyers at auction rather than the sellers who provided most of the income. Historically, this was an immense and very important change. Obviously the art trade was limited in size, and so the general public had to be tapped. This is why press offices became so important and why, in the mid-Seventies, the scramble for profits really began in earnest. The graphs at the back of John Herbert's book, *Inside Christie's,* which give the profits and sales for both Christie's and Sotheby's, show that a jump occurs in both firms at the beginning of the Seventies. It was then that salesroom tactics began to affect the experience of art. This has been a subtle process, not exactly deliberate on the part of the salesrooms, but no less damaging for all that.

Consider this encounter. One summer in the middle of the recent art boom I was in Sotheby's London office to look at a rare enamel I was thinking of writing about. While I was there, the cataloguing for a future "Works of Art" sale was going on around me. Suddenly one of the cataloguers held aloft a

colored wooden carving, a head of a man with his mouth open and his tongue hanging out. "Look at this," he called out. "Have you ever seen anything more hideous?" "Every home should have one," chimed in a colleague, and laughter erupted across the room. None of that hilarity or that attitude was conveyed in the resulting catalogue, of course. But the episode did not end there. Later I taxed Alfred Taubman about it. Was there not something incongruous, even dishonest, in an auction-house employee thinking one thing and writing another? Taubman gave the classic auctioneer's response that someone, somewhere, would find the object attractive. This is plausible but specious. The picture of the ugly princess of Bavaria (figure 1) proves that some objects are too ugly even for auctioneers. If everyone took the sales-room line, museum curators would be justified in putting everything and anything on their walls simply because someone, somewhere, would always be interested.

My point in mentioning this story is to demonstrate that even in the smallest ways the relationship of an auction house to art—to truth, if you like—is a complex one, and is necessarily compromised. Words do not always mean what they appear to. An auction-house catalogue, it should always be remembered, is first and foremost an act of marketing, however much it may pretend to be a labor of scholarship.

There are three important ways in which the modern auction houses have changed our experience of art. The first is best illustrated by the following list, which shows the ten most expensive paintings sold at auction during the boom years 1987–90:

van Gogh	*Portrait of Dr. Gachet*	$82,500,000
Renoir	*Au Moulin de la Galette*	78,100,000
van Gogh	*Irises*	53,900,000
Picasso	*Les Noces de Pierrette*	51,386,623
Picasso	*Self-Portrait: Yo Picasso*	47,850,000
Picasso	*Au Lapin Agile*	40,700,000
van Gogh	*Sunflowers*	39,921,750
Picasso	*Acrobate et Jeune Arlequin*	38,456,600
Pontormo	*Portrait of Cosimo*	35,200,000
van Gogh	*Self-Portrait*	26,400,000

(*Number of different painters = 4*)

It is tempting to dwell on the extraordinary price levels, but there is an equally interesting aspect to this list, never revealed by the salesrooms, that becomes clear only when the list is compared with similar ones for earlier years:

The Top Ten Pictures, 1913–14:

Raphael	Panshanger Madonna	£116,500
Velázquez	*Duke of Olivares*	82,700
Van Dyck	*Paolina Adorno*	82,400
Hoppner	*The Tambourine Girl*	72,300
Titian	*Portrait of Philip II*	60,000
Rembrandt	*Portrait of a Merchant*	51,650
Titian	*Man with Red Cap*	50,000
Romney	*Portrait of Penelope Lee Acton*	45,000
Rembrandt	*David and Bathsheba*	44,000
Mabuse	*Adoration of the Kings*	40,000

(*Number of different painters = 8*)

The Top Ten Pictures, 1928–29:

Raphael	Large Panshanger Madonna	£172,800
Titian	*Cornaro Family*	122,000
French school	Wilton Diptych	90,000
Gainsborough	*The Market Cart (Harvest Wagon)*	74,400
Rembrandt	*Self-Portrait with a Scabbard*	50,400
Van Dyck	*Marchesa Balbi*	50,000
Rembrandt	*Young Man with Cleft Chin*	46,200
Goya	*Red Boy*	33,000
Hobbema	*The House in the Wood*	33,000
Rembrandt	*Lady with a Handkerchief*	31,500

(*Number of different painters = 8*)

The Top Ten Pictures, 1959–60:

Rubens	*Adoration of the Kings*	£275,000
Hals	*An Unknown Cavalier*	182,000
Gainsborough	*Mr. and Mrs. Andrews in a Park*	130,000
Rembrandt	Panshanger equestrian picture	128,000
El Greco	*Christ Healing the Blind*	100,000
El Greco	*Saint James*	72,000
Rembrandt	*Saskia as Juno*	52,500
Rubens	*Holy Family*	50,000
Hals	*Portrait of Frans Post*	48,000
Picasso	*Crouching Woman*	48,000

(*Number of different painters = 6*)

These periods were chosen because the first two were boom times, like 1987–90, and the third, 1959–60, was the beginning of the contemporary world, when the auction houses were starting to modernize themselves. It is clear from these lists that as price levels have soared, the variety of painters and of schools achieving top prices has shrunk. This is the more marked when one considers that there are far more auctions and objects sold now than ever before. Of course a series of "Top Ten" lists would not be enough to convince the Royal College of Statisticians, but the reader will have to take my word for it that lists of the most expensive twenty or fifty paintings would prove my point even more tellingly.

Not all of this can be laid at the door of the auction houses. The supply of Old Masters has dried up because many are now in museums, and this has contributed to the loss in variety of pictures available. But the auction houses' own statistics bear out the above lists. In the early Sixties, 15 to 25 percent of the income at both Christie's and Sotheby's came from Impressionist and modern art, whereas in the late Eighties and early Nineties the figure was between 40 and 50 percent. The auction process, with its emphasis on records and the development of specialist sales, has, perhaps inevitably, brought about a centralizing tendency. By definition, auctions are public; everyone can see what is happening, so the herd instinct finds a ready arena in the salesroom.

The second way the salesrooms have affected our experience of art is through a subtle but significant change in the nature of collecting. Throughout the Seventies there was a growth of specialist sales. This makes sense from the salesroom point of view because it is tidy, easy to conceive, to mount and to publicize. It is also good news if you are a specialist collector. But think of the great collectors of the past, from Beckford to Walpole, Morgan, Frick and von Hirsch. They collected, if not everything, then almost: books, Impressionist pictures, medieval enamels, Renaissance bronzes, carpets, Old Masters, eighteenth-century French furniture, antiquities, drawings. Yet of the serious collectors encountered in Chapters 33 and 36, fully 80 percent collect in only one area. This need not be bad in itself, of course, but put alongside the fact that the great majority of serious collectors specialize in modern art, and that four out of five collect contemporary, modern or Impressionist art, this is a fairly massive negation of the past and of variety.

Again it would be wrong to lay all this at the door of the auction houses, but they have played a role in this tendency. They are natural focal points in the art world because of their resources and techniques of selling. Auctions still take a long time to arrange, a fact that need not matter if by "collecting" is meant "acquiring." If, however, the collector is also interested in "refin-

ing"—that is, selling in order to trade up—auctions are very cumbersome, if not impossible, forms of transaction.

There is also the question of whether the practice of having a relatively short time to examine an object (the cut-off point being the sale itself) affects the process of collecting. Does it mean, for instance, that we tend to be interested in the more aggressive objects, art that makes its impact quickly and that we do not need to work at, rather than in works that grow on us slowly? In his recent book *Nothing If Not Critical,* Robert Hughes drew attention to the fact that "the market pressure for accessible, undemanding, lavishly emotional art is now extreme." He is right.

Then there is the question, almost never aired, of what happens if a collector doesn't like a picture he or she has bought at auction. All collectors are familiar with that mysterious process whereby the mere act of writing a check concentrates the mind wonderfully and produces either a reassurance that one is doing the right thing or, too late, the realization that one has made a ghastly mistake. It seems plausible that this should happen more often at auction because of the limited time for inspection. With dealers one can always trade, but at auction it is not easy to resell art until some time has elapsed, and therefore one is likely to be stuck with one's auction mistakes for a longer period.

None of these matters are large in themselves, though mistakes in collecting are not small matters; yet what they add up to is a shift in collecting. These factors, together with the information on collectors in Chapter 33, suggest that art collecting has become a more concentrated, less varied, less adventurous activity than it was in the past. This has happened in other walks of life and forms of pleasure. Take sport, for example, and examine the British Football League. There, the demands of television for ever-better games has produced the circumstances by which, in order to survive, the top clubs have formed a superleague, shutting out the vast mass of smaller clubs. In the end variety is sacrificed for the needs of a small number of top teams. An analogous development is occurring in the art world.

This has consequences for the future because, I believe, people will grow tired of it. I'm guessing now, but the art world does have cyclical aspects, and a natural consequence of the centralization of taste is that a reaction will set in. The more new collectors learn about art, the more they will realize that auctions may be cost-efficient ways of buying and selling but are cumbersome and coarse ways to collect. As a result, the balance between auctions and dealers may swing back in the direction of the latter. This has already happened in the realm of Old Masters, where clever dealers with a good eye and contacts are now mounting academically or aesthetically interesting shows that attract more acclaim, and therefore feature works of higher

quality, sometimes on consignment, than Old Master auctions do. This is a trend that will probably flourish. Cortlandt Bishop, Peter Wilson and more recent Sotheby's personnel have all predicted the demise of the dealer. They are wrong. The auction houses have made the dealers raise their game, and the better dealers have responded.

All of these predictions could be upset, of course, by political events, some of which we already know about. In 1993 Europe's Common Market opens up fully at last (at least in theory), and it appears that there will be a battle between Sotheby's and Christie's on the one hand and French auctioneers on the other for the souls and wallets of the French people. Sotheby's and Christie's may be bigger, but the French will put up a good fight. Eastern Europe will become still more accessible, benefiting Germany and perhaps France. Picard may be right in believing that Eastern Europe will favor Paris over London, New York and Berlin.

In 1996 Hong Kong returns to China, and this could lead to the dispersal of Hong Kong dealers to Singapore, Thailand, Canada or San Francisco. But the Chinese themselves have been studying the market lately, and they may open their own state shops to bring onto the market in orderly fashion the huge numbers of Chinese antiquities known to be available. In October 1992 the Chinese State Cultural Relics Bureau was authorized for the first time to auction 2,500 antiques in a trial before setting up a permanent cultural relics market. Before the sale, China had strictly banned the overseas sale of almost all antiques made before 1795. The sale was organized in conjunction with a Dutch trade-advisory group, which promised to fly in a thousand European buyers. Dealers like Giuseppe Eskenazi are concerned about this. There is also the lurking problem of the Japanese scandals.

Lurking underneath everything, however, at the end of a long narrative, there is still the question of the proper place of *price* in the artistic experience. This is both the fascination of the art market and the horror, its overriding paradox. Many of us find the obsession with art prices irritating, banal—and irresistible—all at the same time. After van Gogh's *Irises* had sold in 1987 for $39.9 million, a leading London dealer said to me, "No one loves art forty million dollars!" I thought then, and I think now, that his attitude was revealing, and probably commonplace, but coming from a dealer, it was surprising. Many people who are fascinated by stolen art, smuggled art and fake art but have little interest in art itself follow that line, I suspect, because deep down they are intrigued, and even worried, by a feeling they see in others and do not share themselves: they cannot believe that the passions surrounding art are so great, so primeval, perhaps, that others will take risks

to steal it, smuggle it or fake it. They simply don't feel art is worth the trouble. The same is true in regard to very expensive art. Like my dealer friend, they don't see how anyone can love art forty million dollars.

But why not? If art is truly unique, truly represents man's highest abilities and aspirations, should we not applaud, rather than vilify, people who are willing and able to spend enormous sums of money to fulfill their greatest dream—to own these supreme examples of human genius? Or do we all secretly feel that many megarich "collectors" are just showing off, buying their way flashily into the history books?

There is probably some truth to both attitudes. What this narrative enables us to do, I hope, is to discriminate in this shifting world, to identify the truly undesirable elements but also to be realistic about human motivation. Thus we can now acknowledge that the price of art has fascinated people since the seventeenth century at least. And that, since then, many people have been aware that in certain circumstances it can be a good investment. Thus we can admit now that Théodore Duret, Ernest Hoschedé and Jean-Baptiste Faure were all early advocates, and collectors, of the Impressionists, but they were also, in their different ways, speculators. Ambroise Vollard, Félix Fénéon and Daniel-Henri Kahnweiler were critics, writers and advocates of modern painting, but also dealers. J. Pierpont Morgan, Henry Clay Frick and Mrs. Potter Palmer were great collectors who influenced taste immensely but did not pretend to be great connoisseurs. René Gimpel, Nathan and Georges Wildenstein and Jacques Seligmann were dealers *and* connoisseurs, as was David Carritt, and as is Eugene Thaw in our own day. Leo Castelli is a great dealer but, by his own admission, knew hardly any art history when he started.

We can't all be perfect. Morgan didn't see the beauty in Impressionism; Durand-Ruel couldn't stand the paintings that came after the Impressionists; Kahnweiler loved Cubism but thought that abstract art, especially Abstract Expressionism, was worthless.

But what all these great figures in the art market had in common, Morgan as much as Kahnweiler, Frick as much as the Wildensteins, was that despite their aesthetic disagreements they all believed that quality and price are intimately related and that therefore great art (whatever that is) is worth paying a great price for. Equally important, and possibly more so, they were almost all involved, in one way or another, in the scholarship surrounding great art, and this crucial factor kept them on the straight and narrow. Scholarship, the constant improvement and refining of knowledge, which aids judgment, is a purifying process, largely independent of the market.

It follows from this that there is, or ought to be, a natural progression in the art market, and this brings us back to the essay by Alan Bowness,

discussed in the Preface. Art and the criticism/scholarship that surrounds it produce informed dealers and collectors. They may not be in complete agreement, but this is the *rational* basis of a free market. Truly great primary dealers (Durand-Ruel, Vollard, Kahnweiler, Guggenheim, Castelli, for instance) grow up around great artistic movements and must know how to sell. Truly great secondary dealers (Wildenstein, Seligmann, Gimpel, Carritt, Thaw, trading in the work of dead artists) must be connoisseurs who know what to buy. In either case, the dealer truly is as much a scholar as a merchant, and therefore the acquisition of art, on the part of collectors, from such dealers is as much a learning experience as it is a purchase. That is the difference between collecting and shopping.

Buying art through a scholar/dealer is, most of the time, a private, even secretive, transaction, more or less well suited to the contemplation of the art being traded. We know from the history of Knoedler (see above, Chapter 9) that some purchases had a competitive edge to them: millionaire Y would buy picture Z because millionaire A had bought picture B. But this hardly compares with the theatrical, combative, altogether different world of the modern auction.

This book began with a discussion of some of the areas of "doublespeak" in the art market, the corrupted notions of "beauty," "unique" and so on. It is now time to return to the biggest form of doublespeak in the present-day art market, and this too brings us back to the salesrooms. The auction houses have always said that they reject any notion that art should be looked upon as an "investment." This is blatantly disingenuous. They reject the notion on the surface while doing everything to promote it underneath. What other reason could Sotheby's have for inventing, and continuing to publish, the *Art Market Index*? Why else the emphasis on financial records, which all the auction houses indulge in? In early 1992, when the post-*Gachet* art market had declined markedly from the all-time high of May 1990, Sotheby's let its guard slip, so worried was the company by the latest trends, and for the first time in a press release drew attention to the amount by which a number of silver objects coming up for sale had multiplied in price over the years.

But the real attitude of the auction houses was nowhere more evident than in a 1989 report on Sotheby's, produced by Alex Brown and Sons, a Baltimore-based investment bank. This eighteen-page document, clearly drawn up with the cooperation of Sotheby's, concluded with a strong recommendation to buy Sotheby's stock, and among the reasons given were: "The world market for paintings, sculpture and prints is at least a $10 billion entity and is growing at a 15–20 percent annual rate. Contrary to popular belief, this

market rarely experiences cyclical downturns, and we believe its past growth is sustainable over the next five–ten years"; "It is the consensus opinion of veteran observers that the whole world has entered into the first stages of an unprecedented collecting boom! . . . According to *Collectors Books,* the number of people in the U.S.A. who engage in collecting as a hobby has grown at an estimated rate of 10–12 percent per annum since 1980. This growth rate is expected to accelerate as the baby-boom generation moves into the 35–55-year-old age bracket"; "As indicated by the following chart, many of the artists whose works [in the last five years] sold for over $1 million are not well known to the general public" [there then follows a list that includes works by Giacometti, Léger and Dante Gabriel Rossetti]; "Probably the most important factor behind the boom in the art market is the incredible growth in the number of wealthy individuals that has taken place over the last five years. During this period, the number of American households with total money income of $75,000 per annum or more has increased 171 percent from 2.1 million in 1982 to 5.7 million in 1987. . . . According to the Affluent Market Institute, in 1987 there were an estimated 1.2 million millionaires in the United States"; "By combining both the *Forbes* and *Fortune* results [survey of wealthy people], we can identify 480 individuals [worldwide] with an aggregate net worth of $420 billion and an average net worth of $875 million. *Thus, the entire auction market for fine arts amounts to only half of one percent of the combined net worth of these 480 individuals and an individual painting which sells at auction for $53.9 million (Van Gogh's Irises) amounts to 6.2 percent of the average net worth of these super-affluent individuals"* (their italics); "The new breed of megamillionaires are diversifying their wealth and using it to buy things like works of art"; "During the past thirteen years, art has been an exceptional investment vehicle. During the past 13 years, the average work of art tracked by Sotheby's Art Index has appreciated in value at a compound annual rate of 15.5 percent. During the past five years, the growth rate has accelerated to 19.7 percent per annum. During this thirteen-year period, there was only one year in which the Sotheby's Art Index declined (1981) and that decline was modest (less than 5 percent). The dynamics of the art market are fairly simple—an ever-growing number of collectors willing and able to pay large sums of money for a relatively fixed supply of high-quality works of art"; "The art market has successfully weathered every conceivable calamity over the past thirteen years"; "Today's auctions are social events, with standing-room crowds. The spectacle of celebrities and megamillionaires competing for one-of-a-kind works of art is irresistible" (*sic*); "New categories of art. The company has recently entered new collecting fields where the supply of merchandise is abundant and growing. . . . A Sotheby's sale of Scottish paintings in August 1988 brought over

$3 million, and this pattern is being repeated with the works of artists from Canada, Australia, Scandinavia, Russia, Austria, Spain, and many other countries."

━━

It is worth recalling, in the first place, that within a year of the publication of this report, the art market took a dive south from which, at the time of writing (summer 1992), it has yet to recover. So much for Alex Brown's investment advice. We will skip over the bad spelling in the report and the contradictory statements (the supply of art is relatively fixed vs. new and abundant areas are being opened up all the time) and concentrate instead on its tone. Throughout, art is an investment vehicle and nothing more. It is "merchandise," a score on the *Art Market Index,* a media event, a function of net worth. The report is incredibly bright-eyed and bushy-tailed (the whole *world* is on a collecting boom!), but there is no place for scholarship in this document, no concern with merit. That Sotheby's pushes Scottish paintings is quite all right, as long as Scottish paintings sell, irrespective of whether there is any merit in the enterprise. To Alex Brown it is an apparent source of comfort that "unknown" artists like Giacometti, Léger and Rossetti sell for more than a million dollars. This is tantamount to saying that the market is so blue-chip that you can invest in stocks you know nothing about and still make money.

This is surely one of the most cynical, *louche* documents ever produced in the history of the art market. Price and value are completely divorced. In effect, art prices have become a function of the number of millionaires in the world, rather than of the quality of the art. This is not to say that auction houses, or dealers, should ignore millionaires, but simply that the Brown report on Sotheby's seems to consecrate a process that has been going on for some time, although the salesrooms have tried to avoid admitting the fact . . . that in the art market today the tail is wagging the dog. High prices define what is great art, not the other way around.

But the Brown report also highlights one final point in a dramatic way. It shows that the price of *Irises,* $53.9 million, represents 6.2 percent of the average net worth of the 500 richest people in the world. The same document defines "wealthy," in U.S. terms, as households with an annual income of $75,000 and a net worth of $2 million. It is worth pointing out that 6.2 percent of $2 million is $124,000, which puts into perspective the cost of a van Gogh for a megamillionaire. It is a lot of money but by no means out of sight.

This is an important point to end on, for it shows what the British dealer Leslie Waddington has long claimed, that high prices which astonish the rest of us are by no means so astounding at this very top level of wealth. Where

the fault lies is in the almost inevitable way such *medama* prices, aided by the herd instinct generated by the salesrooms, drag all other prices out of kilter, so that value and price become, for a time, divorced. But this has happened before, in the nineteenth century, in the five years to 1914, and in the five years to 1929. In the five years to 1990 it has simply happened on a grander scale.

Perhaps that's what an art boom *means,* that the best works set record levels and second-rate works sell for far more than they are worth. Perhaps that is why art booms always end up being so unpopular: the majority of people pay over the odds and never get their money back.

There is, in truth, no simple answer to the conundrum regarding art and (high) prices. Price has been an integral—yes, integral—aspect of art for hundreds of years, a measure of both the passions and the chicanery that surround this whole area of human creativity. I have tried to describe this aspect, not to characterize auctioneers or dealers or collectors as either heroes or villains in this particular drama, but in the hope that I could give shape to a field where, as far as I was concerned, there was none before. If you will, it is a tentative attempt at scholarship.

Mitchell Kennerley liked to say, "Without books, God is silent." Without scholarship, I believe, the art market is rudderless. But scholarship is not, of course, a complete answer. The great figures in art market history—Durand-Ruel, Seligmann, the Wildensteins, the Gimpels, Vollard, Kahnweiler and a host of more recent figures—all knew that the art world, like life in general, is untidy and imperfect; and that beauty both is and is not a commercial concept.

APPENDIX A

WORLD RECORD PRICES PAID FOR WORKS OF ART

(With Their Present-Day Equivalents)

Date		Price in British Pounds	Equivalent Price Now in U.S. Dollars
1715	*The Seven Sacraments* Poussin	685	121,680
1717	*Vision of Saint Roche* Annibale Carracci	840	149,214
1727	*The Raising of Lazarus* Sebastiano del Piombo	960	184,912
1736	*The Holy Family* Van Dyck	1,400	269,664
1746	*The Magdalen Reading* Correggio (now regarded as a school piece)	6,500	1,237,108
1754	The Sistine Madonna Raphael	8,500	1,617,756
1808	The Altieri Claudes (a pair) Claude Lorrain	12,600	959,243
1814	*The Raising of Lazarus* Sebastiano del Piombo (offered by Louvre)	10,000	683,215

Date		Price in British Pounds	Equivalent Price Now in U.S. Dollars
1816?	*The Raising of Lazarus* Sebastiano del Piombo (offered by Beckford)	13,000	1,088,136
1824	*The Raising of Lazarus* Sebastiano del Piombo (bought by National Gallery, London)	8,000	752,340
1836	The Alba Madonna Raphael	14,000	1,381,613
1852	*The Immaculate Conception* Murillo	24,600	2,934,970
1885	The Ansidei Madonna Raphael	70,000	7,720,639
1901	The Colonna Altarpiece Raphael	100,000	10,466,276
1906	The Cattaneo Portraits Van Dyck	103,300	10,754,459
1911	*The Mill* Rembrandt	103,300	10,423,552
1913	The Panshanger Madonna Raphael	116,500	11,461,619
1914	The Benois Madonna Leonardo da Vinci	310,400	30,629,973
1921	*The Blue Boy* Gainsborough	148,000	6,196,035
1929	Larger Panshanger Madonna Raphael	172,800	9,382,219
1931	*The Adoration of the Magi* Botticelli	173,600	10,130,064
1931	The Alba Madonna Raphael	240,800	14,051,379
1940	*The Three Maries* Van Eyck	300,000	13,902,449

87. *Extreme Unction*, by
Nicolas Poussin, from
"The Seven Sacraments."
(Visual Arts Library)

88. *The Holy Family
(Rest on the Flight to Egypt)*,
by Anthony Van Dyck.
(Hermitage, St. Petersburg)

89. *Vision of Saint Roche*, by
Annibale Carracci. (Dresden,
Gemäldegalerie)

90. *The Raising of Lazarus*,
by Sebastiano del Piombo.
(National Gallery, London)

91, 92. The Altieri Claudes: *The Landing of Aeneas* and *The Father of Psyche Sacrificing at the Temple of Apollo*, by Claude Lorrain. (The National Trust)

93. *The Magdalene Reading*, by Correggio. (The Mansell Collection)

94. *The Immaculate Conception*, by Murillo. (Museo del Prado, Madrid)

95. The Ansidei Madonna, by Raphael.
(National Gallery, London)

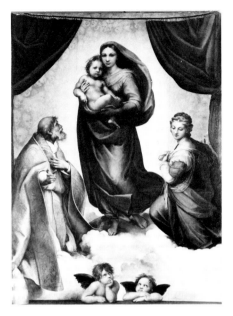

96. The Sistine Madonna, by Raphael.
(Staatliche Kunstsammlungen, Dresden)

97. The Alba Madonna, by Raphael.
(National Gallery of Art, Washington, D.C.)

98. The Colonna Altarpiece: *Madonna and Child Enthroned with Saints,* **by Raphael.** (Metropolitan Museum of Art, Gift of J. Pierpont Morgan, 1916)

99, 100, 101. The Cattaneo Portraits, by Anthony Van Dyck, 1623: *Marchesa Elena Grimaldi, Wife of Marchese Nicola Cattaneo; Filippo Cattaneo, Son of Marchesa Elena Grimaldi; Clelia Cattaneo, Daughter of Marchesa Elena Grimaldi.* (National Gallery of Art, Washington, D.C., Widener Collection)

102. *The Mill,* by Rembrandt, ca. 1605. (National Gallery of Art, Washington, D.C., Widener Collection)

103. The Niccolini-Cowper Madonna (Panshanger Madonna), by Raphael, 1508. (National Gallery of Art, Washington, D.C., Andrew W. Mellon Collection)

104. The Benois Madonna, by Leonardo da Vinci, 1478. (Hermitage, St. Petersburg/ Photo: Novosti)

105. *The Blue Boy,* by Thomas Gainsborough. (Huntington Library)

106. *The Adoration of the Magi,* by Botticelli, early 1480s. (National Gallery of Art, Washington, D.C., Andrew W. Mellon Collection)

107. *Ginevra de' Benci (Portrait of a Lady),* by Leonardo da Vinci, ca. 1474. (National Gallery of Art, Washington, D.C., Ailsa Mellon Bruce Fund)

108. *Juan de Pareja,* **by Velázquez.**
(Metropolitan Museum of Art, New York)

109. *Aristotle with a Bust of Homer,* **by Rembrandt.** (Metropolitan Museum of Art, New York)

110. The Merode Tryptych, now *Triptych of the Annunciation,* **with Joseph in his workshop and kneeling donors, by Robert Campin.** (Metropolitan Museum of Art, New York)

111. *Portrait of a Young Woman,*
by Vermeer. (Metropolitan Museum of Art, New York)

112. The Gospels of Henry the Lion. (Sotheby's)

113. A pair of pear-shaped diamond earpendants, D-flawless. (Sotheby's)

114. *Juliet and Her Nurse,* **by J.M.W. Turner, 1836.** (Private collection)

115. *Seascape: Folkestone,* **by Turner.** (Photo: Prudence Cuming Associates Ltd.)

116. *The Adoration of the Magi*, by Andrea Mantegna, ca. 1495–1505. (The J. Paul Getty Museum, Malibu, California)

117. *Irises*, by Vincent van Gogh, 1889. (The J. Paul Getty Museum, Malibu, California)

118. *Sunflowers (Les Tournesols)*, by Vincent van Gogh. (Christie's)

Date		Price in British Pounds	Equivalent Price Now in U.S. Dollars
1957	Merode Triptych Master of Flémalle (reputed price)	303,500	6,501,032
1959	*Portrait of a Young Woman* Vermeer	400,000 (approx.)	8,270,954
1961	*Aristotle with a Bust of Homer* Rembrandt	821,428	16,257,201
1970	*Juan de Pareja* Velázquez	2,310,000	32,286,508
1980	*Juliet and Her Nurse* Turner	2,700,000	9,351,008
1980	D-Flawless Diamond Earpendants	2,825,000	9,783,925
1983	The Gospels of Henry the Lion	8,140,000	24,818,322
1984	*Seascape: Folkestone* Turner	7,370,000	21,404,023
1985	*The Adoration of the Magi* Mantegna	8,100,000	22,174,981
1987	*Sunflowers* van Gogh	24,750,000	62,903,106
1987	*Irises* van Gogh	30,111,731	76,530,158
1990	*Portrait of Dr. Gachet* van Gogh	43,107,142	88,533,285

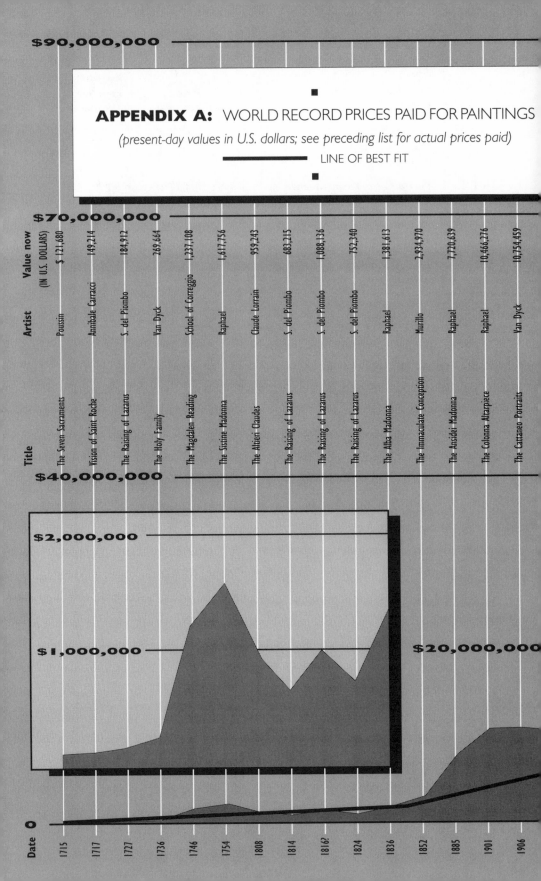

APPENDIX A: WORLD RECORD PRICES PAID FOR PAINTINGS

(present-day values in U.S. dollars; see preceding list for actual prices paid)

LINE OF BEST FIT

Year	Price	Title	Artist
1914	30,629,973	The Benois Madonna	Leonardo da Vinci
1921	6,196,035	The Blue Boy	Gainsborough
1929	9,382,219	Larger Panshanger Madonna	Raphael
1931	10,130,064	The Adoration of the Magi	Botticelli
1931	14,051,379	The Alba Madonna	Raphael
1940	13,902,449	The Three Maries	Van Eyck
1957	6,501,032	Merode Triptych	Master of Flémalle
1959	8,270,954	Portrait of a Young Woman	Vermeer
1961	16,257,201	Aristotle with a Bust of Homer	Rembrandt
1970	32,286,508	Juan de Pareja	Velázquez
1980	9,351,008	Juliet and Her Nurse	Turner
1984	21,404,023	Seascape: Folkestone	Turner
1985	22,174,981	The Adoration of the Magi	Mantegna
1987	62,903,106	Sunflowers	van Gogh
1987	76,530,158	Irises	van Gogh
1990	88,533,285	Portrait of Dr. Gachet	van Gogh

APPENDIX B

THE REAL VALUE OF PAINTINGS IN HISTORY: AN INDEX TO CONVERT PRICES IN THE PAST TO PRESENT-DAY VALUES

DR. B. R. MITCHELL
Fellow of Trinity College, Cambridge

All composite indices of prices are impressionistic in the sense that whilst they may appear to offer precision they are inevitably unable to do more than give an impression of the movement of prices "in general" (or, to put it in another way, of the "value of money") over time. An index of the price of a precisely-defined commodity, such as wheat or forge pig iron, can, of course, be precise. But how many precisely-defined commodities do any of us buy—and, more important, go on buying over a substantial period of time? Even the bread and meat which we eat has changed in quality over a normal lifetime; the fuel that we burn has changed in forms and proportions; we travel by different means; and the iron we now use has been converted into different things, and often combined with other materials of recent invention into goods that were unavailable to our grandparents and parents. In the extreme case they were not available yesterday.

There is no need to labour the point further. Just let us be aware that in trying to assess the "real" cost of Impressionist and other paintings, all we can hope to do is to convey some idea of how the value of the money which bought them has changed from time to time—not provide a foolproof answer. To do this as perfectly as may seem to be possible it would be necessary to know what goods and services the average buyer of such paintings purchased at different times, and in what amounts. Simply to say this is to reveal the impossibility of achieving such perfection. How are we to define the average buyer of Impressionists? How are we to determine what goods and services he or she bought at different times?

Perhaps we could finesse the problem by arbitrarily assuming that buyers of paintings are always well-to-do, and that the rich are the main purchasers of certain reasonably well-defined imported luxuries, such as silk cloth and wines, for which price data are available, and that they also are the main payers of servants' wages. But such a list is very far from complete and is dubiously

representative of the well-to-do in general. Indeed, the variety of purchases open to the rich, coupled with the vast variety of tastes, makes it impossible to devise any index which has a good claim to be representative; and an index which was composed of wine, silk, brandy, servants' wages, and any number of other more or less luxurious items could hardly claim to convey a better impression of the value of money to buyers of paintings than the standard retail price index—for recent decades at any rate.* For whilst it is fairly certain that the weights accorded to various goods and services would be different for the rich than for other groups in society, there is no way of knowing exactly what they should be; and it is at least apparent that the different courses of prices in individual categories of consumers' expenditure have tended to offset each other—though how perfectly is unknowable. For example, it is probable that a higher proportion of the expenditures of the rich are on services and on transportation than is the case with the average consumer, and these items have had respectively a higher and a lower than average increase in their prices over the years.

On balance, then, it seems reasonably safe to conclude that the ordinary retail price index (RPI) will give as good an impression of the "real" value of paintings as any other indicator that we could devise, at least back to 1956, when the basis of that index became *average* consumption expenditure rather than, as previously, working-class household budgets. Before that date, there clearly would be a considerable loss of representativeness for our purpose in continuing to use the retail price index. Fortunately, however, Professor C. H. Feinstein has produced an index of the average value of consumption expenditures in the course of his definitive work on British national accounts since 1855.† In principle this comes quite close to the post-1956 RPI, for it relates the average value of *all* consumers' expenditures in any year to such expenditures in the base-year. This means that, like the modern RPI, it does not relate to the well-to-do in particular. But it is certainly likely to come closer to representing their outlays than are the predecessors of today's RPI, which were known until after the Second World War as the "Working Class Cost-of-Living Index." The table which follows has accordingly spliced together Professor Feinstein's index and the Retail Price Index at the year 1956, whilst continuing to use the former's base-year, 1913. It will give some idea of the difference between this combined index and the cost-of-living index to say that the value of the latter in 1956 would be 305 rather than 443 (implying a figure for 1989 of 3058 instead of 4376). This is far from negligible, and indicates that in the period 1913–56, prices "in general" rose by a good deal more than the prices of the conventional necessities which loom large in working-class budgets.

The year 1913 has been chosen as the base-year for two reasons. The first is a technical one, namely that, as Professor Feinstein says in a footnote to his index,

*As an experiment, an index of the after-tax price of French brandy was constructed for the beginning and end of the period covered here, with 1913 = 100 as the base. The value of the index was 82 for 1870 and 3772 for 1988. Not *very* different from the actual index used.

†C. H. Feinstein, *National Income, Expenditure and Output of the United Kingdom 1855–1965* (Cambridge, 1972), Table 132–Table 135.

Prices of Consumers' Goods and Services in Britain, 1870–1992

1913 = 100

1870	96.0	1911	97.5	1952	393.1
1871	97.6	1912	100.4	1953	401.1
1872	102.1	1913	100	1954	408.9
1873	105.3	1914	99.7	1955	423.4
1874	101.8	1915	112.3	1956	442.8
1875	99.6	1916	132.5	1957	459.3
1876	99.6	1917	166.0	1958	473.2
1877	98.8	1918	202.5	1959	475.8
1878	96.6	1919	222.9	1960	480.6
1879	92.3	1920	257.2	1961	497.1
1880	95.3	1921	235.0	1962	510.0
1881	94.2	1922	202.2	1963	520.1
1882	95.2	1923	190.0	1964	537.2
1883	94.7	1924	188.5	1965	562.8
1884	92.0	1925	189.2	1966	584.9
1885	89.2	1926	187.8	1967	599.5
1886	88.0	1927	183.2	1968	627.6
1887	87.4	1928	182.8	1969	661.7
1888	88.0	1929	181.2	1970	703.9
1889	89.3	1930	176.2	1971	770.2
1890	89.4	1931	168.6	1972	824.9
1891	89.3	1932	164.3	1973	900.7
1892	89.5	1933	160.9	1974	1044.7
1893	89.0	1934	160.7	1975	1298.0
1894	88.2	1935	161.8	1976	1512.8
1895	87.2	1936	163.0	1977	1752.6
1896	86.9	1937	168.6	1978	1898.0
1897	88.1	1938	171.2	1979	2152.2
1898	88.4	1939	182.1	1980	2840.7
1899	88.9	1940	212.3	1981	2840.7
1900	93.6	1941	235.3	1982	3085.3
1901	94.0	1942	252.3	1983	3226.8
1902	94.1	1943	260.7	1984	3387.6
1903	94.3	1944	267.7	1985	3593.7
1904	94.2	1945	275.4	1986	3716.0
1905	94.5	1946	284.0	1987	3871.0
1906	94.5	1947	304.2	1988	4060.9
1907	95.7	1948	323.1	1989	4376.2
1908	96.0	1949	330.5	1990	4790.3
1909	96.6	1950	371.0	1991	5064.0
1910	97.4	1951	371.0	1992	5318.0

it is a "currently weighted average value" one, and as a result "any comparisons between any pair of years not including the base-year may be affected by changes in weights."* The second reason is that 1913 was the last year of the long period of relatively stable prices in Britain, which lasted from the return to the gold standard after the Napoleonic Wars to its de facto suspension at the outbreak of the First World War. It may therefore be regarded as, in some sense, the benchmark year for measuring subsequent instability of prices.

It is perhaps necessary to point out that expressing the combined index to one place of decimals should not be taken to imply a corresponding degree of accuracy. It is so expressed merely for the convenience of anyone who wishes to manipulate the figures further. The limit of what the table enables us to say is, for example, that the value of the money which was used to buy paintings in Britain in 1989 was approximately half of what the same nominal sum had been worth in 1979. One can pursue this theme further, and note that the previous halving of the value of money took a mere five years, whilst the one before that took just over a decade and the one previous to that took almost twice as long. Prior to that, one can say that if the index is graphed, its shape from shortly after the First World War until the middle of the Second is that of a fairly shallow saucer. The same description applies to the period from the early 1870s to 1914, whilst the experience of the First World War and its immediate aftermath was of almost as fast a rate of rise of prices as in the later 1970s. There are, of course, other ways in which the table can be used to compare values over the years. Perhaps for the layman the most vivid way of encapsulating the message of the table is to note that, in general terms, it took £1 in 1989 to buy what in the half-century before the First World War cost between 5.5d and 7d (3.1 to 3.8 new pence). Or to put it the other way round, £1 million in 1913 would be worth roughly £53 million at the time of writing this (mid–1990).

It is not possible to construct a similar price index covering the whole period for the United States of America, or, for that matter, any other major country. However, a rough idea of the different experience with prices of France and the United States can be gathered by splicing together the various indices of consumer prices shown in the appropriate volumes of historical statistics,† continuing them to the later 1980s from the same original sources, and putting them onto a 1913 = 100 basis. The following short table does this, and suggests that the long-run amplitude of price movements was appreciably less in the United States both before and after the wars of the first half of the twentieth century. There the price level *fell* by over a quarter between 1870 and 1913, rose by about half as much as in Britain between then and 1939, and by less than half the British rate

*Feinstein, *National Income*, p.T.135.

†B. R. Mitchell, *European Historical Statistics* (London, 3rd edition, 1992) and *International Historical Statistics: The Americas and Australasia* (London, 1983).

in the following fifty years. French experience, on the other hand, was—not surprisingly—much the same as Britain's during the gold standard period, but then went on to a rate of inflation nearly ten times the British rate during and after the First World War, and much higher still after 1939—though not, it should be noted, after the currency conversion (the *nouveau franc*) of 1958.

Consumer Price Indices, France and the United States (1913 = 100)

	France	United States
1870	93	128
1939	732	141
1987	14000*	1145

*This figure does not take account of the 1958 currency conversion, when a new franc was issued equal to one hundred old francs.

NOTES

Author's Note

p. xxi: The Sickert swimming story is recounted by Osbert Sitwell in *Walter Sickert: A Free House, or the Artist as Craftsman.*

Preface: Beauty as a Commercial Concept

p. xxiv: See William Grampp, *Pricing the Priceless: Art, Artists, and Economics.* Chap. 1, "Art and Economics Reconciled," pp. 15ff., discusses the anti-market mentality in hilarious detail, and it is from this that many of the quotations (Renoir, Duchamp, Wordsworth, etc.) are taken. For a still wider discussion, see: "The Ideal Collector," *Connoisseur* 5, p. 30; "Collecting as an Investment, with Tables of Prices Paid and Realized," *Connoisseur* 7, p. 44; "The Old and New Collector," *Connoisseur* 8, pp. 56–57; "Accumulation and Collecting: An Anthropological Perspective," *Art History* 9, pp. 73–83; "Cost and Value in Seventeenth-Century Dutch Art," *Art History* 10, pp. 455–66. Émile Zola, *L'Oeuvre,* published in English as *His Masterpiece,* p. 32.

p. xxiv: Rembrandt's love of money . . . see Svetlana Alpers, *Rembrandt's Enterprise,* chap. 4, "Freedom, Art and Money," especially pp. 94–109.

p. xxiv: Sodoma, Perugino and Reynolds . . . see Grampp, *op. cit.,* p. 83.

p. xxvi: How artists rise to fame . . . Sir Alan Bowness, *The Conditions of Success.*

p. xxvii: For an entertaining account of Willi Bongard's research, see Grampp, *op. cit.,* pp. 32–34. The most accessible form of his complete research is probably Bongard, "Kunstkompass 1976, Il listino valori dei cento artisti pui famosi degli anni '60 e '70."

p. xxvii: "Pocket-mouthed Meg" . . . see W. A. Baillie-Grohman, "A Portrait of the Ugliest Princess in History."

1 | Selling *Dr. Gachet*

p. 3: The interviews with Christie's staff were carried out at the company's premises in New York between May 9, 1990, and June 11, 1990.

p. 5: Details of Siegfried Kramarsky, Kramarsky family, and the contract with Christie's . . . interview with Werner Kramarsky, New York City, June 11, 1990.

p. 7: Details of *Dr. Gachet* . . . Anne Distel, *Impressionism: The First Collectors,* pp. 195–206.

p. 7: Van Gogh's relation with Gachet and his views on portrait painting . . . Matthew Armstrong, " 'Gachet is very, yes, very like you and me': Portrait du Dr. Gachet."

p. 10: Manet's *Le Banc (Le Jardin de Versailles)* appears on page 459 of John Rewald's *History of Impressionism.*

p. 10: The Bond-Getty deal was first floated in the *Los Angeles Times* on January 12, 1990, but was not confirmed until March 22.

p. 14: The story of how the Yasuda Fire and Marine Insurance Company was first introduced to *Sunflowers* was originally told by John Herbert in *Inside Christie's,* pp. 366–68.

p. 24: Hideto Kobayashi was interviewed in Tokyo, November 21, 1990. Kazuo Fujii was interviewed in Tokyo on November 21 and 22, 1990.

p. 26: Ryoei Saito, "No big deal" . . . *The New York Times,* May 18, 1990.

2 | "This Painful Subject . . . the Ruinous Tendency of Auctioneering"

p. 31: For Kirby and the early days, I have relied mostly on Wesley Towner, *The Elegant Auctioneers.* This book was completed by Stephen Varble after Mr. Towner's death. For the events of 1882–83 see pp. 40ff. J. P. Gutelius . . . Towner, *op. cit.,* pp. 36–37.

p. 32: The anti-auction committee . . . *ibid.,* p. 38.

p. 32: Auctioneering and the Napoleonic wars . . . Brian Learmount, *A History of the Auction,* pp. 30ff.

p. 32: The auction wars . . . *ibid.,* pp. 81ff. James Sutton . . . Towner, *op. cit.,* p. 39.

p. 34: The events of 1883 in New York . . . Sotheby's, *One Hundred Years of Collecting in America;* and Towner, *op. cit.,* pp. 43–44.

p. 34: Andrew Carnegie and others helping with prizes . . . Towner, *op. cit.,* p. 46.

p. 35: George Ingraham Seney . . . *ibid.,* pp. 50ff.

p. 35: Samuel Avery . . . John Walker, *Experts' Choice: One Thousand Years of the Art Trade,* pp. 163 and 176. See also Madeleine Fidell-Beaufort, "A Measure of Taste: Samuel P. Avery's Art Auctions, 1864–1880."

p. 36: The *Evening Post*'s libels . . . Towner, *op. cit.,* pp. 59–60.

p. 36: The Seney sale . . . *ibid.,* pp. 61–64.

p. 37: Sutton and the Impressionists . . . *ibid.,* p. 65.

p. 38: The Hamilton Palace sale . . . Frank Herrmann, *The English as Collectors: A Documentary Chrestomathy,* pp. 348–52. (Cited hereafter as Herrmann, *English.*)

p. 38: James Christie . . . Percy Colson, *A Story of Christie's,* pp. 1–18; and Peter Watson, *Wisdom and Strength: The Biography of a Renaissance Masterpiece,* pp. 233–38.

p. 38: Beckford . . . Herrmann, *English,* pp. 210–17.

p. 39: George Redford on the Hamilton Palace sale . . . *ibid.,* p. 249.

p. 40: Sotheby's sells the Hamilton Palace books at the same time . . . Frank Herrmann, *Sotheby's, Portrait of an Auction House,* pp. 73–80. (Cited hereafter as Herrmann, *Sotheby's.*)

p. 40: The Settled Lands Act . . . Herrmann, *Sotheby's,* pp. 69–70.

p. 41: Aristocratic collections on the market . . . *ibid.,* pp. 83–84.

p. 42: For the details about Manet . . . Theodore Reff, *Manet and Modern Paris: One Hundred Paintings, Drawings, Prints and Photographs by Manet and His Contemporaries,* pp. 13–32; and John Rewald, *The History of Impressionism,* pp. 52–69.

p. 43: Wagner and Renoir . . . Rewald, *Impressionism,* p. 461. The Impressionists' seventh group show . . . *ibid.,* pp. 470–71.

3 | Outroping, Sales by Candle, and Mr. Colnaghi's Levee:
The Early Years of the Art Market

p. 45: William Wethered's invoices . . . Jeremy Maas, *Gambart, Prince of the Victorian Art World,* p. 44.

p. 46: Herodotus's account of the Babylonian marriage market . . . Learmount, *History of the Auction,* pp. 5–6.

p. 46: Roman practices . . . *ibid.,* pp. 7–11; Damasippus . . . Walker, *Experts' Choice,* p. 14. See also: Raymond Chevallier, *L'Artiste, le collectionneur et le faussaire;* H. Bardon, "Sur le goût de Cicéron à l'époque des verrines"; F. Coarelli, "Il commercio delle opere d'arte in età tardorepubblicana"; J. Hatzfield, *Les Trafiquants italiens dans l'Orient hellénique;* J. B. Ward-Perkins, "The Marble Trade and Its Organisation"; A. Giuliano, *Il commercio dei sarcofagi attici.*

p. 47: The Antwerp Pand . . . Dan Ewing, "Marketing Art in Antwerp, 1460–1560: Our Lady's *Pand,*" *Art Bulletin* 72, no. 4 (December 1990), pp. 558–84.

 Dutch pictures produced "on spec" . . . "The Art Market in the South Netherlands in the Fifteenth Century," *Burlington Magazine* 118, pp. 188ff. Jacopo da Strada . . . Walker, *op. cit.,* p. 32; also: Dirk Jacob, "Jacopo Strada et le commerce d'art"; Peter Watson, *Wisdom and Strength,* pp. 33–34.

p. 47: French create *huissiers-priseurs* . . . Paul Guillaumin, *Drouot Hier et*

Aujourd'hui, p. 16; the sales move in Paris . . . Michel Beurdeley, *Trois siècles de ventes publiques,* pp. 13–14. For scholars: Paul Eudel, *L'Hôtel Drouot.*

p. 48: Sale by candle . . . Learmount, *op. cit.,* pp. 17ff. Pepys . . . *ibid.,* p. 17. Covent Garden piazza and its auction houses . . . Iain Pears, *The Discovery of Painting: The Growth of Interest in the Arts in England, 1680–1768,* p. 147; originally in George Vertue, *The Notebooks of George Vertue* 2, p. 133.

p. 48: "Mineing" . . . Learmount, *op cit.,* pp. 21–22. 50,000 paintings flood into Britain . . . Pears, *op. cit.,* pp. 52–53.

p. 49: The art market in the Netherlands . . . the publications by John Michael Montias are *Artists and Artisans in Delft: A Socio-Economic Study of the Seventeenth Century* and "Reflections on Historical Materialism, Economic Theory and the History of Art in the Context of Renaissance and Seventeenth-Century Painting."

p. 49: Rembrandt . . . Svetlana Alpers, *Rembrandt's Enterprise,* especially pp. 100ff.

p. 49: Montias's research . . . *Artists and Artisans.*

p. 50: Boschini and Ridolfi on collections in the Veneto . . . Krzysztof Pomian, *Collectors and Curiosities,* pp. 106ff.

p. 50: Artist-dealers . . . *ibid.,* pp. 109–20.

p. 51: Importation of pictures into Britain . . . Pears, *op. cit.,* 101–105.

p. 51: The virtuoso . . . *ibid.,* pp. 182ff. Grand tours . . . *ibid.,* pp. 68–69. Lord Fauconberg, etc. . . . *ibid.,* pp. 136, 242.

p. 52: Thomas Manby . . . *ibid.,* pp. 72, 77. James Graham . . . *ibid.,* pp. 72, 77, 102. Isaac Colivoe, etc., . . . *ibid.,* pp. 61–62.

p. 52: Andrew Hay . . . *ibid.,* pp. 77–87. Albini and spies . . . Lesley Lewis, *Connoisseurs and Secret Agents in Eighteenth-Century Rome.* Gavin Hamilton . . . Pomian, *op. cit.,* pp. 216–17; also, C. A. Levi, *Le collezioni veneziane d'arte e d'antichità del secolo XVI ai nostri giorni;* "Gavin Hamilton: Archaeologist, Painter, Dealer," *Art Bulletin* 44 (1962), pp. 87ff.

p. 53: Samuel Paris . . . George Vertue, *The Notebooks of George Vertue* 5, p. 13; and Pears, *op. cit.,* pp. 87–92.

p. 53: Attempt to corner the market in 1758 . . . see annotated Victoria and Albert copy of Van Haecken sale catalogue, MS 86-00-18/19 (J. Houlditch), 1711–1758.

p. 53: Samuel Foote's play . . . Samuel Foote, *Taste* (first edition, 1752), in *The Dramatic Works of Samuel Foote* 1. Number of auctions and the 1740s boom . . . Pears, *op. cit.,* pp. 101ff; also Horace Walpole, *Letters* 24, p. 441. Delmé's Poussins . . . Pears, *op. cit.,* p. 247, n. 139.

p. 54: Harenc collection, etc. . . . annotated sale catalogue (Langford, March 1, 1964), print room, Rijksmuseum, Amsterdam; and Pears, *op cit.,* p. 249, n. 174.

p. 54: Portrait painting and Reynolds's appointments book . . . Marcia Pointon, "Portrait Painting as a Business Enterprise in London in the 1780s." Arthur Pond . . . for this section see Louise Lippincott, *Selling Art in Georgian London: The Rise of Arthur Pond.*

p. 56: Lebrun . . . Watson, *op. cit.,* pp. 229–31; Francis Haskell, *Rediscoveries in Art: Some Aspects of Taste, Fashion and Collecting in England and France,* pp. 26–38; Élisabeth Vigée-Lebrun, *Souvenirs.*

p. 56: Outroping . . . Learmount, *op. cit.,* p. 16; also *Notes and Queries,* 5.12.95.

p. 57: Edward Millington and other early auctioneers . . . Pears, *op. cit.,* pp. 60–63.

p. 57: Upholders . . . *ibid.,* pp. 63–64, 101–102.
Christopher Cock . . . *ibid.,* pp. 59–65; also William Stukeley, *The Family Memoirs of the Rev. William Stukeley,* vol. 3, for the Walpole sale at Cock's rooms.

p. 58: Early Paris activity . . . Guillaumin, *op. cit.,* pp. 16ff; P. Savary, *Dictionnaire Universelle de Commerce;* Pomian, *op. cit., passim.* W. McAllister Johnson, "Paintings, Provenance and Price: Speculation on Eighteenth-Century Connoisseurship Apparatus in France." Colin Bailey, "Lebrun et le commerce d'art pendant le blocus continental."

p. 58: Mariette and Gersaint . . . Pomian, *op. cit.,* pp. 147–48.

p. 59: Grimm's pictures . . . *ibid.,* p. 161.
Lazare-Duveaux earnings . . . Gerald Reitlinger, *The Economics of Taste,* vol. 2, pp. 22–36; Walker, *op. cit.,* p. 81.

p. 59: Samuel Baker . . . Herrmann, *Sotheby's,* pp. 2–12. James Christie . . . Percy Colson, *A Story of Christie's,* pp. 1–18.

p. 60: Stewart, Wheatley and Adlard . . . Herrmann, *Sotheby's,* p. 16n.

p. 61: Phillips and Beau Brummel . . . Basil Boothroyd, *Phillips 1796–1974,* no pagination (ca. p. 5).
Hôtel Bullion . . . Guillaumin, *op. cit.,* pp. 59–61. Sébastien Mercier and the "Bande Noire" . . . "Drouot and Auction Rooms in Paris before and after the Revolution," *Connoisseur* 3, pp. 235ff.

p. 61: Christie's move premises . . . Learmount, *op. cit.,* pp. 110ff.

p. 62: The Orléans and other collections cross to Britain . . . Denys Sutton, "The Orléans Sale"; also Francis Haskell, *op. cit.,* pp. 39–44.
William Buchanan . . . Hugh Brigstocke, *William Buchanan and the Nineteenth-Century Art Trade.* Also William Buchanan, *Memoirs of Painting.*

p. 62: Irvine and Wallis . . . Brigstocke, *op. cit.,* 1–15 and *passim.*

p. 63: Michael Bryan . . . *ibid.,* p. 16; also, *Dictionary of National Biography.*

p. 64: George Leigh . . . Herrmann, *Sotheby's,* pp. 5–19.

p. 64: Political activities of *commissaires-priseurs* . . . Guillaumin, *op. cit.,* pp. 51ff. Clerks and criers . . . *ibid.,* p. 106.

p. 65: Robert Harding Evans . . . Herrmann, *Sotheby's*, pp. 30 and 35.

p. 65: Stowe sale . . . Herrmann, *Sotheby's*, pp. 38–40; also Herrmann, *English* pp. 274–79.

p. 66: "Golden age of the living painter" . . . Haskell, *op. cit.*, pp. 140ff.

p. 66: Gambart . . . Jeremy Maas, *Gambart.*
Arrowsmith and John Constable . . . *ibid.*, p. 49.

p. 66: Sir Francis Moon . . . *ibid.*, pp. 28–29 and 243.

p. 67: Denmark Street, Berners Street, etc. . . . *ibid.*, p. 34.

p. 67: "Canaletti manufactory" . . . *ibid.*, pp. 42–43.

p. 68: Exhibition mania . . . *ibid.*, pp. 48–61.

p. 68: Gambart, Goupil and Cadart in the United States . . . Lois Marie Fink, "French Art in the United States 1850–1870"; for Cadart see also Janine Bailly-Herzberg, *L'Eau-forte de peintre au dix-neuvième siècle: La Société des Aquafortistes, 1862–1867.* See also: "Art Collecting and Victorian Middle-Class Taste," *Art History* 10, pp. 328–50; "Art Dealing in the Risorgimento" (1 & 2), *Burlington Magazine,* vol. 115, pp. 44ff., and vol. 121, pp. 492ff. respectively; "London Sales, 1801–1843," *Burlington Magazine* 22, p. 112; Clive Wainwright, "Curiosities to Fine Art: Bond Street's First Dealers"; Nancy Davenport, "Armand Auguste Deforge: An Art Dealer in Nineteenth-Century Paris and 'la peinture de fantaisie.' "

p. 69: £5,000 and £10,000 commissions . . . Maas, *op. cit.*, pp. 120–22.
Colnaghi . . . D. Colnaghi and Co., *Colnaghi's 1790–1960.*

p. 71: Agnew . . . Sir Geoffrey Agnew, *Agnews, 1817–1967.*

4 | Paris in the Golden Age: Manet and the Birth of Modernism

p. 76: Haussmann and Napoleon . . . Reff, *Manet and Modern Paris,* pp. 13–23. Also, Maurice Allemand, *La Vie quotidienne sous le Second Empire;* Michael Fried, "Manet's Sources: Aspects of his Art, 1859–1865"; David Pinkney, *Napoleon III and the Rebuilding of Paris;* Eugenia Herbert, *The Artist and Social Reform;* Victor Fournel, *Paris nouveau et Paris futur;* "Courbet's Landscapes and Their Market," *Art History* 4, pp. 410–31.

p. 76: Café-concerts, etc., . . . Reff, *op. cit.*, pp. 73–94.

p. 77: Baudelaire's role . . . *ibid.*, pp. 23–28. Also Charles Baudelaire, "Le Peintre de la vie moderne" (1863), in *The Painter of Modern Life and other Essays,* trans. Jonathan Mayne.

p. 79: Estrangement, alienation, indifference . . . Reff, *op. cit.*, pp. 26–27.

5 | The Street of Pictures: Rue Laffitte and the First Dealers in Impressionism

p. 81: For this chapter, I have relied heavily on Distel, *Impressionism;* Ambroise Vollard, *Reflections of a Picture Dealer;* Rewald, *Impressionism;* L. Venturi, *Archives of Impressionism.* Note also: Nancy

Davenport, "Armand Auguste Deforge"; Monique Nonne, "Les Marchands de van Gogh"; "The First Impressionist Exhibition: Timing, Commerce and Patriotism," *Art History* 7, pp. 465–76.

p. 81: Durand-Ruel . . . Distel, *op. cit.*, pp. 21–32; also Venturi, *op. cit.*

p. 84: Père Malgras and Naudet . . . Zola, *L'Oeuvre*, p. 32.

Brame . . . Distel, *op. cit.*, pp. 35–36.

p. 85: Petit . . . *ibid.*, pp. 36–40 and *passim;* Rewald, *op. cit.*, pp. 419, 529–32 and 547–48.

p. 86: Bernheim-Jeunes . . . Distel, *op. cit.*, pp. 45–48.

p. 86: Theo van Gogh . . . John Rewald, *Studies in Post-Impressionism*, pp. 7–116.

p. 88: Alex Reid . . . Alex Reid, *Alex Reid and Lefèvre, 1926–1976*, pp. 3–26.

p. 89: Pierre-Firmin Martin . . . Distel, *op. cit.*, pp. 40–41. Rouart . . . *ibid.*, pp. 177–89.

p. 90: Père Tanguy . . . Distel, *op. cit.*, pp. 41–43; Rewald, *Impressionism*, pp. 556–58; Octave Mirbeau, "Le Père Tanguy"; Émile Bernard, "Julian Tanguy, dit le Père Tanguy"; Wayne Anderson, "Cézanne, Tanguy, Chocquet"; Vollard, *op. cit.*, pp. 488–51; Una Johnson, *Ambroise Vollard, Éditeur.*

p. 91: Renoir's letters to Bazille . . . Rewald, *Impressionism* pp. 120–21.

p. 91: Charles Pillet . . . Distel, *op. cit.*, pp. 53–55.

p. 92: Paul-Louis Chevallier . . . *ibid.*, p. 114; H. M. Milan . . . Vollard, *op. cit.*, p. 107.

p. 92: Duret . . . Distel, *op. cit.*, pp. 56–71.

p. 94: Jean-Baptiste Faure . . . *ibid.* pp. 75–93.

p. 96: Ernest Hoschedé . . . *ibid.*, pp. 95–107.

p. 97: Victor Chocquet . . . *ibid.*, pp. 125–39.

p. 98: The secondary circle of Impressionist collectors . . . *ibid.*, pp. 141–76; see also "Dealing in Temperaments: Economic Transformation of the Artistic Field in France during the Second Half of the Nineteenth Century," *Art History* 10, pp. 59–78.

p. 99: British collectors . . . Douglas Cooper, *One Hundred Years of Impressionism*, pp. 15–21; also "Early Buyers of French Impressionism in England," *Burlington Magazine* 108, pp. 141ff. For American collectors: René Brimo, *L'Évolution du goût aux États-Unis;* M. Fidell-Beaufort, H. L. Kleinfeld and J. K. Welcher, eds., *The Diaries 1871–1882 of Samuel P. Avery, Art Dealer;* L. M. Randall, ed., *The Diary of George A. Lucas: An American Agent in Paris, 1857–1909;* "The Status of the American Collector," *Burlington Magazine* 5, p. 335; "The Consequences of the American Invasion," *Burlington Magazine* 5, p. 353.

p. 100: Von Tschudi . . . Robin Lenman, "Painters, Patronage and the Art Market in Germany 1850–1914," p. 117.

Russian collectors . . . Distel, *op. cit.*, p. 51.

6 | The Barbizon Boom: Taste and Prices a Hundred Years Ago

p. 101: For this chapter, I have collected together prices and dates contained in: Venturi, *Archives of Impressionism;* Reitlinger, *Economics of Taste;* Rewald, *Impressionism;* Distel, *Impressionism;* Vollard, *Reflections of a Picture Dealer;* Pierre Assouline, *An Artful Life: A Biography of D. H. Kahnweiler, 1884–1979;* plus several other sources in which prices are given. The interpretation of these figures is, of course, my own.

p. 104: See the sources mentioned immediately above, plus Rewald, *Post-Impressionism* (for Theo van Gogh); Meret Bodelsen, "Early Impressionist Sales, 1874–1894, in the Light of Some Unpublished Procès-Verbaux."

7 | Siegfried Bing, Murray Marks and Their Oriental Friends

p. 107: Edmond de Goncourt . . . Goncourt sale . . . Beurdeley, *Trois siècles,* pp. 138–43.

p. 107: Cult of the East and the history of the ceramics trade . . . see Robert Charleston, ed., *World Ceramics;* D. F. Lunsingh Scheurleer, *Chinese Export Porcelain.* For Duveen and Orientalism, see Reitlinger, *Economics of Taste* 2. David Battie, ed., *Sotheby's Concise Encyclopaedia of Porcelain,* is also good on the trade in objects (especially pp. 29ff.).

p. 108: East India companies . . . Battie, *op. cit.,* p. 56.

p. 109: Père d'Entrecolles . . . *ibid.,* p. 58.
 The Americans move into China . . . *ibid.,* pp. 63–64.

p. 109: The Dutch in Japan . . . *ibid.,* pp. 57, 71; Oriental Ceramics Society, *Porcelain for Palaces: The Story of Old Japan in Europe.*
 Pompadour and Lazare Duveaux . . . Reitlinger, *op. cit.,* vol. 2, pp. 22–36.

p. 110: Missionaries in Canton . . . Battie, *op. cit.,* pp. 54–58; Reitlinger, *op. cit.,* vol. 2, pp. 62–65.

p. 110: Fukagawa and Arita . . . Battie, *op. cit.,* pp. 74ff; see also Oriental Ceramics Society catalogue cited above.
 Félix Bracquemond . . . G. C. Williamson, *Murray Marks and His Friends,* chap. 3.

p. 111: Parisian Oriental dealers . . . Gabriel Weisberg, *Art Nouveau Bing, Paris Style 1900,* pp. 16–17.

p. 111: Siegfried Bing . . . Weisberg, *op. cit., passim.*

p. 111: Van Gogh works for Bing . . . *ibid.,* p. 28.

p. 112: Bing in America . . . *ibid.,* pp. 32–40, 111–19.

p. 112: Whistler . . . see chap. 4 of G. C. Williamson, *Murray Marks and His Friends.*
 Murray Marks . . . Williamson, *op. cit.,* pp. 3–30.

p. 113: Marks's visiting card . . . *ibid.,* p. 14.
 Marks helps von Bode . . . *ibid.,* pp. 187–93.

p. 113: The "blue-and-white mania" . . . *ibid.,* pp. 31–50. Huth, Thompson, Grandidier, Salting etc. . . . *ibid.,* pp. 34–35.

The "Octave" dinners . . . *ibid.,* p. 37.

Marks, the Grosvenor Gallery and Constantine Ionides . . . *ibid.,* p. 99.

p. 114: For an introduction to Fenellosa, Morse and Bigelow . . . W. G. Constable, *Art Collecting in the United States of America.*

p. 115: Dirkan Kelekian . . . Towner, *Elegant Auctioneers,* pp. 328–31. The history of impressionism in Japan . . . this account is chiefly based on two interviews with Kazuo Fujii of the Fujii Gallery in Tokyo, to whom I am deeply grateful. The interviews took place on November 22 and 23, 1990. The account has been supplemented by Michiaki Kawakita, *Modern Currents in Japanese Art.*

p. 116: Togai and Fontanesi . . . Kawakita, *op. cit.,* pp. 32–33.

p. 116: Kuroda . . . *ibid.,* pp. 35–36.

p. 117: Economic-political developments in Japan . . . *ibid.,* pp. 128ff. Kazuo Fujii interviews.

8 | The Widows

p. 118: The Anderson . . . Towner, *Elegant Auctioneers,* pp. 265–66 and 301–18.

p. 118: Alexander Stewart . . . *ibid.,* pp. 110–12.

p. 119: "The Sport" . . . *ibid.,* pp. 109–10.

p. 120: Clarke sale . . . *ibid.,* pp. 389–91.

p. 120: Sutton and the Impressionists . . . *ibid.,* pp. 327–28.

p. 122: Mary Cassatt . . . Aline B. Saarinen, *The Proud Possessors,* pp. 144–65.

p. 123: Special brain cells . . . Saarinen, *op. cit.,* p. 160.

Louisine Havemeyer . . . *ibid.,* p. 144.

The Havemeyers and Granada . . . *ibid.,* p. 165.

p. 124: Louisine Havemeyer's will . . . *ibid.,* p. 170. See also Distel, *Impressionism,* pp. 233–36; and Frances Weitzenhoffer, *The Havemeyers: Impressionism Comes to America.*

p. 125: Berthe Honoré Palmer . . . Saarinen, *op. cit.,* pp. 3–24; World's Columbian Exhibition . . . Towner, *op. cit.,* p. 176.

p. 126: Anders Zorn and Berthe Palmer . . . Saarinen, *op. cit.,* pp. 25–26. Isabella Stewart Gardner . . . *ibid.,* pp. 25–55; and Colin Simpson, *Artful Partners,* pp. 70ff.

p. 127: Charles Eliot Norton . . . Simpson, *op. cit.,* pp. 42–43. Berenson . . . a multitude of sources, including Simpson, *op. cit.,* S. N. Behrman, *Duveen,* Ernest Samuels, *Bernard Berenson: The Making of a Connoisseur.*

p. 129: Mrs. Gardner's frugal streak . . . Saarinen, *op. cit.,* p. 45.

Fenway Court's opening . . . *ibid.,* p. 52.

9 | Du Vesne, Duvane, Duveen

p. 131: Joe Duveen's mendacity . . . Simpson, *Artful Partners,* pp. 203ff; Behrman, *Duveen,* p. 78.

p. 132: Knoedler . . . M. L. Knoedler, *A Catalogue of an Exhibition of Paintings and Prints of Every Description on the Occasion of Knoedler, One Hundred Years, 1846–1946,* pp. 5–9. I am also grateful to Nancy Little, former librarian and archivist of Knoedler, for her cooperation.

p. 134: Chaim Weizmann and *Vanity Fair . . . ibid.,* p. 36.

p. 134: "Brotherhood of Sodomites" . . . *ibid.,* p. 53.
Morelli . . . Giovanni Morelli, *Italian Painters: Critical Studies of Their Works.*
Crowe and Cavalcaselle . . . Sir J. A. Crowe and G. B. Cavalcaselle, *A New History of Painting in Italy from the Second to the Sixteenth Century.*

p. 135: Berenson's "alternative catalogue" . . . Simpson, *op. cit.,* pp. 60–67.

p. 136: Duveen brothers . . . *ibid.,* pp. 67–70.

p. 137: Duveen move to America . . . *ibid.,* p. 27.

p. 137: Henry and King George V . . . *ibid.,* pp. 164–67.

p. 137: Joel falls ill, Joe takes over . . . *ibid.,* pp. 107–11.

p. 138: Wildenstein . . . Cabanne, *The Great Collectors,* pp. 229–56.

p. 138: New Gallery exhibition . . . Simpson, *op. cit.,* pp. 60–67.

p. 139: Dealers' agents in Italy . . . *ibid.,* pp. 60, 97.

p. 139: Berenson and smuggling . . . Simpson, *op. cit.,* p. 89.

p. 140: Arabella Huntington . . . Towner, *Elegant Auctioneers,* pp. 255, 336; and Simpson, *op. cit.,* p. 119.

p. 140: Duveen and Seligmann . . . Simpson, *op. cit.,* p. 118, and Germain Seligmann, *Merchants of Art, 1880–1960, Eighty Years of Professional Collecting.*

p. 141: The "partnership" between Berenson and Duveen . . . Simpson, *op. cit.,* especially pp. 137ff.

p. 141: The great American millionaire collectors . . . Constable, *Art Collecting in the United States, passim.* Saarinen, *Proud Possessors,* throughout; see also Peter Watson, *Wisdom and Strength,* pp. 322–31.

p. 142: J. Pierpont Morgan . . . Ron Chernow, *The House of Morgan,* pp. 116–27.

p. 143: Mellon . . . Robert C. Williams, *Russian Art and American Money: 1900–1940;* Constable, *op. cit.,* pp. 122–26.
Frick . . . George Harvey, *Henry Clay Frick: The Man;* Keith Roberts, "Frick, Gulbenkian and Co."; Watson, *op. cit.,* pp. 344–55.

10 | Quaritch, Hoe and Belle of the Books

p. 145: The beginnings of the "Anderson" . . . Towner, *Elegant Auctioneers,* pp. 245, 265–66.

p. 146: Hoe sale . . . *ibid.,* pp. 266–80.

p. 147: William Roberts . . . *ibid.,* pp. 264–65.

p. 147: For Quaritch, see . . . Herrmann, *Sotheby's,* pp. 60–84.

p. 147: Marx and Engels . . . *ibid.,* p. 61.

p. 148: Belle da Costa Greene . . . Chernow, *House of Morgan,* pp. 116–17 and 169–170; also Towner, *op. cit.,* pp. 272–75.

p. 149: Gutenberg Bible . . . John Carter and Percy Muir, eds., *Printing and the Mind of Man,* pp. 1–2; and Towner, *op. cit.,* pp. 268–71.

p. 149: G. D. Smith . . . Towner, *op. cit.,* pp. 246–47 and 275–80.

p. 150: Hoe record . . . *ibid.,* pp. 278–88, though the calculations updating these figures have been made with the help of Dr. Mitchell's tables (see Appendix B).

11 | Vollard's Paris, Cassirer's Germany

p. 151: The basic work on Vollard is the dealer's own record, Ambroise Vollard, *Recollections of a Picture Dealer;* but see also Anne Distel, *Impressionism,* pp. 48–51 and *passim;* and Maurice de Vlaminck, *Portraits avant décès.*

p. 153: Félix Fénéon . . . Joan Ungersma Halperin, *Félix Fénéon, Aesthete and Anarchist in Fin-de-Siècle Paris.*

p. 154: Baudelaire on the dandy . . . Halperin, *op. cit.,* p. 16.

p. 155: Kahnweiler . . . Assouline, *Kahnweiler.*

p. 156: André Level and La Peau de l'Ours . . . *ibid.,* pp. 110–13; see also "Publication of Works of Art Belonging to Dealers," *Burlington Magazine* 2 (1904), p. 5.

Wertheimer . . . Assouline, *op. cit.,* pp. 24ff.

p. 158: Germans in Paris . . . *ibid.,* p. 20.

The German art market . . . Robin Lenman, "Painters, Patronage and the Art Market in Germany 1850–1914."

p. 158: German taste . . . *ibid.,* pp. 114ff.

p. 159: Paul Cassirer . . . Walter Feilchenfeldt, "Vincent van Gogh and Paul Cassirer," *passim.*

p. 160: Mogens Ballin and *Dr. Gachet* . . . Feilchenfeldt, *op. cit.,* pp. 8 and 17.

p. 161: The Stein family . . . Saarinen, *Proud Possessors,* pp. 174–205; also Towner, *Elegant Auctioneers,* p. 496; Assouline, *op. cit.,* pp. 34, 69 and 216–17; and John Rewald, "The Steins and Their Circle," chapter 4 of *Cézanne and America: Dealers, Collectors, Artists and Critics.*

12 | Sotheby's First Old Master

p. 164: Shakespeare's walking stick . . . Colson, *Story of Christie's,* 77.

Tom and Edward Hodge . . . Herrmann, *Sotheby's,* pp. 74–88.

p. 164: Barlow . . . *ibid.,* pp. 103ff. and *passim.*

p. 165: Duveen in New York . . . Simpson, *Artful Partners,* p. 17.

p. 166: Duveen evades duty . . . *ibid.,* p. 127.

p. 167: Berenson as "Doris" and the "X" ledger . . . *ibid.,* pp. 133ff.

p. 167: Bertram Boggis . . . *ibid.,* pp. 160–62.

p. 168: Barlow stumbles across paintings . . . Herrmann, *Sotheby's,* pp. 135ff.

p. 169: Emilie Grigsby and Charles Yerkes . . . a full account is given in Towner, *Elegant Auctioneers,* pp. 207–33.

p. 172: Prices at the Yerkes sale . . . *ibid.,* pp. 231–41, 287–89.

13 | "291" and the Armory Show

p. 174: John Quinn . . . Judith Zilczer, *The Noble Buyer: John Quinn, Patron of the Avant-Garde;* Milton Brown, *The Story of the Armory Show;* and Saarinen, *Proud Possessors.* See also Martin Green, *New York 1913: The Armory Show and the Patterson Strike Pageant.*

p. 175: For background to the Armory Show . . . Brown, *op. cit.,* pp. 41–118; Saarinen, *op. cit.,* pp. 205–27.

p. 176: Stieglitz and "291" . . . Ileana B. Leavens, *From "291" to Zurich: The Birth of Dada;* on the hoax, see also Rewald, *Cézanne and America,* pp. 129ff. See also: Steven Watson, *Strange Bedfellows: The First American Avant-Garde.*

p. 176: Steichen and the fake Cézannes . . . Rewald, *Cézanne and America,* pp. 133ff.

p. 178: Roger Fry's 1910 show in London . . . Frances Spalding, *Roger Fry,* pp. 298–301; Denys Sutton, *Letters of Roger Fry;* Brown, *op. cit.,* pp. 72–73.

p. 179: The Cologne "Sonderbund" . . . Rewald, *Cézanne and America,* pp. 166–68; also Brown, *op. cit.,* pp. 64–73.

p. 179: Arthur Davies, etc. . . . Brown, *op. cit.,* pp. 50–66, 104–30.

p. 180: Mabel Dodge's letter . . . Rewald, *Cézanne and America,* p. 175.

p. 180: Opening night of the Armory Show . . . Brown, *op. cit.,* pp. 107ff. Duchamp's *Nude Descending a Staircase* . . . *ibid.,* pp. 133ff.

p. 181: The Armory Show travels . . . Brown, *op. cit.,* pp. 215ff. Buyers at the Armory Show . . . *ibid.,* p. 334. See also Zilczer, *op. cit.,* pp. 25ff.

p. 182: Bliss and Eddy . . . Brown, *op. cit.,* pp. 120–21.

p. 182: Arensberg and Dreier . . . *ibid.,* pp. 127–29. Finances of the Armory Show . . . *ibid.,* pp. 119ff.

p. 183: Dealers' earnings at the show . . . *ibid.,* pp. 119ff. Bourgeois letter . . . *ibid.,* pp. 221–22.

p. 184: New galleries open up in New York . . . *ibid.,* pp. 238–39; and Zilczer, *op. cit.,* pp. 28–37. For the Modern Gallery see also: Rewald, *Cézanne and America,* pp. 102, 305; Leavens, *op. cit.,* pp. 41–44, 61–68.

14 | The £10,000 Barrier: Taste and Prices on the Eve of World War I

p. 185: Jacques Doucet . . . Beurdeley, *Trois siècles*, pp. 144–54.

p. 186: Big prices for Old Masters . . . Reitlinger, *Economics of Taste* 1, pp. 108–42.

p. 187: Prices . . . I have used Reitlinger, *op. cit.*, plus several other accounts of the period that mention prices, e.g., Towner, *Elegant Auctioneers*, Rewald, *Cézanne and America*, Assouline, *Kahnweiler*, Halperin, *Félix Fénéon*.

p. 188: La Peau de l'Ours sale . . . Beurdeley, *op. cit.*, pp. 155–60; also Assouline, *op. cit.*, pp. 110–13; and Malcolm Gee, *Dealers, Critics and Collectors of Modern Painting: Aspects of the Parisian Art Market Between 1910 and 1930,* especially chaps. 1–3 and p. 95.

15 | War and the Major

p. 189: Cassirer . . . Feilchenfeldt, "Vincent van Gogh and Paul Cassirer," *passim;* Assouline, *Kahnweiler,* pp. 38–39.

p. 190: Kahnweiler in Switzerland . . . Assouline, pp. 119ff.

p. 190: Montag and Bührle . . . Cabanne, *Great Collectors,* pp. 123ff.
Fénéon returns to Paris . . . Halperin, *Félix Fénéon,* pp. 358–64.

p. 190: War reparations . . . Assouline, *op. cit.,* pp. 147ff.

p. 191: René Gimpel . . . René Gimpel, *Diary of an Art Dealer.*

p. 191: Renoir . . . *ibid.,* pp. 11–16.
Matisse . . . *ibid.,* p. 76.

p. 192: Wartime prices . . . *ibid.,* pp. 33, 65.

p. 192: G. T. ("Gus") Kirby . . . Towner, *Elegant Auctioneers,* pp. 289ff.
Hiram Parke . . . *ibid.,* pp. 292–97, 342–45.

p. 193: Kelekian sale . . . *ibid.,* pp. 328–31.

p. 194: Arabella Huntington and the rat . . . *ibid.,* p. 336.

p. 194: Cortlandt Field Bishop . . . *ibid.,* pp. 349–69 and *passim* thereafter.

p. 195: Mitchell Kennerley . . . *ibid.,* pp. 298–319.
Anthony Comstock . . . *ibid.,* p. 299.

p. 196: Gabriel Wells . . . *ibid.,* pp. 311–13.
Susan Minns . . . *ibid.,* pp. 316–18.

p. 197: Frick's buying . . . Keith Roberts, "Frick, Gulbenkian and Co."

p. 197: Quinn v. Congress . . . Zilczer, *Noble Buyer,* pp. 16, 28–31; see also Saarinen, *Proud Possessors,* pp. 209–10.

p. 198: Early modern-art galleries in New York . . . Leavens, *From "291" to Zurich,* pp. 19–38, 109–22; see also Steven Watson, *Strange Bedfellows,* pp. 251–52. For the general worldwide health of the art market in wartime, see also the interrogation of Karl Haberstock, Hitler's art dealer in the 1930s and World War II (interrogation carried out by the Monuments, Fine Arts and Archives Commission in 1945).

p. 199: Christie's in wartime London . . . Colson, *Story of Christie's,* pp. 87, 129; also H. C. Marillier, *Christie's: 1766 to 1925,* pp. 160–73.

p. 199: Red Cross sales . . . Colson, *op. cit.,* p. 134; Mariller, *op. cit.,* pp. 126–49.

p. 200: Demand for jewels . . . Colson, *op. cit.,* pp. 129, 134; Herrmann, *Sotheby's,* pp. 135–45.

p. 200: Charles Bell . . . Herrmann, *Sotheby's,* pp. 175–82.

p. 201: Japan and *Shirakaba* . . . Kawakita, *Modern Currents in Japanese Art,* p. 107.

p. 201: Japan's Nika Society . . . *ibid.,* p. 108.

p. 202: Differences between Tokyo and Kyoto . . . this subject is stressed by Kawakita (*ibid.,* pp. 91–93) but it was also a theme of my interviews with dealers in Japan, especially Iwao Setsu.
 Umehara Ryuzaburo and Renoir . . . Kawakita, *op. cit.,* pp. 112–14.

16 | The Kahnweiler Affair

p. 203: Charles Des Graz . . . Herrmann, *Sotheby's,* pp. 206–13.
 Britwell . . . Arthur Freeman and Janet Ing Freeman, *Anatomy of an Auction: Rare Books at Ruxley Lodge, 1919,* p. 25; Herrmann, *Sotheby's,* pp. 196–202.

p. 204: Ruxley Lodge . . . Freeman and Freeman, *op. cit.*

p. 206: *The Times* and the British government become involved . . . *ibid.,* pp. 108ff.

p. 206: Tancred Borenius . . . Herrmann, *Sotheby's,* pp. 160–61, 240–43.

p. 207: 1928 as an *annus mirabilis* . . . Reitlinger, *Economics of Taste* 2, pp. 247–58; and Herrmann, *Sotheby's,* pp. 257ff.

p. 207: For the Paris art market in the 1920s, see: Gee, *Dealers, Critics and Collectors,* especially chaps. 1–3; Assouline, *Kahnweiler,* pp. 165ff.; Feilchenfeldt, "Vincent van Gogh and Paul Cassirer," pp. 8–14; Seligmann, *Merchants of Art,* pp. 151–57.

p. 208: Rosenberg . . . Gee, *op. cit.,* pp. 59–66; Assouline, *op. cit.,* pp. 163–79; Gimpel, *op. cit.,* pp. 107–108.

p. 209: Suspect modern sales . . . Gee, *op. cit.,* p. 32.

p. 210: The sales of Kahnweiler's stock . . . Assouline, *op. cit.,* pp. 168ff; Gee, *op. cit.,* pp. 44–58; Paul Guillaume . . . Gee, pp. 59–66.

p. 212: Alex Reid moves south . . . Douglas Cooper introduction in Reid, *Alex Reid and Lefèvre,* pp. 10ff.
 Bignou . . . Assouline, *op. cit.,* p. 229.
 Keller, Bignou, Reid and Lefèvre, etc. . . . Cooper, in Reid, *op. cit.,* pp. 20–22.

p. 213: Samuel Courtauld . . . Cabanne, *Great Collectors,* pp. 83–98; Cooper, *op. cit.,* pp. 22–23.

p. 214: Cortlandt Field Bishop . . . Towner, *Elegant Auctioneers,* pp. 349ff.

p. 215: Chiesa collection . . . *ibid.,* pp. 382–83, 412–14.

p. 216: The Melk Gutenberg . . . *ibid.,* p. 407.

p. 217: Leverhulme Collection . . . *ibid.,* pp. 411–12.

p. 218: Merger between AAA and the Anderson . . . *ibid.,* pp. 454ff.
Edith Nixon . . . *ibid.,* pp. 426–28, 461–86.

17 | The Paris Dynasties

p. 220: Wildenstein . . . Cabanne, *Great Collectors,* pp. 229–56; see also Jean Clay, "L'Épopée de Wildenstein," pp. 77ff; Jonathan Napack, "The Wildenstein Family" (which claims to be based on a wartime paper prepared by Douglas Cooper); and Seligmann, *Merchants of Art, passim.*

p. 221: Kann Collection . . . Gimpel, *Diary,* p. 301.

p. 221: Gimpel-Wildenstein . . . Gimpel, *op. cit.,* p. 141.

p. 222: Gimpel's modern interests (Picasso, etc.) . . . *ibid.,* pp. 107–108.

p. 222: Swindling and "certificates of authenticity," especially in the United States . . . *ibid.,* p. 352.

p. 223: Lord Michelham, etc., and Duveen . . . Simpson, *Artful Partners,* p. 171.

p. 223: Bache, Boggis *et al.* . . . *ibid.,* pp. 209ff.

p. 223: Viscount Lee of Fareham, etc. . . . *ibid.,* pp. 208–209.

p. 224: Seligmann . . . Seligmann, *op. cit.,* p. 121.

p. 225: Wallace-Bagatelle . . . Seligmann, *op. cit.,* pp. 92–103.

18 | The Cult of the Portrait

p. 227: The early vogue in portraits . . . Reitlinger, *Economics of Taste,* vol. 2, pp. 182 ff.

p. 229: The vogue for Sargent . . . Colson, *Story of Christie's,* pp. 114–18; also: Reitlinger, *op. cit.,* vol. 1, pp. 153–54, 212–13.

p. 230: Botticelli, Lotto, etc. . . . Reitlinger, *op. cit.,* pp. 127–28.

p. 231: Van Gogh, Gauguin, the PRB, etc. . . . *ibid.,* vol. 1, pp. 170–74. For van Gogh, see also Carol M. Zemel, *The Formation of a Legend: Van Gogh Criticism 1890–1920.* For Gauguin, see "Gauguin the Collector," *Burlington Magazine* 112, p. 590.

19 | The Great Crash

p. 235: Soutine's calf's head . . . Gimpel, *Diary,* p. 377; German deals . . . Seligmann, *Merchants of Art,* pp. 169–76; "France insulated" from the crash . . . Gimpel, *op. cit.,* pp. 377ff; Kahnweiler's experience . . . Assouline, *Kahnweiler,* pp. 218–45.

p. 236: Christian Dior . . . Assouline, *op. cit.,* p. 230.

p. 236: Pierre Matisse . . . John Russell, "Dean of Dealers Reflects on the Art World," *The New York Times,* July 5, 1981; John Gruen, "Pierre Matisse, Master Dealer," *Architectural Digest,* April 1986.

p. 237: Felix Warre . . . Herrmann, *Sotheby's,* pp. 257–62, 305–16.

p. 237: Agnew's experience . . . *A Dealer's Record: Agnew's 1967–81,* London: Barrie & Jenkins, 1981.

p. 238: Prices in the slump... Gimpel, *op. cit.*, pp. 395ff; Reitlinger, *Economics of Taste*, vol. 1, pp. 207–18; Assouline, *op. cit.*, pp. 222ff.

p. 238: Sotheby's and Christie's merger... Herrmann, *Sotheby's*, pp. 260–61.

p. 238: Sotheby's house sales... *ibid.*, pp. 263–71.
 Sotheby's in Germany... *ibid.*, pp. 276–77.

p. 239: Judge Gary... Towner, *Elegant Auctioneers*, pp. 442–46.

p. 240: Jerome Kern... *ibid.*, pp. 446–50.

p. 240: Milton Mitchill's misfortunes... *ibid.*, pp. 456–66.

p. 241: Edith Nixon... *ibid.*, pp. 461–77.

p. 241: Andrew Mellon's secret deal with the Hermitage pictures... this story is fully told in Robert C. Williams, *Russian Art and American Money.* See also Seligmann, *Merchants of Art*, pp. 169–76.

p. 242: Armand Hammer... there are several biographies, and autobiographies, of Armand Hammer. I have used Robert Considine, *Larger Than Life: A Biography of the Remarkable Dr. Armand Hammer*, especially pp. 162–75, and Steve Weinberg, *Armand Hammer: The Untold Story*, pp. 75–83, 363–83.

p. 242: Mellon... Williams, *op. cit.*, p. 149; also Seligmann, *op. cit.*, pp. 169–76.

p. 243: Knoedler... Williams, *op. cit.*, p. 129 and *passim*; also Knoedler, *A Catalogue of an Exhibition of Paintings and Prints*, pp. 5–9.

20 | Bad Blood

p. 245: There are several accounts of the Whistler trial and this quotation is contained in all of them.
 La Belle Ferronnière... Behrman, *Duveen*, pp. 135–39; and Simpson, *Artful Partners*, pp. 242–43.

p. 246: Harry Hahn, *The Rape of La Belle.*

p. 247: The Wise scandal... Herrmann, *Sotheby's*, pp. 280–86.

p. 248: The Mellon scandal... Robert C. Williams, *Russian Art and American Money.*

p. 248: Shirley Falcke... Towner, *Elegant Auctioneers*, 465–84.

p. 250: The Falcke case... *ibid.*, pp. 511–13.

21 | The Mathematician and the Murderer

p. 252: Rembrandt's bankruptcy... Alpers, *Rembrandt's Enterprise*, pp. 55–57.
 Chester Johnson sale... Towner, *Elegant Auctioneers*, pp. 498–99.

p. 253: Christie's pre-eminence between the wars... Reitlinger, *Economics of Taste*, vol. 1, pp. 207–38.

p. 253: Newton's papers... Herrmann, *Sotheby's*, pp. 290–93.

p. 254: Victor Rothschild sale... *ibid.*, pp. 293–98.

p. 255: "Degenerate art"... B. Hinz, *Art in the Third Reich;* H. Lehmann-Haupt, *Art Under Dictatorship.*

p. 255: Bishop, Nixon, etc. . . . Towner, *op. cit.,* pp. 517ff.

p. 256: Parke and Bernet leave . . . *ibid.,* pp. 523ff.

p. 257: Kennerley's strange behavior . . . *ibid.,* pp. 528–29.

p. 257: The extraordinary story of Milton Logan and John Geery is told in Wesley Towner's book in remarkable detail, pp. 535–44.

22 | The Great Drought: Taste and Prices on the Eve of World War II

p. 261: Léger . . . Gimpel, *Diary,* p. 443.

p. 262: Van Beuningen . . . Cabanne, *Great Collectors,* pp. 139–58.

p. 263: English portraits and other prices . . . Reitlinger, *Economics of Taste,* vol. 1, pp. 182–97, plus the author's own analysis of the prices published in Reitlinger's lists and in Rewald, *Impressionism.*

23 | War and the Marshal

p. 265: Gimpel in Geneva . . . Gimpel, *Diary,* p. 446.

Kahnweiler loses the will to live . . . Assouline, *Kahnweiler,* p. 274.

p. 266: Hans Arp in London . . . *ibid.,* p. 262.

Changes at Sotheby's and Christie's . . . Herrmann, *Sotheby's,* pp. 306–10; Herbert, *The Artist and Social Reform,* p. 28.

p. 266: Change in type of object sent for auction . . . Herrmann, *Sotheby's,* p. 309.

Eumorfopoulos sale . . . *ibid.,* pp. 309–13.

p. 267: Merger talk between Sotheby's and Christie's . . . Herrmann, *Sotheby's,* pp. 313–14.

p. 268: Kahnweiler the anti-Nazi . . . Assouline, *op. cit.,* pp. 259ff.

p. 268: Wildenstein in New York . . . Jonathan Napack, "The Wildenstein Family," which claims to be based on a wartime OSS report prepared by Douglas Cooper (Cooper was British and did not work for the OSS). See also Cabanne, *Great Collectors,* p. 238.

p. 269: The "Otto Office" . . . Assouline, *op. cit.,* pp. 283ff.

p. 270: Philip of Hesse in Italy . . . *Centoquantuno capolavori trafugati dai nazisti e recuperati dallo 007 dell'arte italiana, L'opera ritrovato, Omaggio a Rodolfo Siviero* (Firenze: Cantini, 1974), pp. 17ff.

p. 270: Goudstikker collection . . . Office of Strategic Services, Art Looting Investigation Unit, National Archives, Washington, D.C., record group 239, boxes 25, 41, 70 and 77, and record group 260, box 387. The Art Looting Investigation Unit of the OSS . . . *ibid.,* plus box 42.

p. 271: The Schenker Papers . . . Cecil Gould, "The Schenker Papers." The ERR . . . Report INTR/6922/MA, "The Einsatzstab Reichsleiter Rosenberg." Office of Strategic Services, "Activity of the ERR in France." For other accounts of the art market in France during the Occupation, see: Gilles Ragache and Jean-Robert Ragache, *La Vie quotidienne des écrivains et des artistes sous l'Occupation 1940–1944,* especially pp. 119ff., "Salons privés et vie publique"; Gerhard Hirsch-

field and Patrick Marsh, eds., *Collaboration in France: Politics and Culture during the Nazi Occupation, 1940–1944,* especially pp. 103–25, "Collaboration in the Fine Arts, 1940–1944," by Sarah Wilson; and Hervé le Boterf, *La Vie Parisienne sous l'Occupation,* pp. 97–106, "Les Salles de ventes."

p. 272: Jeu de Paume . . . Office of Strategic Services, "Interim Report on the Art Activities of Hermann Göring."

p. 272: Looted works of art in Switzerland . . . "Looted Works of Art in Switzerland: German Methods of Acquisition," anonymous paper dated January 1, 1945, possibly prepared by Douglas Cooper for the MFA&A.

p. 275: Sotheby's improved finances . . . Herrmann, *Sotheby's,* pp. 313–16.

p. 275: Peggy Guggenheim . . . there are several biographies, plus an autobiography. I have used: Jacqueline Bograd Weld, *Peggy, the Wayward Guggenheim;* Peggy Guggenheim, *Confessions of an Art Addict;* Peggy Guggenheim, *Out of This Century.*

p. 276: The Mayor Gallery . . . Weld, *op. cit.,* pp. 157–58; see also, George Melly, writing in the 1980 issue of *Sotheby's Art at Auction, 1979–80.*

p. 277: The artistic community in New York and Peggy's spring salon . . . Calvin Tomkins, *Off the Wall: Robert Rauschenberg and the Art World of Our Time,* pp. 43–45; and Weld, *op. cit.,* parts 4 and 6.

24 | Peter Wilson Looks West

p. 280: Kahnweiler as a professor . . . Assouline, *Kahnweiler,* p. 305.

p. 281: Peter Wilson . . . Herrmann, *Sotheby's,* pp. 223, 300ff.; Nicholas Faith, *Sold: The Revolution in the Art Market,* pp. 15–20.

p. 281: Peter Wilson as a periwinkle . . . Faith, *op. cit.,* p. 16.

p. 282: Hans and Carmen Gronau . . . Herrmann, *Sotheby's,* pp. 320ff., 358ff.; Faith, *op. cit.,* pp. 42–63 *passim.*

p. 282: The Brummer sale . . . Herrmann, *Sotheby's,* p. 346.

p. 283: Wilson thinks of buying Parke-Bernet . . . Herrmann, *Sotheby's,* pp. 346–47.

p. 283: The Bay Psalm Book and the state of Parke-Bernet . . . Towner, *Elegant Auctioneers,* pp. 550–56.

p. 283: Rosenbach . . . *ibid.,* pp. 529–38.

p. 284: Leslie Hyam, etc. . . . *ibid.,* pp. 563–75. Jake Carter . . . Herrmann, *Sotheby's,* pp. 346–57.

p. 285: New York in the 1950s . . . this account has been compiled from a number of sources, including Calvin Tomkins, *Off the Wall,* and the same author's *Post- to Neo-: The Art World of the 1980s,* especially pp. 9–51 and 211–16. I have also drawn on interviews with New York art-world figures listed in the Author's Note at the beginning of the book.

p. 286: Betty Parsons . . . Tomkins, *Off the Wall,* pp. 55–63.

p. 288: Sidney Janis . . . *ibid.,* pp. 184–85.

p. 289: Cedar Street Tavern and The Club . . . Tomkins, *Off the Wall,* pp. 47–48, 88–92.

p. 290: Ninth Street show . . . *ibid.,* pp. 61, 85; and see especially Dore Ashton, *The New York School: A Cultural Reckoning,* pp. 164–73.
Alfred Barr . . . Alice Goldfarb Marquis, *Alfred H. Barr, Jr., Missionary for the Modern.* This book is not stocked by MoMA's bookshop, for apparently it has offended some of the senior staff at the museum.

25 | Shanghai to Suez, via Hong Kong

p. 291: Hong Kong . . . this section is based mainly on interviews carried out by the author in Hong Kong, November 12–17, 1990. Interviewees are listed in the Author's Note at the beginning of the book.

p. 291: Charlotte Horstmann . . . Robert P. Piccus, "Charlotte Horstmann at Eighty-Two," *Orientations* 21, no. 11 (November 1990), pp. 82–89.

p. 292: Bluett, Spink etc., . . . interview with Dominic Jellinek of Bluett, January 24, 1991.

p. 294: Warren King . . . interview with the author, November 13, 1990.

p. 294: Joseph Chan . . . interview with the author, November 14, 1990.
Edward Chow . . . Beurdeley, *Trois Siècles,* pp. 201–206.

p. 295: Farouk collection . . . Herrmann, *Sotheby's,* pp. 340–45.

26 | The Picasso Business, and the Epiphanies of Leo Castelli

p. 301: Kahnweiler as wholesaler . . . Assouline, *Kahnweiler,* pp. 303ff.

p. 301: Kahnweiler and Picasso . . . *ibid.,* pp. 324ff.

p. 303: Kahnweiler as Picasso's spokesman . . . *ibid.,* pp. 331ff.

p. 303: Gabriel Cognacq . . . Cabanne, *Great Collectors,* pp. 99–122.

p. 304: Raymonde Moulin and the Paris market in the 1950s and 1960s . . . Raymonde Moulin, *The French Art Market: A Sociological View.*

p. 305: Victor and Leslie Waddington . . . author interview with Leslie Waddington, October 11, 1990.

p. 305: Leo Castelli . . . Tomkins, *Post- to Neo-,* pp. 9–51.

p. 308: Castelli encounters Jasper Johns . . . this celebrated meeting is described fully in Tomkins, *ibid.,* pp. 26ff.

p. 310: Frank Stella . . . *ibid.,* pp. 43ff.

p. 310: The Tremaines, Scull, etc. *ibid.,* pp. 32ff.
Ivan Karp . . . interview with the author, October 31, 1990. But see also Tomkins, *Post- to Neo-,* pp. 34ff.

p. 311: Weinberg sale, etc. . . . Towner, *Elegant Auctioneers,* pp. 589, 606; Herrmann, *Sotheby's,* pp. 350–57.

p. 313: Lurcy sale . . . Towner, *op. cit.,* pp. 583–88.

p. 314: Goldschmidt sales . . . Herrmann, *Sotheby's,* pp. 366–71.

p. 315: German quote and the encounter at the Savoy . . . the fullest details are contained in John Herbert, *Inside Christie's,* pp. 19–23.

27 | Sotheby's versus Christie's

p. 318: Alec Martin's blunder . . . Herbert, *Inside Christie's,* p. 13.

p. 319: R. W. Lloyd and his effect on Christie's . . . *ibid.,* pp. 41–42.

 Peter Chance takes over at Christie's . . . *ibid.,* pp. 16, 29.

p. 320: David Carritt . . . *ibid.,* pp. 79–87.

p. 320: "Van Essabell," etc. . . . *ibid.,* p. 83.

p. 321: Peregrine Pollen . . . Herrmann, *Sotheby's,* pp. 374–84.

 Erickson collection . . . Towner, *Elegant Auctioneers,* pp. 603–604.

p. 322: Fribourg sale . . . Herrmann, *Sotheby's,* pp. 378–83.

p. 322: Leslie Hyam's death . . . Towner, *op. cit.,* 602–605.

p. 322: Sotheby's acquisition of Parke-Bernet . . . Herrmann, *Sotheby's,* pp. 384–95.

p. 323: Paris in the late Fifties and early Sixties . . . Moulin, *French Art Market,* pp. 42ff. and 55ff. Also Assouline, *Kahnweiler,* pp. 340–46.

p. 324: Wildenstein and the *Réalités* article . . . Jean Clay, "L'Épopée de Wildenstein." See also Cabanne, *Great Collectors,* pp. 229–56.

p. 326: Richard Bellamy's gallery . . . Tomkins, *Off the Wall,* pp. 176–79.

p. 327: Rauschenberg's prices after winning the Venice Biennale . . . Tomkins, *Post- to Neo-,* p. 41.

p. 327: Castelli's innovations . . . interview with the author, November 2, 1990; author interview with Ivan Karp, October 30, 1990; Tomkins, *Post- to Neo-,* pp. 34ff.

p. 328: Mary Boone . . . interview with the author, November 1, 1990.

p. 328: Sidney Janis . . . Tomkins, *Off the Wall,* pp. 184–85.

28 | The £2 Million Barrier

p. 329: The Norton Simon fiasco . . . Herbert, *Inside Christie's,* pp. 100ff.

p. 331: Northwick Park . . . *ibid.,* pp. 88–94.

p. 332: Julius Weitzner scandal . . . *ibid.,* pp. 98–99.

p. 333: Café de la Nouvelle-Athènes, etc., at SPB in New York . . . Herrmann, *Sotheby's,* p. 401.

p. 333: Christie's in Japan . . . Herbert, *op. cit.,* pp. 148–55.

p. 334: Christie's in Switzerland . . . *ibid.,* pp. 153–56.

p. 335: The de Hory scandal . . . Clive Irving, *Fake! The Story of Elmyr de Hory, the Greatest Art Forger of Our Time,* London: Heinemann, 1970.

29 | Manhattan's New Street of Pictures

p. 339: Leslie Waddington . . . interview with the author, September 12, 1990.

p. 339: Marlborough . . . John Bernard Myers, "The Art Biz," *The New York Review of Books,* October 13, 1983, pp. 32–34; there are several accounts of the Marlborough/Rothko affair. I have used Laurie Adams, *Art on Trial,* pp. 169–210; and Lee Seldes, *The Legacy of Mark Rothko.*

p. 341: The Marlborough/Rothko trial . . . Adams, *op. cit.,* pp. 185–210.

p. 343: Jeremy Maas . . . interview with the author, May 21, 1990. See also Faith, *Sold,* pp. 155–65.

p. 344: Howard Ricketts . . . Herrmann, *Sotheby's,* pp. 410–13.

Sir John Betjeman . . . Betjeman, "The Pantechnicon."

p. 344: Sotheby's Belgravia . . . Herrmann, *Sotheby's,* pp. 409–13; Faith, *op. cit.,* pp. 153–65.

p. 345: Alan Funt . . . Faith, *op. cit.,* pp. 163–64.

p. 346: Paula Cooper . . . telephone interview with the author, November 1, 1990; Cooper interview in *Ocular* magazine, June 1977, pp. 28–37; Cooper interview in *ARTnews,* March 1989, pp. 153–57.

p. 347: Ivan Karp . . . interview with the author, May 10, 1990, New York; Tomkins, *Off the Wall,* pp. 173–79.

p. 348: Ileana Castelli/Sonnabend . . . Tompkins, *Off the Wall,* pp. 139–43, 281–82.

p. 348: André Emmerich . . . interview with the author, New York, May 18, 1990. Also: *The Journal of Art* 2, no. 1 (September/October 1989), pp. 20–21; *Art International,* no. 12 (Autumn 1990), pp. 30–33.

30 | Porcelain and Pensions

p. 351: Christie's flotation . . . Herbert, *op. cit.,* pp. 204–208.

p. 352: For the story of the oil shock and its effects on the art market, see . . . Faith, *Sold,* pp. 143ff. And for a more detailed discussion of the figures mentioned, see Herbert, *Inside Christie's,* pp. 171ff.

p. 352: Lampa Investments and the collapse of the porcelain market . . . interview with Hugh Moss, Hong Kong, November 15, 1990; see also Faith, *op. cit.,* pp. 176ff.

p. 353: The introduction of the buyer's premium has been written about widely, in the press and in the books by Faith, Herbert and Herrmann relied on so heavily here. Of the three, Herbert, *Inside Christie's,* perhaps has the edge so far as clarity is concerned; see pp. 213–28.

p. 354: The British Rail Pension Fund's art investments . . . here Nicholas Faith's book *Sold* offers the best account, pp. 208–14.

p. 355: Annemaria Edelstein quote . . . Herbert, *op. cit.,* p. 220.

p. 356: Sotheby's goes public . . . Herrmann, *Sotheby's,* pp. 424–32.

p. 356: PB 84 . . . *ibid.,* p. 398.

p. 357: Christie's South Kensington . . . Herbert, *op. cit.,* pp. 216–18.

p. 357: Christie's moves into America . . . *ibid.,* pp. 245ff.; Sotheby's spreads across America . . . Herrmann, *Sotheby's,* pp. 420ff.

31 | The Apotheosis of Peter Wilson

p. 359: Mentmore . . . the basic reference is Herrmann, *Sotheby's,* pp. 430–38; but see also Faith, *Sold,* pp. 197–207, for a lively discussion of the

heritage and political issues surrounding the sale (and for a number of anecdotes culled from the press clippings of the sale).

p. 360: David Carritt's discovery (footnote) . . . Faith, *op. cit.,* p. 207.

p. 360: Von Hirsch . . . again, see Herrmann, *Sotheby's,* pp. 434–38, for the basic facts, and Faith, *op. cit.,* pp. 223–30, for commentary.

p. 362: Christie's first night in New York . . . Herbert, *Inside Christie's,* pp. 245ff.

p. 362: David Bathurst at Henry Ford's . . . *ibid.,* pp. 278–80.

p. 363: Cristallina fiasco . . . see Peter Watson, "Christie's Goes on Trial," *The* (London) *Observer,* January 11, 1987; also Herbert, *op. cit.,* pp. 287–94.

p. 365: Tomkins, "A Thousand Flowers" . . . *The New Yorker,* May 19, 1980. Fifty-seventh Street Galleries . . . Robert Becker, "Dealing Contemporary Art on Fifty-seventh Street," and Barnaby Conrad, "A Stroll Down Fifty-seventh Street."

p. 365: Glimcher . . . interview with the author, October 12, 1989.

p. 366: Paula Cooper . . . telephone interview with the author, November 1, 1990; but see also: *ARTnews,* March 1989, pp. 153–57, and Calvin Tomkins, "Boom," *The New Yorker,* December 22, 1980.

p. 366: Frank Stella's lecture . . . Tomkins, *Post- to Neo-,* pp. 144ff.

p. 367: Mary Boone . . . interview with the author, November 1, 1990; Robert Hughes poem "The SoHoiad," originally published in *The New York Review of Books,* was republished in an anthology of Hughes's articles, *Nothing If Not Critical.* For Mary Boone, see also Joan Juliet Buck, "Dealer's Choice."

32 | The Fall of Sotheby's and the Rise of Alfred Taubman

p. 369: Peter Wilson announces his retirement . . . Faith, *Sold,* pp. 231ff.

p. 370: *Fortune* magazine . . . quoted *ibid.,* p. 233.

p. 370: Stephen Lash, etc. . . . interview with the author, May 11, 1990. See also Peter Watson, "Christie's v. Sotheby's: An Uncivil War."

p. 371: Brunton's review . . . the best account is in Faith, *op. cit.,* pp. 236–38, but see also, J. Hofgref, *Wholly Unacceptable: The Bitter Battle for Sotheby's,* pp. 67–160.

p. 372: "Toboggan and Skid," etc. . . . Faith, *op. cit.,* pp. 241ff.; and Hofgref, *op. cit.,* pp. 69ff.

p. 374: Lord Cockfield and the "British establishment" . . . Faith, *op. cit.,* has by far the best account, pp. 246–48.

p. 375: David Metcalfe . . . interview with the author, February 13, 1991, London.

p. 375: Taubman . . . interview with the author, December 7, 1990; see also Peter Watson, "The Architect of Sotheby's Success."

33 | The New Sotheby's and the New Collectors

p. 379: Gould sale . . . Faith, *Sold,* pp. 253–54; and Herbert, *Inside Christie's,* pp. 322–25.

p. 380: The raid on Christie's . . . Herbert, *op. cit.,* p. 323.

p. 381: Diana D. Brooks . . . interview with the author, May 18, 1990.

p. 381: Max Fisher . . . newspaper references too numerous to mention.

p. 382: The Gospels of Henry the Lion . . . *Sotheby's Art at Auction, 1984.*

p. 383: Chatsworth drawings . . . this received copious press coverage at the time, all of which is neatly summed up in Herbert, *op. cit.,* pp. 330–32.

p. 384: Peter Wilson's memorial service . . . Geraldine Norman's article in *The* (London) *Times* is quoted in Faith, *op. cit.,* p. 254.

p. 385: A split develops between Christie's and Sotheby's over financial services . . . see Peter Watson, "Christie's v. Sotheby's: An Uncivil War."

p. 386: Only 1 percent of American millionaires tapped . . . confidential report, part of which was made available to the author by a senior figure at Christie's. Analysis carried out by Mars & Co.

34 | The Japanese Passion for *Medama*

p. 388: Couples as collectors . . . see, for example, "The *ARTnews* 200," *ARTnews,* January 1990, and "The Top 100 Collectors," *Art & Antiques,* March 1990. In the late 1980s these lists were published annually.

p. 389: *La Rue Mosnier aux paveurs* . . . see *Christie's Review of the Season,* 1987, pp. 66–67.

p. 389: Van Gogh's *Sunflowers* . . . article by Ronald Pickvance in *Christie's Review of the Season,* 1987, p.70; and Herbert, *Inside Christie's,* pp. 363–70.

p. 389: Mess over the estimate on *Sunflowers,* and the advice given by Christie's . . . see Peter Watson, "£17 Million Gamble over van Gogh Painting."

p. 391: Background to the purchase of *Sunflowers* by Yasuda Fire and Marine Insurance . . . Herbert, *op. cit.,* pp. 365–68.

p. 392: Finances of the *Sunflowers* sale . . . see Peter Watson, "Tax Bill May Force New Art Master Sale."

p. 392 Mayuyama and Ishiguro . . . interview with Kojiro Ishiguro, November 22, 1990, Tokyo. Mr. Ishiguro also kindly provided me with a number of important catalogues on Japanese trade in Chinese art.

p. 392: Kazuo Fujii . . . interview with the author, November 21 and 22, 1990, Tokyo.

Etsuya Sasazu . . . interview with the author, November 20, 1990.

p. 393: Nichido Gallery . . . interview with Tokushichi Hasegawa, November 22, 1990, and with Toshihiko Yamauchi, July 4, 1991.

Kazuko Shiomi and Sotheby's in Japan . . . interviews with the author, November 20, 1990, and July 2, 1991.

p. 394: Popularity of Nihonga art . . . interview with Iwao Setsu, Tokyo, November 21, 1990; see also Waldemar Januszczak, "In the Country of the Cultural Cocktail."

35 | Van Gogh, Inc., and *Kaneamari Gensho*

p. 396: The Windsor jewels sale . . . see Peter Watson, "How Sotheby's Polished the Windsor Jewels."

p. 397: Nicholas Rayner . . . interview with the author, February 22, 1990, St. Moritz.

p. 397ff.: Van Gogh's *Irises;* sale at Sotheby's . . . see, for example, Peter Watson, "How Art Came Up Roses," *The* (London) *Observer,* November 27, 1988; Peter Watson, "Exposed: Taxman's Lust for Art"; Rita Reif, "Van Gogh's 'Irises' Sells for $53.9 Million"; and Ben Heller, "The *Irises* Affair."

p. 401: The Picasso passion . . . see, for example, Peter Watson, "Picasso, Inc.: A $377 Million Business," *The* (London) *Observer,* October 1, 1989.

p. 401: Van Gogh study day at the National Gallery, London, June 1, 1990 . . . reported by the author, "The Trouble with Vincent," *The* (London) *Observer,* June 3, 1990. During the study day, the most apposite lectures were those by Griselda Pollock, University of Leeds, "Van Gogh in Cultural Politics since the War," and Walter Feilchenfeldt, "Vincent van Gogh and the Art Market, 1890–1990."

p. 401: The Andy Warhol auction . . . see, for example, the author's articles: "Warhol: Enter the Culture Vultures," *The* (London) *Observer,* March 1, 1987, and "Warhol: A $34 Million Junk Hype."

p. 403: Sotheby's Moscow auction . . . for background: Matthew Cullerne Bown, "Russian Avant-Garde and Soviet Contemporary Art in Moscow."
 Lord Gowrie . . . "Earl Grey," *The* (London) *Sunday Times Magazine,* August 5, 1990, pp. 18–24.

p. 404: The Russian "boom" . . . see Peter Watson, "The Hunt for Art Fit for a Czar."

36 | Picasso, Inc., and the Galleries of the Ginza

p. 406: Aska International . . . see, among others, "The Billion Dollar Buyer Who Came from Nowhere," *Business Week,* October 29, 1990, pp. 38ff.

p. 408: The history of Japanese collecting . . . culled from interviews with Kazuo Fujii, Tokyo, November 21 and 22, 1990, Kojiro Ishiguro, November 22, 1990, and Susumu Yamamoto, July 4, 1991.

p. 409: This part of the account is derived from an interview with Susumu Yamamoto, July 4, 1991.

p. 410: Nichido Gallery . . . interview with Chieko Hasegawa, November 21, 1990, and with Toshihiko Yamauchi, July 4, 1991.

p. 410: Japanese collectors . . . see the author's "All Eyes on the Unpredictable Japanese," *The* (London) *Observer,* October 25, 1987; and "New Stars in the East," *The* (London) *Observer,* November 25, 1990.

p. 411: Japan's most profitable dealers . . . *Business Week,* October 29, 1990, p. 39.

pp. 412 & The charts are taken from a private Christie's document leaked to the
413: author. Analysis carried out by Mars & Co.

p. 412: Yasumichi Morishita . . . See *Business Week,* October 29, 1990, pp. 38ff., and Yumiko Ono, "Debt Collector Turns Art Collector."

p. 414: *Business Week* reference . . . *Business Week,* October 29, 1990, p. 62.

p. 414: Morishita's top pictures . . . *ibid.,* p. 39.

p. 415: Shigeki Kameyama . . . Dana Wechsler, "Is the Art Market Ready for Mountain Tortoise?" *Forbes,* March 19, 1990, pp. 72ff.

37 | False Start? The Market in Contemporary Art

p. 416: First Tremaine sale . . . see *Christie's Review of the Season 1989,* pp. 150–51.

 Max Kozloff's quote comes from "Pop Culture, Metaphysical Disgust, and the New Vulgarians," *International,* February 1962, reprinted in Adams, *Art on Trial,* p. 176.

p. 416: For an alternative account of the Scull sale, see Tomkins, *Off the Wall,* pp. 296–97.

p. 419ff.: Lists of collectors . . . culled from the lists of collectors published annually in the late 1980s in *ARTnews* and *Art & Antiques,* supplemented by interviews with dealers in Europe, the United States, Australia, Hong Kong and Japan, as research for this book.

p. 421: Joseph Brown . . . Interview with the author, Melbourne, November 6, 1990.

p. 421: Corporate collecting . . . articles on corporate collecting have become almost as numerous as corporate collections. A good introduction to the entire picture may be had from three references: Rosanne Martorella, *Corporate Art*; Sam Hunter, *Art in Business: the Philip Morris Story*; Montgomery Museum of Fine Arts, *Art Inc.: American Paintings from Corporate Collections.*

38 | The Price of Pleasure: Art as Investment

p. 423: The performance of the Impressionist pictures owned by the British Rail Pension Fund . . . see Peter Watson, "British Rail's Art Auction." Interview with the author: Susan Buddin and Lady Damaris Stewart, London, March 11, 1992.

p. 425: The tax benefits enjoyed in Britain by pension funds . . . see Faith, *Sold,* pp. 208–14.

p. 425: The examples drawn from Reitlinger, *Economics of Taste,* vol. 1 . . . Titian, pp. 464–67; Reynolds, pp. 429–33; Rubens, pp. 441–46.

p. 426: Robin Duthy, *The Successful Investor.*

p. 427: Duthy update . . . "Golden Year for Gilt-Framed Investments." *The Financial Times* (London), May 15, 1990, pp. 12, 14.

p. 428: William Baumol . . . Baumol, "Unnatural Value of Art Investment as Floating Crap Game."

p. 428: Frey and Pommerehne . . . Bruno Frey and Werner Pommerehne, "Art Investment: An Empirical Inquiry."

p. 429: Dates are taken from Frey and Pommerehne's expansion of this paper, published in their book *Muses and Markets: Explorations in the Economics of the Arts;* the arguments and inferences are my own.

39 | Manhattan to the Marais: The Revival of Europe

p. 433: Charles Saatchi's sale of his collection . . . "Saatchi Sneezes and the Art World Shivers," by Andrew Graham-Dixon, and "Saatchi 'Dumps' Unwanted Art," by Geraldine Norman.

p. 434: Sean Scully . . . quoted in "Saatchi Accused over Art Sale," by Stephen Warr, and "Saatchi Denies Tricking the Art World," by Daniel Treisman.

p. 435: East Village in Manhattan . . . Tomkins, *Post- to Neo-,* pp. 71–75, 187 and 192.

p. 435: Estelle Schwartz . . . interview with the author, New York City, November 1, 1990.

p. 436: Jeffrey Deitch . . . articles provided to the author by Mr. Deitch include: "The Education of Jeffrey Deitch," by Alan Jones; "Jeffrey Deitch," *Nikkei Art,* Tokyo, 1989/1, January 1989, pp. 123–27; "Banking on Deitch," by Stuart Greenspan; "Jeffrey Deitch: Asesorar es una forma de expresión," by Mira Sentis.

p. 437: Larry Gagosian . . . interview with the author, New York City, December 7, 1990; also: "Going Places," by Dodie Kazanjian; "Must I Be a Saint?" by Dana Wechsler Linden.

p. 439: Leslie Waddington . . . interview with the author, London, September 12, 1990.

 Anthony d'Offay . . . quoted in "Playing to the Galleries," *The* (London) *Sunday Times Magazine,* September 30, 1990, pp. 40–41.

p. 440: Matthew Flowers, etc. . . . *ibid.,* p. 44.

 Nicholas Logsdail . . . *ibid.,* p. 42.

 David Tunick . . . interview with the author, New York, June 5, 1991.

 Piero Corsini . . . interview with the author, New York, May 10, 1990.

p. 440: Eugene Thaw . . . interview with the author, New York City, Decem-

ber 5, 1990. Also: "Finely Drawn: The Collection of Mr. and Mrs. Eugene V. Thaw," by Rosamund Bernier.

Desmond Corchoran and Martin Summers . . . interview with the author, London, June 18, 1990.

Derek Johns . . . interview with the author, London, June 25, 1990. See also: "A Who's Who of Old Master Dealers in London," by Godfrey Barker.

London *Observer* survey (made by the author) . . . "The Colour of Money," *The* (London) *Observer,* May 5, 1991, p. 10.

p. 441: Marianne Nahon . . . interview with the author, Paris, October 10, 1990.

Glabman-Ring . . . "The New Paris," a round-table discussion in *Art & Auction,* June 1990, pp. 188ff.; also: "Crisis? What Crisis? Dossier Special FIAC," by Joséphine le Poll.

Durand-Dessert . . . "Durand-Dessert: Moving to the Bastille," by Rachel Stella.

Drouot . . . author interviews with Alexandre de Fay, Marie Lanxade, Brigitte Mamani, Paris, October 10, 1990.

Jean-Louis Picard . . . interview with the author, Paris, October 9, 1990.

p. 442: Guy Loudmer . . . interview with the author, Paris, October 8, 1990. See also: "Loudmer Goes into Orbit," by Georgina Adams; also: "Portrait: Auctioneer Guy Loudmer," by Nicholas Powell.

p. 442: Jean-Louis Picard . . . interview with the author, Paris, October 9, 1990; also: "En tête depuis quatre-vingt ans," by François Duret-Robert.

p. 443: Eric Turquin . . . interview with the author, Paris, October 9, 1990. For an alternative view from Paris, see Maître Binoche, *De la peinture moderne en général et de la spéculation en particulier;* Raymond Chevallier, *L'Artiste, le collectionneur et le faussaire.*

p. 444: The Italian statistics are taken from an article on the *Censis* report in *The Art Newspaper,* March 1991, p. 3.

p. 445: Thomas Ammann . . . interview with the author, Gstaad, February 11, 1991.

40 | Climax: The Billion-Dollar Binge

p. 447: Dorrance . . . for background, see *Sotheby's Art at Auction, 1989–90,* "The Collection of John T. Dorrance, Jr."

p. 448: The Mayer collection . . . for background, see *Christie's Review of the Season 1990,* "Contemporary Art Sales," by Martha Baer, pp. 141–42.

p. 450: Paul Mellon's Manet . . . for background, see *Christie's Review of the Season 1990,* p. 90.

p. 450: *Time* magazine . . . "Art and Money," by Robert Hughes. See also the author's article "Smelling of Irises," in the London *Spectator*, December 9, 1989, p. 45–46.

p. 451: Zoffany portrait . . . for background, see *Christie's Review of the Season 1990*, p. 51.

p. 451: Susumu Yamamoto . . . Interview with the author, July 4, 1991, Tokyo.

p. 452: Tomonori Tsurumaki . . . I have used an unpublished article by Peter McGill, the London *Observer*'s Tokyo correspondent, to whom I am grateful for permission to reproduce the material. The article, "Picasso Mogul," is dated December 2, 1989.

p. 453: The Metropolitan Museum changes from "Notable Acquisitions" to "Recent Acquisitions" . . . Hughes, "Art and Money." "A new aesthetic by the Japanese" . . . Souren Melikien, "Asians Sway Market with New Aesthetic."

p. 453: Sir Joseph Robinson . . . for background, see Peter Cannon-Brookes, "The Sir Joseph Robinson Collection."
Henry Blackmer . . . "The Library of Henry Blackmer II," Sotheby's sale, October 11–13, 1989. See essays in catalogue; no pagination.

p. 454: The Garden Ltd. . . . Jay Dillon, "The Power to Move Us: The Collection of The Garden Ltd."
The Patiño sale . . . Nicholas Rayner, "The Jewels of Luz Mila Patiño, Countess du Boisrouvray."

p. 455: The Million-Dollar List . . . Sotheby's, "Million-Dollar List: 1989–90 Sales Season."

41 | Anticlimax: The Art of *Zaiteku*

p. 456 Pierre Matisse/Acquavella/Sotheby's . . . "$142.8 Million Art Purchase by Sotheby's and Dealer," by Rita Reif, *The New York Times*, April 26, 1990; "Self-effacing William Acquavella, Who Struck Art's Biggest Deal," by Grace Glueck, *The New York Times*, May 10, 1990.

p. 457: The sale of *Irises* to the Getty Museum was announced on March 21, 1990, by Lori Starr, head of public information at the museum. See also: John Seabrook, "The Junking of Bond."

p. 458: Tatsuo Hirano's Western-style auction in Tokyo . . . Sarah Jane Checkland, "Danger in the Land of the Rising Sums."
Art and financial engineering . . . the first comprehensive article appears to have been Masayoshi Kanbayashi and Marcus W. Branchli, "Itoman Reveals Role of Japanese Banks."

p. 459: Japan's art scandals . . . this section is based on interviews the author conducted in Tokyo in July 1991. Several people who were interviewed did not wish to be identified, but among those who agreed to be named were: Masanori Hirano, Susumu Yamamoto, Noritsugu Shimose of the Tamenaga Gallery, and Toshihiko Yamauchi, all

interviewed in Tokyo in the week beginning July 1, 1991; also thanks to Yasuhiro Kobayashi and Norio Suzuki of the *Asahi Shimbun,* who helped with research.

p. 460: Kazuko Shiomi . . . interview with the author, Tokyo, July 2, 1991.

p. 460: Golf-club membership fees . . . see, for instance, *Asian Wall Street Journal,* November 19, 1990, p. 5.

p. 461: The Itoman scandal . . . for a fuller account, see Peter Watson, "Japan's Art of Deception."

p. 462: Masanori Hirano . . . interview with the author, Tokyo, July 3, 1991.

p. 464: For the Mitsubishi affair, see also Hiroko Katayama, "Japan's Murky Art Scene."

p. 465: Citibank turned away from Christie's and Sotheby's . . . interview with Christopher Burge, New York, June 5, 1991.

p. 466: Sachiko Hibiya . . . interview with the author, July 3, 1991.

Epilogue | The Post-*Gachet* World

p. 469: Jean-Louis Picard . . . interview with the author, Paris, October 8, 1990.

p. 471: Eugene Thaw . . . " Beauty on the Block," *New Republic,* November 11, 1985.

p. 472: John Herbert's graphs . . . Herbert, *Inside Christie's,* pp. 378–81.
Sotheby's London office . . . see Peter Watson, "Dealers in Hock," London *Spectator,* July 13, 1989, pp. 36–37.

p. 476: Robert Hughes . . . Robert Hughes, *Nothing If Not Critical,* pp. 6ff.

p. 477: Chinese studying the Western art market . . . interview with Giuseppe Eskenazi, Hong Kong, November 11, 1990. Chinese Relics sale . . . "China OKs First Auction of Relics," by Sun Wenge, *China Daily,* April 26, 1992.

p. 479 The Alex Brown report . . . "Sotheby's Holdings, Inc., Has Become Sophisticated Marketing Company Which Will Increase Market Share in Growing Art Market," Basic Analysis by Fred E. Wintzer, Alex Brown & Sons, Inc., Research, Emerging Growth Retailers Group, January 19, 1989.

BIBLIOGRAPHY

The references that follow are intended to be a basic bibliography on the history of the art market, for scholars and others who wish to follow up in more detail issues raised in this book. The list makes no claim to being exhaustive: I have excluded most articles that seemed to me to be primarily expressions of the writers' *opinions* and have concentrated instead on articles and books whose principal aim has been to provide new *information* about this or that aspect of the market. Anonymous articles are listed under the publication concerned. Sources marked with an asterisk also have useful bibliographies.

Reference Works

RILA—The International Repertory of the Literature of Art: A Bibliographical Series of the Getty Art Program.

Vertue, George. *The Notebooks of George Vertue.* Oxford: Walpole Society, 1930–47.

Whitley, W. T. *Art in England, 1800–1828.* Cambridge, 1921.

———. *Artists and Their Friends in England, 1700–1799.* 2 vols. London, 1928.

In addition, the monthly magazine *Art & Auction,* published in New York, is, as its name implies, given over entirely to the international art market. In the bibliography that follows, I have mentioned only those articles in *Art & Auction* that I have specifically referred to.

Other Sources

Adams, Georgina. "Loudmer Goes into Orbit." *ARTnews* (Summer 1990), pp. 43ff.

Adams, Laurie. *Art on Trial.* New York: Walker & Co., 1976. Especially pp. 169–210, "The Matter of Mark Rothko, Deceased."

Agnew, Sir Geoffrey. *Agnews 1817–1967.* London, 1967.

Allemand, Maurice. *La Vie quotidienne sous le Second Empire.* Paris, 1948.

Alpers, Svetlana. *Rembrandt's Enterprise.* Chicago: University of Chicago Press, 1988.

Anderson, Wayne. "Cézanne, Tanguy, Chocquet." *Art Bulletin,* June 1967.

Apollo. "Artists' Bodies and Dealers' Souls." Vol. 35 (January–June 1942), pp. 134–35.

———. "The Six Sale in Amsterdam." Vol. 8, p. 239.

Armstrong, Matthew. "'Gachet is very, yes, very like you and me': Portrait du Dr. Gachet." In *Christie's Review of the Season 1990,* pp. 81–84.

Art & Antiques. "The Top 100 Collectors." March 1990 (but see other years for this annual list).

Art & Auction. "The Future of Corporate Art." April 1988, p. 87.

———. "The Secondary Market for Contemporary Art." June 1989, p. 166.

———. "1992. Its Effect on the Art Market." January 1990.

———. "The New Paris." June 1990, pp. 188ff.

Art Bulletin. "Gavin Hamilton: Archaeologist, Painter, Dealer." Vol. 44 (1962), pp. 87ff.

Art History. "The Avant-Garde: Order and the Art Market, 1916–1923." Vol. 2, pp. 95–106.

———. "Courbet's Landscapes and Their Market." Vol. 4, pp. 410–31.

———. "The First Impressionist Exhibition: Timing, Commerce and Patriotism." Vol. 7, pp. 465–76.

———. "Artistic Taste: The Economy and Social Order in Former Han China." Vol. 9, pp. 285–305.

———. "Dealing in Temperaments: Economic Transformation of the Artistic Field in France during the Second Half of the Nineteenth Century." Vol. 10, pp. 59–78.

———. "Art Collecting and Victorian Middle-Class Taste." Vol. 10, pp. 328–50.

Art International. André Emmerich Interview. No. 12 (Autumn 1990), pp. 30–33.

Art Journal. "The Scull Auction." Vol. 39–40 (1979–80), p. 50.

———. "Avant-Garde and the Potential Market in the Early 1950s." Vol. 47 (1988), p. 215.

ARTnews. Paula Cooper interview. March 1989, pp. 153–57.

———. "The *ARTnews* 200." January 1990 (but see other years for this annual list of top collectors).

Ashton, Dore. *The New York School: A Cultural Reckoning.* New York: Viking, 1973.

Asian Wall Street Journal. "The Market in Golf Club Membership Fees." November 19, 1990, p. 5.

*Assouline, Pierre. *An Artful Life: A Biography of D. H. Kahnweiler, 1884–1979.* New York: Grove and Weidenfeld, 1988.

Bailey, Colin. "Lebrun et le commerce d'art pendant le blocus continental." *Revue de l'art* 63 (1984), pp. 35–46.

Baillie-Grohman, W. A. "A Portrait of the Ugliest Princess in History." *Burlington Magazine* 38 (1921), pp. 172–77.

Bailly-Herzberg, Janine. *L'Eau-forte de peintre au dix-neuvième siècle: La Société des Aquafortistes, 1862–1867.* Paris, 1972.

Bardon, H. "Sur le goût de Cicéron à l'époque des verrines." *Ciceronia,* Rome, 1960, pp. 1–13.

Barker, Godfrey. "A Who's Who of Old Master Dealers in London." *Journal of Art,* November 1990, p. 62.

Battie, David, ed. *Sotheby's Concise Encyclopaedia of Porcelain.* London: Conran Octopus, 1990.

Baudelaire, Charles. *The Painter of Modern Life and Other Essays.* Translated by Jonathan Mayne. London, 1964.

Baumol, William. "Unnatural Value of Art Investment as Floating Crap Game," *American Economic Review Papers & Proceedings,* no. 76 (May 1986), pp. 10–16.

Becker, Robert. "Dealing Contemporary Art on Fifty-seventh Street." *Art & Auction,* March 1984, pp. 36–43.

Behrman, S. N. *Duveen.* New York: Random House, 1952.

Benedict, Philip. "Towards the Comparative Study of the Popular Market for Art: The Ownership of Paintings in Seventeenth-Century Metz." *Past & Present* 109 (1985), pp. 100–117.

Bernard, Émile. "Julian Tanguy, dit le Père Tanguy." *Mercure de France,* December 16, 1908.

Bernier, Georges. *L'art et l'argent: Le Marché de l'art au XX^e siècle.* Paris: Robert Laffont, 1977.

Bernier, Rosamund. "Finely Drawn: The Collection of Mr. and Mrs. Eugene V. Thaw." *House & Garden* (U.S.), May 1986, pp. 156ff.

Betjeman, Sir John. "The Pantechnicon." *Sotheby's Art at Auction, 1970–71,* pp. 448–51.

Beurdeley, Michel. *Trois siècles de ventes publiques.* Paris: Tallandier, 1988.

Binoche, Maître. *De la peinture moderne en général et de la spéculation en particulier.* Paris: Le Pré aux Clercs, 1991.

Bodelsen, Meret. "Early Impressionist Sales, 1874–1894, in the Light of Some Unpublished Procès-Verbaux." *Burlington Magazine,* June 1968.

Bongard, Willi. "Kunstkompass 1976, Il listino valori dei cento artisti piu famosi degli anni '60 e '70." In *Domus,* November 1976, pp. 21–24.

Boothroyd, Basil. *Phillips: 1796–1974.* London, n.d. (1974?).

Boterf, Hervé le. *La Vie Parisienne sous l'Occupation.* Paris: Éditions France-Empire, 1975. Especially Chap. 4: "Les Salles de ventes."

Bowness, Sir Alan. *The Conditions of Success.* London: Thames & Hudson, 1989.

Brigstocke, Hugh. *William Buchanan and the Nineteenth-Century Art Trade.* Published privately by the Paul Mellon Center for Studies in British Art, 1982.

Brimo, René. *L'Évolution du goût aux États-Unis.* Paris, 1938.

Brown, Milton. *The Story of the Armory Show.* New York: Abbeville Press, 1988.

Browse, Lilian. "Some Memories of the London Art World." *Burlington Magazine* 127 (September 1985), pp. 610–13.

Buchanan, William. *Memoirs of Painting.* London, 1824.

Buck, Joan Juliet. "Dealer's Choice." *Vogue* (U.S.), February 1989, pp. 339–43, 390.

Burling, Judith, and Arthur Hart. "Collecting in Wartime Shanghai." *Apollo* 39 (1944), pp. 49–50, with continuation on back cover.

Burlington Magazine. "Publication of Works of Art Belonging to Dealers." Vol. 2 (1904), p. 5.

————. "The Status of the American Collector." Vol. 5, p. 335.

————. "The Consequences of the American Invasion." Vol. 5, p. 353.

————. "The Extinction of the Middle-Class Collector." Vol. 7, p. 173.

————. "Auctioneer as Dealer." Vol. 7, p. 371.

————. "The Trend of the Art Market." Vol. 11, p. 135.

————. "The Fourth International Congress of Art Dealers." Vol. 96, p. 228.

————. "Changes in Taste." Vol. 102, p. 51.

————. "Early Buyers of French Impressionism in England." Vol. 108, pp. 141ff.

————. "Gauguin the Collector." Vol. 112, p. 590.

————. "Art Dealing in the Risorgimento" (1 & 2). Vol. 115, pp. 44ff, and vol. 121, pp. 492ff.

————. "Dutch Pictures in Venice." Vol. 123, pp. 467ff.

Cabanne, Pierre. *The Great Collectors.* London: Cassell, 1963.

Campbell, Lorne. "The Art Market in the Southern Netherlands in the Fifteenth Century." *Burlington Magazine* 118 (1976), pp. 188–98.

Cannon-Brookes, Peter. "The Sir Joseph Robinson Collection." *Sotheby's Art at Auction, 1989–90,* pp. 20ff.

Carter, John, and Percy Muir, eds. *Printing and the Mind of Man.* Cambridge: Cambridge University Press, 1967.

Charleston, Robert, ed. *World Ceramics.* London, 1981.

Checkland, Sarah Jane. "Danger in the Land of the Rising Sums." *The* (London) *Times,* October 13, 1990, p. 23.

Chernow, Ron. *The House of Morgan.* New York: Simon & Schuster, 1990.

Chevallier, Raymond. *L'Artiste, le collectionneur et le faussaire: Pour une sociologie Romain.* Paris: Armand Colin, 1991.

Clay, Jean. "L'Épopée de Wildenstein." *Réalités,* 158 (March 1959), pp. 77ff.

Coarelli, F. "Il commercio delle opere d'arte in età tardo-repubblicana." *Dial. di Archeol.* 3 (1983), Ii 45–53.

Colnaghi, D., & Co. *Colnaghi's, 1790–1960.* With an introduction by Elfrida Manning. London, 1960.

Colnaghi, P. & D., & Co. "Art, Commerce, Scholarship: A Window onto the Art World—Colnaghi 1760 to 1984." Exhibition and Catalogue. Number 7, to December 15, 1984.

Colson, Percy. *A Story of Christie's.* London, 1950.

Connoisseur. "Drouot and Auction Rooms in Paris before and after the Revolution." Vol. 3, pp. 235ff.

————. "The Ideal Collector." Vol. 5, p. 30.

————. "Collecting as an Investment, with Tables of Prices Paid and Realized." Vol. 7, p. 44.

————. "The Old and New Collector." Vol. 8, pp. 56–57.

Conrad, Barnaby. "A Stroll Down Fifty-seventh Street." *Horizon,* April 1981, pp. 26–29.

Considine, Robert. *Larger Than Life: A Biography of the Remarkable Dr. Armand Hammer.* New York: Harper & Row, 1975.

Constable, W. G. *Art Collecting in the United States of America.* London: Nelson, 1964.

Cooper, Douglas. "Looted Works of Art in Switzerland: German Methods of Acquisition." January 21, 1945, Monuments, Fine Arts and Archives Commission.

———. *One Hundred Years of Impressionism.* London: Sotheby's, 1973.

Crowe, Sir J. A., and G. B. Cavalcaselle. *A New History of Painting in Italy from the Second to the Sixteenth Century.* 3 vols. London, 1864–66.

Cullerne Bown, Matthew. "Russian Avant-Garde and Soviet Contemporary Art in Moscow." *Sotheby's Art at Auction, 1987–88,* p. 138.

Davenport, Nancy. "Armand Auguste Deforge: An Art Dealer in Nineteenth-Century Paris and 'la peinture de fantaisie.' " *Gazette des Beaux-Arts* 101 (1983), pp. 81–88.

Davidson, J. P. *Calvinistic Economy and Seventeenth-Century Dutch Art.* Lawrence, Kansas, 1979.

Denucé, J. *Art Export in Seventeenth-Century Antwerp: The Firm Fouchoudt, Sources of the History of Flemish Art.* Antwerp, 1931.

Dillon, Jay. "The Power to Move Us: The Collection of The Garden Ltd." *Sotheby's Art at Auction, 1989–90,* p. 198.

*Distel, Anne. *Impressionism: The First Collectors.* New York: Harry N. Abrams, 1990.

Duret-Robert, François. "En tête depuis quatre-vingt ans" (Picard). *Connaissance des Arts,* 1990, pp. 38–45.

Duthy, Robin. *The Successful Investor.* London: Collins, 1986.

———. "Golden Year for Gilt-Framed Investments." *The Financial Times,* May 15, 1990, pp. 12, 14.

"The Einsatzstab Reichsleiter Rosenberg: An Analysis of the Captured Letter-Register of the ERR, October 29, 1940, through March 9, 1941." Imperial War Museum (London), FO 645, box 349.

Eudel, Paul. *L'Hôtel Drouot.* 8 vols. Paris, 1882–91.

Fairly, Patricia. "How the J. Paul Getty Trust Will Spend $90 Million a Year." *ARTnews* 83, no. 4 (1984), pp. 64–72.

Faith, Nicholas. *Sold: The Revolution in the Art Market.* London: Hamish Hamilton, 1985.

Feilchenfeldt, Walter. "Vincent van Gogh and Paul Cassirer, Berlin: The Reception of van Gogh in Germany from 1901 to 1914." *Cahier Vincent* 2, Rijksmuseum van Gogh. Uitgeverij Waanders, Zwolle, 1988.

———. "Vincent van Gogh and the Art Market, 1890–1990." Lecture given at a study day on van Gogh at the National Gallery, London, June 1, 1990.

Fiddell-Beaufort, Madeleine. "A Measure of Taste: Samuel P. Avery's Art Auctions, 1864–1880." *Gazette des Beaux-Arts* 100 (1982).

Fiddell-Beaufort, Madeleine, H. L. Kleinfeld and J. K. Welcher, eds. *The Diaries 1871–1882 of Samuel P. Avery, Art Dealer.* New York: Ayer, 1979.

Figgess, John. "The Art Market: Western Art and the Japanese." *Apollo* 126 (August 1987), pp. 114–15.

Fink, Lois Marie. "French Art in the United States 1850–1870: Three Dealers and Collectors." *Gazette des Beaux-Arts* 92 (1978), pp. 87ff.

Fitzgerald, Michael. "The 'Peau de l'Ors.' " *Art in America,* February 1992.

Fleming, J. "Messrs. Robert and James Adam, Art Dealers." *Connoisseur,* no. 144 (1959), pp. 168–71.

Foote, Samuel. *The Dramatic Works of Samuel Foote.* London, 1781.

Ford, B. "Thomas Jenkins, Banker, Dealer and Unofficial English Agent." *Apollo* 99 (1974), pp. 416–25.

Fournel, Victor. *Paris nouveau et Paris futur.* Paris, 1865.

Freeman, Arthur, and Janet Ing Freeman. *Anatomy of an Auction: Rare Books at Ruxley Lodge, 1919.* London: The Book Collector, 1990.

*Frey, Bruno, and Werner Pommerehne. "Art Investment: An Empirical Inquiry." Free University of Berlin, *Discussion Papers on Public Sector Economics,* 8807, June 1988.

*———. *Muses and Markets: Explorations in the Economics of the Arts.* Oxford: Basil Blackwell, 1989.

Fried, Michael. "Manet's Sources: Aspects of His Art, 1859–1865." *Artforum* 7, no. 7 (March 1969), pp. 1–82.

Gaspari, Carlo. "I marmi antichi degli Uffizi: Collezionismo mediceo e mercato antiquerio romano tra il XVI ad il XVIII secolo." *Proceedings of an International Conference Held in Florence,* September 20–24, 1987, pp. 217–31.

*Gee, Malcolm. *Dealers, Critics and Collectors of Modern Painting: Aspects of the Parisian Art Market Between 1910 and 1930.* New York and London: Garland Publishing, 1981.

Gimpel, René. *Diary of an Art Dealer.* New York: Farrar, Straus & Giroux, 1966.

Giuliano, A. *Il commercio dei sarcofagi attici.* Rome, 1962.

Gould, Cecil. "The Schenker Papers: Part 1, Accession to German Museums and Galleries during the Occupation of France; Part 2, Purchases of Works of Art in France during the Occupation by and on Behalf of German Dealers and Officials, April 5, 1945." Ref: INTR/62875/1/MFA.

Graham-Dixon, Andrew. "Saatchi Sneezes and the Art World Shivers." *The* (London) *Independent,* October 14, 1989.

Grampp, William. *Pricing the Priceless: Art, Artists, and Economics.* New York: Basic Books, 1989.

Graves, A. *Art Sales from Early in the Eighteenth Century to Early in the Twentieth.* 3 vols. London, 1921.

Green, Martin. *New York 1913: The Armory Show and the Patterson Strike Pageant.* New York: Charles Scribner's Sons, 1988.

Greenspan, Stuart. "Banking on Deitch." *Art & Auction,* September 1988, pp. 32–33.

Guggenheim, Peggy. *Confessions of an Art Addict.* New York: Macmillan, 1960.

———. *Out of This Century.* New York: Universe Books, 1979.

Guillaumin, Paul. *Drouot Hier et Aujourd'hui.* Paris: Les Éditions de l'Amateur, 1986.

Hahn, Harry. *The Rape of La Belle.* New York: Glenn Books, 1945.

Halperin, Joan Ungersma. *Félix Fénéon, Aesthete and Anarchist in Fin-de-Siècle Paris.* New Haven and London: Yale University Press, 1988.

Harvey, George. *Henry Clay Frick: The Man.* Privately printed, 1936.

Haskell, Francis. *Rediscoveries in Art: Some Aspects of Taste, Fashion and Collecting in England and France.* Ithaca, N.Y.: Cornell University Press, 1976.

Hatzfield, J. *Les Trafiquants italiens dans l'Orient hellénique.* Paris, 1919.

Heller, Ben. "The *Irises* Affair." *Art in America,* Summer 1990, pp. 45–53.

Herbert, Eugenia. *The Artist and Social Reform: France and Belgium 1885–1898.* New Haven: Yale University Press, 1961.

Herbert, John. *Inside Christie's.* London: Hodder & Stoughton, 1990.

Herrmann, Frank. *Sotheby's: Portrait of an Auction House.* London: Chatto & Windus, 1980.

———. ed. *The English as Collectors: A Documentary Chrestomathy.* London: Chatto & Windus, 1972.

———. "The Emergence of the Book Auctioneer as a Professional." In *Property of a Gentleman: The Formation, Organization and Dispersal of the Private Library 1620–1920,* edited by Robin Myers and Michael Marrs. Winchester: St. Paul's Bibliographies, 1991.

———. "Peel and Solly, Two Nineteenth-Century Art Collectors and Their Sources of Supply." *Journal of the History of Collectors,* vol. 3, no. 1 (1991), pp. 89–96.

Hinz, B. *Art in the Third Reich.* Oxford: Blackwell, 1980.

Hirschfield, Gerhard, and Patrick Marsh, eds. *Collaboration in France: Politics and Culture during the Nazi Occupation, 1940–1944,* New York: Oxford; Munich: Berg, 1989.

Hofgref, J. *Wholly Unacceptable: The Bitter Battle for Sotheby's.* London: Harrap, 1986.

Hughes, Robert. "Art and Money." *Time* magazine, November 27, 1989, pp. 60–68.

———. *Nothing If Not Critical.* London & New York: Collins Harvill, 1990.

Hunter, Sam. *Art in Business: The Philip Morris Story.* New York: Harry N. Abrams, 1979.

Jacob, Dirk. "Jacopo Strada et le commerce d'art." *Revue de l'art* 77 (1987), pp. 11–21.

Januszczak, Waldemar. "In the Country of the Cultural Cocktail." *The Guardian,* February 4, 1986.

Jensen, R. "The Avant-Garde and the Trade in Art." *Art Journal* 47, no. 4 (Winter 1988), pp. 360–67.

Johnson, Una. *Ambroise Vollard, Éditeur.* New York: Museum of Modern Art, 1977.

Jones, Alan. "The Education of Jeffrey Deitch." *Contemporanea,* November–December 1988, pp. 118–20.

Kanbayashi, Masayoshi, and Marcus W. Branchli. "Itoman Reveals Role of Japanese Banks." *Asian Wall Street Journal,* November 1, 1990, pp. 1, 5.

Katayama, Hiroko. "Japan's Murky Art Scene." *Forbes,* April 29, 1991, p. 57.

Kawakita, Michiaki. *Modern Currents in Japanese Art.* Tokyo: Heibonsha, 1965; English translation, New York: Weatherill, 1974.

Kazanjian, Dodie. "Going Places" (Larry Gagosian). *Vogue* (U.S.), November 1989, pp. 412–17, 462.

Knoedler, M. L. *A Catalogue of an Exhibition of Paintings and Prints of Every Description on the Occasion of Knoedler, One Hundred Years, 1846–1946,* New York, April 1–27, 1946.

Kozloff, Max. "Pop Culture, Metaphysical Disgust, and the New Vulgarians." *Art International,* February 1962.

Learmount, Brian. *A History of the Auction.* London: Barnard & Learmount, 1985.

*Leavens, Ileana B. *From "291" to Zurich: The Birth of Dada.* Ann Arbor: UMI Research Press, 1983.

Lehmann-Haupt, H. *Art Under Dictatorship.* New York: Oxford University Press, 1954.

Lenman, Robin. "Painters, Patronage and the Art Market in Germany 1850–1914." *Past and Present,* no. 123, p. 109.

Levi, C. A. *Le collezioni veneziane d'arte e d'antichità del secolo XVI ai nostri giorni.* Venice, 1900.

Lewis, Leslie. *Connoisseurs and Secret Agents in Eighteenth-Century Rome.* London, 1961.

*Lippincott, Louise. *Selling Art in Georgian London: The Rise of Arthur Pond.* New Haven and London: Yale University Press, 1983.

Lugt, F. *Répertoire des catalogues des ventes publiques interessant l'art ou la curiosité.* 3 vols. The Hague, 1938.

Lunsingh Scheurleer, D. F. *Chinese Export Porcelain.* London, 1974 (English translation of *Chine de Commande*).

Luther Whitington, G. "LA Brat Pack." *Art & Auction,* June 1990, pp. 174ff.

Maas, Jeremy. *Gambart, Prince of the Victorian Art World.* London: Barrie & Jenkins, 1975.

McAllister Johnson, W. "Painting, Provenance and Price: Speculation on Eighteenth-Century Connoisseurship Apparatus in France." *Gazette des Beaux-Arts* 107 (May–June 1986), pp. 191–99.

Mannings, David. "A Note on Some Eighteenth-Century Portrait Prices in Britain." *British Journal for Eighteenth-Century Studies* 6, no. 1 (1983), pp. 185–96.

Mariller, H. C. *Christie's: 1766 to 1925.* London: Constable, 1926.

Marquis, Alice Goldfarb. *Alfred H. Barr, Jr., Missionary for the Modern.* New York: Contemporary Books, 1989.

Martorella, Rosanne. *Corporate Art.* New Brunswick and London: Rutgers University Press, 1990.

Matilla, Antonio Tascon. "Comercio de pintura y alcabalas." *Goya* 178 (1984), pp. 180–81.

Melikien, Souren. "Asians Sway Market with New Aesthetic." *International Herald Tribune,* October 28–29, 1989, pp. 7–8.

Mirbeau, Octave. "Le Père Tanguy." *L'Écho de Paris,* February 13, 1894.

Mireur, H. *Dictionnaire des ventes d'art XVIII-XIXme siècles.* 7 vols. Paris, 1901–12.

Montgomery Museum of Fine Arts. *Art Inc.: American Paintings from Corporate Collections.* Catalogue of an exhibition held at four United States museums in 1979, with an introduction by Mitchell Douglas Kahan.

Montias, John Michael. "Cost and Value in Seventeenth-Century Dutch Art." *Art History* 10, pp. 455–66.

———. "Reflections on Historical Materialism, Economic Theory and the History of Art in the Context of Renaissance and Seventeenth-Century Delft: Evidence from Inventories." *Journal of Cultural Economics* 5 (1981), pp. 19–38.

*———. *Artists and Artisans in Delft: A Socio-Economic Study of the Seventeenth Century.* Princeton: Princeton University Press, 1982.

Morelli, Giovanni. *Italian Painters: Critical Studies of Their Works.* English translation by Constance ffoulkes. 2 vols. London, 1892.

Moulin, Raymonde. *The French Art Market: A Sociological View.* New Brunswick: Rutgers University Press, 1987. An abridged translation by Arthur Goldhammer of *Le Marché de la peinture en France.* Paris: Éditions de Minuit, 1967.

Napack, Jonathan. "The Wildenstein Family." *Spy* magazine, October 1991, pp. 61ff.

Nikkei Art (Tokyo). "Jeffrey Deitch." January 1989, pp. 123–27.

Nonne, Monique. "Les Marchands de van Gogh." In exhibition catalogue "Van Gogh à Paris." Paris: Musée d'Orsay, 1988.

Norman, Geraldine. "Saatchi 'Dumps' Unwanted Art." *The* (London) *Independent,* November 13, 1991.

Ocular magazine. Paula Cooper interview. Summer quarter, June 1977, pp. 28–37.

Office of Strategic Services, Art Looting Investigation Unit. National Archives (Washington, D.C.), record group 239, boxes, 25, 41, 42, 70 and 77, and record group 260, box 387.

———. "Activity of the ERR in France." Orion Report CIR No. 1, August 15, 1945, National Archives (Washington, D.C.), record group 239, box 75.

———. "Interim Report on the Art Activities of Hermann Göring." June 12, 1945. National Archives (Washington, D.C.), record group 153, records of the Judge Advocate General, box 1390, OSS X-2.

Ono, Yumiko. "Debt Collector Turns Art Collector." *The Wall Street Journal,* October 27, 1989.

Oriental Ceramics Society. *Porcelain for Palaces: The Story of Old Japan in Europe.* Catalogue of an exhibition organized by the Oriental Ceramics Society and held in the British Museum, 1990.

Parkinson, R. "The First King of Epithets." *Connoisseur,* April 1978, pp. 269–73.

*Pears, Iain. *The Discovery of Painting: The Growth of Interest in the Arts in England, 1680–1768.* New Haven and London: Yale University Press, 1988.

Piccus, Robert P. "Charlotte Horstmann at Eighty-two." *Orientations* 21, no. 11 (November 1990), pp. 82–89.

Pinkney, David. *Napoleon III and the Rebuilding of Paris.* Princeton: Princeton University Press, 1958.

Pointon, Marcia. "Portrait Painting as a Business Enterprise in London in the 1780s." *Art History* 7, pp. 187–205.

le Poll, Joséphine. "Crisis? What Crisis? Dossier Special FIAC." *Galleries Magazine,* October–November 1990, pp. 211ff.

Pollock, Griselda. "Van Gogh in Cultural Politics Since the War." Lecture given at a study day on Vincent van Gogh at the National Gallery, London, June 1, 1990.

*Pomian, Krzysztof. *Collectors and Curiosities.* Oxford: Basil Blackwell, 1990. Originally published as *Collectionneurs, amateurs et curieux.* Paris: Éditions Gallimard, 1987.

Powell, Nicholas. "Portrait: Auctioneer Guy Loudmer." *Art & Auction,* January 1991, pp. 76–79.

Pulver, Rosalind. "An Early Eighteenth-Century China Shop." *English Ceramics Circle Transactions* 12, no. 2 (1985), pp. 120–23.

Ragache, Gilles, and Jean-Robert Ragache. *La Vie quotidienne des écrivains et des artistes sous l'Occupation 1940–1944.* Paris: Hachette, 1988.

Randall, L. M., ed. *The Diary of George A. Lucas: An American Agent in Paris, 1857–1909.* Princeton: Princeton University Press, 1979.

Rayner, Nicholas. "The Jewels of Luz Mila Patiño, Countess du Boisrouvray." *Sotheby's Art at Auction, 1989–90,* p. 342.

Redford, George. *Art Sales: A History of Sales of Pictures and Other Works of Art.* 2 vols. London, 1888.

Reff, Theodore. *Manet and Modern Paris: One Hundred Paintings, Drawings, Prints and Photographs by Manet and His Contemporaries.* Chicago and London: National Gallery of Art (Washington, D.C.) and University of Chicago Press, 1982.

Reid, Alex. *Alex Reid and Lefèvre, 1926–1976.* With an introduction by Douglas Cooper. London: Lefèvre Galleries, 1976.

Reif, Rita. "Van Gogh's 'Irises' Sells for $53.9 Million." *The New York Times,* November 12, 1987.

Reitlinger, Gerald. *The Economics of Taste.* 3 vols. London: Barrie & Rockliff, 1960–70.

Rewald, John. *The History of Impressionism.* 4th rev. ed. New York: The Museum of Modern Art, 1973; London: Secker & Warburg, 1973.

———. *Studies in Post-Impressionism.* New York: Harry N. Abrams, 1986; London: Thames and Hudson, 1986.

———. *Cézanne and America: Dealers, Collectors, Artists and Critics.* Princeton: Princeton University Press, 1989; London: Thames & Hudson, 1989.

Rivers, Isobel, ed. *Books and Their Readers in Eighteenth-Century England.* Leicester University Press, 1982.

Roberts, Keith. "Frick, Gulbenkian and Co." *Burlington Magazine,* 1972, pp. 405–11.

Robson, Deidre. "The Avant-Garde and the On-Guard: Some Influences on the Potential Market for the First-Generation Abstract Expressionists in the 1940s and Early 1950s." *Art Journal* 47, no. 3 (Fall 1988), pp. 215–21.

Saarinen, Aline. *The Proud Possessors.* New York: Random House, 1958; London: Weidenfeld & Nicolson, 1959.

Samuels, Ernest. *Bernard Berenson: The Making of a Connoisseur.* Cambridge: Harvard University Press, 1980.

Savary, P. *Dictionnaire Universelle de Commerce.* Copenhagen, 1762.

Seabrook, John. "The Junking of Bond." *Vanity Fair,* June 1990, pp. 156ff.

Seldes, Lee. *The Legacy of Mark Rothko.* London: Secker & Warburg, 1978.

Seligmann, Germain. *Merchants of Art, 1880–1960, Eighty Years of Professional Collecting.* New York: Appleton-Century Crofts, 1961.

Sentis, Mira. "Jeffrey Deitch: Asesorar es una forma de expresión." *Lapiz* (Madrid), November 1989, pp. 74–76.

Simpson, Colin. *Artful Partners.* New York: Macmillan, 1986.

Simpson, F. "Dutch Painting in England before 1760." *Burlington Magazine* 95 (1953), pp. 39–42.

Sitwell, Osbert, ed. *Walter Sickert: A Free House, or the Artist as Craftsman.* London: Macmillan, 1947.

Siviero, Rodolfo. *Centoquantuno capolavari trafugati dai nazisti e recuperati dallo 007 dell'arte italiana, L'Opera ritrovato, Omaggio a Rodolfo Siviero,* Firenze: Cantini, 1974.

Sotheby's. *One Hundred Years of Collecting in America: The Story of Sotheby Parke Bernet.* New York: Harry N. Abrams, 1984.

———. *Sotheby's Book Department: Some Notable Sales, 1963–76.* Sotheby-Parke-Bernet & Co., 1977.

———. "Million-Dollar List: 1989–90 Sales Season, Paintings, Drawings and Sculpture." March 13, 1991.

Sotheby's Art at Auction, 1989–90. "The Collection of John T. Dorrance, Jr.," pp. 110ff.

Spalding, Frances. *Roger Fry.* London, 1980.

Stein, J. P. "The Monetary Appreciation of Paintings." *Journal of Political Economy* 85, no. 5 (1977), pp. 1021–35.

Stella, Rachel. "Durand-Dessert: Moving to the Bastille." *Journal of Art,* November 1990, p. 34.

Stukeley, William. *The Family Memoirs of the Rev. William Stukeley.* London: The Surtees Society, 1880.

Sunday Times (London). "Playing to the Galleries," September 30, 1990, pp. 40ff.

Sutton, Denys. *Letters of Roger Fry.* 2 vols. London: Chatto & Windus, 1972.

———. "The Orléans Sale." *Apollo,* November 1983, pp. 357–72.

Tomkins, Calvin. *Off the Wall: Robert Rauschenberg and the Art World of Our Time.* New York: Doubleday, 1980.

———. "A Thousand Flowers." *The New Yorker,* May 19, 1980.

———. "Boom." *The New Yorker,* December 22, 1980.

———. *Post- to Neo-: The Art World of the 1980s.* New York: Henry Holt & Co., 1988.

Towner, Wesley. *The Elegant Auctioneers.* New York: Hill & Wang, 1970. This book was completed by Stephen Varble after Mr. Towner's death.

Treisman, Daniel. "Saatchi Denies Tricking the Art World." *The* (London) *Times,* November 18, 1989.

Venema, Adriaan. "Kunsthandel in Nederland, 1940–1945." Amsterdam: De Arbeiderspers, 1986.

Venturi, L. *Archives of Impressionism.* 2 vols. Paris/New York: Durand-Ruel, 1939.

Verena, Tafel. "Paul Cassirer als Vermittler Deutscher Impressionistischer Malerei in Berlin: Zum Stand der Forschung." *Zeitschrift des Deutschen Vereins für Kunstwissenschaft* 42, no. 3 (1988), pp. 31–46.

Vigée-Lebrun, Élisabeth. *Souvenirs.* 2 vols. Paris, n.d.

Vlaminck, Maurice de. *Portraits avant décès.* Paris, 1943.

Vollard, Ambroise. *Reflections of a Picture Dealer.* New York: Dover, 1978.

Wainwright, Clive. "Curiosities to Fine Art: Bond Street's First Dealers." *Country Life* 179, no. 4632 (May 1986), pp. 1528–29.

Walker, John. *Experts' Choice: One Thousand Years of the Art Trade.* New York: Stewart, Tabori & Chang, 1983.

Ward-Perkins, J. B. "The Marble Trade and Its Organisation." MAAR 36 (1980), pp. 325–38.

Warr, Stephen. "Saatchi Accused over Art Sale," *The* (London) *Times,* November 24, 1989.

Waterhouse, E. K. "A Note on British Collecting of Italian Pictures in the Late Seventeenth century." *Burlington Magazine* 102 (1960), pp. 54–58.

Watson, Peter. "Christie's Goes on Trial." *The* (London) *Observer,* January 11, 1987.

———. "Warhol: A $34 Million Junk Hype." *The* (London) *Observer,* March 1, 1987.

———. "£17 Million Gamble over van Gogh Painting." *The* (London) *Observer,* March 22, 1987.

———. "How Sotheby's Polished the Windsor Jewels." *The* (London) *Observer,* March 29, 1987.

———. *Wisdom and Strength: The Biography of a Renaissance Masterpiece.* New York: Doubleday, 1988; London: Hutchinson, 1991.

———. "Tax Bill May Force New Art Master Sale." *The* (London) *Observer,* December 18, 1988.

———. "British Rail's Art Auction." *The* (London) *Observer,* April 2, 1989.

———. "The Hunt for Art Fit for a Czar." *The New York Times,* March 25, 1990.

———. "Christie's v. Sotheby's: An Uncivil War." *The New York Times,* June 10, 1990.

———. "Exposed: Taxman's Lust for Art." *The* (London) *Observer,* April 28, 1991.

———. "Japan's Art of Deception." *The* (London) *Observer,* July 14, 1991.

Watson, Steven. *Strange Bedfellows: The First American Avant-Garde.* New York: Abbeville Press, 1991.

Wechsler, Dana. "Is the Art Market Ready for Mountain Tortoise." *Forbes,* March 19, 1990.

Wechsler Linden, Dana. "Must I Be a Saint?" (Larry Gagosian). *Forbes,* October 22, 1990, pp. 72–78.

Weinberg, Steve. *Armand Hammer: The Untold Story,* London: Ebury Press, 1989.

Weisberg, Gabriel. *Art Nouveau Bing, Paris Style 1900.* New York: Harry N. Abrams, 1986.

Weitzenhoffer, Frances. *The Havemeyers: Impressionism Comes to America.* New York: Harry N. Abrams, 1986.

Weld, Jacqueline Bograd. *Peggy, the Wayward Guggenheim.* New York: Dutton, 1986.

Williams, Robert C. *Russian Art and American Money: 1900–1940.* Cambridge: Harvard University Press, 1980.

Williamson, G. C. *Murray Marks and His Friends.* London: John Lane, 1923.

Wilson, J. C. Marketing Paintings in Late Medieval Belgium," in *Artistes, artisans et production artistique au Moyen Age: Rapports provisoires,* vol. 2, pp. 1759–66. Paris, 1986.

Wilson, Sarah. "Collaboration in the Fine Arts, 1940–1944." In Hirschfield and Marsh (see above).

Wolfe, Tom. *The Painted Word.* New York: Farrar, Straus & Giroux, 1975.

Zemel, Carol M. *The Formation of a Legend: Van Gogh Criticism 1890–1920.* Ann Arbor and London: UMI Research Press, 1980.

Ziegler, Jean. "L'École de la rue Laffitte 1856: Un texte introuvable de Boissard de Boisdenier sur les amateurs de tableaux et les spéculateurs." *Gazette des Beaux-Arts* 103 (1984), p. 124.

Zilczer, Judith. *The Noble Buyer: John Quinn, Patron of the Avant-Garde.* Published for the Hirschhorn Museum and Sculpture Garden by the Smithsonian Institution Press, Washington, D.C., 1978.

Zola, Émile. *L'Oeuvre.* Published in English as *His Masterpiece.* London: Chatto and Windus, 1902.

INDEX

Abe, Hajime, 391

Absinthe, L' (Degas), 100, 318–19, 333

Abstract Expressionism, xvii, 277, 289, 290, 303, 305, 308, 327, 328, 340, 348, 410

abstraction, 73, 178, 303, 366

Acquavella, William, 363, 456

Acrobat et jeune Arlequin (Picasso), 405, 406–7

Adams, Laurie, 341, 342

Ader, Picard & Tajan, 442–43

Adoration of God the Father, The, 140–41

Adoration of the Magi (Mantegna), 384–85, 386, 387, 388, 397

African art, 199, 212

Agnelli, Giovanni, 382

Agnew (dealer), 11–12, 15, 16, 23, 71–73, 102, 131, 132, 142, 165, 197, 200, 222, 228, 253, 324, 338–39, 383, 384, 440

Agnew, Colin, 212

Agnew, Geoffrey, 237, 330, 337

Agnew, John, 71

Agnew, Lockett, 73, 200

Agnew, Morland, 73

Agnew, Thomas, 71–72

Agnew, William, 72

Ainslie, Michael, 381, 386, 419, 458–59

Alexander, Brooke, 365

Alex Reid Lefèvre, 89

Allegory of Venus Entrusting Eros to Chronos (Tiepolo), 320

Allsopp, Charles, 14, 18, 23, 330, 390–91

Alma-Tadema, Lawrence, 102, 231, 263, 345–46

alternative catalogues, 135–36, 139

Altman, Benjamin, 34, 132, 140, 143, 167, 186, 193, 197

Ambassadors, The (Holbein), 105

American art, 33–35, 357, 388

American Art Association (AAA), 34–37, 118, 120, 121, 122, 124–25, 146–47, 149, 150, 164, 257, 169, 172, 173, 192–93, 194, 195, 196, 214, 215, 216, 218, 239

 Anderson merged with, 240–41, 249, 256–60

 Falcke and, 248–51

American Art Gallery, 33

American Art News, 180–81

Ammann, Thomas, 444, 445–46

Anderson, John, Jr., 118, 145–46

Anderson Auction Company (the Anderson), 145–46, 147, 149, 150, 169, 173, 195, 196, 197, 216–17, 218

 AAA merged with, 240–41, 249, 256–60

 Bishop's buying of, 218

Annesley, Noel, 383, 384

Annunciation (van Eyck), 244

Apollinaire, Guillaume, 152, 162, 212, 277, 407

Arensberg, Walter, 182, 184

Argenteuil sur Seine (Monet), 126

Aristotle Contemplating the Bust of Homer (Rembrandt), 321–22

Armory Show (1913), 163, 175–76, 178, 179–84, 187, 193, 196, 197, 199

Aron, Raymond, 280

Arp, Hans, 266

Arrowsmith, John, 66

Art Amateur, 34

Art & Antiques, 388

Art & Auction, 365

Artemis, 336–37, 440
Art Institute of Chicago, 126
Artist's Family, The (Hals), 169
Art Journal, 344
ARTnews, 309, 335, 388
Art Nouveau, 112
Art of This Century, 277–79, 285
Art-Union, 68
Ashley library, 247
Asquith, Margot, 281
Association of American Painters and
 Sculptors, 179, 181, 182
Auctions (Bidding Agreements) Act
 (1928), 206
Au Jardin de Bellevue (Manet), 316
Au Lapin Agile (Picasso), 450–51
Au Moulin de la Galette (Renoir), 4,
 9–10, 26, 98, 120, 457
Auspitz collection, 262
Avery, Samuel P., 35, 112

Bache, Jules, 223–24
Baker, Russell, xv
Baker, Samuel, 40, 59–60
Balay, Roland, 317
Balcony, The (Manet), 121
Ballard, Thomas, 57
Ballet Rehearsal (Degas), 123
Banc, Le (Le Jardin de Versailles)
 (Manet), 10, 13, 14, 18, 23
Bangs & Co., 145
Bar aux Folies-Bergère, Un (Manet), 42
Barbizon School, 35–37, 95, 102–3,
 122, 314, 345, 410
Baring, Evelyn, 321
Barker, George, 330
Barlow, Montague, 164–65, 168–69,
 200, 203, 206, 207, 237, 319
Barnard, John, 54
Barnes, Albert, 153, 187, 193, 198, 212,
 213
Barr, Alfred H., 286, 288, 290, 309, 310
Bateleurs, Les (Picasso), 188
Bathurst, David, 321, 362–63, 364
Bathurst, Tim, 384–85
Baudelaire, Charles, 76, 77–79, 80, 111,
 153, 154
Bay Psalm Book, 283–84, 398

Baziotes, William, 278, 286, 290
Bearskin, the (La Peau de l'Ours), 156,
 157, 187–88, 189, 211, 337
Beatty, Chester, 389, 392, 400
Beauvoir, Simone de, 280
Beazley, John, 200
Beckett, Samuel, 276
Beckford, Susan Euphemia, 38, 39
Beckford, William, 38–39, 40
Behr, Kurt von, 272
Behrman, S. N., 166
Bell, Charles, 134, 200–201, 206
Bell, Clive, 157, 178
Bellamy, Richard, 209, 326, 327, 416
Belle Ferronnière, La (Leonardo),
 245–46
Bellier, Alphonse, 209, 210, 303, 442
Bellini, Giovanni, 136, 139, 143, 186,
 200
Beltrand, Jacques, 272–73
Bennett, Albert James, 249–50
Benois Madonna (Leonardo), 168
Béraudière, Comtesse de la, 240
Berenson, Bernard "B.B.," xxiv, 128,
 129, 130, 133–36, 139, 141, 149,
 161, 162, 165, 166–67, 168, 186,
 223, 246, 324
Berenson, Mary, 139
Bergère, La (Millet), 103, 105
Berlin Secession, 159, 160
Bernet, Otto, 122, 192, 194–95, 216,
 217, 218, 240, 241, 250, 251, 255,
 256, 268, 283, 356
Bernheim, Alexandre, 86
Bernheim, Gaston, 86
Bernheim, George, 192
Bernheim, Joseph, 86
Bernheim-Jeune, 9, 10, 154–55, 179,
 189, 190, 210, 268
Bernstein, Alex, 339
Beurdeley, Michel, 185, 292
Beyeler, Ernst, 341, 440, 444
Bibles, 149–50, 216–17, 283, 398
Bicknell, Elhanen, 65
Biddle, Margaret Thompson, 311
Bigelow, William Sturgis, 114–15
Bignou, Étienne, 212–13
Bijutsu sale, 333–34

Bing, Siegfried, 111–12
Birdcage (Picasso), 405, 406
Bischofberger, Bruno, 444, 445
Bischoffsheim, Henri-Louis, 320
Bishop, Amy Bend, 214, 218
Bishop, Cortlandt Field, 194–95,
 214–15, 216, 217, 218, 239, 240,
 241, 249, 250, 255, 256, 257, 258,
 418
Bishop, David, 215
Bishop, Mrs. Cortlandt, 255, 256, 257,
 258
Black and White Show (de Kooning),
 286
Henry Blackmer collection, 453–54
Blake, William, xxiii, 66, 314
Bliss, Lillie, 181, 182, 193, 198
Blue Bower, The (Rossetti), 102
Blue Boy (Gainsborough), 193, 211,
 228
Blunt, Anthony, 52, 369
Bode, Wilhelm von, 73, 113, 140, 282
Bodkin, Thomas, 312
Boggis, Bertram, 167–68, 223
Boléro violet (Matisse), 26
Bond, Alan, 10, 26, 391, 400, 421, 457,
 460
Bonheur, Rosa, 92, 119, 187, 230
Bonnard, Pierre, 75, 152, 155, 193
books, xv, xvi, 39, 40, 48–49, 57,
 59–60, 64, 65, 145–50, 173, 196,
 203–6, 207, 240, 247–48, 253–54,
 280, 283–84, 351, 382, 453–54
 Bibles, 149–50, 216–17, 283, 398
Boone, Mary, 328, 367–68, 435
Borenius, Tancred, 206–7, 282, 319
Botticelli, Sandro, 128, 135
Boucher, François, 58, 230
Boudin, Eugène Louis, 83, 84, 121, 253
Boulevard des Capucines (Monet), 96
Bourgeois, Stephen, 183, 184, 198
Boussod & Valadon, 87, 88, 89, 94,
 104, 105
Bracquemond, Félix, 110–11, 112
Brame, Hector-Gustave, 85
Brame, Hector-Henri-Clément, 84–85
Brancusi, Constantin, 198, 285
Brandel, Josef von, 50

Brandt, Mortimer, 287
Braque, Georges, xvii, 88, 100, 151,
 157, 162, 191, 199, 209, 211, 252,
 255, 301, 302
Breakfast in the Studio (Manet), 158
Brentford Lock and Mill (Turner), 329
Breton, André, 208, 277, 279
Breton, Jules, 37, 103, 187
Briggs, Asa, 343
British Museum, 247, 248, 249, 383,
 384
British Rail Pension Fund, 354–56,
 423–25, 455
Britwell library, 203, 204, 206
Brooks, Diana D., 381, 386, 405–6
Brooks, Van Wyck, 127
Brown, Milton, 179, 180, 181, 182, 183
Brown, Oliver, 319
Browning, Robert, 247
Brueghel, Jan, 50, 262
Brummer collection, 282–83, 284, 285
Brunton, Gordon, 371, 372, 373, 376
Bryant, Harriet, 198
Buchanan, William, 61, 62–63, 222
Buffet, Bernard, 304
Burchard, Otto, 292, 293
Burge, Christopher, xvii, 3–5, 10,
 12–26, 363, 364, 455
Burgomaster's Family, The (Hals), 169
Burne-Jones, Edward, 102, 113, 114,
 173, 187, 231
Butler, Mrs. Sydney, 389

Cabanel, Alexandre, 83
Cabanne, Pierre, 220–21, 262, 263, 304,
 324, 325, 326
Cadart and Luquet, 68–69
Café au Lait (Pissarro), 126
Caillebotte, Gustave, 44, 76, 93, 99
Calder, Alexander, 278, 286, 333
Camera Work, 163, 177
Cameron, Julia Margaret, 71
Canoeist's Luncheon, The (Renoir), 126
Carlisle, Jay, 257
Carpenter, Ralph, 370
Carré, Louis, 261, 269, 302, 303
Carritt, David, 320–21, 336–37, 360*n*,
 440

Carroll Gallery, 184, 198
Carstairs, Charles, 133
Carstairs Gallery, 316
Carter, Howard, 200–201
Carter, John "Jake," 247–48, 284–85, 315
Cassatt, Alexander, 126
Cassatt, Mary, 16, 122, 123, 125, 126
Cassirer, Paul, 9, 10, 159–61, 189, 361
Castelli, Ileana, *see* Sonnabend, Ileana
Castelli, Leo, xvii, xxiii, 157, 279, 285, 290, 303, 305–11, 318, 326, 327–28, 338, 346, 347–48, 368, 435, 436, 438, 439
Castiglione & Scott, 204
Cattaneo family portraits (Van Dyck), 164
Cavalcaselle, Giovanni, 134–35
Cavalier on a Gray Horse (Cuyp), 101
Cavalier Taking Refreshment (Meissonier), 263
Cézanne, Paul, xxvii, 9, 42, 43, 81, 84, 90, 92, 94, 97, 104, 105, 116, 125, 151, 152, 153, 162, 176, 177–78, 179, 182, 183, 187, 193, 198, 201, 222, 231, 263, 284, 304, 316, 362
Chagall, Marc, 16, 26, 237, 264, 277
Chamberlain, John, 310
Chan, Joseph, 291, 294
Chance, Ivan (Peter), 253, 319, 322, 330, 331, 334
Chang, Robert, 291
Chapman, Frederick, 196
Charivari, 42–43
Charpentier, Georges, 98
Charpentier, Marguerite, 98
Chatsworth Old Master drawings, 383–84
Chevallier, Paul-Louis, 92, 224
Chiesa collection, 215–16, 217, 218
China, Chinese art, xvi, 46, 107, 108–9, 110, 114, 115, 274–75, 291–95, 454–55
Chocquet, Victor, 9, 86, 90, 97–98
Chocquet sale, 120
Chow, Edward, 291, 292, 294
Christ Healing the Blind (El Greco), 318, 319

Christie, James, 38, 40, 58–62, 64
Christie, James, IV, 319
Christie's, xv, xvii, 15, 16, 39–40, 41, 71, 72, 135, 148, 164, 168, 169, 199, 200, 201, 206, 207, 222, 223, 229–30, 239, 264, 266, 284, 312, 315, 316*n,* 321, 322, 333–34, 336, 350, 351, 352–53, 356, 357, 362, 365, 368, 370, 371, 380, 383–85, 386, 389–92, 397, 398, 405, 407, 410, 411, 414, 416, 417, 431, 433, 441, 448, 451, 454, 457, 458, 472, 475
 buyer's premium at, 353–54, 356, 357, 362, 363, 407, 472
 Cook collection and, 329–31
 credit control at, 19–20
 decline of, 318–19
 guarantees offered by, 385
 Hamilton Palace sale and, 38–40
 history of, 60–65
 Impressionist and modern works as specialty of, 320–21
 Jodidio sale and, 364
 New York site of, 357, 358
 Portrait of Dr. Gachet sold by, xvii, 3–26
 proposed merger of Sotheby's and, 238, 267, 283
 record prices at, 3, 6–7, 25
 seating at, 11–12, 20–22
 Settled Lands Acts and, xv, 40
 Sotheby's vs., 6, 9, 16, 26, 38, 64, 218–20, 253, 318–21, 350, 351, 379, 385
 Switzerland and, 445
 upward turn at, 320–21, 331, 332, 334, 337
Christ in the Garden of Gethsemane (Gauguin), 7
Christo, 437
Chrysler, Walter P., Jr., 322
Citibank, 437
Clark, Kenneth, 282, 384
Clarke, Thomas B., 118, 120, 122
Clert, Iris, 310
Coady, Robert, 198
Cock, Christopher, 57

Cockfield, Lord, 373–74, 377
Cogan, Marshall, 372–75, 376, 377
Cognacq, Gabriel, 303–4
Cole, Brian, 17, 21
Collin, Raphael, 116
Colline des Pauvres (Cézanne), 182
Colnaghi (dealer), 69–71, 132, 135, 139, 222, 243, 324, 440
Colnaghi, Dominic, 70–71
Colnaghi, Martin, 70–71, 220
Colnaghi, Paul, 70
Cologne (Turner), 200
Colonna Altarpiece (Raphael), 120, 132, 164
colorfield painting, 327, 348
Colson, Percy, 65, 199, 229–30
Comstock, Anthony, 195
Conceptualism, 327, 366
Concert in the Tuileries (Manet), 78
Connoisseur, 282
Constable, John, 66, 102, 186, 389
Constable, Rosalind, 287
contemporary art, 176, 336, 365, 388, 431
 collectors of, 416–22
 Saatchi's sale of, 433–35, 436, 438, 439
 Scull auction of, 368, 416–18
 see also modernism
Cook, Hubert, 262, 263
Francis Cook collection, 329–31
Cooper, Douglas, 88, 100, 237, 271, 273, 276
Cooper, Paula, 346–47, 366, 368, 435
Cooper, William, 48–49
Corcoran, Gerald, 338
Cormack, Patrick, 374
Cornaro Family (Titian), 207
Cornell, Joseph, 278
Corot, Jean-Baptiste Camille, 82, 84, 95, 103, 127, 187, 315
corporate collections, 421–22
Cotton, Jack, 317
Coty, François, 226
Countess Spencer (Reynolds), 228
Courbet, Gustave, 83, 86, 91, 94, 187, 304

Courtauld, Samuel, 200, 213–14, 319, 389
Courtenay, William, 39
Cowper Madonna (Panshanger Madonna) (Raphael), 168, 186, 230
Cries of London, 70
Cubism, Cubists, 73, 75, 151, 155, 157, 161, 162, 178, 180, 219, 237, 261, 269, 302, 303, 326
Cuyp, Albert, 101, 186

Dada, 80, 190, 210
Dalí, Salvador, 18, 26, 277
Dancers at the Barre (Degas), 99, 168, 187
Daniel, Charles, 184, 198
Daubigny, Charles-François, 83, 103, 187
Daumier, Honoré, 3, 13, 23, 83, 187
David, Percival, 274, 292, 293, 294
David-Weill collection, 325
Davies, Arthur, 176, 178, 179–80, 181, 182
Dead Toreador, The (Manet), 95
de Bellio, Georges, 93, 96, 98
Déchargeurs, Les (The Dockers) (van Gogh), 332
Decquoy, Roger, 268
Degas, Edgar, xxvii, 15, 76, 77, 79, 81, 82, 85, 86, 94, 99, 100, 104, 105–6, 111, 121, 122, 123, 152, 168, 187, 191, 192, 197, 212, 263, 318–19, 332, 333, 364
de Hooch, Pieter, 101, 186
de Hory, Elmyr, 335
Deitch, Jeffrey, 436–37
Déjeuner sur l'herbe, Le (Manet), 78, 95
de Kooning, Willem, 278, 286, 289, 290, 308, 327, 340, 448
Delacroix, Eugène, 82, 91, 95, 187, 192
Delmé, Peter, 53, 54
Demidoff collection, 91
de Niro, Robert, 278
Depression, Great, 231, 235–41, 243, 244, 249, 252, 253, 255, 261, 281–82
Deprez, E. F., 71
Derain, André, 75, 151, 155, 157, 158, 162, 191, 193, 212, 236

Des Graz, Charles, 203, 266, 283, 319
Desmoiselles d'Avignon, Les (Picasso), 157, 451
de Zayas, Marius, 184, 198–99
Diane de Fontainebleau (Rodin), 272
Dieppe (Turner), 200
Dine, Jim, 326
Dior, Christian, 226, 236
Disciples at Emmaus, The (Vermeer), 262–63
Diver, The (Johns), 418
Dobell, Bertram, 205
Dobell, Percy John, 205
d'Offay, Anthony, 439
Doria, Armand-François-Paul Desfriches, Count, 86, 98
Dorrance sale, 447–48
Philippe Dotremont collection, 333
Double White Map (Johns), 417
Doucet, Jacques, 185
Dream, The (Chagall), 264
Dreier, Katherine Sophie, 182
Dreppard, Carl, 343
Drouin, René, 303, 306, 307, 348
Druet, Eugène, 157, 179
du Barry, Comtesse, 61–62
Duchamp, Marcel, xxiii, 180–81, 182, 276, 277, 302
Duchess of Devonshire (Gainsborough), 102, 132, 228
Duchess of Devonshire (Reynolds), 228
Du Fresne, Charles, 208
Dufy, Raoul, 151, 193, 236–37, 335
Dumas, Alphonse, 152
Duran, Carlos, 229
Durand, Jean-Marie-Fortune, 82
Durand-Ruel, Paul, 37, 69, 81–85, 86, 91, 92, 97–98, 99, 104, 105, 111, 112, 120–22, 156, 157, 179–80, 189, 192, 211n, 220, 327
Dürer, Albrecht, 47, 329, 361
Duret, Théodore, 86, 90, 92–93, 97, 98, 433
Duthy, Robin, 424, 426, 427, 429
Duveen (dealer), 112, 114, 136, 169, 173, 193, 219, 228, 229, 239–40, 242, 243, 257, 278, 319, 324
Duveen, Ben, 165

Duveen, Charles, 138
Duveen, Ernest, 223
Duveen, Henry, 37–38, 136–37, 138, 139, 142, 165–66, 167
Duveen, Joel, 136, 137, 138, 144, 145
Duveen, John, 138
Duveen, Joseph, xvii, 131–32, 133, 136, 137–41, 143, 144, 145, 165–68, 186, 221, 222, 223–24, 227, 245–46, 248, 255, 321, 382
Dyer, Nina, 334

Eddy, Arthur Jerome, 182
Edelstein, Annamaria, 355
Edwards, Francis, 205
Effet de neige à l'hermitage (Pissarro), 16, 23
Egan, Charles, 285–86, 308
Egypt, 295–97
Éluard, Paul, 209
Emmerich, André, 328, 346, 348, 349
English art, 54–55, 62, 65, 66, 102, 227
 portraits, 54–55, 186–87, 201, 227–30, 263, 350
Enlèvement, L' (Cézanne), 125
Ephrussi, Charles, 98
Alfred W. Erickson collection, 321–22
Ernst, Max, 277, 278
Eskenazi, Giuseppe, 305
Étalage, Un (Daumier), 3
Eudel, Paul, 93
Eumorfopoulos, George, 266–67, 292, 293
Evans, Robert Harding, 65
Evening in the Hamlet (Breton), 37
Existentialists, 280

Fabiani, Martin, 268–69
Falcke, Edith Nixon, 218, 241, 255–56, 257, 258
Falcke, Shirley, 248–51, 255, 256, 257, 258
False Start (Johns), 418
Family Party, A (Hogarth), 329
Fantin-Latour, Henri, 88
Farouk collection, 295–96, 440
Faure, Jean-Baptiste, 94–96, 98, 433
Fauvism, 75, 80, 112, 151, 161, 201, 406

Feast of the Gods (Bellini), 143, 200
Féder, Jules, 83
Femme à la lampe, La (Millet), 187
Femme au chapelet (Cézanne), 183
Fenellosa, Ernest, 112, 114, 115
Fénéon, Félix, xvii, 86, 132, 153–55, 157, 190, 219
Fenway Court, 127, 129–30
Ferrargil Galleries, 285
Findlay, Michael, 3–4, 12, 15, 16, 17, 20–22
Fink, Lois Marie, 68
Fischer, Harry, 339
Fischer, Theodor, 255
Fisher, Max, 375, 376, 381
Flechtheim, Alfred, 160, 210
Fletcher & Wheatley, 60
Fleurs dans un vase (van Gogh), 188
Fleurs sur un fond jaune (Gauguin), 183
Flowers, Matthew, 439–40
Floyd, Jo, 6, 22, 353, 385
Fogg Museum, 139
Fontaine d'amour, La (Boucher), 230
Fonthill Abbey, 39
Foote, Samuel, 53
Ford, Edsel, 377
Ford, Henry, I, 362
Ford, Henry, II, 362–63, 376, 381, 382
forgeries, 36, 134, 334–35, 463, 464
Forsdyke, Edgar John, 201
Foule collection, 325
Four Opposites (Pollock), 365
Fragonard, Jean-Honoré, 132, 197, 221, 360n
France, 47–48, 51, 56, 58–59, 64–65, 443–44
 Impressionists in, xv, 37, 42–44
 Napoleonic wars and, 32, 61
 see also Paris
Freeman, Arthur, 204, 205
Freeman, Janet Ing, 204, 205
Freer, Charles Lang, 114, 115
Frey, Bruno, 428, 429, 430, 431, 432
Fribourg collection, 322
Frick, Henry Clay, 132, 133, 143–44, 169, 186, 197, 200, 222, 227, 228, 229, 243
Frick, Mrs. Henry Clay, 227

Friedland, 1807 (Meissonier), 103, 119, 120
Friesz, Othon, 207–8
Fry, Roger, 144, 157, 178, 179, 180, 206, 246
Fujii, Kazuo, 24, 392, 410
Fukimoto, Tamanaki, 463
Funt, Alan, 345–46

Gachet, Paul, 7, 9, 90, 98
Gagosian, Larry, 418, 434, 436, 437–39
Gainsborough, Thomas, 55, 60, 102, 132, 186, 193, 211, 227, 228, 229, 231, 238, 240
Galerie Simon, 210, 236
Gallery Urban, 18, 465
Gambart, Ernst, 66–69, 73, 74, 89, 102, 212, 344
Ganz, Victor, 310, 328
Garçon au gilet rouge (Cézanne), 316–17
Garden Collection, 454
Gardner, Isabella Stewart, 71, 126–30, 139, 228
Gardner, John Lowell "Jack," 127
Garrick, David, 38, 53
Garrick Between Tragedy and Comedy (Reynolds), 228
Gary, Elbert H., 228, 239–40
Gauguin, Paul, 7–8, 84, 87, 94, 100, 104, 156, 178, 183, 187, 188, 193, 231, 303, 311
Gautier, Théophile, 77
Geery, John, 258–60
Geldzahler, Henry, 435
Gérardet, Adolphe, 9
Géricault, Jean Louis, 66, 82
German Expressionism, 80, 158
Germany, 73, 158–59, 179, 388, 444–45
Germany, Nazi, 255, 262, 265, 269–71, 273, 407
Gérôme, Léon, 69, 87
Getty, Ann, 382
Getty, Paul, 60
Getty Museum, 10, 383–84, 385, 400, 457, 472
Gibson, Ralph, 438
Gilles (Watteau), 220, 221

Gimbel, Richard, 323
Gimpel, René, xvii, 86, 131, 191–92, 209, 219, 220, 221–23, 235–36, 261, 265, 324
Glatz, Helen, 352
Glimcher, Arne, 341, 365–66, 368
Gloria (Rauschenberg), 333
Goeneutte, Norbert, 9
Goldenhersh, Sheryn, 17
Henry Goldman collection, 325
Goldschmidt, Erwin, 315
Goldschmidt, Jakob, 5, 314–16
Goldschmidt sale, 314–17, 318, 323
Goncourt, Edmond de, 43, 98, 107, 111
Goncourt, Jules de, 107, 111
Goodman, Marion, 365
Goodyear, George, 322
Göring, Herrmann, 269, 270, 271, 272, 273, 360
Gorky, Arshile, 285
Gospels of Henry the Lion, 382
Goto, Hajime, 391
Gottlieb, Adolph, 286, 289, 348
Goudstikker collection, 270
Gough, Richard, 64
Gould, Cecil, 271, 273
Gould, Florence J., 379–80, 386
Gould, Frank J., 379, 380
Gould, George Jay, 137
Gould, Jay, 34, 133, 379
Gould sale, 379, 382, 386–87, 388
Goupil, Adolphe, 86–87
Goupil, Jean-Baptiste, 35, 66, 68
Goupil, Vibert and Co., 68
Gower Family, The (Romney), 350
Gowrie, Alexander Patrick Greysteil Hare-Ruthven, Lord, 80, 403–4
Goya y Lucientes, Francisco José de, 124, 125, 187, 268
Grafton Galleries, 178–79
Graham, James, 52
Grand Canal and Rialto (Turner), 102
Great Britain, 32–33, 49, 51–58
book auctions in, xv, xvi, 40, 48, 57
history of auctions in, 48–49
paintings imported into, 49, 51–53, 72
see also London

Greco, El, 124, 187, 315, 318, 319
Greenberg, Clement, 278–79
Greene, Belle da Costa, 148–49, 217
Green Gallery, 326, 327, 416
Grenfell, Morgan, 372
Grigsby, Emilie, 169, 171–72, 173
Gris, Juan, 155, 198, 252, 278
Gronau, Carmen, 282, 315, 319
Gronau, Georg, 282
Gronau, Hans, 282
Gruskin, Alan, 287
Guggenheim, Florence Seligmann, 275
Guggenheim, Peggy, 275–79, 285, 286, 287
Guggenheim, Solomon, 276
Guggenheim-Jeune, 276–77
Guillaume, Paul, 191, 199, 211, 212, 219, 304
Gulbenkian, Calouste, 242
Gutekunst, Otto, 71, 135, 243
Gutelius, J. P., 31–32
Gutenberg Bibles, 149–50, 216–17, 283, 398

Haberstock, Karl, 270, 272
Habsburg, Archduke Geza von, 17
Habsburg-Feldman, 4, 17, 18, 20
Habsburg tapestries, 225
Hahn, Andrée, 245–46
Hahn, Harry, 246
Hainauer, Mrs. Oskar, 140
Hainauer, Oskar, 139–40
Hall, Lee, 287, 288, 327
Hall, Samuel Carter, 65
Hallery, Peter, 435
Halperin, Joan, 153–55
Hals, Frans, 168, 169, 173, 186, 237
Halt Before the Inn (Meissonier), 103
Hambrecht, Patricia, 16–19, 23
Hamilton, Alexander, Duke of, 38, 39
Hamilton, Carl, 168
Hamilton, Gavin, 52–53
Hamilton, William, 337
Hamilton Palace sale, 38–40, 148
Hammer, Armand, 242
Hankey, Thomas, 54
Hansa Gallery, 309, 347
Harari, Max, 295

Harari & Johns, 440
Harding, John, 333
Harlech, Lord, 372
Harlow, Jean, 281n
Harvest Wagon (Gainsborough), 228, 240
Hasegawa, Jin, 393, 394
Hasegawa, Rinko, 393
Haskell, Francis, 66
Haussmann, Georges, 76, 77, 78
Havemeyer, Henry Osborne "Harry," 83–84, 123–24, 125–26, 153
Havemeyer, Horace, 123, 124
Havemeyer, Louisine Waldron Elder, 99, 123–26, 129, 168, 187, 240, 381
Havemeyer family, 94, 123
Hay, Andrew, 52, 53
Hayakawa, Fumio, 408
Hayashi, Tadamasa, 111
Hearn, Pat, 435
Heath, Edward, 373–74
Hecht, Albert, 98
Hecht, Henri, 98
Hedin, Sven, 292
Henry the Lion, Gospels of, 382
Henschel, Charles, 133, 243–44, 248
Herbert, John, 253, 319, 321, 330, 331, 350, 351, 355, 362, 364, 379–80, 382, 383, 386, 389, 391
Hermann Doomer, the Gilder (Rembrandt), 101–2
Hermitage Museum, 241–42, 243
Herodotus, 45–46
Hertford, Lord, 225
Hesse, Prince Philip of, 269–70
Hibiya, Sachiko, 24
Hilton, Henry, 119, 120
Hirano, Masanori, 464
Hirsch, Robert von, 360–61
Hirsch sale, 361–62
Hitler, Adolf, 158, 253, 255, 256, 269–70, 271, 272, 273, 360
Hobson, Geoffrey, 275
Hockney, David, xxvi
Hodge, Edward Grose, 40, 164
Hodge, Tom, 164–65
Hoe, Richard, 146
Hoe, Robert, 146–47, 217

Hoe sale, 149–50
Hofer, Walter Andreas, 270, 271, 272–73
Hogarth, William, 54, 58, 102, 186, 329
Holbein, Hans, 47, 56, 105, 186, 223–24
Holford sale, 207, 312, 315, 319, 329
Holland, 47, 48, 49–50, 51, 62
Holmes, Charles, 212
Hoppner, John, 131, 227, 228, 229, 240
Horizon, 301, 365
Horse Fair, The (Bonheur), 119, 120
Horstmann, Charlotte, 291–93, 294
Hoschedé, Ernest, 96–97, 98
Hôtel Drouot, 36, 65, 91, 93, 94, 112, 156, 188, 191, 209, 210, 211, 269, 315, 405
Ho Young Chung, 461–62, 463, 464
Hughes, Robert, 367, 368, 476
Hunt, Holman, 102
Huntington, Arabella, 140, 141, 194, 321
Huntington, Collis P., 34, 133, 137, 140
Huntington, Henry, 140, 141, 149–50, 193, 222, 228, 229
Norman Hurst sale, 350
Hyam, Leslie, 216, 284, 322

Impression, Sunrise (Monet), 96
Impressionism, Impressionists, xxvi–xxvii, 4, 37, 67, 69, 73, 75, 76, 77, 78, 79–80, 81, 91, 92, 93, 98, 103–6, 112, 132, 151, 158, 159, 163, 168, 176, 178, 183, 187, 188, 190, 197, 201, 227, 229, 231, 263, 290, 297, 311, 318–19, 322, 332, 336, 345, 388
Durand-Ruel and, 81–85
effect on art market, xv, 42–44
first dealers in, 81–100
Japanese and, 116–17, 201, 202, 334, 393, 394, 410, 465
Reid and, 89
Scottish, 89
Sutton and, 120–22
Tanguy and, 90
Theo van Gogh and, 86, 87, 88
widow collectors of, 122–26

Improvisation #27 (Kandinsky), 182
Indiana, Robert, 326
Ingres, Jean Auguste Dominique, 192
Inness, George, 120
Interchange (de Kooning), 448
International Art-Union, 68
International Plaza Agreement, 394,
 410, 468
International with Monument, 435
Irises (van Gogh), 3, 6, 9, 10, 18, 24,
 25, 253, 397–400, 421, 450, 457,
 460, 477, 481
Irvine, James, 62, 63
Irving, David, 270, 272
Ise, Hikonobu, 410
Ishiguro, Kojiro, 392
Isoda, Ichiro, 461–62, 463, 464
Italian art, 129, 130, 134–35, 138–39,
 142, 167, 444
Italy, 47, 50–51
Ito, Suemitsu, 462, 463
Iveagh, Edward Cecil Guinness, Lord,
 72

Jackson, Martha, 309, 310, 347
Jade Market, 274–75
James, Henry, 127
James, Ralph, 48
Janis, Sidney, 252, 277, 278, 279, 286,
 288, 305, 307–8, 326–27, 328, 399,
 435
Japanese art market, 14, 24–26, 107,
 108, 109, 110, 111–12, 114, 115–17,
 201–2, 274, 333–34, 335, 352, 388,
 391–95, 397, 406, 407–15, 442–43,
 451–53, 468, 472
 capitalism and, 408
 changing tastes in, 406, 407
 Impressionism and, 116–17, 201, 202,
 334, 393, 394, 410, 465
 scandals in, 459–66
Japon artistique, 111
Jardin public à Arles (van Gogh), 316
Jarves, James Jackson, 141–42
Jeanne Hébuterne con grande capello
 (Modigliani), 13
Jellicoe, Earl, 374, 384
Jenkins, Roy, 350

Jeune Femme se poudrant (Seurat), 193
Jodidio, Dimitri, 363–64
John, Augustus, 175
Johns, Jasper, 308–9, 310, 326, 327,
 416, 417, 418
Johnston, John Taylor, 69, 132
Joni, Icilio, 139
Juan de Pareja (Velázquez), 337, 350
Judgment of Paris (Cranach), 360

Kahnweiler, Daniel-Henri, 82, 132,
 155–58, 162, 189–90, 191, 192, 208,
 209, 210–11, 212, 219, 236, 237,
 253, 265, 268, 280, 301–3, 304,
 305, 310, 311, 323, 326, 327
Kahnweiler, Gustave, 210
Kaiser Friedrich Museum, 73
Kameyama, Shigeki, 406, 412, 415, 448,
 451
Kandinsky, Wassily, 182, 303
Rudolphe Kann collection, 221, 222,
 321, 325
Karp, Ivan, 309, 310, 326, 327, 347,
 435
Kasama Nichido Museum of Art, 393
Kawakita, Michiaki, 116, 201
Kawamura, Yoshihiko, 461–62, 463–64
Keating, Billy, 391, 399n–400n
Kelekian, Dirkan, 115, 126, 193
Keller, George, 213, 316, 317
Kennerley, Mitchell, 195–96, 217–18,
 256, 257, 258, 482
Kern, Jerome, 240
Keynes, John Maynard, 254
Kiesler, Frederick, 277
King, T. Y., 291, 294
Kirby, Gus T., 192, 193, 194, 195, 257
Kirby, Thomas, 31, 33–38, 86, 118,
 119, 122, 146, 150, 172, 173, 192,
 193–94, 195, 408
Kirkman, James, 439
Kline, Franz, 289, 290
Knoedler, Michael, 35, 68, 132–33
Knoedler, Roland, 133
Knoedler & Co., 86, 124, 132–33, 144,
 164, 173, 182, 198, 219, 223, 243,
 278, 317, 324, 335, 365, 435
Kobayashi, Hideto, 24–25, 26

Koenigs collection, 262

Kootz, Sam, 278, 279, 285, 286, 287, 302, 307

Kramarsky, Lola, 5–9

Kramarsky, Siegfried, 5, 6, 160

Kramarsky, Werner (Wynne), 5–9, 14, 18, 22, 26

Kress, Samuel, 143

Kress Foundation, 143

Kuhn, Walt, 175, 176, 179, 180, 181, 182, 183

Kumitaro, Suda, 202

Lachovski, Felix, 258–59

Lady Bingham (Reynolds), 228

Lady Louisa Manners (Hoppner), 229

Lady with a Guitar (Goya), 125

Lai, Eugene, 294

Lambert, Léon, 337

Lampa Investments, 352

Lancaster, Osbert, 331

Landscape with Rising Sun (van Gogh), 386, 388

Lane, Hugh, 94, 100, 169, 197, 213, 319

Lascaux, Elie, 265

Lascelles, Lord, 206–7

Lash, Stephen, 6, 8, 11, 15, 22, 370

Last Supper, The (Vermeer), 262–63

Latouche, Louis, 88

La Tour, Maurice Quentin de, 185, 186

Lavinia (Reynolds), 228

Lawrence, Thomas, 66, 186, 227, 228, 229, 238

Léandre, Charles, 9

Learmount, Brian, 32, 46, 48

Lebrun, Jean-Baptiste-Pierre, 56, 59

Leclercq, Walter, 159, 160

Lee, Viscount, 223–24

Lefebvre, Jules, 83

Lefèvre, Ernest, 212–13, 214

Lefèvre Gallery, 18, 338

Léger, Fernand, 161, 191, 210, 211, 252, 261, 277, 301, 308

Legros, Fernand, 334–35

Lehman, Robert, 10, 16

Leicester Galleries, 212

Leigh, George, 40, 60, 64

Leiris, Louise, 210, 268, 301

Leistikow, Walter, 159

Lely, Peter, 57

Le Nain, Louis, 56

Leonardo da Vinci, 52, 168, 186, 193, 245

Leroy, Louis, 42–43

Lessard, Réal, 334–35

Level, André, 156, 157, 187–88, 211

Levine, Morton, 341

Levy, Julian, 279, 285

Lewin, Christopher, 354–55

Lichtenstein, Roy, 310, 326, 327

Liebermann, Max, 100, 159

Lindsay, Patrick, 320, 321, 329, 330–31, 337

Linnell, Marcus, 370, 396

Lipchitz, Jacques, 208, 277, 340

Lisson Gallery, 440

Little Fortune Teller (Reynolds), 228

Llewellyn, Graham, 370, 371

Lloyd, Frank, 339–40, 341, 342–43

Lloyd, R. W., 319

Lloyd George, David, 203

Loeb, Pierre, 239

Logan, Milton, 257–60, 398

Loge, La (Renoir), 98

Lohse, Bruno, 272

London, xvi, xvii, 38–41, 51–56, 61–68, 305, 338–39, 439–40

London Bulletin, 276

London Gallery, 276

Loo, C. T., 292

Lorenz, Rose, 122

Lot and His Daughters (Rubens), 425

Lothian collection, 249

Loudmer, Guy, 441, 442, 452

Louis XIV, King of France, 58

Louvre, 93, 121, 124, 472

Luce, Maximilien de, 154

Lucius Cecilius Jucundus, 46

Lumley, John, 17, 18, 391

Lurcy, Alice Snow Barbee, 313–14

Lurcy, Georges, 5, 313

Lurcy sale, 313–14, 315, 317

Maas, Jeremy, 66*n,* 67, 339, 343–44

Macbeth Galleries, 184

Macdonald, Flora, 38

Macy, Rowland, 33
Madame Henriot (Renoir), 334
Mademoiselle Pogany (Brancusi), 198
Madonna and Child (Duccio), 332
Madonna of the Pinks, The (Raphael),
 258, 259
Maeght, Aimé, 301, 303
Mainz Psalter, 149
Maître de Ballet (Degas), 100
Mallard, Richard, 59
Manby, Thomas, 52
Maneker, Roberta, 17, 20, 21, 23
Manet, Édouard, xxiii, xxvii, 9–10, 13,
 14, 18, 23, 38, 42–43, 73, 76,
 77–80, 82, 91, 93, 95, 96, 100, 104,
 105, 120, 121, 124, 158, 178, 187,
 311, 316, 388–89, 391, 397
"Manet and Modern Paris," 76
"Manet to Matisse," 225
Man in a Red Cap (Titian), 197
Man in the Café, The (Gris), 198
Mannerism, 51
Manners, Lady Louisa, 131
Mannheim, Charles, 224
Mannheim, Fritz, 225–26
Man Proposes (Landseer), 102
Man Ray, 182
Mansard Gallery, 212
Man's Head and Hand, A (Raphael),
 383
Mantegna, Andrea, 186, 384–85, 386,
 387, 388, 397
Marcus Aurelius, 46
Margaret of Tyrol, Duchess,
 xxvii-xxviii
Mariette, Pierre-Jean, 58, 59
Mariller, H. C., 336
Marion, John, 24, 314, 332, 371, 372,
 377, 381, 398, 448
Marion, Lou, 284, 314, 321, 322,
 332
Marks, Murray, 112–14
Marlborough Fine Arts, 339–40, 341,
 342–43
Martin, Alec, 253, 284, 315, 318, 319,
 374
Martin, Pierre-Firmin, 89–90
Masson, André, 155, 277, 301

Mata Mua (In Olden Times)
 (Gauguin), 7
Maternité, La (Picasso), 405, 406, 412,
 415, 451
Matisse, Henri, 26, 75, 100, 151, 152,
 155, 157, 161, 162, 163, 191–92,
 193, 198, 210, 231, 236–37, 252,
 253, 268, 272, 285, 405
Matisse, Pierre, 236–37, 239, 252–53,
 278, 285, 456–57
Matsuoka Art Museum, 394
Matta Echaurren, Roberto, 277, 278
Maugham, Somerset, 316
Maxwell, Elsa, 288
Robert B. Mayer collection, 448
Mayor, Freddie, 276
Mayor Gallery, 276
Mayuyama & Co., 392
Meadow at Bezons (Monet), 96
Meadows, Alger Hurtle, 334
Meier-Graefe, Julius, 160
Meissonier, Jean-Louis-Ernest, 37, 83,
 85, 92, 103, 119, 133, 172, 187, 263
Melk Gutenberg Bible, 216–17
Mellon, Andrew, 133, 143–44, 168, 230,
 238, 241–44, 248, 250
Mellon, Paul, 317, 339, 450
Mentmore Towers sale, 359–60
Mercier, Sébastien, 61
Méréville, Comte Laborde de, 63
Merleau-Ponty, Maurice, 280
Merowski collection, 325
Méry, Père, 81
Messmore, Carman, 243–44
Metcalfe, Alexis Korda, 375
Metcalfe, David, 375, 376
Metropolitan Museum of Art, 5–6, 9,
 35, 95, 120, 124, 132, 142, 161,
 167, 240, 337, 453
Meyer, Gustav, 71, 243
Michelham, Lord, 223
Midtown Galleries, 287
Millais, John Everett, 102, 187, 231,
 263
Miller, Dorothy, 288, 309
Miller, William Henry, 203
Millet, Jean François, 83, 84, 91, 95,
 103, 105, 187, 394

Millington, Edward, 48, 57
millionaire collectors, 142–44
Minimalism, 327, 366
Minns, Susan, 196–97
Miró, Joan, 239
Miroir, Le (Picasso), 451
Mishino, Akio, 407
Miss Stanhope (Reynolds), 227
Mitani, Keizo, 344
Mitchill, Milton, Jr., 240, 241, 249, 256
Mitsubishi, 464–65
Modern Gallery, 184, 198–99
modernism, 100, 163, 176, 178, 180,
 184, 187, 198, 199, 210, 212,
 263–64, 285, 365, 379, 388, 443
 Armory Show and, 163, 175–76, 178,
 179–84, 187, 193, 196, 199
 birth of, 75–80
 see also contemporary art
Modigliani, Amedeo, 13, 212, 225, 272,
 408
Modiste, La (Renoir), 304
Mondrian, Piet, 15, 26, 277, 308
Monet, Alice Hoschedé, 97
Monet, Camille, 97
Monet, Claude, xvi, xxvii, 13, 24, 42,
 76, 81, 82, 84, 86, 93, 94, 95–96,
 97, 100, 104, 105, 106, 116, 121,
 123, 125, 126, 153, 156, 187, 311
Montag, Charles, 190
Montaignac, Isidore, 86
Montias, John Michael, 49–50
Monticelli, Adolphe, 89
Montmartre (van Gogh), 183
Moon, Sir Francis, 67
Moore, George, 100, 111
Moore, Henry, 336
Moore, Mary Adelaide "Mara," 170,
 171, 172
Moore, Rufus, 33–36
Morelli, Giovanni, 134–35
Morgan, J. Pierpont, 73, 113, 120,
 128–29, 132, 137, 141, 142–43, 149,
 164, 175, 186, 193, 197, 224, 228,
 239
Morgan, Junius, 148
Pierpont Morgan Library, 314
Morishita, Yasumichi, 406, 412–15, 464

Morozov, Ivan, 100, 158
Morozov, Mikhail, 100
Morris, William, 113, 114, 148
Morse, Edward, 114
Motherwell, Robert, 277, 278, 286, 290,
 308, 340, 348
Mother with a Cradle (de Hooch), 101
Moulin, Raymonde, 304–5, 323, 431
Mrs. Sheridan (Gainsborough), 228,
 238
Murillo, 187, 315
Musée d'Orsay, 95, 124
Musée Luxembourg, 91
Muselli collection, 50–51
Museum of Modern Art (MoMA), 182,
 231, 286, 287, 288, 309
Mussolini, Benito, 269, 270

Nabis, 75, 86, 112
Nagashima, Kosuku, 410
Nager, Geraldine, 399
Nash, David, 381, 399, 459
Nasser, Gamal Abdel, 295, 296, 297
National Gallery (Berlin), 100
National Gallery (London), 62, 63, 95,
 105, 131, 169, 206, 207, 212, 263,
 312, 320, 382, 384, 401, 472
National Gallery of Art (Washington,
 D.C.), 76, 95, 144, 243, 248
National Heritage Memorial Fund,
 360, 383
Nature morte au melon verte (Cézanne),
 362
Neumann, J. B., 278, 285
Nevelson, Louise, 278
Neville, Angela, 399n–400n
New Burlington Galleries, 276
New Gallery, 138–39
Newman, Barnett, 287, 288, 289
Newton, Isaac, 253–54
New York, N.Y., xvi, xvii, 33–37, 303,
 305
 East Village area of, 435
 SoHo area of, 328, 346–49, 365, 435
New York School, 286, 289
Niarchos, Stavros, 14, 20, 193, 311,
 316
Nichols, Edward, 129

Nicolson, Ben, 338
Nihonga painting, 394, 406
Nika Society, 201–2
Nixon, Edith, *see* Falcke, Edith Nixon
Noces de Pierrette, Les (Picasso), 452, 453
Northwick Park sale, 331–32
Norton, Charles Eliot, 127–28, 134
Norton, Clifford, 276
Norton, Lady, 276
Nude Descending a Staircase (Duchamp), 180–81, 182

Okada, Kenzo, 289, 368
Okawa, Morimasa, 411
O.K. Harris Gallery, 347
Oldenburg, Claes, 326, 327, 366
Old Masters, 130, 131, 132, 134, 139, 168, 184, 186, 187, 201, 230, 241, 261–62, 319, 383–84, 387, 388, 475, 476–77
Old Woman, An (Hals), 169
Olympia (Manet), 78, 105
Oppenheimer, Robert, 386
Oriental art, xvi, 46, 107–17, 266–67, 274–75, 291–95, 351–52, 388
Oriental Ceramics Society, 267, 292
Orléans collection, 56, 62, 63–64, 66
Out the Window (Johns), 418

Pach, Walter, 176, 179, 181, 183, 184, 198
Pallas Athenée (Rembrandt), 242
Palmer, Berthe Honoré, 125–26, 128
Palmer, Potter, 125–26
Panshanger Madonna (Cowper Madonna) (Raphael), 168, 186, 230
Paris, xvii, 42, 43, 48, 58–59, 61, 64–65, 75–77, 78, 207–8, 303, 440–44
decline of art scene in, 305, 324
in the Fifties, 304–5, 323–24
Impressionists' seventh group show in, 43–44
Paris, Samuel, 53, 54
Parke, Hiram Haney, 192–93, 194, 195, 216, 217, 218, 240, 241, 250, 251, 255, 256–57, 283, 284

Parke-Bernet, 257, 260, 268, 280, 283, 284, 285, 295, 313, 314, 316, 322, 332, 356–57, 371
Sotheby's acquiring of, 321, 322–23
Parsons, Betty, 279, 285, 286–89, 308, 327
Parsons, Florence V., 194
Patiño jewelry sale, 454
Patrick, Andrew, 305
Pâturage nivernais (Bonheur), 230
Payson, Joan Whitney, 9
Payson, John Whitney, 397, 399, 400
Pears, Iain, 52, 54, 57
Peau de l'Ours, La (the Bearskin), 156, 157, 187–88, 189, 211, 337
Peel, Robert, 63, 72
Penrose, Roland, 276
Pensée, La (Renoir), 316, 317
Petit, Georges, 95–96, 97, 152, 157, 213, 236
photography, 73, 102
Photo-Secession Gallery ("291"), 176–78, 198, 199
Picard, Jean-Louis, 441, 442–43
Picasso, Pablo, 6, 9, 37, 75, 79, 80, 88, 100, 152, 155, 157, 161, 162, 163, 188, 189, 191, 199, 211, 231, 252, 253, 255, 264, 265, 269, 272, 286, 301–3, 322, 405–7, 450–51, 452
buying rage for, 400–401
and romantic idea of artist, 401
van Gogh compared with, 401, 405
Pickering and Chatto, 205
Pilkington, Vere, 266, 282
Pillet, Charles, 91–92
Pinkerton, Mary, 257
Pinkie (Lawrence), 229
Pipée aux oiseaux, La (Boucher), 230
Pissarro, Camille, xxvii, 16, 23, 76, 83, 84, 86, 88, 96, 97, 100, 104, 105–6, 121, 123, 126, 153, 187
Pointon, Marcia, 54–55
Pollard, Graham, 247–48
Pollen, Peregrine, 321–22, 356, 369, 370
Pollock, Jackson, 277, 278, 288, 290, 308, 333, 340, 348, 365
Pommerehne, Werner, 428, 429, 430, 431, 432

Pommes et Biscuits (Cézanne), 304
Pompadour, Madame de, 109–10, 240
Pond, Arthur, 55–56
Pont de Trinquetaille, Le (van Gogh),
 391
Pop Art, 80, 310, 326–27, 328, 336,
 443, 469–71
porcelain, 107, 108–9, 113, 352
Port of Boulogne by Moonlight, The
 (Manet), 95
Portrait of a Rabbi (Rembrandt), 173
Portrait of a Woman (Hals), 173
Portrait of a Young Girl (David), 125
Portrait of Clemenceau (Manet), 124
Portrait of Don Juan de Calabazas
 (Velázquez), 329
Portrait of Dr. Gachet (van Gogh), xvii,
 3–26, 160, 379, 385, 455, 457, 467
Portrait of Duke Cosimo I de' Medici
 (Pontormo), 6–7
Portrait of Titus (Rembrandt), 329,
 330–31, 337
portraits, 8, 54–55, 186–87, 201,
 227–30, 263, 350
Posse, Hans, 272
Post-Impressionists, 80, 86, 92, 98, 151,
 178, 183, 187, 190, 193, 201, 231,
 297, 332, 388
Poussin, Nicolas, 53, 54
Pre-Raphaelite Brotherhood, 102, 103,
 187, 231, 344, 345
Price, Carol, 382
Princess Led to the Dragon, The
 (Burne-Jones), 173
prints, 55–56, 67, 70, 71, 73–74, 102
Private Eye, 345
Progress of Love, The (Fragonard), 197
Proust, Antonin, 43
Proust, Marcel, 84, 94, 98, 222
Puttick, Thomas, 60
Puttick & Simpson, 60–61

Quaritch, Bernard, Jr., 142, 147, 148,
 149, 204, 205, 206
Quaritch, Bernard, Sr., 147–48, 149
Quaritch and Kraus, 382
Quinn, John, 174–75, 180, 181–82, 183,
 184, 193, 197–98

Raeburn, Henry, 102, 186, 227, 228
Ragpicker, The (Manet), 96
Railroad, The (Manet), 43
Raphael Santi, 52, 120, 129, 132, 164,
 168, 186, 193, 258, 259, 361, 383,
 398
Rauschenberg, Robert, 308, 309, 310,
 326, 327, 333, 417, 418, 435
Rawlinson, Richard, 57
Rawlinson, Thomas, 57
Rayner, Nicholas, 397
Réalités, 304, 324, 325
Reconnaissance, The (Meissonier),
 172–73
Redford, George, 39
Redon, Odilon, 122, 152
Rees-Mogg, Lord, 205
Reff, Theodore, 76–77, 79
Reid, Alex, 88–89, 212–13, 214
Reinhardt, Ad, 278, 289
Reinshagen, Maria, 18, 23–25
Reis, Bernard, 252, 341, 342
Reitlinger, Gerald, 110, 227, 228, 237,
 253, 350, 354, 425–26, 428
Rembrandt van Rijn, xxiv, 49, 101,
 168, 173, 186, 192, 200, 242, 252,
 321, 329, 330–31, 337, 361
Remy, Pierre, 58, 59
Renoir, Pierre-Auguste, xxiv, xxvii,
 xxviii, 4, 9, 16, 17, 23, 26, 43, 76,
 77, 83, 84, 86, 91, 94, 98, 99, 100,
 104, 105, 106, 116, 120, 121, 126,
 152, 187, 191, 197, 202, 229, 263,
 272, 304, 311, 316, 317, 334
Repos, Le (Courbet), 304
Rewald, John, 10, 42, 43, 83, 86, 96,
 176, 177, 178, 179, 301, 322, 333
Reynolds, Joshua, xxiv, 38, 55, 70, 102,
 186, 200, 227, 228, 229, 238, 425
Rheims, Maurice, 295
Ribbentrop, Joachim von, 273
Ricci, Piero, 240
Richter, Jean Paul, 134, 135
Ricketts, Howard, 344
Ridolfi, Carlo, 50
Ring, Greta, 208
rings (knock-outs), 204–6, 331–32
Rivière, Henri, 9

Road to Calvary (Dürer), 329
Roberts, William, 147
Robertson, Austin, 33
Robinson, Edward G., 193
Rochlitz, Gustav, 273
Rockets and Blue Lights (Turner), 173
Rodin, Auguste, 152, 272
Rolfe, Susan, 12, 15, 17, 20, 21, 23, 26
Romantic Movement, 73
Romney, George, 102, 186, 227, 228, 229, 350
Roosevelt, Eleanor, 314
Rorimer, James, 321
Rose, Barbara, 327–28
Rosebery, Lord, 359
Rosenbach, Abraham, 205, 217, 283–84
Rosenberg, Alfred, 271, 272
Rosenberg, Harold, 290
Rosenberg, Léonce, 190, 191, 208–9, 210, 211, 219, 236
Rosenberg, Paul, 208, 211–12, 268, 273, 278
Rosenquist, James, 326, 327
Ross, Steve, 372, 373
Rossetti, Dante Gabriel, 102, 113, 114, 231
Rothko, Mark, 278, 288, 289, 308, 340–43, 348
Rothschild, Edmund de, 359
Rothschild, Elie de, 337
Rothschild, Emma Luise, 254
Rothschild, Ferdinand de, 227–28
Rothschild, Lionel Nathan de, 227
Rothschild, Mayer Amschel de, 359
Rothschild, Nathan Mayer, 228
Rothschild, Victor, 254, 359
Rothschild family, 82, 254–55, 359
Jakob Rothschild Investment Trust, 351, 356, 359
Rouart, Stanislas-Henri, 98–99
Roundell, James, 14, 26, 391, 407
Roundell, Peter, 391
Rousseau, Theodore, 271
Roussek, E. H., 326
Royal Academy, xvi, 54, 55, 63, 66, 344
Rubens, Peter Paul, 425
Rubin, Lawrence, 365, 368
Rubinstein, Helena, 314

Rue Mosnier aux drapeaux, La (Manet), 316, 450
Rue Mosnier aux paveurs, La (Manet), 388–89, 391, 397
Rumsey, Mrs. Charles, 198
Rupf, Hermann, 158, 210
Ruskin, John, 65, 114, 127, 245
Russian art, 4, 403–4
Ruxley Lodge sale, 204, 205–6, 331, 332
Ryusei, Kishida, 201
Ryuzaburo, Umehara, 202

Saatchi, Charles, 433–35, 436, 438, 439
Saatchi, Doris, 434
Saatchi, Maurice, 434
Sabin, Frank, 205
Sackville-West, Lady, 225
Sagot, Clovis, 88, 157, 161, 199
Sainer, Leonard, 372
Salle, David, 367
Salle des Ventes, 91
Salmon, André, 208
Salon d'Automne, 151, 161, 207
Salon de l'Art Français Indépendants, 208
Salon des Cent, 208
Salon des Indépendants, 207
Salon des Surindépendants, 208
Salon des Tuileries, 208
Salon Unique, 208
Samuels, Mitchell, 257
Sanredam, Peter, xxiv, xxviii
Sargent, John Singer, 127, 199, 229–30, 231, 238, 281, 312, 319
Sarlie, Jacques, 322
Sartre, Jean-Paul, 280
Sasazu, Etsuya, 392, 393, 394
Sawada, Masahiko, 465
Schauss, Hermann, 83
Schenker Papers, 271, 273
Schmidt-Reissig, Georg, 158
Oscar Schmitz collection, 325
Schnabel, Julian, 367, 368
Scholey, David, 373
Schreiber, Charlotte, 113
Schwartz, Estelle, 435–36
Scott, John Murray, 225
Scriver, Strelsa von, 287

Scull, Robert, 310, 326, 368, 416–18
Scully, Sean, 434
Sears, Willard, 129
Seascape: Folkestone (Turner), 384, 385, 386
Sedelmeyer, 92, 132, 164
Seibu department store, 410, 411, 463
Seiki, Kuroda, 116
Self-Portrait (van Gogh), 9–10, 18, 25–26
Self-Portrait: Yo Picasso (Picasso), 6, 400, 433
Seligmann, 132, 140–41, 219, 272, 324
Seligmann, Germain, 190, 224, 225–26, 235, 242, 253
Seligmann, Jacques, 224–25
Seligmann, Kurt, 277
Selz, Peter, 341
Seney, George Ingraham, 35, 36, 118, 120
Settled Lands Acts, xv, 38, 40–42, 65, 71, 73
settlements, 204–5
Seurat, Georges, 84, 86, 121, 154, 193, 231, 264
Shadow of Death, The (Hunt), 102
Shakespeare, William, 206
Shanghai art market, 274–75
Sharpe, Sarah, 213
Sharpe, Sutton, 213
Shaw, James Byam, 324
Shchukin, Sergei, 100, 158
Shikanai, Nobutaka, 452
Shintaro, Yamashita, 116
Shiomi, Kazuko, 393
Shirakaba (White Birch), 201
Sickert, Walter, xxi, 100
Signac, Paul, 121, 122, 154–55
Simon, Norton, 140*n*, 324, 329, 330–31
Simpson, William, 60
Sisley, Alfred, xxvii, 23, 96, 104, 105, 106, 121, 122, 187
Sitwell, Osbert, xxi, 230
Slater, Jim, 352
Smith, G. D., 149, 150, 196, 217
Smith, Joan Irvine, 376
Smith, John, 57, 63
Smoker, The (Meissonier), 37

Société Anonyme, 182
Société des Beaux-Arts, 89
"SoHoiad, The" (Hughes), 367, 368
Soko Gakkei, 465
Soleil du matin à Saint-Mammès (Sisley), 23
Solly, Edward, 63, 72
Solomon, Holly, 365
Solow, Kim, 12, 23
Somerset, David (Duke of Beaufort), 330, 331
Sonderbund, 179
Sonnabend, Ileana Castelli, 305, 306–7, 308–9, 326, 328, 346, 347, 348
Sonnabend, Michael, 310, 348
Sotaro, Yasui, 202
Sotheby, John, 40, 60
Sotheby, Samuel, 40
Sotheby, Samuel Leigh, 40
Sotheby's, xv, xvii, 4, 7, 41, 164–65, 168–69, 199, 200–201, 203, 206, 207, 245, 249, 254, 266–67, 275, 280, 282–83, 284–85, 312, 314, 315, 316, 317, 332–33, 334, 336, 350–51, 364, 369–72, 380–82, 384, 385–86, 392, 405, 417, 423, 433, 441, 448, 451, 454, 457–59, 475
 Belgravia, 344–45, 350, 351, 356, 357
 Berlin office of, 445
 book auctions of, 40, 59–60, 65
 British Rail Pension Fund and, 354–56
 buyer's premium at, 353–54, 355, 356, 472
 Christie's vs., 6, 9, 16, 26, 38, 64, 218–20, 253, 318–21, 350, 351, 379, 385
 Citibank and, 437
 Cogan and Swid's attempted takeover of, 372–75, 376, 377
 evaluation business of, 238
 Farouk collection and, 295, 296–97
 financial services of, 385
 Fribourg sale and, 322
 Heirloom Discovery days at, 357–58
 history of, 40, 59–60, 64, 65
 Irises sold by, 3, 6, 9, 10, 18, 24, 25, 253, 397–400

Sotheby's (*cont.*)
 Japan and, 351–52, 393, 410, 411,
 460, 463
 Matisse estate and, 456–57
 "Million-Dollar List" of, 455
 Moscow sale of, 403–4
 1989 report on, 479–80
 Parke-Bernet acquired by, 321,
 322–23
 proposed merger of Christie's and,
 238, 267, 283
 publishing arm of, 64
 Quaritch and, 148
 Rothschilds and, 359
 stock market crash and, 237, 238–39
 Switzerland and, 445
 Taubman's purchase of, 164, 375–78,
 472
 von Hirsch sale and, 361–62
 Warhol auction and, 401–3
 Windsor jewels sold by, 396–97
Soutine, Chaim, 235
Soviet sales, 241–44
Sower, The (Millet), 394
Spanish Singer, The (Manet), 95
Speelman, Eddie, 317
Spink, John, 48
Spira, Peter, 351, 353, 356, 370
Spirito Santo, Manoel Ricardo, 352
Stamos, Theodoros, 341, 342
Steichen, Edward, 143, 162, 176,
 177–78
Stein, Gertrude, 134, 161–63, 180, 210
Stein, Leo, 161–62, 163, 177
Stein, Michael, 161
Stein, Sarah, 161
Steinberg, Saul, 287
Steinlen, Alexandre, 9
Stella, Frank, 310, 327, 366
Stella, Joseph, 198
Stetson, John B., 195
Stevenson, Hugh, 373
Stewart, Alexander Turney, 118–20
Stewart, Wheatley and Adlard, 60
Stieglitz, Alfred, 163, 176–77, 178, 182,
 196, 198, 199
Still, Clyfford, 278, 288, 289, 348
Still Life with Apples (Gauguin), 311

stock market crash:
 of 1929, 231, 235–41, 243, 244
 of 1987, 398, 400, 448
Stone, Irving, 311
Storming of the Citadel, The
 (Fragonard), 132
Stowe sale, 65
Stratford Mill (Constable), 389
Strauss, Michel, 345
Stroganov Palace sale, 244
Strongin, Barbara, 11–12, 14–17, 20,
 22, 62
Stubbs, George, 66, 102, 186–87
Sulley (dealer), 132, 222, 324
Sullivan, Mrs. Cornelius J., 287
Summers, Martin, 18, 440
*Sunday Afternoon on the Island of La
 Grand Jatte* (Seurat), 121, 231
Sunflowers (van Gogh), 6, 14, 389–92,
 394, 395, 397, 398, 400, 431, 445
Supper Party (Picasso), 252
Surrealism, Surrealists, 276, 277, 279,
 285, 303, 305
Sutton, Denys, 313
Sutton, James F., 33–37, 86, 120–22,
 192, 196
Swann, Arthur, 145–47, 149, 150, 197,
 256
Swarzenski, Georg, 360
Swid, Stephen, 372–75, 376, 377
swindling, 222–23
Switzerland, xvi, 333, 334, 444–45
Symbolism, 153–54

Tajan, Jacques, 442
Takana, Masahiro, 393, 410–11
Talleyrand-Périgord, Charles-Maurice
 de, 61
Tanguy, Julien-François (Père), xxiii,
 90, 92, 94, 157, 237
Tanguy, Yves, 236, 276
Targets (Johns), 309
Tariff Law (1909), 175
Taste of the Town, 58
Tate Gallery, 312, 434
Taubman, A. Alfred, 46, 375–78,
 380–82, 384, 385, 386, 393, 397,
 402, 404, 445, 446, 457, 472, 473

Taylor, Francis Henry, 143
Thames and the Houses of Parliament, The (Monet), 96
Thaw, Eugene, 361, 362, 440, 471
Thaw (Rauschenberg), 417
Thompson, Henry, 113, 114
Thompson, Julian, 371, 381
Three Maries (van Eyck), 262, 263
Thyssen-Bornemisza, Hans Heinrich, 381–82, 390
Tiepolo, Giovanni Batista, 198, 320
Times (London), 38, 39, 206
Tintoretto, 50, 139
Tissot, James, 111, 351
Titian, 135, 135, 139, 186, 197, 207, 425
Togai, Kawakami, 116
Toklas, Alice B., 162
Tokyo Art Club, 408–9
Tomkins, Calvin, 278, 285, 286, 288, 289, 290, 305, 306–7, 308, 309, 310, 327, 328, 349, 365
Tooth, Dudley, 169, 338
Torres, Antony, 70
Torres, Giovanni Battista, 69–70
Torrey, Frederic C., 182
Toulouse-Lautrec, Henri de, 17, 23, 77, 79, 94, 152, 187, 192, 193
Tower of Babel, The (Brueghel), 262
Tragedy of Lucretia, The (Botticelli), 128
Tragic Muse, The (Reynolds), 228, 425
Trial of the Thirty, 154
Triumph of Bacchus (Poussin), 53, 54
Triumph of Pan (Poussin), 53, 54
Troyon, Constant, 95, 103, 187
Trucker, Heidi, 12, 20–21, 23
Truth, 206
Tschudi, Hugo von, 100, 160
Tsurumaki, Tomonori, 452
Tsutsumi, Seiji, 381, 393, 463
Turner, Emory S., 146, 147
Turner, J.M.W., 102, 173, 186, 195, 200, 282, 329, 384, 385, 386
Turquin, Eric, 443–44
"291" (Photo-Secession Gallery), 176–78, 198, 199
Tzara, Tristan, 210

Utrillo, Maurice, 193, 231, 236

Vail, Laurence, 275–76
Vaisman, Meyer, 435
Valentin, Curt, 278, 301
Valentine Dudensing Gallery, 285
Vallotton, Félix, 86, 112, 154
van Beuningen, Daniel George, 262–63
Vanderbilt, Cornelius, 120, 133, 283
Vanderbilt, Mrs. William K., 34
Vanderbilt, William H., 133
Vandergrift, Mary, 216, 284
van Dongen, Kees, 155, 157, 335
Van Dyck, Anthony, 164, 186, 227
van Eyck, Jan, 244, 262, 263
van Gogh, Theo, 7, 86, 87, 88, 89, 104, 105–6, 159, 312
van Gogh, Vincent, xv, xvi, xvii, 3–26, 37, 84, 86, 87, 88–89, 90, 94, 100, 116, 152, 159–60, 178, 183, 187, 188, 193, 222, 229, 231, 253, 263, 311, 316, 332, 386, 388, 389–92, 394, 395, 391, 397, 400–401, 455
 Bing and, 111–12
 Japanese art influenced by, 201, 202
 Picasso compared with, 401, 405
 and romantic idea of artist, 401
 suicide of, 3, 8, 401
van Gogh, Vincent "Uncle Cent," 86, 87
van Gogh-Bonger, Johanna, 159–60, 189
Van Loo, Carle, 59
Van Loo, Jean-Baptiste, 59
van Meergeren, Hans, 263
van Uylenberg, Saskia, 252
Vasari, Giorgio, xxiv
Velázquez, Diego Rodríguez de Silva y, 129, 187, 329, 337
Venus and Adonis (Titian), 425
Vermeer, Johannes, 186, 262–63
Victoriana, 343–46, 356–57
Violoncelliste, Le (Gauguin), 188
Vlaminck, Maurice de, 75, 151, 157, 158, 162, 191
Vollard, Ambroise, xvii, 9, 81, 86, 90, 92, 94, 132, 151–53, 157, 160, 162, 179, 183, 199, 213, 255, 310

Waddington, Leslie, 339, 439
Waddington, Victor, xvii, 305, 338, 339
Wagner, Richard, 43
Walker, George, 19–20
Walker, John, 35
Wallace, Lady, 225
Wallace, Richard, 82, 83, 225
Wallace-Bagatelle collection, 225
Wallace collection, 144, 225
Wallis, George, 62
Walton, Parry, 57
Ward, Eleanor, 289–90
Warhol, Andy, 326, 327, 366, 401–3
Warre, Felix, 237
Waterlilies (Monet), 24
Watteau, Jean-Antoine, 58, 220, 272
Weber, John, 328, 346, 436
Weill, André, 269
Weinberg, William, 5, 285, 311–13, 315, 316, 317, 318, 338
Weitzner, Julius, 332
Wells, Gabriel, 196, 217
Wendland, Hans, 273
Wertheimer, Samson, 156, 219, 324
Wesselmann, Tom, 326
Westmorland, David, 369, 370, 371, 375, 376
Wethered, William, 45
Wexner, Leslie, 381
Wheatley, Benjamin, 60
Whistler, James McNeill, 73, 92, 94, 110, 111, 112, 113, 114, 115, 229
White, Stanford, 115, 137
White Flag (Johns), 418
Whitney, Cornelius Vanderbilt, 283–84
Whitney, John Hay, 9
Widener, Joseph, 143
Widener, P.A.B., 133, 137, 140, 143, 149, 150, 164, 168, 186, 197, 222
Wilde, Oscar, 7, 134
Wildenstein (dealer), 16, 18, 20, 23, 219, 220–21, 237, 268, 278, 295, 324–26, 364
Wildenstein, Alec, 337

Wildenstein, Daniel, 220, 326, 337
Wildenstein, Georges, 220, 221, 236, 242, 253, 268, 324–26
Wildenstein, Lazare, 272
Wildenstein, Nathan, 132, 138, 220–21, 222, 236, 253, 324, 325
Wilkinson, John, 40
Wilson, Anthony, 281
Wilson, Barbara Lister, 281
Wilson, Helen Ranken, 281
Wilson, Martin, 281
Wilson, Peter Cecil, xvii, 266, 267, 281–83, 284, 285, 295, 312, 315, 316, 320, 321, 322, 323, 332–33, 336, 338, 351, 353, 354–55, 356, 364, 369–70, 371, 374, 375, 377, 380, 384, 417–18, 445, 446
Windsor jewels sale, 396–97
Winston, Harry, 257
Wise, Thomas James, 247–48, 284
Wolfe, Catherine Lorillard, 214
Wolfe, Tom, 336
Woman after a Bath (Renoir), 465
Woman Reading (Renoir), 465
Woman with a Hat (Matisse), 161
Woman with a Parrot (Manet), 96
Woodner, Ian, 13
Wordsworth, William, xxiii
World War II, 265–75, 279, 280
Wright, Joseph, 55

Yamamoto, Susumu, 412, 451–52, 460
Yamanaka, 292
Yasuda Fire and Marine Insurance, 391, 393
Yerkes, Charles Tyson, 169–73
Young, Alexander, 200
Yuichi, Takahashi, 116

Zanetti, Vittore, 71
Zietz, Rainer, 361
Zola, Émile, xxiii, 84, 85, 89, 93, 97, 111, 136, 152, 389
Zorn, Anders, 125, 126–27

About the Author

PETER WATSON was educated at the universities of Durham, London and Rome. He has been a correspondent for *The Sunday Times* (London), *The Times* (London), and the London *Observer,* for which he now writes a regular column about the art world. He also writes for *The New York Times.*

In 1982 he exposed a gang of art thieves who were smuggling stolen Italian Old Masters into the United States. His account of that, *The Caravaggio Conspiracy,* was filmed by both ABC-TV and the BBC. The book won a Gold Dagger Award from the Crime Writers Association of Great Britain.

Peter Watson has published nine other books, which have been translated into more than a dozen languages. He lives in London and France.

About the Type

This book was set in Times Roman, designed by Stanley Morison specifically for *The Times* of London. The typeface was introduced in the newspaper in 1932. Times Roman has had its greatest success in the United States as a book and commercial typeface, rather than one used in newspapers.